KANDINSKY
Complete Writings
on Art

KANDINSKY
Complete Writings on Art

Edited by Kenneth C. Lindsay
and Peter Vergo

Da Capo Press
New York

Library of Congress Cataloging in Publication Data

Kandinsky, Wassily, 1866-1944.
 Kandinsky, complete writings on art / edited by Kenneth C. Lindsay and Peter Vergo. — 1st Da Capo Press ed.
 p. cm.
 Originally published: Boston, Mass.: G. K. Hall, c1982.
(Documents of twentieth century art). In two vols.
 ISBN 0-306-80570-7
 1. Art, Modern — 20th century. I. Lindsay, Kenneth Clement, 1919– . II. Vergo, Peter. III. Title.
N6490.K293 1994 93-33694
700 — dc20 CIP

First Da Capo Press edition 1994

This Da Capo Press paperback edition of *Kandinsky: Complete Writings on Art* is an unabridged republication of the edition published in Boston in 1982, with the addition of a new preface by the editors and 25 plates originally omitted from *Sounds*. It is reprinted by arrangement with Editions Denoel, Paris, and with G.K. Hall & Co., New York

Da Capo Press would like to acknowledge the invaluable assistance of Kenneth C. Lindsay, Peter Vergo, and Patrick J. McGrady in making this volume as complete as possible.

Published by Da Capo Press, Inc.
A Subsidiary of Plenum Publishing Corporation
233 Spring Street, New York, N.Y. 10013

"I want people to see finally what lies *behind* my paintings."
—Kandinsky to Will Grohmann, November 21, 1925

Preface to the Da Capo Edition

The editors of this book are pleased to see it reprinted in paperback form because it can now reach a larger audience. Credit must go to Da Capo Press, who had the vision to republish this book and who made corrections and added the full page illustrations of *Klänge* (*Sounds*), which were not included in the original edition due to budget limitations. The corrections were contributed by Peter Vergo and the added illustrations were contributed by Patrick McGrady. In his doctoral dissertation, *An Interpretation of Wassily Kandinsky's Klänge* (SUNY Binghamton, 1989) McGrady showed how the illustrations of *Klänge* were inextricably involved with the meaning of the poems.

The two articles Kandinsky published in Russian ethnographic journals during 1889 were only summarized in our original book; their translator, John Bowlt, did not think they were directly related to art, an opinion we then shared. However, the studies of Peg Weiss (first presented on October 17, 1985 to Kenneth Lindsay's Kandinsky Seminar at SUNY Binghamton) demonstrated the effect Kandinsky's early study of Russian law and religious beliefs in the Vologda province had upon his ensuing artistic imagination. Her work will be published late 1994 by Yale University Press; therefore we have not altered our presentation of this material.

Peter Vergo
Kenneth Lindsay

Table of Contents

1919

1920

1921

1922

Contents

Contents

Appendix

Preface and
Acknowledgments

This volume presents, for the first time in English, all of
Kandinsky's writings on art published during his lifetime, as
well as a selection of interviews and lecture notes.[1]* The
texts were written over a period of more than forty years;
they range from statements a few lines long (see p. 53) to
whole books like *On the Spiritual in Art* and *Point and Line
to Plane*. Kandinsky wrote in Russian, German, and French,
but his writings appeared in languages as diverse as Serbo-
Croatian, Danish, Dutch, and Italian. In each case, it is the
first *published* appearance that has been taken as the basis
for these translations.[2]

Other editions of these writings in various languages have
for the most part been based on secondary sources or on
republications, not on the original texts. In this way, the
errors that have crept in from edition to edition, and from
translation to translation, have been compounded. In making
these new translations, we have gone back wherever possible
to the original publications. In those rare instances where we
have been unable to locate an original copy of a particular
item, the headnote preceding the translation indicates that
we have depended upon a secondary source.[3]

In general, the texts are arranged chronologically by date of
publication. Some of Kandinsky's statements lay unpub-
lished for several years: for example, his essay on *Composi-
tion 4*, dated March 1911, first appeared, together with three
other essays, in the Sturm album of 1913 (see pp. 348–354). It

*Superscript numbers refer to the editors' notes beginning on p. 861.

is therefore placed under 1913, not 1911, in this collection. The only exceptions to this rule are the foreword to the second edition of the *Blaue Reiter Almanac* (1914) and the foreword to the second edition of *Point and Line to Plane* (1928), which are printed along with the first editions of 1912 and 1926, respectively. Some items have been grouped together for ease of reference, for example, Kandinsky's "Letters from Munich," published in *Apollon* (pp. 54–80) and his contributions to *XX^e Siècle* (pp. 813–828). Any indication of the date and place of writing has been retained, but to avoid unnecessary repetition, the artist's name, when printed at top or bottom of an individual article or essay, has been omitted.

Kandinsky both wrote and thought visually, and layout and typography were matters of great importance to him. He would separate passages of text by spaces of different size, sometimes interposing little stars or little dots as a kind of visual punctuation. (These marks *do not* indicate omissions; abridgements in text are specifically noted.) He also employed italics, capitalization, and different type sizes, not only to stress a point, but often for visual effect. We have tried as far as possible to reproduce the appearance of the original texts, following, for example, the fashion for all lower-case letters in some of the writings of the Bauhaus period. The reader will also notice the use of s p a c e d type to give emphasis to a particular phrase or paragraph; this convention, although unfamiliar to an English-speaking audience, has also been preserved. Kandinsky was a great lover of footnotes, which were nearly always placed at the bottom of the page; we have marked them *, †, ‡, etc., to distinguish them from editors' notes, which are collected at the end of the volume and indicated by Arabic numerals (e.g.,[1]). In the texts themselves, editorial intervention has been kept to a minimum; such intervention is indicated by the use of square brackets.

Where linguistic problems obtrude, the original word or phrase is included for comparison, for example, [*bezpredmetnyi*].

Kandinsky's two books and many of his articles were illustrated. Where illustrations are integral to the text, they have been reproduced in this edition, as far as possible in their original positions. Particular care has been taken to preserve a sense of scale and spacing. The cover of the first edition of *On the Spiritual in Art,* its title page, and the title page of *Point and Line to Plane* have been reproduced to convey something of the flavor of the originals. Some of the artist's designs for catalogues or journals have also been included. On the other hand, we have omitted reproductions that serve merely as a kind of visual accompaniment to the texts, and have refrained from interposing handsome illustrations of our own choosing. All photographs have been taken from the original publications.

It would, however, be idle to pretend that what is presented here is a kind of facsimile in translation. In the texts themselves, some attempt at standardization was considered desirable for the sake of clarity. Paragraphs, for example, are usually indented, except where, in the original, they are clearly separated from one another by spaces (but see also pp. 702–705, where the layout of Kandinsky's article "The Value of Theoretical Instruction in Painting" is so idiosyncratic that the only solution was to mimic the original). References have also been standardized to conform to modern scholarly usage (picture titles and the titles of books in italics, journal articles and names of exhibiting societies and commercial galleries are printed in Roman type (e.g., the Neue Künstler-Vereinigung). Where in German a noun is preceded by an adjective, our rendering preserves the weak form of the adjective, regardless of whether the definite or indefinite article is present (hence "the Blaue Reiter," not "the Blauer Reiter";

"the Deutsche Künstler-Verein," not "the Deutscher Künstler-Verein").

The transliteration of Russian into English is a subject of heated debate wherever that language is taught or learned. We have, advisedly, adopted what seemed to us the most logical system, which rejoices in the cumbersome title "British Standard 2979:1958," but with final "y" in personal names, and with some slight modifications to take account of the latest international agreements, except where some other spelling is especially favored (e.g., "Jawlensky" for "Yavlensky"). Otherwise, both spelling and punctuation conform to modern American usage.

The task of the translator, as of the editor, demands a good deal of tact. In general, our guiding principle has been that meaning comes first, literalness second. There are, however, some exceptions to this rule. Kandinsky thought not only visually, as we have noted, but also poetically, and the sounds of certain words intrigued him, not only in his poetry but in his prose writings as well. Particularly in the prose poems, it has sometimes been necessary to translate for sound rather than sense. At the other end of the scale, Kandinsky often expresses himself clumsily, especially in German, and in these cases we have tried to render the ungainly character of his writing, resisting the temptation to "polish up" the original. Occasionally, he makes some statement that is as good as meaningless; in these rare instances, the translator has resorted to a note to give vent to his frustration. Misprints and misspellings in the original have been corrected without specific mention; wrong dates, mistaken references and the like, on the other hand, are dealt with in the editors' notes.

Even where Kandinsky expresses himself clearly and elegantly in the original, it is often impossible to find an entirely

satisfactory English equivalent. Both German and Russian lend themselves to abstract thought to a far greater extent than does English, and abstract concepts are notoriously difficult to translate. For example, Kandinsky frequently uses the German word *Gesetzmässigkeit* which, ideally, one would wish to translate with a single English word, but no one word by itself will do. Phrases such as "law-governed character" or "tendency to conform to law" capture the meaning, but are unlikely to impress the reader by their elegance or economy. Particular texts, moreover, pose particular problems. In *Point and Line to Plane*, the author makes frequent use of the word *Grundfläche*—so frequent that in the last chapter he abbreviates it to *GF.* By *Grundfläche*, however, he means several different things, although he himself fails to distinguish among his various uses of the term. Sometimes the word is used to denote "ground" (as opposed to "figure"); sometimes it means "basic plane" (or "picture plane"); on other occasions, it is clearly the *surface* of the canvas that he has in mind. One may try to capture the shifting nuances of *Grundfläche* by using different English words or phrases, depending on the context; but for *GF,* it was necessary to devise a standard abbreviation (PP) that could be employed throughout the final chapter regardless of any changes in meaning. The translator is only too aware of the unsatisfactory nature of the solution finally adopted.

Essays originally published in languages Kandinsky did not speak, such as Dutch and Danish, also presented a certain difficulty. He presumably submitted a German or Russian manuscript, which would then have been translated, quite possibly by someone unfamiliar with his way of thinking and expressing himself. The result is sometimes convoluted and often betrays a foreign accent. Words and expressions occur that Kandinsky himself never used. One is reminded of a filtrate that has picked up something of the flavor of the filter

paper. Nonetheless, we have kept to the reality of the printed statement, translating the text as faithfully as possible, instead of trying to imagine what Kandinsky might have said had he spoken Danish or Dutch. (By the same token, where texts were first published in English, we have simply reproduced untouched the translations by Eddy, or whomever, as they originally appeared). Even where Kandinsky quotes from his own earlier writings, we have decided against trying to match the translation to the original German or Russian, but rather translated the text we had before us. If consistency suffers as a result, so much the worse for consistency.

A few of the texts printed here were already available in English translations. In particular, the reader should note Robert L. Herbert's excellent rendering of "Reminiscences" (in *Modern Artists on Art: Ten Unabridged Essays* [Englewood Cliffs, N.J., Prentice-Hall, 1964], and Klaus Lankheit's useful documentary edition of the *Blaue Reiter Almanac* (New York, Viking Press, 1974). There are also two almost complete editions of Kandinsky's writings in other languages: *W. Kandinsky, Écrits Complets*, édition établie et présentée par Philippe Sers (Paris: Denoël-Gonthier, 1970, and subsequent vols.); and *W. Kandinsky: Tutti gli Scritti* (Milan, Feltrinelli, 1974).

The critical apparatus that follows is not to be read as a surrogate monograph on Kandinsky. Our aim throughout has been to present the original texts, as far as possible, in a clear and manageable way. The headnotes are designed to provide essential background information, and to place Kandinsky's writings in their historical context; they are not intended as a resumé of Kandinsky scholarship to date. Where further clarification seemed necessary, chronological and other issues are examined in the footnotes. However, considerations such as ease of use ultimately prevailed over exhaustiveness.

Thus, not every issue is touched on, not every problem of chronology, nor indeed of translation, discussed. Information easily available elsewhere has been rigorously excluded, such as biographical notes on individual artists and well-known personalities. Only where a particularly obscure reference might cause the reader genuine puzzlement is this kind of material included in an explanatory note.

Finally, we should perhaps stress that what follows is the product of our combined efforts. Any notional division of responsibilities between the two editors soon vanished in a welter of discussions, enthusiasms, and frustrations, from which emerged a mutual affection and respect that renders any acknowledgment each to the other superfluous. We wish, on the other hand, to express our profound gratitude to our respective institutions, and to the many friends and colleagues who have helped us in our work. Our particular thanks to the late Mme. Nina Kandinsky and to the late Gabriele Münter who both graciously hosted and aided Kenneth Lindsay in 1949–1950 and 1958, respectively; also to Professor John E. Bowlt, the late Will Grohmann, Angelica Rudenstine, and Dr. Peg Weiss, all of whom helped by locating or providing rare material and by giving invaluable information and advice. Our thanks also to the following individuals and institutions for their cooperation, and for their efforts on our behalf: Norbert Adler; Professor Aldo Bernardo; Professor Alan Birnholz; Professor Albert Boime; Dr. Klaus Brisch; Barbara Burn; Margit Chanin; the late Agnes Charnstrom; Professor Svend Eriksen; Phyllis Freeman; Curt Johnson; Professor William Klenz; Professor John Lakich; Jean and Suzanne Leppien; Guy Lindsay for making photographs of the illustrations; Robert Maas; William Clark McGuire; Dr. Penelope Mayo; Professor Clark V. Poling; Professor Daniel Robbins; Carol Schuler; the library and staff of the Museum of Modern Art, New York, and especially

Pearl Moeller, Supervisor of Special Collections; the New York Public Library; the Solomon R. Guggenheim Museum; the Pierpont Morgan Library, and in particular William Voelkle; Gisela Brotherston; Judith Butler; Christian Derouet; Larissa Haskell; Candida Holland; Professor Michael Podro; Dr. Thomas Puttfarken; Marie-Agnes von Puttkamer; Maureen Reid; the library and staff of the Victoria and Albert Museum; the library and staff of the Warburg Institute, University of London; the British Library; the Rijksbureau voor Kunsthistorische Documentatie, the Hague, and especially Dr. W.H.K. van Dam; the library of the Zentralinstitut für Kunstgeschichte, Munich, and especially Dr. Günter Passavant; the Städtische Galerie im Lenbachhaus, Munich, its director, Dr. Armin Zweite, and members of the staff both present and past, in particular Dr. Rosel Gollek, Dr. Erika Hanfstaengl, Frl. Sabine Helms, and Fr. Friedel Lautenbacher. In 1969–1970, Dr. Hans Konrad Roethel, then director of the Städtische Galerie, kindly allowed Peter Vergo access to the important collections of the Gabriele Münter Stiftung and to the documents and other archive materials in possession of the Gabriele Münter und Johannes Eichner Stiftung; our thanks to him and his assistant, Dr. Jelena Hahl, for their cooperation at that time. It is, however, painful to record that Dr. Roethel, in his capacity as director of the Münter-Eichner Stiftung, has in more recent years found himself unable to assist either editor in any way in the preparation of this volume.

The Research Foundation of the State University of New York and the University of Essex Research Endowment Fund both provided welcome financial support. Our editor at G. K. Hall and Company, Caroline L. Birdsall, supplied an all too

rare combination of patience, encouragement, and understanding. Without the help, support, and scrutiny of Christine Lindsay and Sara Selwood, this book would probably never have been finished.

Kenneth C. Lindsay
State University of New York at Binghamton

Peter Vergo
University of Essex

Introduction

In general we expect writing of quality and literary purpose only from professional writers. The act sets them apart from those who dislike putting words down on paper, or who conceive of writing as a simplistic act, grudgingly executed, performed only to obtain some daily need. Scribes from the ancient civilizations of the Near East were held in high esteem because they recorded scripture with their magical "pen." Even today an aura of respect surrounds the writer, albeit mixed with suspicion: the soldier who scribbles away at night, the scrivener in the office, the diarist—these are people who are up to something.

Particularly open to mistrust are artists who write. Is such an artist using the recorded word to foster his own posterity? Does he write to compensate for an insufficient talent? Are his paintings little more than justification of his theory? These are unfriendly questions, asked mostly by hostile critics and the artist's competitors.

The historian is more kindly disposed. On the lookout for clues and insights, he welcomes every scrap of written information for whatever assistance it can yield. The art public, to whom the historian must communicate with words, is often so beholden to the word that its eye becomes inhibited. With catalogue in hand, the viewer genuflects before the painting's label and the art work itself becomes only a confirmation of the "superior" truth of language.

Kandinsky was aware of these issues. In his early art reviews he mocked catalogue clutchers. Responsive to the problems of art history, he admonished critics to grasp the totality of an artist's *oeuvre* before making judgments, but he responded to questionnaires with scrupulous care. He recognized the virtue of verbal reasoning for an artist and encouraged it to roam freely except during the act of creation. Only when the brush has completed its odyssey should the mind examine the findings with words.

He realized, correctly, that the central meaning of each art form defies

translation. For him, art produced emotions too subtle to be expressed in words. Indeed, the emancipation of art from the tyranny of literature was basic to Kandinsky's thinking. The very title of his first album of woodcuts, *Poems without Words* (1904), declares this point of view. Consequently, he accepted without animus the imperative "Artist, create, don't talk!" in response to his solicitations for articles for the *Blaue Reiter Almanac,* and also Matisse's answer, "One must be a writer to do something like that."[1]

As for the question of self-promotion, it was natural that Kandinsky should defend his own achievements. He understood the way writing enhances the artist's public image. But the attentive reader of this book will discover that personal aggrandizement played a minor role in motivating his writing; the issues that stirred him were mainly larger ones.

Kandinsky wrote poetry throughout most of his career. Early attempts, such as the few lines he wrote to Gabriele Münter in 1903, were not auspicious,[2] but his mature works have a distinctive flavor. Though they stand outside the larger tradition of modern poetry, as do the poems of Degas, they show an awareness of the potency of words when, weighed like colors in a painting, they function pictorially in the structure of evolving mood.[3] Kandinsky was also sensitive to the ancient sacral aspect of writing, a responsiveness that infused later essays like "Empty Canvas" with a spirit of incantation.

As a young man of twenty-three, Kandinsky savored the pleasure of publication for the first time. His first two works, published in 1889 by the Imperial Society of the Friends of Natural Science, Anthropology, and Ethnography, and by the *Ethnographic Review,* were studious and disciplined reports on law and social customs.[4] By 1895 Kandinsky had dropped his academic work in order to manage a Moscow printing establishment. Having become disillusioned with positivism and theory, he wanted to experience practical matters, such as wages. The printing of photographs fascinated him. This and the smell of printer's ink made him accustomed to the art of publication and at the same time introduced him to the creative possibilities of illustrated books and typographical variability. There is no doubt that this early experience in Moscow helped him in the preparation of the *Blaue Reiter Almanac* years later.

Kandinsky wrote voluminously. His letters, lecture notes, and notebook jottings are probably as extensive as the formal writings presented in this book. Sandwiched between the creation of a sizable output of art works, his writing must have flowed easily from his pen. A 1943 handwritten statement for the artist César Domela, published in facsimile by Seuphor, appears to be a first draft, corrected with word changes and deletions.[5] The writing process here is in keeping with the twofold process of his late painting, in which each drawing was followed closely by the painting to which it gave rise. By contrast, Kandinsky's larger and more formative writings of 1910-1913 went through a series of drafts, reflecting the complex evolution of his paintings of that time.

Our decision to present Kandinsky's writings chronologically differs from the grouping by subject preferred by Philippe Sers, editor of the French edition of the *Écrits Complets*.[6] Kandinsky probably would have agreed with Sers: in 1920 he maintained that there was no "guiding principle or system" in the way most museums display art works chronologically. Kandinsky was somewhat indifferent to the significance underlying the abstraction of dates. He referred to personal experiences that had signal importance for the evolution of his thought—witnessing Monet's *Landscape with Haystack*, hearing Wagner's *Lohengrin*, seeing one of his pictures placed sideways in the light, beginning the writing of *On the Spiritual in Art*—with exasperating lack of concern for time and place. Referring to the Russian version of *On the Spiritual in Art*, he doubly erred by calling it an article and dating it "Petersburg, 1910" (the manuscript was read at a conference in St. Petersburg in December 1911, and published in 1914). He asserted that he was the first to paint a nonobjective painting (he dated this work 1911 and located it in Russia), but later soft-pedaled the primacy of the act.[7] In spite of his meticulously kept House Catalogue, this work remained innocent of title, catalogue number, and specific location. To this date no one has been able to identify with certainty the work he had in mind.[8]

This ambiguity about chronological time helps us to understand how in the late 1930s he could misdate his early watercolors (including the most famous *First Abstract Watercolor*).[9] Ambiguity does not, however, explain the precise chronological structure of the House Catalogue—unless one pushes irony to the limit. This issue assumes a different coloration if we accept Gabriele Münter's claim that she herself inaugurated the House Catalogue system.[10] Thus we could see

Kandinsky—fascinated with this Germanic way of thinking—
overcompensating by using the system as a way to protect himself from
himself.

Although he kept to the letter of cataloguing, he did not grasp its
spirit. His sense of time blew like the wind. Mysterious yet palpable, it
gave him a bold view of history and the temporal aspects of the arts, and
above all, to traits that often escape modern chronologists: optimism
and the privilege of faith.

Kandinsky's writings on art have a distinct character. Although his
writings changed in tone and style during his career, they rarely lose a
certain family resemblance. This identity is achieved not by the
semaphoring of literary flourish or belligerent stance, but by his earnest
appeal for vivification—the desire to infuse life into mundane things (as
Cézanne did with teacups). He responded to the demand that untouched
white paper, like a breathing entity waiting for the fertilizing touch, be
treated with reverence. Here Kandinsky affirmed the "enthusiastic at-
titude" of the romantics whereby the artist, possessed by the gods, finds
the vibrancy of life in all things.

His writings were rarely confessional. Because of its autobiographical
nature, *Reminiscences* brings us a step closer to the artist's persona, but
the self-consciousness inherent in this genre formalizes our approach.
Kandinsky's guard goes down momentarily in the 1914 lecture, where
he candidly admits to his lingering need for the object as a bridge to the
goal of nonobjectivity.

Even his verbal humor is reserved. Not as spritely as the humor in his
painting, it ranged from the dark and oblique moods of his poetry to the
sardonic "quartet" he invented to refute the hostile Swedish critics in
1916, and to the pungent comparisons he made in the essays of the
1930s. In some of these late essays Kandinsky countered attacks like a
lawyer: he went on the offensive with a deft touch, ironically com-
pounding food and art imagery so as to make his aesthetic homiletics
more palatable.

Letters and the recollections of friends are other resources we can use
to evaluate the man and locate his formal essays in a broader framework.
Kandinsky's letters cannot compare with those of Mozart or van Gogh,
for many are preoccupied with practical considerations like exhibitions,
arrangements, and sales. Only when we look past the Werther pose of
his early letters to Münter do we discover the human dimensions of the

man. Occasionally, in his correspondence with Grohmann and J.B. Neumann, Kandinsky reveals secrets of his iconography and shares ideas that will become the substance of later essays. But his letters to his only real friend, Franz Marc, are special. They show his firm grasp of the complexities of organization, the warmth of his enthusiasm, and the immensity of his energies.

An artist's letters, books, and essays are documents of a specific time. They tell their tale without the distraction of afterthought. By comparison, the recollections of friends and acquaintances—often conflicting, sometimes self-serving—must be subordinate in value. Still, both types of data serve to limn Kandinsky's career as a network of personal circumstances intersected by historical events.

Although Kandinsky studied in Germany and began his career there, his focus remained on Russia. Most of his writings during the first decade of this century were in Russian, including the inscriptions in the House Catalogue, as well as the first formulations of *Sounds* and possibly of *On the Spiritual in Art*. During his travels he returned frequently to his native country, maintained contacts there, and kept abreast of the rapidly emerging art scene. Moscow was his "spiritual tuning fork," and the *Arrival of the Merchants* (1907) was painted, in fact, "as an escape valve" for his longing for Russia.[11]

It is not, however, a foregone conclusion that Kandinsky would have eventually returned to Russia had the war of 1914 not forced him to do so. The Blaue Reiter experience solidified his leadership in the avantgarde of Munich and, above all, affirmed the idea of *synthesis*—an idea that transcended national boundaries. Synthesis justified assembling the disparate photographs reproduced in the *Blaue Reiter Almanac*, it provided the rationale for the coexistence of art and music, and it paved the way for his daring equation of the Great Abstraction with the Great Realism.

Synthetic ideology is opposed to barriers that artificially separate. Artists are human beings first and Germans, French, Americans, or Russians second. Even though German national pride was a dominating force in the Munich middle class, and fostered the vituperative attacks of local artists against the "foreigners,"[12] Munich was still a hospitable place. It was in Munich that Duchamp resolved his artistic problems in the summer of 1912, and it was there that Spengler outlined the thesis for his *Decline of the West*, a radical kind of historical expressionism that, by rupturing traditional borders of time and space, provided a

dramatic new interpretation of history.

The ending of a war tends to shame nations into momentary yearnings for unity. The League of Nations and the United Nations were both postwar courtships of synthesis. But Kandinsky dreamed of synthesis prior to the war and he realized that dream in his art. Although the League died and the United Nations falters, Kandinsky's flag remained unfurled throughout his lifetime, until he died in 1944. Half-mast after the Second World War, it inspired an entire generation of artists.

To understand how the interaction of private and public events shaped Kandinsky's theory of synthesis, it will be helpful to glance at the end of his career first—to see, so to speak, how the story turned out.

People who knew Kandinsky in Paris during the last decade of his life found him leading a regulated, outwardly bourgeois existence. Work, punctual meals, siestas, walks in the Bois de Boulogne, vacations, and attendance at concerts, circuses, or the theater—all were measured out in discrete time packages. It was the lifestyle of a Peter Paul Rubens rather than of a Modigliani. A sense of tranquility and contentment characterized Kandinsky's life during these later years. When the Nazis overran France, and colleagues of his in the artistic and scientific community escaped to America, Kandinsky refused to flee from a dictatorship for the third time,[13] deciding to remain in Paris. Earlier, in 1931, he had turned down an invitation to teach at the Art Students League in New York City.[14] One reason for this stasis was Kandinsky's age, a factor that the vitality of his late paintings belies. But if his daily life became more settled in routine, his mind and imagination continued to be active. He read Nelidov's new book on Russian theater the year of its publication; he disagreed with Alfred Barr's diagrammatical analysis of modern art (on the jacket of his *Cubism and Abstract Art*, 1936) and met almost everyone of importance in the Paris art world.

Kandinsky's late paintings—those from the last five years of his life—show a remarkable range of inner voyaging. The late writings, on the other hand, do not have the same adventurousness. Frequently they cite earlier writings of his formative years or restate old arguments in new ways. Synthesis sufficed. Not needing further development, it provided the artist with serenity of spirit, and contrasted sharply with the last-minute doubts Mondrian was feeling about his own pictorial problems at approximately the same time.[15]

This elder statesman walking quietly through the Bois de Boulogne was a far cry from the relatively young bicycle-riding artist who com-

pleted his training shortly before the Wright brothers flew the first airplane. In 1900, one year before he finished his studies with Stuck at the academy in Munich, he exhibited for the first time. Stung by the superficiality of art criticism, the thirty-five-year-old "graduate" entered the fray, a formidable opponent because of his legal, academic, and managerial experience. In his first art publication (April 1901) he crossed swords with the great Tolstoy, whose *What Is Art?* had recently appeared. With biting sarcasm he assailed the lesser Russian critics of Moscow and Odessa newspapers. He also decried the audacity of the critic G. I. Rossolimo in describing art works exhibited by the Association of Moscow Artists as "product[s] of a sick mind ... of degeneracy"—the same phrases used by the Nazis thirty-six years later in Munich.[16]

At the end of spring 1901, Kandinsky organized the Phalanx exhibition club, and by the end of the year he had established the Phalanx art school. This "impulse to activity"—to use Klaus Brisch's appropriate phrase[17]—led to extensive travel and contacts. It drew Kandinsky inexorably into the main currents of modern art. His trips back to Russia and all over continental Europe—to arrange for Phalanx exhibitions—served to acquaint him with new personalities and new movements, as well as new opportunities for exhibiting his own works. His trip to North Africa in 1904 was mostly an extended painting excursion. There, as Delacroix, Gérôme, and Bekhteev had done before him, and as Klee and Macke were to do later, he savored the forms, customs, and colors of that exotic continent.

On 22 May 1906, Kandinsky and Gabriele Münter arrived in Paris and rented a house in Sèvres until 9 June 1907. This quiet suburb southwest of Paris provided him with parks to paint and ride in, and solitude. Like his later havens, Murnau and Neuilly, Sèvres was a place of semiretreat for the artist.

Kandinsky's behavior in Paris was curious. If he profited—as Jonathan Fineberg has shown he undoubtedly did—from his contact with the journal *Les Tendances Nouvelles,* there is no evidence that he sought out those artists who were then making history in Paris—Matisse, Picasso, and Braque.[18] After Paris and before Murnau there were several months in Berlin; then, a nervous breakdown.

Even though Kandinsky did no formal writing during the restless years between 1903 and 1908, his mind was sponging up everything pertinent to his emerging philosophy. The ferment of new ideas that

bubbled in Munich was seasoned by his French experience and his travels to Russia. Just as his painting reflected the influence of these experiences, so did his writing. One has only to compare his "Correspondence from Munich" of 1902 with the "Letters from Munich" of 1909-1910 to see the maturation that took place. His favorites of 1902—Zuloaga, Gandara, Ménard, Cottet, Brangwyn, and Leistikow—were replaced in 1909 by a new battery—Cézanne, van Gogh, Matisse, Gauguin, and Manet.

Two unrelated factors appear to have fueled Kandinsky's need to write. The first springs from negative experiences imposed by major historical events; the second was a positive response to his affiliations and the recognition accorded him through exhibitions. On the negative side, his expulsion from Germany when war broke out in 1914 prompted the first notes for *Point and Line to Plane*, and his flight from Nazism in 1934 led him to the competitive art world of Paris. On the positive side, his literary proclivities were fired by the Phalanx enterprises, the formation of the Neue Künstler-Vereinigung [New Artists' Association] and the Blaue Reiter, the one-man shows given him by *Der Sturm* (1912) and by Gummesson in Sweden (1916 and 1922), his participation in the utopian dream of the USSR (1918-1921), the Bauhaus experience, and his jubilee exhibitions of 1926.

Kandinsky's universalism manifested itself throughout all aspects of his life. One might think that his taking of German citizenship papers in March 1927 and French papers in July 1939 indicated an abandonment of his basic philosophy. The truth is, Kandinsky took such papers to obtain what was necessary for a citizen of the world: freedom of movement.[19] He resented being canned like a sardine by external circumstances. Perhaps this was why he often told visitors that his lineage extended, on his father's side, to a Tartar princess in a mythic Far East. In essence, he was saying, "Even though you see me inhabiting this country at this time, I hail from a magical land and cannot be pinned down like a butterfly in a display case."

Universalism explains how he, a Russian Orthodox, could respond favorably to the best aspects of theosophy, for theosophy ignored barriers of country and sect. It also explains his aversion to the familiar typecasting of politics. Witness, for example, his quaint but succinct reply to a 1938 questionnaire:

National anthems have now been sung in almost all countries; but I am content not to be a singer. . . . These national anthems are precisely a type of lure. But there does exist a propagandistic art—for the best chocolate in the world and "Balto" cigarettes.

Finally, universalism excludes racism. Kandinsky's liberal philosophy, clearly evident in his writings, precluded narrow prejudices like anti-Semitism. But an inflammatory issue often distorts reasoned assessment. In 1923 even Arnold Schoenberg was disposed to believe rumors that threatened to poison his friendship with Kandinsky. When Schoenberg's letters were published a few years ago, this issue was presented in such a way that careless critics fanned these flames anew.[20] Apparently it did not seem strange to them that a well-known photograph—reproduced in Grohmann's book—showed Schoenberg and Kandinsky with their wives in 1927, enjoying each other's company on the shore of the Wörthersee. Nina Kandinsky's book tells the whole story: it puts the vicious rumor to rest on the broad lap of its perpetrator, Alma Mahler.[21]

Compared to those of his own generation, Kandinsky was a late starter. By the time he finished art school, many in his age group had already made their mark, such as Ensor, Munch, Seurat, Signac, Denis, Erler, Stuck, Behrens, Bergson, and Wölfflin. Though a tardy beginning can be discouraging, given the right circumstances and temperament, a late starter can harvest the best and highest fruit from his generational tree. This happened with Kandinsky. His extensive travels and belief in synthesis put him into a position to pluck the fruit that most of his predecessors in France, Russia, and Germany could see but not reach—nonobjective painting.

In *Les Tendances Nouvelles* Mérodack-Jeaneau and Henri Rovel published a fund of information dealing with synesthesia, correspondence among the arts, the need for an artist to be guided by "his internal beacon," and the subordination of form to content. These were topics that greatly concerned an artist striving to exceed the limitations of the merely decorative. In Russia the issue of art as a valid language was stimulated by Aleksandr Potebnia's query: "Thought can dispense with words. Is not that which is expressed in musical tones, in graphic forms, or in colors also thought?"[22] For the "Salon, International Exhibition of Art," held in Odessa, Vladimir Izdebsky, in his 1909 introduction to the catalogue described the route art was taking:

The artist who has defeated the old forms and mastered the secret of colors and lines now feels bored with this chaos and is tired of amusing himself with the brightness of color and sunshine. He is searching for a new synthesis, a new reality for his spirit. He reveals his innermost secrets and extends the content of his creative work without converting it into publicity or photography. The artist strives for something greater than merely capturing the mood—he yearns to excite, to invite man to reveal the intimacies of his ego, to give art the emotion of revelation and an understanding of the miracle of line and color.[23]

As Peg Weiss has shown,[24] in Germany, especially in Munich, there were numerous attempts to explain the rationale for a new art without objects, but their authors—Endell, Eckmann, Lipps, Hölzel, Behrens, Avenarius, Obrist, and others—somehow never seemed quite able to finish their paragraphs. People in the crafts did complete those paragraphs—but in the "lower case" of the craft tradition. They could do this because the decorative tradition was more compatible with abstract devices, and made no pretensions to High Art. Kandinsky, also nurtured in the craft tradition, saw its potential but also recognized its limitations. The slow, groping evolution of his style, and his doubts en route, bore witness to the earnestness of his quest.

There was no satisfactory name for the elusive ideal that stimulated his search. The hostile minds that had invented the labels Impressionism, Fauvism, and Cubism went on a convenient holiday, leaving the field open for people like Kahnweiler, Picasso's supporter, to drag up the specter of decoration.[25] *Decoration* was both incorrect and negative. *Nonobjective* was more accurate, but still sounded negative; it did not acquire broad usage until later, and then only with difficulty.

There were problems from the beginning. When Kandinsky used the Russian word *bezpredmetnyi* [without object] in 1910 to describe Manet's work, he meant that Manet painted "purely"—that is, without a literary objective in mind. In 1911 Kandinsky used the phrase "pure painting" to describe expression by means of color, form, plane, and line interrelations, with real objects such as "a man, a tree, a cloud" giving only "an allusion or aroma in the composition." The less precise the object, the more intense the "purely painterly composition."

A legal mind, like Arthur Jerome Eddy's, could see the next logical step: completely eliminate the object and thus maximize the intensity. When Eddy questioned Kandinsky on these matters in 1913, he patiently replied that remnants of objectivity emit a secondary tone (the

"allusion or aroma" of 1911), but should not be important to the spectator. And he added that the cannons in *Improvisation No. 30* had been selected for his own use. Kandinsky expanded upon this perfunctory explanation shortly afterward, in his Cologne lecture of 1914, saying that he retained veiled objects in his paintings so that the spectator, gradually recognizing them, could savor their overtones, and also because he, the artist, still needed objects during his transitional years to help him bridge the gap to pure abstract form. Small wonder that later he sometimes had difficulty in specifying which of his early works qualified as nonobjective.[26]

In "Reminiscences" (1913) Kandinsky used the expression "nonobjective painting" [*gegenstandslose Malerei*] to explain how the old trunk of art was growing into two equal "branches of development." He appears to have used the expression descriptively and, perhaps out of indecision, reserved name-giving for the attendant footnote. There he called the two branches "the virtuoso manner" and the "compositional manner." In the compositional manner, today generally (but still not satisfactorily) known as the *nonobjective,* he wrote that the "work springs mainly or exclusively from 'out of the artist.'" By using *mainly* instead of *exclusively,* Kandinsky reflected his equivocation. His phrase *compositional manner* did not take hold.

In 1919 he used *abstract,* which derived from his earlier writings, overlooking his 1914 revisions for a new edition of *On the Spiritual in Art.* There he had acknowledged the inadequacy of the word *abstract* by giving it the qualifier *purely.* But both *abstract* and *purely abstract* lost their relevance as the field of modern art became crowded. In letters to Hilla Rebay in 1936 and 1937 he explained the misunderstandings inherent in the term *abstract* ("abstracted from some object"), and said he preferred *nonobjective* (that which "creates its own elements").[27] Concurrently, he promoted the term *concrete* for the European public.

Kandinsky held no fundamental bias against objects. He allowed for the Great Realism that deploys material things in realistic settings. During the latter part of his career, by admitting that objects can "insinuate" themselves, he acknowledged the role the unconscious had played in the creation of his art. Thus, his paintings offer a triple challenge of interpretation: as pure painting, as painting with veiled subject matter, and as documentation of the unconscious.

By eluding satisfactory nomenclature, Kandinsky's work joins the art of the past hundred years in which, increasingly, pictorial invention has

outstripped nomenclature. Perhaps our heightened historical awareness aggravates the situation by making us suppose that we can and should capture change with names. Art is not alone in this respect: musicologists and musicians also struggle with the momentous changes that have occurred in their field. The major historical problem consists of distinguishing expected evolution from what, if anything, might be called fundamental change.

In the watershed year 1912 art dramatically completed its substantive shift into modernity. Absorbing the implications of previous efforts, artists realized they could shed the entire logical skin of the external world and fashion their own pictorial universes, each with its own internal consistency. Recognizing their new rights (and following their inclinations), artists manipulated fragmentary remembrances of the given world or constructed a new world by purely pictorial means. Some artists moved through this transition with ease and little fanfare. Others simply jumped on the moving bandwagon. Still others, like Picabia (who well might have anticipated nonobjective art in 1909), moved rapidly from one possibility to another.

Kandinsky, however, did not experience 1912 easily or superficially. With pen in hand he piled hope upon doubt, informed us of his anguish, and recorded these heroic times as few other artists did. During the time when his unnamed art was being realized, when he and others shook themselves free from the embrace of post-Romanesque art, even the weather seemed portentous. Kandinsky noticed during the unusually hot summer of 1911 that everything seemed white. Whiteness, by bleaching out the contours of what had previously existed, begged for new voyaging on new paths.

The increasingly obscured subject matter that dominated Kandinsky's painting between 1909 and 1914 reflected his new awareness. In one group a horseman rides his steed along a mountain range, hunts with bow and arrow, glides through the air; at times he battles with another horseman or gallops up mountains of little pleasures; at other times he races with two other horsemen across a romantic landscape or pulls a troika. A second group shows the horsemen transformed into apocalyptic riders, holy people emerging during All Saints' Eve, the waters of the Deluge overflowing the land, or the blast of trumpets of the Last Judgment toppling high towers. This second group, comprising eschatological subjects which had not greatly concerned painters for over half a

century, is so unusual that we must address their iconological signifi-
cance. What did these curious subjects mean for Kandinsky and for art in
general?

Some of the paintings from both groups yield to hermeneutics; others
retain their secrets.[28] Still the lone horseman appears to be Kandinsky's
emblem of self-identification, a motif that reflected both his personal
aspirations and those of his generation. This emblem continued to
haunt the paintings of his last twenty-five years.[29] The eschatological
subjects, however, are more elusive. They concern us here because of
their bearing on his breakthrough into nonobjective art and his writings
of that time.

There are a number of ways to approach this topic. Sixten Ringbom
and Rose-Carol Washton Long emphasize the predilection that the
theosophist Rudolf Steiner had for the writings of St. John and the
impact this in turn had upon Kandinsky.[30] Some of their evidence is
persuasive, but it tells only part of the story. Although Kandinsky
appreciated Steiner's methodology and the ways in which occult ex-
perimentation coincided with his own interests in dematerialization, he
maintained a skeptical distance: he was a painter, not a theurgist. Detlev
W. Schuman, in his study of "Motifs of Cultural Eschatology in German
Poetry from Naturalism to Expressionism,"[31] showed that general
interest in these topics peaked around 1910-1913, the very time Kan-
dinsky was using them in his paintings. Because Schuman concentrated
upon German literature, he had to overlook Russian interest in the
apocalyptic during the same period[32] and could not touch upon the
peculiar lucidity with which art sometimes informs fundamental
change. Kandinsky's eschatological motifs must be viewed first in rela-
tion to theological tradition, then in wider art historical perspectives.

The Judgment and All Saints are closely related and pertain to the Last
Things described in the apocalypse. The Old Testament Deluge has been
associated with them because of their common concern with new be-
ginnings that follow the endings of eras.[33] Kandinsky captured this
apocalyptic spirit in his painting *Composition 6* (1913), for which the
motivating subject was the Deluge. He ends his descriptions of this
work on an affirmative note: "What thus appears in objective terms a
mighty collapse is, when one isolates its sound, a living paean of praise,
the hymn of that new creation that follows upon the destruction of the
world."

There are other aspects of early Christian thought that curiously, and

of course unintentionally, describe conditions that correspond to the operative world of nonobjective art. If, after Judgment, a day is like a thousand years,[34] then chronological time ceases to be the yardstick by which the events and stories of realist art are measured. Instead, a timelessness prevails in which colors and forms can function on their own terms. In this immensity of transhuman time, the traditional technique of chiaroscuro cannot be applied. Old sources tell us that after the cataclysm the secular shadows of time yield to the "new lights of eternity."[35] Nonobjective painting keeps pace with this vision: shadows cast by candles, moons, and suns vanish so that a new kind of light can emanate from within the picture's core.

Of all the factors this theological tradition and nonobjective art share—the loss of corporeality, the stopping of mundane time, the extinguishing of secular light—light reveals itself most tellingly. Some civilizations—like that of China—never have a shadow cast in their paintings. Neither did artists of the Middle Ages use cast shadows. Erwin Panofsky observed the use of "genuine cast-shadows projected on the ground" in the March picture of the *Très Riches Heures* of the Duc de Berry, which comes as a real surprise, for this device had not been used since Hellenistic antiquity.[36] Real light, which creates shadows, seems to turn on and off during nodal points of history. Thus, we can speak literally of the "Dark Ages." The realistic light in the March picture apparently heeds the burgeoning Renaissance and points the way to the Enlightenment. The turning off of external light in early twentieth century art signals the arrival of new thought and value systems. Because our society is pluralistic, our "victory over the sun" carries multiple meaning. In discussing what this might signify for the study of Kandinsky's art and thought, a backward glance will aid our cause and show how deeply rooted in Western tradition these matters are.

In the Middle Ages the elimination of directional light did not preclude other kinds of light. Light can be used as an abstract symbol possessing specialized meanings of high order, and during the Middle Ages Neoplatonist metaphysics made the eternal and infinite luminosity of God transcend real time, empty spaces, and solid bodies. Artists symbolized it with gold or with bright colors.[37] Bodies immersed in this effulgence were positioned symbolically, not realistically. The time that rendered these bodies operative was measured by a cosmic clock, not an earthly one, and so when figures acted narratively, their actions were

transhumanized into the nontime of symbolism.

In Dante's *Divine Comedy* for example, the sun, conspicuous by its absence in the Inferno, makes its appearance in Purgatory, where it functions as a guide to Dante and Vergil.[38] While in this region, only Dante casts a shadow, for he alone has a material body. His body breaks the sun's light (Canto 3), thus symbolically obstructing God's enlightenment (Canto 15). Yet the sunlight is their guide, for without it at night they make no progress upward. Step by step Dante prepares himself to view the light, which grows ever stronger. In Paradise, he transcends his mortal self to experience the brilliant light that is everywhere. Dante's transhumanization means that he will no longer be capable of casting a shadow and will no longer yield to the law of gravity. Finally, in Canto 33, he has the Beatific Vision and sees the Supreme Light. Viewing the three colored circles of the Trinity and wanting to "see how the human image was conformed to the divine circle and has a place in it," Dante needs the illumination of Grace. St. Bernard gives him this capacity to discover human measure in the colored circles of the divine nonobjective display. It is ironic that Italy's highest expression of the medieval quest for transcendence resisted convincing pictorial visualization until modern art made it possible.

Kandinsky's art is closer to medieval visions than it is to the fleshiness of Renaissance and Baroque art. Many of his paintings, for example *Light Picture* of 1913, radiate an inner glow. As his writings show, he approached painting with Vergil (reason) as guide, but when he painted, Beatrice (intuition) directed his hand. Spectators who wish to experience his art must act as their own St. Bernard.

In many respects we now live in a "Middle Ages in reverse."[39] Our modern Inferno is not dark, but blazes with rushing electrons. Though the sun as God's enlightenment is extinguished, the modern pilgrim moves in all directions, like a particle dancing the Brownian movement of hither and yon. Ultimate confrontation being absent, he must find temporary consolation in the abstract workings of his art and science.

From Kandinsky's point of view before the war, we lived in a world full of optimism, a world that was both new and traditional at the same time. He felt that, like the joyous figures in his All Saints pictures, people should rise from their graves of material existence and greet the new promise of the coming "Epoch of the Great Spiritual." But man did nothing of the sort. For four years he soaked the mud of Europe with his own blood.

After the outbreak of the war Kandinsky had to leave Germany in haste. He rented a house in Goldach, a tiny Swiss town on Lake Constance, near Rorschach and some fifty miles from Zurich. Except for exchanging a few letters with Paul Klee, he cut himself off from all contact with the world. Here, even more than in Sèvres, he became a recluse. His time was spent systematizing his thought into what later resulted in the book *Point and Line to Plane*. Had he known Lenin, another Russian refugee in Switzerland who was calling secret conferences and scribbling away in libraries at that time, there would have been little to talk about. Kandinsky was as apathetic about politics as Lenin was about art.

Riding the crest of political events, Lenin returned in a sealed German train to Russia and to triumph. Three years earlier, in December of 1914, Kandinsky returned via the southern route, alone in his individuality and unwelcomed by the fractious Russian artists. He spent seven years accommodating to and participating in the new Communist society.

His artistic output slackened during these years. Watercolor, an easily transportable medium, became his favored technique. He filled two notebooks with intense, smaller works; some carried forward his style of 1914, while a few depicted fighting scenes with running horsemen. The *Bagatelles*, done in Sweden in 1916, exude a Biedermeier sensibility. A few landscapes, close in spirit to his small oil studies of 1901-1903, and figurative paintings in the *Hinterglasmalerei* technique of 1909-1913, indicate a temporary loss of nerve, a comfort in repeating previous solutions. Like many other creative men, Kandinsky momentarily side-stepped history during the war. His reaction resembled Schoenberg's, although it lacked the intensity of the composer's withdrawal. Unlike Picasso, Kandinsky did not find creative challenge in the refuge of neoclassical drawing, nor did he fully capitulate to it, as Severini and de Chirico did. He regained his momentum only after a few years.

Kandinsky was young enough in spirit to capture the heart of an attractive Russian girl still in her teens, Nina Andreevskaia, and he reacted trustingly to the idealism of the Russian Revolution, immersing himself in the problems of building up art resources in the new society. His letter to the journalist Adolf Behne—published in the Socialist Berlin newspaper *Die Freiheit* in early 1919—described with enthusiasm the vigorous accomplishments in all the arts. The International Bureau of the Department of Fine Arts sent Ludwig Bähr west in December of 1918 to call for "international unity in the creation of a

new artistic culture." Bähr brought back friendly responses from a number of active organizations. In this way Kandinsky kept abreast of what was happening in Germany and established contacts that soon became useful to him: his correspondent from the Worpswede Artists' Union, Hugo Zehder, published the first monograph on Kandinsky in 1920; and his correspondent from the Bauhaus (State Building School) in Weimar, Walter Gropius, appointed him to his faculty in 1922. Being an insider in the cultural administration of Anatoly Lunacharsky, Kandinsky saw to the Russian revision and publication of his autobiography in 1918. His paintings were purchased by the newly formed Museum of the Culture of Painting, an institution that he had helped establish. Like George Grosz, Kandinsky was always a good businessman.

As one reads the artist's writings during this period and observes how he gracefully adjusted here and there to the revolutionary ideology, how he unleashed his old dreams of synthesis by suggesting a worldwide edifice of art to be called "The Great Utopia," and how at the same time he aggressively promoted his career, one can suppose that Kandinsky was something of an irritant to his Russian contemporaries. His success must have provoked envy; and the recollection of his early pioneering accomplishments must have been salt in the wounds of younger men who were equally proud of their accomplishments and who fought for them with unceasing polemics.

But there were other, more basic reasons that made Kandinsky realize he could not "go home again." The substance of his spiritual outlook had derived from a prewar mood that was foreign to the argumentative materialism of Soviet society. As early as 1911, younger voices were speaking out for change. In a lecture in Madrid on mathematical thought, Ortega y Gasset attacked the triumph of continuity, evolutionism, and infinitism that dominated mathematics, physics, biology, and history, by suggesting discontinuity and finitism.[40] In 1913 even Kandinsky's good friend David Burliuk began to denounce "that talk about content and spirituality" as "the greatest crime against genuine art."[41] And the literary group known as Acmeists "scorned the mystical vagueness of symbolism, its vaunted spirit of music."[42]

Thus, at the moment of Kandinsky's breakthrough, members of a younger generation were proclaiming a basic change in values. Now the scholastic discipline of Cubism and the hard-nosed aspect of Futurism came to the fore. By the time Kandinsky was reestablished in Moscow, these forces had gained an ascendant position. Puni, Popova, Rod-

chenko, Tatlin, Malevich, and El Lissitzky cajoled their pictorial dreams into the tight embrace of finite graphic outlines. As later oblique references suggest, Kandinsky seemed unable to forgive them their success. They, in turn—even those who shared his utopian dreams—must have found the presence of the old blue rider embarrassing, for as he clung to his old ideology, he responded to some of the new values with disturbingly audacious and direct criticism. In a 10 July 1921 interview Kandinsky touched upon the incipient academic reaction.

Rather than wait for the avant-garde to strangle itself with its own excess,[43] Kandinsky left Russia, not waiting to hear Lunarcharsky proclaim that the "only type of art which the modern bourgeoisie can enjoy and understand is nonobjective and purely formal art."[44]

The time of the horse was over. The time of the bull had come. Kandinsky's magnificent steed (Picture with Archer [1909]), with its outstretched neck that had developed from Boecklin's and Rousseau's "War" horses of the 1890s, had become fully realized in Lyric of 1911. This painting was a startling visual statement of the hopes of Europe before its house dissolved in heartbreak. But Lyric was challenged immediately. Burliuk made it a Death Rider; Carrà a hobbyhorse; and from 1917 on, Picasso gored it with a bull.[45]

Did Kandinsky leave Russia because he was disenchanted with a souring situation or because of the allure of new horizons? Was it a matter of escape or quest? This is a question that our limited data cannot fully satisfy. We do know that Kandinsky was forced to resign from the Institute of Art Culture in 1921;[46] that other artists left before and after he did; and that he departed with permission to stay abroad for three months and, failing to return, lost his citizenship.[47] Will Grohmann, who knew the artist intimately from 1923 on, maintained that Kandinsky had planned to make a new start in Germany, giving as evidence the artist's use in 1922 of German titles in the House Catalogue.[48] Nina Kandinsky, who considered Grohmann's biography the definitive work, provides a different version of why Kandinsky left Russia. She asserts that in the fall of 1921 Kandinsky received Gropius's invitation to the Bauhaus, which was channeled via the Kremlin by Karl Radek (one of the leading members of the Communist International).[49] Corroborating information in support of her view would confirm that Kandinsky's reason for "going" superseded his reason for "leaving."

Germany was ready to be conquered by Kandinsky again. He had long been known and admired in the west. A painter like the young Alberto

Magnelli, for example, in London during 1915, had read *On the Spiritual in Art* and was converted overnight to the new manner of expression.[50] A Kandinsky exhibition in Helsingfors in 1917 suddenly opened all doors for the architect Alvar Aalto.[51] Hans Goltz in Munich and Herwarth Walden in Berlin refused to let a state of war prevent them from exhibiting Kandinsky's work. The Galerie von Garvens (Hanover) and the Galerie Nierendorf (Cologne) presented his paintings in 1921. The Swiss Dadaists also showed his works and read his poetry; Hugo Ball—who considered Kandinsky the ideal modern artist—lectured on him in Zurich, comparing Kandinsky the "monk" to Picasso the "faun."[52]

Within five months after Kandinsky's arrival in Berlin, the Galerie Goldschmidt-Wallerstein staged a Kandinsky exhibition and requested that the artist speak on the state of Soviet art. This exhibition made a strong impression on Tomoyoshi Murayama, an art student who had recently arrived in Berlin and was to become the first person to take Kandinsky's work back to Japan. Murayama described the exhibition in colorful terms:

> The familiar things about the earlier paintings of Kandinsky had been a feast of entangled colors and running lines. But I found no movement in the ten paintings. Clearcut shapes were stuck on the earthen base color. Some of them were embossed as if they were hooked together by many threads. Shapes were round, oval, triangular or wavy. . . . I was standing out of myself in the center of the room. "Is it permissible that pictures like these should be so beautiful?" I asked my heart. "Very beautiful! I cried, as if I had met a girl who was extremely clean, cultured, and gay, but who could never be the object of sexual appetite. I approached the pictures and scrutinized them one by one. The gay girls named *Picture with a White Circle*, *Picture with a Yellow Angle*, *Picture with a Red Triangle*, etc., were standing as if restraining themselves before a guest. When I approached, I could smell a healthy fragrance come from them.[53]

Bruno Taut and Adolf Behne had also prepared the ground for Kandinsky's return to Germany. Even before he had left, Taut's appreciation of his contribution was published in *Der Sturm* (February 1914): "The architect must bring into his creative work all possible architectural forms, in the same way that they manifest themselves pictorially in the brilliant compositions of Kandinsky. . . . "[54] Marcel Franciscono's study of the creation of the Bauhaus in Weimar shows how Taut—influenced by the architectural fantasist Paul Scheerbart and by Kandinsky—

proposed a great utopian building, a symbol of the future, which would, as a synthetic demonstration, house the achievements of all the arts. This idea in turn anticipated Kandinsky's plan of 1921 for an art building to be called "The Great Utopia." Adolf Behne, also influenced by Kandinsky's thought and terminology, joined Taut in translating the Deutsche Werkbund [German Labor Federation] cooperative idealism into the thinking of the Arbeitsrat für Kunst [Workers' Council for Art], which in turn laid the groundwork for the formation of the Bauhaus.[55] It was Behne to whom Kandinsky had written in 1919 concerning the new flowering of art in the USSR. A socialist writing for the *Sozialistische Monatshefte,* Behne must have been instrumental in seeing that Kandinsky's exhibition at the Galerie Goldschmidt-Wallerstein was reviewed in that journal,[56] and may well have helped Kandinsky receive his appointment at the Bauhaus.

During his ten Bauhaus years Kandinsky's recognition and productivity in all fields peaked (with the exception of poetry). Without doubt, this would not have happened had he remained in the USSR. During his first year at the Bauhaus, his work was exhibited in Düsseldorf, Berlin, Munich, Stockholm, and New York. In the following years his exhibition record was overwhelming—except in Paris. When finally, in 1929, he had his first one-man show there, it was a Russian who presented it (at the Galerie Zak).

At the Bauhaus, Kandinsky's previously amorphous forms were now crystallized into clearly outlined structures situated in the nonmetrics of illusory space. He had already begun moving in this direction in Russia, but now this new style predominated, with loose and painterly works becoming the exception rather than the rule. His writing followed suit. Kandinsky now organized his thoughts more succinctly, and his reasoning often unfolded in numbered sequence, buttressed by precise graphic designs. His book *Point and Line to Plane* epitomized this period, as *On the Spiritual in Art* had epitomized the prewar years.

It must have been gratifying to Kandinsky to see his vision of synthesis flower in the fertile Bauhaus soil. He described its practice in curriculum statements and approved of colleagues like Paul Klee and Oskar Schlemmer, who went beyond the limits of a specialized approach. Like thoughtful artists of the preceding four centuries, he recognized the difficulty of placing art and technique in parity.[57] If the early Bauhaus (and its Russian equivalent, the Vkhutemas of 1919) tipped the scale in favor of technique, the Dessau years (where the Bauhaus moved

in 1925) realized a more just equilibrium. One cannot help wondering why he did not use the school's ample facilities to stage *Yellow Sound*, but that ill-fated play was so hedged with excuses that he might have realized its difficulties and preferred to see his new work, *Pictures at an Exhibition*, placed in performance.

Kandinsky was demanding of his students. He required them to think precisely and to discuss their works "on purely theoretical grounds." As a counterfactor, he invoked the injunction of his first teacher in Munich, Anton Ažbè: Know your anatomy, but forget it in front of your easel. This search for equipoise between reason and intuition helps elucidate a comment he made in his essay honoring Klee. Recalling the early heroic days of the Bauhaus, he mentioned the students' hitchhiker image and the "long hair, which after a few days began to get shorter." Hair length—also mentioned by Paul Klee's son, Felix, Bauhaus student (and later master) Alfred Arndt, and Tut Schlemmer—seemed to Kandinsky to be inversely proportional to a student's dedication.[58] It would be a mistake, however, to relate this prejudice to either the Beatles revolution of the 1960s or the stay-comb fad of the 1920s. In the early 1920s a haircut reflected the trimming down of expressionistic extravagance, the long wavy locks of Jugendstil (or Art Nouveau), in favor of Art Deco discipline. Kandinsky's own art showed this general shift, but did so without losing its underlying character: though circles replaced his earlier impetuous horsemen, passion remained beneath cool circumscription.

In Dessau, Kandinsky shared a two-family master's house with Klee. Gropius's sharp-edge white-walled structure replaced the prewar rural Murnau with its view of the mountains beyond the Moos. The new apartment in Neuilly—which the Kandinskys entered in 1934—had aspects of both, plus the special atmosphere of Paris. He had remained loyal to the Bauhaus until the end; but nothing could stop the spreading political virus which usually claims art as its first victim.

In France Kandinsky, now approaching seventy, wrote in a more relaxed manner. His mode of thought moved at a slower pace, interspersed sometimes with playful imagery and at other times with a legal thrust of argument. In spite of adverse economic conditions, he reminded his readers that material goods never suffice, and that war and household machines do not deserve reverence. His exhortation to penetrate the outer husk of things and seek the living interior recalls notions that extend back to the early Christian era. The battle between mate-

rialism and synthesis, between the economic crisis and the spiritual crisis, will end, he said, with the victory of the latter—a victory that will lead us to the "music of the spheres."

Occasionally, Kandinsky departed from general issues and commented on specific art styles. For example, he found the work of the Soviet Constructivists particularly disquieting. Although he mentioned no one by name, he was probably referring to Tatlin and El Lissitzky. Also, the dream imagery of the Surrealists repelled him and gave him an uneasy feeling about the ontic aspects of his own art. The Surrealists, he said, "set out from nature to form an object," just as "older forms of expression" did, whereas he "invents" his forms. Significantly, he did not refer to the other source of Surrealist painting, automatism: perhaps this would have come too close to the way he saw objects unconsciously turn up in his own work. Such objects, he conceded, have a "disturbing effect," but he has allowed them to remain. Admitting that possibly "all our abstract forms" are, in the end, "forms in nature," he sidestepped the challenge of Surrealism and seemed to toss the question back to Arthur Jerome Eddy.

Considered as a whole, Kandinsky's writings exceed expectations of what artists should accomplish in this medium. Not only do his ideas and observations modify our thinking about the nature of art and the way it reflects the aspirations of a certain time, but they touch on matters that concern the human situation.

Artists sometimes adopt a word or phrase that is central to their thought. For Alberti, it was *historia*; for Reynolds, the *element of mind*; for Cézanne, the *motif*; and for Kandinsky, *inner necessity*.[59] Kandinsky used this phrase with a quiet yet assertive conviction. Many paragraphs in his writing lead into thickets of unprovables, leaving this phrase to be discovered in the dense center, lying in wait like the serene smile on a Buddha's face.

Kandinsky's art appeared modern when it was produced; it still does today. It differs so radically from traditional art that people are inclined to think him altogether estranged from the past. But Kandinsky's writings rectify this impression by revealing how deeply his thinking—and ultimately his painting—was rooted in European thought and values.

32

Critique of Critics

["Kritika Kritikov"] *Novosti dnia*
(Moscow), 1901

Together with his survey of Munich exhibitions pub-
lished in *Mir Iskusstva* [The World of Art] (see p. 45), this
was Kandinsky's first major essay on art. Although he had
published articles in Russia as early as 1889, his interests
then were ethnographical and anthropological, not artistic.[1]
The theme of this essay—the inability of Russian critics to
understand and appreciate modern art—was discussed fre-
quently among Kandinsky's colleagues in art and literature,
especially members of the St. Petersburg World of Art group,
with which Kandinsky was associated. Artists and critics
such as Aleksandr Benois, Igor Grabar, and Sergei Diagilev
published a number of articles in the *World of Art* magazine
(1898–1904), in which they also condemned the contempo-
rary state of Russian criticism and attempted to establish
meaningful aesthetic criteria. Kandinsky's own artistic pref-
erences at this time—for Boecklin, Lenbach, Stuck, and so
on—paralleled the sympathies of Benois, Diagilev, and their
friends. Like them, Kandinsky rejected the tendentious and
naive art and criticism of late nineteenth century Russia.
The hack writers he censures in this essay were themselves
an outgrowth of this strong nineteenth century tradition
which was dependent on the Realist interpretations of Ilia
Repin, Vladimir Stasov, and Leo Tolstoy. The powerful critic
Stasov and his lesser brethren, whom Kandinsky mentions
here, relied on a narrative and nationalist approach to art, one
that could not, of course, accommodate the styles of Impres-
sionism and Symbolism. For example, when confronted with

examples of Russian Symbolist painting at a Moscow exhibition as late as 1906, Stasov declared that they were all the "ravings of an old man lying incurably ill in a sick bay."[2] Kandinsky and the World of Art artists reacted consciously and constructively against this kind of *reportage* and endeavored to replace superficial impression with intrinsic analysis and to emphasize "aesthetics" rather than "ethics." Diagilev himself was a primary representative of this new trend. In spite of this valiant effort, however, the "naked" and "half-naked" critics continued to dominate the artistic arena in Russia until at least 1917. Reference to the critical reception afforded the later avant-garde exhibitions such as "Tramway V" (Petrograd, 1915) and "0.10" (Petrograd, 1915–1916) demonstrates the unabated hostility shown by "Tom, Dick, and Harry" to the new trends. Only with the development of the Formalist school of criticism in the early 1920s, supported by Nikolai Punin and Nikolai Tarabukin,[3] in particular, did Soviet Russia produce art criticism of value and influence. But its existence was brief and, unfortunately, the naked and the half-naked critics returned in force, rejecting modern art as the "product of a sick mind . . . of degeneracy."

Es ist leicht, eine kluge Grimasse zu schneiden
Und ein kluges Gesicht
Und gewichtig zu sagen: Dies mag ich leiden
Und jenes nicht.
Und weil ich Dies leiden mag so muss es gut sein,
Und jenes nicht—
Vor solchen Leuten musst Du auf der Hut sein
Mit deinem Gedicht!

—Fr. Bodenstedt

It is easy to put on a clever expression
An intelligent face
And to say self-importantly: This I can tolerate
And the other not.
And since I can tolerate this, it must be good,
And the other not—
Poet, beware of such people,
You and your poem!

In matters of any kind we usually listen to, and take note of, only the opinions of those who are acquainted both in theory and in practice with the matter at hand, i.e., the so-called specialists. Only for art and literature is an honorable exception made. It is precisely in this sphere that any fellow can pronounce with a *kluge Grimasse*, loudly and with weighty authority, "Now this is beautiful, but that's no good at all." Anybody who wishes to see his "works" in print, and to receive an honorarium for them, takes up the pen and writes whatever comes into his mind. If this Tom, Dick, or Harry is exceptionally brazen, he can walk onto the rostrum and utter all kinds of rot from its heights. And the audience "rewards the speaker with warm applause." In one of his poems, the poet Bodenstedt, whom I have quoted above, asks, "Is it true that the Shah is a man of innate wisdom?" and he answers in the words of the author Mirza Shaff: "The Shah knows how credulous and blind the crowd is, and merely exploits it." Indeed, this crowd is credulous, but how could it be otherwise? When it understands nothing of the question under discussion, how can it not heed the audacious ignoramus who proclaims his vulgar "truths" with such authority and inspiration?

I would venture to raise one simple question: Can any Tom, Dick, or Harry really resolve all the problems of art? Any person with the slightest sense who gives some thought to the role and aims of art criticism can answer this simple question. There is a radical difference between the public and the artist: artists devote the greater part of their

lives to something that the public patronizes just for a couple of hours at leisure. Consequently, what for the artist is a very difficult, crucial, and serious matter—the main thing in his life—is for the public simply a means of introducing diversity and excitement into a life that is quite alien to art. As a result of this difference, a deep misunderstanding of the artist's way of life, his goals, his ideals, has long since arisen among the public. This misunderstanding runs so deep that even the representatives of one branch of art cannot fully fathom the existence of another; hence to the public they appear to be talking about an art form quite foreign to them.

Such is the case with Count L. N. Tolstoy, the great writer and artist of the pen, who represents himself as "one of the crowd" in matters of painting. Because only a man quite foreign to painting could define the artist's aims as he does in his book on art: The artist is a man who devotes his life to acquiring the capacity of recording (!) anything that enters his field of vision.* This is actually an opinion concerning the artist's aims that is shared by the vast majority of the public. And only to a tiny, unknown minority can and will the artist reveal the wealth that nature bestows upon man, the treasures into which talent and knowledge can transform these blessed gifts of nature. This select group can expand to a greater or lesser extent, and whether it grows or not depends to a considerable extent on whether there are people around who will devote much time and energy to art, who will cherish it: and art has existed for so long and possesses so much that even to recognize its essentials requires much hard work. Such persons must (1) be able to pinpoint what is of value in the work of this or that artist; (2) reveal this value to others—to let the eyes of the blind be opened. Obviously, in order to fulfill the first task, one must possess a particularly acute instinct for art, a particular kind of eye that can perceive the particular and noble (not vulgar, mundane) beauty of art, a particular psyche that can accord only with the truly beautiful. Such persons must be able to comprehend what the artist takes from nature and what, by virtue of his talent and knowledge, he cleanses of superfluous accretions and transforms into a work of art. Such persons have the right to be called critics. There are periods when artists discover whole new spheres of beauty in

*[Notes appearing at the foot of the page are by Kandinsky and appeared in the original publication.—Eds.] I glanced through the book some time ago and I apologize for not quoting it literally, but I don't have it at hand. The sense, however, remains the same.[4]

nature, unseen by their precursors. In their astonishment, they strive to isolate these new pearls from the mass of nature and, by a supreme effort, to reveal them to others. And to evaluate an artist's endeavors in such epochs is a task more complicated than usual: one's instinct must be even sharper, one's eye more acute, one's psyche more sensitive. That is why these moments present as much difficulty for the critic as for the artist. Right now we are living in just such an epoch, and have been for some time.

As mentioned above, the serious and effective critic cannot limit himself to mere evaluation of certain phenomena, since he is obliged to make such phenomena accessible to less sensitive persons, to explain them to others. Any sensitive person can appreciate what is good, can evaluate half-consciously that which is beautiful. But it is a more difficult task to introduce the elements of consciousness and comprehension into this sensitivity. To achieve this, knowledge is essential. Only one who possesses both these human qualities in due measure—acute sensitivity and knowledge—can be a critic. Only this kind of critic is desirable and effective.

I.

Let us now see how our Russian critics (in the overwhelming majority) satisfy these two essential requirements. I have at hand some rather meager material consisting almost exclusively of "critical articles" published in various newspapers (mainly in Moscow) during the first year of this new century. True, it is not worth the trouble to collect such material or set any particular store by it as a whole when just two or three excerpts are quite characteristic.* As [Hans Christian] Andersen said, once upon a time there was a strange king. Imagining that he was dressed in luxurious clothes, he went about the streets naked, and the crowd greeted him, praising his clothes. And this happened simply because certain cunning people who had stolen all the expensive mate-

*Incidentally, during my moments of leisure I am compiling a selection of masterpieces of Russian criticism. I hope to make them into a bouquet in memory of their authors.

rial for the king's clothes said that only a fool could not see these clothes—which, they maintained, they had made, but which did not exist. Relying on my own material, I would say that even now there are people who have convinced others that they are covered top to toe in the armor of knowledge and sensitivity, but who walk naked and complacently acknowledge the respectful greetings of the crowd. Some do not cover their nakedness at all; others, from shame, put on a few scraps of knowledge that they have acquired by chance or a few terms, names, and definitions that they have picked up. Is it not time to tear the mask from these venerable and not-so-venerable connoisseurs and to expose this ancient deceit? I am going to do this first with the former group, i.e., with those critics who are quite naked; and then with the second group, with those who are half-naked and who sport pitiful scraps of empty words.

Naked critics confine themselves almost exclusively to reproducing what they term the "loud exclamations of the public" in the press. If they themselves had not invented these exclamations as they idled away their time, and if they limited themselves only to them, their reports would be not without interest, like any solid reporting. But unfortunately they see themselves as authors and, unable to say anything sensible, are forced involuntarily to confine themselves to a torrent of vulgar, hackneyed witticisms, of quasi-satirical descriptions and . . . downright abuse. These authors, incidentally, are in no way ashamed of their total ignorance of the commonest art terms and make a brutal mess of them. The various Messrs. "Not a Feuilletonist" and "Majuscule," etc., etc., for example, mix up the concepts drawing and painting in the most naive fashion. While thinking of painting, they say that the "artist has drawn a study," and are quite capable of saying that a pencil sketch has been "painted." From time to time they will throw in words, such as "expression," "perspective," "background," "coloring," "a rich brush," and imagine that they can hide their ignorance from people who do know the business of art. Further, if they must deal with the modern movement in art, they will include—for added piquancy—a couple of lines of "decadent" poetry (inevitably: "Violet hands on the enamel wall," "Oh, cover your pale legs," "Worms like a black shawl," etc.). Then they add a couple of "witty" remarks that, to tell the truth, I am ashamed to quote. A certain Mr. Bozhidarov, for example, invented a witty remark by some "venerable connoisseurs of painting": "We are walking along (after visiting the exhibition) . . . and we keep bumping

into people—because we've 'got something in our eyes'." Isn't that nice? The same Mr. Bozhidarov, dissatisfied with the way some paintings have been hung, expresses himself as follows: "One has to look at their artistic cancan by squatting on one's haunches." But it is hard to please this Mr. Bozhidarov—one exhibition appears too disturbing to him, another too monotonous. An exhibition that included works by Corot, Diaz, Daubigny, Lenbach, and Stuck he found boring, "unimportant bits and pieces," according to this venerable critic. "I am not a keen supporter of many (?) of them," says Mr. Bozhidarov quite uninhibitedly. "All their aridity (!) and remarkable tediousness (!!) are represented very clearly at this exhibition." And, can you imagine, Mr. Bozhidarov liked "best of all" a picture by Schleich: "It has been painted with great sensitivity, it is alive. What more could one ask of a painting?" Of course, what more could a critic like Mr. Bozhidarov ask! . . . So why do artists rack their brains over the problems of drawing and painting, over drawing in the narrow sense of the word, over form, modeling, harmony, etc., etc., when all the purely artistic aspect turns out to be superfluous? How wonderful that Mr. Bozhidarov has taken up his pen and, with such remarkable simplicity, has elucidated the real demands that the artist must satisfy! . . . And the same critic, referring to a mosaic by V. D. Polenov as a "piece of needlework," confesses in all frankness, "I really don't know what to say about this phenomenon (!)." But remembering, I daresay, that the art of the mosaic existed long before the birth of V. D. Polenov (if Bozhidarov has ever heard about this),* he proposes: "Either this (i.e., the mosaic) is a kind of 'disease in stone' . . . or simply a 'pastime for the elderly.'" In reproducing these stupid witticisms, I again experience absolute amazement at this man who so heroically decides to expose his nakedness in public. . . . As for wit, well, one of the prime masters is Mr. Majuscule. In his opinion, in Berkos's painting *Behind the Monastery Wall* there are "real miracles: such luxurious flowers that they would merit a gold medal at a horticultural exhibition." Mr. Majuscule does not balk at the chance to ridicule an artist's surname. Speaking of Mr. Passé, he remarks playfully that "there really is a genre painter of that name." The same critic found an "old" sun in a painting by Mr. Ovsiannikov and added very sweetly, "Let astronomers think of this what they will." Well, let the public think of Mr. Majuscule what they will.

*Since this critic goes on to accuse E. M. Tatevosiants of derivativeness, I would assume that he has never heard anything about mosaics.

I now turn to Mr. V. G., who constructed the whole of his *feuilleton* on the exhibition of the Association of Moscow Artists on the same kind of witticism. The interested reader can find this pearl in *The Moscow Gazette*.[5] Mr. V. G. found a misprint in the catalog of the Association of Moscow Artists: *"plener"* was printed instead of *"plein air."* And the critic fabricated a whole history of ignorance of artists precisely on the basis of this misprint. The elucidation of this theory begins with the following darling of a pun. When he saw the word *Plener* in the catalog, Mr. V. G. could not at first make out the meaning (it's obvious from the start what a clever and quick mind the critic has) and began to reason as follows: "I thought that one of our Moscow artists had exhibited his portrait of an Austrian state official by the name of Plener. But which one? Was it the old man Ignatius Plener, who had played a leading role in the fight of the parliamentary parties in the 1860s, or was it his son, Ernest?" And he went on in the same tone for another eighty printed lines! . . . Only after these eighty lines did Mr. V. G. realize that the word was *plein air*. After this divination, the reader was obliged to read another forty printed lines by the indignant author on the same subject.

And then another four columns of this long *feuilleton* continued on the subject of this same misprint, in which logical arguments constantly give way to downright abuse and attempts to show off erudition at the expense of the artist. In this passage you will find Latin, German, and French dicta, and you will be staggered by the author's erudition. For example, I was simply overwhelmed by his *Ignoti nulla cupido* [the unknown is disdained]. It would have been better if Mr. V. G. had translated his "terrible" words into Russian, since the ignorant supporters of the "modern barbaric movement" might not understand even his Latin quotation. I had very great difficulty in translating it. And I think that artists who have not had the good fortune to acquaint themselves with the wisdom of the Classics will be surprised—no less than I was—at the translation I made: *Ignoti nulla cupido* means "The aspirations of an ignoramus are fruitless." How can one not be surprised that Mr. V. G., knowing these really fine words of caution, still decided to take up his pen and rush into a sphere of art that is quite foreign to him, and there to make judgments, to instruct, and to utter his amazing sentiments! . . . By proceeding in this manner, he has transgressed and forces me to remind him of another, no less beautiful dictum: "There is no breach of conduct without proper retribution"—"*Nulla poena sine lege.*" If Mr. V. G. had at least said something definite in his huge

feuilleton about what these "eternal laws of art" are "in accordance with which paintings have been, are, and always will be painted," he might have proved to the reader that he had some knowledge in this area apart from words of abuse. If, for example, he had proved that Titian and Raphael, da Vinci and Rembrandt, Michelangelo and Veronese painted in accordance with the same "eternal laws," well, one could have been surprised at the strength of his dialectic and his sophistry at least, and might have glimpsed in this perhaps some hint of knowledge about art. But as it stands, all we have is abuse, just downright abuse and . . . nothing else! Is this what you call criticism, Mr. V. G.? Well, probably so, because I have found all kinds of abuse being used by a whole succession of critics ("daubing," "barbarism," "dirty dauber," "smeared it on hastily, to no purpose," etc.), but there's not one line that, albeit primitively, refutes the principles fundamental to the new school of art! These are the critics who know absolutely nothing about art, whom I have called naked.

Their colleagues of the pen, the half-naked ones, do manifest some symptoms of being serious. Here, in fact, you will find art terms, in addition to all manner of dicta, and also names of foreign artists, who sometimes really suffer at the hands of our Russian reviewers. For example, Mr. Si-v (*Russian Gazette*),[6] in order to show off his erudition and give authority to his articles, likes now and then to flaunt two or three names that he juxtaposes purely by caprice. In his review of the same exhibition of the Association of Moscow Artists, he says: "While pursuing (why not "while creating"?) new trends, artists in the West do not cease to respect form, perspective, and in general, (!) drawing. Suffice it to mention, for example, the names of Roll, Cottet, de Gas, et al." Why did he choose precisely these three names and why is Degas, that great and famous artist, transformed into de Gas? Is it not because Mr. Si-v has never seen Degas's signature on his paintings, i.e., has never seen Degas's paintings? Indeed, only such ignorance of Degas can explain the critic's statement that this artist has not ceased to "respect" drawing. How could Degas not "respect" drawing when this celebrated master is among the "foremost" draftsmen of our time?

A certain reviewer from Odessa read the names of some German artists in French—and the famous Franz Stuck turned into "Stiuk," Samberger into "Sanberzher," and Toorop really got caught: he ended up as "Tort."

Another Odessa reviewer by the name of Mr. Antonovich (*Odessa*

Page)[7] was bold enough to put Puvis de Chavannes among the . . . Impressionists.

Such are the miracles that come to pass when second-rate critics begin to flaunt their knowledge of Western art! . . . They are eager to accuse artists of illiteracy in art. Well, what do you expect? He who lives by the sword must die by the sword! . . .

As for art terms that can decorate an article, give it authority and aplomb, well, the critics pour forth words such as: "rich," "broad," "air," "back," (or "distant") "ground," "forms," "drawing," "perspective," etc. Even our Mr. Si-v takes it upon himself to make a decisive judgment on an artist in the sphere of drawing. Mr. Si-v provides us with the following statement, so delightfully naive: "The figure of the peasant appears too short . . . and, so it seems to us,* this happens because the inflection of the body leaning on the fence cannot be perceived properly, thanks to the absence of shadow in the lower part of the figure." Mr. Si-v who, year in, year out, has been writing on art, really ought to know (one would think) that a bodily inflection is determined not by shadow but by drawing, (which he loves to talk about so much). A clean contour is a perfectly adequate means of expressing any movement—"shadows" have nothing to do with it. I can assure the critic that the following judgments and expressions provide not a little entertainment to any artist: "Mr. Pokretsky's large painting, *The Mausoleum of Tamerlane,* shows us an interesting type of cupola construction from Central Asia"; "There is not much feeling of deep ground in this landscape"; "Not to mention V. V. Vereshchagin's studies and pictures . . . his pencil sketches present human types full of ethnographic and psychological interest"; "The painting . . . has little psychological interest because the Chinese depicted there have turned their backs to the viewer." Psychology, archaeology, ethnography! What has art to do with all this? It would be interesting to hear the critic's opinion of Titian, for example, an opinion dictated by his own education in art and not culled from the encyclopedia.

Alas! Our critics do resort to this source, flavoring its useful information with their own thought. But it is precisely this desire to put in their own little word that exposes the depths of the critic's illiteracy in art. The above-mentioned Mr. Antonovich started along this slippery path

*If this is a question of "it seems," then it would be better not to say anything at all.

when he wished to explain to himself (but, above all, to his credulous readers) the Impressionist movement in art. Anyone with the slightest interest in painting will see the mess Antonovich got himself into on this path, writing: Some French artists "have managed to free themselves from the *strange technique* (Antonovich's italics) of early Impressionism, such as its capricious coloring, its green air, blue foliage, and other absurdities." When will we be free of such an absurdity as color, air, and foliage being called . . . technique?

I think that I have introduced enough excerpts to demonstrate the illiteracy of many Russian critics in art, their matchless audacity and complacency. If the reader does not find my assertions well grounded, then I would ask him to read in its entirety any article by any of the above-named reviewers: he will find so many extraordinary examples, like those already mentioned, that he will wonder whether to believe his eyes.

In conclusion, I would point out that in the irresponsible and ignorant hands of Max Nordau, "art" reviews are being engulfed by references to the sickness of the modern school in art, to the psychological derangement of contemporary artists, whom our critics cleverly propose placing in *Kunstkammern* [curio cabinets], panopticons, and lunatic asylums. A particularly large number of such flattering good wishes greeted the last exhibition of the Association of Moscow Artists, for which the exhibitors have to thank mainly G. I. Rossolimo and his lecture "Art, Bad Nerves, and Education." Not having had the pleasure of hearing this erudite lecturer, I found out only from a short newspaper report that in his presentation Dr. Rossolimo "outlined all kinds of art, elucidated the diversity of creative processes . . . and came to the conclusion that modern art is no more or less than a product of a sick mind . . . of degeneracy." I must thank Dr. Rossolimo, who "coming to the end of his most interesting paper, said that it was, of course, impossible to cure art." This is, of course, a great shame. It would be interesting to see what this connoisseur of "all kinds of art"—who has discovered, moreover, the "whole diversity of creative processes" and is also a doctor of medicine—would do with such "degenerates" as Stuck, Thoma, Lenbach, and Boecklin! And what a great medical practice this psychiatrist would have: artists and sculptors who have for many years now been arranging exhibitions of modern art and all the German Secessions, professors from the academies, architects whose buildings now cover the whole of Europe, composers who fill whole concert programs. All

43

these *moderne Meister* and *artistes modernes* would terminate their unseemly creations, sit under lock and key in a colossal madhouse, and remain at the complete disposal of this lecturer, whose audience "rewarded him with warm applause."

Everyone is free, says the magnanimous Mr. V. G.—the artist, the critic, the public. Well, let me take advantage of this freedom to tell all the above-mentioned critics and interpreters of modern art: You are naked! Cover your nakedness or stay at home, because it is immodest to appear in public without clothes on. . . . With these words I simply appeal to the sense of shame which our critics, I imagine, must still have.

Munich, 8–21 April 1901[8]

Correspondence from Munich
["Korrespondentsiia iz Miunkhena"]
Mir Iskusstva
(St. Petersburg), 1902

Kandinsky was not a member of Sergei Diagilev's circle, and "Correspondence from Munich" was his only written contribution to Diagilev's journal *Mir Iskusstva* [The World of Art], published in St. Petersburg between 1898 and 1904.[1] He was, however, more closely associated with the World of Art movement than one might think. Gabriele Münter recalled that Kandinsky "rarely spoke of his earlier Russian associations," but that he "did mention Bakst from time to time."[2] His Russian "fairy tale" pictures have an evident affinity with the illustrations made for *Mir Iskusstva* by artists such as Aleksandr Benois and Ivan Bilibin.[3] Many Western artists whose names occur in Kandinsky's early reviews, the English painter Frank Brangwyn, for example, had been introduced to Russia either through the exhibitions organized by Diagilev and his companions, or through the pages of *Mir Iskusstva.* Moreover, Kandinsky's style as critic is somewhat reminiscent of Diagilev's own; compare, for example, the latter's article "Difficult Questions" ["Slozhnye Voprosy"] in the first issue of *Mir Iskusstva.*[4] This influence persisted in later years; in *On the Spiritual in Art,* Kandinsky still referred to such figures as Dmitry Merezhkovsky, the prominent Symbolist writer and a frequent contributor to Diagilev's journal.

In Munich during the first years of the century, Kandinsky was deeply involved not only in reviewing exhibitions, but

also in organizing them. (As president of the artists' association Phalanx, he was responsible for bringing to Munich the work of a number of important contemporary artists from abroad, including in 1903 a collection of sixteen paintings by Claude Monet.[5]) He takes, not surprisingly, an unfavorable view of the city's "official" exhibiting societies, such as the Künstler-Genossenschaft [Artists' Association]. More unexpected is his evident distaste for Jugendstil artists like Angelo Jank: Kandinsky numbered among his friends several leading Jugendstil designers and graphic artists, including Hermann Obrist and Peter Behrens.[6] The influence of Jugendstil prints, such as the illustrations found in Georg Hirth's periodical *Die Jugend* (which gave its name to the new movement), is also reflected in Kandinsky's own graphic work of this period.[7]

I. International Exhibition of the Secession

After a degree of internal confusion and confrontation between the younger members of the Secession and the "old guard" (among whom even F. Stuck is numbered), but perhaps mainly as a consequence of the incipient rivalry with Berlin for the title of "Kunststadt" [city of art], the leaders and organizers of the Munich Secession have evidently decided to put on a special effort this year.

After their brilliant debut and comparatively rapid success with the more artistically minded members of the public, the exhibitions of the Secession suddenly appeared to wane. The catalogues contain, for the most part, the names of the same local artists who aroused lively interest in the past. But hanging on the walls, it seems, are the "same old things" we saw long ago, only somewhat faded—pictures that take as their point of departure the literal repetition of nature and thus forfeit the luster of the artist's intentions; temperament has been replaced by "method." One of the happy exceptions is Ludwig Herterich, who, professorship notwithstanding, has turned his back on his "success" and, with a restlessness normally associated only with younger artists,

has set himself entirely new problems. At the same time, the Secession has stopped trying to attract foreigners to take part in its exhibitions (and it was, remember, the Secession to which, in its day, Munich owed the "discovery" of Scottish, Russian, and Scandinavian artists). Instead, little by little, year by year, the purely local, secessionistic air has begun to stagnate—the air of the "new academy."

Thanks to this growing stagnation, Munich (*die Kunststadt München*) has seen Zuloaga for the *first* time only this year. The organizers of the exhibition have taken the trouble to obtain from the Bremen Society of Artists the apparently world-famous portrait of the actress Consuelo (see the reproduction in *World of Art*, nos. 8–9 [1901]). Again for the first time in Munich can be seen A. de la Gandara, who has sent his portrait of the president of the Paris council, Escudier, as well as his *Young Woman Sleeping*—pieces distinguished by their calm majesty, their seriousness of line and pure painting. The Secession has also given us the opportunity of seeing a number of first-class Frenchmen: here we find Ménard's *Stormy Evening,* the large *Procession* by Cottet, built on the contrast between a whole group of brightly colored patches (figures in Breton costume, banners in sunlight) and the overall, peaceful shadow, in which groups of figures on either side merge with the landscape background, an excellent Blanche, a wonderful, small picture by Aman-Jean (a brightly painted lady with a black fan), and twelve rather dull cartoons (drawings for the decoration of the hospital chapel at Berck) by Besnard. Among the English contingent we encounter what were formerly some of the regular contributors to the Munich Secession: Austen Brown, Brangwyn, Greiffenhagen, Lavery, Neven du Mont, Alex, Roche, etc., as well as the anglicized Sauter, who on this occasion has utilized for his *Morning Conversation* no other colors than black and a grayish white, thus ensuring a certain harmony. Apart from a number of insignificant Italians and, I think, one Hungarian, the Secession has obtained several pictures from various other German towns. Hans Thoma has sent his *Herd of Goats* (see the reproduction in *World of Art*, nos. 8–9 [1901]) and his quietly poetic *Summer Landscape,* done as long ago as '72—paintings that fully merit the German epithet "*echt*" [genuine]. From among the Berlin Secessionists, who maintain a formal link with Munich, we saw two good pictures by Leistikow, and the not-too-bad L. von Hoffmann.

As far as Munich itself is concerned, one should single out first the young artist Lichtenberger, who is here exhibiting for only the second

time. His rare love of "painting" has fallen upon the fertile soil of an amazingly delicate feeling for proportion, and a clear understanding of the application of color. His interiors, pure specimens of intimate painting, are a source of delight for the true connoisseur of color. Among the youngsters, Exter, who has turned away from his *Jugend*-style for the sake of the more pictorial, is very interesting. Franz Stuck has contributed, apart from his "commercial" heads, to which we have grown so accustomed in recent years, a large double portrait: he himself stands in his studio in front of a big, still-untouched canvas, apparently making ready to paint his wife who stands before him. Uhde, Habermann, Samberger, Kaiser, Becker, Keller, Reutlingen and, of the younger artists, Schramm, Jank, and Winternitz have altered not a whit; one might well think they could now paint blindfold.

II. Annual Exhibition of the Glaspalast

A huge building, consisting of seventy-five different-sized rooms, its interior so carefully designed to be secluded from the light that, wandering around this labyrinth on a dull day, one asks oneself, "Why build it of glass from floor to roof?" But in these times, it is easier to hide from the sun in a glass building than to shut out the "fresh air" of art.

Recently (in particular, during the last one and a half to two years), the Künstler-Genossenschaft has been divided by misunderstanding and discord, mostly as a result of the misconduct and negligence of the jury. Even many of the older professors have left the ranks of the society and are trying to establish themselves, with all their mountain landscapes, painted deer, and jolly Tyroleans, within the younger associations; or, as a consequence of their (more than frequent) lack of success, they are now showing in the commercial galleries. Instead of Lenbach, we find the presidential chair occupied by the "famous marine artist" Petersen. The only trouble is that all these internal changes have made no difference whatever to the outward appearance of the Künstler-Genossenschaft exhibition itself.

Despite its extraordinary productivity, this, the oldest of the Munich societies, has been unable to fill the whole of its building, and has simply put on the doors of several rooms the notice *"geschlossen"* [closed]. It has called on the help of colleagues from other German towns, with whom it felt a particular spiritual affinity, even foreigners, to whom it has given over this year a total of sixteen rooms. The younger Munich

societies that are springing up (the latest being the Vereinigung für Graphische Kunst [Association for Graphic Art]) have, on the other hand, willingly taken the separate rooms placed at their disposal at the insistence of the Prince Regent, who had been disquieted by the decline of the "patrimonial principle" in the arts. Apart from that already referred to, two other societies (Scholle and Luitpoldgruppe) have this year obtained nineteen rooms. It is difficult to describe the feeling one experiences at the sometimes unexpected transition from a room hung with "conscientious" and "assiduous" *landscapists, portraitists,* and *genre painters* to a room where one sees *paintings* deprived of any kind of assiduity. It is like being flayed on the eyes with a knout! Sometimes, one cannot even say at once whether or not something is beautiful, just as, if one were plunged into running water on a hot day, one would be unable to decide immediately how cold it was. Sometimes, on the contrary, the room where the don't-cares hang seems extraordinarily beautiful, and a certain amount of time is necessary before one can distinguish what is good from what merely appears so. One has this feeling most strongly in the room occupied by the *"Scholle"* group.

A picture by F. Erler, described as a "panel for a music room," presents a strikingly powerful contrast between a huge white area (a white divan on which sits an entirely white lady, with white face and white hair, even a white Borzoi dog) and a thin strip of dark, indigo sea; between a gray sky, across which are dragged dark gray clouds in the shape of huge wild geese, and a bright yellow cage with a yellow canary, which appears to be hanging from the sky. Dull and muddy in his portraits, this still-youthful artist is both excessively spectacular and forcedly original in his other paintings. It cannot of course be otherwise; an artist who interprets nature so weakly and limply (in his portraits) must *contrive* problems without having real ground beneath his feet; deprived of the necessary link with his prime source of inspiration, he *must* build his house "on sand." I heard that Erler painted the above-mentioned picture in one week immediately preceding the exhibition. One is told this fact partly with reverence, partly with rapturous astonishment. And yet I don't know why it should occasion such rejoicing... Boecklin once said that the true picture "must *appear* like a great improvisation." May I be allowed to add that it is therefore a matter of complete indifference whether the actual picture was painted in eight days or eight years. I feel obliged to linger upon this point because in Munich of late one finds increasing value being placed on "speed of execution." To comply with

this fashion, artists pile up heaps of colors and apply them with quite extraordinary flourish—supposedly to express their personalities. There can be nothing more distasteful and harmful than this kind of *artificial* technical fad. Real personality does not submit to this kind of approach, but expresses itself in its own terms, eventually demanding attention in its own right. This rare quality distinguishes another member of the Scholle—Eichler. One usually encounters in his pictures an inspired poetry and a subtle, well-tempered humor, which is not contrived, but comes into being of its own accord, the consequence of a pure love of nature. On a hot day, four elderly gentlemen are walking along the edge of a hill in the shade of the dense foliage of the forest, their frock coats over their arms, their hats, with pine twigs entwined in the brims, pushed back on their heads. Below, in a sunlit dale peasants are taking in the hay. Walter Georgi has taken up the whole of one small room with a frieze designed to be printed in simple colors, and constructed from a combination of white, gray-green, bright yellow, and pale lilac. It consists of various autumnal landscapes, sometimes with one or two small figures: a large white house up on a hill, in front of it a park whose variegated leaves merge on one side with a large, bright yellow patch; a slender gray bridge, on which stand two figures, a man dressed in black and a woman in pale lilac; or a gray day, long rows of gray benches and tables outside a country cafe, golden chestnut trees, and a couple of melancholy hens in the foreground.

With their sixteen rooms, the L u i t p o l d - g r u p p e manage to produce less of interest than the Scholle, with their three small ones. The "star" of the group remains Raphael Schuster-Woldan, whose work on this occasion, paradoxically, is not very interesting. Bartels, Marr, Thor, and many of the others seem to have copied their own earlier pictures. These days, one comes across many such "nice" pictures, which, once seen, are instantly forgotten.

A large collection of paintings by the recently deceased Faber du Faur makes, when all is said and done, a wearisome impression. His early works are dry, academic, and often just plain bad. Subsequently, he experimented with the interaction of powerful effects of color, on which are based a whole series of sketches, some of them extremely interesting. But in his paintings he appears quite unable to capture the essence of what he devised in his sketches.

Lenbach, who also has a large exhibition at the Künstlerhaus, occupies his usual room. What we see at the Glaspalast is not new, for the

most part, but what is new is in no way inferior to the old. Even minor works by this venerable celebrity are excellent. Like the Bourbons, he has forgotten nothing; but how can one expect an old dog to learn new tricks?

In the rooms of the Künstler-Genossenschaft, with its German, French, Italian, and other members, among dreary pictures by the "old" school, one's eyes are here and there offended by shameless imitations of Dill, Zügel, all the French masters, and finally, most frequently of all, Boecklin; pitiful, commercial imitations, in front of which one cannot even stand and laugh.

1909–1910

Foreword to the Catalogue of the First Exhibition of the Neue Künstler-Vereinigung, Munich
Neue Künstler-Vereinigung München E.V., (Turnus), 1910

 Kandinsky returned from Berlin to Munich, together with Gabriele Münter, in the summer of 1908 and was soon active again in organizing exhibitions. As early as 22 March 1909, the name of a new exhibiting society appears in the city records—the Neue Künstler-Vereinigung München [New Artists' Association of Munich]. The core of the association consisted originally of painters close to Kandinsky and Münter, but the membership soon expanded to embrace writers and theoreticians, as well as artists working in quite different fields, such as the sculptor Moshe Kogan and the dancer Aleksandr Sakharov. Kandinsky was elected president; his compatriot, the painter Alexei von Jawlensky, became vice-president. The aims of the society were to promote exhibitions both in Germany and abroad and to organize lectures, publications, and other events.[1]

 The first two exhibitions of the NKVM (1–15 December 1909 and 1–14 September 1910) were held in the gallery belonging to the Munich dealer Heinrich Thannhauser. They created a furor. Kandinsky describes the first exhibition and the aims of the association in his "Letters from Munich" (see pp. 59–63), where he quotes from the numerous hostile press notices. He also recalled the adverse reactions of press and public, many years after the event, in his letter to Paul Westheim describing the origins of the Blaue Reiter (p. 744)

and his recollections of Franz Marc (pp. 793–797). Immediately before the society's third exhibition, in December 1911, Kandinsky resigned from the NKVM following disagreements over his *Composition 5* (Switzerland, private collection).[2]

The following text appeared in the catalogue of the first Munich exhibition and, with minor stylistic emendations, in a second printing of the catalogue, inscribed "Turnus 1910," apparently intended to accompany the exhibition on tour; the latter version is reprinted here. It is in fact an extract from a circular Kandinsky drafted early in 1909 to announce the founding of the Neue Künstler-Vereinigung; the full text of the circular is published in Roethel 1970, pp. 438–9. (See this edition, p. 860, for list of abbreviated titles.)

. . . Our point of departure is the belief that the artist, apart from those impressions that he receives from the world of external appearances, continually accumulates experiences within his own inner world. We seek artistic forms that should express the reciprocal permeation of all these experiences—forms that must be freed from everything incidental, in order powerfully to pronounce only that which is necessary—in short, artistic synthesis. This seems to us a solution that once more today unites in spirit increasing numbers of artists. . . .

1909–1910

Letters from Munich
["Pis'mo iz Miunkhena"]
Apollon
(St. Petersburg), 1909–1910

When *Mir Iskusstva* [The World of Art] ceased publication in 1904, other journals soon appeared to fill the gap, and there was no shortage of aspiring editors eager to assume the mantle of Diagilev. One was the patron and collector Nikolai Riabushinsky, whose magazine *Zolotoe Runo* [The Golden Fleece] even surpassed *Mir Iskusstva* in its sumptuousness. Another was Sergei Makovsky, editor of the monthly *Apollon,* which began publication in the autumn of 1909 with a strong literary bias (each number contained a "literary almanac" in which poetry and even short plays were published). The first issue alone offered poems and essays by most of the leading Symbolist writers, among them Viacheslav Ivanov, Konstantin Bal'mont, Valery Briusov, and F. Sologub. There were, however, extensive sections on art and music as well, and lengthy exhibition reviews, which constitute an important record of artistic life in Russia before the First World War. Some space was also given to reviews from abroad, keeping readers informed of latest developments in Paris and Rome, Munich and Berlin. For the first year of the magazine's existence, Kandinsky acted as Munich correspondent, submitting five "Letters," which appeared in the "Chronicle" section of *Apollon* between October 1909 and October–November 1910.

"Letters from Munich" mark the high point of Kandinsky's activity as a critic. As in his earlier "Correspondence from Munich" (pp. 45–51), he attacks the atrophied art establishment of the Bavarian capital and comments scathingly upon

54

the exhibitions of societies such as the Künstlerhaus, while lavishing praise upon individual dealers like Brakl and Thannhauser who had the courage to put on exhibitions of contemporary foreign painting. He writes with admiration about Hugo von Tschudi, the newly appointed director of the Bavarian State Galleries, who in his previous capacity as director of the National Gallery in Berlin had aroused heated opposition by acquiring paintings by modern French masters.[1] On the other hand, Kandinsky takes a rather dim view of contemporary German painting. Leo Putz, Lovis Corinth, Max Slevogt, and even his own teacher Franz von Stuck all feel the rough edge of his tongue. He also seizes the opportunity to indulge in a fair amount of propaganda for the Neue Künstler-Vereinigung. These "Letters" provide a number of details that have gone otherwise unrecorded, such as Izdebsky's membership of the NKVM (see also p. 63),[2] and the fact that the association's first exhibition was originally to have been held at Brakl's gallery on Munich's Goethestrasse, rather than at Thannhauser's. Kandinsky's detailed account, in the last "Letter," of the large summer exhibition of Eastern art held in Munich in 1910 is equally valuable,[3] especially for his remarks concerning the "inner life" of ancient art, a subject to which he returns in his major treatise, *On the Spiritual in Art.* (See pp. 114–220).

[I]

Surrounded by deep moats and fortifications, artistic Munich seems to slumber. The eye of the dispassionate observer or chance tourist comes back again to the same iron and glass fortress of the Glaspalast, the same blind facades of the Secession, the same sombre, oppressive pomp of the Künstlerhaus. What is more, it appears as if the same thousands of pictures are to hang for all time in the Glaspalast and in the Secession,

while the Künstlerhaus is still the same chronic wilderness.

When I returned to Munich a year ago, I found everything still in the same old place. And I thought: this really is that fairy kingdom in which pictures sleep on the walls, the custodians in their corners, the public with their catalogues in their hands, the Munich artists with their same broad brushstroke, the critics with their pens between their teeth. And the buyer, who in former times went indefatigably with his money into the secretary's office—he too, as in the story, has been overcome by sleep on the way, and left rooted to the spot.

But one of my old friends told me: "They're waiting for something," "Something's got to happen," "Everyone who knows about such things realizes it can't go on like this," etc. And I learned that two furious attacks had been mounted, two bombs been daringly exploded, although the attacks had been beaten off in the same furious and concerted manner, while the bombs, although they went off with a loud bang, had exploded without hurting anybody.

These two incidents were:

First, the exhibition (which took place nearly three years ago) of recent French artists at the Kunstverein, which everyone had been trying to bring up to date, without the slightest success: Cézanne, Gauguin, van Gogh, Manguin, Matisse, etc., for the most part from Schuffenecker's collection. The organizer of this exhibition was one Meyer, a German domiciled in Paris.

And second, the large collection of van Gogh (about a hundred paintings), which was shown eighteen months ago at Brakl's Moderne Galerie. (Brakl, the most advanced art dealer in Munich, "introduced," among others, the members of the Scholle group: Münzer, Eichler, Georgi, Püttner, and, first and foremost, Fritz Erler, now actively feted in Munich. All these artists, as is well known, are among the principal contributors to [the periodical] *Jugend.*)

Both these experiments ended in apparent failure.

Out of the entire van Gogh collection, it seems that only one single work was bought, with his last pfennig, by a Russian artist living in Munich.

The above-mentioned Frenchmen, moreover, were not recognized as "serious artists," and the better "local masters," those pillars of the artistic establishment, protested both verbally and in writing (!) at such an affront to serious art and public taste.

And yet, despite this, last spring the Secession printed in its

catalogue—along with the names of young artists just "starting out" (which means, almost exclusively, the more ingratiating pupils of our own luminaries; the spring Secession is the touchstone, the coming-out party for these youngsters)—the name of Cézanne.

In the very last room, one wall was devoted to his work, a wall on which hung eight of his pictures (a large landscape; still-lifes filled with an inner resonance; a large, powerfully painted head). Although there were, evidently, fears about the effect of this whole wall: five of the best pictures (mainly portraits) were hung in the offices of the secretariat, whither all who desired admission were, it is true, courteously admitted—assuming of course that they had found out by chance about this new fashion of exhibiting "badly drawn" pictures. It is whispered that this involuntary Secession within the Secession was the outcome of heated discussions. And yet Cézanne was after all graciously treated (who knows in what godforsaken place they might have hidden him!), and he was able to display everything—in fact, his pictures were hung by the very same hands that signed the above-mentioned protest.

Indeed, people had realized, "It can't go on like this." The Berlin Secession, having agreed to differ from the same Munich Secession from which it originally derived, since which time it has constantly disturbed the complacency of its Munich brethren, has for some years displayed in moderate numbers collections of these latest "Frenchmen." Two years ago Cassirer showed a big exhibition of the strongest and most "extreme" among them. All this may be just a temporary aberration in art, but still, you can't lock it out—that is the view of the Berliners. Unwillingly, Munich is obliged to follow suit, obsessed by the same old nightmare: the "decline of Munich as an artistic center." And Munich has that selfsame Berlin to thank for that nightmare.

The prophecy that "something's got to happen" likewise turned out to be not inaccurate. Something of the utmost importance for artistic life in Bavaria happened: [Hugo] von Tschudi, who had left a similar position in Berlin "from force of circumstances," was invited by the government to take the place of the recently deceased director of the Bavarian galleries. Tschudi accepted this invitation, and arrived here this summer with his steely, quiet energy, to come to grips at once with the seemingly hopeless problem of our museums. As if by magic, the Alte Pinakothek was swept clean of a whole series of inferior pictures, while the important and powerful ones reappeared, hung in such a way that their whole significance and profundity meets the eye at first

glance. What will become of the Neue Pinakothek?

This same Geheimrat [Privy Counsellor] von Tschudi immediately showed great interest in an association that had just been formed by the mutual efforts of a group of Russian and German artists, the Neue Künstler-Vereinigung München [New Artists' Association of Munich]. Thanks to his active involvement, the association has received serious support from several quarters and is now making its debut at the end of November at the Galerie Brakl, whence it will embark on a grand tour of Germany (more about this association in due course).

At the same time, another organization has sprung from the soil of the idea borrowed from the Parisian *Indépendants,* but alas, freely translated not into the language of the Germans, but of the Philistines. This—the Deutsche Künstler-Verband—is intended to organize exhibitions without a jury. To the shame of the Munich artists who took part in its constitutive assemblies, statutes were passed and adopted as part of the constitution denying the right of membership to both foreigners and women. (An interesting detail is that foreigners whose native tongue is German can become members, e.g., Austrians, Swiss—but not Austrian Slavs, Swiss-French, etc.!) At the moment, this society is still going through a period of inner organization and inner conflict. One can only hope it will reject this kind of pettiness and succeed in hammering out its aims, as, it appears, has already happened once again in the case of Berlin, where the first exhibition of a similar society is firmly planned. Other such enterprises are taking shape in a number of German towns.

Bridges are being built across the moats; here and there the fortifications are being razed to the ground. The walls are beginning to crumble.

Is there in truth a subterranean force to be found that is already preparing itself for a surprise attack on the enemy, that will succeed in banishing the "innovators" and temporarily shoring up the old walls, so that one will in conscience be able to say, "All's well"?

Or will we in fact soon feel a breath of fresh air? Will it reach the *"Kunststadt München"* [Munich, the city of art]?

Apart from the international exhibition in the Glaspalast, combined this year with that of the Secession (this meeting of the "old" and the "new" under one roof occurs from time to time as the result of a compromise between the latter and the government), where many laugh and few stand in wonder in front of the large canvas by Hodler— admittedly, almost the only serious and powerful work in an exhibition

that habitually abounds in pictures—apart from this exhibition, there has now opened in the rooms of the so-called "Ausstellung München 1908" [Munich Exhibition 1908] a special exhibition of Far Eastern and Asiatic, predominantly Japanese art, "Japan und Ostasien in der Kunst" [Japan and East Asian Art]. Its patron, Prince Rupprecht of Bavaria, has contributed a whole series of works that he personally collected in the Orient, many prints, paintings, etc., of an amazing depth and subtlety. The Berlin and Cologne museums and a very large number of private persons are represented by their collections, which occupy up to twenty rooms: a huge collection of prints, starting with the primitives and going on to hand-colored engravings, a collection of powerful and delicate sculpture, painting (China from the twelfth century), books, and articles of applied art. A whole room is devoted to landscape prints. Here, along with the truly Oriental gift for combining the subtlest details into an overall consonance, one finds landscapes of an extraordinary breadth and abstraction in the handling of color and form, subordinated to a sense of rhythm that is the pure expression of a unique, wholly artistic temperament. Again and again, so much that is part of Western art becomes clear when one sees the infinite variety of the works of the East, which are, nonetheless, subordinated to and united by the same fundamental "tone"! It is precisely this general "i n n e r tone" that the West lacks. Indeed, it cannot be helped: we have turned, for reasons obscure to us, away from the internal toward the e x t e r n a l. And yet, perhaps we Westerners shall not, after all, have to wait too long before the same inner sound, so strangely silenced, reawakens within us and, sounding forth from the innermost depths, involuntarily reveals its affinity with the East—just as in the very heart of all peoples, in the now darkest depth of depths of the spirit, there shall resound o n e universal sound, albeit at present inaudible to us—the sound of the spirit of m a n.

Munich, 3 October 1909

[II]

If you want to watch the crowds in Munich, do not go to the art exhibitions—especially out of season, when the number of tourists drops to a minimum. During this "dead period," the number of visitors

at exhibitions is usually small—artists, students (no groups), a tiny handful of genuine art lovers and patrons, and the occasional chance visitor. Only in recent years have these numbers been swelled by an inconsiderable part of Munich's more elegant public, who are, for the most part, not of local origin. This new element now represents a significant percentage of those who attend exhibitions and, what is especially interesting, who bring with them a real involvement in art.

And yet, all the same, the exhibition galleries remain deserted during the out-of-season months.

How great, therefore, was the surprise of the inhabitants of Munich when, last Sunday, in the course of three hours one exhibition attracted more than two hundred people.

This incident occurred in the Moderne Galerie, which had given over its large downstairs room (decorated in an extremely simple, restful style), to the Neue Künstler-Vereinigung München, about which I wrote in passing in my first letter. In all, there were 138 works, counting graphics and a small number of sculptures.

"He who wishes to give himself a 'treat' of an altogether unique kind needs only to visit Thannhauser's Moderne Galerie, in the new Arcopalais. If, lost to first impressions, he does not immediately take flight as fast as his legs will carry him, but continues to look as a matter of disposition or taste, he will either begin to utter fearful oaths, or else fall about laughing, or even—for such a thing, regrettably, is not impossible—be dumbfounded with surprise and, overcome with delight, collapse into one of the comfortable wicker chairs that stand around the room. The reason for this extraordinary excitement is the exhibition of the Neue Künstler-Vereinigung München, which, founded in the spring, is here appearing for the first time. . . ." This was the response the exhibition elicited from one of the local critics, who has, until now, been supported by all the rest of his colleagues.

Indeed, the public—that is, those who do look (as a matter of disposition)—in various forms and to various degrees give vent to their expressions of disgust, mockery, and offense. They jab the pictures with their fingers, they employ the most forceful and impolite expressions; some even, so to speak . . . spit. The kind and courageous owner of the exhibition gallery has heard no shortage of such "words," even semiofficial "remarks" from the "big shots." But he has not lost heart yet and asks philosophically: "Who would have expected anything different?

Wasn't it exactly the same at the first exhibition of van Gogh?"* But that same Herr Thannhauser has also succeeded in overhearing isolated, but extremely warm expressions of goodwill and congratulation at this serious and powerful exhibition. He has received similar words of praise from people having both considerable influence and well-known names, although (for the most part) no direct connection with art. But, of course, even among the general public one finds a certain body of people who look long and attentively, making a real intellectual effort, coming back several times to look again. And let me emphasize again, this body of people is that same elegant stratum of the public, i.e., the nonindigenous element. Nor am I alone in this impression. "Just look!" a well-known German sculptor said to me, an extremely "unruly" fellow, himself not a local, although he has lived here for years. "Just look! So many foreigners are settling in Munich; its whole physiognomy is changing, although only gradually. But suddenly, Munich is showing signs of waking up!"

It is, of course, a pity that it is impossible to "gauge" the impression produced by this exhibition. Press opinions, but also those private letters that I personally have had to receive regarding the organization of this exhibition, are the product of that impression formed by the professional, i.e., in the vast majority of cases, by a man whose immediacy of feeling has been deadened by all kinds of "knowledge," by his preconceptions, and his indescribable fear of encountering something he cannot understand, in the face of which his cabin trunks stuffed with theory, even his hand luggage, are shown to be insufficient. But what of those people who look attentively, conversing among themselves in quiet voices, or going around singly with open minds—what do they feel?

*I mentioned this exhibition, which occasioned such violent protests, in my first letter. Although now, precisely in connection with the exhibition I have just been describing, it appears that part of the press idolizes this same master of genius (of course, what they idolize is not the really profound aspect of his art, but on the contrary, its wholly unimportant and accidental characteristics—I wonder whether they took the trouble to read his letters!). On the other hand, another part of the press proudly affirms, although with a degree of caution, that its opinion regarding this "incident" (van Gogh) " remains unaltered." Discussion of this question has started up again, due to the fact that Brakl (Moderne Kunsthandlung) has, in opposition to the NKVM, organized another van Gogh exhibition, which appears to be an almost literal repetition of the previous exhibition he arranged, and which I discussed in my first letter.

It is not for me, as a member and one of the founders of the Neue Künstler Vereinigung München, to attempt to evaluate its debut. I shall limit myself to an account of the aims and strivings of this as yet comparatively small group, which, despite all attacks (or in part even because of them), has evidently obtained a firm foothold not only in Munich, but indeed throughout Germany, to the extent that this first exhibition has already been eagerly welcomed by a whole succession of central and north German towns, so that its tour will extend right up until the autumn of the coming year. Impressionism (combined with *peinture,* especially highly prized in Berlin); the wretched persistence in studying the organic and organic structure; and finally, the striving for a broad, external decorative effect (our "latest school")—these are the three elements that make up, and continue to embroil, the soulless "Munich school of painting." Composition is neither striven for, nor demanded by any kind of inner impulse. Naked bodies in the open air, without any attempt at painting. Women lying on the ground with their heels toward the spectator, sometimes with disheveled faces. Geese flapping their wings. Pale women set against rose-colored backgrounds (silver mixed with pink!). And year after year, red-coated huntsmen on dappled steeds jumping over hurdles. The cheerless call of a great fat trumpet: Stuck, Stuck, Stuck! And latterly, the dull thump of the already tiresome drum: Putz, Putz, Putz! This kind of art, or what passes for art, is like a well-made, brightly painted, dead, utterly dead doll—see what the Munich exhibitions have substituted for the live, striking, vibrant, stirring spirit.

"Our point of departure is the belief," so goes the circular put out by the NKVM, "that the artist, apart from those impressions that he receives from external phenomena, continually accumulates experiences from within his own inner world, that he must seek artistic forms suitable to express the interaction and interrelation of all these elements, striving to liberate these forms from everything accidental, in order to express all the more forcefully only that which is essential, in short, the search for artistic synthesis." Recently, such desires have again "made themselves felt," and the aim of the Association is to "unite the arts in the name of this task." Of course, quite apart from this declaration of the Association itself, it must be "pointed out" that synthesis is nothing new in art. Such fear of the new! To affirm this principle, to demonstrate it afresh—not, of course, only in words—to turn our e y e s away from the enjoyment of the a c c i d e n t a l play of

colors, the accidental fascination of form, to devote oneself to—what is now as good as scorned—artistic content, to shift the center of gravity away from the question "how" (purely technical) to the question "what"—these, although not new (and today, it is as well that they are not new), are the now absolutely necessary tasks that this new Artists' Association has taken upon itself.

While remaining objective, I would be so bold as to state that the atmosphere created by this first exhibition of the Association bears no resemblance to the usual exhibitions here, which produce a superficial effect upon the eyes, and a (sometimes unpleasant) tickling sensation in one's nerves. The whole strength, the whole energy of this small exhibition resides in the fact that every member understands not only *how* to express himself, but also *what** he has to express. Different spirits produce different spiritual sounds and, as a consequence, employ different forms: different scales of color, different "clefs" of construction, different kinds of drawing. And, nonetheless, everything here is the product of one shared aim: to speak from soul to soul. It is this that produces the great, joyful unity of this exhibition.

It does not seem necessary to enumerate or even attempt to characterize individual works in objective terms. Any such attempt would in this instance appear especially perfunctory.

Apart from which, it is possible that the artists and public of St. Petersburg will have the opportunity this winter of judging the NKVM.

Participating members of the Association:
V. G. Bekhteev, E. Bossi, M. V. Verefkina, A. Erbslöh, K. Hofer, P. Girieud, V. A. Izdebsky, V. V. Kandinsky, A. Kandolt, M. Kogan, A. Kubin, G. Münter.

I have by chance discovered that in Berlin preparations are being made to constitute a new *Verein* [organization], with aims close to those of the Munich Association. Finally, I would mention that one of the most powerful and most serious German companies has assumed management of all business aspects of the exhibitions of the NKVM, whose appearance it welcomes as a timely protest against the copying [*Abmalen*] of "accidental pieces of nature, carried almost to absurdity."

[January 1910]

*This *what* is here not to be understood, of course, in the sense of literary or anecdotal "content."

[III]

Exhibitions

One of the innumerable anecdotes about arguments between a man from Berlin and a man from Munich goes as follows. The Berliner was telling of the extraordinary operations performed by Prussian doctors. To which the Münchener replied that he knew of only one comparable operation performed by a Bavarian doctor, who had "slit a Prussian patient's mouth open as far as his ears, so that he would be able to open it all the wider."* Apropos the question of jury-free exhibitions, which is now† exercising both artists and the press (and which I mentioned on an earlier occasion), the Berliners appear once again to have exaggerated somewhat in their statements regarding preparations for their own jury-free association—the Freie Künstler-Verband. It was even reported (prematurely, as it happened) that the Berlin Secession had offered its rooms for the purpose. I remember how the times of opening of the first exhibition were advertised. And suddenly comes the news, not only that there will be no exhibition, but also that the association itself has closed down "for technical reasons." Just what these technical reasons are, the curious may be allowed to hazard a guess.

Munich has shown itself (to what extent is already well known) more serious as regards this matter. Our own Deutsche Künstler-Verband has already opened its doors to the public for its first exhibition. An exhibition we were promised and an exhibition we got. And how many debates, arguments, near-scandals were needed to get it off the ground!

*Das Maul aufsperren, grosses Maul haben: to exaggerate, boast, etc.

†A series of articles on this subject has appeared both in the daily press and in the specialized periodicals. Among them, I cannot fail to comment on the few scornful remarks by our eminent Heinrich Zügel, published in Werkstatt der Kunst (no. 17, January): "I have not seen the exhibition of the Deutsche Künstler-Verband, but all the same, I consider it to be entirely worthless; even in Paris, where one can expect more of the public, this kind of innovation is unlikely to survive for long." Note the pure professorial style adopted by this eminent authority! As is well known, this "innovation" has existed in Paris for some twenty-six years. The name Indépendants, and the results of their activities, are so widely known that one cannot fail to be astonished by Professor Zügel's opinion.

Several hundred members were enrolled—so the story goes. With extravagant claims, a garish circular was distributed—one for general circulation, another "for the public" in particular (the latter even printed on red paper and in the style of a revolutionary proclamation, with bold, gaudy type and a swarm of exclamation marks).

But the mountain brought forth a mouse. "For lack of space," only a miserable percentage of the members actually turned up at the exhibition. It was the "youngsters" who were chiefly missing, and the presence of a number of artists with famous names, even professorial titles, did little to compensate for their absence. Nevertheless, this exhibition was able to flaunt the label "Made in Munich"; they had "outwitted" the Berliners and . . . the critics were in ecstasies. They even scolded o n l y o n e of the younger artists. Although it is, perhaps, scarcely a coincidence that o n l y o n e of the younger artists was of any interest.

Of course it is obvious, and will come as news to nobody, that one must find at such a jury-free exhibition much—even the greater part— that is unsatisfactory. But there are different degrees of badness. It is only when the "bad" is couched almost exclusively in ready-made forms and expressed by means of a highly accomplished technique, only when it bears witness to an u n u s u a l level of outward maturity and to an irredeemable inner vacuity that it produces a pitiful, horrifying, aggravating effect.

For a number of reasons, this outward "accomplishment," with its attendant superfluous forms, has become the scourge of art in Munich. One must display one's "ability"—that is the o n l y aim of every young artist. I was recently invited to look at an exhibition of graphics several downright "youngsters" organized in their studio. And what happened? Scarcely had I set foot in this outwardly well-arranged exhibition than I was overpowered by the strident, obtrusive, highly finished, refinedly conventional forms on the walls and on the tables, b e y o n d which there lay nothing. It made one think of a cheerful, well-lighted drawing room, in which one expects to meet interesting, important people, but in which there is not a living soul—only perfectly made, perfectly dressed wax dolls. It produces a frightening effect, as if in a nightmare. Above all, one is filled with the desire to leave.

Nowhere is so dreadful a caricature of art created with such assiduity, such conscientiousness, as in Germany. The German people (of which, naturally, the strong of mind and profound of spirit constitute o n l y the better part) is unable, by its very nature, to discover just those forms, just those means of expression necessary for that as yet dimly perceived

future content. Other nations, far more gifted from the formal point of view, do not e n t i r e l y lose touch with the ground under their feet when the general state of culture oppresses and to all appearances banishes the s p i r i t from life. The Germans, on the other hand, in this preeminently formal period, are found wanting and have no alternative but to seek foreign help. They have talent, but lack a firm basis; they have strength, but lack the material; they have ambition, but lack the goal. The result is dreary and abhorrent.

Here and there, one encounters some consciousness of this internal disorder, the search for a cure. Man is, however, inclined to mistake effects for causes, and thus not infrequently attacks the former, rather than the latter. This is what has happened in this case. It is made to seem as if those responsible for the dispirited state of German art are not those who have banished the spirit from our lives, i.e., for the most part the Germans themselves, but rather those at whom they clutched in their helplessness, i.e., the French. This strange logic has made rapid strides and has led to the facile conclusion: We must turn our backs on the French, and German art will be born anew. This is the root of the present patriotism and of the unpleasantly naive measures already taken by two artists' associations, aimed at the exclusion of foreigners.

I have already mentioned similar attempts on the part of our own *Indépendants,* who have sought above all to guard themselves against non-German members.*

*And now, once again, their circular addressed "to the public," printed on red paper, rattles with jingoistic slogans and a plethora of exclamation marks. But the other circular (addressed, so it says, to all—on white paper) attempts to modify somewhat this outrageously anti-international principle, even going so far as to declare that, according to the latest decree, foreigners too may be admitted to membership, provided (1) that they have resided for a long time in Germany, and (2) that they intend taking up German nationality. To which is added that such foreigners will be admitted to the society's first exhibition, e v e n w i t h o u t any p r e v i o u s t r i a l of their knowledge or capabilities! It is touching to see to what lengths the principle of equity may be stretched: We are a jury-free society, and you, even though you are a foreigner, you can be admitted without passing the test of the jury! Finally, in the same circular, there is a rather obscure hint that for the second large exhibition, in May, there will even be certain preferential rights granted to the foreigners. . . . For women, on the other hand, no quarter is given. In small print at the bottom of the posters (red, of course)—recently put up by the same society that has invited all artists to collaborate in making preparations for the May exhibition—appears the remark: "Since ladies cannot be members of the society, this invitation does not extend to them." Short and unambiguous.

On the same—indeed even more hotly defended—principle, inadmissible by any standards, the artists' association Werdandi was founded two years ago. In the foreword to its catalogue, after criticisms of French tendencies and French "decadence," German artists are invited to "turn back"; it is even expressed in the very words, "*So rufen wir zurück.*"

"Zurück!"

By which is meant, apparently, that "our 'backward' is at the same time the most powerful 'forward.'" The preface concludes in bold type: "G e r m a n a r t — G e r m a n c u l t u r e." To which it is necessary to add that this exhibition (which took place in Berlin), reports of which may perhaps have reached the Russian public, was, if not actually downright bad, of little interest and soon forgotten. Other activities of the Werdandi, who could count during their first year of existence up to 150 members (some with extremely well-known names) have failed to reach my ears. But whatever efforts may have been made, the results must have left much to be desired. Any such premeditated principle, precisely because of a fixedly f o r w a r d orientation, having no natural link with art, does not enliven art but rather saps its vitality.

And yet, alongside this nationalism, almost as if in defiance of it, one finds in Munich more and more foreign exhibitions. The more sensitive among our organizers of art "salons" understand only too well that the time has passed in which one might build afresh the Great Wall of China, that one cannot hermetically seal the door against foreign art. In the first place, it will get in, all the same, through some crack; in the second place, there is a demand for it, which, although slight, grows apace;* and in the third place, our critics are prepared to accept it so that, tapping some young foreigner on the shoulder, they may in the end make clear, to the point of absurdity, their view that true, great art must be produced here, rooted here.

The same Moderne Galerie Thannhauser which put on the exhibition I discussed in my last letter, organized by the Neue Künstler-Vereinigung München (a society dedicated to internationalist aims), has now arranged another, purely literary exhibition of two Swiss artists (and not Swiss-German, but one French, and the other Italian): Cuno

*There are even in Munich (to say nothing of Germany in general) rich collectors who buy only French art or even, e.g., only van Gogh.

Amiet and Giovanni Giacometti. And immediately following upon that, an exhibition of "young" French artists (almost exclusively land-scapists): Manguin, Puy, Vlaminck, Friesz, Girieud, Marquet, and finally, a few small works by Matisse from one private collection here. Among the works by these artists, there is not one that is mediocre. All are interesting, beautiful, serious. Much of the work consists of miraculous painting (*peinture*). But among them, only Matisse has gone beyond the "accidental forms of nature"—or, better expressed, only he has succeeded in entirely discarding the inessential (negative) aspect of these forms, replacing it with, so to speak, his own forms (positive element).

All the other artists here represented (least of all, perhaps, Girieud) display almost to the extent of complete inviolability that contingent attitude toward line, the same accidental delimitation of form that they have discovered in nature. It is curious to observe how their whole creative energies are directed solely toward color. Why? Why is it only color that undergoes these modifications, violations, substitutions? What prevents the artist from likewise submitting the linear and planar aspects of nature to the same artistically necessary transformation? Why does the creative urge direct itself solely toward "*peinture*," and why does the other, uniquely powerful, essential aspect of painting—what we rather vaguely refer to as "drawing"—remain untouchable? Going from one canvas to another, one ends up with the impression of nature simply decked out in various colors, just as one might paint one's house, one's chair, one's cupboard. These different objects may, depending upon their colors (ornamental juxtaposition of color-tones), produce different effects upon the spectator, but they remain, for all that, objects, and not the transformations wrought by "pure art," i.e., not art understood in terms of concrete forms, not (in the accepted use of the term) abstract. These were the thoughts going through my head as I looked at these really beautiful, richly painted pictures. I could not free myself from the question: Why is it necessary to "paint" nature in different colors? If it is to derive pictorial composition, the inner sound of the picture, then why does this "composition," this "sound," extend only as far as the transformation of color? And why is drawing, that is to say, the nonpainterly, incidental aspect of art, so carefully avoided, thus, as it were, clipping the wings of the artist's creative imagination and power?

Strange, how it appears necessary to find, discover, resurrect anew

that principle of subordinating d r a w i n g, too, to internal aims that was so clearly, so definitely resurrected from the dead by Cézanne! In fact, if it were not for the presence of Matisse at this exhibition, one would suspect that this spirit had already departed again. That only one of the "younger" French artists exhibiting here has kept it alive may be explained by the fact that the others have not as yet impressed upon themselves the imperative necessity of creating p i c t o r i a l com- p o s i t i o n, or indeed, developing the necessary language.

It is uncertain how far the spectator's imagination might have led him on looking at the above-mentioned Frenchmen, were it not for the fact that the Moderne Galerie recently took it upon itself to give over its large downstairs room (its native section) to two Berlin luminaries: Slevogt and Corinth. Here, one's imagination leads nowhere, or rather, if it leads anywhere, then it is not into artistic realms, but rather . . . anatomical or even gynecological. Into the latter, even the most modest spectator might well be led by, for example, Corinth's much-vaunted *Bathsheba*. A large, soft female is lying on her back. Naturally, with her legs apart. Naturally, naked. For some reason, around her waist a scrap of what appears to be black fur hangs down, disappearing between her large, soft thighs. In her right hand she holds a flower. A noble picture!

Slevogt, among many other works, has shown here a portrait of A. P. Pavlova. They say it does not resemble her. This wouldn't be so bad if there were not so many paintings in this room that —apart from this portrait of [St.] Petersburg's prima ballerina—bear no resemblance to what they portray. But it is, in any case, utterly pitiable.

[April 1910]

[IV]

Our "spring" Secession provides the touchstone of our younger talents. And behind the canvases, I seem to see the evilly grinning faces of our "celebrities": the youngsters have not succeeded in reaching their Olympus, are not allowed to seat themselves upon the comfortable, richly gilded thrones, amidst dense clouds of incense!

They are bad, these youngsters—so bad that, had the selection been at all strict, scarcely a third of them would be hanging in the halls of the Secession; indeed, the spring Secession would not have taken place. How one's heart sinks at this show of impotence! One would have to be completely indifferent to art, blinded by one's paltry preoccupation with

one's own self, to view such a demonstration without feeling disturbed. And who could have the heart not merely to look at these sickly objects, but actually to select them and arrange for their hanging? In this exhibition, the hanging appears to be completely random, or perhaps the works were arranged according to the size of the frames, literally thrown on to the walls by a cold, unfeeling hand.

The big names are absent; the less well known (second generation) are met with only rarely. For which thank God, since there is little joy to be had from observing their decline. Those of whom ten years ago one might have expected something—not much, it is true, but perhaps love and a little talent—falter before our eyes. Even the crisp lightness of technique characteristic of Munich, the cheerful playfulness in the use of the palette, are missing. Only a weak shimmer . . . a smoking, guttering lamp to light one's last breath . . . And at once . . . dissolution.

Munich has never mastered painting; indeed, it seems as if in her naivete she has never suspected its existence. There has, on the other hand, been an intensive study of organic form. It is linear form, in all its aspects, that has been the guiding principle in the schools (apart, of course, from the drawing classes of the Academy, where what is demanded is either simply fluency of technique, or else the careful annotation of every fold, boil, wart, and chance spot on face and body), and it has constituted the criterion of artistic production in the eyes of the liberal juries. One has only to think of the influence of Stuck, the advocate of the "transition from one form to another," where rivers of light become interlaced! Or again, the influence of Habermann, with his entwined, spiral forms for cheeks, hands, noses. Or finally, of the departed Lenbach, who doggedly pursued the asymmetrical structure of the anatomy. And now, perhaps for the same reason, Professor Mollier's lively, interesting, and ardent lectures on anatomy (presenting, for example, a special model with the strongly developed muscles of a tailor) are filled, benches to breaking point, aisles to overflowing, walls to bursting, with avid young listeners. And yet, into what sieve is all this effort poured? The idea of "inability" to draw as an attribute of "modernity" has not yet entered the minds of our youth, and where they succeed in mastering some organic form, they give it no quarter, but drag it triumphantly into the light. When these accidental forms of nature, however, are reluctant to be united in one single whole, and dissipate themselves in all directions, then what inexperience is revealed! It is an extraordinarily strange feeling, downright amazing, to see how an ex-

perienced and mature landscapist "constructs" a bridge, on which it is impossible either to walk or to ride, and which stands with its nose buried in the ground, the path leading to it performing a triple somersault in the air. . . .

One has a vision as of a big, antiquated machine, which has for years been turning out canvases covered with geese, calves, ladies, fields, hunters; but the sands of time have got into it, it has lost its precision, and it keeps missing its stroke.

As if despairing both of this pitiful younger generation and of its own resources—or else eagerly baring its breast to the thrust of competition—the committee of the Secession has this year decided upon a great step: to invite all the members of the Berlin Secession (peace has broken out again!) as well as all those Russian artists who were represented last summer at the Glaspalast, and who were assiduously vetted by our most official critic, Baron Ostini, to participate in this summer's international exhibition (from the middle of May to the end of October). And there, indeed, we shall have once more the opportunity of seeing not only Repin, Nesterov, A. Vasnetsov, etc., etc., but also Zarubin, and Stolitsa, and even, perhaps, Kondratenko, whose "collection of colossal paintings" has already been shown in . . . Augsburg. Evidently, even the senior officers of the Secession are favorably disposed toward Russian art.

At all events, one must prepare oneself for a summer rich in various events, which will attract countless hordes of German and foreign visitors. These events will, of course, be of quite different kinds. They will start with the "Eastern Exhibition" in the huge halls of the Grosse Münchner Ausstellung (on the Theresienhöhe), which will doubtless be exceptionally rich and interesting, and end with the exceptionally uninteresting and world-famous folk representation of the Passion of Our Lord in the village of Oberammergau, whither it is even intended to fly through the air from Munich. And between these two extreme points, a succession of the most various enterprises imaginable: a large jury-free exhibition (from May onward for the whole summer); a musical festival in memory of Schumann (May, in the Grosse Ausstellung); a Wagner "week"; a Mozart "week"; an R. Strauss "week" (Prinz-Regententheater); and of course, the Secession, the Glaspalast, the Munich Art Theater (at the "Grosse Ausstellung"); every possible kind of exhibition in the private galleries, among which, in truth, pride of place is taken by a whole collection of forty works by Manet (on their

way from Berlin via Munich to New York, London, and Paris); and—last but not least—in September, the exhibition (in the same Galerie Thann-hauser) of the Neue Künstler-Vereinigung, which will present the latest tendencies in French, Russian, German, Swiss art (permeated by the same spirit). This last exhibition, like its predecessor, will then go on tour in Germany throughout the winter and spring of 1911.

The question of the necessity, or the irrelevance, of juries, their abolition, or the harmful influence they exert, continues to occupy not only artists. The conservative and clerical press (the "black press") has been airing its fears that the lack of juries may open yet wider the doors for some . . . impropriety (*chacun à son goût!*).

And it is with joyful triumph that the following words from a speech by the professor at Munich University and Obermedizinalrat [Senior Medical Counsellor] von Gruber are quoted: "Neither art nor literature has shown itself to be unconditionally necessary for the life of the nation; what is necessary is healthy youth! The whole totality of artistic production, taken together, is not as important as the health of our youth. It would be preferable that the storm should annihilate every-thing that is best and most elevated that the arts have created than that we should perish in a slough of decadence!" . . . A fine kettle of fish, in which this truly positive Medizinalrat would land us! "As long as the German professors continue to serve the cause of reaction to such an extent," wrote one Munich artist in this connection, "there can be for us no possibility of change, no future, and German culture remains an empty phrase." Here we find ourselves face to face with the true evil of our day!

Meanwhile, life continues, although slowly and with great effort, on a forward path. While the Munich artists have made their first experi-ment with a jury-free exhibition, to be followed, we are promised, by a second uncommonly interesting show; while the Prussian Ministry of Culture is preparing to turn over to Berlin accommodation on the Lehrter Bahnhof for holding jury-free exhibitions "provided that the works shown are vouched for by worthwhile artists"—meanwhile, things are already stirring in the provinces: no more nor less than Danzig has already seen such an exhibition. It was extraordinarily bad, which, of course, surprised nobody.

I, on the other hand, believe that those inclined primarily toward the conventional are much less disturbed by all these jury-free, i.e., unoffi-cial, elements than by the restlessness and agitation of a highly placed

official personage such as Privy Counsellor von Tschudi. What particularly irritates them is constantly waiting for the unexpected. Having turned the whole of the Alte Pinakothek upside down (remember how we all thought no human power sufficient to undertake such a task!), Tschudi has no intention of sitting back. Working incessantly, receiving in person anyone and everyone at all hours, he turns up in Paris, or in Florence, or in various Bavarian provincial museums, with which he exchanges pictures, thus creating from each town his own "monumental canvas," which is painted not with colors, but with pictures themselves. One meets him constantly in the galleries of the Pinakothek itself, serious, deep in thought, staring, staring now at Titian, now at the old Flemish masters, now at El Greco, which he himself bought, thereby stirring up so much conservative blood. His lack of patriotism, his purchases awaited with horror of all kinds of mad foreigners for the State Galleries, give his opponents no respite. Scarcely a week goes by without some attack on him in the newspapers, or even in the periodical press, attacks that he counters calmly and sometimes maliciously, exploiting all his world of expertise and feeling. Oh, for the old director, whose name nobody could even remember! Of course, the Russian reader will have heard all about these unsuccessful attacks, just as he will know about the unceasing, endless, tangled discussions over the Berlin "Flora." A marvelous opportunity for many of the headhunters who wish to undermine and defeat such obstacles as Tschudi and Bode, who show no desire to conduct themselves in an ingratiating manner or to swim with the current. Of course, once one stirs up the water, all the mud comes to the top. . . . But better to have the mud on top than—below the surface of a dark, peaceful river—finding all the dirt at the bottom.

[May–June 1910]

[V]

The exhibition of Eastern art in Munich has far exceeded all hopes, a huge collection of the most diverse objects, which are, almost without exception, of the first quality: carpets, majolica, weapons, ceramics, textiles, and finally—the most arresting of all and closest to us today—Persian miniatures.

My first opportunity of seeing Persian miniatures was in the Kaiser Friedrich-Museum in Berlin. I came across them by chance. And sud-

denly, I seemed to see before my eyes the embodiment of that dream, that reverie I had long carried around with me, unknowing. . . . It seemed unbelievable that this could have been created by human hands. Standing before it, I felt it had come into being of its own accord, as if it had come down from heaven, like a revelation. This was one of those occasions when the spirit partakes of spiritual refreshment for which it has been waiting, searching, without knowing where to find it. It was as if a curtain had parted before one, revealing new depths of happiness. And then, as the eye became accustomed, as it immersed itself and began to comprehend these treasures, the eternal question in art, "How?"—as one sees the combination of such priceless dreams, the unification of the irreconcilable.

Its simplicity is almost barbaric, its complexity bewildering. Its elegance is that of a highly refined people lost in sensuous dreams. It has a seriousness, a strength, and occasionally a crudity of draftsmanship such as one finds in the old icons. And a gentle, pliant, at times cunning beauty of line. The primitive use of color appears an added adornment. And so keen is the understanding of, so delicate the feeling for, the combination of the different tones, so inevitable their unification and division that this primitive ornament suddenly turns into the highest form of painting. A sense of endless depth, a profundity of inward expression, to which everything—even this infinite external beauty—is subordinated.

It seemed to me I could envisage the artist himself living so naturally in this "internal" world, speaking of it so naturally, that the external could never be for him terrifying or pernicious, since it served his ends, placing at his feet a whole wealth of pictorial possibilities.

By what miracle is he able to combine his original, intense, primitively expressed impression, in which the internal seems to be laid bare (it is this impression that invariably dominates, that is never lost to sight, and that we Europeans so mistakenly try to turn into "decoration") with a teeming abundance of details that not only do not weaken this first impression, but miraculously enrich it with a thousand resonances, refrains, a thousand shimmering echoes?

I stood and looked, and as I did so, everything that had previously seemed true in our own "decadent" art, everything to which the soul responded with such joy that it felt like pain: "This is truth; this, beauty!"—everything else was eclipsed, obscured, forgotten.

And again, on this later occasion, the same thought awakened within

me, and I began to compare this art of the past with that of our own times. It became clear to me how great was the power of this mature art, with its roots deep in the soil, the fruit of centuries of inner life, by comparison with our own, beneath which the soil has scarcely begun to form, growing in an atmosphere that in its uppermost strata is only gradually beginning to free itself from the stifling accretions of the materialism of "yesterday."

But the folios of the Kaiser Friedrich-Museum are a drop in the ocean compared to the riches of the present Munich exhibition. There, it was a question of one or two blooms of the same species; here, a fabulous garden. Just a word or two about externals, since it is not possible to give an exhaustive account. The means, the "technique," used by the Persian miniaturists are calculated with the utmost precision. Their "knowledge," their ability to draw, is carried to such a high level that it is, evidently, just taken for granted—as if one were to say of a man who knows how to read, "Ah, he knows the alphabet!" The portraits, of which there are a very large number in the exhibition (most of them the size of a postage stamp!) are irreproachably, even "plastically," drawn, although they do not attempt to go "beyond the frame," but remain confined to the flat surface upon which their life is conceived. But around them the colors sing, the costumes, flowers, turbans, rocks, shrubs, palaces, birds, deer, butterflies, horses resound with color. Horses! I remember one drawing of a team of black horses running as if pursued by devils from right to left across the picture. In this sheet, without the seductive effect of color, the whole power and beauty, the decisiveness and expediency of drawing are revealed with particular clarity. Let us take as an example just one of the details that least defies description: the heads of the horses in the most distant rows are turned in such a way that they appear nearer to the viewer, so that not one single head should be concealed. These heads, with their mouths strangely drawn back and chins hanging woodenly, have to be visible; imagine them obscured, and the whole strength not only of the linear composition, but also the whole "inner harmony" of the picture would be lost. In the same way, not only perspective but also "naturalness" are calmly set at naught. In these breathtaking compositions, everything that art needs, even today, is treated freely, purposefully, while the superfluous is set aside with equal freedom, simplicity, and naturalness. So it is that in art the end determines the means. This is that artistic freedom for which we seek by day with a lighted torch, against which the critics

sharpen their pens, and to which mankind so loves to take exception. . . .

But why were the Persians themselves not offended by this kind of art?

In our own era, it has somehow come about that the whole store of "knowledge" has suddenly slipped from the hand of the artist and passed into that of . . . the spectator. Thus, there have been few artists who understood in what art consisted, what it is necessary to seek, and how one would embark on the search. On the other hand, you would find among the dedicated public scarcely a single person (quite apart, of course, from the critics) who did not know all this! Admittedly, one would come across members of the public whose comprehension was a bit shaky—on the subject of d r a w i n g and p a i n t i n g, for example— but for all that, one might well say that there was scarcely a member of that same public who did not know what was right, who could not tell the difference between an accurate drawing and an inaccurate one. Naturally, the nonartist, seeing the extent to which artists themselves were illiterate, making mistake after mistake (sometimes almost as if deliberately, in order to conceal their incompetence!?), found it difficult to restrain his derision, his judgement, his own suggestions for improvement. . . . Whereas the Persians have been spared this curious, fatal phenomenon.

Is it, then, any wonder that we have fallen upon an era of decadence?

In order to remind us of this sorry state of affairs, we have in Munich no less than three powerful organizations, each patronized in one way or another by the state: (1) Glaspalast (several thousand pictures), (2) Secession (several hundred), and (3) the jury-free exhibition (likewise about a hundred). And of course, a whole series of *Kunstsalons* [art salons].

The jury-free exhibition was, as is well known, awaited with some interest, despite the failure of its first, experimental debut. The city provided large premises—rather like a "covered market," which was hung throughout with pictures. The very last tiny room was allotted "to the French." Our own influential critic, Baron von Ostini, devoted a long article to those *Indépendants*, in which he weakly, idly, and altogether shamelessly shows that Munich is still alive by denigrating its younger talents. The article ends on an unexpectedly sweet note: the author requests the public not to think of the pictures it sees at the jury-free exhibition as "outcasts." On the contrary, one of the principles

of the jury-free exhibitions is not to show works that have already been rejected by any other exhibition.

I have already had to read a number of German views of our Secession, the views of critics who pride themselves on maintaining a critical distance. And now, this year, one newspaper asks why the Secession should have called its summer exhibition "international"? Only the blame for this inaccurate description falls not so much upon the Secession itself as upon its Russian contributors (or indeed, perhaps upon foreign artists in general). As I mentioned in my last letter, the Secession has invited a whole succession of Russian artists to take part. Nor was it the fault of the Secession if, as happened in many other cases, only two Russians actually appeared at the exhibition. The name of one of them escapes me (his was a large, dark brownish-gray picture representing, I think, a Little Russian wedding). The other was Iuri Repin, who likewise contributed a large canvas: a rather shapeless Peter the Great, seated on a rather shapeless horse and, as one critic pointed out, apparently smiling at somebody. How strangely constructed is a critic's eye! But perhaps Peter the Great is not smiling at everyone (myself, for example, he passed over with a stern glance) but only at those who, like the aforementioned critic, thought he came out of the paintbox of Professor Ilia Repin. One just has to smile, involuntarily. Of course, it is a very involved question. After all, the picture hangs in one of the most prominent places—surely the Secession themselves didn't think. . . ? But among our mighty critics, one even finds such as consider Repin to be a "Russian, or rather a Finn." Why a Finn should have interested himself in portraying the riding figure of Peter the Great, the critic could not, naturally, have asked himself, since he didn't recognize Peter, to whom he refers simply as "a horseman."

For the rest, the Secession remains—the Secession.

The Glaspalast has decided this year to go it alone, without the French—indeed, without any foreigners at all; there is scarcely one to be seen. But even here, I did find two compatriots: Pimonenko, suffused with the Little Russian sun, and Stolitsa, sunk deep in the snowdrifts of Greater Russia. I could not help thinking: Only two pictures, and yet the whole of Russia is here represented.

Among the Germans, there were two "big hits." One was the memorial exhibition of Hermann von Kaulbach (where one hears ceaselessly the words *"sehr schön"* [very beautiful]), and the very large picture by

Clementz—*Christ among the People*—was the other. And of course—especially in front of the latter insipid and singularly untalented picture—a whole mass of spectators. Usually the Glaspalast is filled with hordes of visitors, like autumn mosquitoes, avidly reading the catalogue and casting an occasional glance at the pictures. But here the crowd stands as if rooted to the spot, and worships. I glanced at their faces, and saw many of them were praying.

A new subject for artists is Zeppelin's airship, as it steers its course through dense spirals of cloud. Otherwise, the same old violinists, playing their violins in the woods to the delectation of the gnomes, the same fallen horsemen, the same deer, barking in the hills (I have never seen a single Glaspalast exhibition without such deer)—even the same large-scale compositions that have been trotted out at exhibitions for the past forty years and are devoted to the war of 1870: cuirassiers ride, cannons roar, stricken horses and Frenchmen collapse, and the whole proclaims the valor of German arms. An island amidst all these heaps of rubbish, one small room offers Japanese prints, which have turned up here for reasons not immediately apparent, and from which the public averts its gaze. Here also is to be found a mountain of German graphics, born ten years ago and now (at least to judge by this exhibition) already dead. Equally weak, and of absolutely routine character, is this year's small architectural section.* It is appalling to think how much effort, care, money—even how many lives—it costs to put on this kind of huge irrelevance. The irrelevance of this kind of exhibition at the Glaspalast may be seen from the fact that this particular public has, over so many years, decades, had such a fill of its "own" kind of art that it has become indifferent to it, scarcely reacts to it. There are not even many purchases. Only the Bavarian state goes on faithfully buying, as if choosing as a matter of principle, from among the worst pictures, the trashiest of all.

I went again this spring to the Moderne Galerie Thannhauser, thinking that the Manet collection, regardless of its repute, would scarcely convey to me anything new; I thought I would merely be seeing once again the same great master I had seen already many times in the

*As far as architecture is concerned, in Bavaria its development, although very gradual, is undoubtedly interesting and genuine. It is pleasant to observe, *inter alia*, what charming cottages the state railways are gradually building for the signalmen and other employees, and also the little station buildings.

past. . . . I was, therefore, all the more struck the moment I crossed the threshold of the large hall. Not only were my eyes struck; I was shaken inwardly. The whole atmosphere of the room seemed permeated with an all-devouring, fantastic, superhuman, elemental talent. Everything I dislike about this kind of art was forgotten. It seized me just as man himself is seized by some gigantic, mighty natural phenomenon. I was conquered by this boundless, objectless [*bezpredmetnyi*][4] love of painting. Yes, objectless! For indeed, like the forces of nature, there is nothing of that definite longing one finds for example in the work of Cézanne, but simply—elemental creativity. This was how it appeared to me in the very first moments. Manet lived, looked, saw. Some chance appearance would persistently, peremptorily capture his glance (not his soul)—a woman with black hair, a *vendeuse* at the bar, Claude Monet painting a study in a boat, several people breakfasting in their studio, an actress or a cocotte in front of the mirror . . . and so on . . . and so on . . . and immediately he would become slave to that appearance, so that it would evolve within him until, inevitably, inescapably, it would be repeated upon the canvas. Not that this repetition was purely mechanical, of course, nor did it by any means involve fixing e v e r y aspect of reality. His stature, his greatness, lay precisely in his ability to select from the merely accidental that which is artistically necessary. For Manet, this artistic necessity consisted almost exclusively in what was pictorially necessary, that which beauty demanded, but not, at the same time, that which was i n t e r n a l l y n e c e s s a r y. I said "almost." When I paused to consider this "almost," there appeared before my eyes with unexpected clarity the link that exists between the objectless song of Manet and that definite i n t e r n a l n e c e s s i t y which, translated by the talent of the artist from the realms of unconscious possibility to those of conscious creation, has been explored by no less outstanding talents—Cézanne, van Gogh, and Gauguin, and later preeminently, by Matisse and Picasso. . . . Slowly, one thing has led to another. And slowly, the inwardly necessary has assumed and continues to assume preponderance over the outwardly necessary, just as throughout the whole of our youthful culture, the spiritual is beginning to outweigh the purely material. Slowly but inexorably, conscious creativity comes into its own, and with it the elements that will constitute the already advancing composition of the future: a kind of composition that is pure, untrammeled, exclusively pictorial, based upon evident laws of combination, of movement, of the consonance and dissonance of form, of line and color.

And now, once again in the same Moderne Galerie, is to be seen a collection of Gauguins. He too is one of those greats before whom one wants to take off one's hat. Once again, a purely pictorial talent, a purely pictorial genius—more limited than Manet, but nonetheless more profound, more concentrated. Yes, "concentrated"! There is nothing of that elemental superabundance of energy—cast out in all directions, like some gigantic star whose light illuminates every corner—but rather, a direct, clearly defined, blinding ray of light in one direction: here! The weakest aspect of Gauguin lies precisely in his excessively close connection with Manet (although it must be said that both are marked by their indecisiveness of drawing, or, to put it more exactly, linear composition). What beguiled Cézanne all his life, and what before his death he regarded as barely touched on in his art, now gives life to the works of Matisse, Picasso, and many other artists. Linear composition remained foreign to Gauguin, although his gift for it went further than Manet's and became more complex—in the end, more powerful, more resonant. If he did see, then he saw only dimly what infinite importance, what power, attaches to this element of painting—l i n e a r c o m p o s i t i o n. In painting, just as in all art, it is insufficient simply to render the appearance of nature, its external reality, for it contains too much that is accidental. What is necessary (just as it is "necessary" that man should have a heart) is that beneath a greater or lesser degree of "reality" should lie, apparent or concealed, a firm, permanent structure: the structure of those parts that are independent, that relate to one another, and that united within the picture, constitute the structure of the whole.

[October–November 1910]

From the Catalogue of the Second Exhibition of the Neue Künstler-Vereinigung, Munich

Neue Künstler-Vereinigung München E.V., II Ausstellung, Turnus 1910–11

The second exhibition of the Neue Künstler-Vereinigung opened in Munich in September 1910. It included works by Vladimir Bekhteev, Erma Bossi, Georges Braque, André Derain, Kees van Dongen, Francisco Durio, Adolf Erbslöh, Le Fauconnier, Pierre Girieud, Hermann Haller, Bernhard Hoetger, Aleksei von Jawlensky, Eugen Kahler, Kandinsky, Alexander Kanoldt, Moshe Kogan, Alfred Kubin, Alexander Mogilevsky, Gabriele Münter, Adolf Nieder, Picasso, Georges Rouault, Edwin Scharff, Seraphim Sudbinin, Maurice de Vlaminck, and Marianne von Werefkin; Kandinsky's friends David and Vladimir Burliuk and the Moscow artist Vasily Denisov were also represented. Kandinsky's paintings came in for particular attack. The critic G. J. Wolf, writing in the periodical *Die Kunst für Alle*, observed:

> A colorful hodgepodge of Kandinsky's is called, significantly, *Composition 2*; presumably, the artist himself was unable to think of a title for this involuntary conglomeration of colors. I would have fewer objections if it said underneath, "Color Sketch for a Modern Carpet." But far from it! These people who are exhibiting here are too good to let themselves be put

on a par with "designers." They create free, pure, high art—so they say. For my part, all their snorting and wheezing reminds me of the cackling of a lame hen.[1]

The catalogue contained introductory statements by a number of artists, among them Le Fauconnier, the Burliuk brothers, and Odilon Redon (whose works were not shown in the exhibition). Kandinsky's text smacks of his contemporary preoccupation with mysticism and occultism, what he described in his "Reminiscences" as his "tendency toward the hidden, the concealed."[2] August Macke poked fun at the somewhat pretentious opening in a letter to Franz Marc dated mid-December 1910.[3]

At an unspecified moment, from a source that today remains concealed from us, and yet inevitably, the work of art comes into the world.

Cold calculation, patches leaping at random, mathematically exact construction (clearly apparent or concealed), silent, screaming drawing, meticulous working out, fanfares of colors, their violin *pianissimo*, great, calm, heavy, disintegrating surfaces.

Is this not form?

Is this not the **means?**

*　　*
*

Suffering, searching, tormented souls with a deep rift, caused by the collision of the spiritual with the material. That which has been found. The living element of living and "dead" nature. The consolation in the appearances of the world—external, internal. Premonitions of joy. The call. Speaking of the hidden by means of the hidden.

Is this not content?

Is this not the conscious or unconscious **purpose** of the compulsive urge to create?

*　　*
*

Shame upon him who has the power to put the necessary words into the mouth of art, but does not do so.

Shame upon him who turns his spiritual ear away from the mouth of art.

Human being speaks to human being about that which is superhuman—the **language** of art.

MURNAU (Oberbayern), August 1910

1910–1911

Content and Form
["Soderzhanie i forma"]
Salon 2 . . .
(Odessa), 1910–1911

The sculptor Vladimir Izdebsky was one of Kandinsky's most interesting contacts among the artists of the Russian avant-garde. They had met in 1903, when Izdebsky was studying in Munich; the latter soon became *persona non grata* in Russia for political reasons, and spent a period of self-imposed exile in Paris, where he continued his studies at the Ecole des Beaux Arts.[1] By 1909 he was back in Odessa, active as a publisher and organizer of international exhibitions. Izdebsky intended to publish a selection of Kandinsky's poems, later collected by Piper in Munich under the title *Sounds* (see pp. 291–346). There were also plans for a Russian monograph on Kandinsky, or possibly an album with reproductions of his works, for which the artist supplied Izdebsky with a cover design[2] related to his painting *Composition 4* (Düsseldorf; Kunstsammlung Nordrhein-Westfalen p. 125). Neither of these projects was realized.

Izdebsky was rather more successful as an organizer of exhibitions, which went under the generic title of "Salon." The first "International Salon" organized by Izdebsky opened in Odessa in December 1909 and included a remarkable group of modern French paintings, among them works by Braque, Vuillard, Vallotton, Gleizes, Metzinger, Le Fauconnier, Denis, Matisse, Marquet, Redon, Rousseau, Signac, and Friesz.[3] The second "Salon" was devoted mainly to Russian painting, and included fifty-four works by Kandinsky, among

them an important group of early "Improvisations" (Nos. 2–7) and his first three "Compositions." The catalogue of this second exhibition bears a cover design by Kandinsky; it contains his essay "Content and Form," his translation of Schoenberg's "On Parallel Octaves and Fifths" (see p. 91), and articles on the "Philosophy of Contemporary Art," by A. Grünbaum, "The City of the Future," by Izdebsky himself, and "Harmony in Painting and Music," by Henri Rovel, an author to whom Kandinsky refers in On the Spiritual in Art.[4] Together with the exhibition—which, significantly, included a number of children's drawings—the catalogue constitutes an important precedent for the "Blaue Reiter idea," not merely because of the amount of musical material it contains, but also because of its "synthetic" approach to the question of the unity of the arts.

Kandinsky's "Content and Form" has often been confused with his 1913 essay "Painting as Pure Art" (p. 348)[5] because of its very similar opening; but it continues quite differently, and in the latter part of the article, the author discusses several topics, among them the "monumental art" of the future, that recur in On the Spiritual in Art, his major theoretical treatise of this period. There exists among Kandinsky's papers a German manuscript version of "Content and Form," but the essay appears not to have been published in that language.

The work of art comprises two elements:

the inner and

the outer.

The inner element, taken in isolation, is the emotion in the soul of the artist that causes a corresponding vibration (in material terms, like the note of one musical instrument that causes the corresponding note on another instrument to vibrate in sympathy) in the soul of another person, the receiver.

As long as the soul remains joined to the body, it can as a rule only receive vibrations via the medium of the senses, which form a bridge from the immaterial to the material (in the case of the artist) and from the material to the immaterial (in the case of the spectator).

Emotion—sensation—the work of art—sensation—emotion.

The vibration in the soul of the artist must therefore find a material form, a means of expression, which is capable of being picked up by the receiver. This material form is thus the second, i.e., external, element of the work of art.

The work of art is the inseparable, indispensable, unavoidable combination of the internal and the external element, i.e., of content and form.

Those "accidental" forms that lie scattered around the world summon up their own distinctive family of vibrations. This family is so numerous and so various that the effect produced by the "accidental" (e.g., natural) forms appears to us equally accidental and undetermined.

In art, form is invariably determined by content. And only that form is correct which expresses, materializes its corresponding content. All other considerations, in particular, whether the chosen form corresponds to what is called "nature," i.e., external nature, are inessential and damaging, in that they detract from the sole purpose of form—the embodiment of its content. Form is the material expression of abstract content. Thus, only its author can fully assess the caliber of a work of art; only he is capable of seeing whether and to what extent the form he has devised corresponds to that content which imperiously demands embodiment. The greater or lesser degree of this correspondence is the criterion by which the "beauty" of the work of art may be judged. The most beautiful work is that whose external form corresponds entirely to its internal content (which is, so to speak, an eternally unrealizable ideal). Thus in essence, the form of a

work of art is determined according to internal necessity.

The principle of internal necessity is in essence the one, invariable law of art.

<div align="center">* *
*</div>

Every art disposes of a given form peculiar to itself which, infinitely variable, gives birth to the individual forms of different works of art. Thus, each different art will clothe even the selfsame spiritual emotion in the form that is peculiar to itself. It is thus that individual works belonging to that art form come into being. For this reason, it is impossible to substitute the product of one art form for another. Hence derives not merely the possibility, but also the necessity of developing monumental art, whose first shoots we can perceive already today, and which will bloom tomorrow.

This monumental art is the combination of every art in one single work, whereby (1) each art, while remaining exclusively within the bounds of its given form, becomes a joint begetter of the work, and (2) within this work, each art is brought to the fore or relegated to the background, according to the principle of direct or inverted contrast.

That is, the principle according to which this work is constructed remains the same as that which likewise constitutes the unique basis of creation in every individual art.

The great epoch of the Spiritual which is already beginning, or, in embryonic form, began already yesterday amidst the apparent victory of materialism, provides and will provide the soil in which this kind of monumental work of art must come to fruition. In every realm of the spirit, values are reviewed as if in preparation for one of the greatest battles against materialism. The superfluous is discarded; the essential examined in every detail. And this is happening also in one of the greatest realms of the spirit, that of pre-eternal and eternal art.

<div align="center">* *
*</div>

The means of expression of each art are predetermined, preordained, and in essence, incapable of change. But just as the spirit is continually being "refined"—or constantly detaches itself from its material aspect—so too the means of art must, even partly in advance, become inevitably, incontestably "refined."

Thus, (1) every art is eternal and unchangeable, and (2) every art employs changing forms. Art must march at the head of spiritual evolution, adapting its forms to this greater refinement, its prophetic role. Its inner content is unchanging, its outward form changeable. Thus, both immutability and mutability are the laws of art.

The essentially immutable means [of artistic expression] are:

music—sound and time
literature—words and time
architecture—line and extension
sculpture—extension and space
painting—color and space

 * *
 *

Color plays its part in painting in the guise of paint.[6] Space—in the guise of form, delineating space ("painterly"), or drawing. These two elements—color and form—are the essential, eternal, immutable language of painting.

Each color, taken in isolation, produces under different conditions one and the same spiritual vibration. In reality, however, one cannot isolate colors, with the result that their absolute inner sound is always varied by different circumstances. Of these, the most important are (1) the proximity of another color-tone, and (2) the space (and its form) that the given tone occupies.

From the former circumstance derives the task of pure painting, or painterly form. Painting is that combination of color-tones determined by internal necessity. The combination is infinitely subtle and refined, infinitely complex and complicated.

From the latter circumstance derives the task of line, or linear form. Form is that combination of linear surfaces determined by internal necessity. Its subtlety and complexity are infinite.

The former task, in real life indivisibly linked with the latter, is in general the principal problem of linear-pictorial composition, which must now manifest itself with an as yet unknown power, and to which the so-called "new painting" serves as threshold. It is self-evident that this novelty is, at bottom, not qualitative, but quantitative. This kind of composition, which constituted an immutable law for all earlier periods

of art, beginning with the primitive art of the "savages," must be the foremost prophet of the advancing Epoch of the Great Spiritual that now dawns before our fortunate eyes—a prophet that already guides the more farsighted spirits and will soon lead the whole world.

This kind of composition will be constructed upon that same basis which is already known to us in embryonic form, only which now will develop into the clarity and complexity of musical "counterpoint." This counterpoint (for which, in our terms, we have as yet no word) will be found further on, on the path of the Great Tomorrow, by the same eternally unchanging guide—Feeling. Once found and crystallized, it will provide the expression of the Epoch of the Great Spiritual. And however powerful or subtle it may be in its detailed characteristics, these characteristics will rest upon the greatest of all foundations—**upon the Principle of Internal Necessity.**

Footnotes to Schoenberg's "On Parallel Octaves and Fifths"
["Paralleli v oktavakh i kvintakh"]
Salon 2 . . .
(Odessa), 1910–1911

Kandinsky's interest in the works of the Viennese composer Arnold Schoenberg dates from the beginning of 1911.[1] In January of that year, together with Franz Marc and other friends, he attended a concert of Schoenberg's music in Munich, which included piano works, Lieder, and the first two string quartets. Marc described this concert in a lively letter to his friend August Macke in Bonn, depicting the audience's appalling behavior and trying to give Macke some idea of the composer's theories:

> Can you imagine a kind of music in which tonality (that is, adherence to any key) has completely disappeared? Schoenberg starts from the principle that the concepts consonance and dissonance simply do not exist. A so-called dissonance is simply a further-removed consonance.[2]

The fact that Schoenberg, in the last movement of his Second String Quartet, had set words by the poet Stefan George can scarcely have failed to command Kandinsky's sympathy; he, too, was a great admirer of George's work.[3] But it was Schoenberg's theories, more than his music, that captured Kandinsky's attention, especially the short text printed in the concert program. He was so intrigued by this program note that he wrote to the composer, whom he had never met,

asking for elucidation. It emerges from Schoenberg's reply that the agency responsible for promoting the concert had reprinted, without his consent (or even his knowledge), an extract from his article "On Parallel Octaves and Fifths." The article, which had appeared in the Berlin journal *Die Musik* in February 1910,[4] was in turn part of Schoenberg's *Theory of Harmony* [*Harmonielehre*], then being prepared for publication by Universal Edition in Vienna. Kandinsky procured a copy of the article, and his enthusiasm was such that, without waiting for Schoenberg's permission, he translated it into Russian, adding footnotes of his own, and had it included in the catalogue of Izdebsky's exhibition *Salon 2,* in which his own essay "Content and Form" also appeared (see pp. 84–90).

It is not difficult to see why Schoenberg's article should have been of such interest to Kandinsky. The composer's attack on the "arbitrary" ban imposed by the academic teaching of harmony on the use of parallel octaves and fifths in musical composition echoes the painter's utterances concerning academic "rules" in art. In his footnotes, Kandinsky draws specific attention to the importance of this point. Schoenberg's remarks on dissonance are no less important. He suggests that dissonances "differ from consonances only in degree; they are nothing other than more distant consonances, whose analysis presents the ear with greater difficulties, because of their remoteness but which, once analysis has brought them nearer, have just as much chance of becoming consonances as the more immediate overtones."[5] In other words, his own use of unresolved dissonances in his compositions of this period was not mere "willfulness"; on the contrary, it could be justified by reference to those fundamental laws of acoustics that govern all musical creation. Kandinsky evidently regarded this argument as a model

worthy of emulation in his own attempts to formulate a theoretical justification for the abandonment of representation in painting.

Only those passages of Schoenberg's article that Kandinsky singled out for commentary are reproduced below: they are set in smaller type. Kandinsky's footnotes, as elsewhere in this volume, are marked *, †, ‡, etc.

Parallel Octaves and Fifths*

* This translation I have made is part of an article published in *Die Musik* (X,2). The article is an excerpt from the author's *Theory of Harmony,* shortly to be brought out by the publisher Universal Edition. Schoenberg is one of the most radical, consistent, gifted, and sincere creators of the "new" music. I venture to recommend to all those interested in art not to be put off by the specialized title, and to read this brief extract. And to notice in particular how keenly this revolutionary composer feels the inviolable, *organic* link, the inevitable natural development of the new music out of the old, indeed from the depths of its most remote sources. "Art travels . . . along the path of human nature." With the development of the human spirit, art too is eternally enriched, and enriches in its turn with new means of expression the human spirit. There is a limit, however, to the attainments of every age, just as there is a limit to the inner knowledge attainable by each era of human development. Schoenberg, too, is of this opinion: every chord, every progression is permissible, "but I feel even today that there are certain limits which determine my use of this or that dissonance."

Schoenberg combines in his thinking the greatest freedom with the greatest belief in the ordered development of the spirit!

> Orthodoxy, which no longer has any need to fight for what others have already achieved, instead makes it its business to fix that achievement by means of exaggeration. Goes into all the ramifications; but because of its exaggerations, not only leads to error, but succeeds in constructing a bulwark against any further advance . . .†

†These few brief lines convey clearly the reality that lies behind all human progress (in the spiritual realm; in the material realm, on the

other hand, people are inclined to grasp eagerly at every "novelty." Hence, for example, the present craze for aeronautics, especially in Western Europe.) People, filled with panic, hide their heads in the sand or arm themselves by legitimate or illicit means against every new achievement, which they must, however, ultimately acknowledge as their salavation. Only then will the new credo *immediately* come about. What yesterday was rejected with derision today is deified. Any "breach" of its law is regarded as an affront before the Almighty. And woe to him who comes bringing with him new progress, a new law. And the same old story repeats itself over again. This human tendency, to reject the "new," and then to cast it into an iron form—in other words, an immeasurable spiritual fatalism—is perhaps the worst, most tragic aspect of the human condition.

> What, then, must be the pupil's attitude to this question? I wish to deal now with the question in more detail, as I intend later to refer to this discussion in general terms, without rehearsing it every time. One may pose the question as follows: If, then, parallel octaves and fifths are not bad, why should the student not be allowed to compose them? . . .‡

‡ Here the author touches upon one of the most vexed questions, giving rise to doubts even in the mind of the most "radical" artist-teacher. The problem is exactly the same in painting: once painting no longer recognizes organic-anatomical construction, i.e., consistently rejects it in favor of linear-painterly construction, does it not follow that one should exclude from one's instruction all the preliminary exercises practiced by earlier schools, in particular the mastery of organic-anatomical construction? Here one must remember earlier epochs and the outstanding works produced by the great early masters, who from lack of knowledge made what appear to our eyes unpardonable and often amusing mistakes of anatomy (Persians, Japanese, early Italians, early Germans—among them the great artist, draftsman and painter Albrecht Dürer). In the works of these masters, their mistakes served, as if involuntarily, creative purposes. And who would dare raise his hand to correct Dürer for drawing a *fibula* in one of his engravings, instead of the *crista fibulae*, or the *tibia* instead of the *malleolus externus?* Then again, should—or could—the contemporary artist, like the musician who rules out parallel octaves, tell us, his pupil: You absolutely *must* know that the *malleolus externus* is the lower, external appendage of the *fibula?* Above all,

it seems to me wrong for the teacher to instruct the pupil in art in the same way a sergeant-major instructs a soldier in the use of firearms. Moreover, I do not believe that the teacher is obliged to burden (and, as often happens, to fetter) his student with "immutable" laws. Rather, his task is to open before his students' eyes the doors of the great arsenal of resources, i.e., means of expression in art, and to say: Look! Over there, in that dusty corner, you'll find a heap of expressive weapons no longer in use *today.* Among them you'll find organic-anatomical construction; if you need it, you know where to look for it. . . . The time has come to open these great doors.

Whither the "New" Art?
["Kuda idet 'novoe' iskusstvo"?]
Odesskie novosti
(Odessa), 1911

Kandinsky's several publications in Russian newspapers and journals at this time, and his frequent contributions to Russian exhibitions, indicate his continued interest in the artistic life of Moscow, St. Petersburg, and Odessa. This particular article, while not as provocative as *On the Spiritual in Art* (published in Germany the same year), was in some ways a sequel to his "Content and Form" (see p. 84). Generally speaking, "Whither the 'New' Art" owes much to the ideas and ideals of the European and Russian Symbolists. Many of the references here betray Kandinsky's support of the Symbolist aesthetic, e.g., his admiration of the Symbolist "heroes" Boecklin, Maeterlinck, and Wagner, his praise of the "new" Russian literature (the prose and poetry of Andrei Bely, Aleksandr Blok, Viacheslav Ivanov), and his allusions to the "godseeking" initiated by the philosopher Vladimir Solovev and popularized by the social historian Vasily Pankratov.

Kandinsky's concern with the Symbolist worldview is evident, above all, in his own philosophical interpretation of art and existence. His concept of the inner meaning or resonance beyond external appearance is very much in keeping with the Symbolists' wish to penetrate to the essence of the objective world. Similarly, Kandinsky's notion that expressiveness is of greater import than the documentary rendering of reality repeats what Bely and other Symbolist thinkers were asserting in the early 1900s. Moreover, Kandinsky's assertion "Movement is life; life is movement," however axiomatic,

was central to the Russian Symbolists' interpretation of art: defining reality also in these terms, they argued that all the arts should aspire toward the state of music, the most "mobile" medium. Like the Symbolists, although somewhat belatedly, Kandinsky shared the anticipation of a new epoch, of a revelation whereby the "essence" or the "absolute" would be attained. It is not accidental that Kandinsky expressed his apocalyptic vision in a language reminiscent of Bely's and Blok's and that he resorted to a Biblical—or perhaps one should say, Zarathustran—tone.

Like many of the Russian modernists, particularly Bely, Kandinsky was familiar with scientific discovery, but his attitude toward it was ambiguous. On the one hand, he admired its progress (implicit in his opening remarks on the pathologist Rudolf Virchow);[1] on the other, he condemned it, identifying it with the ills of nineteenth century positivism. To the positivist camp, Kandinsky allotted the Realist artists, specifically the Russian Wanderers (members of the so-called Society of Wandering Exhibitions)[2] whose narrative, didactic themes of socio-political disorders and sentimental scenes retarded the development of "painting as painting" in late nineteenth century Russian art. Kandinsky, therefore, was justified in contrasting the most famous member of the Wanderers, Ilia Repin, with the more contemplative, more "Symbolist" Isaak Levitan. Like Kandinsky, Levitan was associated with the St. Petersburg World of Art group and, in the history of Russian painting, played an important connective role similar to that of Chekhov in literature and Skriabin in music. Levitan followed the transition *ab realibus ad realiora* identifiable with much Russian art at the turn of the century. This process culminated in the Symbolist work of Viktor Borisov-Musatov and the Blue Rose group; and Kandinsky's own abstraction derived in part from this lyrical, subjective tradition.

Virchow, the great scientist of international fame, once said, "I have opened up thousands of corpses, but I never managed to see a soul." Great individuals always express their era. And unwittingly, in these superficial and flippant words, this great man has expressed the entire superficiality and flippancy of the nineteenth century.

In this era of the deification of matter, only the physical, that which can be seen by the physical "eye," is given recognition. The soul has been abolished as a matter of course. Similarly, the heavens have been devastated. Since we "only live once," first and foremost, we are supposed to make life pleasant. Even people with that small reservoir of "love for one's neighbor," called altruism and equated with inverted egoism, have set themselves the aim of granting themselves and their neighbors (or most of their neighbors) the greatest number of material blessings. For most people, the accumulation of material blessings with the minimum expenditure of energy (a principle of economic science) has become the ideal of human activity and life. Everything that contributes to this aim and hence to any kind of "comfort" has become all-important. A turbulent flood of technological inventions has poured forth. The finest minds, the greatest talents, the most heroic natures have thrown themselves unhesitatingly to this side of life, for no longer can they see the other: It does not exist.

It does, of course—but as a trickle, a wretched little stream stifled by the roar of the turbulent flood. People deafened by the flood not only do not wish to, but are unable to hear the tiny stream. Everything has been cast at the feet of materialism. The same with art. It has been ruled and guided by Realism (which in Russia was expressed by the Wanderers movement).

That is why the artists of true art work in silence and are unseen. Their art is eternal and can never suffer interruption. Imperceptibly, they have forged a new link in the eternal chain, that link which has now fallen so unexpectedly onto the heads of the Realists and their public—hitherto so secure. Unrecognized, alone, that is how Segantini lived his heroic life, fleeing from the cities and losing himself on the mountain tops; or Boecklin, who fled his native Switzerland; or Gauguin, who fled his native France; or Van Gogh and the genius Cézanne, who hid themselves in the provinces. This was done in silence; it was enclosed and concealed deep down in the soul.

And the further the inner meaning of life retreated from the surface, the more it sank into oblivion and was lost. But the outer meaning

remained on the surface distinct and clear. Yet as soon as man began to lose this outer meaning, he was confronted immediately by a vacuum. And since the outer meaning is unstable and slithers so easily from view, the disillusioned and the desperate arose in their thousands. And their cry echoed the confused question asked by those not yet poisoned by life, by those still preparing for life: Where is the meaning of life? Where lies the aim of life?

And the surrounding silence answered: There is no aim in life.

The darkness gathered, the air thickened, all escape was blocked.

And, unrecognized, the soul was sick.

Those who had lost all hope beat their hands on the locked doors and with those same hands strangled themselves: life was worth nothing.

And there poured forth a turbulent flood of violence, outrage, war, murder, suicide.

And now, slowly but surely, like a large spot of oil, loss of faith and materialism are seeping through the strata of the populace, into its very depths. And so it will continue for a long time yet.

At such dark moments nobody needs art. All people need is its auxiliary role, its service as a lackey. Artists, themselves permeated through and through by materialism, forget their vocation and slavishly ask the public, "What can I do for you?" Serving sacred art becomes a gesture of amusement. "I've ordered a portrait, so get on with it—what do I care about your 'painting?'" says the complacent client to the meritorious artist. "Give me a bit of nature in a landscape," says the all-powerful customer. "Make the bush like a real one! What do I care about your painting!" And the artist does his best to give gratification. From being a prophet and a leader, he turns into a parrot and a slave. Ladies fainted and men felt sick in front of Repin's picture *Ivan the Terrible and His Son Ivan*[3]—the blood flowing and clotting in lumps was so well done, so real. "What do I care about painting?"—it was as if Repin himself was speaking—"I want the blooood to flow, I want the smell of blooood." More refined painting was merely "mood," the incantation of melancholy and inconsolable grief. It was precisely this kind of painting (like great Russian literature) that reflected the despair before the locked doors. Both in Chekhov's works and in Levitan's landscapes a perpetual atmosphere of terror existed and was conveyed by them as a cold, clammy, slippery, stifling fog. In works such as these art fulfills only half its mission.

The art generated by any epoch is first and foremost its reflection. It is a spiritual mirror.

Secondly, every art bears within it the seeds of the future and awakens the strings of the soul, whether they have fallen silent or whether they have yet to resound. Art is the seer of the future and is a leader.

It was this second element that was lacking in the works of "mood." And that is why that kind of art was indeterminate and ephemeral.

It was precisely this element that, in embryo, lived mainly in Western European art (Impressionism). Only as a vague allusion did it enter the work of Russian artists during the World of Art period (particularly of the Muscovites). While rejecting any material, tangible "content," these artists could neither see nor find a new "content" (i.e., an immaterial one, possessed only by art and effused only by it). Hence, they declared any content to be unartistic and alien to art. Art does not have an aim, they said; it has an aim unto itself. *L'art pour l'art!*

This very statement contained the seedling of the salvation and liberation of art from its servility to material: once art is self-sufficient, it must concentrate on itself and, above all, must attend to itself and its own means of expression.

Art, as it were, turns its back on life (so it appears) and turns to its own arsenal. In this arsenal (which had fallen into virtual oblivion), it finds its own means of expression; and it is endowed with a titanic strength and a spiritual resonance not to be found in any other field.

This embarkation on an almost forgotten path of prophetic revelations took place almost simultaneously in the various other arts.

Contemporary with one of the most extreme Realists (E. Zola), M. Maeterlinck was beginning to write his first works in French, too. With a single blow he wrenched the action from the ambience of the materialist Rougon and transferred the incarnation of feeling into the realm of phantasmal, schematic Hjalmars and Maleines. His personages were incarnated in the ether of feeling. Of course, this new ambience required new means of expression. The Word! Maeterlinck listened to its inner sound—beyond the outer meaning of the word. The word that sounds "simple" by itself acquires a particular, inexpressible, but definite sound when one enters it more deeply. Hair! Tree! Sky! It is on this resonance that Maeterlinck builds his *Serres Chaudes.*[4] It is as if he learns from music, borrowing its most forceful means of expression—repetition (e.g., in his dialogues). The broad current of "new" literature, which has many very talented representatives in Russia, is the logical

and organic development of this process. He who does not "understand" this current—let him remember that the word is like a living being, which radiates its own spiritual aroma. The inhalation of this aroma by the soul is a precondition for the "understanding" of literature.

Similarly, R. Wagner began to use the medium of his art—sound. The heroes of his operas are expressed not only by material form, but also by sound—the *leitmotif*. This sound is, as it were, the spiritual aroma surrounding and expressing the hero: each Wagnerian hero "sounds" in his own way.

A. Rodin does not lay his art at the feet of man and material, but subordinates them to the aims of his art—sculpture. Via man he seeks to express the movement, distribution and consonance, etc., of lines and form. For him, organic form is merely a convenient pretext for creating plastic forms. The material serves the abstract.

These heralds of daybreak augur a change, one that is now occurring slowly and inexorably, one that we can already recognize throughout the spiritual atmosphere. A general interest in abstraction is being reborn, both in the superficial form of the movement towards the spiritual, and in the forms of occultism, spiritualism, monism, the "new" Christianity, theosophy, and religion in its broadest sense. Circles, societies, journals, lectures, symposia dedicated to the problems of the abstract are growing up like mushrooms. Undoubtedly, most Russian readers are familiar with Pankratov's book *Seekers of God*.[5] In it the author describes very well, although not exhaustively, Russia's religious quests of today, and in all milieus right down to student groups.

Finally, science itself, in its most positive branches—physics and chemistry—is reaching a threshold whereon is inscribed the Great Question: Is there such a thing as matter?

The spiritual atmosphere is like the physical one and, like the physical, it is saturated with certain elements; to inhale these elements spiritually creates a spiritual flesh and blood, "attunes" the soul—all those souls that, in increasing numbers, are aspiring towards the single aim by the single path. And this, our present path, is the path of the spirit; our aim is the refinement and growth of the soul.

Like the body, the soul grows by exercise. Like the body, it grows by movement. Movement is life; life is movement. It is in this that the meaning, the sense and the aim of art is manifested. The whole of nature, the whole world acts ceaselessly on the soul. That is how individuals and nations grow. Every phenomenon passes man, leaving

behind its trace, brushing against his soul. The strings resound, vibrating like the strings of a musical instrument. And just as an instrument is improved, becomes finer the more its strings are made to oscillate (a "mellowed" violin), so it is with the soul. But natural phenomena, expressed in fortuitous sounds, spots of color, lines (everything in the world resounds by tone, color, and line) evoke in man confusion, disorder, and illogicality. These phenomena are like the collection of words in a lexicon. A force is required to put these fortuitous sounds of the universe into systematic combinations for systematic effect on the soul. This force is art. The systematic combination of scattered elements, i.e., that combination which corresponds most to the above aim, is beauty.

Every great epoch has its inner aim. Hence every great epoch has its outer beauty, which lies in the exposition of its inner meaning. Thus, we should not look backward, nor measure our newborn beauty by the old yardstick of the past. Every new beauty seems ugly because it contains no image from the past. That is why people always hate those who are destined to seek and find a new beauty, the beauty of "tomorrow"—the ugliness of "yesterday." The Viennese composer Professor Schoenberg,* one of the few radical reformers in music, writes in his *Theory of Harmony,* "In order not to look back, you must always be contemporary."[6] I would add, however, that some people should look back—not we artists and not you the public, but art historians—but only after the new harmony, the new law, the new beauty has been found, and after it has flowered at the end of our epoch (a long and great one because it is the epoch of the Spiritual). And when that day comes (which will also be the end of our era), the historian will see that our ugliness was harmony; he will see that it was in no way the rejection of all previous kinds of harmony and beauty, but was their organic, immutable, and natural continuation. So the new branch is the continuation of the same tree. And the leaf is of the same branch.

When we first see these individual kinds of (apparent) beauty, we are disoriented and stupefied, but however contradictory and antithetical they may be, they all constitute a Single Beauty. And this single beauty is a single path. The path to the "ideal," to the "Divine."

That is why art is so subtle. That is why it is not "understood." The artist's task is to understand, i.e., to know, which means of expression at

*He is perhaps the freest of all with regard to the general form of the new music, and is more consistent than Debussy (France), R. Strauss (Germany), Skriabin (Russia), etc.

his disposal can attain the long-desired inner meaning; and to a lesser extent this is also the critic's task. But it is certainly not the public's. So often we hear the public say those rather embarrassed and modest words, "I don't understand anything in art." As if, on being served some dish or other, I should refuse it and in embarrassment, say "But I don't understand anything about the culinary art." In this instance, unless you want to stay hungry, you need not understand—you simply open your mouth and eat. Art is spiritual bread. The chef-artist has to "understand it," but the "elite" should bare their souls to it and apprehend it. "Oh! For heaven's sake, don't understand it!" This is the *cri de coeur* in which every true artist, writer, and composer joins unhesitatingly.

One way or another true art inevitably acts on the soul. The soul vibrates and "grows." That is the exclusive aim of the artist, whether he himself is fully aware of it or not.

Painting as such, i.e., as "pure painting," will affect the soul by its own original means of expression—paint (color), form, i.e., the distribution of planes and lines, their interrelations (movement). An object (a real one—a man, a tree, a cloud) is, as it were, merely an allusion to the real, an allusion or aroma in the composition. That is why the object (the real object) need not be reproduced with precision. On the contrary, its imprecision only intensifies the purely painterly composition. The timely (or truly contemporary) work of art, as I've already stated, reflects, *inter alia*, its epoch. And our epoch is a time of tragic collision between matter and spirit and of the downfall of the purely material worldview; for many, many people it is a time of terrible, inescapable vacuum, a time of enormous questions; but for a few people it is a time of presentiment or of precognition of the path of Truth. Be that as it may, everything that once appeared to stand so eternally, so steadfastly, that seemed to contain eternal, true knowledge, suddenly turns out to have been crushed (and in places smashed to pieces) by the merciless and salutory question, "Is that really so?" Consciously or unconsciously, the genius of Nietzsche began the "transvaluation of values." What had stood firm was displaced—as if a great earthquake had erupted in the soul. And it is this tragedy of displacement, instability, and weakness of the material world that is reflected in art by imprecision and by dissonance. When we look at paintings from this point of view, we should not, I repeat, understand and not know, but simply feel, baring our soul completely. Art is the living face not of the mind, but of feeling and only feeling. For anyone who cannot feel, art is dark and silent. But

only in art will he find salvation. Art will give him both hunger and nourishment.

I shall not be irreverent if I conclude these lines (far too schematic) and these vast problems, which, inevitably, I have merely touched upon, with the words: Who hath ears to hear, let him hear.

And . . . our hearts are full of grief!

Munich, January 1911

The Battle for Art
[*Im Kampf um die Kunst:
Die Antwort auf den
"Protest Deutscher Künstler"*]
(Munich), 1911

The following essay appeared in *The Battle for Art: An
Answer to the "Protest of German Artists,"* published by
Reinhard Piper in Munich in the autumn of 1911. This vol-
ume was conceived as a reply to a polemical tract edited by
the Worpswede painter Carl Vinnen, which had been pub-
lished earlier the same year by the firm of Eugen Diederichs
in Jena under the title *Protest of German Artists against the
Importation of French Art.*[1] Vinnen and his colleagues ad-
vanced an overtly chauvinistic view of German art and at-
tacked the acquisitions policy of institutions like the Bremen
Kunsthalle and the Berlin National Gallery. (Such views
were by no means unusual at this time: Hugo von Tschudi,
former director of the Berlin Museum, had encountered
fierce opposition in his attempts to enrich the foreign collec-
tions by acquiring masterpieces of French nineteenth cen-
tury painting.) The *Protest of German Artists* provoked a
storm of counterprotests from artists, writers, and museum
directors of more international outlook. Liebermann,
Corinth, Slevogt, Klimt, Rohlfs, Pechstein, van de Velde,
Marc, Kandinsky, and Macke; Worringer, Hausenstein,
Tietze, and Uhde; Pauli, Osthaus, Lichtwark, and Cassirer all
contributed to *The Battle for Art.* Together with the *Blaue
Reiter Almanac* and Kandinsky's *On the Spiritual in Art,*
this publication helped establish Piper's reputation as one of

the foremost champions of avant-garde art in Germany.

Kandinsky's essay must strike the casual reader as rather curious. Couched in obscure, even mystical language, it makes no reference to Vinnen's publication or to the situation of contemporary German art. Rather, the principal object of attack seems to be the naturalism of much nineteenth century academic painting, what Marc described as the striving after "ever closer agreement with natural appearances, the bright, daylight appeal of which frightens away the mysterious and abstract images of inner life."[2] Kandinsky also touches upon two important topics to which he will return in subsequent writings: the "stamp" impressed upon the work of art by factors such as time and personality (a subject discussed in much greater detail in *On the Spiritual*); and the construction of the work of art as a reflection of the "planned and purposeful" character of modern life—one of the principal themes of his essay "On the Question of Form" (see pp. 235–256).

Man, like the world, like the cosmos, consists of two elements: the internal and the external.

The external element of man, or external man, remains in continuous contact with the external aspect of the world that surrounds him. There are no means capable of dissolving this continuous contact. These surroundings are at the same time the source of life of external man.

The internal element of man, or internal man, remains in continuous contact with the internal aspect of the world that surrounds him. This contact is inescapable. It is at the same time the source of life of internal man.

To put it schematically, his external element is the means by which modern man is able to remain in contact with the life of the internal aspect of the world, and to draw from it his life force.

Thus, every internal, spiritual force also needs its external element.

The greatest internal, spiritual force is art.

Thus art also has two elements: the internal and the external.

These two indispensible elements are reflected in every work of art.

The complete harmony of the work of art is therefore the ultimate balance between the internal and the external, i.e., between content and form.

Therefore, all artistic content seeks its [particular] form.

Thus, form may change in order to conform to the inner nature of the artist.

Thus, too, form may change in order to conform to the internal nature of its own epoch.

The connection between the work of art and the artist impresses upon the former the stamp of the artist's personality, his style.

The connection between the work of art and its epoch impresses upon the former the stamp of the period and its style.

Thus, in every work of art two styles are to be found: that of the "individual" and that of the "school."

The now-dawning twentieth century is the century of the "internal," in contrast to the nineteenth, which was that of the "external."

The once "lost" and now "found" inner life confers again upon "modern" art, which exists already today, the lost balance of the two elements: the internal and the external. There will arise a "new" harmony or beauty, which, as always, will at first be called disharmony or ugliness.

This harmony will consist of the perfect conformity or, subsequently, subjection of the external element (that of form) to the internal (that of content), without regard for any other considerations, including those of "the natural."

Since our inner life (like every visible form of life) is ordered according to plan and purpose, the expression of this life demands a planned and purposeful form.

Thus, even today the absolute necessity in art of plan and purpose—i.e., of construction—is quite clear. Every contemporary artist must inevitably make his creation conform to this necessity.

After music, painting will be the second of the arts to be unthinkable without construction, which even today is already the case.

Thus painting will attain to the higher level of pure art, upon which music has already stood for several centuries.

This will be the great aim of all "young artists," or "fauves," of every spiritually great country. And there is no power capable of halting this progress of art.

Before this lofty striving, the greatest hindrance appears no more than a leaf in the face of the oncoming storm.

Munich

The First Exhibition of the Editors of the *Blaue Reiter*
[*Die Erste Ausstellung der Redaktion Der Blaue Reiter*] (Munich), 1911

The "Editors of the *Blaue Reiter*" were none other than Kandinsky and Franz Marc. On 19 June 1911, Kandinsky had written to Marc with a "new plan," suggesting that they should start to collect articles and illustrations for a kind of almanac or yearbook, to be called "'The Chain,' or some such title."[1] It is not known exactly when, or for what reason, the title was changed to "The Blaue Reiter." Kandinsky later recalled that the name "invented itself" over coffee in the garden at Sindelsdorf, the Bavarian village where Marc occupied a small farmhouse. "We both liked the color blue: Marc—horses, I—riders."[2] Marc also approached the Berlin industrialist Bernhard Koehler to provide financial support for the venture. (Koehler was uncle to August Macke's wife, Elisabeth.)[3] Reinhard Piper, for whose volume *The Animal in Art* Marc had already supplied illustrations, agreed to publish the almanac. The whole of the autumn of 1911 passed in a fever of soliciting articles, editing manuscripts, choosing illustrations. "Everything was examined, discussed, accepted or rejected, not without a certain amount of disagreement and friction."[4] There were endless debates about the "synthetic" aims of the book, about the relationship between written and visual material, between art and "ethnography," between different forms of art.

Kandinsky's involvement with this project may partly

have compensated for his growing disenchantment with the Neue Künstler-Vereinigung. As early as August 1911, Marc wrote to Macke, then in Bonn: "I can foresee clearly, with Kandinsky, that the next jury (in the late autumn) will be the occasion for a dreadful altercation, and then, or the next time, a split, or else the resignation of one or the other party, and the question will be, who *stays.*"[5] The storm finally broke in December of that year, when the jury of the NKVM rejected Kandinsky's *Composition 5,* which the artist had intended to exhibit at the association's third exhibition later that month. Kandinsky, Marc, and Münter resigned in protest.

Having foreseen the probable outcome of the dissension within the NKVM, Kandinsky and Marc had already entered into negotiations with the dealer Heinrich Thannhauser, who agreed to afford them space for an independent exhibition next to the rooms reserved for their former colleagues. Since plans for the almanac were already so far advanced, the editors borrowed the name "Der Blaue Reiter" and used it for the exhibition as well, which opened in Munich on 18 December. There was no jury; Kandinsky and Marc simply invited like-minded artists to contribute to the first exhibition, selecting works in what the latter described as a "purely dictatorial" manner.[6] The first Blaue Reiter show included paintings by Henri Rousseau, Albert Bloch, the Burliuk brothers, Heinrich Campendonck, Robert Delaunay, Elizabeth Epstein, Eugen Kahler, August Macke, Gabriele Münter, Jean Niestlé, and Arnold Schoenberg. Marc exhibited four paintings, among them one landscape; Kandinsky showed his disputed *Composition 5, Improvisation No. 22,* and the now-lost *Impression "Moscow,"* as well as three paintings on glass, not listed in the catalogue.[7]

The texts that follow are taken from the second of two versions of the exhibition catalogue. (The earlier version of the catalogue contains only the shorter of the two texts.)

Here, we find Kandinsky at his most aphoristic. Also remarkable, given the brevity of these two untitled statements, are the idiosyncracies of layout and typography, especially the use not just of different typefaces, but also of different sizes of type within the same short piece. (On the *Blaue Reiter Almanac,* see further pp. 229–285; on the second Blaue Reiter exhibition, see pp. 227–228.)

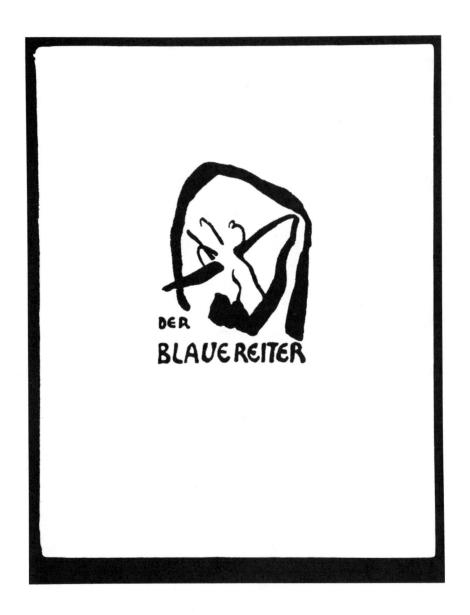

—Cover, Exhibition Catalogue, First Exhibition of the "Blaue Reiter"

In this small exhibition, we do not seek to propagate[8] any **one** precise and special form; rather, we aim to show by means of the **variety** of forms represented how the **inner wishes** of the artist are embodied in manifold ways.

The great revolution;
The shifting center of gravity in art, literature, and music;
The variety of forms: the constructive, compositional [aspect] of these forms;
The intensive turning toward the inner [aspect] of nature and, bound up with it, the rejection of any prettifying of the external aspect—
—THESE ARE IN GENERAL THE SIGNS OF THE NEW INNER RENAISSANCE.
To show the characteristic expressions of this change,
to emphasize its internal relationship with past epochs,
to make known the expression of inner strivings in EVERY form having its own inner sound—
—this is the goal that *Der Blaue Reiter* will endeavor to attain.

1911–1912

On the Spiritual in Art
[*Über das Geistige in der Kunst*]
2d ed., (Munich), 1912

Kandinsky wrote only two full-length books: *On the Spiritual in Art* and *Point and Line to Plane.* The former summarizes his ideas and experiences during the first decade of his artistic activity. In "Reminiscences," he recalled that the drafts and jottings for *On the Spiritual* had "accumulated over a span of at least ten years." If this statement is to be taken literally, the notes to which he refers must date back to the years immediately after his arrival in Munich, since the typescript of the German version of his text is dated "Murnau, 3 August 1909."[1] A large quantity of handwritten notes for *On the Spiritual in Art* is preserved as part of the Gabriele Münter und Johannes Eichner Stiftung; most of them cannot, however, be dated with any exactitude. Kandinsky also recalled that the completed book lay in his drawer for several years, "since not a single publisher had the courage to wager the (as it turned out, quite low) costs of publication." It was, in fact, thanks to Franz Marc that he finally succeeded in persuading Reinhard Piper to publish his text.[2] The first edition appeared in December 1911, in time for the first Blaue Reiter exhibition;[3] it bore the date 1912, a common device in order that a book which came out in time for Christmas might still count as "new" for the following twelve months.

The genesis of *On the Spiritual* was, however, more complex than the above description suggests. The first edition differs from the German typescript in several important respects, not least in that it includes a considerable amount of material not to be found in the latter; the whole of the last

chapter, for example, is missing from the typescript. There also exist a Russian manuscript and a Russian typescript, each different from the other, and different again from any of the published versions of the book. A Russian version of *On the Spiritual* was read aloud to the Pan-Russian Congress of Artists, which opened in St. Petersburg in December 1911, and published in the proceedings of the congress.[4] Although this version was shorter than the full German text, its reading still took up more time than had originally been allotted, and an extra day had to be set aside for its completion and discussion.[5] This feat of elocution was performed by Kandinsky's friend, the military doctor and *avant-gardiste* Nikolai Kul'bin. The author himself was absent, which perhaps explains why, in later years, he consistently mistook the date of the St. Petersburg session, ascribing it to 1910 rather than 1911.

As for the German edition, Piper need not have worried about recouping his losses. *On the Spiritual in Art* was an instant success, going through two further editions in the course of the same year, 1912. To the second edition, Kandinsky added two further passages, consisting of several paragraphs each, as well as a number of small stylistic changes;[6] the third edition is identical to the second. A fourth German edition was planned to appear in 1914, but these plans were frustrated by the outbreak of war. It is known, however, that Kandinsky intended to make further changes to this fourth edition: a manuscript headed *Kleine Änderungen zum "Geistigen"* [Small Changes to *On the Spiritual*] was found in his studio at Neuilly, and has been partly published by Lindsay.[7]

The long period of gestation and the fact that *On the Spiritual* was cobbled together from such a variety of drafts and sketches make it a text that is, at times, far from easy to

read. Kandinsky's arguments are often convoluted, and he sometimes seems unsure precisely what he wants to say. For example, he devotes much space to discussing the psychological effects of colors and forms, observed in isolation; but, mindful of what he calls the "danger of ornamental form," he seems to doubt whether colors and forms, in themselves, can constitute an entire pictorial language. Even in the second edition of 1912, he is still adamant that "using exclusively pure, abstract forms, the artist today cannot manage." Interestingly, his opinion changed in the course of the next two years: in the *Kleine Änderungen* of 1914, he altered this crucial paragraph so as to affirm the possibility of an entirely abstract art. On other important questions, too, his view was initially far from clear. As a thinker, Kandinsky was highly eclectic, and his discussion of color theory in *On the Spiritual in Art* is deeply influenced by the optical studies of Goethe and Schopenhauer. Like Goethe, Kandinsky concentrates primarily upon the metaphorical and associative values of colors, beginning his account with the same pair of polar opposites, blue and yellow upon which Goethe's theory is based.[8] He evidently feels obliged, however, to give some account of the physical properties of colors as well, but insists that his observations are not based upon any positivistic method, being the result of "empirical-spiritual experiences." He also tries, not altogether successfully, to illustrate his view by recourse to the musical notion of *Generalbass,* or "figured bass,"[9] using the term to symbolize that balance between logic and inspiration which, he believed, could be neither taught nor learned, but only felt.

The mystical tone Kandinsky sometimes adopts, coupled with his distrust of cerebration and the methods of positivistic science, has led certain commentators to interpret *On the*

Spiritual in Art in terms of occult influences, as a quasi-mystical tract. The subject of Kandinsky's interest in theosophy, and in the writings of Rudolf Steiner and Madame Blavatsky, has been much discussed.[10] Certainly, Kandinsky refers to both Steiner and Blavatsky in the book; although he himself was never a member of the Theosophical Society, some of his best friends were theosophists. We also know that he attended some of Steiner's lectures in Berlin early in 1908. But theosophy was only one of a number of influences on Kandinsky at this time. The third chapter of *On the Spiritual*, in which he quotes from Blavatsky's *Key to Theosophy*, is nothing other than an extended review of contemporary intellectual and artistic trends, in the course of which the author refers to figures as diverse as Boecklin and Skriabin, Karl Marx and Edgar Allan Poe. Moreover, *On the Spiritual* is the only published text in which Kandinsky makes any extended mention of theosophy. His occult interests were evidently of limited duration: by 1911, when he and Marc were considering what material should be included in the *Blaue Reiter Almanac,* Kandinsky was already suggesting that any reference to the theosophists should be "short and emphatic";[11] but when the almanac finally appeared, in May 1912, it contained no allusion to theosophy whatever.[12] It is also significant that all the theosophical references in *On the Spiritual in Art* are already present in the German typescript of 1909; the passages that Kandinsky added at the last moment, and that evidently have to do with his latest preoccupations, either deal with contemporary art movements (Cubism), or else reflect his reading of Worringer and the influence of Riegl's theories.

The changes that occur from one version of *On the Spiritual in Art* to the next are of considerable significance for any study of Kandinsky's intellectual development. It has

not, however, proved feasible here to provide a complete variorum edition, and only the more significant changes have been indicated in the editors' footnotes. The published Russian version, in particular, differs substantially from the German, being considerably abbreviated and sometimes discussing topics in a different order. In the end, however, a comparison of the German and Russian editions adds little to our understanding of Kandinsky's ideas. On the other hand, the additions he made to the second German edition and the projected changes for the unrealized fourth edition are noted, since they represent, in the editors' opinion, alterations of substance. Minor stylistic emendations have gone unremarked.

The text followed here is that of the second German edition of 1912, which is the final published version of the book. The woodcuts that decorate the cover, the flyleaf, and the beginning of each chapter are reproduced in their rightful places. The accompanying full-page reproductions, however, were originally placed more or less at random, bearing no evident relation to the surrounding text (they were also differently placed in the first edition). For this edition, the editors have exercised their discretion in positioning these illustrations where most appropriate.

KANDINSKY

ÜBER
DAS GEISTIGE
IN DER KUNST

KANDINSKY

ÜBER DAS GEISTIGE
IN DER KUNST

INSBESONDERE IN DER MALEREI

MIT ACHT TAFELN
UND ZEHN ORIGINALHOLZSCHNITTEN

MÜNCHEN 1912
R. PIPER & CO., VERLAG

KANDINSKY

ON THE SPIRITUAL IN ART

AND PAINTING IN PARTICULAR

WITH EIGHT PLATES
AND TEN ORIGINAL WOODCUTS

SECOND EDITION

MUNICH 1912
R. PIPER & CO.

DEDICATED TO
THE MEMORY OF
ELISABETH TIKHEEV

CONTENTS

PLATES

FOREWORD TO THE FIRST EDITION

The thoughts I develop here are the results of observations and emotional experiences that have accumulated gradually in the course of the last five or six years. I had intended to write a bigger book on this subject, which would have necessitated many experiments in the realm of the emotions. Occupied with other, equally important tasks, I was obliged for the moment to abandon my original plan. Perhaps I shall never accomplish it. Someone else will do it better and more exhaustively, for this matter is one of urgency. I am therefore compelled to remain within the bounds of a simple schema, and to content myself with pointing to the greater problem. I shall consider myself fortunate if this pointer is not lost in the void.

FOREWORD TO THE SECOND EDITION

This little book was written in the year 1910.[16] Before the publication of the first edition (January 1912), I included further experiences I had undergone in the meantime.[17] Since then, another half year has elapsed, and today I can see many things more freely, with a broader horizon. Upon mature reflection, I refrained from further additions, which would produce an uneven effect, clarifying only certain passages. I decided to add this new material to other penetrating observations and experiences I have been building up for several years, which will in time perhaps constitute, as chapters of a kind of *"Theory of Harmony* of Painting" [*Harmonielehre der Malerei*],[18] the natural continuation of this book. The form of the text has remained, therefore, virtually untouched in the second edition, which followed very quickly upon the first. My article "On the Question of Form" in the *Blaue Reiter* [*Almanac*] is a fragment (alternatively, completion) of this further development.

Munich, April 1912

A. GENERAL

I.

INTRODUCTION

Every work of art is the child of its time, often it is the mother of our emotions.

Thus, every period of culture produces its own art, which can never be repeated. Any attempt to give new life to the artistic principles of the past can at best only result in a work of art that resembles a stillborn child. For example, it is impossible for our inner lives, our feelings, to be like those of the ancient Greeks. Efforts, therefore, to apply Greek principles, e.g., to sculpture, can only produce forms similar to those employed by the Greeks, a work that remains soulless for all time. This sort of imitation resembles the mimicry of the ape. To all outward appearances, the movements of apes are exactly like those of human beings. The ape will sit holding a book in front of its nose, leafing through with a thoughtful expression on its face, but the inner meaning

of these gestures is completely lacking.

There exists, however, another outward similarity of artistic forms that is rooted in a deeper necessity. The similarity of inner strivings within the whole spiritual-moral atmosphere—striving after goals that have already been pursued, but afterward forgotten—this similarity of the inner mood of an entire period can lead logically to the use of forms successfully employed to the same ends in an earlier period. Our sympathy, our understanding, our inner feeling for the primitives arose partly in this way. Just like us, those pure artists wanted to capture in their works the inner essence of things, which of itself brought about a rejection of the external, the accidental.

This important point of inner contact is, however, for all its importance, only a point. Our souls, which are only now beginning to awaken after the long reign of materialism, harbor seeds of desperation, unbelief, lack of purpose. The whole nightmare of the materialistic attitude, which has turned the life of the universe into an evil, purposeless game, is not yet over. The awakening soul is still deeply under the influence of this nightmare. Only a weak light glimmers, like a tiny point in an enormous circle of blackness. This weak light is no more than an intimation that the soul scarcely has the courage to perceive, doubtful whether this light might not itself be a dream, and the circle of blackness, reality. This doubt, and the still-oppressive suffering caused by a materialistic philosophy create a sharp distinction between our souls and those of the "primitives." Our souls, when one succeeds in touching them, give out a hollow ring, like a beautiful vase discovered cracked in the depths of the earth. For this reason the movement toward the primitive, which we are experiencing at this moment, can only be, with its present borrowed forms, of short duration.

These two similarities between modern art and the forms of bygone periods are, as can easily be seen, diametrically opposed. The first is external and thus has no future. The second is internal and therefore conceals the seeds of the future within itself. After the period of materialistic trials to which the soul had apparently succumbed, yet which it rejected as an evil temptation, the soul emerges, refined by struggle and suffering. Coarser emotions such as terror, joy, sorrow, etc., which served as the content of art during this period of trial, will now hold little attraction for the artist. He will strive to awaken as yet nameless feelings of a finer nature. He himself leads a relatively refined and complex existence, and the work he produces will necessarily awaken

finer emotions in the spectator who is capable of them, emotions that we cannot put into words.

The spectator of today is, however, rarely capable of perceiving such vibrations. What he seeks in a work of art is either the pure imitation of nature, serving practical ends (such as portraiture in the normal sense of the word, and the like), or an imitation of nature that comprises a specific interpretation ("Impressionist" painting), or, ultimately, a particular state of mind clothed in the forms of nature (which one calls "mood").* All these forms, if truly artistic, fulfill their purpose and provide (even in the first instance) spiritual nourishment—but particularly in the third example, where the spectator finds a sympathetic vibration within his own soul. Moreover, a sympathetic—or even an unsympathetic—vibration cannot remain merely empty or superficial; on the contrary, the "mood" of the work can intensify—and transform—the mood of the spectator. In any case, such works prevent the soul from becoming coarsened. They maintain it at a certain pitch, as do tuning-pegs the strings of an instrument. But the refinement and extension of these vibrations in time and space remain merely one-sided and by no means exhaust the possible effects of art.[19]

* *

*

Imagine a large, very large, small, or medium-sized building divided up into various rooms. All the walls of the rooms are hung with small, large, and medium-sized canvases. Often several thousand canvases. On them, by means of the application of paint, pieces of "nature" are portrayed: animals in light and shadow, standing at the edge of the water, drinking the water, lying in the grass, next to them a crucifixion of Christ, portrayed by a painter who does not believe in Christ, flowers, human forms sitting, standing, walking, often naked, many naked women (often seen in foreshortening from behind), apples, and silver dishes, a portrait of Privy Counsellor So-and-so, the evening sun, a woman in pink, flying ducks, a portrait of the Baroness X, flying geese, a woman in white, calves in shadow dappled with bright yellow sunlight, a portrait of His Excellency Y, a woman in green. All this is carefully

*Alas, this word, which indicates the poetical strivings of the living soul of the artist, has been misused and eventually discredited. Was there ever any great word that the masses have not instantly sought to desecrate?

printed in a book; names of the artists, titles of the pictures. People holding these books in their hands go from canvas to canvas, leaf through and read the names. And then they leave, just as rich or poor as when they came in, immediately absorbed once again by their own interests, which have nothing whatever to do with art. Why ever did they go? In every picture, secretly, a whole life is concealed, a whole life with many torments, doubts, and moments of enthusiasm and enlightenment.

What is the aim of this life? To whom is the soul of the artist crying out, assuming that it too was involved in the act of creation? What is it trying to communicate? "To shine light into the depths of the human heart is the profession of the artist," says Schumann. "A painter is a man who can draw and paint everything," says Tolstoy.[20]

Of these two definitions of the artist's activity we must choose the latter, if we think of the exhibition just described. With a greater or lesser degree of facility, virtuosity, and brio, objects are given life upon the canvas, which belong to coarser or finer categories of "painting." The harmonization of the whole upon the canvas is the path that leads to the work of art. This work is observed with cold eyes and indifferent spirit. Connoisseurs admire the "technique" (just as one admires a tightrope walker), enjoy the *"peinture"* (just as one enjoys *pâté*).

Hungry souls go away hungry.

The great masses wander through the rooms, find the canvases "nice" or "great." The man who could have said something to his fellow man has said nothing, and he who might have heard has heard nothing.

This condition of art is called *l'art pour l'art.*

This annihilation of those inner sounds that are the life of the colors, this dissipation of the artist's powers, is "art for art's sake."

The artist seeks material rewards for his skill, his powers of invention and observation. His aim becomes the satisfaction of his own ambition and greed. Instead of a close collaboration among artists, there is a scramble for these rewards. There are complaints about competition and overproduction. Hatred, bias, factions, jealousy and intrigue are the consequences of this purposeless, materialistic art.*

*The few solitary exceptions do not nullify this bleak, doom-laden picture, and even these exceptions are mainly artists whose credo is *l'art pour l'art.* They serve, therefore, a higher ideal, which, regarded as a whole, constitutes the purposeless dissipation of their strength. External beauty is a constituent element of the contemporary ethos. But apart from its positive side (for beautiful = good), this art suffers from a lack of fully occupied talent (talent in the sense of the Gospel).

The spectator turns tranquilly away from the artist who cannot see the purpose of his life in a purposeless art, but rather has higher aims before him.

"Understanding" entails the spectator's familiarity with the standpoint of the artist. It has been said earlier that art is the child of its time. But the kind of art just described can only repeat in artistic form that which already quite c l e a r l y constitutes the content of the contemporary ethos. This art, which conceals no future potentialities, and which is therefore only a child of its time and can never become mother of the future, is a castrated art. It is of short duration and dies, to all intents and purposes, as soon as the ethos that gave rise to it changes.

<p style="text-align:center">* *</p>
<p style="text-align:center">*</p>

The other type of art, however, capable of further development, also has its roots in its own spiritual period; yet at the same time it is not only an echo, a mirror of that period, buc also has an awakening p r o p h e t-i c p o w e r, which can have a widespread and profound effect.

The spiritual life, to which art also belongs and in which it is one of the most powerful agents, is a complex but definite movement forward and upward—a progress, moreover, that can be translated into simple terms. This progress is the progress of knowledge. It can take various forms, but fundamentally it maintains always the same inner sense, purpose.

The origins of the necessity that drives man onward and upward "by the sweat of his brow," through suffering, evil, and torture, are veiled in darkness. Even after one has progressed to the next stopping point and removed many a troublesome stone from one's path, an evil, invisible hand casts new obstacles in the way, which sometimes appear completely to block the path ahead and render it unrecognizable.

And then, without fail, there appears among us a man like the rest of us in every way, but who conceals within himself the secret, inborn power of "vision."

He sees and points. Sometimes he would gladly be rid of this higher gift, which is often a heavy cross for him to bear. But he cannot. Through mockery and hatred, he continues to drag the heavy cartload of struggling humanity, getting stuck amidst the stones, ever onward and upward.

Often his bodily s e l f has long since disappeared from the face of the earth, whereupon people try by every possible means to recapture his

physical aspect in gigantic proportions, in marble or iron or bronze or stone. As if there were any importance to be attached to the corporeal element of these divine martyrs, servants of mankind, who despised the physical and served only the spiritual. And yet, this raising up of marble monuments signals that a greater mass of humanity has now reached the point at which he once stood whom now they celebrate.

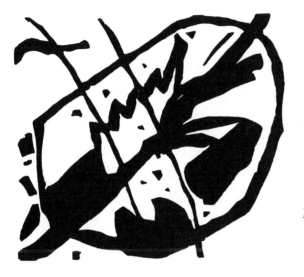

II.

MOVEMENT

The spiritual life can be accurately represented by a diagram of a large acute triangle divided into unequal parts, with the most acute and smallest division at the top. The farther down one goes, the larger, broader, more extensive, and deeper become the divisions of the triangle.

The whole triangle moves slowly, barely perceptibly, forward and upward, so that where the highest point is "today"; the next division is "tomorrow,"* i.e., what is today comprehensible only to the topmost segment of the triangle and to the rest of the triangle is gibberish, becomes tomorrow the sensible and emotional content of the life of the second segment.

At the apex of the topmost division there stands sometimes only a single man. His joyful vision is like an inner, immeasurable sorrow.[21]

*This "today" and "tomorrow" inwardly resemble the biblical "days" of creation.

Those who are closest to him do not understand him and in their indignation, call him deranged: a phoney or a candidate for the madhouse. Thus, Beethoven in his own lifetime stood alone and discredited upon the peak.* How many years had to elapse before a larger portion of the triangle reached the point at which he once stood alone? And in spite of all the monuments—are there really so many who have yet managed to climb to this point?†

In every division of the triangle, one can find artists. Every one of them who is able to see beyond the frontiers of his own segment is the prophet of his environment, and helps the forward movement of the obstinate cartload of humanity. But if he does not possess the necessary sharp eye, or if he misuses or even closes it from unworthy motives or for unworthy purposes, then he is fully understood and celebrated by all his companions within his own segment.[22] The bigger this segment is (and the lower down, therefore, it lies), the greater is the mass of people who find the artist's language comprehensible. It is obvious that every such segment hungers—consciously or (much more often) completely unconsciously—after its corresponding spiritual bread. This bread is given it by its artists, and tomorrow the next segment will reach for that same bread.

<div align="center">* *

*</div>

This schematic representation does not, admittedly, exhaust the whole picture of the spiritual life. Among other things, it does not show the dark side, a great, dead b l a c k e x p a n s e. For it happens all too often that this same spiritual bread becomes food for many who already live in higher divisions of the triangle. For such people, this bread becomes poison: in small doses it has the effect of causing the soul to sink

*Weber, composer of *Der Freischütz*, said (with reference to Beethoven's Seventh Symphony): "Now the excesses of this 'genius' have gone beyond all bounds: Beethoven is ripe for the madhouse." And at the exciting moment at the beginning of the first movement, with its repeated E,[23] Abbé Stadler, on first hearing, called to a neighbour: "That same old E—he's run out of ideas, the old bore!" (August Göllerich, *Beethoven*, No. 1 in the series Die Musik, edited by R. Strauss.)

†Do not many monuments provide a sad answer to this question?

gradually from a higher to a lower division; taken in large doses, this poison brings about a total collapse, thrusting the soul down into lower and lower regions. Sienkiewicz in one of his novels compares the spiritual life to swimming: he who does not struggle tirelessly and battle continually against the forces dragging him down will surely sink.[24] Here, the gifts of one man, his "talents" (in the Biblical sense) can become a curse—not only for the artist who possesses them, but also for all who eat of this poisonous bread. The artist uses his powers to pander to baser needs; he peddles impure content in an ostensibly artistic form; he attracts weaker elements to himself, bringing them into continual contact with the bad; he deceives people and helps people deceive themselves that they are suffering from spiritual thirst, a thirst that can be slaked at this pure spring. Such works of art do not assist the upward movement—they hinder it, dragging back those who are struggling forward and spreading pestilence about them.

Such periods, when art possesses no outstanding representative, when the transubstantiated bread remains inaccessible, are periods of decline in the spiritual world. Souls fall incessantly from higher to lower regions, and the whole triangle seems to remain motionless or to move backward and downward. At such blind, dumb times men place exclusive value upon outward success, concern themselves only with material goods, and hail technical progress, which serves and can only serve the body, as a great achievement. Purely spiritual values are at best underestimated, or go generally unnoticed. Those lonely souls who hunger and possess the power of vision are mocked or regarded as mentally abnormal. But the voices of those rare souls who cannot be smothered in sleep and who feel dark longings for spiritual life, for knowledge and progress, stand out wailing and disconsolate amidst the crude chorus of materialism. Spiritual night falls gradually deeper and deeper. Darker and darker it becomes, surrounding such dismayed souls, and their bearers, tortured by doubt and fear, often prefer the sudden violent plunge into blackness to this gradual darkening that surrounds them.

Art, which at such times leads a degraded life, is used exclusively for materialistic ends. It seeks in hard material the stuff of which it is made, for it knows no finer. Thus, objects whose portrayal it regards as its only purpose, remain the same, unchanged. The question "What?" in art disappears eo ipso. Only the question "How?"—How will the artist succeed in recapturing that same material object?—remains. This question becomes the artist's "credo." Art is without a soul.

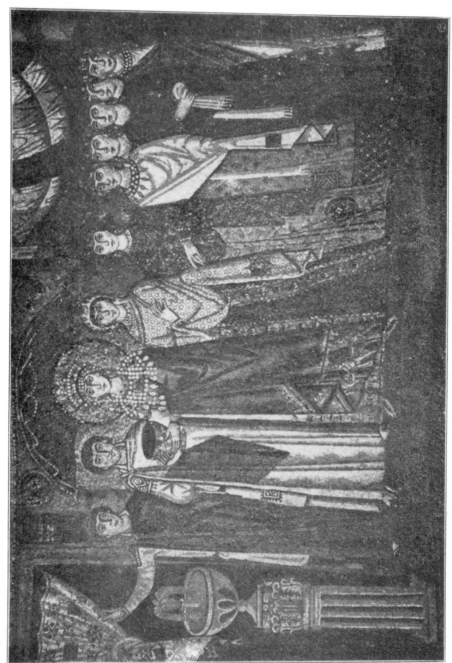

Mosaic in S. Vitale

Art moves forward on the path of "How?" It becomes specialized, comprehensible only to artists, who begin to complain of the indifference the public displays toward their works. Since the artist on the whole needs to say little at such times, having already been singled out because of some small "idiosyncracy" and exalted for it by certain groups of patrons and connoisseurs (an event that can bring with it considerable material benefits!), a great number of outwardly gifted and enlightened people descend upon this art that is apparently so easy to grasp. In every "artistic center" there live thousands and thousands of such artists, of whom the majority seek only after new styles and create without enthusiasm, with cold hearts and sleeping souls, millions of works of art.

"Competition" increases. The wild chase after success makes the search ever more external. Little groups, who have by chance managed to extricate themselves from this chaos of artists and pictures, entrench themselves in their already won positions. The public, left behind, watches uncomprehendingly, loses all interest in such art and calmly turns its back on it.

<div align="center">*　　　*

*</div>

And yet, in spite of being thus continually dazzled, in spite of this chaos, this wild chase, in reality the spiritual triangle moves forward and upward, slowly but surely and with irresistible force.

Invisible, Moses comes down from the mountain, sees the dance around the golden calf.[25] Yet he brings with him new wisdom for men.

His voice, inaudible to the masses, is heard first by the artist. At first unconsciously, without noticing it, he follows the call. Even in that same question "How?" lies a hidden germ of healing. Even if in general "How?" remains barren, nevertheless in that same "idiosyncracy"

(which today we also call "personality"), lies the possibility of seeing in the object not only the pure hard material, but also something less physical than the object itself, which in an age of realism one sought merely to represent "as it is," with "no nonsense."*

Moreover, if this "How?" includes the emotion of the artist's soul and is capable of disseminating his finer experiences, then art is already on the threshold once again of finding its later infallible way back to the lost "What?"—the same "What?" that constitutes the spiritual bread for the spiritual awakening now beginning. This "What?" will no longer be the material, objective "What?" of the period left behind, but rather an artistic content, the soul of art, without which its body (the "How?") can never lead a full healthy life, just like an individual or a whole people.

This "What?" is that content which only art can contain, and to which only art can give clear expression through the means available to it.

*We often speak of "material" and "nonmaterial," and of the in-between states, which are categorized as "more or less" material. Is everything matter? Is everything spirit? Is it not possible that the distinctions we draw between matter and spirit are merely degrees of matter or spirit? Thought, which in positivistic science is categorized as the product of the "spirit," is matter too, but a kind of matter that only fine and not coarse senses can perceive. Is spirit that which the physical hand cannot touch? In this brief essay there is no room to discuss this further, and it is sufficient if one avoids drawing over-sharp distinctions.[26]

III.

SPIRITUAL TURNING-POINT

The spiritual triangle moves slowly forward and upward. Today, one of the largest of the lower divisions has grasped the elementary slogans of the materialistic "credo." As regards religion, its inhabitants bear various titles. They call themselves Jews, Catholics, Protestants, etc. In fact, they are atheists, a fact that a few of the most daring or most stupid openly admit. "Heaven" is empty. "God is dead." Politically, these inhabitants are republicans or democrats. The fear, distaste, and hatred they felt yesterday for these political views are today directed at the term anarchy, about which they know nothing save the terrifying name. Economically, these people are socialists. They sharpen the sword of justice to deal the fatal blow to the capitalist hydra and cut off the head of evil.

Since the inhabitants of this large division of the triangle have never managed to solve a problem for themselves and have always been pulled along in the cart of humanity by their self-sacrificing fellow men standing far above them, they know nothing of the effort of pulling, which

they have never observed except from a great distance. For this reason, they imagine this effort to be very easy, believing in infallible remedies and prescriptions of universal application.

The next and lower division is dragged blindly upward by the one just described. But it hangs grimly onto its former position, struggling in fear of the unknown, of being deceived.

The higher divisions, religiously speaking, are not only blindly atheistic, but are able to justify their godlessness with the words of others (for example, Virchow's saying, unworthy of an educated man: "I have dissected many corpses, but never yet discovered a soul"). Politically, they are even more often republicans, are familiar with various parliamentary usages, and read the leading articles on politics in the newspapers. Economically, they are socialists of various shades, supporting their "convictions" with a wealth of quotations (everything from Schweitzer's *Emma* to Lasalle's *Iron Law* and Marx's *Capital*, and much more).[27]

In these higher divisions, other disciplines gradually emerge that were missing from those just described: science and art, to which belong also literature and music.

Scientifically, these people are positivists, recognizing only what can be weighed and measured. They regard anything else as potentially harmful nonsense, the same nonsense they yesterday called today's "proven" theories.

In art they are naturalists, which permits them to recognize and even prize personality, individuality, and temperament in the artist, up to a certain limit designated by others and in which, for this very reason, they believe unswervingly.

<p style="text-align:center">* *
*</p>

In these higher compartments there exists, despite the visible order and certainty and infallible principles, a hidden fear, a confusion, a vacillation, an uncertainty—as in the heads of passengers aboard a great, steady ocean liner when black clouds gather over the sea, the dry land is hidden in mist, and the bleak wind heaps up the water into black mountains. And this is thanks to their education. For they know that the man who is today revered as intellectual, statesman, or artist was yesterday a ridiculed self-seeker, charlatan, or incompetent, unworthy of serious consideration.

And the higher one ascends the spiritual triangle, the more obvious becomes this sharp-edged fear, this insecurity. First, one finds here and there eyes capable of seeing for themselves, heads capable of putting two and two together. People with these gifts ask themselves, "If this wisdom of the day before yesterday has been overthrown by that of yesterday, and the latter by that of today, then could it not also be somehow possible that the wisdom of today could be supplanted by that of tomorrow?" And the bravest of them reply, "It is within the bounds of possibility."

Second, one finds eyes capable of seeing what is "not yet explained" by modern-day science. Such people ask themselves: "Will science ever reach a solution to this problem if it continues along the same path it has been following until now? And if it reaches one, will we be able to rely on its answer?"

In these compartments can also be found professional intellectuals, who can remember how established facts, recognized by the academies, were first greeted by those same academies. Here, too, can be found art historians, who write books full of praise and deep sentiments—about an art that yesterday was regarded as senseless. By means of these books, they remove the hurdles over which art has long since jumped, and set up new ones, which this time are supposed to stay permanently and firmly in place. Engaged in this occupation, they fail to notice that they are building their barriers behind art rather than in front of it. If they notice it tomorrow, then they will quickly write more books in order to remove their barriers one stage further. And this occupation will continue unchanged until it is realized that the external principles of art can only be valid for the past and not for the future. No theory derived from these principles can account for the path ahead, which lies in the realm of the nonmaterial. One cannot crystallize in material form what does not yet exist in material form. The spirit that will lead us into the realms of tomorrow can only be recognized through feeling (to which the talent of the artist is the path). Theory is the lantern that illuminates the crystallized forms of yesterday and before. (See also Chapter VII, "Theory.")

And if we climb still higher, we see even greater confusion, as if in a great city, built solidly according to all architectural and mathematical rules, that is suddenly shaken by a mighty force. The people who live in this division indeed live in just such a spiritual city, where such forces are at work, and with which the spiritual architects and mathematicians

have not reckoned. Here, part of the massive wall lies fallen like a house of cards. There, an enormous tower that once reached to the sky, built of many slender, and yet "immortal" spiritual pinnacles, lies in ruins. The old, forgotten cemetery quakes. Old, forgotten graves open, and forgotten ghosts rise up out of them. The sun, framed so artistically, shows spots and darkens, and what can replace it in the fight against darkness?

Also in this town live deaf people, deafened by unfamiliar wisdom, who cannot hear the collapse, blind people also—for unfamiliar wisdom has blinded them, and they say, "Our sun gets brighter and brighter—soon we shall see the last spots disappear." But these people too will hear and see.

<div align="center">* *
*</div>

And higher still we find that there is no more fear. The work done here boldly shakes the pinnacles that men have set up. Here, too, we find professional intellectuals who examine matter over and over again and finally cast doubt upon matter itself, which yesterday was the basis of everything, and upon which the whole universe was supported. The electron theory—i.e., the theory of moving electricity, which is supposed completely to replace matter, has found lately many keen proponents, who from time to time overreach the limits of caution and thus perish in the conquest of this new stronghold of science, like heedless soldiers, sacrificing themselves for others at the desperate storming of some beleaguered fortress. But "there is no fortress so strong that it cannot be taken."

<div align="center">* *
*</div>

On the other hand, such facts as the science of yesterday greeted with the usual word "swindle" are on the increase, or are merely becoming more generally known. Even the newspapers, those habitually most obedient servants of success and of the plebs, who base their business on "giving the people what they want," find themselves in many cases obliged to limit or even to suppress altogether the ironic tone of their articles about the latest "miracles." Various educated men, pure materialists among them, devote their powers of scientific investi-

gation to those puzzling facts that can no longer be denied or kept quiet.*

<div align="center">* *</div>
<div align="center">*</div>

On the other hand, the number of people who set no store by the methods of materialistic science in matters concerning the "nonmaterial," or matter that is not perceptible to our senses, is at last increasing. And just as art seeks help from the primitives, these people turn for help to half-forgotten times, with their half-forgotten methods. These very methods, however, are still current among those people we have been accustomed to look upon with contemptuous sympathy from the heights of our knowledge.

The Indians, for example, are among such peoples who from time to time present the intellectuals of our civilization with puzzling facts, which have either gone hitherto unobserved, or which people have tried to brush away, like troublesome flies, with superficial words† and explanations. Mrs. H. P. Blavatsky was perhaps the first person who, after years spent in India, established a firm link between these "savages" and our own civilization. This was the starting point of one of the greatest spiritual movements, which today unites a large number of people and has even given material form to this spiritual union through the Theosophical Society. This society consists of brotherhoods of those who attempt to approach more closely the problems of the spirit by the path of inner consciousness. Their methods, which are the complete

*Zöllner, Wagner, Butlerov (St. Petersburg), Crookes (London), etc. Later, Ch. Richet, C. Flammarion (even the Paris *Matin* published the pronouncements of the latter about two years ago under the title "Je le constate mais je ne l'explique pas"). Finally C. Lombroso, originator of the anthropological method in questions of crime, has, with Eusapia Palladino, gone over to thoroughgoing spiritualist seances and recognizes the phenomena. Apart from other intellectuals who devote themselves of their own accord to similar studies, there are gradually being formed whole scientific bodies and societies that pursue the same ends (e.g., the Société des Etudes Psychiques in Paris, which even organizes lecture tours in France to acquaint the public in a thoroughly objective manner with the results they have obtained).

†The word "hypnosis" is often used in such cases, that same hypnosis upon which, in its early form mesmerism, various academies turned their backs with contempt.

V. and H. Dünwegge, *Crucifixion of Christ*]

opposite of those of the positivists, take their starting point from tradition and are given relatively precise form.*

The theosophical theory that serves as the basis for the movement has been set out by Blavatsky in question and answer form, in which the student receives from the theosophist precise answers to his questions.† Theosophy, according to Blavatsky, can be equated with e t e r n a l t r u t h (p. 248). "A new emissary of truth will find the human race prepared for his message through the Theosophical Society: there will exist a form of expression in which he will be able to clothe the new truths, an organization which, in a certain sense, expects his coming, and exists for the purpose of clearing away material hindrances and difficulties from his path" (p. 250). And then Blavatsky ends her book with the prophecy that "in the twenty-first century this earth will be a paradise by comparison with what it is now."

In any case, even if some observers are skeptical of the theosophists' tendency to theorize and their somewhat premature delight in putting an answer in place of the great, eternal question mark, nonetheless the great, yea s p i r i t u a l, movement remains. It is a powerful agent in the spiritual climate, striking, even in this form, a note of salvation that reaches the desperate hearts of many who are enveloped in darkness and night—a hand that points the way offers help.

* *

*

When religion, science, and morality are shaken (the last by the mighty hand of Nietzsche), when the external supports threaten to collapse, then man's gaze turns away from the external t o w a r d h i m s e l f.

Literature, music, and art are the first and most sensitive realms where this spiritual change becomes noticeable in real form. These spheres immediately reflect the murky present; they provide an intima-

*See, e.g., Dr. Steiner's *Theosophy* and his article in *Lucifer-Gnosis* on paths of knowledge.[28]

†H. P. Blavatsky, *Der Schlüssel der Theosophie* (Leipzig: Max Altmann, 1907). The book appeared in English in London, 1889.[29]

tion of that greatness which first becomes noticeable only to a few, as just a tiny point, and which for the masses does not exist at all.

They reflect the great darkness that appeared with hardly any warning. They themselves become dark and murky. On the other hand, they turn away from the soulless content of modern life, toward materials and environments that give a free hand to the nonmaterial strivings and searchings of the thirsty soul.

One such poet in the realm of literature is Maeterlinck. He led us into a world that can only be described as fantastic—or, more correctly, supersensible. His *Princesse Maleine, Sept Princesses, Les Aveugles,* etc., etc., are not figures of ancient times, as the stylized heroes of Shakespeare appear to us. They are souls searching in the mist, threatened with suffocation, over whom hovers a dark invisible power. Spiritual darkness, the uncertainty of ignorance, and fear of ignorance is the world his heroes inhabit.[30] And so Maeterlinck is perhaps one of the first prophets, one of the first of the artistic sages and clairvoyants to foretell the decline described above. The darkening of the spiritual atmosphere, the destroying and, at the same time, guiding hand—and the desperate fear it instills—the lost path, the leader gone astray, all are clearly reflected in these works.*

He builds up this atmosphere by purely artistic means, whereby material means (dark castles, moonlit nights, quagmires, the wind, owls, etc.) play a more symbolic role and are used more as inner sounds.†

*Also among the first rank of these prophets of decay belongs Alfred Kubin. One is dragged by an irresistible force into the terrifying realm of the stony void. This force streams forth from Kubin's drawings, just as it does from his novel *Die Andere Seite.*

†When several of Maeterlinck's plays were performed in St. Petersburg under his own direction, at one of the rehearsals he had a piece of canvas hung up to represent a missing tower. He did not think it important to have a carefully imitated piece of scenery prepared. Instead, he acted just as children would, the greatest fantasists of all time, who in their games make a horse out of a stick, or pretend that paper crows are whole regiments of cavalry, with a fold in the paper sufficing to turn a cavalry officer into a horse (Kügelgen, *Erinnerungen eines alten Mannes*). This tendency to arouse the imagination of the audience plays a considerable part in today's theatre. The Russian stage in particular has done much work and made a great deal of progress in this field, which for the theater of the future will provide a necessary transition from the material to the spiritual.

Maeterlinck's principal means is his use of words.

Words are inner sounds. This inner sound arises partly—perhaps principally—from the object for which the word serves as a name. But when the object itself is not seen, but only its name is heard, an abstract conception arises in the mind of the listener, a dematerialized object that at once conjures up a vibration in the "heart." The green or yellow or red tree as it stands in the meadow is merely a material occurrence, an accidental materialization of the form of that tree we feel within ourselves when we hear the word *tree*. Skillful use of a word (according to poetic feeling)—an internally necessary repetition of the same word twice, three times, many times—can lead not only to the growth of the inner sound, but also bring to light still other, unrealized spiritual qualities of the word. Eventually, manifold repetition of a word (a favorite childhood game, later forgotten) makes it lose its external sense as a name. In this way, even the sense of the word as an abstract indication of the object is forgotten, and only the pure sound of the word remains. We may also, perhaps unconsciously, hear this "pure" sound at the same time as we perceive the real, or subsequently, the abstract object. In the latter case, however, this pure sound comes to the fore and exercises a direct influence upon the soul. The soul experiences a nonobjective vibration that is more complex—I would say more "supersensible"—than the effect on the soul produced by a bell, a vibrating string, a falling board, etc. Here, great possibilities open up for the literature of the future. This power of the word has already been exploited in embryonic form, e.g., in *Serres Chaudes.* A word that may at first appear neutral assumes dark overtones in Maeterlinck's usage. An ordinary, common word (e.g., *Haare* [hair]) can, given the right feeling for usage, convey an atmosphere of inconsolable desperation. This is how Maeterlinck uses his material: pointing to thunder and lightning, the moon appearing from behind scudding clouds, as external, material means that on the stage, even more than in nature itself, correspond to childhood "ogres." True inner means do not lose their power and effect so easily.* And words that have thus two meanings—the first direct, the second inner—are the pure stuff of poetry and literature, the mate-

*This is clearly apparent when one compares the works of Maeterlinck with those of Poe. And this is yet another example of the progress of artistic means away from the material and toward the abstract.

rial that only this art can exploit, and through which it speaks to the soul.

Richard Wagner achieved something similar in music. His famous use of *leitmotiv* is likewise an attempt to characterize the hero not by theatrical props, make-up, and lighting, but by a certain, precise motif—that is, by purely musical means. This motif is a kind of musically expressed spiritual ethos proceeding from the hero, which thus emanates from him at a distance.*

The most modern musicians, such as Debussy, create spiritual impressions, which they often derive from nature, translating them into spiritual pictures in purely musical form. Hence Debussy himself is often compared with the Impressionist painters, not only for his character traits, but also for his aim of recreating natural appearances in his works. This example simply illustrates how, in our own time, the different arts learn from one another and often resemble one another in their aims. It would, however, be rash to maintain that Debussy's significance is exhausted by the above definition. Despite his point of contact with the Impressionists, this composer's compulsion toward inner content in his works is so strong that one can instantly hear the cracked ring of the soul of the present, with all its tormenting pain and shattered nerves. Moreover, even in his "impressionistic" pictures, Debussy never employs a wholly material effect, which is characteristic of program music, but continues to exploit the inner value of appearances.[31]

Russian music (Mussorgsky) has exerted a great influence upon Debussy. It is, therefore, not surprising that he has a certain affinity with the young Russian composers, of whom Skriabin must be reckoned among the foremost. There is a related inner sound to be heard in the works of both composers. And the listener is often put off by the same mistake. That is to say, both composers are suddenly torn away from the realm of "modern ugliness," and pursue the charms of more or less conventional "beauty." The listener often feels genuinely offended, for he is tossed backward and forward like a tennis ball over a net that

*Many experiments have shown that this kind of spiritual atmosphere accompanies not just heroes, but every man. Sensitive people cannot, for example, remain in a room where another person has been who is spiritually antagonistic to them, even if they know nothing of his presence.

separates two opposing sides: the side of external "beauty" and the side of internal "beauty." This inner beauty is achieved by renouncing customary beauty, and is occasioned by the demands of internal necessity. This inner beauty naturally appears ugly to those not accustomed to it, since man in general inclines toward the external, and does not willingly recognize internal necessity. (This is especially true today!) The Viennese composer Arnold Schoenberg, with his total renunciation of accepted beauty, regarding as sacred every means that serves the purpose of self-expression, goes his lonely way unrecognized, even today, by all but a few enthusiasts. This "publicity seeker," "charlatan," and "bungler" says in his *Theory of Harmony:* "Every chord, every progression is possible. And yet I feel already today that even here there are certain conditions that govern whether I choose this or that dissonance."*

Schoenberg here feels clearly that the greatest freedom, which is the free and unrestricted fresh air of art, cannot be absolute. Every age has its own particular measure of this freedom. And the power of the greatest genius is not sufficient to exceed the bounds of this freedom. But this measure must be—and will be—exhausted every time. The obstinate cart may struggle as it will! Schoenberg also seeks to exhaust this freedom, and on the path of internal necessity he has already tapped the veins of gold of the new beauty. Schoenberg's music leads us into a new realm, where musical experiences are no longer acoustic, but purely spiritual. Here begins the "music of the future."

In painting, realistic ideals[33] are subsequently followed by the liberating strivings of Impressionism. The latter finds its final, dogmatic form in the purely naturalistic aims of the theory of Neo-Impressionism, which at the same time reaches out toward the abstract. Its theory (regarded by the Neo-Impressionists as a universal method) is not to fix upon the canvas some chance excerpt from nature, but to represent the whole of nature in all its glory and splendor.†

More or less at the same time we notice three totally different

*Excerpt from the *Harmonielehre* [Theory of Harmony]
(Universal Edition), *Die Musik* X, 2, p. 104.[32]

†See, e.g., Signac, *De Delacroix au Néo-Impressionisme* (German edition published by Axel Juncker, Charlottenburg, 1910).

Dürer, Lamentation of Christ

phenomena: (1) Rossetti and his pupil Burne-Jones, with their series of followers; (2) Boecklin and, deriving from him, Stuck, and their followers; and (3) Segantini, also followed by a train of worthless formal imitators.

These three names have been chosen as characteristic of the search carried out in the realms of the nonmaterial. Rossetti turned towards Raphael's forerunners and tried to re-animate their abstract forms. Boecklin penetrated the realms of the mythological and the world of fairy-tales, clothing his abstract figures (in contrast to Rossetti) in strongly developed corporeal and material forms. Segantini, who externally is the most material of the three, took ready-made natural forms, which he sometimes worked out right down to the tiniest detail (e.g., mountain ranges, stones, animals, etc.). Nevertheless, he always understood how to create abstract forms in spite of the visible, material forms, by virtue of which he is perhaps internally the least material of the group.

These are the artists who seek the internal in the world of the external.

Using other means, which are closer to the purely pictorial, Cézanne, the seeker after new laws of form, sets himself a similar task. He knows how to create a living being out of a teacup—or rather, how to recognize such a being within this cup. He can raise "still-life" to a level where externally "dead" objects come internally alive. He treats these objects just as he does people, for he had the gift of seeing inner life everywhere. He expresses them in terms of color, thus creating an inner, painterly note, and molds them into a form that can be raised to the level of abstract-sounding, harmonious, often mathematical formulas. It is not a man, nor an apple, nor a tree that is represented; they are all used by Cézanne to create an object with an internal, painterly quality: a picture. This is what Henri Matisse, one of the greatest of the modern French painters, also calls his works. He paints "pictures," and in these "pictures" he seeks to reproduce the "divine."* To achieve this, the only resources he uses are the object (a person or whatever it may be), which he uses as a point of departure, and those means that belong to painting and painting alone—color and form.[34]

Guided by his purely personal qualities, with his particularly French

*See his article in *Kunst and Künstler*, (1909).[35]

chromatic gift, Matisse stresses and exaggerates color. Like Debussy, he is unable to free himself for long from conventional beauty: Impressionism is in his blood. And so with Matisse, among pictures possessing great inner life, one finds other pictures that, owing their origin principally to external causes, to external stimuli (how often this makes one think of Manet!), possess principally or exclusively a merely external life. In these pictures, the specifically French, refined, gourmandizing, purely melodic beauty of painting is raised up to cool heights above the clouds.

The other great Parisian, the Spaniard Pablo P i c a s s o, never sucumbs to t h i s kind of beauty. Led on always by the need for self-expression, often driven wildly onward, Picasso throws himself from one external means to another. If a chasm lies between them, Picasso makes a wild leap, and there he is, standing on the other side, much to the horror of his incredibly numerous followers. They had just thought they had caught up with him; now they must begin the painful descent and start the climb all over again. In this way arose the latest "French" movement, Cubism, which is discussed more fully in Part II. Picasso seeks to achieve the constructive element through numerical relations. In his latest works (1911), he arrives at the destruction of the material object by a logical path, not by dissolving it, but by breaking it up into its individual parts and scattering these parts in a constructive fashion over the canvas. In this process he seems, strangely enough, to wish to retain a semblance of the material object. Picasso is not frightened of any means, and if color distracts him from solving the problem of purely linear form, he throws it overboard and paints a picture in browns and whites. These problems also constitute his chief strength. Matisse— color. Picasso—form. Two great pointers toward one great goal.

IV.

THE
PYRAMID

And so, gradually, the different arts have set forth on the path of saying what they are best able to say, through means that are peculiar to each.

And in spite of, or thanks to, this differentiation, the arts as such have never in recent times been closer to one another than in this latest period of spiritual transformation.

In all that we have discussed above lie hidden the seeds of the struggle toward the nonnaturalistic, the abstract, toward inner nature. Consciously or unconsciously, they obey the words of Socrates: "Know thyself!" Consciously or unconsciously, artists turn gradually toward an emphasis on their materials, examining them spiritually, weighing in the balance the inner worth of those elements out of which their art is best suited to create.

From this effort there arises of its own accord the natural consequence—the comparison of their own elements with those of other arts. In this case, the richest lessons are to be learned from music. With few exceptions and deviations, music has for several centuries been the art that uses its resources not to represent natural appearances, but to express the inner life of the artist and to create a unique life of musical tones.

An artist who sees that the imitation of natural appearances, however artistic, is not for him—the kind of creative artist who wants to, and has to, express his own inner world—sees with envy how naturally and easily such goals can be attained in music, the least material of the arts today. Understandably, he may turn toward it and try to find the same means in his own art. Hence the current search for rhythm in painting, for mathematical, abstract construction, the value placed today upon the repetition of color-tones, the way colors are set in motion, etc.

Comparing the resources of totally different arts, one art learning from another, can only be successful and victorious if not merely the externals, but also the principles are learned. I.e., one art has to learn from another how it tackles its own materials and, having learned this, use in principle the materials peculiar to itself in a similar way, i.e., according to the principle that belongs to itself alone. The artist must not forget, while learning this, that each one of his materials conceals within itself the way in which it should be used, and it is this application that the artist must discover.

In its use of form, music can attain results that cannot be achieved by painting. On the other hand, music lacks many of the characteristics of painting. E.g., music has time, the duration of time, at its disposal. Painting, on the other hand, while not possessing this advantage, can in an instant present the spectator with the entire content of the work, which music is unable to do.* Music, which externally is completely emancipated from nature, does not need to borrow external forms from

*The differences are, like everything else in this world, to be understood as relative. In a certain sense music can avoid the duration of time, while painting can make use of it. As I have said, all assertions are of only relative value.

anywhere in order to create its language.* Painting today is still almost entirely dependent upon natural forms, upon forms borrowed from nature. And its task today is to examine its forces and its materials, to become acquainted with them, as music has long since done, and to attempt to use these materials and forces in a purely painterly way for the purpose of creation.

And while the preoccupation of each art with its own problems distinguishes it from the other arts, their comparison brings them closer together as regards their i n n e r strivings. And thus one notices that each art has its own forces, which cannot be replaced by those of another art. And so, finally, one will arrive at a combination of the particular forces belonging to different arts. Out of this combination will arise in time a new art, an art we can foresee even today, a truly m o n u m e n t a l a r t.

And every artist who buries himself in the hidden i n n e r treasures of his art is a man to be envied, a coworker upon the spiritual pyramid that will one day reach to heaven.

*How lamentable are attempts to use musical means to represent external form is shown by program music in the narrower sense. Such experiments have been made right up to the present time. Imitations of frogs croaking, of farmyards, of knives being sharpened, are worthy of the variety stage and maybe very amusing as a form of entertainment. In serious music, however, such excesses remain valuable examples of the failure of attempts to "imitate nature." Nature has its own language, which affects us with its inexorable power. This language cannot be imitated. If one tries to represent a farmyard musically in order to recapture the mood of nature and to put the listener in this mood, then it becomes clear that this is an impossible and unnecessary task. This sort of mood can be created by every art form; not by the external imitation of nature, but by the artistic re-creation of this mood in its i n n e r value.

B. PAINTING

V.

EFFECTS OF COLOR

Letting one's eyes wander over a palette laid out with colors has two main results:

(1) There occurs a purely physical effect, i.e., the eye itself is charmed by the beauty and other qualities of the color. The spectator experiences a feeling of satisfaction, of pleasure, like a gourmet who has a tasty morsel in his mouth. Or the eye is titillated, as is one's palate by a highly spiced dish. It can also be calmed or cooled again, as one's finger can when it touches ice. These are all physical sensations and as such can only be of short duration. They are also superficial, leaving behind no lasting impression if the soul remains closed. Just as one can only experience a physical feeling of cold on touching ice (which one forgets after having warmed one's fingers again), so too the physical effect of color is forgotten when one's eyes are turned away. And as the physical sensation of the coldness of the ice, penetrating deeper, can give rise to other, deeper sensations and set off a whole chain of psychic experi-

ences, so the superficial effect of color can also develop into a [deeper] form of experience.

Only familiar objects will have a wholly superficial effect upon a moderately sensitive person. Those, however, that we encounter for the first time immediately have a spiritual effect upon us. A child, for whom every object is new, experiences the world in this way: it sees light, is attracted by it, wants to grasp it, burns its finger in the process, and thus learns fear and respect for the flame. And then it learns that light has not only an unfriendly, but also a friendly side: banishing darkness and prolonging the day, warming and cooking, delighting the eye. One becomes familiar with light by collecting these experiences and storing away this knowledge in the brain. The p o w e r f u l, i n t e n s e interest in light vanishes, and its attribute of delighting the eye is met with indifference. Gradually, in this way, the world loses its magic. One knows that trees provide shade, that horses gallop quickly, and that cars go even faster, that dogs bite, that the moon is far away, and that the man one sees in the mirror is not real.

The constantly growing awareness of the qualities of different objects and beings is only possible given a high level of development in the individual. With further development, these objects and beings take on an inner value, eventually an i n n e r s o u n d. So it is with color, which if one's spiritual sensitivity is at a low stage of development, can only create a superficial effect, an effect that soon disappears once the stimulus has ceased. Yet, even at this stage, this extremely simple effect can vary. The eye is more strongly attracted by the brighter colors, and still more by the brighter and warmer: vermilion attracts and pleases the eye as does flame, which men always regard covetously. Bright lemon yellow hurts the eye after a short time, as a high note on the trumpet hurts the ear. The eye becomes disturbed, cannot bear it any longer, and seeks depth and repose in blue or green.

At a higher level of development, however, there arises from this elementary impression a more profound effect, which occasions a deep emotional response. In this case we have:

(2) The second main consequence of the contemplation of color, i.e., the p s y c h o l o g i c a l effect of color. The psychological power of color becomes apparent, calling forth a vibration from the soul. Its primary, elementary physical power becomes simply the path by which color reaches the soul.

Whether this second consequence is in fact a direct one, as might be

supposed from these last few lines, or whether it is achieved by means of association, remains perhaps questionable. Since in general the soul is closely connected to the body, it is possible that one emotional response may conjure up another, corresponding form of emotion by means of association. For example, the color red may cause a spiritual vibration like flame, since red is the color of flame. A warm red has a stimulating effect and can increase in intensity until it induces a painful sensation, perhaps also because of its resemblance to flowing blood. This color can thus conjure up the memory of another physical agent, which necessarily exerts a painful effect upon the soul.

If this were the case, it would be easy to find an associative explanation for the other physical effects of color,[36] i.e., its effects not only upon our sight, but also upon our other senses. One might assume that, e.g., bright yellow produces a sour effect by analogy with lemons.

It is, however, hardly possible to maintain this kind of explanation. As far as tasting colors is concerned, many examples are known where this explanation does not apply. A Dresden doctor tells how one of his patients, whom he describes as "spiritually, unusually highly developed," invariably found that a certain sauce had a "blue" taste, i.e., it affected him like the color blue.* One might perhaps assume another similar, and yet different, explanation; that in the case of such highly developed people the paths leading to the soul are so direct, and the impressions it receives are so quickly produced, that an effect immediately communicated to the soul via the medium of taste sets up vibrations along the corresponding paths leading away from the soul to the other sensory organs (in this case, the eye). This effect would seem to be a sort of echo or resonance, as in the case of musical instruments, which without themselves being touched, vibrate in sympathy with another instrument being played. Such highly sensitive people are like good, much-played violins, which vibrate in all their parts and fibers at every touch of the bow.

If one accepts this explanation, then admittedly, sight must be related not only to taste, but also to all the other senses. Which is indeed the

*Dr. med. Freudenberg, "Spaltung der Persönlichkeit," Uebersinnliche Welt, no. 2 (1908): 64–65. Here, too, hearing colors is discussed (p. 65), in which connection the author notes that tables of comparison do not constitute laws of general application. Cf. L. Sabaneev in the weekly Music (Moscow), no. 9 (1911); here, the author points to the definite possibility of soon formulating such laws.

case. Many colors have an uneven, prickly appearance, while others feel smooth, like velvet, so that one wants to stroke them (dark ultramarine, chrome-oxide green, madder). Even the distinction between cold and warm tones depends upon this sensation. There are also colors that appear soft (madder), others that always strike one as hard (cobalt green, green-blue oxide), so that one might mistake them for already dry when freshly squeezed from the tube.

The expression "the scent of colors" is common usage.

Finally, our hearing of colors is so precise that it would perhaps be impossible to find anyone who would try to represent his impression of bright yellow by means of the bottom register of the piano, or describe dark madder as being like a soprano voice.* [37]

This explanation (that is, in terms of association) is, however, insufficient in many instances that are for us of particular importance. Anyone who has heard of color therapy knows that colored light can have a particular effect upon the entire body. Various attempts to exploit this power of color and apply it to different nervous disorders have again noted that red light has an enlivening and stimulating effect upon the heart, while blue, on the other hand, can lead to temporary paralysis. If this sort of effect can also be observed in the case of animals, and even plants, then any explanation in terms of association completely falls down. These facts in any case prove that color contains within itself a little-studied but enormous power, which can influence the entire human body as a physical organism.

If association does not seem a sufficient explanation in this case, then it cannot satisfy us as regards the effect of color upon the psyche. In

*Much theoretical and also practical work has already been done on this subject. People are concerned with the possibility of constructing a system of counterpoint for painting also, in terms of these many-sided similarities (e.g., the physical vibrations of air and light). On the other hand, there have been in practice successful attempts to impress a tune upon unmusical children with the help of color (e.g., by means of flowers). Mrs. A. Zakharin-Unkovsky has been working on this subject for many years, and has constructed a special, precise method of "translating the colors of nature into music, of painting the sounds of nature, of s e e i n g s o u n d s i n c o l o r a n d h e a r i n g c o l o r s m u s i c a l l y."[38] This method has been used for many years in the school run by its inventor, and has been recognized as useful by the St. Petersburg Conservatory. On the other hand, Skriabin has constructed e m p i r i c a l l y a parallel table of equivalent tones in color and music, which very closely resembles the more physical table of Mrs. Unkovsky. Skriabin has made convincing use of his method in his *Prometheus*. (See the table reproduced in the weekly *Music* [Moscow], no. 9 [1911].

general, therefore, color is a means of exerting a direct influence upon the soul. Color is the keyboard. The eye is the hammer. The soul is the piano, with its many strings.

The artist is the hand that purposefully sets the soul vibrating by means of this or that key.

Thus it is clear that the harmony of colors can only be based upon the principle of purposefully touching the human soul.

This basic tenet we shall call the principle of internal necessity.

VI.

THE LANGUAGE OF
FORMS AND COLORS

The man that hath no music in himself,
Nor is not mov'd with concord of sweet sounds,
Is fit for treasons, stratagems and spoils;
The motions of his spirit are dull as night
And his affections dark as Erebus:
Let no such man be trusted. — Mark the music.

—Shakespeare

Musical sound has direct access to the soul. It finds there an echo, for man "hath music in himself."

"Everybody knows that yellow, orange, and red induce and represent ideas of joy and of riches" (Delacroix).*

*P. Signac, op. cit. See also the interesting article by K. Scheffler, "Notizen über die Farbe," *Dekorative Kunst* (Feb. 1901).

These two quotations demonstrate the profound relationship between the arts in general, and between music and painting in particular.[39] It was surely this striking relationship that inspired Goethe's thought to the effect that there must be a thorough-bass of painting.[40] This prophetic utterance of Goethe anticipates the situation in which painting finds itself today. This situation is the point of departure from which painting, with the help of the means at its disposal, will become art in the abstract sense, and will eventually achieve purely pictorial composition.

The means at its disposal to achieve this form of composition are as follows:

1. Color.
2. Form.

Form alone, as the representation of an object (whether real or unreal), or as the purely abstract dividing up of a space, of a surface, can exist *per se*.

Not so color. Color cannot extend without limits. One can only imagine an infinite red, can only see it in one's mind's eye. When one hears the word red, this red in our imagination has no boundaries. One must, if necessary, force oneself to envisage them. This red, which one does not see materially, but imagines in the abstract, awakens on the other hand a certain precise, and yet imprecise, representation [*Vorstellung*] having a purely internal, psychological sound.*[41] This red, echoing from the word ["red"], has of itself no particularly pronounced tendency toward warm or cold. This must also be imagined, as fine gradations of the shade of red. For this reason, I have described this way of seeing as mentally imprecise. It is, however, at the same time precise, since the inner sound is left bare, without particularities arising from an accidental tendency toward warm or cold, etc. This inner sound resembles the sound of a trumpet, or of the instrument one pictures in one's mind when one hears the word trumpet, etc., where all particularities are excluded. In fact, one imagines the sound without even taking account of the changes it undergoes, depending on whether it is heard in the open air or in an enclosed space, alone or with other instruments,

*A very similar result is produced in the following example by t r e e, in which, however, the material element of the representation occupies more space.

whether played by a postilion, a huntsman, a soldier, or a virtuoso.

If, however, this red has to be rendered in material form (as in painting), then it must (1) have a particular shade chosen from the infinite range of different possible shades of red, being thus, so to speak, subjectively characterized; and (2) be limited in its extension upon the surface of the canvas, limited by other colors that are there of n e c e s s i t y and can in no case be avoided, and by means of which (by limitation and proximity) the subjective character is changed (given a veneer of objectivity): the objective element here raises its voice.

This inevitable relationship between color and form brings us to a consideration of the effects of form upon color. Form itself, even if completely abstract, resembling geometrical form, has its own inner sound, is a spiritual being possessing qualities that are identical with that form. A triangle (without more detailed description as to whether it is acute, or obtuse, or equilateral) is one such being, with its own particular spiritual perfume. In conjunction with other forms, this perfume becomes differentiated, receiving additional nuances, but remaining in essence unchangeable, like the scent of a rose, which can never be confused with that of a violet. Likewise the circle, the square, and all other possible forms.* And, therefore, the same situation as we found previously with red: subjective substance encased in an objective shell.

Here, the interaction of form and color becomes clear. A triangle filled with yellow, a circle with blue, a square with green, then again a triangle with green, a circle with yellow, a square with blue, etc. These are all completely different entities, having completely different effects.

Here, it may easily be remarked that the value of many colors is reinforced by certain forms and weakened by others. At all events, sharp colors have a stronger sound in sharp forms (e.g., yellow in a triangle). The effect of deeper colors is emphasized by rounded forms (e.g., blue in a circle). Of course, it is clear on the one hand that the incompatibility of certain forms and certain colors should be regarded not as something "disharmonious," but conversely, as offering new possibilities—i.e., also [a form of] harmony.

Since the number of forms and colors is infinite, the number of possible combinations is likewise infinite as well as their effects. This material is inexhaustible.

*The direction in which, e.g., a triangle is pointing, viz., movement, also plays a significant role. This is of great importance for painting.

Raphael, *Holy Family.*

Form in the narrower sense is nothing more than the delimitation of one surface from another. This is its external description. Since, however, everything external necessarily conceals within itself the internal (which appears more or less strongly upon the surface), e v e r y f o r m h a s i n n e r c o n t e n t.* Form is, therefore, the expression of inner content. This is its internal description. Here, we must think of the example used a few moments ago—that of the piano, and for "color" substitute "form": the artist is the hand that purposefully sets the human soul vibrating by pressing this or that key (= form). Thus it is clear that the harmony of forms can only be based upon the purposeful touching of the human soul.

This is the principle we have called the principle of internal necessity.

The two aspects of form previously mentioned are at the same time its two aims. And thus its external delimitation is wholly purposeful when it most expressively reveals the inner content belonging to the form.†
The external element of form, i.e., its delimitation, where in this case form serves as a means, can assume many different aspects.

And yet, in spite of all the differences form may display, it will never exceed two external limits, which are as follows:

1. Either the form, as contour, serves the purpose of representing the three dimensions of a material object upon a flat surface, i.e., of delineating this material object upon the surface plane. Or else:

2. The form remains abstract, i.e., it does not describe any real object, but is rather a totally abstract entity. Such pure abstract entities, which as such have their own existence, their own influence and

*If a form produces an indifferent effect and, so to speak, "says nothing," then this should not be understood literally. There is no form, any more than anything else in this world, that says nothing. Still, what it has to say often fails to reach our souls, and this is what happens when what is said is itself indifferent or—more correctly—has not been used in the right place.

†This description of something as "expressive" should be correctly understood: sometimes form can be expressive when muted. Form may sometimes reveal the necessary most expressively by not going to the very limit, but by a gesture, merely showing the path that leads to external expression.

effect, are the square, the circle, the triangle, the rhombus, the trapezoid, and all the other innumerable forms, becoming ever more complicated, having no description in mathematical terms. All these forms are citizens of equal status in the realm of abstraction.

Between these two boundaries lie the infinite number of forms in which both elements are present, and where either the material or the abstract [element] predominates.

These forms are at present that store from which the artist borrows all the individual elements of his creations.

Today, the artist cannot manage exclusively with purely abstract forms. These forms are too imprecise for him. To limit oneself exclusively to the imprecise is to deprive oneself of possibilities, to exclude the purely human and thus impoverish one's means of expression.[42]

On the other hand, there are no purely material forms in art. It is not possible to represent a material form exactly. For good or evil, the artist is dependent upon h i s eye, h i s hand, which in this case are more artistic than his soul, which has no desire to exceed purely photographic aims. The conscious artist, however, who cannot be satisfied with minutely recording the material object, necessarily strives to give expression to the object being represented. This in earlier times was known as idealization, more recently stylization, and tomorrow will be called something else again.*

The impossibility and pointlessness (in art) of aimlessly copying the object, the effort to give to the object an expressive element, these are the points of departure from which the artist sets out on the long path that leads from the "literary" coloration of the object toward purely artistic (or pictorial) aims. This is the path that leads to composition.

With reference to form, purely pictorial composition has two tasks

*The essential element of "idealization" lay in the attempt to beautify organic form, to make it ideal, often resulting in the schematic, whereby the personal, inner sound became muted. "Stylization," arising more out of Impressionism, had as its principal aim not the "beautification" of organic form, but its powerful characterization by the omission of external details. Thus, the sound that arose in this case was of a highly personal nature, but giving undue emphasis to the external. The future handling and transformation of organic form has as its aim the laying bare of the i n n e r sound. The organic form no longer serves in this case as the direct object, but is merely one element in that divine language which is couched in human terms, because it is addressed by man to man.

before it:

1. The composition of the whole picture.
2. The creation of the individual forms that are related to each other in various combinations, while remaining subordinate to the whole composition.* Thus, many objects (real, or possibly abstract)[43] are subordinated within the picture to a s i n g l e overall form and altered to make them compatible with this form, which they comprise. In this case, the individual form, which mainly serves the overall form of the composition, can retain little of its own personal sound and should be regarded principally as an element of that form. The individual form is shaped in this particular way not because i t s own inner sound (regarded as separate from the overall composition) necessarily requires it, but mainly because it is called upon to serve as a building block for this composition. Here, the first task—the composition of the whole picture—is pursued as a definite goal.†

In this way, the abstract element in art gradually has come increas-

*The overall composition can of course consist of smaller, closed compositions, which externally may even stand in a hostile relationship one to another, yet still serve the purpose of the overall composition (and in this example, specifically by means of this hostile relationship). These smaller compositions also consist of individual forms with their own different inner coloration.

†A cogent example of this: the bathing women by Cézanne, composition in triangular form. (The mystical triangle!) This construction by geometrical form is an old principle, which has of late been rejected because it had degenerated into a rigid academic formula no longer possessing any inner meaning, any soul. Cézanne's application of this principle gave it a new soul, with a strong emphasis upon the purely pictorial-compositional. In this important instance, the triangle is not an auxiliary means employed to bring about the harmonization of the group, but is itself the clearly expressed artistic aim. Here, geometrical form becomes at the same time a means of composition in painting: the emphasis lies upon the purely artistic aim, with a strong concordance of the abstract element. For this reason, Cézanne quite rightly alters the proportions of the human body: not only must the whole figure strive toward the point of the triangle, but even the individual parts of the body are themselves driven more and more strongly upward from below, as if by an inner storm, they become lighter and lighter and expand visibly.

ingly to the fore, [that same element] which only yesterday concealed itself shyly, hardly visible behind purely materialistic strivings.

And this growth and eventual predominance of the abstract is a natural process.

Natural, because the more organic form is pushed into the background, the more this abstract element comes to the fore of its own accord, with increasing stridency.

The remaining organic element has, however, as already noted, its own inner sound, which may either be identical with the inner sound of the second constituent element (the abstract) within the same form (a simple combination of the two elements), or which may be of a different nature (a complicated, and possibly necessarily disharmonious combination). In any case, the sound of the organic element, even when pushed right into the background, is able to make itself heard within the chosen form. For this reason, the choice of real objects is of some importance. As regards the two notes (a spiritual chord)[44] sounded by the two constituent elements of the form, the organic may either reinforce the abstract (by means of consonance or dissonance) or disturb it. The object itself may constitute only a contingent sound that, when replaced by another, causes no e s s e n t i a l change in the basic sound.

A composition in the form of a rhombus can, for example, be constructed so as to include a number of human figures. After examining them in the light of one's sensibility [Gefühl], one asks oneself the question: Are the human figures essential to the composition, or could they be replaced by other organic forms that would avoid disturbing the basic i n n e r sound of the composition? And if so, then we are faced with an example in which the sound of the object not only does not help the sound of the abstract element, but is directly inimical to it: an indifferent sound on the part of the object weakens the abstract. In fact, this is not only logically, but also artistically the case. In this instance, therefore, one should either find another object more compatible with the inner sound of the abstract element (compatible either as consonance or dissonance), or else choose to let the whole form remain purely abstract.[45] Here let us once again remember the example of the piano. Instead of [the words] color and form, substitute object. Every object (regardless of whether it was created directly by "nature" or by human hand) is a being with its own life and, inevitably, with its own effect flowing from it. Man is constantly subject to this psychological effect. Many of the results will remain in the "subconscious" (where they exert

168

just as lively and creative an effect). Many rise to the level of the "conscious." One can free oneself from many of them simply by closing one's soul to them. "Nature," i.e., the ever-changing external environment of man, continually sets the strings of the piano (the soul) in vibration, by means of the keys (objects). These effects, which often seem chaotic to us, consist of three elements: the effect of the color of the object, the effect of its form, and the effect—independent of color and form—of the object itself.

Now, however, in the place of nature we have the artist, who has the same three elements at his disposal. And without further ado, we arrive at our conclusion: Here too it is the element of purpose that is the deciding factor. So it is clear that the choice of object (= a contributory element in the harmony of form) must be based only upon the principle of the purposeful touching of the human soul.

Therefore, the choice of object also arises from the principle of internal necessity.

The more freely abstract the form becomes, the purer, and also the more primitive it sounds. Therefore, in a composition in which corporeal elements are more or less superfluous, they can be more or less omitted and replaced by purely abstract forms, or by corporeal forms that have been completely abstracted. In every instance of this kind of transposition, or composition using purely abstract forms, the only judge, guide, and arbitrator should be one's feelings. Moreover, the more the artist utilizes these abstracted or abstract forms, the more at home he becomes in this sphere, and the deeper he is able to penetrate it. The spectator too, guided by the artist, likewise increases his knowledge of this abstract language and finally masters it.

Here, we are confronted by the question: Must we not then renounce the object altogether, throw it to the winds and instead lay bare the purely abstract? This is a question that naturally arises, the answer to which is at once indicated by an analysis of the concordance of the two elements of form (the objective and the abstract). Just as every word spoken (tree, sky, man) awakens an inner vibration, so too does every pictorially represented object.[46] To deprive oneself of the possibility of thus calling up vibrations would be to narrow one's arsenal of expressive means. At least, that is how it is today. But apart from today's answer, the above question receives the eternal answer to every question in art that begins with "must." There is no "must" in art, which is forever

free. Art flees before the word "must," as day flees from night.

Regarding the second task of composition, the creation of individual forms as building blocks for the whole composition, it should also be remarked that the same form always produces the same sound under the same conditions. Only the conditions always differ; which permits us to draw two conclusions:

1. The ideal sound changes when combined with other forms.

2. It changes, even in the same context (inasmuch as it is possible for the context to remain the same), if the direction of the form changes.* From these two conclusions arises automatically another.

Nothing is absolute. And formal composition, which is based upon this relativity, is dependent upon (1) the variability of the combinations of forms, and (2) upon the variability, down to the tiniest detail, of every individual form. Every form is as fragile as a puff of smoke: the tiniest, barely perceptible alteration of any of its parts changes it essentially. And this goes so far that it is perhaps easier to achieve the expression of the same sound by the use of different forms than by the repetition of the same form: a really exact repetition lies beyond the bounds of possibility. As long as we remain particularly sensitive only to the overall effect of the composition, then this fact is more of theoretical importance. But as people develop greater and more refined sensitivity through the use of more and more abstract forms (which will receive no interpretation in physical terms), then this fact will have ever-increasing practical importance. Thus, on the one hand, the difficulty of art will increase, but on the other, the wealth of forms available as means of expression will qualitatively and quantitively increase with it. The question of "distortion" will, of its own accord, disappear in the process, to be replaced by another, far more artistic one: To what extent is the inner sound of the given form concealed or laid bare? This change of viewpoint will once again lead to still further enrichment of the available means of expression, since concealment wields an enormous power in art. The combination of the revealed and the hidden will constitute a further possibility of creating new motifs for formal composition.

*What one calls motion; e.g., a triangle that is simply standing upright has a more peaceful, motionless, stable sound than if the same triangle is placed obliquely upon the surface.

Without such developments in this field, formal composition would remain impossible. This will, as a way of composing a picture, always seem mere unfounded willfulness to those who remain deaf to the inner sound of form (corporeal and especially, abstract form). The dislocation of individual forms upon the picture surface appears merely inconsequential, a meaningless formal game. Here, we find the same criterion and the same principle we have found up to now, in every case, to be the only purely artistic one, free from the accidental: the principle of internal necessity.

If, e.g., facial features or different parts of the body have been dislocated or "distorted" for artistic reasons, one comes up against not only purely pictorial problems, but also anatomical ones, which confine the scope of the artistic intention, forcing irrelevant considerations upon it. In our case, however, everything irrelevant disappears of its own accord, and only the essential remains—the artistic aim. And it is this apparently willful, but in fact strictly determinable, possibility of distorting forms which is one of the sources of an infinite series of purely artistic creations.

Thus, on the one hand, the flexibility of the individual forms, the so-to-speak internal-organic changes they undergo, their direction within the picture (movement), and the emphasis upon the corporeal or the abstract element of these individual forms; on the other hand, the juxtaposition of forms that together constitute the larger formal patterns, built up out of groups of forms; the juxtaposition of individual forms with these larger groups of forms, which makes up the overall composition of the whole picture; further, the principles of consonance or disonance of all those parts mentioned, i.e., the meeting of individual forms, the limitation of one form by another, likewise the jostling, the confluence or dismemberment [*Mit- und Zerreissen*] of the individual forms; similar treatment of different groups of forms, the combination of the hidden and the revealed, of the rhythmic and the arhythmic upon the same surface, of abstract forms—on the one hand purely geometrical (simple or more complex), on the other, indescribable in geometrical terms; combinations of delimitations of forms one from one another (more/less strongly), etc., etc.—all these are the elements that constitute the possibility of a purely graphic "counterpoint" and will give rise to it. And all this is only the counterpoint of an art of black and white, as long as we exclude color.

Color, which itself affords material for counterpoint, and which con-

Cézanne, *Bathers*

ceals endless possibilities within itself, will give rise, in combination with drawing, to that great pictorial counterpoint, by means of which painting also will attain the level of composition and thus place itself in the service of the divine, as a totally pure art. And it is always the same infallible guide that leads us on toward these dizzy heights: the principle of internal necessity![47]

<p style="text-align:center">* *
*</p>

Internal necessity arises from three mystical sources. It is composed of three mystical necessities:

1. Every artist, as creator, must express what is peculiar to himself (element of personality).
2. Every artist, as child of his time, must express what is peculiar to his own time (element of style, in its inner value, compounded of the language of the time and the language of the race, as long as the race exists as such).
3. Every artist, as servant of art, must express what is peculiar to art in general (element of the pure and eternally artistic, which pervades every individual, every people, every age, and which is to be seen in the works of every artist, of every nation, and of every period, and which, being the principal element of art, knows neither time nor space).

One must simply penetrate these first two elements with one's spiritual eye to reveal the third element. And then one sees that a "crudely" carved column from an Indian temple is just as much animated by the same soul as any living, "modern" work.

There has been, and still is today, much talk of the personal element in art; now and again, and today with increasing frequency, one hears talk of the style to come. Even if these questions are of great importance, they will gradually lose their urgency and their significance when viewed from across centuries and finally across millenia, eventually becoming indifferent and dead.

Only the third element, that of the pure, the eternally artistic, remains immortal. It does not lose its strength with time; on the contrary, it gains in strength continually. Egyptian sculpture certainly moves us more today than it was able to move its contemporaries: it was muted by

being far too closely bound to its contemporaries by then still-living characteristics of time and personality. Today, we are able to hear revealed in it the sound of an eternal art. On the other hand, the more a "present-day" work possesses of the first two elements, the more easily it will, of course, be able to find access to the souls of its contemporaries. And further: the more strongly the third element is present in this modern work, the more the first two elements are overshadowed, and the more difficult becomes this access to the souls of its contemporaries. For this reason, centuries must sometimes elapse before the sound of the third element can reach the souls of men.

Thus, the predominance of this third element in a work of art is the sign of its greatness and of the greatness of the artist.[48]

These three mystical necessities are the three necessary elements of the work of art, which are closely bound up with one another, i.e., they interact upon each other, a phenomenon that in every age expresses the unity of the work of art. The first two elements, however, embrace the temporal and the spatial, constituting in relation to the element of the pure and eternally artistic, which is beyond time and space, a kind of relatively opaque outer skin. The process of the development of art consists to a certain extent in the ability of the pure and eternally artistic to free itself from the elements of personality and temporal style. Therefore, these two forces act not only in conjunction, but also as brakes.

Personal and temporal style give rise in every epoch to many precisely determined forms, which, despite their considerable apparent dissimilarity, are so organically related that they can be described as o n e s i n - g l e f o r m: their inner sound is ultimately o n e o v e r a l l s o u n d.

These two elements are of a subjective nature. The whole period wants to reflect i t s e l f, to express i t s own life in artistic form. Likewise, the artist wants to express h i s own self, and selects only those forms that are emotionally appropriate to h i m.

Slowly but surely, the style of the period becomes formed, i.e., a certain external and subjective form. The element of the pure and eternally artistic is, as opposed to this, the objective element, which becomes comprehensible with the help of the subjective.

This ineluctable will for expression of the objective is the force described here as internal necessity, which requires from the subjective today o n e general form, tomorrow a n o t h e r. It is the constant tireless impulse, the spring that drives [us] continually "forward." The

spirit progresses, and hence today's inner laws of harmony are tomorrow's external laws, which in their further application continue to have life only by virtue of this same necessity, which has become externalized. It is clear that the spiritual, inner power of art merely uses contemporary forms as a stepping stone to further progress.

In short, then, the effect of inner necessity, and thus the development of art, is the advancing expression of the external-objective in terms of the temporal-subjective. Thus, again, the struggle of the objective against the subjective.

For example, today's accepted form is the triumph of yesterday's inner necessity, which has attained a certain external level of emancipation, of freedom. This present-day freedom was secured by means of a struggle, and appears to many, as always, to be the "last word." One of the canons of this limited freedom is that the artist may utilize every form as a means of expression, as long as he bases his art upon forms borrowed from nature. This demand is, however, like all previous demands, merely temporal. It is the external expression of today, i.e., today's external necessity. Seen from the standpoint of inner necessity, such a limitation cannot be imposed, and the artist today is free to base his art entirely upon that inner principle from which today's external limitation is derived, and which may thus be defined as follows: the artist may utilize every form as a means of expression.

So we see, finally (and this is of immeasurable importance for all periods, and especially "today"!), that the search for the personal, for style (and thus, incidentally, for the national) not only cannot be arrived at intentionally, but also is not of such importance as we think today. And we see that the common relationship between works of art, which is not weakened by the passage of millenia, but is increasingly strengthened, does not lie in the exterior, in the external, but in the root of roots—in the mystical content of art. We see that the dependence upon "schools," the search for "direction," the demand for "principles" in a work of art and for definite means of expression appropriate to the age, can only lead us astray, bringing in their train misunderstanding, obscurity, and unintelligibility.

The artist should be blind to "accepted" or "unaccepted" form, deaf to the precepts and demands of his time.

His eyes should be always directed toward his own inner life, and his ears turned to the voice of internal necessity.

Then he will seize upon all permitted means, and just as easily upon

175

all forbidden means.

This is the only way of giving expression to mystical necessity.

All means are moral if they are internally necessary.

All means are sinful if they did not spring from the source of internal necessity.

On the other hand, even if one can today speculate *ad infinitum* along these lines, it is nonetheless premature to theorize about the further details. Theory is never in advance of practice in art, never drags practice in its train, but vice versa. Everything depends on feeling, especially at first. What is right artistically can only be attained through feeling, particularly at the outset. Even if overall construction can be arrived at purely by theory, nevertheless there remains something extra, which is the true spirit of creation (and thus, to a certain extent, its very essence as well), which can never be created or discovered through theory, but only suddenly inspired by feeling. Since art affects the emotions, it can only exert its effect by means of the emotions. The right result, even given the most careful proportions, the finest weights and scales, can never be the result of mental calculation of deductive reasoning. These proportions cannot be calculated, nor these scales be found ready-made.*[49] Proportions and scales are to be found not outside, but within the artist; they are what one might call a feeling for artistic limits, a sense of tact—qualities the artist is born with, which are heightened by enthusiasm so as to reveal genius. It is in this sense that Goethe's prophecy of the possibility of a thorough-bass of painting is to be understood. This kind of grammar of painting can at the moment only be guessed at, and if it eventually comes about, it will be constructed not so much on the basis of physical laws (as has already been attempted, and is being attempted again today: Cubism), but rather upon the laws of internal necessity, which may quite correctly be described as spiritual.

*That great and versatile master, Leonardo da Vinci, devised a system or scale of little spoons for measuring out the various colors. One was supposed to be able to achieve an automatic harmony by this method. One of his pupils went to a lot of trouble to learn how to apply this method and, disheartened by his lack of success, asked another colleague how the master managed with these measuring spoons. "The master never uses them," replied his colleague. (Merezhkovsky, *Leonardo da Vinci*, German translation by A. Eliasberg, published by R. Piper and Co., Munich.)[50]

<p style="text-align:center">* *</p>
<p style="text-align:center">*</p>

Thus we see that the internal lies at the heart of the very tiniest problem, and also at the heart of the greatest problems in painting. The path upon which we find ourselves today, and which is the greatest good fortune of our time, leads us to rid ourselves of the external,* to replace this basis by another diametrically opposed to it: the basis of internal necessity. But just as the body is strengthened and developed through exercise, so too is the spirit. Just as the body, if neglected, becomes weak and incapable, so too does the spirit. The sense of feeling with which the artist is born resembles the talent of which the Bible speaks, which is not to be buried. The artist who does not use his gifts is a lazy servant.

For this reason, it is not only not harmful, but positively necessary for the artist to be acquainted with the starting point of these exercises.

This starting point consists in the weighing-up of the inner value of one's materials, on an objective scale, i.e., the examination—in our case—of color, which by and large must affect every man.

Thus we need not become involved here with the deep and subtle complexities of color, but shall content ourselves with the elementary representation of the simple colors.

One concentrates first upon color in isolation, letting oneself be affected by single colors. In this way we are confronted with the simplest possible schema. The whole question can be couched in the simplest possible terms.

The two great divisions, which at once become obvious, are:

1. warmth or coldness of a color
2. lightness or darkness of a color

*The concept "external" should not here be confused with the concept "material." I employ the former concept simply as a substitute for "external necessity," which can never lead us beyond the bounds of accepted and hence mere traditional "beauty." "Internal necessity" recognizes no such boundaries, and thus often creates things we are accustomed to describe as "ugly." "Ugly" is hence merely a conventional concept, dragging out a semblance of continued existence as the external result of an inner necessity that has already produced its effect and has long since been made incarnate. In earlier times everything unrelated to internal necessity was stamped with the term ugly. The beautiful, on the other hand, was defined as that which was related to it. And rightly—everything that arises from internal necessity is beautiful in consequence. And is sooner or later recognized as such.

In this way, for every color there are four main sounds [*vier Hauptklänge*]: (I) w a r m, and either (1) l i g h t, or (2) d a r k; or (II) c o l d, and either (1) l i g h t, or (2) d a r k.

TABLE I.

first pair
of opposites: I and II

(of an inner character, as
emotional effect)

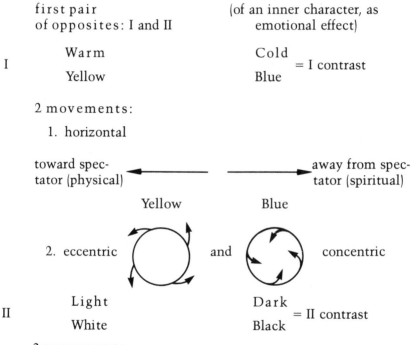

I

Warm

Yellow

Cold

Blue

= I contrast

2 movements:

1. horizontal

toward spec-
tator (physical)

away from spec-
tator (spiritual)

Yellow Blue

2. eccentric and concentric

II

Light

White

Dark

Black

= II contrast

2 movements:

1. The movement of resistance

Eternal resistance
and yet possibili-
ty (birth)

White Black

complete lack of
resistance and no
possibility (death)

2. Eccentric and concentric, as in the case of yellow and blue,
but in petrified form.

In the most general terms, the warmth or coldness of a color is due to its inclination toward yellow or toward blue. This is a distinction that occurs, so to speak, within the same plane, whereby the color retains its basic tonality, but this tonality becomes more material or more immaterial. It is a horizontal movement, the warm colors moving in this horizontal plane in the direction of the spectator, striving toward him; the cold, away from him.

The colors that cause the horizontal movement of another color are themselves characterized by this same movement; they have, however, another very different movement that distinguishes them sharply one from another as regards their inner effect. They constitute thereby the first great contrast in terms of inner values. The inclination of a color toward cold or warm is thus of incalculable i n t e r n a l importance and significance.

The second great contrast is the difference between white and black, i.e., those colors that produce the other opposing pair, which together make up the four main possibilities of tone: the inclination of the color toward light or dark. These also have the same movement toward or away from the spectator, although not in dynamic, but in static, rigid form (see Table I).

The second movement that concerns yellow and blue, and contributes to the first great contrast, is their eccentric or concentric motion.* If one makes two circles of the same size and fills one with yellow and the other with blue, one notices after only a short period of concentrating upon these circles that the yellow streams outward, moves away from the center, and approaches almost visibly toward the spectator. The blue, however, develops a centripetal movement (like a snail disappearing into its shell), and withdraws from the spectator. The eye is stung by the first circle, while it immerses itself in the second.

This effect is heightened if one adds the contrast between light and dark: the effect of yellow is increased by lightening the tone (or, put simply, by adding white), while the effect of blue is intensified by increased darkness of tone (admixture of black). This fact assumes even greater significance when one notices that yellow tends toward light (i.e., white) to such an extent that no very dark yellow can exist. There is, therefore, a profound relationship in physical terms between yellow

*All these assertions are the results of empirical-spiritual experience and are not based upon any positive science.

and white, just as between blue and black, for blue can assume so deep a tone that it verges on black. In addition to this physical resemblance, there is also a moral similarity that sharply distinguishes the two pairs (yellow and white on the one hand, blue and black on the other) in their inner values, while closely relating the two constituents of each pair (of which more later, when discussing white and black).

If one tries to make yellow (this typically warm color) colder, it takes on a greenish hue, and at once loses much of both its movements (horizontal and centrifugal). It assumes a somewhat sickly and super-natural character, like someone full of drive and energy prevented by external circumstances from using them. Blue, having the completely opposite motion, affects yellow like a brake; eventually, upon further addition of blue, both directionally opposed motions cancel each other out, resulting in motionlessness and tranquillity. The result is g r e e n.

The same occurs when white is darkened by adding black. It loses its constancy, and the eventual result is g r a y, which is very close to green in its moral value.

The only difference is that within green are hidden the paralyzed forces of yellow and blue, which may yet become active again. A living possibility exists in green that is totally lacking in gray. It is lacking because gray consists of colors that possess no purely active power (of movement), but consist on the one hand of motionless resistance, and on the other of immobility incapable of resistance (like an infinitely strong wall stretching off into infinity and an endless, bottomless pit).

Since both the colors that make up green are active and have move-ment within themselves, one can in fact establish their spiritual effect purely theoretically, on the basis of the character of the movement. Likewise, if one proceeds in a purely experimental fashion, letting the colors affect oneself, one comes to the same conclusion. In fact, both the primary movement of yellow, that of striving t o w a r d the spectator, which can be raised to the level of importunity (by increasing the intensity of the yellow), and its secondary movement, which causes it to leap over its boundaries, dissipating its strength upon its sur-roundings—both resemble the properties of any material force that exerts itself unthinkingly upon the object and pours forth aimlessly in every direction. On the other hand, yellow, when directly observed (in some kind of geometrical form), is disquieting to the spectator, pricking him, stimulating him, revealing the nature of the power expressed in this color, which has an effect upon our sensibilities at once impudent

and importunate.* This property of yellow, a color that inclines considerably toward the brighter tones, can be raised to a pitch of intensity unbearable to the eye and to the spirit. Upon such intensification, it affects us like the shrill sound of a trumpet being played louder and louder, or the sound of a high-pitched fanfare.†

Yellow is the typical earthly color. Yellow cannot be pushed very far into the depths. When made colder with blue it takes on, as mentioned above, a sickly hue. If one compares it to human states of mind, it could have the effect of representing madness—not melancholy or hypochondria, but rather mania, blind madness, or frenzy—like the lunatic who attacks people, destroying everything, dissipating his physical strength in every direction, expending it without plan and without limit until utterly exhausted. It is also like the reckless pouring out of the last forces of summer in the brilliant foliage of autumn, which is deprived of peaceful blue, rising to heaven. There arise colors full of a wild power, which, however, lack any gift for depth.

We find this gift for depth in blue, and likewise, first of all theoretically, in its physical movement (1) away from the spectator, and (2) toward its own center. And this is the result produced by letting blue (in no matter what geometrical form) affect our senses. The inclination of blue toward depth is so great that it becomes more intense the darker the tone, and has a more characteristic inner effect. The deeper the blue becomes, the more strongly it calls man toward the infinite, awakening in him a desire for the pure and, finally, for the supernatural. It is the color of the heavens, the same color we picture to ourselves when we hear the sound of the word "heaven."

*This is, e.g., the effect produced by the yellow Bavarian mailboxes, assuming that they have not lost their original color. It is interesting to notice that lemons are yellow (acid taste), and that canaries are also yellow (shrill sound of their singing). These are examples of a particular intensity of the color-tone.

†The correspondence between color and musical tones is of course only relative. Just as a violin can produce very different tones, so, e.g., can yellow in its various shades be expressed by the sounds of different instruments. In the case of such parallels, one should think of the pure mid-tone in color, and in music the middle tone produced when not varied by use of vibrato, mute, etc.

Blue is the typically heavenly color.* Blue unfolds in its lowest depths the element of tranquility.† As it deepens toward black, it assumes overtones of a superhuman sorrow.‡ It becomes like an infinite self-absorption into that profound state of seriousness which has, and can have, no end. As it tends toward the bright [tones], to which blue is, however, less suited, it takes on a more indifferent character and appears to the spectator remote and impersonal, like the high, pale-blue sky. The brighter it becomes, the more it loses in sound, until it turns into silent stillness and becomes white. Represented in musical terms, light blue resembles the flute, dark blue the 'cello, darker still the wonderful sounds of the double bass; while in a deep, solemn form the sound of blue can be compared to that of the deep notes of the organ.

Yellow easily becomes acute and cannot sink to great depths.

Blues becomes acute only with difficulty and cannot rise to great heights.

The ideal balance of these two colors—diametrically opposed in every respect—when they are mixed, produces green. The horizontal movement of one color cancels out that of the other. The movement toward and away from the center cancels itself out in the same way. Tranquility results. This logical conclusion can easily be arrived at theoretically. And the direct effect upon the eye and, finally, through the eye upon the

*"... les nymbes ... sont dorés pour l'empereur et les prophètes (i.e., for human beings) et bleu de ciel pour les personnages symboliques (i.e., for those beings which have only spiritual existence). N. Kondakov, *Histoire de l'art byzantin consid. princip. dans les miniatures*, vol. 2, p. 38, 2 (Paris: 1886–1891).

†Unlike green—which, as we shall see later, conveys earthly, self-satisfied repose—but rather solemn, superterrestrial absorption. This should be understood literally: The "earthly" lies on the path which leads to the "super[terrestrial]," and cannot be avoided. All the torments and questionings and contradictions of earthly life must be experienced. No man has succeeded in escaping them. Here too is internal necessity, concealed under the cover of the external. The recognition of this necessity is the source of "peace." Since, however, it is this very peace which is most distant from us, it is only with difficulty, even in the realms of color, that we are able to approach inwardly the state of this predominance of blue.

‡Different again from violet, as described below.

soul, gives rise to the same result. This fact has been known not only to doctors (and in particular to oculists), but to everyone for some time. Absolute green is the most peaceful color there is: it does not move in any direction, has no overtones of joy or sorrow or passion, demands nothing, calls out to no one. This continual absence of movement is a property that has a beneficial effect upon tired people and tired souls, but which after a certain period of repose can easily become tedious. Paintings composed as harmonies in green confirm this assertion. Just as a picture painted in yellow gives out a spiritual warmth, while a blue one will appear too chill (i.e., an active effect, for man, as an element of the cosmos, is created for continual, perhaps eternal activity), so does green appear merely tedious (passive effect). Passivity is the most characteristic quality of absolute green, a quality tainted by a suggestion of obese self-satisfaction. Thus, pure green is to the realm of color what the so-called bourgeoisie is to human society: it is an immobile, complacent element, limited in every respect. This green is like a fat, extremely healthy cow, lying motionless, fit only for chewing the cud, regarding the world with stupid, lackluster eyes.* Green is the principal color of summer, when nature has outlived the year's time of storm and stress, the spring, and has sunk into self-contented repose (see Table II).

If we disturb the balance of pure green, making it tend toward yellow, it comes alive, full of joy and youth. By the admixture of yellow, an active force is brought into play again. If, however, blue predominates, the green becomes deeper, taking on a quite different sound: it becomes serious and, so to speak, pensive. In this case, therefore, another active element has come to the fore, but one of a totally different character than in the case of the warmer green.

When tending toward light or dark, green still retains its original character of equanimity and peace, in the case of light green the former characteristic predominating, of dark green the latter. Which is natural enough, since these changes are brought about by the addition of white or black. In musical terms, I would think the best way of characterizing absolute green would be the quiet, expansive middle register of the violin.

These two last-named colors—white and black—have already been defined in general terms. As a closer definition, white, which is often

*This is the effect of this ideal, much-vaunted "balance." As Christ put it, "You are neither cold nor warm. . . ."

TABLE II.

Second Pair of (of a physical character,
Opposites: III and IV as complementary colors)

III Red Green = III Contrast

 1 Movement spiritual resolution of the
 I. Contrast

Movement within itself

 = potential mobility
 = immobility

 Red

Eccentric and concentric movement disappear completely
When mixed optically = Gray
as with mechanical mixture of white and black = Gray

IV Orange Violet = IV Contrast

 arising out of the I contrast thus
 1. effect of active element yellow on red = Orange
 2. effect of passive element blue on red = Violet

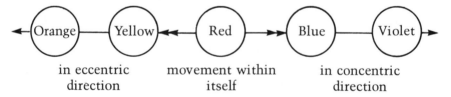

 in eccentric movement within in concentric
 direction itself direction

regarded as a n o n c o l o r (due in particular to the Impressionists, who see "no white in nature"),* is like the symbol of a world where all colors, as material qualities and substances, have disappeared. This world is so far above us that no sound from it can reach our ears. We hear only a great silence that, represented in material terms, appears to us like an insurmountable, cold indestructible wall, stretching away to infinity. For this reason, white also affects our psyche like a great silence, which for us is absolute. Its inner sound is like the absence of sound, corresponding in many cases to pauses in music, which constitute only a momentary interruption of the development of a movement or of the [musical] content, as opposed to the definite conclusion of that development. It is a silence that is not dead, but full of possibilities. White has the sound as of a silence that suddenly becomes comprehensible. It is a nothingness having the character of youth or, more exactly, the nothingness that exists before the b e g i n n i n g, before birth. Perhaps the earth sounded thus in the white period of the ice age.

B l a c k has an inner sound of nothingness bereft of possibilities, a dead nothingness as if the sun had become extinct, an eternal silence without future, without hope. Musically, it is represented by a general pause, after which any continuation seems like the beginning of another world, for that part which was brought to a close by this pause remains finished, complete for all time: the wheel has come full circle. Black is something extinguished, like a spent funeral-pyre, something motionless, like a corpse, which is dead to all sensations, which lets everything simply pass it by. It is like the silence of the body after death, the close of life. Black is externally the most toneless color, against which all other colors, even the weakest, sound stronger and more precise. Not so with white, compared with which the sound of nearly all other colors be-

*Van Gogh in his letters asks the question whether he should not depict a white wall simply as white. This question, which can present no difficulties to the nonnaturalistic painter, who uses colors according to their inner sound, appears to an impressionistic-naturalistic painter as a dangerous attack upon nature. The question must appear just as revolutionary and insane to such an artist as the substitution of blue shadows for brown appeared in his own times (the favorite example of "green sky and blue grass"). Just as in the latter case it is possible to recognize the transition from academicism and realism to Impressionism and Naturalism, so in Van Gogh's question we see the seeds of the "interpretation of nature"—i.e., the tendency to represent nature not in terms of external appearances, but rather to emphasize the element of i n n e r i m p r e s s i o n, which recently has become known as e x p r e s s i o n.

comes dulled, while many dissolve completely, leaving nothing but a weak, paralyzed echo behind them.*

It was not for nothing that white was chosen as the vestment of pure joy and immaculate purity. And black as the vestment of the greatest, most profound mourning and as the symbol of death. The balance between these two colors that is achieved by mechanically mixing them together forms gray. Naturally enough, a color that has come into being in this way can have no external sound, nor display any movement. Gray is toneless and immobile. This immobility, however, is of a different character from the tranquillity of green, which is the product of two active colors and lies midway between them. Gray is therefore the disconsolate lack of motion. The deeper this gray becomes, the more the disconsolate element is emphasized, until it becomes suffocating. As the color becomes lighter, we feel a breath of air, the possibility of respiring, for it contains a certain element of concealed hope. A similar gray is formed by the optical mixture of green and red, arising out of a mixture, in spiritual terms, of self-complacent passivity, and a powerful, active, inner glow.†

Red, as one imagines it, is a limitless, characteristically warm color, with the inner effect of a highly lively, living, turbulent color, yet which lacks the rather light-minded character of yellow, dissipating itself in every direction, but rather reveals, for all its energy and intensity, a powerful note of immense, almost purposeful strength. In this burning, glowing character, which is principally within itself and very little directed toward the external, we find, so to speak, a kind of masculine maturity (see Table II).

This ideal red, however, can in reality undergo any number of changes, permutations, and variations. Red is very rich and various in its material form. One need only think of red lead, vermilion, English red, madder, from the lightest to the darkest tones! This color displays the possibility

*Vermilion, e.g., appears dull and dirty next to white, whereas next to black it assumes a bright, pure, striking power. Bright yellow becomes weak and runny next to white; next to black, its effect is so strong that it tears itself free from the background, hovers in the air, and leaps into one's eye.

†Gray—immobility and peace. Delacroix sensed this when he sought to achieve the effect of peace by the mixture of green and red (Signac, op. cit.).

186

of maintaining more or less the same basic tone, while appearing at the same time characteristically warm or cold.*

Bright, warm red (m i n i u m) has a certain affinity with mid-yellow (it also contains quite a large amount of yellow as a pigment), and evokes feelings of power, energy, striving, determination, joy, triumph (pure), etc. In musical terms, it reminds one again of the sound of a fanfare, in which the tuba can also be heard—a determined, insistent, powerful sound.

In its middle tones, such as v e r m i l i o n, red has more of the constancy of powerful emotion: it is like a steadily burning passion, a self-confident power that cannot easily be subdued, but can be extinguished by blue, as a red-hot iron by water. This red cannot bear anything cold, and in combination with it loses its sound and meaning. Or, to put it better: This violent, tragic cooling produces a tone that is avoided and decried by artists, particularly today, as "m u d d y." Now this is wrong. Mud, in its material form, as a material representation, a material being possesses, like all other material beings, its own inner sound. For this reason, avoiding mud in painting today is just as unfair and biased as yesterday's fear of "pure" colors. It should never be forgotten that all means are pure that arise from internal necessity. Here, the externally "dirty" is internally pure. Or else, the externally pure is internally dirty. By comparison with yellow, red lead and vermilion are of similar character, but their movement toward the spectator is considerably less: these reds glow, but more w i t h i n t h e m s e l v e s, lacking entirely the rather maniacal character of yellow. For this reason, perhaps, they are more popular than yellow: one often finds a predilection for red in primitive peasant ornamentation, and also in folk costumes where, in the open air, as the complementary of green it has a particularly "beautiful" effect. This red is of a principally material and very active character (in isolation) and has no tendency toward the deeper tones, any more than yellow. Only when it penetrates a higher milieu does this red take on a deeper tone. Darkening it with black is dangerous, for dead black extinguishes the glow or reduces it to a minimum. There results then b r o w n: blunt, hard, capable of little movement, and in which red sounds as a scarcely audible murmur. Yet

*Admittedly, every color can be either warm or cold, but nowhere does one find so great a contrast as in the case of red. A whole fund of internal possibilities!

from this externally weak tone arises an internally strong and powerful one. From the necessary application of brown springs an indescribable inner beauty—that of restraint. Vermilion has a sound like a tuba, and a parallel can be drawn with the sound of a loud drum beat.

Like every fundamentally cold color, c o l d r e d (such as madder) can be considerably darkened (especially by the addition of ultramarine). It also changes considerably in character: the impression of a deep glow increases, but the active element gradually disappears completely. This active element is, however, not so totally absent in, as e.g., dark green, but rather gives an intimation of its presence, the expectation of a new energetic upsurge, like some animal that has retreated into its lair and is lying hidden but nevertheless on the watch, ready to make a wild spring. Herein lies the great difference between red and the deepening tones of blue, for red, even in this state, still produces an impression of the corporeal. It reminds one of the passion-laden middle and lower registers of the 'cello. Cold red, when bright, gains more of the corporeal element, but of the purely corporeal, giving the impression of pure youthful joy, like the fresh, pure figure of a young girl. This same image can easily be expressed in musical terms by the high, clear, singing tones of the violin.* This color, which can only be intensified by the admixture of white, is popular among young girls as a color for dresses.

Warm red, when lightened by the use of related yellow, becomes o r a n g e. By this addition, the inward movement of red is transformed into the beginning stages of outward-streaming movement, flowing out into its surroundings. Red, however, which plays a considerable part in [the constitution of] orange, also preserves in this color an undertone of seriousness. It resembles a man sure of his powers, and for this reason evokes a particularly healthy feeling. This color is like a medium-toned church bell ringing the Angelus, or a powerful contralto voice, or a viola playing a largo.

While the approach of red toward the spectator brings about orange, the [effect of] withdrawal that blue exerts upon red constitutes v i o l e t, which has a tendency to move away from the spectator. Here, however, the basic red must be cold, for warm red cannot be mixed with cold blue (not by any means), which is also true in spiritual terms.

*The pure, joyful, often consecutive tones of little bells (and of sleigh-bells) are described in Russian as a "raspberry-colored sound." The color of raspberry juice is close to that of the bright, cold red just described.

Violet is thus a cooled-down red, in both a physical and a psychological sense. It therefore has something sad, an air of something sickly, something extinguished about it (like a slag heap!). It is not for nothing that this color is considered suitable for the clothes of old women. The Chinese in fact use it as the color of mourning. It is like the sound of the *cor-anglais*, of the shawm, and in its deeper tones resembles those of the lower woodwind (e.g., the bassoon).*

The last two colors, which arise from a modification of red by yellow or blue, are made up of an unstable balance of forces.[51] In the mixing of colors one notices their tendency to lose this equilibrium. One has the feeling as of watching a tightrope walker, who has to take care to maintain his balance on both sides continually. Where does orange begin, and red and yellow stop? Where is the borderline that divides violet strictly from red or blue?†

These two last-defined colors (orange and violet) constitute the fourth and last pair of opposites in the realm of the simple, primitive colors, which means that in a physical sense they stand in the same relationship to one another as do those of the third pair (red and green), i.e., as complementary colors (see Table II).

The six colors that constitute the three great pairs of opposites confront us like a great circle, like a snake biting its own tail (the symbol of infinity and of eternity). And to right and left, the two great possibilities of silence: the silence of birth and the silence of death (see Table III).

<div align="center">* *</div>
<div align="center">*</div>

It is clear that all the descriptions employed for these quite simple colors are extremely provisional and clumsy. So too are the emotions we have used to characterize these colors (joy, sorrow, etc.). These emotions are no more than material states of the soul. The different tones of the colors, like those of music, are of a much subtler nature and awaken far

*Artists sometimes reply jokingly to the question "How are you?" with the words "All violet," which signifies far from happy.

†Violet also has the tendency to turn into lilac. And when does the one end and the other begin?

Table III

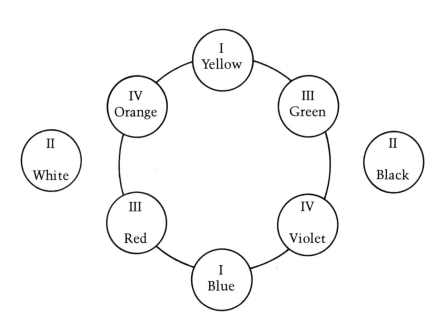

The pairs of opposites represented as a ring between two poles = the life of the simple colors between birth and death.

(The Roman numerals indicate the pairs of opposites.)

subtler vibrations in the soul than can be described in words. With time, every tone can very probably find its own material expression even in words, but there will always remain something extra that cannot be exhausted by words, and yet is not merely an elaborate accident of the particular tone, but its very essential. For this reason, words are and remain mere indications, somewhat external labels for colors. In the impossibility of replacing the essential element of color by words or other means lies the possibility of a monumental art. Here, amidst extremely rich and different combinations, there remains to be discovered one that is based upon the principle just established. I.e., the same inner sound can be rendered at the same moment by different arts. But apart from this general sound, each art will display that extra element which is essential and peculiar to itself, thereby adding to that inner sound which they have in common a richness and power that cannot be attained by one art alone.

And, in addition to this [kind of] harmony, everyone will be able to see what equally powerful and profound disharmonies and what infinite combinations are possible on the basis of the preponderance of one art, or the preponderance of the contrast between various arts, set against the tranquil concordance of yet others, etc., etc.

One often hears the opinion that the possibility of substituting one art for another (e.g., by the [written] word in the case of literature) would refute the necessity of differentiating between the arts. This, however, is not the case. As has been said, the exact repetition of the same sound by different arts is not possible. Yet even were it possible, the repetition of the same sound would at least have a different external coloration. Even if this were not the case—if the repetition of the same sound by the means of the different arts were in every case exactly the same (both externally and internally)—even so, this kind of repetition would not be superfluous, because different people have a leaning towards different arts (either active or passive, i.e., as transmitter or receiver of the sound). Even if this were not the case, this repetition would still not be completely meaningless. Repetition, the piling-up of the same sounds, enriches the spiritual atmosphere necessary to the maturing of one's emotions (even of the finest substance), just as the richer air of the greenhouse is a necessary condition for the ripening of various fruits. A simple example of this is the way in which the repetition of actions and thoughts and feelings can eventually make a powerful impression upon the individual, even if he is not particularly adept at taking in the single

actions, etc., by themselves, as a rather thick material [at first fails to absorb] drops of rain.*

One must conceive the spiritual atmosphere, however, not only in the form of such tangible examples. This, like the air, can either be pure or filled with foreign bodies. Not only actions that can be observed, thoughts and feelings that can find external expression, but also perfectly secret actions that "no-one knows about," unuttered thoughts, and unexpressed feelings (i.e., the actions that take place within people) are the elements that constitute the spiritual atmosphere. Suicide, murder, violence, unworthy and base thoughts, hatred, enmity, egotism, envy, "patriotism," prejudice are all spiritual forms, spiritual entities that go to create the [spiritual] atmosphere† And on the contrary, self-sacrifice, help, pure, high-minded thoughts, love, altruism, delight in the happiness of others, humanity, and justice are also such entities, which can kill the others as the sun kills microbes, and can reconstitute the pure atmosphere.‡

The other (and more complex) form of repetition is that in which different elements participate in different forms. In our case, these different elements are the different arts (i.e., realized and synthesized—monumental art). This form of repetition is all the more powerful in that people of different natures react differently to the individual means. For one, the most direct medium is that of musical form (which in general has an effect upon everyone—the exceptions are too rare); for another, the pictorial; for a third, the literary, etc. Apart from this, however, the forces that are hidden within the various arts are

*The effects of advertising are externally based upon this form of repetition.

†There exist periods of suicide, of warlike feelings, etc. Wars and revolutions (the latter in smaller doses than the former) are the products of this sort of atmosphere, which is further infected by them. By the measure by which thou judgest shalt thou also be judged!

‡History knows such periods also. Did there ever exist a greater one than that of Christianity, which swept the weakest along with it in the spiritual struggle? Even amidst war and revolution, there are forces of this kind at work, which cleanse the plague-laden air.

themselves fundamentally different, so that the result to be achieved (even in the case of the same person) will be more intense than if each of the different arts were to work independently, in isolation.

<p style="text-align:center">* *
*</p>

This difficult-to-define effect produced by the simple, isolated colors is the basis upon which the h a r m o n i z a t i o n of different values can be achieved. There are pictures (in the realm of the applied arts: whole interiors) that are executed throughout in a particular local color, chosen according to artistic feeling. The permeation of a particular tone-color, the joining together of two contiguous colors by means of a mixture of one with the other, is the basis upon which the harmony of colors is often constructed. From what has just been said about the effects of color, and from the fact that we live in a time full of questions and premonitions and omens—hence full of contradictions (consider too the divisions of the triangle)—we can easily conclude that harmonization on the basis of simple colors is precisely the least suitable for our own time. It is perhaps with envy, or with a sad feeling of sympathy, that we listen to the works of Mozart. They create a welcome pause amidst the storms of our inner life, a vision of consolation and hope, but we hear them like the sounds of another, vanished, and essentially unfamiliar age. Clashing discords, loss of equilibrium, "principles" overthrown, unexpected drumbeats, great questionings, apparently purposeless strivings, stress and longing (apparently torn apart), chains and fetters broken (which had united many), opposites and contradictions—this is our h a r m o n y. C o m p o s i t i o n on the basis of this harmony is the juxtaposition of coloristic and linear forms that have an independent existence as such, derived from internal necessity, which create within the common life arising from this source a whole that is called a picture.

Only these individual constituents are essential. All the rest (i.e., including the objective element) are incidental. The rest merely provide overtones.

From this proceeds logically the juxtaposition of two color-tones one with another. On the same principle of antilogic, colors long considered disharmonious are now placed next to each other. For example, the juxtaposition of red and blue, these physically unrelated colors, is today chosen as one of the most strongly effective and most suitably harmoni-

ous because of the great spiritual contrast between them. Our harmony is based mainly upon the principle of contrast, the most important principle in art at all times. Our constrast, however, is one of internal opposition, which stands alone and excludes the possibility of all help (which would today be disturbance and superfluity) from any other harmonizing principles!

It is remarkable that this very juxtaposition of red and blue was so popular with the primitives (the ancient Germans and Italians, etc.) that it has been preserved until the present day in the remaining fragments of this period (e.g., in religious folk-carvings).* One very often sees in such paintings and painted sculptures the Mother of God portrayed in a red dress with a blue mantle thrown over it; it seems as if the artists wanted to portray heavenly grace bestowed upon earthly man, and hence covered the human with the divine.[52] From the description of our harmony it is logical to conclude that even "today," inner necessity demands an infinitely great arsenal of expressive possibilities.

"Permitted" and "forbidden" combinations, the clash of different colors, the overriding of one color by another, or of many colors by a single color, the emergence of one color from the depths of another, the precise delimitation of an area of color, the dissolution of simple or complex colors,[53] the retention of the flowing color area by linear boundaries, the bubbling over of the color beyond these boundaries, the intermingling [of colors] or [their] sharp division, etc., etc.—all this opens up purely pictorial (= painterly) possibilities in an infinite series stretching into the unattainable distance.

As far as drawing and painting are concerned, the turn away from the representational—and one of the first steps into the realm of the abstract—was the exclusion of the third dimension, i.e., the attempt to keep the "picture" as painting upon a flat surface. Modeling was abandoned. In this way, the real object was moved nearer to the abstract, a move that indicated a certain progress. As an immediate consequence, however, one's possibilities became pinned down to the real surface of the canvas, so that painting took on new, purely material overtones. This pinning down was at the same time a limitation of possibilities.

*Probably one of the first artists of "yesterday" to introduce this juxtaposition into his early paintings, accompanied by a great number of coloristic excuses, was Frank Brangwyn.

The attempt to free oneself from this material [element], from this limitation, combined with the effort toward the compositional, naturally necessitated the abandonment of any one picture plane. An attempt was made to constitute the picture upon an ideal plane, which thus had to be in front of the material surface of the canvas.* In this way, composition with flat triangles became composition with triangles that had turned plastic, three-dimensional, i.e., pyramids (so-called "Cubism"). Here also, however, inertia very quickly set in. Attention was concentrated especially upon this one particular form, hence leading once again to an impoverishment of resources. This is the inevitable result of the external application of a principle arising from internal necessity.

Particularly in this case, which is of very great importance, one should not forget that there are other means of both retaining the material surface and constituting an ideal surface, not only of fixing the latter as a flat plane, but also of exploiting it as a three-dimensional space. The very thinness or thickness of a line, the positioning of the form upon the surface, and the superimposition of one form upon another provide sufficient examples of the linear extension of space. Similar possibilities are offered by the correct use of color, which can recede or advance, strive forward or backward, and turn the picture into a being hovering in mid-air, which signifies the same as the pictorial extension of space.

The unification of these two kinds of extension in harmonious or disharmonious combinations is one of the richest and most powerful elements of linear-pictorial composition.

*See, e.g., Le Fauconnier's article in the catalogue of the second exhibition of the Neue Künstler-Vereinigung München (1910– 1911).[54]

VII.

THEORY

The characteristics of our harmony today make it self-evident that in our own time it is less possible than ever to establish a ready-made theory,* to construct set procedures of pictorial harmonization [*einen konstruierten malerischen Generalbaß*]. Any such attempts would in practice lead to the same result as that achieved by, e.g., the little spoons of Leonardo da Vinci already mentioned. It would, however, be over-

*Such attempts have been made, to which much has been contributed by the parallelism with music, e.g., *Tendances Nouvelles*, no. 35: Henri R o v e l, *Les lois d'harmonie de la peinture et de la musique sont les mêmes* (p. 721).

hasty to maintain that in painting there can never be any hard and fast rules, principles resembling those of harmonization in music—or that such principles would always lead only to academicism. Music too has its own grammar, which, like all living things, changes during great periods, yet has always found successful application as an auxiliary means, as a kind of dictionary.

Our painting today is, however, in a different state: its emancipation from direct dependence upon "nature" is in its very earliest stages. If, up until now, color and form have been used as inner forces, this use has been largely unconscious. The subjugation of composition to geometrical form had been used already in ancient art (e.g., in the art of the Persians). Construction upon a purely spiritual basis, however, is a lengthy process, which begins relatively blindly and at random. Thus it is essential that the painter should develop not only his eyes, but also his soul, so that it too may be capable of weighing colors in the balance, and active not only in receiving external impressions (also, admittedly, sometimes internal ones), but also as a determining force in the creation of works of art.

If, even today, we were to begin to dissolve completely the tie that binds us to nature, to direct our energies toward forcible emancipation and content ourselves exclusively with the combination of pure color and independent form, we would create works having the appearance of geometrical ornament, which would—to put it crudely—be like a tie or a carpet. Beauty of color and form (despite the assertions of pure aesthetes or naturalists, whose principal aim is "beauty") is not a sufficient aim of art. Precisely because of the elementary state of our painting today, we are as yet scarcely able to derive inner experience from composition with wholly emancipated forms and colors. The nervous vibrations will, admittedly, be there (rather as in the case of the applied arts), but they will be largely confined to the area of the nerves, because the vibrations of our spirit, the movement of our soul that they conjure up, are too weak. If, however, we consider that the spiritual revolution has taken on a new, fiery tempo, that even the most "established" basis of man's intellectual life, i.e., positivistic science, is being dragged along with it and stands on the threshold of the dissolution of matter, then we can maintain that only a few "hours" separate us from this pure composition.[55]

Even ornamentation is not, admittedly, an entirely lifeless being. It has its own inner life, which is either no longer comprehensible to us

Kandinsky, *Impression No. 4*

(ancient ornament) or else is only an illogical confusion, a world in which, so to speak, grown men and embryos are treated in the same way and play the same role in society, where dismembered beings are placed side by side with independently living noses and toes and navels. It is like the confusion of a kaleidoscope,* in which material accident rather than the spirit has the upper hand. And yet, despite this incomprehensibility or inability ever to be understood, ornament has an effect upon us, albeit at random.† Internally, Oriental ornament is altogether different from Swedish or Negro or ancient Greek ornament, etc. It is, e.g., not without reason that we generally describe pieces of patterned material as gay or serious, sad, lively, etc.—i.e., employing the same adjectives as are always used by musicians (*allegro, serioso, grave, vivace,* etc.) to determine how a piece is to be performed. It is quite possible that ornamentation originally derived from nature (even modern designers seek their motifs in fields and woods). And yet, even if we were to assume no other source besides external nature, in good ornamentation the forms and colors of nature were treated not in a purely external way, but as symbols, and finally, almost as hieroglyphs. Precisely for this reason, these symbols have gradually become incomprehensible, and we are no longer able to decipher their inner value. For example, a Chinese dragon, which has, even in its ornamental form retained much of its precise physical appearance, has so little effect upon us that we can quite happily tolerate its presence in our dining rooms or bedrooms, and it makes no more impression upon us than a tablecloth embroidered with daisies.

Perhaps at the close of our now-dawning period a new style of ornamentation will arise, but it is hardly likely to consist of geometrical forms. At the juncture we have reached today, any attempt to create such a style of ornamentation by force would be like trying to open a scarcely formed bud into a full-blown flower with one's fingers.

Today we are still firmly bound to the outward appearance of nature and must draw our forms from it.[56] The question is, how are we to do

*This confusion is of course also a precise [form of] life, but belongs to another sphere.

†The world here described is nevertheless one that has its own, wholly individual inner sound, is fundamentally and in principle necessary, and itself presents possibilities.

it?—i.e., how far does our freedom extend to alter these forms, and with which colors should they be connected?

This freedom extends as far as the sensibility of the artist can reach. Seen from this point of view, it can be at once understood just how infinitely important it is to cultivate this sensibility.

A few examples will suffice to answer the second part of this question.

The color red, which, regarded in isolation, is always warm and exciting, will undergo a fundamental change in inner value when no longer isolated or regarded as an abstract sound, but used as an element of another entity when associated with a natural form. This association of red[57] with different natural forms will also produce different internal effects, which will still appear related, owing to the permanent effect of red when regarded in isolation. Let us, for instance, associate red with sky, flower, dress, face, horse, tree. A red sky conjures up associations of sunset, fire, and so forth. It is therefore a "natural" (in this case, solemn or threatening) effect that is thereby produced. Now admittedly, much depends upon how the other objects juxtaposed with the red sky are treated. If they are placed in a causal relationship and combined with colors that are in turn possible for such objects, then the natural aspect of the sky sounds even stronger. If, however, these other objects are far removed from nature, they may thus weaken the "natural" impression of the sky and possibly even eliminate it. Much the same thing occurs when the color red is combined with a face, where red can have the effect of conveying the emotions of the figure portrayed, or can be explained by a special effect of lighting. Such effects could only be annulled by the predominant abstraction of the other parts of the painting.

A red dress, on the other hand, is quite a different case, since a dress can be any color one likes. Under these circumstances, red will perhaps have the best chance of producing its effect as "painterly" necessity, since red can here be treated by itself, without being directly associated with material purposes. The effect produced, however, is reciprocal, since the red of the dress acts upon the figure clothed in this same red, and vice versa. If, for example, the overall tone of the picture is sad, and this tone is particularly concentrated upon the red-clothed figure (by the positioning of the figure within the whole composition and by its own movement, facial features, carriage of the head, color of the face, etc.), then this red of the dress will, as an emotional dissonance, particularly emphasize the sadness of the picture, and especially of the principal figure. Another color that itself produced a sad effect would certainly, by

lessening the dramatic element, weaken the impression produced.* Thus, [we find] once again the principle of contrast. Here, the element of drama arises only because of the inclusion of the color red in the overall sad composition, for red, when completely isolated (i.e., when it is mirrored in the calm surface of the soul) cannot under normal conditions have an effect of sadness.†

The effect produced will be different again if this same red is used for a tree. The basic tone of the red remains the same as in all the previously-mentioned cases. But with it will be associated the spiritual values of autumn (for the word "autumn" is itself a spiritual unity, like every other real or abstract, incorporeal or corporeal concept). The color combines completely with the object to form an isolated element, which creates its effect without the dramatic overtones of the red dress I have just described.

Finally, a red horse is a completely different case. The very sound of the words creates an altogether different atmosphere. The natural impossibility of a red horse necessarily demands a likewise unnatural milieu in which this horse is placed. Otherwise, the overall effect is either that of a curiosity (i.e., a purely superficial and inartistic effect), or else a clumsily conceived fairy tale ‡ (i.e., a well-founded curiosity having an inartistic effect). A normal, naturalistically painted landscape with modeled, anatomically precise figures would produce such a discord when placed together with this horse that no feeling would follow from it, and it would prove impossible to fuse these elements into a single unity. What is to be understood by this "unity," and what it might

*Here, it must once again be expressly emphasized that all such cases, examples, etc., are to be regarded purely in terms of schematic values. All this is conventional, and can be altered by the overall effect of the composition—or just as simply by a single brushstroke. The series of possibilities is infinite.

†It must be continually emphasized that expressions such as "sad," "happy," etc., are extremely clumsy and can only serve as pointers to the delicate, incorporeal vibrations of the spirit.

‡If the fable is not "transposed" in its entirety, then the result resembles the effect produced by cinematographic fairy-tale pictures.

be, is shown by the definition of our modern-day harmony. From which we may conclude that it is possible to split up the entire picture, to indulge in contradictions, to lead [the spectator] through and to build upon any and every sort of external plane, while the inner plane remains the same. The elements of construction of the picture are no longer to be sought in terms of external, but rather of internal necessity.

Also, the spectator in such cases is all too often accustomed to seek a "meaning," i.e., an external connection between the parts of the picture. Once again, this same materialistic period has, in life in general and therefore also in art, produced the kind of a spectator who is unable simply to relate to the picture (especially true of "connoisseurs"), and who looks for everything possible in the painting (imitation of nature, nature seen through the temperament of the artist—and therefore temperament itself, the direct conjuring-up of mood, *"peinture,"* anatomy, perspective, external mood, etc., etc.); what he does not attempt is to experience for himself the inner life of the picture, to let the picture affect him directly. Dazzled by external devices, his spiritual eye is unable to seek out what it is that lives by these means. If we carry on an interesting conversation with someone, we attempt to penetrate the depths of his soul; we seek an inner form, his thoughts and feelings. We do not worry about the fact that he employs words, which consist of letters, which are in turn nothing more than purposeful sounds,[58] which require for their formation the drawing of breath into the lungs (anatomical aspect), and which, through the expulsion of air from the lungs, special positioning of tongue, lips, etc., cause vibrations of the air (physical aspect), which, moreover, impinge upon our consciousness through the intermediary of the eardrum (psychological aspect), producing a nervous reaction (physiological aspect), etc., *ad infinitum.* We know that all these factors are merely incidental to our conversation, purely contingent, but must be utilized as momentarily necessary external means, and that the essential aspect of the conversation is the communication of ideas and feelings. It is in this way that one should approach a work of art, experiencing the direct, abstract effect. Then, with time will develop the possibility of speaking through purely artistic means, and it will become no longer necessary to borrow the forms for this inner speech from the external world, forms that today provide us with the opportunity, by the use of color and form, to increase or diminish their inner significance. Juxtaposition of opposites (such as the

Kandinsky, *Improvisation No. 18*

red dress in the sad composition) can produce an effect of unlimited power, but must still remain upon one and the same moral plane.

Even if such a plane is readily accessible, however, the problem of color in our example is not altogether solved. "Unnatural" objects and their appropriate colors can easily assume literary overtones, whereby the composition takes on the effect of a fairy-tale. The spectator readily accepts this atmosphere because it is like a fairy-tale; in it he (1) looks for the story, and (2) remains unaffected or little affected by the pure impression of color. In any case, the direct, pure, inner effect of color is now no longer possible, since the external aspect easily outweighs the internal. And man is generally not willing to plumb the depths, but prefers to remain on the surface, because this demands less effort. There is, admittedly, "nothing more profound than superficiality," but this depth is like that of a bog. On the other hand, is there any form of art more readily assimilated than the "plastic"? And yet, as soon as the spectator believes himself to be in fairyland, he is at once immune to strong spiritual vibrations. Thus, the purpose of the work of art is nullified. For this reason, a form must be found that first excludes the fairy-tale effect,* and secondly, in no way inhibits the pure effect of color. For this purpose neither form, movement, color, nor the objects borrowed from nature (real or unreal) must produce any external or externally associated narrative effect. And the less externally motivated, e.g., movement is, the purer, deeper, more inner its effect.

<p style="text-align:center">* *
*</p>

A very simple movement, whose purpose is unknown, produces of its own accord a significant, mysterious, and solemn effect. This, provided that one is unaware of the external, practical purpose of the movement. Then it has the effect of a pure sound. A simple, concerted action (e.g., preparing to lift a heavy weight) produces, if its purpose is unknown, an effect so significant, so mysterious and dramatic and striking, that one involuntarily stops still as if in the presence of a vision, of life upon

*This battle against the atmosphere of fairyland resembles the battle against nature. How easily, how often contrary to the will of the artist composing with color, does nature intrude into the work of its own accord. It is easier to depict nature than to fight against it!

another plane—until all of a sudden the magic vanishes, the practical explanation comes like a bolt from the blue, and the mysterious procedure and the reasons behind it are laid bare. In this simple movement, which to all external appearances is unmotivated, lies an immeasurable wealth of possibilities. Such occurrences come to pass particularly easily if one is given to wandering about plunged in abstract thoughts. Such thoughts drag one away from one's everyday, practical, purposeful actions. In this way, the observation of such simple movements becomes possible outside the sphere of practical experience. As soon as one reminds oneself, however, that nothing inexplicable is allowed to happen on our streets, then in the same instant one's interest in the movement ceases. The practical sense behind the movement extinguishes its abstract sense.[59] It is upon this principle that the "new ballet"—which is the only way of exploiting the w h o l e significance, the entire inner meaning of movement in t i m e a n d s p a c e—should be and will be built. The origin of dance is apparently of a purely sexual nature. Even today we can still see this original element revealed in folk dance. The necessity, which is later in origin, of employing dance as part of divine service (as a means of inspiration), remains, so to speak, upon the level of the applied use of movement. Gradually, over the centuries, these two practical applications assumed artistic overtones, culminating in the language of movement that is ballet. This language today is understood only by a few, and still loses in clarity. What is more, it is far too naive for the era to come: it has served only as the expression of material feelings (love, fear, etc.), and must be replaced by another capable of bringing forth subtler spiritual vibrations. For this reason, the reformers of ballet have in our own times turned their eyes toward forms from the past, whence they seek help even today. Thus originated the link forged by Isadora Duncan between Greek dance and the dance of the future. This happened for exactly the same reasons as those which prompted the painters' search for help among the primitives. Of course, in the case of dance (as in the case of painting), this is only a transitional stage. We are faced with the necessity of creating a new dance form, the dance of the future. The same law of exploiting uncompromisingly the i n n e r sense of movement as the principal element of dance will produce its effect here, too, and lead us toward our goal. Here, too, conventional "beauty" of movement must be thrown overboard, and the "natural" progress of the action (narrative = the literary element) explained as unnecessary and ultimately distracting. Just as in music and

in painting, there exist no "ugly sounds" and no external "dissonance"; i.e., just as in both these arts every sound or concordance of sounds is beautiful (= purposeful), provided that it arises from internal necessity, so too in ballet we will soon be able to sense the inner value of every movement, and inner beauty will replace outer beauty. From these "unbeautiful" movements that now suddenly become beautiful streams forth at once an undreamed-of power and living strength. From this moment begins the dance of the future.

<center>* *</center>
<center>*</center>

This dance of the future, which is thus raised to the level of the music and painting of today, will in the same instant become capable of contributing as a third element to the creation of a form of stage composition that will constitute the first work of Monumental Art.

Stage composition will consist initially of these three elements:

1. musical movement,
2. pictorial movement,
3. dance movement.

Everyone will understand from what has been said above on the subject of pure pictorial composition what I mean by the threefold effect of internal movement (= stage composition).

Just as each of the two principal elements of painting (linear and painterly form) leads an independent existence, each speaking through its own medium, through means peculiar to itself—just as composition in painting arises out of the combination of these elements and their collective characteristics and possibilities—so in the same way composition on the stage will become possible by means of the juxtaposition (= opposition) of the three already mentioned types of movement.

Skriabin's experiment referred to above (the attempt to heighten the effects of musical tones through the effects produced by the corresponding color-tones) is of course a very elementary one and represents only one possibility. Apart from the concordance of two, or eventually all three, elements of stage composition, the following can also be utilized: discordance, the alternation of the effects of individual elements, the exploitation of the complete (and of course, external) independence of each of the separate elements, etc. Arnold Schoenberg has already utilized precisely this last method in his quartets. Here, one can see just

to what extent the i n n e r harmony gains in strength and significance if the e x t e r n a l harmony is used in this way. Now one can imagine the brave new world of the three mighty elements in the service of one single creative aim. I am here compelled to renounce further development of this important topic. The reader should merely apply the corresponding principles laid down for painting, and of its own accord the happy dream of the theater of the future will rise up before his spiritual eyes. Upon the tortuous paths of this new kingdom—which lie through dark jungles and over immeasureable chasms, to icy heights and to the edge of the heady abyss, like an endless maze stretching out in front of the explorer—the same guide will lead him with unfailing hand: the principle of internal necessity.

<div align="center">* *

*</div>

From the previously examined examples of the use of color, from the necessity and significance of the use of "natural" forms in combination with color (on account of their sound), can be deduced (1) w h e r e the path that leads to painting lies, and (2) h o w as a g e n e r a l principle this path is to be followed. This path lies between two realms (which today constitute two dangers): on the right lies the completely abstract, wholly emancipated use of color in "geometrical" form (ornament); on the left, the more realistic use of color in "corporeal" form (fantasy)[60] — but which is excessively impeded by external forms. And (possibly only today) we are faced with the possibility of veering too much to the right and . . . overstepping the limits, or likewise, of tending too much to the left, and experiencing the same result. Beyond these limits (here I abandon my schematic path) lie, on the right, p u r e a b s t r a c t i o n (i.e., greater abstraction than that of geometrical form) and, on the left, p u r e r e a l i s m (i.e., a higher form of fantasy—fantasy in hardest material). And between the two—unlimited freedom, depth, breadth, a wealth of possibilities, and beyond them the realms of pure abstraction and realism—e v e r y t h i n g today is, thanks to the moment at which we find ourselves, placed at the service of the artist. Today is a day of freedom only conceivable when a great epoch is in the making.* And, at the same

*On this question, see my article "Über die Formfrage" in the *Blaue Reiter* [*Almanac*] (R. Piper & Co., 1912). Here I take as my starting point the work of Henri Rousseau, in order to prove that the coming realism of our period is not only the equivalent of abstraction, but identical to it.[61]

time, this freedom constitutes one of the greatest limitations, since all these possibilities between, within, and beyond these limits stem from one and the same root: from the categorical demands of Internal Necessity.

That art is above nature is by no means a new discovery.* New principles do not, moreover, come down from heaven, but rather stand in a causal relationship to the past and the future. All we need to consider is where this principle lies today and what point we may be able to reach with its help tomorrow. Moreover, this principle, as must be emphasized again and again, must never be applied by force. If the artist, taking this for his tuning fork, attunes his soul to it, then his works will of their own accord be cast in the same key.[63] Most important of all, the advancing "emancipation" of today rises from the foundations of inner necessity, which, as has already been described, is the spiritual force behind the objective in art. The objective [element] in art seeks today to reveal itself with particular intensity. Temporal forms are therefore loosened so that the objective may be more clearly expressed. Natural forms impose limitations that in many cases hinder this expression. They are therefore pushed aside to make room for the "objective [element of] form"—construction as the aim of composition. Thus can be explained the pressure already evident today to uncover the constructive forms of our age. Cubism, for example, as a transitional form reveals how often natural forms must be forcibly subordinated to constructive ends, and the unnecessary hindrances these forms constitute in such cases.

At all events, a clearly visible kind of construction is in general used today, which appears to be the only possible way of giving expression to the objective element of form. But if we think of the definition of

*Literature in particular has long since expressed this principle. E.g., Goethe says: "The artist with his free spirit takes precedence over nature, and can adapt her according to his higher aims. . . . He is at once her master and her slave. He is her slave inasmuch as he must work with earthly means in order to be understood (NB!), and yet her master inasmuch as he submits these earthly means to his higher intentions, the former in the service of the latter. The artist desires to speak to the world by means of a whole; this whole is not, however, to be found in nature, but it is rather the fruit of his own spirit or, if you prefer, a breath of fruitful divinity." (Karl Heinemann, Goethe, 1899, p. 684.) In our own time, O. Wilde: "Art only begins where imitation ends" (De Profundis).[62] In painting, too, we often find similar ideas. Delacroix, e.g., said that for artists, nature was no more than a dictionary. And elsewhere: "One should define realism as the antithesis of art" (Mein Tagebuch, p. 246, published by Bruno Cassirer, Berlin 1903).

208

modern day harmony given in this book, then even in the realm of construction we are able to recognize the spirit of the times. Not the immediately obvious, eye-catching type of ("geometrical") construction, not the richest in possibilities, nor the most expressive, but rather the hidden type that emerges unnoticed from the picture and thus is less suited to the eye than to the soul.

This hidden construction can consist of forms apparently scattered at random upon the canvas, which—again, apparently—have no relationship one to another: the external absence of any such relationship here constitutes its internal presence. What externally has been loosened has internally been fused into a single unity. And this remains for both elements—i.e., for both linear and painterly form.

Precisely here lies the future theory of harmony for painting [*Harmonielehre der Malerei*].[64] These "somehow" related forms have a fundamental and precise relationship to one another. Ultimately, this relationship may be expressed in mathematical form, except that here one will perhaps operate more with irregular than with regular numbers.

In every art, number remains the ultimate form of abstract expression.

It goes without saying that this objective element must, on the other hand, require the use of reason, the conscious, as a collaborating force (objective knowledge—the thorough-bass of painting). And this objective element will enable the works of today to say, even in the future, not "I was," but "I am."

VIII.

ART AND ARTIST

In a mysterious, puzzling, and mystical way, the true work of art arises "from out of the artist." Once released from him, it assumes its own independent life, takes on a personality, and becomes a self-sufficient, spiritually breathing subject that also leads a real material life: it is a being. It is not, therefore, an indifferent phenomenon arising from chance, living out an indifferent spiritual life, but rather possesses—like every living being—further creative, active forces. It lives and acts and plays a part in the creation of the spiritual atmosphere that we have discussed. It is also exclusively from this inner standpoint that one must answer the question whether the work is good or bad. If it is "bad" formally, or too weak, then this form is unsuitable or too weak to

produce any kind of pure, spiritual vibration within the soul.* Thus, a "well-painted" picture is in reality not one that is correct in values (the inevitable *valeurs* of the French) or divided up almost scientifically into cold and warm, but rather one that leads a full inner life. Likewise, "good draftsmanship" is where nothing can be altered without destroying this inner life, regardless of whether this draftsmanship contradicts anatomy or botany or any other science. It is not here a question of whether an external (hence always merely incidental) form has been distorted, but simply of whether the artist needs to use this form as it is in its externals. Colors, too, must be used in the same way, not dependent upon the existence of this particular sound [Klang] in nature, but upon the necessity of this particular sound within the picture. In short, the artist is not only entitled, but obliged to treat his forms in whatever way is **necessary** for **his** purpose. There is no necessity for anatomy and so forth on the one hand, nor, on the other, for overthrowing these sciences as a matter of principle, but what is necessary is the complete, unlimited freedom of the artist in his choice of means.† This necessity is the right to unlimited freedom, which becomes an abuse as soon as it ceases to rest upon that same necessity. Artistically speaking, this right constitutes the moral plane already discussed. In one's entire life (hence in art too) one's aims must be pure.

In particular: purposeless adherence to scientific facts is never so harmful as their purposeless rejection. In the former case, a (material) imitation of nature results, which may well be employed for various

*Those works that are called, e.g., "immoral" are either altogether incapable of producing a vibration of the soul (in which case they are, according to our definition, inartistic), or else they produce a different vibration of the soul, inasmuch as they possess a form that is correct in some respect. Then they are "good." If, however, apart from this spiritual vibration, they also produce purely carnal vibrations of a lower order (as they are called today), then one should not conclude that it is the work that is to be despised, rather than the person reacting to it by baser vibrations.

†This unlimited freedom must be founded upon the basis of internal necessity (which one calls probity). And this principle is one that belongs not only to art, but also to life. This principle is the mightiest sword of the true superman against philistinism.

special purposes.* In the latter, artistic deceit, a sin that gives rise to a long chain of evil consequences. In the first instance, the moral atmosphere is left empty, petrified. In the second, it becomes poisoned and plague-ridden.

Painting is an art, and art in general is not a mere purposeless creating of things that dissipate themselves in a void, but a power that has a purpose and must serve the development and refinement of the human soul—the movement of the triangle. It is a language that speaks in its own unique way to the soul about things that are for the soul its daily bread, which it can only obtain in this form.

If art renounces this task, then this gap must remain unfilled, for there is no other power that can replace art.† Always at those times when the human soul leads a stronger life, art too becomes more alive, for soul and art complement and interact upon each other. While in those periods in which the soul is neglected and deadened by materialistic views, by disbelief, and their resultant, purely practical strivings, the opinion arises that "pure" art is not given to man for a special reason, but is purposeless; that art exists only for art's sake (*l'art pour l'art*).‡ Here, the bond between art and soul becomes half anaesthetized. The reckoning, however, soon follows; since the artist and the spectator (who communicate by means of this language of the soul) can no longer understand each other, the latter turns his back on the former, or gapes at him as he would at a conjuror, whose outward skill and powers of invention command one's admiration.

*It is clear that this imitation of nature, if it derives from the hand of an artist who is spiritually alive, never remains merely a lifeless repetition of nature. In this form, too, the soul may speak and be heard. Take as an example the landscapes of Canaletto, as opposed to, e.g., the alas all-too-famous heads by Denner (Alte Pinakothek, Munich).

†This gap can also be easily filled by poison and pestilence.

‡This view is one of the few expressions of idealism to be found at such times. It is an unconscious protest against materialism, which would have everything practical and purposeful. It is further proof of how strong and inviolable art is, and of the power of the human soul, which is living and eternal, which can be numbed, but never killed.

First of all, then, the artist must seek to alter this state of affairs by recognizing his duty t o w a r d a r t and t o w a r d h i m s e l f, regarding himself not as master of the situation, but as the servant of higher ends, whose duty is precise and great and holy. He must e d u c a t e himself, immerse himself in his own soul, and above all, cultivate and develop this soul of his so that his external talents have something they can clothe, not like a lost glove from an unknown hand, which is an empty, purposeless semblance of a hand.

The artist must have something to say, for his task is not the mastery of form, but the suitability of that form to its content.*

The artist is no Sunday's Child of life: he has no right to a life without responsibility. He has a difficult task to fulfill, which often becomes a cross to bear. He must know that every one of his actions and thoughts and feelings constitutes the subtle, intangible, and yet firm material out of which his works are created, and that hence he cannot be free in life—only in art.

From which it is self-evident that the artist, as opposed to the nonartist, has a threefold responsibility: (1) he must render up again that talent which has been bestowed upon him; (2) his actions and thoughts and feelings, like those of every human being, constitute the spiritual atmosphere, in such a way that they purify or infect the spiritual air; and (3) these actions and thoughts and feelings are the material for his creations, which likewise play a part in constituting the spiritual atmo-

*It is, of course, clear that we are here talking about the education of the soul, not about the necessity of forcibly injecting into every work some specific content, or forcibly clothing in artistic guise this content one has thought up! In such cases, the end result would only be lifeless cerebration. As I have already stated: The true work of art comes about in a mysterious way. No, if the soul of the artist is alive, then there is no need to bolster it with cerebration and theories. It will find something to say of its own accord, something that may, at that moment, remain unclear even to the artist himself. The i n n e r v o i c e o f h i s s o u l will also tell him which form to use, and where to find it (external or internal "nature"). Every artist who works according to so-called feeling knows just how suddenly and unexpectedly a form that he himself has conceived can appear distasteful, and how another, correct form substitutes itself "as if on its own initiative" for what has been discarded. Boecklin used to say that the true work of art must be like a great improvisation, i.e., reflection, construction, previous working out of the composition should be no more than preliminary steps in the direction of that goal, which may appear unexpected even to the artist himself. It is thus the application of our future counterpoint is to be understood.

sphere. He is a "king," as Sar Peladan calls him, not only in the sense that he has great power, but also in that he has great responsibilities.

If the artist is priest of the "beautiful," then this beauty is also to be found by means of this same principle of inner value, which we have found in every case to be present. This "beauty" can only be measured with the yardstick of inner greatness and necessity, which until now has throughout and in every case afforded us faithful service.

Whatever arises from internal, spiritual necessity is beautiful. The beautiful is that which is inwardly beautiful.*

Maeterlinck, one of the original pioneers, one of the first spiritual composers of the art of today, out of which the art of tomorrow will be born, has said:

"There is nothing on earth more desirous of beauty, and which is more easily beautified, than the soul. . . . Thus there are very few souls on earth who will resist the domination of a soul that is devoted to beauty."†

And this quality of the soul is that fluid which makes possible the slow, barely visible, at times outwardly stilled, and yet continuous and inexorable, progress of the spiritual triangle onward and upward.[65]

*By this beauty we are, of course, to understand not external, nor even internal morality (such as is generally accepted), but everything that, even in a wholly intangible form, refines and enriches the soul. Thus, e.g., in painting, every color is inwardly beautiful, since every color causes a vibration of the soul and every vibration enriches the soul. Hence everything can, in the end, be inwardly beautiful, even if it is outwardly "ugly." As it is in art, so it is in life. And thus there is nothing that is "ugly" in its inner result, i.e., its effect upon the souls of others.

†Von der inneren Schönheit (K. Robert Langewiesche Verlag, Düsseldorf and Leipzig, p. 187).

CONCLUSION

The accompanying six reproductions[66] are examples of tendencies towards construction in painting.

The forms that these attempts take may be divided into two main groups:

1. Simple composition, which is subordinated to a clearly apparent, simple form. I call this type of composition m e l o d i c.
2. Complex composition, consisting of several forms, again subordinated to an obvious or concealed principal form. This principal form may externally be very hard to find, whereby the inner basis assumes a particularly powerful tone. This complex type of composition I call s y m p h o n i c.

Between these two main groups there lie various transitional forms, in which the melodic principle is always necessarily present.

The whole process of development is strikingly similar to that in music. Deviations in both these processes result when some other law comes into play that has until now always been ultimately subordinated to the primary law of development. Thus, these deviations are not significant here.

If one removes the objective element from a m e l o d i c composition, thus revealing the basic pictorial form, then one finds primitive geometrical forms or a structure of simple lines serving the general movement. This general movement is repeated in the individual parts

215

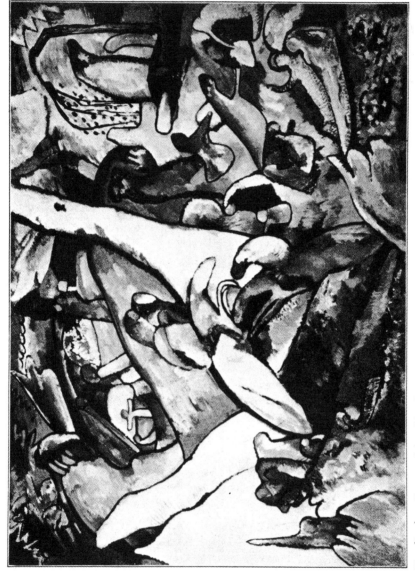

Kandinsky, Composition No. 2

[of the picture], and sometimes varied by means of individual lines or forms. These individual lines or forms can in this latter case serve various purposes. They can, e.g., create a kind of closing to which I give the musical name *fermata*.* All these constructional forms have a simple inner sound, as all melodies do. It is for this reason that I call them melodic. Revitalized by Cézanne and later by Hodler, these melodic compositions acquired in our own time the description rhythmic. These were the seeds of the rebirth of compositional aims. It is, however, obvious at first sight that the exclusive limitation of the concept rhythmic to these particular instances is too narrow. Just as in music, every structure possesses its own rhythm, just as in the completely "random" distribution of objects in nature, a rhythm is always present, so too in painting. It is merely that in nature, this rhythm is sometimes not apparent to us because its purposes (in many of the most important instances) are not clear. This unclear juxtaposition is thus called arhythmic. This distinction between rhythmic and arhythmic is, therefore, wholly relative and conventional (like the distinction between consonance and dissonance, which at bottom does not exist).†

Many pictures, woodcuts, miniatures, etc., from earlier periods of art are examples of complex, 'rhythmic' composition with a strong intimation of the symphonic principle. One need only think of the old German masters, of the Persians, the Japanese, of Russian icons and especially folk prints, etc., etc.‡

In nearly all these works, symphonic composition is still bound very closely to the melodic. That is to say, if one takes away the objective element so as to reveal the compositional, a composition comes to light that is built out of feelings of repose, of tranquil repetition, of a fairly

*See, e.g., the Ravenna mosaic, where the principal group is in the form of a triangle, toward which the other figures are ever more imperceptibly oriented. The outstretched arm and the curtain in front of the door create the fermata.

†Cézanne's *Bathers* is reproduced in this book as an example of this clearly laid out, melodic composition with open rhythms.

‡Many of Hodler's pictures are melodic compositions with symphonic undertones.

balanced division of parts.* Early choral music, Mozart, and finally, Beethoven spring involuntarily to mind. These are all works having more or less of a kinship with the elevated, tranquil, and dignified style of architecture of a Gothic cathedral: balance and the equal distribution of individual parts are the keynote and spiritual basis of this type of construction. Such works belong to transitional form.

I have included reproductions of three of my own paintings as examples of the new symphonic type of construction, in which the melodic element is used only occasionally, as one of the subordinate parts—thus taking on a new form.

These reproductions are examples of three different sources:

1. The direct impression of "external nature," expressed in linear-painterly form. I call these pictures "Impressions."
2. Chiefly unconscious, for the most part suddenly arising expressions of events of an inner character, hence impressions of "internal nature." I call this type "Improvisations."
3. The expressions of feelings that have been forming within me in a similar way (but over a very long period of time), which, after the first preliminary sketches, I have slowly and almost pedantically examined and worked out. This kind of picture I call a "Composition." Here, reason, the conscious, the deliberate, and the purposeful play a preponderant role. Except that I always decide in favor of feeling rather than calculation.

It will, presumably, be clear to the long-suffering reader of this book what conscious or unconscious [principle of] construction lies at the root of all three categories of my painting.

In conclusion, I would remark that in my opinion we are approaching the time when a conscious, reasoned system of composition will be

*Here, tradition plays a great part, particularly in art that has become part of popular lore. Such works occur mainly during the flowering of a particular period of artistic culture (or else encroach upon the period following). The fully formed, open flower spreads an atmosphere of inner peace. During periods of gestation, too many warring, conflicting, obstructing elements exist for this peace to achieve obvious prominence. In the last analysis, of course, every serious work of art is peaceful. This ultimate peace (exaltation), however, is not easy for contemporary man to find. Every serious work of art has an inner sound like the peaceful and exalted words "I am here." Love or hatred of the work of art are dissolved and dissipated. The sound of these words is eternal.

possible, when the painter will be proud to be able to explain his works in constructional terms (as opposed to the Impressionists, who were proud of the fact that they were unable to explain anything). We see already before us an age of purposeful creation, and this spirit in painting stands in a direct, organic relationship to the creation of a new spiritual realm that is already beginning, for this spirit is the soul of the epoch of the great spiritual.

———————

Schoenberg's Pictures

["Die Bilder,"] *Arnold Schönberg.*
Mit Beiträgen von Alban Berg . . .
(Munich), 1912

During the years prior to the First World War, Schoenberg painted continually. In a radio interview given many years later, he maintained that had he devoted himself to painting rather than music, he might have become just as significant a figure in the development of modern art as he in fact became in his own chosen field of composition.[1] In Vienna he had become acquainted with the young Austrian painter Richard Gerstl, whose suicide in 1908 robbed modern European painting of a precocious talent. Throughout his tragically short life, Gerstl preferred to associate with musicians rather than painters, and for a period lodged with Schoenberg and his family. His art exerted a decisive influence on Schoenberg's development as a painter.[2]

Kandinsky, as already noted, interested himself first of all in Schoenberg's theories of composition; but he soon became equally intrigued by the composer's paintings, of which Schoenberg sent him snapshots. Three pictures by Schoenberg were shown in the first Blaue Reiter exhibition in Munich at the end of 1911, and two of the same paintings were reproduced in the *Blaue Reiter Almanac,* in addition to the composer's essay "Das Verhältnis zum Text" [The Relationship to the Text] and his setting of Maeterlinck's poem "Feuillages du Coeur." Kandinsky esteemed Schoenberg's paintings for much the same reasons as those for which he valued the work of Henri Rousseau: he saw in them a direct-

ness of expression and a disdain for academic precepts that, he thought, constituted a link between the best of modern painting and the art of the primitives.

While the *Blaue Reiter Almanac* was in the press Schoenberg's friend and pupil Anton von Webern wrote to Kandinsky with a request.[3] Schoenberg was to conduct a concert of his own music, including his symphonic poem *Pelléas and Mélisande*, in Prague on 29 February 1912. (Schoenberg, whose music usually met hostile reception from critics and public, later remarked with some irony that, since it was a leap year and the concert promoter had an extra day he did not know what to do with, it had been decided, for once, to let him loose on the rostrum.)[4] His pupils, among them Alban Berg, Anton von Webern, and Heinrich Jalowetz, wished to mark the occasion by publishing a volume of essays in honor of their master. Webern informed Kandinsky of their plans, swore him to secrecy, and invited him to contribute a short essay on Schoenberg as a painter. Kandinsky, always punctilious in matters of friendship, agreed readily, and delivered the following text; his observations on the subject of naive art in general are no less interesting than his appreciation of Schoenberg's works.

Schoenberg, as is clear from his correspondence, was deeply touched, both by the volume as a whole and by Kandinsky's contribution. His friendship with the Russian artist survived the war years; the famous misunderstanding on the subject of anti-Semitism at the Bauhaus, which temporarily soured their relationship in the early 1920s, seems to have resulted from malicious meddling by Alma Mahler.[5] That their friendship and mutual esteem survived these ups and downs is attested by a later photograph showing the Kandinskys and the Schoenbergs in swimsuits on the shore of the Wörthersee in 1927,[6] and a letter to Schoenberg of July 1936

in which Kandinsky recalls their first meeting, on the Starn-
bergersee in the summer of 1911, and the triumphs of the
spirit for which both artists then so devoutly wished.[7]

Schoenberg's pictures fall into two groups: those painted directly from
nature (people, landscapes); and those intuitively felt heads that he calls
"visions."

Schoenberg himself describes the former as five-finger exercises,
which he finds necessary, but to which he attaches no special impor-
tance, exhibiting them only unwillingly.

The latter he paints (just as rarely as the former) in order to give
expression to those motions of his spirit that are not couched in musical
form.

These two groups are outwardly different. Inwardly, they have their
origin in one and the same soul, which is made to vibrate sometimes by
external nature, sometimes—by internal.

This dichotomy is, of course, only of very general significance, having
a pronouncedly schematic character.

But in reality, internal and external experiences cannot be so brus-
quely separated. Both kinds of experience have, so to speak, many long
roots, fibers, branches that permeate one another, become intertwined,
and as a final result, constitute a complex of enduring significance for
the soul of the artist.

This complex is, as it were, the soul's digestive system, its transform-
ing, creative power. This complex is the prime mover in that inner
process of transformation which expresses itself outwardly in altered
form. It is due to the characteristics of this same complex, unique every
time, that the creative system of the individual artist produces works
that, as one says, bear his "stamp," enable one to recognize the artist's
"handwriting." Of course, these popular descriptions are entirely sup-
erficial, because they emphasize only the external, formal aspect and
leave the internal almost completely out of the picture. That is, in this
case—as so often—too much reverence is accorded to the external in
general.

For the artist, the external is not merely determined, but indeed
created by the internal, as is the case in every form of creation, including

the cosmic.

Regarded from this point of view, Schoenberg's pictorial works enable us to recognize, beneath the stamp of his own form, his spiritual complex.

For one thing, we see at once that Schoenberg paints, not in order to produce "beautiful," "nice," etc., pictures; rather, while painting he does not even think about the picture itself. Ignoring the objective result, he seeks only to pin down his subjective "sensation," and in doing so, employs only those resources that appear to him at that moment indispensable. Not even all professional painters can boast of this manner of painting! Or, in other words, there are very few professional painters who possess this fortunate ability, at times heroism, this capacity for rejection, which enables them to ignore (or even reject) all kinds of pictorial pearls and diamonds thrust upon them. Schoenberg proceeds in a straight line, directly toward his goal or, guided by his goal, directly toward the result that is here necessary.

* *

*

The purpose of a picture is to give in pictorial form outward expression to an inner impression. This may sound like a well-known definition! But if we draw from this the logical conclusion, namely, that a picture has no other purpose, then I would like to ask: How many pictures can be described as lucid, unclouded by anything superfluous? Or: How many pictures are entitled to the name after being subjected to this strict, undeviating test? And not *"objets d'art,"* which willfully deceive us as to the necessity of their existence.

* *

*

A picture is the external expression of an internal impression in pictorial form.

He who, after carefully examining this definition of a picture, accepts it, has accepted therein a correct and, it should be emphasized, unalterable criterion that may be applied to every picture, regardless of whether it was painted today, stands still wet upon the easel, or has come to light as a fresco in the course of excavating a city long buried in the earth.

Accepting this definition involves altering many "opinions" regard-

ing questions of art. In passing, I would like to rescue one such opinion from the darkness of accepted prejudice, in the light of the above definition. Not only art critics and public, but also as a rule artists themselves perceive in an artist's "development" the search for that artist's own corresponding form.

From this opinion often derive quite different, fatal consequences.

The artist himself maintains that, having "at last found his own form," he can now continue calmly to create further works of art. Unfortunately, he himself usually fails to notice that from this very moment (from the "calmly") on, he rapidly begins to lose this form he has at last discovered.

The public (in part led by the critics) is not so quick to observe this lapse, and feeds on these products of a dying form. On the other hand, convinced of the possibility of an artist's "finally attaining the appropriate form," it sternly condemns those artists who have remained without such a form, who reject one form after another in their search for the "right" one. The works of such artists are deprived of the respect they deserve, nor does the public attempt to draw from these works their necessary content.

Thus, there arises an entirely wrong attitude to art, whereby the dead passes for the living, and vice versa.

In reality, the artist's progress consists not of external development (the search for a form that corresponds to the unchanging condition of the soul), but of internal development (reflection of spiritual desires attained in pictorial form).

It is the content of the artist's soul that develops, becomes more precise, assuming ever greater internal dimensions: upward, downward, in all directions. In that moment at which a certain inner level is attained, one will find at one's disposal an outward form corresponding to this inner value.

Moreover, in the moment at which this inner development is halted and falls victim to the decrease of this inner dimension, then too that form which the artist has "already attained" escapes from his grasp. Thus, we see often this etiolation of form that corresponds to the etiolation of inner desire. Thus, the artist frequently loses control over his own form, which becomes dull, weak, bad. Thus is to be explained the phenomenon of the artist suddenly, e.g., no longer able to draw, or whose color, previously alive, now lies upon the canvas as a mere lifeless semblance, like a pictorial carcass.

The decline of form is the decline of the soul, i.e., of content. And the growth of form is the growth of content, i.e., of the soul.

*　　　*

*

If we apply the criterion I have described to Schoenberg's pictorial works, we see at once that we are here confronted with painting, whether this painting stands "outside" the mainstream "present-day movement" or not.

We observe that in every one of Schoenberg's pictures, the inner desire of the artist speaks forth in a form appropriate to it. Just as in his music (insofar as I, being a layman, may venture an opinion), in his paintings Schoenberg renounces the superfluous (i.e., the harmful) and pursues a direct path toward the essential (i.e., the necessary). All prettification, all refinements of *peinture* are ignored.

His *Self Portrait* is painted with the so-called "scrapings of the palette." And yet, what other colors could he choose to achieve this powerful, sober, precise, concise effect?

A portrait of a lady reveals, more or less pronouncedly, only the sickly pink color of the dress—no other "colors."

One landscape is gray-green—only gray-green. The drawing is simple and quite "unskilled."

One of the *Visions*, painted on a tiny canvas (or else on a piece of cardboard) consists only of a head. Highly expressive are only the eyes ringed with red.[8]

I would prefer to describe Schoenberg's painting as *Nurmalerei* [only painting].

Schoenberg personally reproaches himself for his "deficient technique."

I would like to amend this reproach in accordance with the above-defined criterion: Schoenberg is mistaken—it is not his technique that fails to satisfy him, but his inner desires, his soul, of which he demands more than it is today able to give.

I would wish that all painters should suffer the same dissatisfaction—for all time.

It is not difficult to make outward progress. It is not easy to progress inwardly.

May "fate" grant that we should not avert our inner ear from the voice of the soul.

Second Exhibition of the Editors of the *Blaue Reiter*
[*Die Zweite Ausstellung der Redaktion Der Blaue Reiter*]
(Munich), 1912

The following untitled statement is taken from the catalogue of the second Blaue Reiter exhibition, which opened in the Munich gallery Neue Kunst, owned by Hans Goltz in the Briennerstrasse, in February 1912. Although restricted to graphic work, this second exhibition was, like the first, intended to demonstrate the variety, rather than the uniformity, of contemporary artistic strivings. Here, however, the organizers cast their net far more widely than in the case of the previous show; this second exhibition, subtitled *"schwarz-weiss"* [black and white], included works by artists as diverse as Picasso and Braque, Delaunay and de la Fresnaye, Larionov and Goncharova, Malevich and Wilhelm Morgner, as well as the painters of the Brücke: Otto Müller, Max Pechstein, and Ernst Ludwig Kirchner. Also exhibited were eight Russian folk prints, or *lubki,* a genre of which Kandinsky was particularly fond. A brief note, presumably by Kandinsky himself, explaining the significance of the *lubok* appears on page 15 of the catalogue:

> Original sheets of this kind were made mainly in Moscow from the beginning up until the middle of the nineteenth century. They were taken for sale by traveling book merchants even to the most remote villages. One still encounters them today in farmhouses, even though crowded out by lithographs and oleographs, etc.

One can explain it in terms of divine providence or of Darwinian theory. It is not that which is important here, but rather the evident operation of law.

Nature—that is to say, the world from a worm's eye view—or the siderial world, charms us by two aspects.

One of these is known to every man: the "infinite" variety, the "unlimited" richness of natural forms: elephant, ant, fir, rose, mountain, pebble.

The other aspect is known to the educated man: the suitability of form to necessity (the elephant's trunk, the ant's bite).

Men immerse themselves in the way necessity is reflected in natural forms. They lay out zoological gardens so they can see this wealth. They undertake journeys as far as possible—to India, Australia, to the North Pole—to feast their eyes upon this variety and penetrate over and over again the reflection of necessity.

Art here resembles nature: the wealth of its forms is unlimited; the variety of its forms, infinite; necessity creates these forms.

Why do many people become annoyed when they see this natural aspect of art, instead of rejoicing?

Nature creates form for its purpose.

Art creates form for its purpose.

One should not become annoyed at the elephant's trunk, and likewise one should not become annoyed at a form that the artist employs.

It is our warm desire to arouse joy by showing examples of the inexhaustible wealth of forms that, unceasingly, the world of art creates by the operation of law.

1911–1912

The Blaue Reiter Almanac
[Der Blaue Reiter]
(Munich), 1912

The genesis of the *Blaue Reiter Almanac* has been frequently described.[1] Kandinsky himself gave perhaps the clearest account of his aims and intentions, and explained the origin of the title, in his later essay "The Blaue Reiter (Recollection)" (see pp. 744–748); the name "The Blue Rider" has also been linked with Kandinsky's eponymous painting of 1903.[2] As already discussed, plans for the publication of an "almanac or yearbook" go back to the summer of 1911. Originally conceived by Kandinsky, the idea was taken up enthusiastically by Franz Marc; later, Marc's friend August Macke also assisted in preparing the volume for publication,[3] especially by editing the considerable amount of ethnographic material; he also wrote the essay "Masks."[4] The success of the venture was temporarily threatened by the publishers' refusal to proceed without financial guarantees; these were eventually provided by the industrialist Bernhard Koehler.[5] "Without his helping hand," Kandinsky recorded later, "the *Blaue Reiter* [*Almanac*] would have remained a beautiful Utopia."

The Blaue Reiter Almanac appeared in May 1912 under the banner of the Munich firm of R. Piper & Co., in an edition of 1100 copies. It was dedicated to the memory of Hugo von Tschudi, recently deceased director of the Bavarian State Collections, who had given his support not only to plans for the Almanac, but also to the first Blaue Reiter exhibition. Considerable emphasis was placed on the illustrative material;[6] the volume finally included more than 140 reproduc-

tions, as well as 14 major articles, a surprising proportion of which deal with music rather than painting. There was also a musical "supplement," with facsimiles of short song settings by Schoenberg and his two most gifted pupils, Alban Berg and Anton von Webern.[7] Quickly out of print, a new edition of the almanac was published in 1914,[8] for which Kandinsky and Marc each provided a new foreword. Plans for a second volume remained unrealized, owing to the outbreak of war.

Kandinsky contributed three major texts to the *Blaue Reiter Almanac:* his articles "On the Question of Form" and "On Stage Composition," and his play *Yellow Sound.* They are preceded by his brief but warmly worded obituary of the painter Eugen Kahler, who was, like Kandinsky, a former pupil of Franz von Stuck at the Munich Academy. Kahler had exhibited two drawings at the first Blaue Reiter exhibition in December 1911, the month of his death. There follows "On the Question of Form," Kandinsky's most important theoretical statement of this period apart from *On the Spiritual in Art.* Several of the ideas put forward in the latter are developed in more detail in this essay, which its author regarded as the logical continuation of his earlier treatise. "On the Question of Form" evidently occupied a special place in his affections, since he referred to it repeatedly in his later writings. Of particular interest for the historian are his remarks on the painter Henri Rousseau, father of what is termed "the great realism," which Kandinsky regarded as the opposite pole to his own, increasingly nonnaturalistic art.

Kandinsky believed that "the question of form does not, in principle, exist." His notion that the content of a work of art exists independent of its means of expression, and his assertion that a form that is externally correct may be internally wrong, and vice versa, may be compared with Schoenberg's statements regarding appropriate forms of musical expression in his essay "The Relationship to the Text," which also

appeared in the *Blaue Reiter Almanac*.[9] As theorists, Kandinsky and Schoenberg had much in common, not least their allegiance to the philosophy of German idealism, especially the writings of Schopenhauer, whom Schoenberg quotes in "The Relationship to the Text."[10] There is also a marked resemblance between Kandinsky's "stage composition" *Yellow Sound*, and Schoenberg's music drama *The Lucky Hand* [*Die Glückliche Hand*];[11] although Schoenberg was having difficulty finishing the music for *The Lucky Hand* at exactly the time his acquaintance with Kandinsky was ripening into friendship, the libretto had already been published in the Viennese periodical *Der Merker* in June 1911.

Yellow Sound was never performed during Kandinsky's lifetime. He himself recalled later that the piece had been scheduled for production no less than three times: in Munich in the autumn of 1914, at the Volksbühne in Berlin in 1922, and at the Bauhaus under Oskar Schlemmer.[12] The first performance, like the projected second volume of the *Blaue Reiter Almanac*, was prevented by the outbreak of war. Weiss has suggested that the "play" may have been originally written for Georg Fuchs's Künstlertheater in Munich: "Both in its description of a reductive symbolist stage and its demands on colored light, the script of Kandinsky's advanced stage composition suggests the characteristics of Fuchs' theater."[13] Of the artist's other dramatic efforts, only *Violet* was later published (in part), in the magazine *bauhaus* (see pp. 719–721). The unpublished manuscripts of three other such plays, *Daphnis and Chloe*, *Black and White*, and *Green Sound* have been preserved.[13a]

Kandinsky's essay "On Stage Composition," which he later published in Russian in the journal *Izobrazitel'noe Iskusstvo*,[14] was originally intended as a kind of preface to *Yellow Sound*; it stands, however, as an important theoretical statement in its own right. Here, the author develops one

of the central topics of the preceding essay, "On the Question of Form": that of the inner unity that supposedly derives from the external dissimilarity between the constituent elements of a work of "monumental" art. As Weiss has noted, the idea of the "total work of art" was much discussed by Jugendstil poets and writers such as Stefan George.[15] A number of references in the text also reveal Kandinsky's detailed reading of earlier source material; for example, the mention of Lessing points to Wagner's essay "Opera and Drama."[16] The brief discussion of Wagner's dramatic aims suggests in any case that Kandinsky was well acquainted with the composer's theoretical writings.

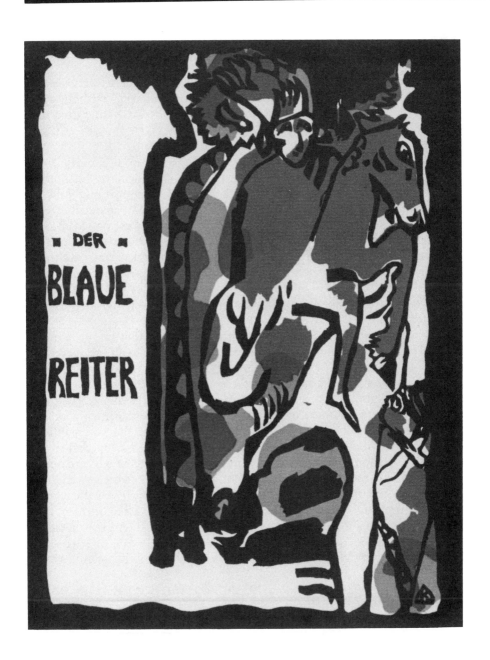

EUGEN KAHLER

On 13 December 1911 Eugen Kahler died in Prague, scarcely thirty years old. Death came upon him tenderly, without suffering, without its gruesome, often ugly accompaniments. One might say: Kahler died in Biblical fashion.

In this, Kahler's death corresponded to his life.

He was born in Prague on 6 January 1882 of a well-to-do family. For five years he attended high school [*Gymnasium*], and later business college [*Handelsakademie*], which today seems to us almost incredible, so spiritually remote was he from everything practical, so deeply immersed in his world of dreams. In 1902 he was supposed to go to Munich as an art student, but suffered an inflammation of the kidneys and had to undergo an operation in Berlin. Despite this first ominous attack, Kahler was able to devote himself entirely to the study of art. Two years at Knirr's school, a year at the Munich Academy under Franz Stuck, a year's study with Habermann, and Kahler felt strong enough to pursue his path alone.

His inner voice was so clear, so distinct, so precise that he could rely entirely upon its promptings. A succession of voyages to different countries (Paris, Brussels, Berlin, London, Egypt, Tunisia, Italy, and Spain) was in reality the selfsame voyage through one and the same country. Through the same world, which one can only describe as Kahler's world. Occasionally, the same illness would recur, and sometimes Kahler would have to spend weeks in bed. But he remained the same; lying down, he would draw and paint his dreams, read extensively, and continue to develop his extraordinarily intense inner life. Thus he created, e.g., in London many genuinely Kahlerian watercolors, which would in themselves be sufficient return for a life devoted to art. It was the same in the winter of 1911 in Munich, where confined to a sanatorium, he again painted a long series of wonderful watercolors. And so it continued; traveling from one sanatorium to another, remaining true to himself, right up to his last breath. And his death was as beautiful as his life.

Kahler's sensitive, dreamy, lighthearted spirit, with its somewhat Hebraic overtones of ineffable, mystical sadness, feared only one thing: the "common." And his own spirit, noble through and through, seemed not to belong in our own day. It was as if this spirit had been mysteriously sent with some hidden purpose from Biblical times into our own.

It was as if a benevolent hand wished to free him once more from our epoch.

Kahler left behind him numerous oil paintings, watercolors, drawings, and etchings.

About a year and a half ago he had a small collective exhibition in Munich in the Moderne Galerie Thannhauser, which was greeted by the critics in the usual supercilious way, with much instructive advice.

A large number of deeply felt poems, about which he had never spoken, were discovered after his death.

ON THE QUESTION OF FORM

At a particular time, necessities come to fruition. I.e., the creating spirit (which one can call the abstract spirit) finds access to the [individual] soul, subsequently to [many] souls, and calls forth a longing, an inner compulsion.

If those conditions are fulfilled which are necessary for a precise form to come to maturity, then this longing, this inner compulsion is empowered to create a new value in the human mind, which, consciously or unconsciously, begins to live within man.

Consciously or unconsciously, from this moment man seeks a material form for this new value that lives in spiritual form within him.

Thus the spiritual value seeks its materialization. Matter is here a reserve of supplies from which the spirit, like a cook, selects what is necessary in this case.

This is the positive, the creative [element]. This is the good. The white, fructifying ray.

This white ray leads to evolution, to sublimation. Thus, behind matter, within matter, the creative spirit lies concealed.

The spirit is often concealed within matter to such an extent that few people are generally capable of perceiving it. Indeed, there are many people who are incapable of seeing the spirit even when incorporated in a spiritual form. Thus, especially today, many people cannot see the spirit in religion, in art. There are whole periods in which the existence of the spirit is denied, since in general the eyes of men cannot see the spirit at such times. It was so in the nineteenth century and, by and large, it is still so today.

Men become blinded.

A black hand covers their eyes. This black hand is the hand of hatred.

He who hates seeks by every means to impede the progress of evolution, of sublimation.

This is the negative, the destructive [element]. This is the bad. The black, death-dealing hand.

<div align="center">* *</div>
<div align="center">*</div>

Evolution, progress forward and upward, is only possible if the path is unimpeded, i.e., if no barriers stand in the way. This is the external condition.

The power that impels the human spirit forward and upward on this untrammeled path is the abstract spirit. Of course, it must be able to sound forth, to make itself heard. It must be possible to hear the call. This is the internal condition.

The black hand seeks to impede the progress of evolution by destroying these two conditions.

The means that it uses are: fear of the untrammeled path, fear of freedom (philistinism), and deafness to the call of the spirit (crass materialism).

For this reason, mankind regards each new value with hostility. One seeks to combat it with mockery and denigration. He who brings new values is represented as laughable and dishonorable. People scoff at or decry this new value.

This is the horror of life.

The joy of life consists in the inevitable, continual triumph of new values.

This triumph makes slow progress. Only gradually do new values conquer mankind. And by the time such a value has become, in the eyes of many, indubitable, then it becomes, although it was today necessary and inevitable, a wall erected in defiance of the future.

This transformation of new values (the fruit of freedom) into a petrified form (the wall shutting out freedom) is the work of the black hand.

The whole of evolution, i.e., inner development and the outward products of culture, is thus a setting aside of barriers.

Barriers destroy freedom and thereby prevent the possibility of hearing the new revelation of the spirit.

These barriers are continually being made out of those new values which have overturned the barriers of the past.

Thus one sees that it is not basically the new value that is of prime

importance, but rather the spirit that is revealed in this value, as well as the freedom necessary for this revelation.

Thus one sees that it is not in the form (materialism) that the absolute is to be sought.

Form is always temporal, i.e., relative, since it is nothing more than the means necessary today, the means by which the revelation of today sounds forth, manifests itself.

This sound is thus the soul of form, form that can have life only by virtue of this sound and that produces its effect upon the external world from within.

Form is the external expression of inner content.

<div align="center">

* *

*

</div>

Thus one should not make an idol out of form. And one should not battle over form for any longer than it can serve as the means of expression for this inner sound. One should not, therefore, seek one's salvation in any one form.

This assertion must be correctly understood. For every artist (i.e., every productive rather than "imitative" artist), his own means of expression (= form) is the best, since it best incorporates what he is obliged to communicate. Yet the false conclusion is often drawn that this means of expression is, or should be, the best for other artists also.

Since form is merely the expression of content, and since content differs in the case of different artists, it is clear that there can exist at the same time many different, equally valid forms.

Form is the product of necessity. Fish that live at great depths have no eyes. The elephant has a trunk. The chameleon can change its color etc., etc.

Thus, form reflects the spirit of the individual artist. Form bears the stamp of personality.

Of course, personality cannot be imagined as something existing outside time and space. Rather, it is to a certain extent subordinate to time (period) and space (nationality).

Just as every individual artist has his own message to communicate, so too every nation (including, therefore, that nation to which this artist belongs). Form reflects this relationship, which is characterized by the national element in the work of art.

Ultimately, every period has its own, specially ordained task, that revelation of which it is capable. The reflection of this temporal element we recognize as s t y l e in the work of art.

These three elements that leave their stamp upon the work of art are all inevitable. It is not only superfluous, but indeed damaging to attempt to ensure their presence, for the element of force can here achieve nothing more than a semblance, a temporal deception.

On the other hand, it is self-evident that it is superfluous and damaging if one tries to give particular emphasis to only one of these three elements. Just as today many occupy themselves with the element of nationality, others with the element of style, so recently, particular attention has been paid to the cult of personality (of the individual).

As was said at the beginning, the abstract spirit first takes over a single human spirit; later it rules an ever-increasing proportion of mankind. At this moment, individual artists are subordinate to the spirit of the times, which drives them to make use of individual forms related one to another which thus likewise possess a certain external similarity.

One calls this moment a m o v e m e n t.

It is perfectly justified and (as the individual form is for the single artist) indispensible for a group of artists.

Just as salvation is not to be sought in the single form of the individual artist, neither is it to be sought in this group form. For every group, their own form is the best, since it best incorporates what they are obliged to communicate. One should not, however, draw the conclusion that this form is, or should be the best for all [artists]. Here, too, complete freedom must reign, and one must concede validity to every form, one must regard as correct (= artistic) every form that is the external expression of inner content. If one behaves otherwise, then one serves no longer the free spirit (the white ray), but rather the petrified barrier (the black hand).

Thus, one arrives at the same result as we have seen above: It is not form (material) that is of prime importance, but content (spirit).

Thus form can produce a pleasant or an unpleasant effect, can appear beautiful or unbeautiful, harmonious or disharmonious, skilled or clumsy, refined or coarse, etc., etc.; yet it must be neither accepted on account of what appear to be its positive qualities, nor rejected for its seemingly negative characteristics. All these terms are wholly relative, as one sees at a glance as soon as one contemplates the infinite variety of previously existing forms.

And equally relative, therefore, is form itself. So too must be one's conception and evaluation of form. One's attitude to the work of art must be such that the form produces an effect upon the soul. And by means of the form, the content (spirit, inner sound). Otherwise, one exalts the relative to the level of the absolute.

In one's practical life one will rarely find anyone who, wishing to travel to Berlin, gets out of the train at Regensburg. In the spiritual life, getting out at Regensburg is a comparatively frequent occurrence. Sometimes, even the engine driver does not want to go any further, and everyone has to get out at Regensburg. How many of those who sought God ultimately remained standing before a graven image? How many of those who sought after art remained dependent upon a form that an individual artist had used for his own purposes, be it Giotto, Raphael, Dürer, or van Gogh!

Thus, we must establish as our ultimate conclusion: It is not of prime importance whether form is personal or national or styleful [stilvoll], whether or not it corresponds to the principal movement of one's contemporaries, whether or not it is related to few or many other forms, whether or not it exists entirely independently, etc., etc.; rather, of prime importance in the question of form is whether or not form has arisen out of internal necessity.*

$$*\qquad\qquad*$$
$$*$$

The availability of forms in a certain time and space is thus likewise explicable in terms of the inner necessity of that time and space.

For this reason, it will eventually be possible to separate the distinguishing characteristics of the [particular] time and nation and represent them in schematic fashion.

And it is self-evident that the greater the epoch, i.e., the greater (quantitatively and qualitatively) the strivings toward the spiritual, the richer will be the number of [available] forms, and the greater the common tendencies (group movements) to be observed.

*I.e., one should not turn a form into a uniform. Works of art are not soldiers. Further, one and the same form can, even in the case of the same artist, be on one occasion the best; on another, the worst. In the first case, it has sprung from the soil of internal necessity; in the second, from that of external necessity: from ambition and greed.

We can see these characteristics of a great spiritual period (which has been prophesied, and which manifests itself today in one of its earliest stages) in the art of the present. These are:

1. great freedom, which to many appears boundless, and which
2. makes audible the call of the spirit, which
3. we see reveal itself in things with particular power, and which
4. will make and is already making for itself an implement out of every spiritual realm, whereby
5. it creates in every spiritual realm, and therefore in the plastic arts also (and especially in painting) many different means of expression (forms), which exist independently, or which unite whole groups, and
6. which today can draw upon all reserves; i.e., every kind of material, from the "hardest" to those which have only two-dimensional (abstract) existence, can be used as elements of form.

Re (1). As far as freedom is concerned, it finds expression in the striving toward emancipation from those forms which have already embodied their goal—i.e., from bygone forms, in the striving toward the creation of new, infinitely various forms.

Re (2). Our involuntary search for the ultimate limits of the means of expression of our present period (those means of expression that are determined by personality, national characteristics, and the period) is, on the other hand, a subjugation, determined by the spirit of the times, of our apparently limitless freedom, and a precise indication of the direction in which this search must take place. The little beetle, scurrying in all directions beneath an upturned glass, believes it can see before it unlimited freedom. After a certain distance, however, it comes up against the edge of the glass; it can see beyond it, but it can go no further. Moving the glass forward offers the possibility of its covering new ground. And so its overall direction is determined by the guiding hand. Thus, too, our own period, which believes itself entirely free, will come up against certain limits, but which "tomorrow" will be displaced.

Re (3). This apparently limitless freedom, and the intervention of the spirit, arises from the fact that we have begun to sense the spirit, the inner sound within every object. At the same time, this incipient capacity becomes a riper fruit of this apparently limitless freedom and of the intervening spirit.

Re (4). We cannot attempt here to define more precisely the effects that we have indicated upon every other realm of spiritual activity. It should, however, be self-evident to all that the collaboration of freedom and of the spirit must sooner or later be everywhere reflected.*

Re (5). In the plastic arts (and in painting in particular) we encounter today a remarkable wealth of forms, which partly appear as those forms belonging to the great, individual personalities and partly carry with them whole groups of artists in one great, roaring, precisely determined stream.

Despite the great variety of these forms, their common striving can easily be recognized. Indeed, it is in the mass movement itself that the all-embracing spirit of form can today be recognized. Therefore, it suffices to say: E v e r y t h i n g i s p e r m i t t e d. And yet, what is allowed today cannot be surpassed. What is forbidden today remains unshakable.

One should set oneself no limits, since those limits exist anyway. This applies not only to him who transmits (the artist), but also to him who receives (the spectator). He can and must follow the artist and should not be afraid of being led astray. Man cannot move in a straight line, even in purely physical terms (think of the paths one comes across in fields and meadows!) and even less in spiritual terms. And, particularly with spiritual paths, it is often the straight way that turns out to be the longest, because it is the wrong one, while that which appears to be the wrong one is often right.

That "feeling" which has been made to speak forth will sooner or later lead the artist, and likewise the spectator, in the right direction. Nervously hanging onto o n e particular form leads inevitably to a dead end, while open sentiments lead to freedom. The former is adherence to matter; the latter, adherence to the spirit: the spirit creates one form and goes on to create others.

Re (6). The eye, when concentrating upon a single point (whether it be form or content), is incapable of covering a large surface. Or, if it wanders inattentively over the surface and is thus able to take in this large area, or a part thereof, it nevertheless remains tied to external details and loses itself in contradictions. The reason for these contradictions lies in the variety of means that the spirit of today wrests, apparently at ran-

*I have discussed this question in somewhat more detail in my book *On the Spiritual in Art* (published by R. Piper & Co., Munich).

dom, from our reserve of supplies. "Anarchy" is what many term the present state of painting. The same word is also used here and there to characterize the state of contemporary music. It connotes, incorrectly, an aimless inconoclasm and lack of order. Anarchy consists rather of a certain systematicity and order that are created not by virtue of an external and ultimately unreliable force, but rather by o n e 's f e e l i n g for what is good. Thus, here too are limits that must be characterized as internal and will have to replace the external. And these limits too are constantly widened, whereby arises that ever-increasing freedom which, for its part, opens the way for further revelations.

Contemporary art, which in this sense may rightly be called anarchistic, reflects not only the spiritual standpoint that has already been attained, but also embodies as a materializing force that spiritual element now ready to reveal itself.

The forms employed for the embodiment [of the spirit], which the spirit has wrested from the reserves of matter, may easily be divided between two poles.

These two poles are:

1. the Great Abstraction
2. the Great Realism

These two poles open up t w o p a t h s, which lead ultimately to a single goal.

Between these two poles lie many possible combinations of different juxtapositions of the abstract with the real.

These two elements were always present in art and were to be characterized as the "purely artistic" and "objective." The former expressed itself in the latter, while the latter served the former. An ever-varying balancing act, which apparently sought to attain the ultimate Ideal by means of absolute equilibrium.

And it seems that today one no longer sees in this ideal a goal to be pursued, as if the spring supporting the pans of the scale has disappeared, and the two scale-pans intend to lead a separate existence as self-sufficient entities, independent of each other. In this splitting up of the ideal scales, one again discerns "anarchy." Art has apparently put an end to the welcome complementation of the abstract by means of the objective and vice versa.

On the one hand, the abstract is deprived of the distracting support of

the objective [element], and the spectator feels himself left hanging in mid-air. People say: Art has lost its ground. On the other hand, the objective is deprived of the distracting idealization provided by the abstract (the "artistic" element), and the spectator feels himself nailed to the ground. People say: Art has lost its ideal.

These complaints arise from the lack of a properly developed sensibility. The habit of paying principal attention to form, and arising from it, the way in which the spectator is conditioned to look for the accustomed form of balance—these are the blinding forces that leave no room for free feelings.

<div align="center">* *</div>
<div align="center">*</div>

The great realism, already mentioned, which has as yet scarcely begun to flower, is a desire to exclude from the picture the externally artistic [element] and to embody the content of the work of art by means of the simple ("inartistic") rendering of the simple, hard object. The outer shell of the object, conceived in this manner and fixed within the picture, and the simultaneous exclusion of accustomed, importunate beauty reveal in the surest way the inner sound of the thing. By reducing the "artistic" element to a minimum, the soul of the object sounds forth most strongly from within this outer shell, because external, palatable beauty can no longer distract us.*

And this is only possible because we are continually progressing along a path that enables us to hear the whole world just as it is, i.e., not with any prettifying interpretation.

That "artistic" element which has here been reduced to a minimum must be recognized as the most powerfully

*The spirit has already absorbed the content of accustomed beauty and can find no new nourishment therein. The form of this accustomed beauty gives the accustomed pleasure to the indolent corporeal eye. The effect produced by the work of art remains limited to the realm of the corporeal. Spiritual experience becomes impossible. Hence this kind of beauty often constitutes a force that leads not toward the spirit, but away from it.

affective abstract element.*

The great abstraction provides the great contrast to this realism, consisting as it does of the apparent wish to exclude completely the objective (real) element and to embody the content of the work of art in "nonmaterial" forms. Conceived in this manner and fixed within the picture, the abstract life of objective forms that have been reduced to a minimum—hence the noticeable predominance of abstract elements—reveals in the surest way the inner sound of the picture. Just as in the case of realism the inner sound is intensified by the exclusion of the abstract, so too in the case of abstraction this sound is intensified by the exclusion of the real. In the former case it was customary, external, palatable beauty that produced a dampening effect. In the latter it is the customary, external, supporting object.

In order to "understand" this kind of picture, the same emancipation is necessary as in the case of realism, i.e., it must here too become possible to hear the whole world just as it is, without objective interpretation. Here, those abstracted or abstract forms (lines, planes, patches, etc.) are not important in themselves, but rather for their inner sound, their life. Just as in the case of realism, it is not the object itself, nor its external shell, but its inner sound, its life that are important.

That "objective" element which has been reduced to a minimum must, in the case of abstraction, be recognized as

*The quantitative diminution of the abstract thus equals the qualitative augmentation of the abstract. Here we touch upon one of the most important laws: The external augmentation of a means of expression can under certain circumstances lead to the diminution of its internal strength. Here, 2 + 1 equals less than 2 − 1. This law of course manifests itself even in the smallest forms of expression: a patch of color often loses in intensity and effect on account of external magnification and external increase in strength. A particularly powerful movement of color often arises on account of its limitation: a painful effect can be achieved by means of the outright sweetness of the color, etc. All this is the expression of the further consequences of the law of contrast. In short: True form arises out of the combination of emotion and science. Here I must recall once again the [example of the] cook! Good bodily food arises out of the combination of a good recipe (where everything is indicated exactly in pounds and grams) with the guidance of feeling. One of the great distinguishing characteristics of our time is the ascendancy of knowledge: the science of art gradually occupies its rightful place. This is the coming "through-bass," before which there stands, of course, an endless process of change and development!

the most powerfully affective real element.*

Thus, finally, we see that if in the case of great realism the real element appears noticeably large and the abstract noticeably small, and if in the case of great abstraction this relationship appears to be reversed, then in their ultimate basis (= goal) these two poles equal one another. Between these two antipodes can be put an = sign:

Realism = Abstraction

Abstraction = Realism

The greatest external dissimilarity becomes the greatest internal similarity.

<div style="text-align:center">* *
*</div>

A few examples will take us out of the realm of reflection and into the realm of the tangible. If the reader of these lines looks at one of the letters with unaccustomed eyes, i.e., not as a customary sign for a part of a word, but rather as a thing, then he will see in this letter, apart from the practical-purposive abstract form created by man for the purpose of invariably indicating a particular sound, another corporeal form, which quite independently produces a certain external and internal impression—i.e., independent of its abstract form already mentioned. In this sense, the letter consists of:

1. Its principal form (= overall appearance), which, very crudely characterized, appears "gay," "sad," "striving," "striking," "defiant," "ostentatious," etc., etc.
2. The letter consists of individual lines, bent this way or that, which on each occasion also produce a certain internal impression, i.e., are likewise "gay," "sad," etc.

As soon as the reader has sensed these two elements of the letter, there arises in him a feeling that this letter produces as a being with its own inner life.

*Thus at the opposite pole we encounter the same law mentioned above, according to which quantitative decrease equals qualitative increase.

Here, one should not object that this letter will affect one person in one way, another person in another. This is incidental and can be understood. In general, every being will produce a different effect upon different people. We can only consider that the letter consists of two elements that ultimately express one sound. The individual lines of the second element may be "gay," and yet the whole (element 1) can produce a "sad" effect, etc. The individual movements of the second element are organic parts of the first. We can observe just such kinds of construction, just such a subordination of the individual elements to one sound in every song, every piano piece, every symphony. And precisely the same procedures go to make up a drawing, a sketch, a picture. Here, the laws of construction are revealed. For the moment, only one thing is of importance for us: that the letter has an effect. And, as has been said, this effect is twofold:

1. The letter produces an effect as a sign having a particular purpose.
2. It produces an effect, first of all as form, and later as the inner sound belonging to this form, which is self-sufficient and completely independent.

It is important for us that these two effects are not mutually interrelated, and while the first effect is external, the second has an inner meaning.

The conclusion we draw is that the external effect can be different from the internal effect, which is produced by the inner sound, which is one of the most powerful and profound means of expression in every form of composition.*

<p style="text-align:center">* *</p>
<p style="text-align:center">*</p>

Let us take another example. We see in this same book a dash. This dash, if used in the right place—as here—is a line that has a practical and purposeful significance. Now let us lengthen this little line, although leaving it in the right place: the sense of the line is retained, likewise its significance; yet on account of the unaccustomed aspect of the in-

*Here, I can only touch in passing upon such weighty problems. The reader has only to involve himself more deeply in these questions, and the mysterious, irresistable seductive power of, e.g., this latter conclusion will become clear of its own accord.

creased length, it takes on an indefinable coloration [*Färbung*], which makes the reader ask why the line is so long, and whether this length has a practical or purposeful aim. If we put this same line in the wrong place (as in this—instance) the [possibility of the] correct practical or purposeful element is lost, and can no longer be found, while the overtones of doubt are considerably increased. There remains the thought that it might be a misprint, i.e., a distortion of the practical-purposive. This last here produces a negative sound. But now let us put this same line on a blank page, e.g., long and curved. This instance is very similar to the previous one, except that one still thinks (as long as one may continue to hope for an explanation) that it may be a correct use of the practical-purposive. Or later (if no one explanation can be found), one thinks of the negative instance.

As long as this or that line remains in a book, the practical or purposeful element cannot be definitely excluded.

Let us therefore put a similar line in a setting that is able to avoid completely the practical-purposive. E.g., on a canvas. As long as the spectator (no longer reader) regards the line on the canvas as a means of delineating an object, he is subjected in this instance also to the effect of the practical-purposive. At the moment, however, at which he says to himself that a practical object plays at most an accidental and not a purely pictorial role within the picture, and that a line sometimes has an exclusively purely pictorial significance,* at that moment the soul of the spectator is ready to experience the p u r e, i n n e r s o u n d of this line.

Does this mean that objects, things, are exiled from the picture?

No. A line is, as we have seen above, a thing that has a practical or purposeful significance just as much as a chair, a fountain, a knife, a book, etc. And, in this last example, this thing is employed as a purely pictorial means without those other aspects which it may otherwise possess—i.e., for the sake of its pure, inner sound. If, therefore, within the picture, a line is freed from the purpose of indicating an object, and itself functions as a thing, its inner sound is not weakened by being forced to play an incidental role, and assumes its full, inner power.

Thus, we come to the conclusion that pure abstraction also makes use of things that lead their own material life, just as in pure realism. The most powerful denial of the objective and its most powerful assertion

*Van Gogh used line as such with particular power, without in any way wishing thus to delineate an object.

can once again be linked by an equal sign. And this sign can be justified because of the same goal in each case: the embodiment of the same inner sound.

Here we see that, in principle, it is of absolutely no significance whether the artist uses a real or an abstract form.

For both forms are internally the same. The artist must be left free to choose, for he himself must know best by which means he can most clearly put into material form the content of his art.

In abstract terms: **The question of form does not in principle exist.**

<div align="center">

* *

*

</div>

In fact, if there were in principle a question of form, then an answer would also be possible. And anyone who knew that answer would be able to create works of art. I.e., at that same moment art would cease to exist. In practical terms, the question of form becomes the question: Which form should I employ in this instance to achieve the necessary expression of my inner experience? The answer is in this instance always scientifically precise, absolute, and for all other instances only relative. I.e., a form that is the best in one case can be the worst in another: here, everything depends on internal necessity, which alone can justify any form. And a particular form can only have relevance in more than one instance if internal necessity, under the pressure of time and space, selects individual forms that are related one to another. This does not, however, disprove the relative significance of form, for even in this case the correct form may be wrong in many other instances.

<div align="center">

* *

*

</div>

All the rules discovered in earlier art, together with those discovered later, and to which art historians attach exaggerated importance, are not general rules, nor do they lead to art. If I know the rules of carpentry, I will always be able to make a table. He who knows the supposed rules of painting, however, cannot necessarily create a work of art.

These supposed rules, which will soon lead to a "thorough-bass" of painting, are nothing more than the recognition of the internal effect produced by individual means and their combinations. Yet there will never exist rules by means of which, in any particular case, the neces-

sary application of the effect of form and combinations of individual resources can be attained.

The practical consequence is: One must never believe a theoretician (art historian, critic, etc.) if he maintains that he has discerned an objective error in a work of art.

And: The only thing the theoretician can rightfully say is that until now, he has never known an instance of this or that particular employment of resources. And: those theoreticians who, taking as their starting point the analysis of previously existing forms, accord a work praise or blame are the most seditious saboteurs, who erect a wall between the work of art and the naive spectator.

From this standpoint (alas, for the most part the only possible one), art criticism is the worst enemy of art.

The ideal art critic, therefore, would not be the kind of critic who would seek to discover the "mistakes,"* "aberrations," "lack of knowledge," "plagiarisms," etc., etc., but who would try to feel the inner effect of this or that form, and then communicate to the public in an expressive way the totality of his experience.

In this case, the critic would of course need the soul of a poet, for the poet must be able to feel objectively in order to embody what he has experienced subjectively. I.e., the critic would need to possess creative powers. In reality, however, critics are often failed artists, who, lacking creative powers themselves, therefore feel a vocation to guide the creative powers of others.

The question as to form is often damaging to art also because untalented people (i.e., people who have no inner compulsion toward art) use borrowed forms to create sham works, thereby furthering confusion.

<p style="text-align:center">* *
*</p>

Here, I must be precise. To use a borrowed form is called a crime, a deception, by critics, by the public, and often by artists. In reality, however, this is only the case if the "artist" employs these borrowed forms without [their being demanded by] internal necessity, thereby creating a dead, lifeless semblance of a work of art. If, however, the artist makes use of one or another "borrowed" form, according to [the de-

*E.g., "anatomical mistakes," "distortions," and the like, or later infringements against the coming "thorough-bass."

mands of] inner truth, in order to express his inner emotions and experiences, he is exercising his right to make use of any form that is in te r-nally necessary for him—no matter whether it is an object of everyday use, a heavenly body or a form that has been materialized in art by another artist.

This whole question of "imitation"* is in any case far from having the significance that criticism attaches to it.† The living remains. The dead disappears.

Indeed, the further we look into the past, the fewer imitations, sham works we find. They have mysteriously disappeared. Only the genuine art-objects remain, i.e., those that have within their bodies (form) a soul (content).

Further, if the reader looks at any object he pleases on his table (even if it is only a cigar butt), he will at once notice the same two effects. No matter where and when (in the street or in church, in the sky or the water, in the stable or in the woods), the same two effects will everywhere become manifest, and in every case the inner sound will be independent of the external significance.

The world sounds. It is a cosmos of spiritually affective beings. Thus, dead matter is living spirit.

<p align="center">* *
*</p>

If we draw what is for us the necessary conclusion from this independent effect of the inner sound, we see that this inner sound gains in strength if the external, practical, or purposeful significance that supresses it is excluded. Here lies one explanation of the pronounced effect that a child's drawing has upon the unbiased, untraditional spectator. The practical-purposive element is foreign to the child, since it regards

*Every artist knows how imaginative criticism can be in this sphere. The critics know that here they can air the craziest views with complete impunity. E.g., the *Negress* by Eugen Kahler, a good, naturalistic *atelier* study, was recently compared with . . . Gauguin. The only possible occasion for this comparison can have been the brown skin of the model (see the *Münchener Neueste Nachrichten*, 12 October 1911), etc., etc.

†And, thanks to the exaggerated importance that is generally attached to this question, the artist is discredited with impunity.

every object with unaccustomed eyes and still possesses an undimmed capacity for taking in the object itself. The practical-purposive becomes familiar only later through many, often unhappy experiences. Thus, in every child's drawing without exception is revealed the inner sound of the object itself. Grownups, especially teachers, take pains to impress upon the child the practical-purposive, and it is precisely from this dimwitted standpoint that they criticize the child's drawing: "Your man can't walk—he's only got one leg"; "you can't sit on your chair because it's crooked"; etc.* The child laughs at itself. It ought to cry.

Now apart from the ability to suppress the external element, the gifted child also has the power to clothe the remaining internal element in a form in which this element appears most strongly and thus produces an effect (as one also says, "speaks"!).

Every form is many-sided. One constantly discovers in it new and fortunate characteristics. Here, however, I wish only to stress one side of good children's art, which is for the moment important for us: the compositional. Here at once, there springs to the eye the unconscious (as if spontaneous) use of the two aspects of the letter of the alphabet referred to above, i.e., (1) the overall appearance, which is very often precise and occasionally is raised to the level of the purely schematic, and (2) the individual forms that comprise the overall form, each of which leads its own life (e.g., *Arabs* by Lydia Wieber).[17] There is an unconscious, enormous power in children that expresses itself here and places the work of children on the same level as (and often much higher than!) the work of adults.†

For every glowing fire there waits a cooling. For every early bud, the menacing frost. For every young talent, an academy. These are not merely tragic words, but a sorry fact. The academy is the surest means of putting an end to that power of children just described. In this respect the academy puts more or less of a brake on even the greatest and strongest talent. The less-gifted perish by the hundreds. An academ-

*As if often the case, one attempts to teach those who should themselves be teaching. And then later one wonders why nothing comes of gifted children.

†"Folk art" also possesses this surprising attribute of compositional form. (See, e.g., the votive picture for the plague, from the church at Murnau.)

ically trained man of average gifts is distinguished by the fact that he has learned to recognize the practical-purposive and has lost the ability to hear the inner sound. This kind of person will provide a "correct" drawing that is nonetheless dead.

But if a person without artistic training—and thus without knowledge of objective, artistic facts—paints something, the result is never merely an empty sham. Here, we see an example of the effect of that inner power which is influenced only by the most g e n e r a l knowledge of the practical-purposive.

Yet, since the application of this general knowledge can here be only limited, the external is suppressed in this instance, too (to a lesser, although considerable, extent than in the case of the child), and the inner sound gains in strength: it is not a dead but a living thing that is created. (See, e.g., the four heads reproduced here.)

Christ said: Let the little children come unto me, for theirs is the kingdom of Heaven.

The artist, who for his whole lifetime resembles the child in many ways, can often succeed in reaching the inner sound of things more easily than others. In this connection, it is particularly interesting to see how simply and surely the composer Arnold Schoenberg employs pictorial means. As a rule, he is interested only in this inner sound, he has no regard for any decorative or delicate effects, and the "poorest" form becomes in his hands the richest. (See his self-portrait.)

Here lie the roots of the new greater realism. The complete and exclusively simple rendering of the external shell of things constitutes the divorce of the object from any practical purpose, hence permitting the inner element to sound forth. Henri Rousseau, who may be characterized as the father of this [kind of] realism, has, with one simple and totally convincing gesture, shown us the way. (See the portrait, and his other pictures.)*

*The majority of the pictures by Rousseau reproduced here are taken from the sympathetic, warm-hearted book by U h d e (*Henri Rousseau*, Paris: Eugène Figuière et Cie. Editeurs, 1911). I take this opportunity to thank Herr Uhde most cordially for his cooperation.

Henri Rousseau has opened the way for simplicity, and for the new possibilities it offers. This aspect of his many-sided talent now has for us the most significant value.

<p style="text-align:center">* *</p>
<p style="text-align:center">*</p>

Objects, or the object (i.e., it and the parts that constitute it) must stand in some kind of relationship one to another. This relationship may be noticeably harmonious or noticeably disharmonious. A schematized rhythm or a concealed rhythm can here be employed.

The inexorable impulse to manifest the purely compositional element, to reveal the future laws of our great epoch—this is the force which today causes the artist to strive by means of different paths towards one single goal.

It is only natural that man should in such cases turn towards the most regular and at the same time the most abstract [forms]. Thus we see how the triangle has been used as the basis for construction in different periods of art. This triangle was often equilateral, and thus numbers, i.e. the completely abstract element of the triangle, came to take on a significance. Today, in the search for abstract relationships, numbers play an important rôle. Every formula is as cold as an icy mountain top, and, being the ultimate [geometrical] regularity, as immovable as a block of marble. Cold and immovable like all necessity. The attempt to express the compositional element in terms of a formula is the reason behind this development of so-called Cubism. This 'mathematical' construction is a form which must sometimes lead to—and, when used consistently, does lead to the ultimate degree of destruction of the material connexion between the parts of objects. (See for example Picasso.)

The ultimate goal which is to be attained by this path also is to create a picture which is brought to life, becomes a being, by virtue of its own schematically constructed organs. If any general objections may be raised with respect to this method, they consist of n o t h i n g o t h e r t h a n that here we have an excessively limited use of numbers. Everything can be represented as a mathematical formula, or simply as a number. There are, however, many different numbers: 1 and 0.3333 . . . are beings with their own inner sound, with equal rights, equal life. Why should one be contented merely with 1? Why should one exclude 0.3333 . . . ? In this context the question presents itself: Why should one

narrow one's means of artistic expression by the e x c l u s i v e use of triangles and similar geometrical forms and bodies? It must, however, be repeated that the compositional strivings of the Cubists stand in a direct relationship to the necessity of creating purely pictorial beings that, on the one hand, speak through and by means of the objective [element], and on the other, go over ultimately to pure abstraction, by means of different combinations with the more or less strongly sounding object.

Between the realism of purely abstract and purely realistic composition lie all the possibilities of combining abstract and real elements within the one picture. The reproductions in this book show how great and manifold the possibilities of combination are, how strongly the life of the work itself pulses in all these examples—and hence how freely one should behave with regard to the question of form.

The combination of the abstract with the representational, the choice between the infinite number of abstract forms and those forms built out of representational material—i.e., the choice between the individual means within each sphere—is and remains entirely according to the inner wishes of the artist. The form that today is prohibited or despised, apparently far from the mainstream, merely awaits its own master. This form is not dead, but only remains sunk in a kind of lethargy. When that content comes to maturity, that spirit which can only manifest itself through this same apparently dead form, when the hour of its materialization has struck, then it will enter into this form and speak through it.

In particular, the layman should not approach the work of art with the question: "What has the artist n o t done?" or, put differently, "Wherein has the artist permitted himself to ignore m y wishes?" Rather, he should ask himself: "What has the artist done?" or, "To which of h i s inner desires has the artist here given expression?" I believe that the time will yet come when the task of criticism will be seen not as searching for the negative, the mistaken, but rather as seeking and communicating the positive, the correct. One of the most "important" concerns of present-day criticism with regard to abstract art is anxiety over how to distinguish between the false and the correct, i.e., for the most part, how one should discover the negative? One's attitude toward the work of art should be different from one's attitude toward a horse one is thinking of buying: the horse is made worthless by the discovery of one negative attribute, which cancels out all its positive qualities; in the case of a work of art, this relationship is reversed: one important

positive quality renders it valuable and makes up for all its negative attributes.

If one takes account of this simple thought, then absolute questions of form in principle will disappear of their own accord, the question of form will take on its relative value, and among other things, the artist will finally be left free to choose that form which is necessary for him and for the work in question.

<div align="center">

* *

*

</div>

As a conclusion to these, alas, only fleeting observations regarding the question of form, I wish to draw attention to several examples of construction that occur in this book.[18] I.e., I am here obliged to stress only one of the many aspects of the work of art, completely ignoring all the other manifold qualities that characterize not only the particular work, but also the soul of the artist.

The two pictures by Henri Matisse demonstrate how "rhythmical" composition *(Dance)* has a different inner life, hence a different inner sound, from compositions in which the parts of the picture are juxtaposed in an apparently arhythmic way *(Music)*. This comparison is the best proof of the fact that salvation lies not only in the purely schematic, in pure rhythm.

The strong abstract sound of corporeal form does not necessarily demand the destruction of the representational element. We see in the picture by Marc *(The Bull)* that here, too, there can be no general rules. The object can retain completely its own internal and external sound, and yet its individual parts can be transformed into independently sounding, abstract forms, which thus occasion an overall, abstract sound.

The still-life by Münter demonstrates that the different interpretation of objects to a different degree within one and the same picture is not only not harmful, but rather can, if correctly used, attain a powerful, complex inner sound. That concordance of sounds which produces an

externally disharmonious impression is in this instance the source of the inner harmonious effect.

The two pictures by Le Fauconnier provide a compelling, instructive example. Similar "relief" forms in these pictures, by means of the division of "weights," achieve two, diametrically opposed inner effects. *Abondance* produces a sound that is like a tragic overloading [*tragische Überladung der Gewichte*]. *Paysage Lacustre* reminds one of a clear, transparent poem.

<div align="center">* *
*</div>

If the reader of this book is temporarily able to banish his own wishes, thoughts, and feelings, and then leafs through the book, passing from a votive picture to Delaunay, from Cézanne to a Russian folk-print, from a mask to Picasso, from a glass picture to Kubin, etc., etc., then his soul will experience a multitude of vibrations and enter into the realm of art. Then he will find here not irritating insufficiency and annoying mistakes, but rather will arrive spiritually not at a minus, but at a plus. These vibrations and the plus that derives from them will be a kind of enrichment of the soul that cannot be attained by any other means than those of art.

Later, the reader can, with the artist, go over to objective observations, to scientific analysis. He will find that all the examples given here obey one single inner call—composition—and that they all rest upon the same inner basis—construction.

<div align="center">* *
*</div>

The inner content of the work of art can belong to one of two processes, which today (whether only today? or particularly evident today?) resolve all other ancillary movements within themselves.

These two processes are:

1. The destruction of the soulless material life of the nineteenth century, i.e., the collapse of those supports of the material [life] that have firmly been regarded as unique, and the crumbling and the dissolution of the individual components thereof.

2. The building-up of the spiritual-intellectual life of the twentieth century, which we too experience, and which already manifests and embodies itself in powerful, expressive, and definite forms.

These two processes are the two facets of the "modern movement." To qualify the phenomena that have already been attained, or even to attempt to establish the final goal of this movement, would be a piece of presumption that would at once be cruelly punished by loss of freedom.

As has been often said already, we should strive not toward limitation, but emancipation. One should reject nothing without a determined attempt to discover the living element within it. It is better to regard death as life than to mistake life for death. Even if only once. And it is only upon space that has been cleared anew that further growth is possible. The man who is free seeks to enrich himself by every means and allow the life of every being to produce its effect upon him—even if it is only a spent match.

Only through freedom can what is to come be received.

And one should not stand to one side like the barren tree under which Christ saw lying, already prepared, the sword.

ON STAGE COMPOSITION

Every art has its own language, i.e., those means which it alone possesses.

Thus every art is something self-contained. Every art is an individual life. It is a realm of its own.

For this reason, the means belonging to the different arts are externally quite different. Sound, color, words! . . .

In the last essentials, these means are wholly alike: the final goal extinguishes the external dissimilarities and reveals the inner identity.

This final goal (knowledge) is attained by the human soul through finer vibrations of the same. These finer vibrations, however, which are identical in their final goal, have in themselves different inner motions and are thereby distinguished from one another.

This indefinable and yet definite activity of the soul (vibration) is the aim of the individual artistic means.

A certain complex of vibrations—the goal of a work of art.

The progressive refinement of the soul by means of the accumulation of different complexes—the aim of art.

Art is for this reason indispendable and purposeful.

The correct means that the artist discovers is a material form of that vibration of his soul to which he is forced to give expression.

If this means is correct, it causes a virtually identical vibration in the receiving soul.

This is inevitable. But this second vibration is complex. First, it can be powerful or weak, depending upon the degree of development of him who receives it, and also upon temporal influences (degree of absorption of the soul). Second, this vibration of the receiving soul will cause other strings within the soul to vibrate in sympathy. This is a way of exciting the "fantasy" of the receiving subject, which "continues to exert its creative activity" upon the work of art* [am Werke "weiter schafft"]. Strings of the soul that are made to vibrate frequently will, on almost every occasion other strings are touched, also vibrate in sympathy. And sometimes so strongly that they drown the original sound: there are people who are made to cry when they hear "cheerful" music, and vice versa. For this reason, the individual effects of a work of art become more or less strongly colored in the case of different receiving subjects.

Yet in this case the original sound is not destroyed, but continues to live and works, even if imperceptibly, upon the soul.†

Therefore, there is no man who cannot receive art. Every work of art and every one of the individual means belonging to that work produces in every man without exception a vibration that is at bottom identical to that of the artist.

<p style="text-align:center">*　　　*
*</p>

The internal, ultimately discoverable identity of the individual means of different arts has been the basis upon which the attempt has

*Among others, theater designers in particular count today upon this "collaboration," which has of course always been employed by artists. Hence derived also the demand for a certain distance, which should separate the work of art from the ultimate degree of expressiveness. This not-saying-the-ultimate was called for by, e.g., Lessing and Delacroix, among others. This distance leaves space free for the operation of fantasy.

†Thus, in time, every work is correctly "understood."

been made to support and to strengthen a particular sound of one art by the identical sound belonging to another art, thereby attaining a particularly powerful effect. This is one means of producing [such] an effect.

Duplicating the resources of one art (e.g., music), however, by the identical resources of another art (e.g., painting) is only one instance, one possibility. If this possibility is used as an internal means also (e.g., in the case of Skriabin),* we find within the realm of contrast, of complex composition, first the antithesis of this duplication and later a series of possibilities that lie between collaboration and opposition. This material is inexhaustible.

<div align="center">* *

*</div>

The nineteenth century distinguished itself as a time far removed from inner creation. Concentration upon material phenomena and upon the material aspect of phenomena logically brought about the decline of creative power upon the internal plane, which apparently led to the ultimate degree of abasement.

Out of this one-sidedness other biases naturally had to develop.

Thus, too, on the stage:

1. There necessarily occurred here also (as in other spheres) the painstaking elaboration of individual, already existing (previously created) constituent parts, which had for the sake of convenience been firmly and definitively separated one from another. Here, one sees reflected the specialization that always comes about immediately when no new forms are being created.

2. The positive character of the spirit of the times could only lead to a form of combination that was equally positive. Indeed, people thought: two is greater than one, and sought to strengthen every effect by means of repetition. As regards the inner effect, however, the reverse may be true, and often one is greater than two. Mathematically, $1 + 1 = 2$. Spiritually, $1 - 1$ can $= 2$.

Re (1). Through the primary consequence of materialism, i.e., through specialization, and bound up with it, the further external development of the individual [constituent] parts, there arose and be-

*See the article by L. Sabaneev in this book.[19]

came petrified three classes of stage works, which were separated from one another by high walls:

A) Drama
B) Opera
C) Ballet

(A) Nineteenth century drama is in general the more or less refined and profound narration of happenings of a more or less personal character. It is usually the description of external life, where the spiritual life of man is involved only insofar as it has to do with his external life.* The cosmic element is completely lacking.

External happenings, and the external unity of the action comprise the form of drama today.

(B) Opera is drama to which music is added as a principal element, whereby the refinement and profundity of the dramatic aspect suffer greatly. The two constituent [elements] are bound up with one another in a completely external way. I.e., either the music illustrates (or strengthens) the dramatic action, or else the dramatic action is called upon to help explain the music.

Wagner noticed this weakness and sought to alleviate it by various means. His principal object was to join the individual parts with one another in an organic way, thereby creating a monumental work of art.†

Wagner sought to strengthen his resources by the repetition of one and the same external movement in two substantive forms, and to raise the effect produced to a monumental level. His mistake in this case was to think that he disposed of a means of universal application. This device is in reality only one of the series of often more powerful possibilities in

*We find few exceptions. And even these few (e.g., Maeterlinck, Ibsen's *Ghosts*, Andreev's *The Life of Man*, etc.) remain dominated by external action.

†This thought of Wagner's took over half a century to cross the Alps, on the other side of which it was expressed in the form of an official paragraph. The musical "manifesto" of the Futurists reads: "Proclamer comme une nécessité absolue que le musicien soit l'auteur du poème dramatique on tragique qu'il doit mettre en musique" [To proclaim as an absolute necessity that the musician should be the author of the dramatic poem or tragedy that he would set to music] (May 1911, Milan).[20]

[the realm of] monumental art.

Yet apart from the fact that a parallel repetition constitutes only one means, and that this repetition is only external, Wagner gave to it a new form that necessarily led to others. E.g., movement had before Wagner a purely external and superficial sense in opera (perhaps only debased). It was a naive appurtenance of opera: pressing one's hands to one's breast (love), lifting one's arms (prayer), stretching out one's arms (powerful emotion), etc. These childish forms (which even today one can still see every evening) were externally related to the text of the opera, which in turn was illustrated by the music. Wagner here created a direct (artistic) link between movement and the progress of the music: movement was subordinated to tempo.

The link is, however, only of an external nature. The inner sound of movement does not come into play.

In the same artistic, but likewise external way, Wagner on the other hand subordinated the music to the text, i.e., movement in a broad sense. The hissing of red-hot iron in water, the sound of the smith's hammer, etc., were represented musically.

This changing subordination has been, however, yet another enrichment of means, which of necessity led to further combinations.

Thus, Wagner on the one hand enriched the effect of one means, and on the other hand diminished the inner sense—the purely artistic inner meaning of the auxiliary means.

These forms are merely the mechanical reproduction (not inner collaboration) of the purposive progress of the action. Also of a similar nature is the other kind of combination of music with movement (in the broad sense of the word), i.e., the musical "characterization" of the individual roles. This obstinate recurrence of a [particular] musical phrase at the appearance of a hero finally loses its power and gives rise to an effect upon the ear like that which an old, well-known label on a bottle produces upon the eye. One's feelings finally revolt against this kind of consistent, programmatic use of one and the same form.*

Finally, Wagner uses words as a means of narration, of expressing his thoughts. He fails, however, to create an appropriate setting for such

*This programmatic element runs right through Wagner's work, and is probably to be explained in terms not only of the character of the artist, but also of the search for a precise form for this new type of creation, upon which the spirit of the nineteenth century impressed its stamp of the "positive."

aims, since as a rule the words are drowned by the orchestra. It is not sufficient to allow the words to be heard in numerous recitatives. But the device of interrupting the continuous singing has already dealt a powerful blow to the "unity." And yet the external action remains untouched even by this.

Apart from the fact that Wagner here remains entirely in the old traditions of the external, in spite of his efforts to create a text (movement), he still neglects the third element, which is used today in isolated cases in a still more primitive form*—color, and connected with it, pictorial form (decoration).

External action, the external connection between its individual parts and the two means employed (drama and music) is the form of opera today.

(C) Ballet is a form of drama with all the characteristics already described and also the same content. Only here, the seriousness of drama loses even more than in the case of opera. In opera, in addition to love, other themes occur: religious, political, and social conditions provide the ground upon which enthusiasm, despair, honor, hatred, and other similar feelings grow. Ballet contents itself with love in the form of a childish fairy-tale. Apart from music, individual and group movement both help to contribute. Everything remains in a naive form of external relationships. It even happens that individual dances are in practice included or left out at will. The "whole" is so problematic that such goings-on go completely unnoticed.

External action, the external connection between its individual parts and the three means employed (drama, music, and dance) is the form of ballet today.

Re (2). Through the secondary consequence of materialism, i.e., on account of positive addition ($1 + 1 = 2, 2 + 1 = 3$), the only form that was employed involved the use of combination (alternatively, reinforcement), which demanded a parallel progression of means. E.g., powerful emotions are at once emphasized by an *ff* in music. This mathematical principle also constructs affective forms upon a purely external basis.

All the above-mentioned forms, which I call substantive forms [*Substanzformen*] (drama—words; opera—sound; ballet—movement),

*See the article by Sabaneev.

and likewise the combinations of the individual means, which I call affective means [*Wirkungsmittel*], are composed into an external unity. Because all these forms arose out of the principle of external necessity.

Out of this springs as a logical result the limitation, the one-sidedness (= impoverishment) of forms and means. They gradually become orthodox, and every minute change appears revolutionary.

<p style="text-align:center">* *
*</p>

Viewing the question from the standpoint of the internal, the whole matter becomes fundamentally different.

1. Suddenly, the external appearance of each element vanishes. And its inner value takes on its full sound.
2. It becomes clear that, if one is using the inner sound, the external action can be not only incidental, but also, because it obscures our view, dangerous.
3. The worth of the external unity appears in its correct light, i.e., as unnecessarily limiting, weakening the inner effect.
4. There arises of its own accord one's feeling for the necessity of the inner unity, which is supported and even constituted by the external lack of unity.
5. The possibility is revealed for each of the elements to retain its own external life, which externally contradicts the external life of another element.

Further, if we go beyond these abstract discoveries to practical creation, we see that it is possible

re (1) to take only the inner sound of an element as one's means;

re (2) to eliminate the external procedure (= the action);

re (3) by means of which the external connection between the parts collapses of its own accord;

likewise,

re (4) the external unity, and

re (5) the inner unity place in our hands an innumerable series of means, which could not previously have existed.

Here, the only source thus becomes that of internal necessity.

The following short stage composition is an attempt to draw upon this source.

There are here three elements that are used as external means, but for their inner value:

1. musical sound and its movement
2. bodily spiritual sound and its movement, expressed by people and objects
3. color-tones and their movement (a special resource of the stage)

Thus, ultimately, drama consists here of the complex of inner experiences (spiritual vibrations) of the spectator.

re 1. From opera has been taken the principle element—music—as the source of inner sounds, which need in no way be subordinated to the external progress of the action.

re 2. From ballet has been taken dance, which is used as movement that produces an abstract effect with an inner sound.

re 3. Color-tones take on an independent significance and are treated as a means of equal importance.

All three elements play an equally significant role, remain externally self-sufficient, and are treated in a similar way, i.e., subordinated to the inner purpose.

Thus, e.g., music can be completely suppressed, or pushed into the background, if the effect, e.g., of the movement is sufficiently expressive, and could be weakened by combination with the powerful effect of the music. The growth of musical movement can correspond to a decrease in the movement of the dance, whereby both movements (the positive and the negative) take on a greater inner value, etc., etc. A series of combinations, which lie between the two poles: collaboration and opposition. Conceived graphically, the three elements can take entirely individual, in external terms, completely independent paths.

Words as such, or linked together in sentences, have been used to create a particular "mood," which prepares the ground of the soul and makes it receptive. The sound of the human voice has also been used purely, i.e., without being obscured by words, by the sense of the words.

<center>* *</center>
<center>*</center>

The reader is asked not to ascribe to the principle the weaknesses of the following short composition, *Yellow Sound*, but to attribute them to the author.

YELLOW SOUND

A Stage Composition
by KANDINSKY

Yellow Sound

A Stage Composition*

Participants:

Five Giants

*

Indistinct Beings

*

Tenor
(behind the stage)

*

A Child

*

A Man

*

People in flowing garb

*

People in tights

*

Chorus
(behind the stage)

*Thomas v. Hartmann was responsible for the music.[21]

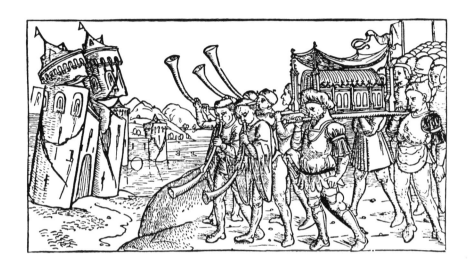

INTRODUCTION

Some indeterminate chords from the orchestra.

Curtain

Over the stage, dark-blue twilight, which at first has a pale tinge and later becomes a more intense dark blue. After a time, a small light becomes visible in the center, increasing in brightness as the color becomes deeper. After a time, music from the orchestra. Pause.

Behind the stage, a chorus is heard, which must be so arranged that the source of the singing is unrecognizable. The bass voices predominate. The singing is even, without expression, with pauses indicated by dots.

At first, deep voices:

> Stone-hard dreams . . . And speaking rocks . . .
> Clods of earth pregnant with puzzling questions . . .
> The heaven turns . . . The stones . . . melt . . .
> Growing up more invisible . . . rampart . . .

High voices:

> Tears and laughter . . . Praying and cursing . . .
> Joy of reconciliation and blackest slaughter.

All:

> Murky light on the . . . sunniest . . . day
> \qquad (quickly and suddenly cut off).
> Brilliant shadows in darkest night!!

The light disappears. It grows suddenly dark. Long pause. Then orchestral introduction.

French (19th century)

German (15th century)

SCENE I

(Right and left as seen by the spectator)
The stage must be as deep as possible. A long way back, a broad green hill. Behind the hill a smooth, matt, blue, fairly dark-toned curtain.

The music begins straightaway, at first in the higher registers, then descending immediately to the lower. At the same time, the background becomes dark blue (in time with the music) and assumes broad black edges (like a picture). Behind the stage can be heard a chorus, without words, which produces an entirely wooden and mechanical sound, without feeling. After the choir has finished singing, a general pause: no movement, no sound. Then darkness.

Later, the same scene is illuminated. Five bright yellow giants (as big as possible) appear from right to left (as if hovering directly above the ground).

They remain standing next to one another right at the back, some with raised, others with lowered shoulders, and with strange, yellow faces which are indistinct.

Very slowly, they turn their heads toward one another and make simple arm movements.

The music becomes more definite.

Immediately afterward, the giants' very low singing, without words, becomes audible (*pp*), and the giants approach the ramp very slowly. Quickly, red, indistinct creatures, somewhat reminiscent of birds, fly from left to right, with big heads, bearing a distant resemblance to human ones. This flight is reflected in the music.

The giants continue to sing more and more softly. As they do so, they become more indistinct. The hill behind grows slowly and becomes

brighter and brighter, finally white. The sky becomes completely black.

Behind the stage, the same wooden chorus becomes audible. The giants are no longer to be heard.

The apron stage turns blue and becomes ever more opaque.

The orchestra competes with the chorus and drowns it.

A dense, blue mist makes the whole stage invisible.

Egyptian

Dance Mask

Russian

SCENE 2

The blue mist recedes gradually before the light, which is a perfect, brilliant white. At the back of the stage, a bright green hill, completely round and as large as possible.

The background violet, fairly bright.

The music is shrill and tempestuous, with oft-repeated *a* and *b* and *b* and *a-flat*. These individual notes are finally swallowed up by the raging storm. Suddenly, there is complete stillness. A pause. Again is heard the plangent complaint, albeit precise and sharp, of *a* and *b*. This lasts for some time. Then, a further pause.

At this point the background suddenly turns a dirty brown. The hill becomes dirty green. And right in the middle of the hill forms an indefinite black patch, which appears now distinct, now blurred. At each change in definition, the brilliant white light becomes progressively grayer. On the left side of the hill a big yellow flower suddenly becomes visible. It bears a distant resemblance to a large, bent cucumber, and its color becomes more and more intense. Its stem is long and thin. Only one narrow, prickly leaf grows sideways out of the middle of the stem. Long pause.

Later, in complete silence, the flower begins to sway very slowly from right to left; still later the leaf, but not together. Still later, both begin to sway in an uneven tempo. Then again separately, whereupon a very thin *b* accompanies the movement of the flower, a very deep *a* that of the leaf. Then both sway together again, and both notes sound together. The flower trembles violently and then remains motionless. In the music, the two notes continue to sound. At the same time, many people come on from the left in long, garish, shapeless garments (one entirely blue, a second red, a third green, etc.; only yellow is missing). The people hold in their hands very large white flowers that resemble the flower on the hill. The people keep as close together as possible, pass directly in front of the hill and remain on the right-hand side of the stage, almost huddled together. They speak with various different voices and recite:

> The flowers cover all, cover all, cover all.
> Close your eyes! Close your eyes!
> We look. We look.
> Cover conception with innocence.
> Open your eyes! Open your eyes!
> Gone. Gone.

At first, they all recite together, as if in ecstasy (very distinctly). Then, they repeat the same thing individually: one after the other—alto, bass and soprano voices. At "We look, we look" *b* sounds; at "Gone, gone" *a*. Occasional voices become hoarse. Some cry out as if possessed. Here and there a voice becomes nasal, sometimes slowly, sometimes with lightning rapidity. In the first instance, the stage is suddenly rendered indistinct by a dull red light. In the second, a lurid blue light alternates with total darkness. In the third, everything suddenly turns a sickly gray (all colors disappear!). Only the yellow flower continues to glow more strongly!

Gradually, the orchestra strikes up and drowns the voices. The music becomes restless, jumping from *ff* to *pp*. The light brightens somewhat, and one can recognize indistinctly the colors of the people. Very slowly, tiny figures cross the hill from right to left, indistinct and having a gray color of indeterminate value. They look before them. The moment the first figure appears, the yellow flower writhes as if in pain. Later it suddenly disappears. With equal suddenness, all the white flowers turn yellow.

The people walk slowly, as if in a dream, toward the apron stage, and separate more and more from one another.

The music dies down, and again one hears the same recitative.* Suddenly, the people stop dead as if spellbound and turn around. All at once they notice the little figures, which are still crossing the hill in an endless line. The people turn away and take several swift paces toward the apron stage, stop once more, turn around again, and remain motionless, as if rooted to the spot.† At last they throw away the flowers as if they were filled with blood, and wrenching themselves free from their rigidity, run together toward the front of the stage. They look around frequently.‡ It turns suddenly dark.

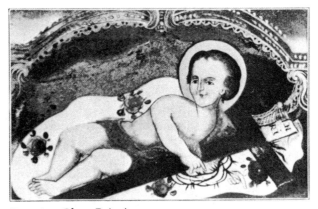

Bavarian Glass Painting

*Half the sentence spoken in unison; the end of the sentence very indistinctly by one voice. Alternating frequently.

†This movement must be executed as if at drill.

‡These movements should not be in time to the music.

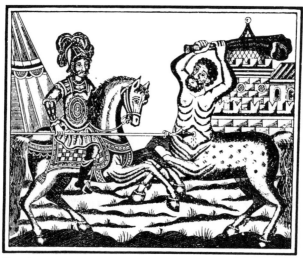

Russian

SCENE 3

At the back of the stage: two large rust-brown rocks, one sharp, the other rounded and larger than the first. Backdrop: black. Between the rocks stand the giants (as in Scene 1) and whisper noiselessly to one another. Sometimes they whisper in pairs; sometimes all their heads come together. Their bodies remain motionless. In quick succession, brightly colored rays fall from all sides (blue, red, violet, and green alternate several times). Then all these rays meet in the center, becoming intermingled. Everything remains motionless. The giants are almost invisible. Suddenly, all colors vanish. For a moment, there is blackness. Then a dull yellow light floods the stage, which gradually becomes more intense, until the whole stage is a bright lemon yellow. As the light is intensified, the music grows deeper and darker (this motion reminds one of a snail retreating into its shell). During these two movements, nothing but light is to be seen on the stage: no objects. The brightest level of light is reached, the music entirely dissolved. The giants become distinguishable again, are immovable, and look before them. The rocks appear no more. Only the giants are on the stage: they now stand further apart and have grown bigger. Backdrop and background remain black. Long pause. Suddenly, one hears from behind the stage a shrill tenor voice, filled with fear, shouting entirely indistinguishable words very quickly (one hears frequently [the letter] *a:* e.g., "Kalasimunafakola!"). Pause. For a moment it becomes dark.

Russian

SCENE 4

To the left of the stage a small crooked building (like a very simple chapel), with neither door nor window. On one side of the building (springing from the roof) a narrow, crooked turret with a small, cracked bell. Hanging from the bell a rope. A small child is pulling slowly and rhythmically at the lower end of the rope, wearing a white blouse and sitting on the ground (turned toward the spectator). To the right, on the same level, stands a very fat man, dressed entirely in black. His face completely white, very indistinct. The chapel is a dirty red. The tower bright blue. The bell made of brass. Background gray, even, smooth. The black man stands with legs apart, his hands on his hips.

The man (very loud, imperiously; with a beautiful voice):

Silence!!

The child drops the rope. It becomes dark.

Egyptian

SCENE 5

The stage is gradually saturated with a cold, red light, which slowly grows stronger and equally slowly turns yellow. At this point, the giants behind become visible (as in Scene 3). The same rocks are also there.

The giants are whispering again (as in Scene 3). At the moment their heads come together again, one hears from behind the stage the same cry, only very quick and short. It becomes dark for a moment; then the same action is repeated again.* As it grows light, (white light, without shadows) the giants are still whispering, but are also making feeble gestures with their hands (these gestures must be different, but feeble). Occasionally, one of them stretches out his arms (this gesture must, likewise, be the merest suggestion), and puts his head a little to one side, looking at the spectator. Twice, all the giants let their arms drop suddenly, grow somewhat taller, and stand motionless, looking at the spectator. Then their bodies are racked by a kind of spasm (as in the case of the yellow flower), and they start whispering again, occasionally stretching out an arm as if in feeble protest. The music gradually becomes shriller. The giants remain motionless. From the left appear many people, clad in tights of different colors. Their hair is covered with the corresponding color. Likewise their faces. (The people resemble marionettes.) First there appear gray, then black, then white, and finally

*Naturally, the music must also be repeated each time.

280

different-colored people. The movements of each group are different; one proceeds quickly forward, another slowly, as if with difficulty; a third makes occasional merry leaps; a fourth keeps turning around; a fifth comes on with solemn, theatrical steps, arms crossed; a sixth walks on tiptoe, palm upraised, etc.

All take up different positions on the stage; some sit in small, close-knit groups, others by themselves. The whole arrangement should be neither "beautiful" nor particularly definite. It should n o t, however, represent c o m p l e t e confusion. The people look in different directions, some with heads raised, others with lowered heads, some with heads sunk on their chests. As if overcome by exhaustion, they rarely shift their position. The light remains white. The music undergoes frequent changes of tempo; occasionally, it too subsides in exhaustion. At precisely these moments, one of the white figures on the left (fairly far back) makes indefinite, but very much quicker movements sometimes with his arms, sometimes with his legs. From time to time he continues one movement for a longer space of time, and remains for several moments in the corresponding position. It is like a kind of dance, only with frequent changes of tempo, sometimes corresponding with the music, sometimes not. (This simple action must be rehearsed with extreme care, so that what follows produces an expressive and startling effect.) The other people gradually start to stare at the white figure. Many crane their necks. In the end, they are all looking at him. This dance ends, however, quite suddenly; the white figure sits down, stretches out one arm as if in ceremonious preparation and, slowly bending this arm at the elbow, brings it towards his head. The general tension is especially expressive. The white figure, however, rests his elbow on his knee and puts his head in his hand. For a moment, it becomes dark. Then one perceives again the same groupings and attitudes. Many of the groups are illuminated from above with stronger or weaker lights of different colors: one seated group is illuminated with a powerful red, a large seated group with pale blue, etc. The bright yellow light is (apart from the giants, who now become particularly distinct) concentrated exclusively upon the seated white figure. Suddenly, all the colors disappear (the giants remain yellow), and white twilight floods the stage. In the orchestra, individual colors begin to stand out. Correspondingly, individual figures stand up in different places: quickly, in haste, solemnly, slowly; and as they do so, they look up. Some remain standing. Some sit down again. Then all are once more overcome by exhaustion, and

everything remains motionless.

The giants whisper. But they, too, remain now motionless and erect, as from behind the stage the wooden chorus, which lasts only for a short time, becomes audible.

Then one hears again in the orchestra individual colors. Red light travels across the rocks, and they begin to tremble. The giants tremble in alternation with the passage of light.

At different ends of the stage, movement is noticeable.

The orchestra repeats several times *b* and *a:* on their own, together, sometimes very shrill, sometimes scarcely audible.

Various people leave their places and go, some quickly, some slowly, over to other groups. The ones who stood by themselves form smaller groups of two or three people, or spread themselves among the larger groups. The big groups split up. Many people run in haste from the stage, looking behind them. In the process, all the black, gray, and white people disappear; in the end, there remain only the differently colored people on stage.

Gradually, everything takes on an arhythmical movement. In the orchestra—confusion. The same shrill cry as in Scene 3 is heard. The giants tremble. Various lights cross the stage and overlap.

Whole groups run from the stage. A general dance strikes up, starting at various points and gradually subsiding, carrying all the people with it. Running, jumping, running to and fro, falling down. Some, standing still, make rapid movements with their arms alone, others only with their legs, heads, or behinds. Some combine all these movements. S o m e t i m e s, there are group movements. S o m e t i m e s, whole groups make one and the same movement.

At that moment, at which the greatest confusion in the orchestra, in the movement and in the lighting occurs, it s u d d e n l y becomes dark and silent. Only the yellow giants remain visible at the back of the stage, being only slowly swallowed up by the darkness. The giants seem to go out like a lamp, i.e., the light glimmers several times before total darkness ensues.

Russian

SCENE 6

(This scene must follow as quickly as possible.)

Dull blue background, as in Scene 1 (without black edges).

In the middle of the stage, a bright yellow giant, with an indistinct, white face and large, round, black eyes. Backdrop and background black.

He slowly lifts both arms parallel with his body (palms downward), and, in doing so, grows upward.

At the moment he reaches the full height of the stage, and his figure resembles a cross, it becomes s u d d e n l y dark. The music is expressive, resembling the action on stage.

FOREWORD TO THE SECOND EDITION[22]

Since the appearance of this book, two years have elapsed. One of our aims—in my eyes, the principal aim—has remained virtually unachieved. It was to demonstrate, by means of examples, practical juxtapositions, and theoretical proofs, that the question of form in art is of secondary importance, that the question of art is above all a question of content.

In practice, the *Blaue Reiter* has been proved right: what arose out of purely formal preoccupations has perished. It lived—supposedly lived—scarcely two years. What arose from necessity has "developed" further. Thanks to the haste of our times, what was more easily assimilated has turned into "schools." Thus, in general terms, the movement reflected here has broadened and yet, at the same time, become more compact. Those explosions that were originally necessary for the breakthrough are therefore decreasing—in favor of a more peaceful, broader, and more concentrated current, gaining in strength.

This widening of the spiritual movement and, on the other hand, its powerful centripetal force, which constantly attracts new elements to itself, are signs of its naturally determined character and its visible goal.

And thus life, reality, follows its own path. In an almost inexplicable way, these thunderclaps that characterize this great epoch go unnoticed: the public (which includes many theoreticians [*Kunsttheoretiker*]) continues, in contrast to the spiritual strivings of the time, to attend to, to analyze, and to systematize more exclusively than ever the element of form.

So the time for "hearing" and "seeing" is perhaps not yet ripe.

But the justified hope that this maturity may come about also has its roots in necessity.

And this hope is the most important reason for the reappearance of the *Blaue Reiter.*

At the same time, the future has in several instances come closer to us in the course of these two years. Thus the possibility of precise evaluation has increased. Further possibilities develop organically from the general. This growth, and the now particularly evident connection between the individual, at first sight totally separate realms of spiritual life, their growing toward one another, and to a certain extent the mutual penetration of the complex and therefore richer forms that arise in this way constitute the necessity for further development of the ideas in this book, indicating [the need for] a new publication.

On Understanding Art
["Über Kunstverstehen"]
Der Sturm
(Berlin), 1912

"On Understanding Art" is the first of an important group of articles and essays by Kandinsky to be published by Herwarth Walden in Berlin. Walden's activities as publisher, as editor, and as organizer of exhibitions helped transform the Prussian capital into the main center of Expressionism in literature and the visual arts during the years immediately before the First World War.[1] It was he who summoned the young Kokoschka to Berlin to help him edit his journal *Der Sturm* [The Storm], a name he also gave to his publishing house and to the gallery he ran, first in the Königin Augustastrasse, later in the Potsdamerstrasse.[2] It was also Walden who was responsible for bringing the works of the Blaue Reiter artists to Berlin in the spring of 1912. In the famous exhibition he organized in September 1913 under the title "Erste Deutsche Herbstsalon" [First German Salon d'Automne], he created the most important conspectus of prewar Expressionist painting in Europe.

Der Sturm had already published an extract from Kandinsky's *On the Spiritual in Art* in April 1912,[3] but "On Understanding Art" was the first essay Kandinsky wrote specifically for Walden. The text was accompanied by three original woodcuts from the years 1906–1910.[4] A Russian translation of this article, entitled "O Ponimanii Iskusstva," appeared in the catalogue of the "Spring Exhibition of Paintings" held in Odessa in March 1914.[5]

W. Kandinsky: Originalholzschnitt 1910

In great epochs, the spiritual atmosphere is filled with a precise desire, a definite necessity, to the extent that one can easily turn into a prophet.

This is characteristic of periods of transition, when that i n n e r maturity which is concealed from the superficial eye gives an invisible, irresistible push to the spiritual pendulum.

It is that same pendulum which, to the same superficial eye, appears merely as an object moving to and fro around the same point.

It travels, in obedience to the law, uphill. Remains there for a moment, an inexpressibly short moment, and then commences upon its new course, its new direction.

At that incredibly short moment at which it stands motionless, anyone can without difficulty prophesy the new direction it will take.

It is remarkable, almost inexplicable, that the "broad masses" refuse to believe in this "prophet."

Everything "precise," analytical, sharply delineated, concrete, determinate, that goes back for centuries and that, to our present horror, developed in all-embracing form during the nineteenth century, is today "suddenly" so foreign, so detached, and, as it seems to many, so "super-

fluous" that one has to force upon oneself the thought, the memory: "It was only vesterday." And . . . "there are still to be found within me many remnants of that era." In this latter thought, each one of us believes just as little as in our own personal death. But here, mere knowledge is not of much help either.

I cannot believe that there exists today a single critic who is not aware that "Impressionism is dead." Many even recognize that it was the logical conclusion of the naturalistic impulse in art.

It appears that even external events are trying to make up for "lost time."

The process of "development" continues with desperate rapidity.

Three years ago, every new picture was attacked by the general public, by the connoisseur, by the amateur, by the critic.

And today . . . who does not talk about cubes, about the dividing up of surfaces, the juxtaposition of colors, the vertical, rhythm?

This is what causes the desperation.

Put simply: It is just impossible that all these terms should be used comprehendingly. People are simply rinsing out their mouths with modern-sounding words.

"On sauve les apparences." One is afraid of seeming stupid. And has, as a rule, no idea how stupid one seems as a result. And indeed is!

In short, there is no worse evil than art-understanding.

Dimly sensing the existence of this evil, artists have always been timid of "explaining" their works, or more recently, of talking about them at all. Many even consider that they debase themselves by explanations. Far be it from me to drag them down from their lofty perch.

Two hoary, eternally new principles govern the spiritual world:

1. The fear of the new, hatred of what one has never experienced.
2. The over-hasty tendency to hang a choking definition around the neck of this new, never before experienced.

The wicked rejoice. They laugh, for these principles are the finest blossoms in their evil-smelling garden.

Hatred and empty noise! Old, faithful companions of the strong, the essential.

Hatred is the murderer.

Empty noise is the gravedigger.
But there is always resurrection.

 * *

 *

In our case, resurrection consists of not understanding art.

Even today, this statement may sound paradoxical.

But the time will soon come when this paradox will be transformed into the correct, the unmistakably clear.

Explaining art, making it comprehensible, can have two consequences:

1. Through words and their spiritual effects new ideas are awakened, and

2. The possible and the more welcome consequence of the foregoing: spiritual forces are unleashed by these effects, which extract what is essential from the work of art—in other words, the work is experienced.

There are two kinds of people: those who content themselves with the inward experience of phenomena (including inner phenomena, among them the work of art); and those who seek to define this inner experience.

To us, however, only experience is itself important, since definitions are impossible without prior experience.

But in any case, these two consequences are the beneficial results of explanations.

These two consequences are, like all living things, capable of further development, inasmuch as they enrich the soul and lead it onward by means of the ideas and creative forces thus awakened, as well as opening the way to shared experiences.

This same kind of explanation can have, however, different consequences:

1. The words themselves give rise to no new ideas, but merely soothe the ailing aspect of the soul: one says to oneself, "Now I know it too," and proceeds to give oneself airs.

2. What is the possible and the more unwelcome consequence of the foregoing: no spiritual forces are awakened by these words; rather, the living work is ousted by the dead word (label).

Thus, it is clear that explanations as such cannot themselves bring the work of art nearer. The work of art is spirit, which speaks, manifests itself, and propagates itself by means of form. Thus, one can explain form and make clear what forms have been employed in a work and for what reasons. Not that this actually enables one to hear the spirit. In the same way, it is easy to give an account of what chemical substances constitute a particular food; one knows the substances, but not the taste. And one's hunger remains unappeased.

Thus, it is clear that explaining art can produce only an indirect effect, that explanations are two-sided, and thus point in two directions: toward life and toward death.

Thus, it is clear what fearful consequences explanations, which are in themselves dead, can bring in their train.

And thus, finally, it is clear that the will alone, even transformed by love, cannot produce any fructifying explanation.

This fructification can only and exclusively come about when the pure will, transformed by love, encounters just such another.

Thus, one should not approach art by means of reason and understanding, but through the soul, through experience.

Reason and understanding are to be found in the arsenal of the well-armed artist, since he must have ready every means that the end might demand.

And he for whom the work was created has only to open wide his s o u l to e x p e r i e n c e.

Then shall he too be blessed.

Munich, September 1912

Sounds
[Klänge]
(Munich), 1912

The album *Sounds* is, without doubt, the most beautiful and most extraordinary of all Kandinsky's publications. Dedicated "TO MY PARENTS," the volume contained thirty-eight prose poems, accompanied by twelve color and forty-four black-and-white woodcuts, handprinted under the artist's supervision by the firm of F. Bruckmann in Munich.[1] The cover was embossed in gold on a fuchsia-colored material. The edition was limited to 345 copies. According to the terms of Kandinsky's contract with his publisher, Reinhard Piper, *Sounds* was scheduled to appear in the autumn of 1912; the exact date of publication remains uncertain.

The woodcuts included span the years 1907–1912; according to Kandinsky, the poems were written between 1909 and 1911.[2] He initially conceived of the album as a "musical" publication,[3] believing that the juxtaposition of woodcuts and poems created a kind of "synthetic" unity. It is not altogether easy to see what this unity consisted in, especially since a quite different layout was envisaged for the ill-fated Russian edition.[4] Kandinsky, however, was most sensitive about the context in which his poems appeared: see his letter of protest to the editor of the Russian newspaper *Russkoe Slovo* regarding the illicit reprinting of four of the poems in the Futurist anthology *Poshchechina obshchestvennomu vkusu* [A Slap in the Face of Public Taste] (see p. 347).

This is not the place to try to evaluate Kandinsky's contribution to the development of twentieth century literature. Suffice it to say that *Sounds* is quite unlike any other publication of its date. In these prose poems, the author's fascination with the sounds of words and with the gulf between

sound and sense is clearly apparent. He also uses frequent repetition to divorce words from their meanings, a technique he discusses in *On the Spiritual in Art*. Layout, typography, and punctuation, as well as more specifically poetic devices like assonance and ellipsis, are all exploited in quite unconventional ways. Unique in the succession of images they employ and the sense of dreamlike disorientation they induce, it is no coincidence that Kandinsky's poems were adopted with such enthusiasm by the Dada painters and poets. Extracts from *Sounds* were read at the famous *soirées* of the Cabaret Voltaire, founded in Zurich in February 1916 by Kandinsky's friend Hugo Ball;[5] and the single poem "Sehen" [See] was published in the sole number of the review *Cabaret Voltaire* in June 1916. Arp wrote, many years later: "Kandinsky has conjured up out of 'pure being' beauties unheard-of in this world. In these poems sequences of words and sentences cropped up such as had never previously existed in poetry . . . shadows rise up, powerful as eloquent mountains . . . anthropomorphic shapes dissolve into teasing phantasms. . . . In these poems, we experience the pulse, the becoming and decay, the transformation of this world. Kandinsky's poetry lays bare the vacuousness of phenomena and of reason."[6]

Unfortunately, the terms of Kandinsky's original contract with Piper forbade any subsequent edition of the whole volume, so that in later years, both poems and woodcuts were reproduced singly in various publications, further destroying the unity the artist had envisaged.[7] In this edition, we have tried to preserve the original layout of the poems themselves, and to indicate the relationship between the texts and the accompanying vignettes. (See also Kandinsky's essay 'My Woodcuts,' pp. 817–819.)

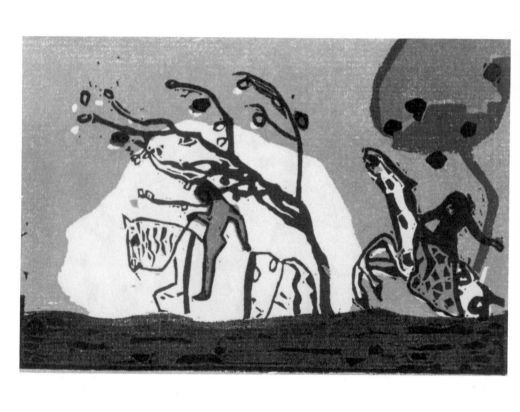

HILLS

A mass of hills in every conceivable, imaginable color. Of all different sizes, but always the same shape, i.e.: Broad at the bottom, with swollen sides and rounded tops. Simple, ordinary hills, of the kind one always imagines and never sees.

Between the hills winds a narrow path of simple white, i.e., neither blue-white nor yellow-white, having neither blue nor yellow in it.

Clad in a long, black, seamless robe, which covers even his ankles, a man walks along this path. His face is pale, except for two patches of red on his cheeks. His lips, too, are red. Hung about him is a big drum, and he drums.

The man walks very oddly.

Sometimes he runs, dealing his drum feverish, irregular blows. Sometimes he walks slowly, perhaps immersed in thought, and drums almost mechanically, in a long drawn out rhythm: one . . . one . . . one . . . one . . . sometimes he stands quite still and thumps like the soft white pet rabbit we all love.

But he doesn't stand still for long.

Then the man starts to run again, dealing his drum feverish, irregular blows.

As if completely exhausted, he lies there, the black man, stretched out on the white path, amidst the hills of all colors. His drum lies beside him, and the two drumsticks as well.

He stands up. He is about to run again.

I observed all this from above and request you likewise to look down on it from above.

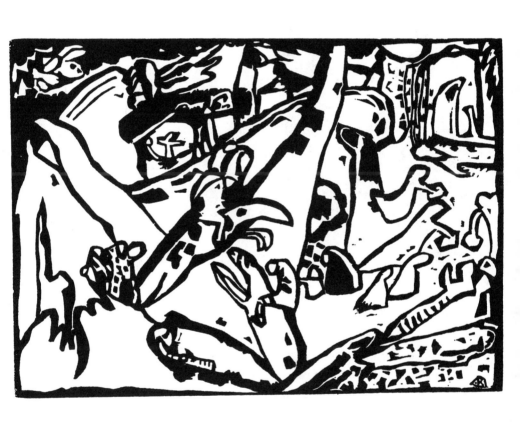

SEE

Blue, blue, rose up, rose up, and fell.
Sharp, thin whistled and pressed in, but could not prick through.
There was a droning in every corner.
Fat brown hung seemingly for all eternity.
 Seemingly. Seemingly.
You must stretch your arms out wider.
 Wider. Wider.
And you must cover your face with a red cloth.
And perhaps it has not yet been moved: only you have been
moved.
White crack after white crack.

And after this white crack another white crack.
And in this white crack a white crack. In every white crack á white crack.
It just won't do that you can't see the opaque: the opaque is just where it is.
And that's how it all starts
...................... There was a crash

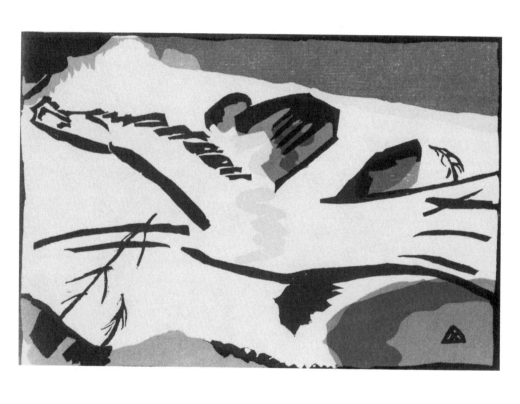

BASSOON

Great big houses suddenly collapsed. Little houses stood calm.
A thick, hard, egg-shaped orange-cloud suddenly hung above
the town. It appeared to hang from the pointed pinnacle of the
tall, thin town-hall tower, and radiated violet.
A barren, bare tree stretched out to the deep sky its shaking,
trembling, long branches. It was quite black, like a hole in a white
sheet of paper. The four small leaves trembled for a long time.
But there was no wind.

But when the storm came and the walls of many a stout building collapsed, the thin branches remained motionless. The small leaves turned stiff: as if cast in iron.

A flock of crows flew through the air in a dead-straight line across the town.

And once again everything was still.

The orange-cloud disappeared. The sky became a piercing blue. The town plangent yellow.

And through this silence rang only one sound: of horses' hooves.

And then one knew that through the totally deserted streets a white horse was wandering all alone. The sound lasted a long time, a long, long time. For this reason, no one could tell exactly when it would stop. Who can tell when silence begins?

Through extended, long drawn-out, somewhat expressionless, unsympathetic tones of a bassoon, resounding in the empty depths, everything became green. At first dark and rather dirty. Then ever brighter, colder, more poisonous, still brighter, still colder, still more poisonous.

The buildings grew upward and became narrower. They all inclined toward a point to the right, where the dawn perhaps is. It made itself felt as a striving toward the dawn.

And still brighter, still colder, still more poisonous became the green of the sky, the houses, the pavement, and the people walking on it. They walked slowly, constantly, without ceasing, always looking in front of them. And always alone.

But the bare tree took on a correspondingly large, rich crown of foliage. This crown was lofty and had a compact, sausage-like shape, curving upward. Only this crown was such a lurid yellow that no heart could bear it.

It is as well that none of the people walking underneath saw this crown. Only the bassoon tried to indicate this color. It climbed higher and higher, its strained tone becoming harsh and nasal. How fortunate the bassoon could not reach this tone.

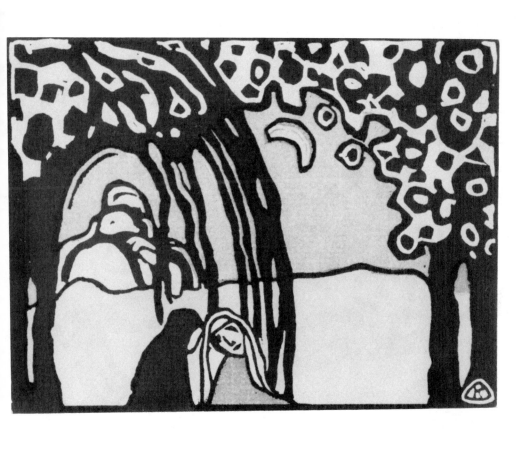

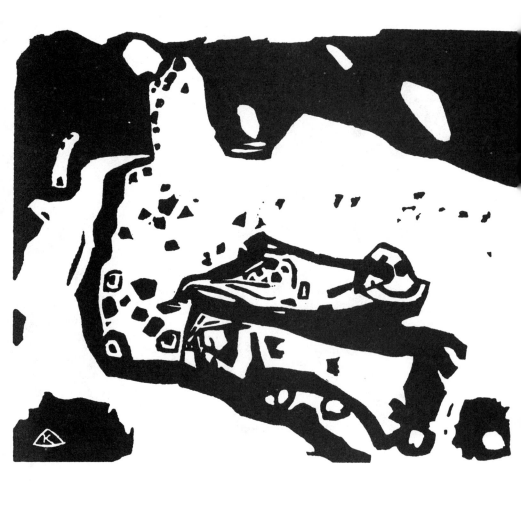

OPEN

Now vanishing slowly in the green grass.
Now sticking in the gray mud.
Now vanishing slowly in the white snow.
Now sticking in the gray mud.
Lay long: thick long black reeds.
Lay long.
Long reeds.
Reeds.
Reeds.

EARLY SPRING

A gentleman took his hat off in the street. I saw black and white hair, stuck down with brilliantine to right and left of the parting. Another gentleman took his hat off. I saw a large pink, rather greasy pate, with a bluish reflection.
The two gentlemen looked at each other, and each showed the other crooked, grayish-yellow teeth with fillings.

CAGE

It was torn. I took it in both hands and held the two ends together. Round about, something grew. Close about me. And yet there was nothing to be seen.

Indeed, I thought there was nothing there. And yet I could not move forward. I was like a fly under a cheese cover.

I.e., nothing visible, and yet insuperable. It was even empty. All alone in front of me stood a tree, in fact a sapling. Its leaves as green as verdigris. Thick as iron and just as hard. Small red apples hung with a blood-colored glow from the branches. That was all.

THAT

You all know this giant cloud that is like a cauliflower. You can chew its snow-white hardness. And your tongue remains dry. So it weighed heavily upon the deep blue air.
And below, below it on the earth, on the earth stood a burning house. It was strongly, oh, strongly built of dark red bricks.
And it was a mass of yellow flames.
And in front of this house on the earth. . . .

BELL

Once upon a time, a man in Weisskirchen said: "I shall never, never do that." At exactly the same time a woman in Mühlhausen said: "Beef with horseradish."
Each said his own sentence, for they had no alternative.
I hold a pen in my hand and write with it. I would not be able to write with it if it had no ink.

The big strong beast, which greatly enjoyed chewing and ruminating, was stunned by quick, successive, dully resounding hammer blows upon its skull. It collapsed. From an opening in its body, blood flowed freely. Much thick, sticky, odorous blood flowed interminably.

With what marvelous skill the thick, warm, velvet skin, with its beautiful pattern of brown-white hairs, was carved up. Flayed skin and red, steaming, reeking flesh.

Very flat country, vanishing flatly to every horizon. At the extreme left, a small birch coppice. Still very young, tender white trunks and bare branches. Nothing but brown fields, neatly plowed in straight furrows. In the midst of this gigantic circle a small village, only a few gray-white houses. Right in the middle a church tower. The little bell is tolled by a rope and goes: ding, ding, ding, ding, ding. . . .

EARTH

The heavy earth was loaded with heavy spades onto carts. The carts were loaded and grew heavy. Men shouted at the horses. Men cracked their whips. Heavily drew the horses the heavy carts with the heavy earth.

WHY?

"No one has come out."
"No one?
"No one.
"Someone?
"No.
"Yes! But as I came past, someone was standing there.
"In front of the door?
"In front of the door. He stretched out his arms.
"Yes! Because he won't let anyone in.
"No one has gone in?
"No one.
"He who stretches out his arms, was he there?
"Inside?
"Yes. Inside.
"I don't know. He only stretches out his arms so that no one could get in.
"Was he sent here so that No one should get in? Who stretches out his arms?
"No. He came and put himself here and stretched out his arms.
"And No one, No one, No one has come out?
"No one, No one."

UNALTERED

My bench is blue, but not always there. Only the day before yesterday did I find it again. Beside it stuck the cooled-off thunderbolt, as usual. This time, the grass around the thunderbolt was a bit burned. Perhaps the thunderbolt had suddenly started to glow in secret, with its point in the earth. Otherwise, I found nothing changed: everything in the same old place. It was as always. I sat on my bench. On my right, the thunderbolt—with its tip sunk in the earth: the tip, which had alone perhaps glowed. In front of me the great plain. Fifty paces away on my right, the woman with the black cloth pressed to her bosom, like a banana. She is looking at the red mushroom. On my left the same weather-beaten inscription:

'Ban! Anna!'*

*[The German reads here "*Bann! Ahne!*"—a play upon the word '*Banane*' in the penultimate sentence. The translator has tried to render the sound, in this instance, rather than the sense.]

I have read it often and knew from afar off the sound on this weather-beaten white stone. As usual, the four green houses grew up out of the ground two hundred paces from me. Noiselessly. The door of the second from the left opened. The fat, red-haired man in his pale violet tights (I always think of dropsy when I see him) led his piebald horse out from the last house on the right by the hill, leaped upon it and rode (as one says) like the wind. As usual, his frightful shout could be heard thundering from afar:

Just wait! Ha! I'll pay you in fright full!

Then at once, the thin Turk came as usual out of the second house (from the right) with his white watering can, watered his withered sapling with tinted inks, sat down, leaned his back against the trunk, and laughed. (I could not hear him laugh.) And I had the same mad thought that the tinted inks must tickle him. Then one heard in the distance an invisible bell strike
 "tint-tint."
And the woman turned her gaze on me.

OBOE

Nepomuk had his beautiful new outdoor coat on as he sat down on the small round flat hill.

Below, the small blue green lake pricked the eyes.

Nepomuk leaned against the trunk of the small white green birch tree, pulled out his big long black oboe and played many well-known songs. He played for a very long time with a great deal of feeling. Getting on for two hours. As he started on *"Es kam ein Vogel geflogen,"* and had just got to *"geflo . . .,"* Meinrad, hot and out of breath, came running up the hill and, with his crooked, pointed, sharp, curved, gleaming sabre, cut a large chunk off the oboe.

SPRING

Be quiet, you garish fellow!
Slowly, the old house slides down the hill. The old blue sky sticks
hopelessly amidst branches and leaves.
Stop calling me!

Hopelessly, the ringing hangs in the air, like a spoon in a thick gruel.

One's feet stick in the grass. And the grass wants to prick through the invisible with its points.

Lift your axe above your head and chop! Chop!

Your words can't reach me. They're hanging on the bushes like wet tatters.

Why doesn't anything grow, only this rotting wooden cross at the fork in the road? And its arms have penetrated the air to right and to left. And its head has pierced a hole in the sky. And from its edges creep stifling red-blue clouds. And thunderbolts tear and cut them in places you least expect, and their cuts and tears mend invisibly. And somebody falls like a soft eiderdown. And somebody speaks, speaks - - - speaks - - -

Is that you again, you garish fellow? You again?

SOME THINGS

A fish went deeper and deeper into the water. It was silver. The water blue. I followed it with my eyes. The fish went deeper and deeper. But I could still see it. I could see it no more. I could still see it, even when I could not see it.
Yet, yet, I saw the fish. Yet, yet, I saw it. I saw it. I saw it. I saw it. I saw it. I saw it. I saw it.
A white horse stood quietly on long legs. The sky was blue. Its legs were long. The horse was motionless. Its mane hung down and did not move. The horse stood motionless on long legs. But it was alive. No flexing of the muscles, no quivering of the hide. It was alive.

Yet, yet. It was alive.

On the broad meadow grew a flower. The flower was blue. There was only one flower on the broad meadow.

Yet, yet, yet. It was there.

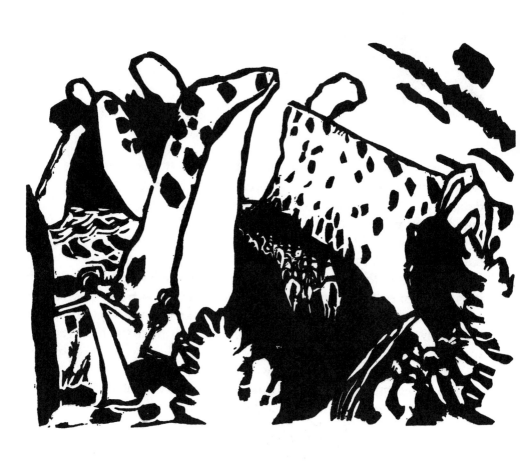

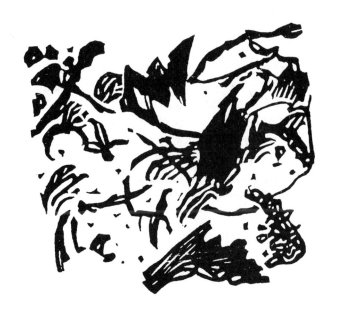

NOT

The jumping man interested me a great deal. He excited me. He has dug a small, very round hollow in the flat, hard, dry earth, and every day he jumped ceaselessly across it from four o'clock until five.—He jumped from one side of the hollow to the other with an effort that would have sufficed for a hole three yards wide. And at once back again.

And at once back again. And at once back! Back, back. Oh! back again, back again! Again, again. Oh again, again, again. A-gain . . . A-gai-n. . . .

You shouldn't be a witness to something like that.

But if you happened to be there already, even if only once, one single tiny time, then . . . yes, then . . . how are you supposed to avert your eyes? How could you not go? Not go? The not is sometimes impossible to attain. Who among men, who at this time live out the second (and last) half of their life on earth, does not know? . . . Everyone knows! Which is why I have to keep going to the jumping man. And he excites me. He makes me sad. He . . . Never go!! Never look at him!! Never!!

.

.

.

It is already after half past three. I must go. Otherwise I shall be late.

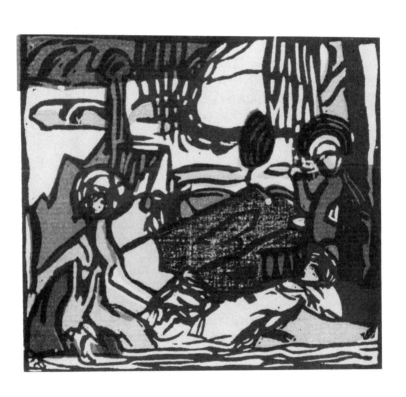

YET AGAIN?

Thou, wild foam.
Thou, useless snail, you that do not love me.
Empty stillness of unending soldiers' steps, which from here I cannot hear.
You, four square windows with a cross in the middle.
You, windows of the empty hall, the white wall, against which no one leaned. You eloquent windows with inaudible sighs. You show yourselves cold toward me: you were not built for me.
 Thou, real glue.
Thou, pensive swallow, you that do not love me.
Self-devouring stillness of the rolling wheels, which hunt and create the figures.
You thousands of stones, which were not laid for me, sunk in with hammers. You keep my feet in thrall. You are small, hard, and gray. Who has empowered you to show me the gleaming gold? Thou, eloquent gold. Thou wait'st for me. Thou show'st thyself warm toward me: for me art thou built.
 Thou, spiritual glue.

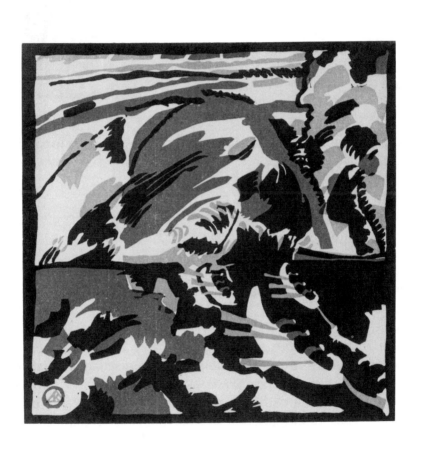

SOUNDS

Face.
Distance.
Cloud.
. . . .
. . . .
There stands a man with a long sword. The sword is long, and broad, too. Very broad.
. . . .
. . . .
He often sought to deceive me, and I confess he succeeded—in deceiving me. And perhaps too often.
. . . .
.
Eyes, eyes, eyes . . . eyes.
.
.
A woman, who is thin and not young, who has a cloth on her head, which sticks out like a shield over her face, leaving her face in shadow.
The woman pulls a calf on a rope, still small and shaky on its crooked legs. Sometimes the calf runs along behind quite willingly. Sometimes he doesn't want to. Then the woman pulls on the rope. It lowers its head and shakes it and splays its legs. But its legs are weak, and the rope does not break.
The rope does not break.
.
.
Eyes look from a distance.
The cloud ascends.

.

.

The face.

The distance.

The cloud.

The sword.

The rope.

WATER

Across the yellow sand walked a small, thin, red man. He kept slipping. He looked as if he were walking on ice. But it was the yellow sand of the unbounded plain.

From time to time he said, "Water. . . . Blue water." And he himself did not understand why he said it.

A rider dressed in a green, pleated coat rode furiously past on a yellow horse.

The green rider drew his thick white bow, turned in his saddle, and shot the arrow at the red man. The arrow whistled like a sob, and was aimed so as to penetrate the heart of the red man. At the last moment, the red man grasped it and threw it aside.

The green rider smiled, bent over the neck of the yellow horse, and vanished in the distance.

The red man grew bigger and his tread became more secure. "Blue Water," he said.

He walked on, and the sand turned into dunes and hard hills that were gray. The further he went, the harder, grayer, higher were the hills, until at last the cliffs began.

And he had to force himself on between the cliffs, for he could neither stop nor go back. One cannot go back.

As he was walking past a very high, pointed rock, he observed that the white man who squatted atop it was about to drop a thick gray block on him. One cannot go back. He had to pass through the narrow defile. He went. Just as he was beneath the rock, the man above, panting with exertion, gave the final heave.

And the block fell on the red man. He caught it on his left shoulder, and threw it behind his back. The white man above smiled and inclined his head amicably. The red man became still bigger, i.e., taller. - - "Water, water," he said. - - The path between the rocks grew broader and broader, until finally flat sand dunes ensued once more, which became still flatter and still flatter, until they ceased altogether.

—Instead, only another plain.

THE BREAK

The small man wanted to break the chain and of course could not. The big man broke it quite easily. The small man wanted to escape straightaway.
The big man held him by the sleeve, leaned toward him, and said softly in his ear:
"we must keep quiet about this." And they both laughed heartily.

DIFFERENT

It was a big 3—white on dark brown. The curve at the top was the same size as the curve at the bottom. So thought many people. And yet the top was

 slightly, slightly, slightly

bigger than the bottom.

This 3 looked always to the left—never to the right. At the same time it looked slightly downward, for the figure only seemed to stand perfectly upright. In reality, although it was not easy to notice, the larger top part was

 slightly, slightly, slightly

inclined to the left.

So this big white 3 looked always to the left and a fraction downward.

It could perhaps have been different.

EXIT

You clapped your hands. Don't bend your head to your happiness.
Never, never.
And then he cuts again with his knife.
Again he cuts through with his knife. And the thunder rumbles in the sky.
Who brought you in further?
In the dark, deep, still water, the trees have their tops downward.
Always. Always.
And then he sighs. A deep sigh. Again he sighed. He sighed.
And the stick hits something dry.
Who points to the door, the exit?

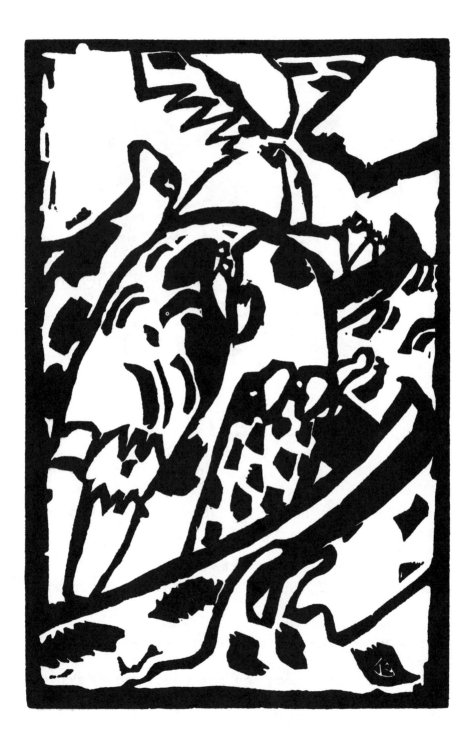

IN THE WOOD

The wood grew denser and denser. The red trunks thicker and thicker. The green foliage heavier and heavier. The air darker and darker. The bushes more and more profuse. The toadstools more and more numerous. In the end one found oneself treading on nothing but toadstools. The man found it more and more difficult to walk, to push his way through without slipping. But he went on, repeating more and more quickly the same sentence: — —

Healing scars.

Corresponding colors.

To his left and a little behind him walked a woman. Each time the man stopped saying this sentence, she would say with great conviction, rolling her "r"s:

verrry prrractical.

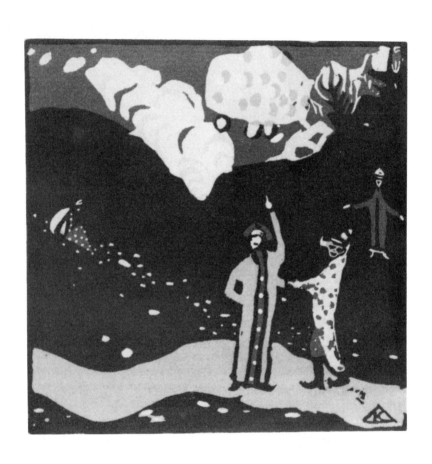

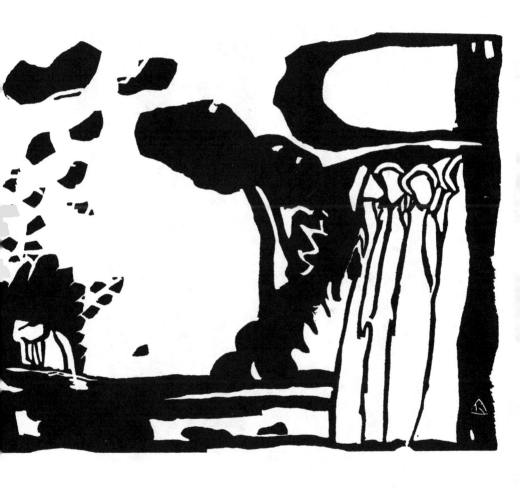

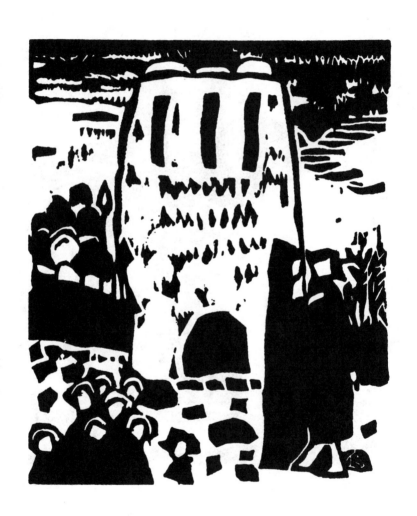

CURTAIN

The rope came down and the curtain went up. We had all been waiting so long for this moment. The curtain hung. The curtain hung. The curtain hung. It hung down. Now it's up. As it went up (started to go), we were all so overjoyed.

WHITE FOAM

I should very much like to know why it is so and not otherwise. It could be different, quite, quite different.

On a raven-colored horse, a woman rides across flat green meadows. I cannot see the far side of these meadows. The woman is dressed in red, her face concealed by a canary-yellow veil. The woman whips the horse unmercifully. But it cannot gallop any faster. It's gasping as it is, increasingly covered with hot white foam. The woman sits upright, unswerving, and whips the black horse.

Don't you think it would be better for the black horse to die? It's all white with hot white foam!

But it cannot die. Oh no! It cannot.

How different it might be, quite different.

HYMN

There the blue wave rocks.
The torn red cloth
Red rags. Blue waves.
The old book closed up.
Gaze in silence at the distance.
Wander blindly in the wood.
The blue waves deeper grow.
The red cloth soon sinks below.

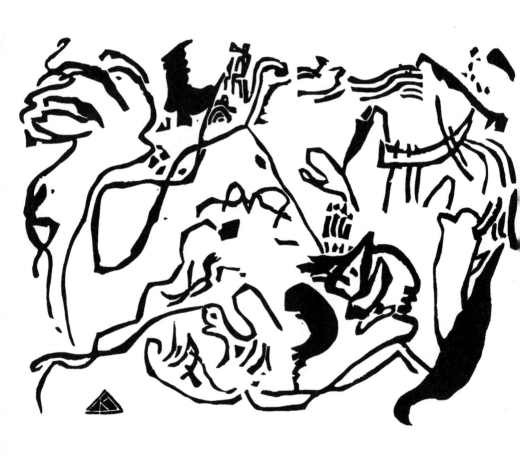

LATER

I shall find you in the deep heights. Where the smooth pricks. Where the sharp cannot cut. You hold the ring in your left hand. I hold the ring in my right hand. Neither sees the chain. But these rings are the last links in the chain.

The beginning.
The end.

ADVENTURE

I once visited a group of villas where nobody lived. All the houses were decorated in white and had firmly closed green shutters. In the middle of this group of villas was a green square covered with grass. In the middle of this square stood a very old church with a high belltower with a pointed roof. The big clock went, but did not strike. At the foot of this bell tower stood a red cow with a very fat belly. It stood motionless, chewing sleepily. Whenever the minute hand on the clock pointed to the quarter, the half-hour, or the hour, the cow would bellow, "Eh! Don't be so frightened!" Then it would start chewing again.

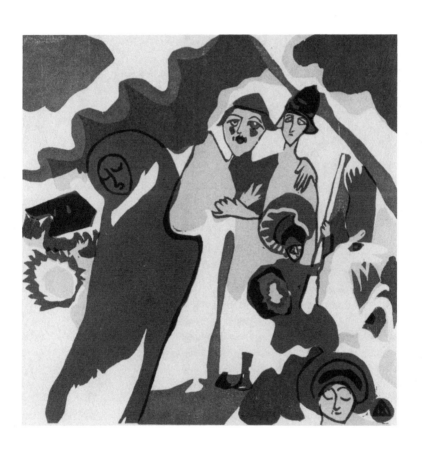

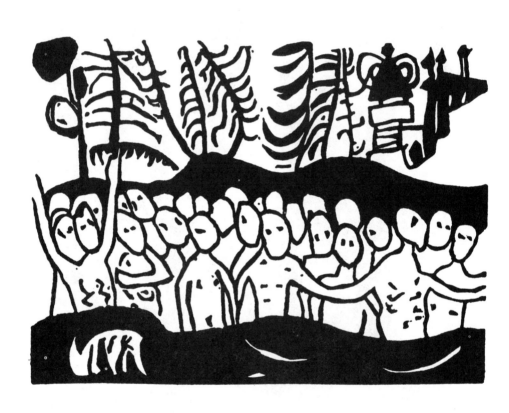

CHALK AND SOOT

Oh, how slowly he walks.
If only there were someone who could say to the man: Faster,
walk faster, faster, faster, faster, faster.
But there is no one. Or is there?
That black face with white lips, completely white lips, as if drawn,
smeared, made up with chalk.
And the green ears!
Were they green? Or not? Or were they?
Every autumn, the trees lose their foliage, their clothing, their
finery, their body, their crown.

Every autumn. And how many more? How many more autumns? Eternity? Or not? Or is it?

How slowly he walks.

And every spring the violets grow. And smell, smell. They always smell.

Will they never stop smelling. Or will they?

Would you prefer it if he had a white face and black lips, as if they had been smeared, drawn, made up with soot? Would you, prefer that?

Or is there someone who will say to the man, is perhaps already saying: Faster, faster, faster.

Faster, faster, faster, faster, faster.

SPRINGTIME

1.

In the west the new moon.
In front of the new moon's horns, a star.
A narrow, tall black house.
Three lighted windows.
Three windows.

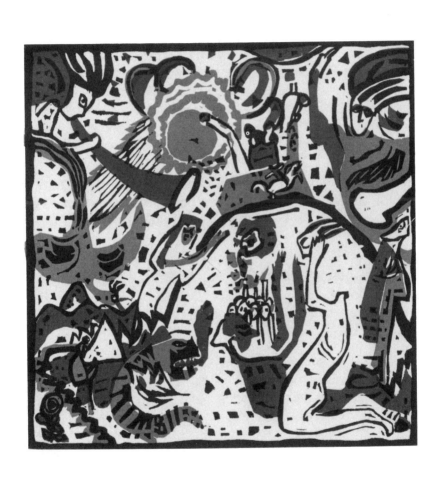

2.

In the brilliant yellow are pale blue flecks. Only my eyes saw the pale blue flecks. They did my eyes good. Why did nobody else see the pale blue flecks in the yellow brilliance?

3.

Dip your fingers in the boiling water.
Boil your fingers.
Let your fingers sing of pain.

LEAVES

I can remember something.
A very large, triangular black mountain reached up to the sky.
Scarcely visible was its silvery summit. To the right of this
mountain stood a tree, which was very thick and had a thick
green crown. This crown was so thick that the individual leaves
could not be separated from one another. To the left there grew
only on one patch, but very densely, small white blossoms that
looked like little flat plates.
Otherwise, there was nothing.
I stood in front of this landscape and looked.

Suddenly, a man comes riding up from the right. He rode a white ram, which looked perfectly ordinary, except that its horns pointed not backward but forward. And its tail was not turned up in the usual impudent way, but hung down, and was bald.

The man, however, had a blue face and a short snub nose. He laughed, showing his small, wide-apart, rather worn, and yet very white teeth. I also noticed something sharp-red.

I was very surprised when the man grinned at me.

He rode slowly past and disappeared behind the mountain.

The curious thing was that when I looked again at the landscape, all the leaves lay on the ground, and on the left the flowers had all gone. There were only red berries.

The mountain, of course, remained motionless.

This time.

SONG

There sits a man
In the narrow circle,
In the narrow circle
Of frugality.
He is satisfied.
He has no ear.
His eyes are missing.
Of the red sound
Of the sun's globe
He can perceive no trace.
What has been razed
Will rise again.
And what was speechless
Now sings a song.
He will, this man
Who has no ear
Whose eyes are missing
Of the red sound
Of the sun's globe
Perceive faint traces.

ROOT

Rapid little spiders fled before my hand. Little agile spiders. My eyes were thrown back by your pupils.

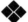

—"Does he remember the tree?
—"The birch?

The light of the evening star at the appointed hour will come. Do you know when?

—"The tree I saw he knows not.
—"The tree grows in its growing from hour to hour.
—"And the flame destroys the dry foliage.
—"The dry foliage.

The bell tries to strike holes in the air.
And cannot.
It keeps getting caught.

—"He can remember the tree. The tree trembled from bottom, from the root, to top, to the crown.
—"Oh!! the topmost leaves.
—"He can still remember the tree!!
—"The birch?

TABLE

It was a long table. Oh, a long, long table. To right and left of this
table sat many, many, many people,
people, people,
people.
Oh, long, long they sat, these people at this long, long table.

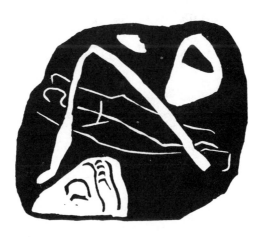

BRIGHT MEADOW

In a meadow, in which there was no grass, but only flowers,
which were extremely colorful, five men sat in a straight line. A
sixth stood to one side.
The first said
'The roof is firm. . . . Is firm the roof. . . . Firm. . . .

After a while, the second said:

'Don't touch me: I sweat. . . . I'm sweating. . . . Yes!

And then the third:

'Not over the wall!

Not over the wall! No!

Whereupon the fourth:

'Ripening fruit!!

After a long silence, the fifth cried with a piercing voice:

'Wake him up! Make him open his eyes wide! There's a stone rolling down from the mountain. A, stone, a stone, a stone, a stone! . . . From the mountain! . . . It's rolling down! . . . Make his ears eager! Oh make his eyes wide! Make his legs long! Long, long . . . his legs!!

The sixth, who stood to one side, cried out short and sharp:

'Silence!

GAZE

Why do you look at me through the white curtain? I did not call for you, I did not ask you to look through the white curtain at me. Why does it conceal your face from me? Why can't I see your face behind the white curtain? Don't look at me through the white curtain! I did not call for you. I did not ask you. Through closed lids I can see you looking at me, you who look at me through the white curtain. I shall pull the white curtain aside and see your face, and you will not see mine. Why can I not pull the white curtain aside? Why does it hide your face from me?

THE TOWER

Man in green tights with his moustache turned upward lay almost full-length upon the green meadow. I never liked him. Red toadstools were all around.
Woman came from out of the green forest. She was blue, and I found her unpleasant.
She sat down beside him and all the toadstools vanished. Were gone.
Man stood up and went. And woman beside him. Thus they walked out of the green forest toward the big red house.
The gray door was firmly locked. The door was not there.
She went in. Then he too went in.
They often both stand right up at the top of the tower, something that is unpleasant.
The gray door is firmly locked.

GAZE AND THUNDERBOLT

That while he (the man) wanted to feed himself, the thick white comb cast off the rosebird. Now she rubs the windows wet in wooden towels!—Not to the distant, but to the bent.—Discharged itself the chapel—hey! hey! Semicircular pure—circles press almost upon chess boards and! iron books! Kneeling beside the jagged ox wants Nuremberg wants to lie—horrifying weight of the eyebrows. Heaven, heaven, imprinted ribbons you can bear.... Even from my head the leg of the short-tailed horse with the pointed mouth might grow. But the red prong, the yellow heel at the north polack like a rocket at midday!

SOFT

Each lay upon his own horse, which was unattractive and unseemly. It is certainly better if a fat bird sits on a thin branch that is not his own with its small, trembling, quaking, living leaf. Everyone can kneel (anyone who doesn't know how can learn). Can everyone see the pointed towers? Open the door! Or the fold will tear the roof off!

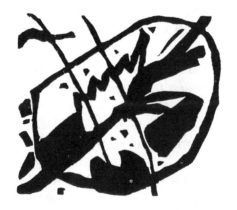

Autobiographical Note/Postscript
[An untitled essay and "Ergänzung"]
Kandinsky: Kollektiv-Ausstellung, 1902–12
(Munich), 1913

The following texts—a brief autobiographical note,
untitled as such, and Postscript [Ergänzung]—appeared in
the second edition of the catalogue *Kandinsky: Kollektiv-
Ausstellung, 1902–12,* early in 1913. The second edition,
like the first, was issued by the Munich dealer and publisher
Hans Goltz, who had shown the second Blaue Reiter exhibi-
tion the previous spring; the first edition, however, did not
contain the Postscript. The catalogue was later reissued by
Herwarth Walden in Berlin under the imprint of his own
Verlag "Der Sturm"; this republication also differs in a
number of ways from the two editions published by Goltz.[1]
In all three editions, the cover is adorned with a line etching
that depicts a rowboat and a figure on horseback on either
side of a giant sunflower;[2] the sunflower also occurs in the
woodcut *Three Riders in Red, Blue, and Black* of 1911,
published in the album *Sounds* (see pp. 291–340).[3]
Despite its brevity, the autobiographical note is of interest,
since it tells us a number of details, otherwise unrecorded,
about the artist's early life in Russia. The Postscript deals
largely with the criticisms leveled at his book *On the
Spiritual in Art*—in particular, the assertion that the artist's
aim was to depict music (alternatively, states of mind).[4]
Kandinsky returns to these same criticisms, which seem to
have offended him deeply, in the notes for his Cologne lec-
ture (see pp. 392–400).

KANDINSKY
KOLLEKTIV-AUSSTELLUNG
1902 1912

VERLAG „NEUE KUNST"
HANS GOLTZ, MÜNCHEN

[Autobiographical Note]

I was born on 5 December 1866 in Moscow.[5] Up to my thirtieth year I longed to be a painter, since I loved painting above all else, and it was not easy for me to fight against this longing. It appeared to me at that time that art was an unallowable extravagance for a Russian.

For this reason I chose to specialize in economics at the university. The faculty offered me the opportunity to devote my life to an academic career. As "assistant" at the University of Moscow, I was even given official opportunity to do so.

After six years, however, I began to notice that my earlier belief in the beneficial value of the social sciences and, ultimately, in the absolute rightness of positivistic methods had seriously diminished. Finally, I decided to throw overboard the results of many years' work. And it seemed to me then that all that time had been wasted. Today, I know just how much I accumulated during those years, and I am grateful.

Previously, I had concentrated upon the theoretical side of the problem of wages. Now I wanted to approach this same problem from the practical side, and I took up the position of manager in one of the largest printing firms in Moscow. My new speciality was heliographic reproduction, which to some extent brought me into contact with art. My environment was one of working people.

I stayed in this job, however, for only one year. At the age of thirty, the thought overcame me: now or never. My gradual inner development, of which until now I had been unconscious, had progressed so far that I could sense my artistic powers with complete clarity, while inwardly I was sufficiently mature to realize with equal clarity that I had every right to be a painter.

And so I went to Munich, whose art schools were at that time highly regarded in Russia. For two years I went to the famous Ažbè school, and forced myself to study the organic side of drawing, which I found uncongenial. After which I tried for the drawing classes of the Munich Academy, but failed the [entrance] examination. After a year spent working by myself, I showed my sketches to Franz Stuck, and was accepted into his painting class at the Academy. I owe a great deal to his instruction, particularly his advice concerning the completion of a picture.

After a year, however, I found that I had to pursue my work by myself, and this was the beginning of my artistic career.

Since then, a decade has passed, years that are reflected in this collection.

This collection shows that my aims have always remained the same, but have only gained in clarity, and that my entire development has consisted only in the concentration of means necessary to attain this goal, means that gradually liberated themselves from everything that was for me incidental.

Munich, September 1912

Postscript

In general, it is the fate of the artist to be misunderstood. This, like every fact, has two sides. I.e., out of this misunderstanding arise possibilities of discovering new qualities in a work of art, and therefore new sources of experience. Thus, volumes have been written about works of art, and the content of these volumes would astonish many an author of the works in question. This is the fine, beneficial aspect of misunderstanding, which here brings to light hidden, undreamed-of riches from the work of art.

The more unpleasant aspect of misunderstanding is usually the first to reveal itself. This is the source of the hatred directed against the author, and of his suffering. This unpleasant aspect is, however, only really damaging when the artist's principal aim appears in a false light, and his work thus takes on a ghostly, deformed, and unreal existence. Here, explanations are of no help. The artist feels caught in a nightmare: he must run to reach his goal, but his legs seem as if tied together, and his trembling knees give way under him. That is to say, it is not only absolutely, but for the most part also relatively impossible for the artist to make plausible, to represent clearly, correctly, exhaustively this "goal." It is boring to go on indefatigably repeating ancient truths. I must force myself, however, and say: Art cannot be exhaustively explained either in absolute or in relative terms.

Only one method is possible: the process of elimination. Of combating the wrong "explanations" that fundamentally ruin the whole existence of the work of art.

As far as I and my own particular "goals" are concerned, unfortunately, I all too often come across the two following "explanations," which, while perhaps ingenious, nevertheless distort my entire work by causing it to be seen in a false light.

1. It is fondly maintained that I paint music. This assertion comes

from superficial readers of my book *On the Spiritual in Art*. In this book I write at great length, for pages and pages, of the fact that it is an impossible and useless task to attempt to replace one form of art by another, that it is our good fortune that the different arts dispose of fundamentally different means. Just as the spectator in general looks for the object, or beauty, or *peinture*, or whatever (according to fashion) in a picture, so too the reader in general reads a book. That is to say, he reads words and sentences and has really no idea of the content of the book. In my book, the reader often comes across the word "music," and from this he concludes that I paint music. Some people are not willing to, and the rest are not able to understand the meaning of what is written.

2. Because in the same book I discuss the spiritual and devote a special chapter to the effects of pictorial form upon the soul, even more superficial readers conclude that I paint psychic states—in particular, my own. Especially since in my latest pictures objects are no longer recognizable. This example of logic may—and indeed should—remain unchallenged. I, for my part, have no desire to attempt to shake it.

I am content to point out the irrelevance of this question.

It is as obvious as ABC that no work of art can come into being without "psychic states"—only a dead semblance, chewed at with delight by the unfeeling. This is graced with the official name of connoisseurship.

Far be it from me to deprive people even of this pleasure.

Whether one believes me or not, I would only like to emphasize one thing here: The desires of the artist himself are irrelevant—what is, however, relevant is whether the work of art is alive or not. That is to say, if ultimately the work of art is in fact alive, it does not matter from what cause it may have arisen: every cause is in this instance equally good. And every cause is equally bad if the result is a work that is dead.

And finally: I personally am unable to paint music, since I believe any such kind of painting to be basically impossible, basically unattainable. And I have no desire to paint my own psychic states, since I am firmly convinced that they cannot be of any interest or concern to others.

My aim is: to create by pictorial means, which I love above all other artistic means, pictures that as purely pictorial objects have their own independent, intense life.

My personal qualities consist in the ability to make the inner element sound forth more strongly by limiting the external. Conciseness is my favorite device. For this reason, I do not carry even purely pictorial means to the highest level. Conciseness demands the imprecise (i.e., no pictorial form—whether drawing or painting—that produces too strong an effect). I have an explicit distaste for "shoving things under people's noses." I am little affected by works that, like street vendors, proclaim their excellence in loud tones to the entire marketplace. Least of all would I like to think that my own pictures were like such street vendors. It is preferable that people I do not know should plaster my stall with all kinds of misleading labels.

If it is somewhat against my will that I have written these few lines of "explanation," it is only out of a desire to remove from the path of the well-meaning spectator the two worst barriers that the "connoisseurs" and "aestheticians" have with light hearts and in so careless a way succeeded in putting in his way.

Munich, 1 January 1913

1912–1913

Letter to the Editor
Russkoe Slovo (Moscow), 1913

As already mentioned, plans for a Russian edition of *Sounds* remained unrealized. Four of the poems, however, were published, apparently without Kandinsky's consent or knowledge, in the famous Futurist anthology *A Slap in the Face of Public Taste* [*Poshchechina obshchestvennomu vkusu*], produced in Moscow by the self-styled "Hylaean" poets in December 1912.[1] The four poems were "Cage," "See," "Bassoon," and "Why." Kandinsky was clearly irritated by the iconoclastic tone of the anthology,[2] which rejected the Russian classics ("Pushkin, Dostoyevsky, Tolstoy, et al., et al.") and proclaimed the "New-Coming Beauty of the Self-sufficient (Self-centered) Word." He protested in aggrieved tones to the editor of the Moscow newspaper *Russkoe Slovo* [Russian Word] at being made to appear in such company.[3]

I ask you to be so kind as to place the following announcement in your respected newspaper. From the prospectus for the book *A Slap in the Face of Public Taste*, I learned *quite by chance* that my name and my texts had been published both in the prospectus and in the book itself. Both the former and the latter were done *without my permission*. I warmly condone every honest attempt at artistic creativity, and I am prepared to forgive even a certain rashness and immaturity of young authors: with time and with the correct development of talent both faults will disappear. But under no circumstances do I consider permissible the tone in which the prospectus was written. I condemn this tone categorically, no matter whose it is.

1912–1913

Painting as Pure Art
["Malerei als reine Kunst"]
Der Sturm
(Berlin), 1913

After the publication of "On Understanding Art" (October 1912), Kandinsky's name was rarely absent from the pages of *Der Sturm*. His works were frequently reproduced; there were articles and appreciations (by Leonhard, Walden, and others),[1] and almost the whole of March 1913 was taken up with heated polemic in defense of the artist, occasioned by acrimonious reviews of the exhibition of his paintings shown by Bock in Hamburg in January of that year.[2] Walden's involvement with Kandinsky reached its zenith in the autumn of 1913: in September, he invited the artist to participate in the "Erste Deutsche Herbstsalon" [First German Salon d'Automne],[3] and published his article "Painting as Pure Art"; at the beginning of October, *Der Sturm* advertised the album *Kandinsky, 1901–1913,* containing sixty reproductions, which finally appeared toward the end of the month and also included the artist's "Reminiscences" and essays on three of his recent paintings (see pp. 355–391).

The essays in the Sturm album are Kandinsky's last published statements prior to the outbreak of the Great War. They represent, to some extent, the summation of his ideas and experiences of the Munich period. By comparison, "Painting as Pure Art" displays an evident affinity with his publications of the preceding year, especially *On the Spiritual in Art*. A number of commentators have remarked on the resemblances between this essay and "Content and

Form" of 1910 (see pp. 84–90); but despite the identical opening, the two are very different.[4] Nor can "Content and Form" plausibly be regarded as a first version of "Painting as Pure Art," as has been suggested. The title of the latter essay may well have been inspired by an article on Delaunay by Guillaume Apollinaire, published in *Der Sturm* in December 1912 under the heading "Réalité, peinture pure."[5] Apollinaire's article consists, however, of little more than a résumé of Delaunay's theories, and these bear little relationship to Kandinsky's views put forward in "Painting as Pure Art." There is, on the other hand, a marked similarity between Kandinsky's article—particularly its account of the origins of dance—and van de Velde's essay "On Line," published in the Berlin periodical *Die Zukunft;*[6] Kandinsky jotted down the title of this essay in one of his notebooks.

Content and Form

The work of art consists of two elements: the inner and the outer.

The inner element, taken by itself, is the emotion in the soul of the artist. This emotion is capable of calling forth what is, essentially, a corresponding emotion in the soul of the observer.

As long as the soul is joined to the body, it can as a rule only receive vibrations via the medium of the feelings.[7] Feelings are therefore a bridge from the nonmaterial to the material (in the case of the artist) and from the material to the nonmaterial (in the case of the observer).

Emotion—feelings—the work of art—feelings—emotion.

The inner element of the work of art is its content. Thus, there must be a vibration in the soul. Unless this is the case, a work of art cannot come into being. Or, that is to say, what is produced is a mere sham.

The inner element, created by the soul's vibration, is the content of the work of art. Without inner content, no work of art can exist.

For the content, which exists first of all only *"in abstracto,"* to become a work of art, the second element—the external—must serve as

its embodiment. Thus content seeks a means of expression, a "material" form.

Thus the work of art is an inevitable, inseparable joining together of the internal and external elements, of the content and the form.

The determining element is the content. Just as the concept determines the word, and not the word the concept, so too the content determines the form: form is the material expression of abstract content.

Therefore, the choice of form is determined by internal necessity, which, essentially, is the only unalterable law of art.

A work of art which has come into being in the way described is "beautiful." Thus a beautiful work of art is an ordered combination of the two elements, the internal and the external. It is this combination that confers upon the work its unity. The work of art becomes a subject. A painting is a spiritual organism that, like every material organism, consists of many individual parts.

In isolation, these individual parts are lifeless, like a chopped-off finger. The life of the finger, its effectiveness is determined by its ordered juxtaposition with other parts of the body. This ordered juxtaposition is called construction.

Like the work of nature, the work of art is subordinated to the same law, that of construction. The individual parts have life only by virtue of the whole.

The infinite number of individual parts may, as regards painting, be divided into two groups:

linear form and

painterly form.

It is the planned and purposeful combination of the individual parts belonging to both groups that results in the picture.

Nature

If we apply these two categories (the constituent elements of the work of art, and in particular of the picture) to individual works, we come upon what appears to be the accidental presence of foreign elements within the picture. This is what is called nature. But nature had no place in

either category. How does she come to be in the picture?

The origins of painting are the same as those of every other art and of every human action. They are purely practical.

If a primitive hunter hunts game for days on end, it is hunger that drives him to do so.

If today a princely huntsman hunts game, it is pleasure that spurs him on. While hunger is a bodily quality, pleasure is here an aesthetic quality.

When primitive man employs artificially produced noises as an accompaniment to his dance, it is the sexual drive that impels him. These artificial noises, out of which, through millennia, present-day music developed, were for primitive man an incitement to the movement that today we call dance, which has its origin in the desire for the female.

When modern man goes to a concert, he does so not for practical ends; rather, it is pleasure that he seeks in the music.

Here, also, the original bodily or practical impulse has become an aesthetic impulse. That is to say, what was originally a bodily need has become a spiritual need.

In the course of this process of refinement (or spiritualization) of the simplest practical (or bodily) needs, one consistently notices two consequences: the separation of the spiritual from the bodily element, and its further independent development, by means of which the various arts come into being.

Here, gradually, but ever more precisely, the above-mentioned laws (of content and form) apply, eventually creating out of each transitional art a pure art.

This process is one of tranquil, natural growth, like the growth of a tree.

Painting

The same process is to be seen in painting.

First period—Origin: the practical desire to fix the transitory corporeal element.

Second period—Development: the gradual departure from this practical goal and the gradual predominance of the spiritual element.

Third period—Goal: the attainment of the high level of pure art, whereby the remains of practical desires are eliminated. This art speaks in artistic language from spirit to spirit, is a realm of

painterly-spiritual essences (subjects).

In the state in which painting finds itself today, all three characteristics can be observed in different combinations and in different degrees. It is, however, the characteristics of development (second period) that constitute the determining factor. That is:

First period: Realistic painting (realism is here understood in the sense in which it traditionally developed up to the nineteenth century): predominance of those characteristics one associates with the term origin—the practical desire to fix the transitory corporeal element (portraits. landscape, history-painting in the direct sense).

Second period: Naturalistic painting (in the form of Impressionism, Neo-Impressionism, and Expressionism—to which belong in part Cubism and Futurism): the departure from practical goals and the gradual predominance of the spiritual element (starting with Impressionism, an ever-increasing departure and an ever-greater predominance, by way of Neo-Impressionism to Expressionism).

In this period the inner desire to attribute exclusive significance to the spiritual element is so intense that even the impressionistic "credo" declares: "The essential in art consists not of 'what' (by which is meant nature, not artistic content), but of 'how.'"

It would appear that so little importance is attached to the remains of the first period (origin) that no account whatsoever is taken of nature as such. It would appear that nature is regarded exclusively as a point of departure, a pretext for giving expression to spiritual content. At all events, these views are recognized and proclaimed even by the Impressionists as vital parts of the "credo."

In reality, however, this "credo" is no more than a *pium desiderium* of painting of the second period.

If the choice of subject (nature) were indifferent to this kind of painting, then it would not be necessary to seek after "motifs." Here, on the contrary, it is the object which determines the manner of treatment, the choice of form is not free, but is dependent upon the object.

If, in looking at a picture of this period, we exclude the subject matter (nature), so that only the purely artistic element in the picture remains, we notice at once that the subject matter (nature) constitutes a kind of support without which the purely artistic structure (construction) collapses for lack of form. Or it transpires that, having excluded the subject matter, there remain on the canvas nothing but wholly indeterminate,

accidental artistic forms (in an embryonic state), incapable of independent existence. Thus nature (which this painting regards as the "what") is by no means incidental in this kind of painting, but essential.

This exclusion of the practical element, of subject matter (nature) is only possible if this essential element is replaced by another equally essential component. And this component is purely artistic form, which can confer upon the painting the strength necessary for independent life, and which is able to raise the picture to the level of a spiritual subject.

It is clear that this essential component can only be—as described and defined above—construction.

This substitution is to be found in the third period of painting which is beginning today—

compositional painting

In terms of the schema of the three periods outlined above, we have thus arrived at the third period, which was characterized as the goal.

In compositional painting, which we see today developing before our eyes, we notice at once the signs of having reached the higher level of pure art, where the remains of practical desires may be completely put aside, where spirit can speak to spirit in purely artistic language—a realm of painterly-spiritual essenses (subjects).

It should be immediately and irrevocably clear to all that a painting of this third period, which has neither any support in practical aims (as in the first period) nor the kind of spiritual content that requires the support of subject matter (as in the second period), can exist only as a constructive being.

Today, the tendency, which makes itself strongly (and ever more strongly) felt, consciously or even unconsciously to replace subject matter by construction, is the first step on the path that leads to pure art, although this development rightfully and inevitably presupposes the existence of the art of earlier periods.

In this short essay I have attempted to sketch in broad outline the whole development and in particular the present state of painting.

Hence the many gaps that must remain unfilled. Hence the omission of the many deviations and jumps that are, however, as indispensable to all forms of development as are the branches of a tree, despite its upward

striving.

Likewise, the further development of painting must undergo many apparent contradictions and diversions, just as has been the case in music, which we recognize already today as pure art.

History teaches us that the development of humanity consists in the spiritualization of many values. Among these values art takes first place.

Among the arts, painting has set foot on the path that leads from the practically purposeful to the spiritually purposeful. From subject matter to composition.

1912–1913

Reminiscences/Three Pictures

["Rückblicke"; "Komposition 4";
"Komposition 6"; "Bild mit weissem
Rand"]
Kandinsky, 1901–1913
(Berlin), 1913

"Reminiscences" and Kandinsky's descriptions of his
paintings *Composition 4, Composition 6,* and *Picture with
the White Edge* appeared in the album *Kandinsky, 1901–
1913,* published by the Verlag "Der Sturm" late in October
1913. The album was advertised in *Der Sturm* as a "mono-
graph with sixty full-page reproductions;" the advertisement
appeared throughout October (in the first issue for
November, it is accompanied by the words "just published").
Of the four essays, "Reminiscences" was the most recent,
dated June 1913. *"Composition 6"* and *"Picture with the
White Edge"* are both dated May 1913, while *"Composition
4"* goes back more than two years, to March 1911.
The three shorter essays have remained comparatively
little known; they deserve a better fate, for they offer a
fascinating insight into Kandinsky's work. The essay on
Composition 6 makes clear the important role played in the
genesis of that picture by his glass-painting of the Deluge (in
general, Kandinsky's paintings behind glass are crucial to an
understanding of the way in which traditional iconography is
"dissolved" in many of his apparently abstract pictures).[1] His
description of *Composition 4* is also interesting, since in
1911 the artist evidently felt compelled to write about his
painting both in abstract terms (describing the effects pro-

duced on the spectator by particular colors and forms) and in terms of recognizable objects (battle, castle, lances).[2] These essays are unique within Kandinsky's published *oeuvre*, inasmuch as they describe not only particular paintings, but also the artist's method of working and the problems that confronted him.[3] Only on one other occasion, toward the end of his life, did Kandinsky devote a short article to one specific painting (see p. 834).

It is, however, not difficult to see why "Reminiscences" should have become so much more famous than its companion pieces. Marvelously evocative, entertaining and serious by turns, it remains an outstanding monument to Kandinsky's literary gifts. It also poses considerable difficulties for the translator, since here, as in the prose poems, Kandinsky frequently chooses words for their sound, rather than their sense; the passage that describes Moscow's "sunset hour" is a case in point. The artist's love of Moscow, and of Russia generally, is clearly reflected in this essay, and at many points in the text one is forcibly reminded of the strength of the ties that bound Kandinsky to his homeland during these early years.

As a narrative, "Reminiscences" is not always easy to follow. Here, as elsewhere, Kandinsky writes somewhat in the manner of a rondo, the recurring "subject" being recollections of his early life in Russia, which are interspersed with more recent ideas and experiences.[4] Sometimes, the reader is uncertain to which period of the artist's life he should ascribe a particular event. For instance, the famous passage concerning the "dissolution of the atom" occurs in the context of Kandinsky's student days; but we may be tempted to think that the writer is here superimposing a subsequent event upon his earlier memories, especially in light of Franz Marc's recollection that the latest scientific discoveries constituted

a frequent topic of conversation during the Blaue Reiter period.[5] Likewise, it is possible that the "synesthetic" significance of *Lohengrin* occurred to Kandinsky only at a much later date. The reader may also notice that Kandinsky makes no mention in this text of painting his first abstract picture, although he referred repeatedly to his "discovery" of abstract painting much later in life, especially during the 1930s.[6]

"Reminiscences" has undergone numerous translations, the most significant being the artist's own Russian version, entitled "Steps" ["Stupeni"], published in Moscow in 1918 by IZO, the Fine Arts Department of the Commissariat of Enlightenment. Unlike the original publication, "Steps" was accompanied by four vignettes and twenty-five reproductions of paintings dating from the years 1902–1917; the text also differs significantly from the German version in several places.[7] These changes are not, however, sufficiently far-reaching to merit a separate translation of the whole piece, and differences between the German and Russian versions are, as in the case of *On the Spiritual in Art,* indicated in the notes.[8] Kandinsky's own footnotes, as elsewhere in this edition, are placed on the page.

Reminiscences

The first colors to make a powerful impression on me were light juicy green, white, carmine red, black, and yellow ochre. These memories go as far back as the age of three. I observed these colors on various objects that today appear less distinctly before my eyes than the colors themselves.

Like all children, I was passionately fond of "riding."[9] To this end, our coachman[10] used to strip the bark from thin branches for me so as to create a spiral pattern, cutting away both layers of bark from the first spiral, and from the second only the top layer, so that my horses usually consisted of three colors: the brownish yellow of the outer bark (which I

disliked, and would gladly have seen replaced by another), the juicy green of the second layer of bark (which I loved most particularly and which, even in a withered state, still had something magical about it), and finally the ivory-white wood of the branch (which smelled damp, tempting one to lick it, but soon withered miserably and dried, so that my pleasure in this white was spoiled from the outset).

I seem to remember that my grandparents[11] moved into a new apartment shortly before my parents' departure for Italy (whither I was also taken as a three-year-old child, together with my nanny). I have the impression that this apartment was still completely empty, i.e., that it contained neither furniture nor people. In one of the smaller rooms, all by itself, hung a wall clock. I stood in front of it, quite alone, enjoying the white of the dial and the carmine red of the rose painted on it.

My Muscovite nursemaid was amazed that my parents were undertaking such a long journey to admire "tumbled-down buildings and old stones": "We've got enough of those in Moscow." Of all the "stones" of Rome, I can remember only an invincible forest of thick columns, that terrifying forest of St Peter's, where I seem to recall it took my nanny and me a long, long time to find the way out.[12]

And then the whole of Italy is colored by two memories in black. I am traveling with my mother in a black coach across a bridge (water underneath—dirty yellow, I think): I am being taken to a kindergarten in Florence. And black again—steps leading down into black water, on which floats a frightening, long, black boat with a black box in the middle: we are boarding a gondola at night. It was here that I developed a gift that made me famous "throughout the whole of Italy," and bawled my head off.[13]

I had a piebald stallion (with yellow ochre on the body and a bright yellow mane) in one of my games of horse racing, of which my aunt* and I were particularly fond. There were strict rules about taking turns: one time round, I would have this stallion among my jockeys, the next time, it was my aunt's turn. Love of such horses has not deserted me to this day. It is a joy for me to see such a horse on the streets of Munich: one appears every summer when they sprinkle the streets. He wakes the

*Elizabeth Tikheev, who had a great, ineradicable influence on my entire development. My mother's eldest sister, she had played a very large part in my mother's upbringing. But also many other people who came in contact with her cannot forget her radiant inner nature.[14]

living sunshine within me. He is immortal, for in the fifteen years I have known him, he has grown not a day older. This was one of my first impressions—and the most powerful—when, prior to this period, I moved to Munich. I stood and watched him for a long time.[15] And a half-conscious but ebullient promise stirred in my heart. It brought to life the little lead horse within me, linking Munich to my childhood. This piebald nag suddenly made me feel at home in Munich.[16] As a child, I spoke a great deal of German (my maternal grandmother was a Balt). The German fairy-tales I had heard so often as a child came to life. The tall, narrow roofs of the Promenadenplatz and Maximiliansplatz, which have now disappeared, the old part of Schwabing, and especially the Au, which I discovered by chance on one occasion, turned these fairy-tales into reality. The blue trams threaded their way through the streets like an incarnation of the air of a fairy-story, which one inhales with delightful ease. The yellow mailboxes sang their shrill, canary-yellow song from the street corners. I welcomed the label "art-mill," and felt I was in the city of art, which for me was the same as being in fairyland. The medieval paintings I did later owe their origin to these impressions. On good advice, I visited Rothenburg ob der Tauber. I still cannot forget the endless changing from fast train to slow train, from slow train to stopping train, with its overgrown tracks, the thin whistle of the long-necked engine, the rattling and squeaking of the sleepy wheels, and the old peasant with big silver buttons, who insisted on talking to me about Paris, and whom I had great difficulty in understanding. It was an unreal journey. I felt as if a magic power had, contrary to all the laws of nature, transplanted me from century to century, ever deeper into the past. I leave the tiny (improbable) station, go across a meadow and through the gate. Gateways, ditches, narrow houses, bending their heads across the narrow streets and gazing deep into each other's eyes, the massive entrance to the inn, which leads straight into the huge, gloomy dining room, from whose midst a broad, heavy, dark oak stair-case leads up to the bedrooms, the narrow room and the sea of bright red rooftops I can see from my window. It rained the whole time. Big, round raindrops fell on my palette, shook hands waggishly from afar, shook and shivered, suddenly and unexpectedly uniting to form thin, cunning threads, which scampered quickly and boisterously between my colors and now and again ran up my sleeves. I do not know where these studies are lurking; they have vanished. Only one picture has survived from this trip, *The Old Town*,[17] which I painted from memory only after my

return to Munich. It is sunny, and I made the roofs just as bright a red as I then knew how.[18]

Even in this picture, I was actually hunting for a particular hour, which always was and remains the most beautiful hour of the Moscow day. The sun is already getting low and has attained its full intensity which it has been seeking all day, for which it has striven all day. This image does not last long: a few minutes, and the sunlight grows red with effort, redder and redder, cold at first, and then increasing in warmth. The sun dissolves the whole of Moscow into a single spot, which, like a wild tuba, sets all one's soul vibrating. No, this red fusion is not the most beautiful hour! It is only the final chord of the symphony, which brings every color vividly to life, which allows and forces the whole of Moscow to resound like the *fff* of a giant orchestra. Pink, lilac, yellow, white, blue, pistachio green, flame red houses, churches, each an independent song—the garish green of the grass, the deeper tremolo of the trees, the singing snow with its thousand voices, or the *allegretto* of the bare branches, the red, stiff, silent ring of the Kremlin walls, and above, towering over everything, like a shout of triumph, like a self-oblivious hallelujah, the long, white, graceful, serious line of the Bell Tower of Ivan the Great. And upon its tall, tense neck, stretched up toward heaven in eternal yearning, the golden head of the cupola, which among the golden and colored stars of the other cupolas, is Moscow's sun.

To paint this hour, I thought, must be for an artist the most impossible, the greatest joy.

These impressions were repeated on each sunny day. They were a delight that shook me to the depths of my soul, that raised me to ecstasy. And at the same time, they were a torment, since I was conscious of the weakness of art in general, and of my own abilities in particular, in the face of nature. Years had to elapse before I arrived, by intuition and reflection, at the simple solution that the aims (and hence the resources too) of nature and of art were fundamentally, organically, and by the very nature of the world different—and equally great, which also means equally powerful. This solution, which guides my work today, and which is so simple and beautifully natural, put an end to the useless torment of the useless tasks that I then, despite their unattainability, inwardly set myself. It cancelled out this torment, and thus my joy in nature and art rose to unclouded heights. Since then I have been able to enjoy both these world-elements to the full. To my enjoyment is added a profound sense of gratitude.

This solution set me free and opened up new worlds for me. Everything "dead" trembled. Everything showed me its face, its innermost being, its secret soul, inclined more often to silence than to speech—not only the stars, moon, woods, flowers of which poets sing, but even a cigar butt lying in the ashtray, a patient white trouser-button looking up at you from a puddle on the street, a submissive piece of bark carried through the long grass in the ant's strong jaws to some uncertain and vital end, the page of a calendar, torn forcibly by one's consciously outstretched hand from the warm companionship of the block of remaining pages. Likewise, every still and every moving point (= line) became for me just as alive and revealed to me its soul. This was enough for me to "comprehend," with my entire being and with all my senses, the possibility and existence of that art which today is called "abstract," as opposed to "objective."

At that time, however, in my student days, when I could devote only my leisure hours to painting, I sought—impossible though it might seem—to capture on the canvas the "chorus of colors" (as I called it) that nature, with staggering force, impressed upon my entire soul. I made desperate attempts to express the w h o l e p o w e r of its resonance, but in vain.

At the same time, my soul was kept in a state of constant vibration by other, purely human disturbances, to the extent that I never had an hour's peace. It was the time of the creation of a pan-student organization that was to embrace the student body not simply of one university, but of all the Russian and (as its ultimate goal) Western European universities as well. The students' struggle against the cunning and undisguised universities bill of 1885 was still going on. "Disturbances," assaults on the old Muscovite traditions of freedom, the abolition by the authorities of organizations already established, our new societies, the subterranean rumblings of political movements, the development of student autonomy* continually brought new experiences in their train and thus made the strings of one's soul sensitive, receptive, exceptionally ready to vibrate.

*This autonomy, or individual "initiative," is one of the most hopeful aspects (though, alas, far too little cultivated) of a life that has become compressed into rigid forms. Every individual (personal or collective) action is productive because it undermines the stability of our form of existence—whether it achieves "practical results" or not. It

Fortunately, politics did not completely absorb me. My various studies trained me to acquire the necessary gift of immersing myself in the finer realms of the material, otherwise known as the "abstract." Apart from my chosen specialization (economics, which I studied under the tutelage of a highly gifted intellectual and one of the most unusual people I have every met, Prof. A. I. Chuprov), I was strongly attracted, sometimes by turns, sometimes simultaneously, by various other disciplines. Roman law (which enchanted me on account of its intricate, conscious, refined "construction," but which could ultimately never satisfy me as a Slav because of its far too cold, far too rational, inflexible logic); criminal law (which affected me, perhaps too much to the exclusion of all else, by way of what was then the new theory of Lombroso); the history of Russian law and peasant law (which, by contrast to Roman law, commanded my deepest respect and sincere affection for its freedom and happy resolution of the fundamental [problems of] law;* ethnography, which also touched upon this same discipline (and which, I promised myself initially, would reveal to me the soul of the people); all these occupied my time and helped me acquire the capacity for abstract thought.

I loved all these sciences, and today I still think with gratitude of the

generates a critical attitude toward accustomed phenomena, which as a result of dull habit, continually harden the soul and make it more and more immobile. Hence the dull-wittedness of the masses, who have always given more liberated spirits grounds for bitter complaint. Corporate bodies should be formed, as far as possible, in the least restrictive way, so that they have far more inclination to adapt themselves to new phenomena and to adhere far less to "precedent," than was formerly common. Every organization should be conceived of as the transition to freedom, a tie that is still necessary, but is as loose as possible and does not impede large strides in the direction of further progress.[19]

*After the "emancipation" of the serfs in Russia, the government gave them control of their own economy, which to the surprise of many people made the peasants politically mature, and their own courts, where within certain limits judges chosen by the serfs from among their own number resolve disputes and may even punish "criminal" actions. Here, in particular, the people have devised the most human principle, punishing lesser guilt severely and greater offenses leniently or not at all. The serfs have their own expression for this: "according to the man." Thus, it was not a stiff code of law that was established (as, e.g., in Roman law—especially the jus strictum!), but an extremely free and flexible form, determined not by the external, but exclusively by the internal.[20]

enthusiasm and perhaps inspiration they gave me. Only these hours paled into insignificance at my first contact with art, which alone had the power of transporting me beyond time and place. Never had scientific work given me such experiences, inner tensions, creative moments.

I was not, however, confident enough to consider myself entitled to renounce my other responsibilities and lead, as it seemed to me then, the boundlessly happy life of an artist. Apart from which, life in Russia was at that time especially bleak, my scientific work was highly thought of, and I decided to become a scientist. In my chosen field of economics, however, my only love apart from the question of wages was purely abstract calculation. Banking, the practical side of monetary affairs, I found utterly repellent. I had, however, no choice other than to accept these aspects along with the rest.

At the same time, I experienced two events that stamped my whole life and shook me to the depths of my being. These were an exhibition of French Impressionists in Moscow—first and foremost, *The Haystack*, by Claude Monet[21]—and a performance of Wagner at the Court Theatre[22]—*Lohengrin*.

Previously, I had known only realistic art, in fact only the Russians and had often remained standing for a long time before the hand of Franz Liszt in the portrait by Repin, etc.[23] And suddenly, for the first time, I saw a picture. That it was a haystack, the catalogue informed me. I didn't recognize it. I found this nonrecognition painful, and thought that the painter had no right to paint so indistinctly. I had a dull feeling that the object was lacking in this picture. And I noticed with surprise and confusion that the picture not only gripped me, but impressed itself ineradicably upon my memory, always hovering quite unexpectedly before my eyes, down to the last detail. It was all unclear to me, and I was not able to draw the simple conclusions from this experience. What was, however, quite clear to me was the unsuspected power of the palette, previously concealed from me, which exceeded all my dreams. Painting took on a fairy-tale power and splendor. And, albeit unconsciously, objects were discredited as an essential element within the picture. I had the overall impression that a tiny fragment of my fairy-tale Moscow already existed on canvas.*

*The "light and air" problem of the Impressionists interested me very little. I always

Lohengrin,[24] on the other hand, seemed to me the complete realization of that Moscow. The violins, the deep tones of the basses, and especially the wind instruments at that time embodied for me all the power of that pre-nocturnal hour. I saw all my colors in my mind; they stood before my eyes. Wild, almost crazy lines were sketched in front of me. I did not dare use the expression that Wagner had painted "my hour" musically. It became, however, quite clear to me that art in general was far more powerful than I had thought, and on the other hand, that painting could develop just such powers as music possesses. And the impossibility of seeking out these powers, let alone discovering them, made my renunciation all the more bitter.

I was, however, never strong enough to shoulder my responsibilities heedless of all else, and succumbed to temptations that proved too strong for me.[25]

A scientific event removed one of the most important obstacles from my path. This was the further division of the atom. The collapse of the atom was equated, in my soul, with the collapse of the whole world. Suddenly, the stoutest walls crumbled. Everything became uncertain, precarious and insubstantial. I would not have been surprised had a stone dissolved into thin air before my eyes and become invisible. Science seemed destroyed: its most important basis was only an illusion, an error of the learned, who were not building their divine edifice stone by stone with steady hands, by transfigured light, but were groping at random for truth in the darkness and blindly mistaking one object for another.

Even as a child, I had been tortured by joyous hours of inward tension that promised embodiment. Such hours filled me with inward tremors, indistinct longings that demanded something incomprehensible of me, stifling my heart by day[27] and filling my soul with turmoil by night, giving me fantastic dreams full of terror and joy. Like many children and youths, I tried writing poetry, which I sooner or later tore up.[28] I can remember that drawing alleviated this condition, i.e., it allowed me to exist outside of time and space, so that I was no longer conscious of my

found that erudite conversations about this problem had very little to do with painting. Later, the theories of the Neo-Impressionists seemed to me more important, since they were talking ultimately about the effects of colors and left the atmosphere alone. Nonetheless, I felt, first dimly and later consciously, that every theory based on external resources[26] is always only one instance, alongside which many other instances might exist with equal validity. Still later, I realized that the external grows from the internal, or else is stillborn.

self. Early on, my father* noticed my love of drawing and allowed me, even as a schoolboy, to take drawing lessons. I remember how I loved the materials themselves, how the colors and pencils were for me especially beautiful, attractive, and alive.[29] From my mistakes, I learned lessons, nearly all of which still affect me with their original force. As a very small child, I sketched a piebald horse in watercolors; everything was done except for the hooves. My aunt, who was helping me with my painting, had to go out, and advised me to leave the hooves until she came back. I remained alone in front of the unfinished picture, fretting at the impossibility of putting the last touches of color on the paper. This final task appeared to me so easy. I thought, if I make the hooves really black, they are bound to be completely true to life. I put as much black on my brush as it would hold. An instant—and I was looking at four black, disgusting, ugly spots, quite foreign to the paper, on the feet of the horse. I was in despair and felt cruelly punished![33] Later, I could well understand the Impressionists' fear of black, and even later, the prospect of putting pure black on the canvas would still put the fear of God into me. This kind of childhood disaster throws a long, long shadow over many years of later life.[34]

The other particularly powerful impressions I experienced during my student days, which again exerted a decisive effect in later years, were Rembrandt in the Hermitage in St. Petersburg and my journey to the province of Vologda, where in the capacity of ethnographer and jurist, I was sent by the Imperial Society for Science, Anthropology, and Ethnography.[35] My task was two-fold: in the case of the Russian population to study peasant criminal law (to discover the principles of primitive law), and in the case of the fishing and hunting communities of the slowly disappearing Syryenians, to salvage the remnants of their pagan religion.[36]

*My father, with extraordinary patience, let me chase after my dreams and whims my entire life.[30] When I was ten years old, he tried to educate me into choosing between grammar school and secondary school: by explaining the differences between these two schools, he helped me, to the best of his ability, to make the choice for myself. With great generosity, he supported me financially for many long years.[31] At the turning points in my life he would talk to me like an older friend, and in important matters never exerted a trace of pressure on me. His principles of upbringing were complete trust and a friendly relationship with me. He knows how grateful I am to him. Let these lines be a lesson for those parents who often try forcibly to deflect their children (and especially the artistically gifted ones) from their right career, thus making them unhappy.[32]

Rembrandt moved me deeply. The great divisions of light and dark, the blending of secondary tones into the larger areas, the way in which these tones melt together in these areas (which from a distance produced the effect of a mighty chord and reminded me immediately of Wagner's trumpets) revealed to me entirely new possibilities, the superhuman power of color in its own right, and in particular, the intensification of that power achieved by combinations, i.e., contrasts. I realized that there was nothing magical in itself about any large surface, that each of these surfaces immediately betrays its derivation from the palette, but that this surface, by virtue of its juxtaposition with the next, indeed assumes a fairy-tale power, so that on first impression its derivation from the palette appears incredible. It was not, however, part of my nature to employ a particular device, once seen, without further ado. Unconsciously, I approached other people's pictures in the same way I now approach "nature"; I greeted them with reverence and profound joy, but felt that this was nonetheless a power foreign to me. On the other hand, I sensed fairly unconsciously that Rembrandt's great divisions give his pictures a quality I had never seen until then. I felt that his pictures "last a long time," explaining this to myself by the fact that I had gradually to exhaust first one part, and then the next. Later, I realized this division conjures on to the canvas an initially foreign and apparently inacessible element for painting—time.*

My pictures painted ten or twelve years ago[37] in Munich were to acquire this characteristic. I painted only three or four such pictures, trying to infuse into every part an "endless" series of initially concealed color-tones. They had to lie in such a way that they were completely hidden† at first (especially in the darker parts), revealing themselves only in the course of t i m e to the engrossed, attentive viewer, indistinct

*A simple instance of the application of time.

†From this period dates my habit of jotting down individual thoughts. Thus On the Spiritual in Art came into being without my noticing it. My jottings accumulated over a span of at least ten years. One of my first notes concerning the beauty of color in a painting is as follows: "The splendor of color in a picture must seize the viewer, and at the same time it must conceal the underlying content." By this I meant the pictorial content, though not yet in pure form (in the sense I now understand it); rather, the emotion or emotions of the artist that he expresses through painting. At that time I was

and at the same time tentative, quizzical at first, and then sounding forth more and more, with increasing, "uncanny" power. To my great astonishment, I noticed that I was working according to the Rembrandt principle. That was a moment of bitter disappointment and gnawing distrust of my own abilities, distrust as to the possibility of finding my own means of expression. Also, it soon appeared to me "too cheap" to incorporate my then most highly prized elements in this way—the concealed, time, and the uncanny.

At that time, I was working especially hard, often until late into the night, when I would be interrupted in my work by total exhaustion and forced to go quickly to bed. Days on which I did not work (rare though they were!) I considered wasted, and tormented myself on their account. If the weather was at all decent, I would paint every day for an hour or two, mostly in the old part of Schwabing, which was then slowly becoming a suburb of Munich. At a time when I was disappointed with my studio work and the pictures painted from memory, I painted large numbers of landscapes, which, nevertheless, gave me little satisfaction, so that later there were very few of them I worked up into pictures.[39] I considered wandering around with my paintbox, with the feeling of a hunter in my heart, less responsible than painting pictures in which, even then, I was searching half consciously, half unconsciously, for the compositional. I was inwardly moved by the word c o m p o s i t i o n and later made it my aim in life to paint a "c o m p o s i t i o n." This word itself affected me like a prayer. It filled me with reverence.[40] In my studies, I let myself go. I had little thought for houses and trees, drawing colored lines and blobs on the canvas with my palette knife, making them sing just as powerfully as I knew how. Within me sounded Moscow's evening hour, but before my eyes was the brightly colored atmosphere of Munich, saturated with light, its scale of values sounding thunderous depths in the shadows. Later, especially at home, always profound disappointment. My colors looked weak and dull, the whole study—a vain effort to capture the power of nature. How strange it was to hear that I exaggerated the colors of nature, that this exaggeration made my

still suffering from the delusion that the viewer approaches the picture with an open mind, expecting to pick out in it a language to which he can relate. Such viewers do indeed exist (that is no delusion), but they are as rare as gold nuggets in sand. There are even viewers who, having no personal affinity with the language of the work, give themselves to it and derive something from it. I have met such people in my life.[38]

pictures incomprehensible, and that my own salvation would be to learn to "break the hold" of color.[41] The Munich critics (who to some extent, especially at the beginning, adopted a very favorable attitude toward me)*wanted to explain my "richness of color" in terms of Byzantine influences. The Russian critics (who, almost without exception, abused me in unparliamentary language) decided I had degenerated under the influence of Munich art.[42] I saw then for the first time how critics go about their task—mindless, wrong-headed, oblivious. This also explains the *sang froid* with which talented artists receive the most malicious articles about themselves.

My tendency toward the "hidden," the concealed, saved me from the harmful side of folk art, which I saw for the first time on its own ground and in its original form on my journey through the province of Vologda. I traveled initially by train, with the feeling that I was journeying to another planet, then for several days by boat along the tranquil and introverted Sukhona river, then by primitive coach through endless forests, between brightly colored hills, over swamps and deserts.[44] I traveled completely alone, which was of incalculable benefit as regards absorbing myself in my surroundings and in my own self. It was often scorching hot during the day[45] and frosty at night, and I remember with gratitude my coachmen, who would often wrap me more snugly in my traveling quilt, which had slid from me as a result of the jolting and lurching of the unsprung coach.[46] I would arrive in villages where suddenly the entire population was clad in gray from head to toe, with yellowish-green faces and hair, or suddenly displayed variegated costumes that ran about like brightly colored, living pictures on two legs.[47] I shall never forget the great wooden houses[48] covered with carvings. In these magical houses I experienced something I have never encountered again since. They taught me to move w i t h i n t h e p i c t u r e, to live in the picture. I still remember how I entered the living room for the first time and stood rooted to the spot before this unexpected scene. The table, the benches, the great stove (indispensable in Russian farmhouses), the

*Even today, many critics discern talent in my earlier pictures, which is a good proof of their weakness. In the later and more recent ones they find confusion, a dead end, deterioration, and very often, a fraud, which is a good proof of the ever-increasing power of these pictures.[43] Here, I am speaking of course not only about Munich critics: they—with very few exceptions—consider my books malicious bungling. It would be a pity if their verdict were otherwise.

cupboards, and every other object were covered with brightly colored, elaborate ornaments. Folk pictures[49] on the walls: a symbolic representation of a hero, a battle, a painted folk song. The "red" corner (red is the same as beautiful in old Russian[50]) thickly, completely covered with painted and printed pictures of the saints,[51] burning in front of it the red flame of a small pendant lamp, glowing and blowing like a knowing, discreetly murmuring, modest, and triumphant star, existing in and for itself. When I finally entered the room, I felt surrounded on all sides by painting, into which I had thus penetrated. The same feeling had previously lain dormant within me, quite unconsciously, when I had been in the Moscow churches, and especially in the main cathedral of the Kremlin.[52] When I next visited these churches after returning from my journey, the same feeling sprang to life inside me with total clarity. Later, I often had the same experience in Bavarian and Tyrolean chapels. Of course, on each occasion the impression was quite differently colored, being formed by quite different constituents: Church! Russian Church! Chapel! Catholic Chapel!

I made many sketches—these tables and various ornaments. They were never petty and so strongly painted that t h e o b j e c t within them became d i s s o l v e d. This impression, too, impinged on my consciousness only much later.

It was probably through these impressions, rather than in any other way, that my further wishes and aims as regards my own art formed themselves within me. For many years I have sought the possibility of letting the viewer "stroll" w i t h i n t h e p i c t u r e, forcing him to become absorbed in the picture, forgetful of himself.

Sometimes, too, I succeeded: I have observed it in the spectators. Out of the unintended effect that painting produces upon the painted object, causing it to become dissolved, my own ability to o v e r l o o k objects in pictures also developed further. Much later, after my arrival in Munich, I was enchanted on one occasion by an unexpected spectacle that confronted me in my studio. It was the hour when dusk draws in. I returned home with my painting box having finished a study, still dreamy and absorbed in the work I had completed, and suddenly saw an indescribably beautiful picture, pervaded by an inner glow. At first, I stopped short and then quickly approached this mysterious picture, on which I could discern only forms and colors and whose content was incomprehensible. At once, I discovered the key to the puzzle: it was a picture I had painted, standing on its side against the wall. The next day, I tried to

369

re-create my impression of the picture from the previous evening by daylight. I only half succeeded, however; even on its side, I constantly recognized objects, and the fine bloom of dusk was missing. Now I could see clearly that objects harmed my pictures.

A terrifying abyss of all kinds of questions, a wealth of responsibilities stretched before me. And most important of all: What is to replace the missing object? The danger of ornament revealed itself clearly to me; the dead semblance of stylized forms I found merely repugnant.[53]

Only after many years of patient toil and strenuous thought, numerous painstaking attempts, and my constantly developing ability to conceive of pictorial forms in purely abstract terms, engrossing myself more and more in these measureless depths, did I arrive at the pictorial forms I use today, on which I am working today and which, as I hope and desire, will themselves develop much further.

It took a very long time before I arrived at the correct answer to the question: What is to replace the object? I sometimes look back at the past and despair at how long this solution took me. My only consolation is that I have never been able to persuade myself to use a form that arose within me by way of logic, rather than feeling. I could not devise such forms, and it disgusts me when I see them. Every form I ever used arrived "of its own accord," presenting itself fully fledged before my eyes, so that I had only to copy it, or else constituting itself actually in the course of work,[54] often to my own surprise. Over the years I have now learned to control this formative power to a certain extent. I have trained myself not simply to let myself go, but to bridle the force operating within me, to guide it. Over the years, I have realized it is not enough to work with hammering heart, hands clasped to your breast (which only makes your ribs ache), your whole body tense.[55] This can only exhaust the artist, but not his task.[56] The horse carries the rider quickly and sturdily. The rider, however, guides the horse. The artist's talent carries him to great heights quickly and sturdily. The artist, however, guides his talent.[57] This is the "conscious," the "calculated" element in one's work, or whatever one wishes to call it.[58] The artist must know his gifts through and through, like an astute businessman leaving no jot unused or forgotten; he must exploit and develop every morsel, to the very limit of his capability.[59]

This development and refinement of one's talents demands a great capacity for concentration, which leads, on the other hand, to a decline of one's other faculties. I have observed this clearly in myself. I never possessed what is commonly called a good memory: in particular, I was

never capable of memorizing numbers, names, or even poems. My multiplication tables always presented me with insuperable difficulties, which I have not overcome to this day and which drove my teacher to despair. From the first, I had to summon my visual memory to my aid,[60] and then I was all right. In my final examination in statistics I recited a whole page of figures, simply because in my excitement I could see this page in my mind.[61] Thus, even as a child I was able, as far as my technical knowledge allowed, to paint pictures from memory at home that had intrigued me in exhibitions. Later, I was sometimes able to paint a landscape better "by heart" than from nature. In this way I painted *The Old Town*, and later many colored Dutch and Arabian drawings.[62] In the same way, I could recite by heart the names of all the shops in a long street, without mistakes, because I saw them in front of me. Quite unconsciously, I was continually absorbing impressions, sometimes so intensively and continuously that I felt as if my chest would burst, and breathing became difficult. I became so overtired and overfed that I often thought with envy of civil servants who, after work, may and can relax completely. I longed for dull-witted repose, for what Boecklin called porters' eyes. I had, however, to see continuously.[63]

A few years ago, I noticed all at once that this capacity had diminished. Initially, I was deeply startled,[64] but I realized later that my capacity for continual observation was being channeled in another direction by my improved powers of concentration, enabling me to achieve other things that now were far more necessary to me. My capacity for engrossing myself in the inner life of art (and, therefore, of my soul as well) increased to such an extent that I often passed by external events without noticing them, something which could not have occurred previously.

So far as I understand, I did not force myself to develop this capacity by mechanical means—it had always existed organically within me, but in embryonic form.[65]

As a thirteen or fourteen-year-old boy, I gradually saved up enough money to buy myself a paintbox containing oil paints. I can still feel today the sensation I experienced then—or, to put it better, the experience I underwent then—of the paints emerging from the tube. One squeeze of the fingers, and out came these strange beings, one after the other, which one calls colors—exultant, solemn, brooding, dreamy, self-absorbed, deeply serious, with roguish exuberance, with a sigh of release, with a deep sound of mourning, with defiant power and resis-

tance, with submissive suppleness and devotion,[66] with obstinate self-control, with sensitive, precarious balance. Living an independent life of their own, with all the necessary qualities for further, autonomous existence, prepared to make way readily, in an instant, for new combinations, to mingle with one another and create an infinite succession of new worlds. Many lie there, already exhausted, weakened, petrified— spent forces, a living reminder of bygone possibilities, rejected by destiny. Fresh colors emerge from the tube, like in a battle, young forces replacing old. In the middle of the palette exists a strange world, made up of the remains of colors already used, which now far from their source, promenade across canvases in necessary incarnations. Here is a world partly formed by the will to create pictures long since painted, partly generated and determined by chance, by the mysterious play of forces foreign to the artist. And I for my part owe much to chance: it has taught me more than any teacher or master. I spent not infrequent hours studying its effects with love and admiration. Praise be to the palette for the delights it offers; formed from the elements defined above, it is itself a "work," more beautiful indeed than many a work.[67] It sometimes seemed to me as if the brush, as it tore pieces with inexorable will from this living being that is color, conjured up in the process a musical sound. Sometimes I could hear the hiss of the colors as they mingled. It was an experience such as one might hear in the mysterious kitchens of the arcane alchemists.

How often this first paintbox maliciously jeered and laughed at me. Sometimes the paint would trickle off the canvas; sometimes, within a short space of time, it would reveal cracks; sometimes it would turn paler, sometimes darker; sometimes it would appear to jump off the canvas and swim in mid-air; sometimes it would go dull and increasingly murky, resembling a dead bird as it starts to decompose—I don't know how it all happened.[68]

Later, I heard that a very well-known artist (I can no longer remember who it was) used to say, "When painting, one look at the canvas, half at the palette, and ten at the model." It sounded very good, but I soon found that for me, it has to be the other way around: Ten looks at the canvas, one at the palette, and half at nature. In this way, I learned to struggle with the canvas, to recognize it as an entity opposed to my wishes (= dreams), and to force it to submit to these wishes.[69] At first, it stands there like a pure, chaste maiden, with clear gaze and heavenly joy—this pure canvas that is itself as beautiful as a picture. And then comes the

imperious brush, conquering it gradually, first here, then there, employing all its native energy, like a European colonist who with axe, spade, hammer, saw penetrates the virgin jungle where no human foot has trod, bending it to conform to his will. I gradually learned not to see the defiant white tone of the canvas, checking it only for a fleeting instant, rather than seeing in it the colors that still had to replace it—thus, one thing slowly followed upon another.

Painting is like a thundering collision of different worlds that are destined in and through conflict to create that new world called the work.[70] Technically, every work of art comes into being in the same way as the cosmos—by means of catastrophes, which ultimately create out of the cacophony of the various instruments that symphony we call the music of the spheres. The creation of the work of art is the creation of the world.

In this way, I derived spiritual experiences from the sensations of colors on the palette (and also in the tubes, which resemble those people who, strong in spirit but modest in appearance, in an emergency suddenly reveal and deploy their previously hidden powers). These experiences, moreover, became the starting point for the ideas I started consciously to accumulate as much as ten or twelve years ago,[71] which led to my book *On the Spiritual in Art.* It was not so much a question of my writing this book as of its writing itself. I jotted down individual experiences that, as I later observed, stood in an organic relationship to one another. I felt with increasing strength and clarity that it is not the "formal" element in art that matters, but an inner impulse (= content) that peremptorily determines form.[72] One advance in this respect—which took me a shamefully long time—was solving the question of art exclusively on the basis of internal necessity, which was capable at every moment of overturning every known rule and limit.[73]

For me, the province of art and the province of nature thus became more and more widely separated, until I was able to experience both as completely independent realms. This occurred to the full extent only this year.[74]

Here, I touch upon a memory that was, at the time, a source of torment for me. I arrived in Munich with the sense of being born anew, toil behind me, recreation in front of me: but I quickly encountered a constraint upon my freedom that turned me into a slave, even if only temporarily and in a new guise—studying from the model.

Anton Ažbè's* then extremely famous school was, as I could see, heavily frequented. Two or three models "sat for heads" or "posed nude." Students of both sexes and from various countries thronged around these smelly, apathetic, expressionless, characterless natural phenomena, who were paid fifty to seventy pfennigs an hour. They drew carefully on paper or canvas with a soft, sibilant sound, trying to represent exactly the anatomy, structure, and character of these people who were of no concern to them. They used cross-hatchings to denote the coordination of the muscles, particular treatments of surface or line to model a nostril or a lip, or to construct the whole head "on spherical lines"; and they spent, as it seemed to me, not one second thinking about art. The play of lines of the nude sometimes interested me greatly. Sometimes, however, I found it repulsive. In many positions of certain bodies I was put off by the effect of the lines and had to force myself to reproduce them. I was in almost continual conflict with myself. Only out on the street could I breathe freely again, and I not infrequently succumbed to the temptation to "skip" classes and go off with my paintbox to capture Schwabing, the English Garden, or the banks of the Isar after my own fashion. Or else I would stay at home and try to paint a picture from memory, from studies, or by way of improvisation—a picture that had not a great deal to do with the laws of nature.[76] On this account, my colleagues thought of me as lazy and often as untalented, which on occasion hurt me deeply, since I could feel clearly within me my own joy in working, my own industry and talent. In the end, I began to feel isolated and alienated in this environment, as well, and became all the more absorbed in my own wishes.

I did, however, feel obliged to follow the course in anatomy, which I did conscientiously, and indeed, twice. The second time, I attended the course given by the spirited and lively Prof. Dr. Moillet.[77] I drew the apparatus, made notes from the lectures, and breathed the corpse-ridden

*Anton Ažbè was a gifted artist[75] and an uncommonly good person. Many of his numerous students studied with him free of charge. His invariable reply to apologies about not being able to pay was "Just mind you work hard!" He seemed to lead a very unhappy life. One heard him laugh, but never saw him do so: the corners of his mouth scarcely lifted, and his eyes always remained sad. I do not know whether anyone else was acquainted with the puzzle of his lonely life. And his death was just as lonely as his life: he died completely alone in his studio. Despite his very large income, he left only a few thousand marks. Only after his death did the extent of his generosity become known.

air. Unconsciously, however, I was somewhat put out to hear talk of the direct relationship between anatomy and art. It even offended me[78] —in the same way that I had taken offense at being taught that a tree trunk "must always be depicted as joined to the ground." There was no one to help me overcome these feelings, the confusion I experienced in this darkness. Admittedly, I never took my doubts to anyone else. I still think today that such doubts must be resolved by oneself, in one's soul, and that any other way would be to desecrate the strength of one's own solution.

I then soon found, however, that every head, even if it appears very "ugly" at first, is perfectly beautiful. The natural law of construction, manifesting itself so completely and irreproachably in each head, gives that head a touch of beauty. I would often stand in front of an "ugly" model and say to myself, "How ingenious." There is, indeed, an infinite ingenuity that manifests itself in every detail: e.g., every nostril awakens in me the same feeling of admiration as the flight of the wild duck, the connection of the leaf with the stem, the way the frog swims—the pelican's beak, etc., etc. I also had at once this feeling of admiration for beauty and ingenuity at Prof. Moillet's lectures.[79]

I felt dimly that I was experiencing mysteries belonging to a realm of their own. But I was unable to see the connection between this realm and the realm of art. I visited the Alte Pinakothek, and noticed that not one of the great masters had attained the exhaustive beauty and ingenuity of natural modeling: nature herself remained untouched. Sometimes, she seemed to me to be laughing at these efforts. But more often she appeared to me, in an abstract sense, "divine": she created as she saw fit; she followed her path toward her goals, which are lost in the mists; she lived in her domain, which existed in a curious way outside myself. What relation had she to art?

When some of my colleagues saw the work I had done at home, they labeled me a "colorist." Several called me, not without malice, the "landscape painter." Both those names offended me, although I could see their justification. All the more! In fact, I felt far more at home in the realms of color than in those of drawing.[80] And I had no idea how to defend myself from this pernicious threat.

At that time, Franz Stuck was "Germany's foremost draftsman," and I approached him—alas, only with my school work. He thought everything rather distorted and advised me to work for a year in the drawing class at the Academy.[81] I failed the examination, which only annoyed,

but by no means discouraged me: at this examination, drawings were pronounced good that I quite rightly found stupid, untalented, and utterly lacking in any kind of knowledge.[82] After a year working at home, I approached Franz Stuck a second time—on this occasion solely with sketches for pictures I had not yet been able to complete, and a few landscape studies. He accepted me into his painting class, and in reply to my question about my drawing, he answered that it was expressive. Stuck opposed my "extravagant" use of color, even in the first studies I made at the Academy, and advised me to paint initially in black and white, so as to study form by itself. He spoke with a surprising affection about art, about the play of forms, about the way forms flow into one another, and won my entire sympathy. I wanted to study only drawing with him, since I had observed at once that he possessed little sensitivity to color, and submitted entirely to his advice. In the end, although I sometimes experienced bitter discontent,[83] I remember with gratitude this year spent studying with him. Stuck always spoke very little, and sometimes not very clearly. After his corrections, I sometimes had to ponder at length over his pronouncements—but later nearly always found them useful. He cured my pernicious inability to finish a picture with one single utterance. He told me I worked too nervously, that I singled out the interesting bit straightaway, and that I spoiled this interesting bit by leaving the routine part of the work until too late. "You must wake up with the thought: Today I am allowed to do this or that." This "allowed" revealed to me not only Stuck's profound love and respect for art,[84] but also the secret of serious work. And at home, I finished my first painting.

For many years, however, I remained like a monkey caught in a net: the organic laws of construction fettered my desires, and only through great pains, efforts, and experiments did I succeed in overthrowing this "wall around art." So it was that I finally entered into the realm of art, which, like nature, like science, like political institutions,[85] is a realm in itself, regulated by its own laws peculiar to itself and which, together with all other realms, will ultimately constitute that mighty kingdom that we can now only dimly conceive.

Today is the great day of one of the revelations of this kingdom. The affinities between these individual realms have been illuminated as if by a blast of lightning; unbidden, startling, and heart-warming, they emerge from the darkness. Never have they been so closely linked, nor so sharply divided. This lightning is the progeny of the darkening of the

spiritual heavens that hang above us, black, stifling, and dead. Here begins the great period of the spiritual,[86] the revelation of the spirit. Father—Son—Spirit.

In the course of time, and only gradually, I have come to realize that "truth" generally, and especially in art, is not an x, not always some imperfectly known but constant figure, but that its magnitude is variable, is in a state of continual, albeit gradual progression. Suddenly, it looked to me like a slow-moving snail, seeming hardly to move from its spot, leaving behind it a sticky trail to which short-sighted spirits remain attached. Here, too, I observed this important phenomenon first of all in art, and only later did I realize that, in this case too, the same law likewise determines other realms of life. The progress of truth is extremely complex: the untrue becomes true, the true untrue. Many parts fall away like the shell from the nut, time planes down this shell, causing many people to mistake the shell for the nut and to ascribe to the shell the life of the nut. Many people wrestle for this shell, and the nut rolls away. A new truth comes down from heaven and looks so precise, so stiff and hard, appears so infinitely tall that many people clamber up it, as up a long wooden pole, and are convinced that this time they will reach heaven . . . until it breaks, and the clamberers fall back like frogs into the mire, into murky incertitude. Man often resembles a beetle kept lying on its back: it moves its legs in mute yearning, clutches at every stalk held before it, and constantly believes it will find salvation in this stalk. During my periods of "disbelief" I used to ask myself: Who is it that is keeping me on my back? Whose hand holds the stalk in front of me and takes it away again? Or am I simply lying on my back on the dusty, indifferent ground, clutching at stalks that grow around me "of their own accord"? And yet, how often I felt this hand at my back, and another that covered my eyes, so that I found myself plunged in deepest night while the sun shone.

Art in many respects resembles religion.[87] Its development consists not of new discoveries that obliterate old truths and stamp them as false (as is apparently the case in science). Its development consists in moments of sudden illumination, resembling a flash of lightning, of explosions that burst in the sky like fireworks, scattering a whole "bouquet" of different-colored stars around them. This illumination reveals with blinding clarity new perspectives, new truths that are in essence nothing other than the organic development, the continuing organic growth of earlier wisdom, which is not cancelled out by the

latter, but remains living and productive as truth and as wisdom.[88] The new branch does not render the tree trunk superfluous: the trunk determines the possibility of the branch.[89] Would the new testament have been possible without the old? Would our epoch, the threshold of the "third" revelation, have been conceivable without the second? It is simply the further replication of the original tree trunk, where "everything begins." And this replication, further growth, and complexity, which often appear confusing and disheartening, are the necessary stages that lead to the mighty crown; the stages that lead ultimately to the creation of the green tree.[90]

Christ, in his own words, came not to overthrow the old law. When he said, "It was said unto you . . . and I say unto you," he transformed the old material law into his own spiritual law. The men of his time, in contrast to those of Moses' time, had become capable of understanding and experiencing the commandments "Thou shalt not kill," "Thou shalt not be unchaste," not only in direct, material form, but also in the more abstract form of sins of the mind.[91]

Simple, precise, and rigid thought is thus not ousted, but on the contrary, required as a preliminary to the thoughts that develop further from it. And these further thoughts, which are more malleable, less precise, and less material, resemble new, softer, and further branches that bore new holes in the sky.

On the scales of Christ,[92] phenomena are evaluated not in terms of external, rigid actions, but inner, flexible ones. Here lie the roots of that further transvaluation of values that continues uninterrupted today; these are at the same moment the roots of that internalization which in the realm of art, too, we shall gradually attain. And in our day, in a powerfully revolutionary form. In this way, I have since come to conceive of nonobjective painting not as a negation of all previous art, but as an uncommonly vital, primordial division of the one old trunk into two main branches of development,* indispensable to the creation of the crown of the green tree.

*By these two main branches, I understand two different ways of going about the practice of art. The virtuoso manner (long since known to music as a special manner, corresponding in literature to dramatic art) rests upon more or less personal experience and upon the artistic, creative interpretation of "nature." (A significant instance—portraiture.) By nature we may here understand also an already existing work created by some other hand: the virtuoso piece that springs from it belongs to the

I have always felt this more or less clearly, and have always been put out by assertions that I intended to overthrow the old [tradition of] painting. I could never see any such intention in my works: in them I could feel only the inwardly logical, outwardly organic, inevitable further growth of art. In the end, I came to experience consciously my earlier feelings of freedom, and thus the merely incidental demands I made of art gradually disappeared.[94] They vanished in favor of one single demand: the demand for i n n e r life in the work of art. Here, I noticed to my astonishment that this demand grew from the same basis as that which Christ had established as a qualitative criterion.[95] I observed that this conception of art was Christian, and that, at the same time, it concealed within itself the elements necessary for receiving the "third" revelation, the revelation of the spirit.*

same species as a picture painted "from nature." As a rule, the desire to create virtuoso works of this kind has until now been suppressed by artists, which can only be regretted.[93] So-called copies, too, belong to this species: the copyist tries to get as near to someone else's work, in the same way a conductor treats someone else's composition.

The other manner is t h e c o m p o s i t i o n a l, where the work springs mainly or exclusively from "out of the artist," as has been the case for centuries in music. In this respect, painting has caught up with music, and both assume an ever-increasing tendency to create "absolute" works, i.e., completely "objective" works that, like the works of nature, come into existence "of their own accord," as the product of natural laws, as independent b e i n g s. Such works are closer to that art which lives *in abstracto*, and they alone, perhaps, are destined in the foreseeable future to embody this art existing in the abstract.

*In this sense, Russian peasant law, described above, is likewise Christian and should be contrasted with the heathen Roman law.[96] Keen logic may explain its inner qualification as follows: In the case of this person, this action is not a crime, even if generally speaking it would be regarded as a crime in the case of other people. Therefore: In this case a crime is not a crime. And further: Absolute crime does not exist. (What a contrast to *nulla poena sine lege!*) Still further: It is not the deed (real), but its root (abstract) that constitutes evil (and good). And finally: Every deed is ambivalent.[97] It is balanced on a knife edge. It is the will that gives it a push—it falls to right or left. Outward flexibility and inward precision is, in this instance, highly developed in the Russian people, and I do not think I am exaggerating when I say I recognize a marked capacity for this development in Russians generally. Thus, it is no wonder that peoples who have developed according to the often valuable principles laid down by the formal,

Yet I consider it equally logical that canceling out the object in painting makes very considerable demands of one's ability inwardly to experience purely pictorial form, so that the spectator's development in this direction is absolutely essential, and can on no account be avoided.[99] This is the way to create the conditions that constitute a new atmosphere. In this atmosphere, although much, much later, p u r e a r t will be formed, an art that today hovers before our eyes with indescribable allure, in dreams that slip between our fingers.

I realized in time that my gradual (to a certain extent forced) development of tolerance toward o t h e r people's works was in no way damaging to me; on the contrary, it contributed a great deal to the one-sidedness of m y own strivings. For this reason, I would like partly to limit, partly to extend the adage "The artist should be one-sided" to read, "The artist should be one-sided in his works." The ability to experience others' works (which naturally occurs, and must occur, in one's own individual way) renders one's soul more sensitive, more capable of vibrations, making it richer, broader, more refined, and increasingly adapted to one's own purposes. Experiencing the works of others is, in the broadest sense, the same as experiencing nature. And should, or can, an artist be blind and deaf? I would say that one embarks on one's own work in a happier spirit, with a more tranquil glow, seeing that other possibilities (which are infinite) are being exploited correctly (or more or less correctly) in art. As far as I personally am concerned, I love every form that has arisen of necessity out of the spirit, been created by the spirit. Just as I hate every form that has not.

I believe the philosophy of the future, apart from the existence of phenomena, will also study their spirit with particular attention. Then the atmosphere will be created that will enable mankind in general to feel the spirit of things, to experience this spirit, even if wholly unconsciously, just as people in general today still experience the external aspect of phenomena unconsciously, which explains the public's delight in representational art. Then, however, it will be necessary for man

outwardly most precise Roman mind (think of the *jus strictum* of the e a r l y period) either shake their heads over the Russian way of life, or else reject it with contempt. In particular, superficial observation allows the unfamiliar eye to recognize in this remarkable form of life only its softness and outward flexibility, which is taken for disorder, because its inner precision lies below the surface. As a result, free-thinking Russians show far more tolerance of other peoples than is shown them. And in many cases this tolerance is transformed into enthusiasm.[98]

initially to experience the spiritual in material phenomena, in order subsequently to be able to experience the spiritual in abstract phenomena. And through this new capacity, conceived under the sign of the "spirit," an enjoyment of abstract (= absolute) art will come about.

My book *On the Spiritual in Art* and the *Blaue Reiter* [*Almanac*],* too, had as their principal aim to awaken this capacity for experiencing the spiritual in material and in abstract phenomena, which will be indispensable in the future, making unlimited kinds of experiences possible. My desire to conjure up in people who still did not possess it this rewarding talent was the main purpose of both publications.

Both books were, and are, often misunderstood. They are thought of as "manifestoes," and their authors branded as artists who have "come adrift" as a result of theorizing, who have wandered by mistake into the realms of cerebral activity. Nothing, however, was further from my mind than to appeal to the understanding, to reason. This task would still be premature today and will present itself to artists as the next, vital, and inevitable aim (= step) in the further development of art.[101] No longer can anything endanger the firmly established spirit that has taken powerful root, not even calculation in art, which is so widely distrusted.[102]

After our Italian journey mentioned above, and our brief return to Moscow, my parents and my aunt, Elizabeth Tikheev, to whom I owe no less than to my parents, were obliged, when I was barely five years old, to move to Southern Russia (Odessa)[103] for reasons of my father's health. There, I later attended grammar school, but always felt like a temporary visitor in this town, which was unfamiliar to all my family. Our desire to be able to go back to Moscow never left us, and this town unfolded in my heart a longing similar to that described by Chekhov in his *Three Sisters.*[104] From my thirteenth year, my father used to take me with him to Moscow every summer, and at the age of eighteen, I finally moved there, with the feeling of being home again at last. My father comes from Eastern Siberia,[105] to which his forefathers were banished from Western Siberia for political reasons. He was educated in Moscow, and came to

*My *On the Spiritual* lay written in my drawer for several years. The chance to realize the *Blaue Reiter* [*Almanac*] was not forthcoming. Franz Marc smoothed out the practical difficulties impeding the former.[100] The latter he also supported through his sensitive, understanding, and gifted spiritual collaboration and help.

love this town no less than his home country. His profoundly human and affectionate spirit understood the "Moscow soul," and he knew the external visage of Moscow no less well.[106] It is always a pleasure for me to hear him, for example, reciting in reverential tones the innumerable churches, with their wonderful ancient names.[107] Without a doubt, this is the echo of an artistic spirit.[108] My mother is a Muscovite by birth, and combines qualities that for me are the embodiment of Moscow: external, striking, serious, and severe beauty through and through, well-bred simplicity, inexhaustible energy, and a unique accord between [a sense of] tradition and genuine freedom of thought, in which pronounced nervousness, impressive, majestic tranquility, and heroic self-control are interwoven. In short: "white-stone," "gold-crowned," "Mother Moscow" in human guise.[109] Moscow: the duality, the complexity, the extreme agitation, the conflict, and the confusion that mark its external appearance and in the end constitute a unified, individual countenance; the same qualities in its inner life, incomprehensible to the unfamiliar eye (hence the many contradictory opinions of Moscow held by foreigners); and yet, just as unique and, in the end, wholly unified—I regard this entire city of Moscow, both its internal and external aspect, as the origin of my artistic ambitions. It is the tuning fork for my painting. I have a feeling that it was always so, and that in time, thanks to my external, formal progress, I have simply painted, and am still painting, this same "model" with ever greater expressiveness, in more perfect form, more in its essentials. The detours I have made from what is in fact a straight path have, by and large, not been harmful to me; and the few moments of apparent demise, when I lacked strength and felt I had come to a dead end in my work, were for the most part pauses for rest in preparation for some new departure, making further advance possible.

I have much with which to reproach myself, but I have always remained faithful to one thing—the inner voice that defined my goal in art, which I hope to follow until my dying hour.[110]

Munich, June 1913[111]

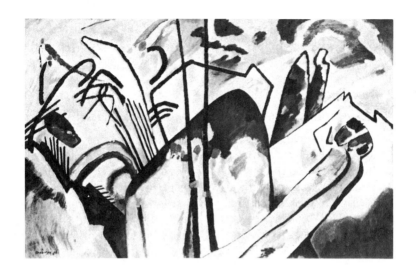

COMPOSITION 4[112]

Supplementary definition

1. **Masses** (Weights)
 lower center—blue (gives the whole picture a cold tone)
 upper right—divided blue, red, yellow
 upper left—black lines of the entangled horses
 lower right—extended lines of reclining figures

2. **Contrasts**
 between mass and line
 between precise and blurred
 between entangled line and entangled color, and
 principal contrast: between angular, sharp movement (battle)
 and light-cold-sweet colors

3. **Running-over**
 of color beyond the outlines

Only the complete contour of the castle is diminished by the way in which the sky flows in over its outline
4. **Two centers**
 1. Entangled lines
 2. Acute form modeled in blue

separated from one another by the two vertical black lines (lances).

The whole composition is intended to produce a very bright effect, with many sweet colors, which often run into one another (resolution), while the yellow, too, is cold. The juxtaposition of this bright-sweet-cold tone with angular movement (battle) is the principal contrast in the picture. It seems to me that this contrast is here, by comparison with *Composition 2*,[113] more powerful, but at the same time harder (inwardly), clearer, the advantage of which is that it produces a more precise effect, the disadvantage being that this precision has too great a clarity.

<div align="center">* *

*</div>

The following are the basic elements of the composition:

1. Concord of passive masses.
2. Passive movement principally to the right and upward.
3. Mainly acute movement to the left and upward.
4. Counter-movements in both directions (the movement to the right is contradicted by smaller forms that move toward the left, and so on).
5. Concord between masses and lines that simply recline.
6. Contrast between blurred and contoured forms (i.e., line as itself (5), but also as contour, which itself has in addition the effect of pure line).
7. The running-over of color beyond the boundaries of form.
8. The predominance of color over form.
9. Resolutions.

March 1911

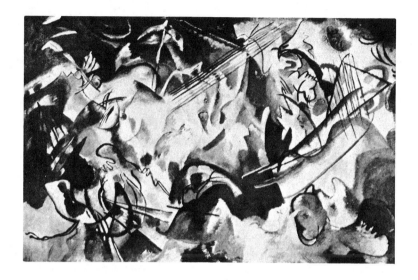

COMPOSITION 6[114]

I carried this picture around in my mind for a year and a half, and often thought I would not be able to finish it. My starting point was the Deluge. My point of departure was a glass-painting that I had made more for my own satisfaction.[115] Here are to be found various objective forms, which are in part amusing (I enjoyed mingling serious forms with amusing external expressions): nudes, the Ark, animals, palm trees, lightning, rain, etc. When the glass-painting was finished, there arose in me the desire to treat this theme as the subject of a Composition, and I saw at that time fairly clearly how I should do it. But this feeling quickly vanished, and I lost myself amidst corporeal forms, which I had painted merely in order to heighten and clarify my image of the picture. I gained in confusion rather than in clarity. In a number of sketches I dissolved the corporeal forms; in others I sought to achieve the impression by purely abstract means. But it didn't work. This happened because I was still obedient to the expression of the Deluge, instead of heeding the expression of the word "Deluge." I was ruled not by the inner sound, but by the external impression. Weeks passed and I tried again, but still without success. I tried the tested method of putting the task aside for a

time, waiting to look at the better sketches again all at once, with new eyes. Then I saw that they contained much that was correct, but still could not separate the kernel from the shell. I thought of a snake not quite able to slough its skin. The skin itself looked perfectly dead—but it still stuck.

In the same way, for a year and half, that element which was foreign to my inner picture of that catastrophe called the Deluge still stuck to me.

My glass-painting was at that time away on exhibition. When it came back and I saw it again, I at once received the same inner jolt I had experienced on creating the glass-painting. But I was mistrustful, and did not now believe I would be able to create the big picture. Still, I looked from time to time at the glass-painting that hung in my studio. Every time I was struck, first by the colors, then by the compositional element, and then by the linear form itself, without reference to the object. This glass-painting had become detached from me. It appeared to me strange that I had painted it. And it affected me just like many real objects or concepts that have the power of awakening within me, by means of a vibration of the soul, purely pictorial images, and that finally lead me to create a picture. Finally, the day came, and a well-known, tranquil, inner tension made me fully certain. I at once made, almost without corrections, the final design, which in general pleased me very much.* Now I knew that under normal circumstances I would be able to paint the picture. No sooner had I received the canvas I had ordered than I began the laying-in. It advanced quickly, and nearly everything was right the first time. In two or three days the main body of the picture was complete. The great battle, the conquest of the canvas, was accomplished. If for some reason I had been prevented from continuing work on the picture, it would still have existed—the main part was done. Then came the subtle, enjoyable, and yet exhausting task of balancing the individual elements one against the other. How I used to torture myself previously when some detail seemed to me wrong and I tried to improve it! Years of experience have taught me that the mistake is rarely to be found where one looks for it. It is often the case that to improve the bottom left-hand corner, one needs to change something in the upper right. If the left-hand scale goes down too far, then you have to put a heavier weight on the right—and the left will come up of its own accord.

*Koehler Collection.

The exhausting search for the right scale, for the exact missing weight, the way in which the left scale trembles at the merest touch on the right, the tiniest alterations of drawing and color in such a place that the whole picture is made to vibrate—this permanently living, immeasurably sensitive quality of a successful picture—this is the third, beautiful and tormenting moment in painting. These tiniest weights, which one here employs, and which exert so powerful an effect upon the whole picture—the indescribable accuracy of the operation of a hidden law, which leaves room for the intervention of the trained hand and to which that same hand is subservient—is just as delightful as the initial piling-up of masses upon the canvas. Each of these moments has its own tension. How many unsuccessful or uncompleted pictures owe their sickly state simply to the fact that the wrong tension was applied.

In this picture one can see two centers:

1. on the left the delicate, rosy, somewhat blurred center, with weak, indefinite lines in the middle;

2. on the right (somewhat higher than the left) the crude, red-blue, rather discordant area, with sharp, rather evil, strong, very precise lines.

Between these two centers is a third (nearer to the left), which one only recognizes subsequently as being a center, but is, in the end, the principal center. Here the pink and the white seethe in such a way that they seem to lie neither upon the surface of the canvas nor upon any ideal surface. Rather, they appear as if hovering in the air, as if surrounded by steam. This apparent absence of surface, the same uncertainty as to distance can, e.g., be observed in Russian steam baths. A man standing in the steam is neither close to nor far away; he is just somewhere. This feeling of "somewhere" about the principal center determines the inner sound of the whole picture. I toiled over this part until I succeeded in creating what I had at first only dimly desired and subsequently became ever clearer within me.

The smaller forms within the picture demanded an effect at the same time very simple and very broad (largo). To this end, I employed the same long, solemn lines I had already used in Composition 4. I was very pleased to see how this same device here produced such a different effect. These lines are linked with the thicker lines running obliquely toward them in the upper part of the picture, with which they come into direct conflict.

To mitigate the dramatic effect of the lines, i.e., to distort the excessively importunate voice of the dramatic element (put a muzzle on it), I created a whole fugue out of flecks of different shades of pink, which plays itself out upon the canvas. Thus, the greatest disturbance becomes clothed in the greatest tranquility, the whole action becomes objectified. This solemn, tranquil character is, on the other hand, interrupted by the various patches of blue, which produce an internally warm effect. The warm effect produced by this (in itself) cold color thus heightens once more the dramatic element in a noble and objective manner. The very deep brown forms (particularly in the upper left) introduce a blunted, extremely abstract-sounding tone, which brings to mind an element of hopelessness. Green and yellow animate this state of mind, giving it the missing activity.

The alternation of rough and smooth, and other tricks in the treatment of the canvas itself, have here been exploited to a high degree. Thus, the spectator will experience a different response again on approaching the canvas more closely.

So it is that all these elements, even those that contradict one another, inwardly attain total equilibrium, in such a way that no single element gains the upper hand, while the original motif out of which the picture came into being (the Deluge) is dissolved and transformed into an internal, purely pictorial, independent, and objective existence. Nothing could be more misleading than to dub this picture the representation of an event.

What thus appears a mighty collapse in objective terms is, when one isolates its sound, a living paean of praise, the hymn of that new creation that follows upon the destruction of the world.

May 1913

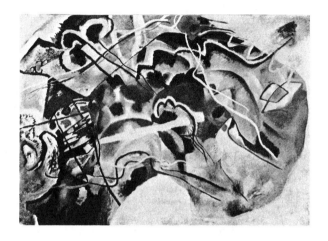

PICTURE WITH THE WHITE EDGE[116]

For this picture, I made numerous designs, sketches, and drawings. I made the first design immediately after my return from Moscow in December 1912. It was the outcome of those recent, as always extremely powerful impressions I had experienced in Moscow—or more correctly, of Moscow itself. This first design was very concise and restricted. But already in the second design, I succeeded in "dissolving" the colors and forms of the actions taking place in the lower right-hand corner. In the upper left remained the troika motif,* which I had long since harbored within me and which I had already employed in various drawings. This left-hand corner had to be extremely simple, i.e., its impression had to be directly conveyed, untrammeled by the form. Right in the corner are white zig-zag forms, expressing a feeling I am unable to convey in words. It awakens the feeling, perhaps, of an obstacle, which is, however, ultimately unable to deter the progress of the troika. Described in this

*[troika] = three-horse sled. This is what I call the three lines, curved at the top, which, with different variations, run parallel to one another. The lines of the backs of the three horses in a Russian troika led me to adopt this form.

way, this combination of forms takes on a wooden quality that I find distasteful. For instance, the color green often (or sometimes) awakens in the soul (unconsciously) overtones of summer. And this dimly perceived vibration, combined with a cool purity and clarity, can in this case be exactly right. But how distasteful it would be if these overtones were so clear and pronounced that they made one think of the "joys" of summer: e.g., how nice it is in summer to be able to leave off one's coat without danger of catching cold.

Thus, clarity and simplicity in the upper left-hand corner, blurred dissolution, with smaller dissolved forms vaguely seen in the lower right. And as often with me, two centers (which are, however, less independent than in, e.g., *Composition 6*, where one could make two pictures out of the one, pictures with their own independent life, but which have grown together).

The one center, to the left: combination of standing forms, which approach the second center, with pure, powerfully sounding touches of color; the red somewhat runny, the blue self-absorbed (pronounced concentric movement). The means employed are thus also extremely simple, and quite undisguised and clear.

The other center, on the right: broad, curving brushstrokes (which cost me a great deal of effort). This second center has, both toward the outside and on the inside, incandescent (almost white) zigzag forms, which bestow upon the rather melancholy character of this curved shape the overtones of an energetic "inner boiling." Which is extinguished (in a sense, putting it over-explicitly) by the dull blue tones, which only occasionally attain a more strident pitch and which, taken together, enclose the upper part of the picture with a more or less egg-shaped background. It is like a small, autonomous realm—not a foreign body that has merely been tacked onto the whole, but more like a flower springing out of the soil. At its edges, I have treated this more or less egg-shaped form so that it lies clearly revealed, but does not produce too conspicuous or strident an effect: I have, for example, made the edges clearer toward the top, less distinct at the bottom. Following this edge with one's eye, one experiences an inner sensation like a succession of waves.

These two centers are separated, and at the same time linked, by numerous more or less distinct forms, which are in part simple patches and areas of green. It was quite unconsciously—and, as I see now, purposefully—that I used so much green: I had no desire to introduce

into this admittedly stormy picture too great an unrest. Rather, I wanted, as I noticed later, to use turmoil to express repose. I even used too much green, and especially too much Paris blue (a dully sonorous, cold color), with the result that it was only with exertion and difficulty that I was later able to balance and correct the excess of these colors.

Between the simplicity of the upper part of the picture and the two centers, my inner voice insisted upon the application of a technique I like to call *Quetschtechnik* [literally, squashing technique]: I squashed the brush against the canvas in such a way that little points and mounds were produced. I used this technique quite correctly, and once again, with a clear sense of purpose: how necessary this t e c h n i c a l disruption was, occurring as it did between the three above-mentioned regions.

At the bottom left, there is a b a t t l e in black and white, which is divorced from the dramatic clarity of the upper left-hand corner by Naples yellow. The way in which black smudges rotate within the white I call "i n n e r b o i l i n g w i t h i n a d i f f u s e f o r m."

The opposite corner, upper right, is also similar, but that is itself part of the white edge.

I made slow progress with the white edge. My sketches did little to help, that is, the individual forms became clear within me—and yet, I could still not bring myself to paint the picture. It tormented me. After several weeks, I would bring out the sketches again, and still I felt unprepared. It is only over the years that I have learned to exercise patience in such moments and not smash the picture over my knee.

Thus, it was not until after nearly five months that I was sitting looking in the twilight at the second large-scale study, when it suddenly dawned on me what was missing—the white edge.

I scarcely dared believe it; nonetheless, I went straightaway to my supplier and ordered the canvas. My doubts as to the size of the canvas lasted at most half an hour (Length: 160? 180? 200? [centimeters]).

I treated this white edge itself in the same capricious way it had treated me: in the lower left a chasm, out of which rises a white wave that suddenly subsides, only to flow around the right-hand side of the picture in lazy coils, forming in the upper right a lake (where the black bubbling comes about), disappearing toward the upper left-hand corner, where it makes its last, definitive appearance in the picture in the form of a white zigzag.

Since this white edge proved the solution to the picture, I named the whole picture after it.

May 1913

1914

Cologne Lecture
"Kandinsky über seine Entwicklung"
Johannes Eichner, *Kandinsky und Gabriele Münter, von Ursprüngen Moderner Kunst* (**Munich**), **1957**

At the beginning of 1914, the newly formed society Kreis für Kunst Köln staged a Kandinsky exhibition in the foyer of the Deutsches Theater in Cologne.[1] To mark the opening they invited the artist to deliver a lecture about himself and his work. Kandinsky declined to travel to Cologne for the opening, on 30 January,[2] but sent the typescript of a lecture, which was not, in fact, given. The typescript is lost, but Kandinsky's manuscript draft, complete except for the first page, is preserved among his papers. Unpublished during his lifetime, this manuscript is of such important that it is included here among his published statements.

Kandinsky's lecture is much more than, as Bouillon suggests,[3] a postscript to the Sturm album of 1913. The artist gives a far more direct account here than he does in "Reminiscences" of the problems encountered in abandoning representational form and his need still to "bridge the gap" by means of objects. Although he believed he had now embarked upon a new phase in his development, his description of the "resonances" set up by objects in his paintings remains crucial to an understanding of much of his work up to the outbreak of the First World War.

The manuscript poses considerable problems for the editor. Kandinsky's draft, though legible, at times verges on telegraphese, to say nothing of his idiosyncratic manner of

writing and his disdain for the rules of grammar and syntax. Johannes Eichner, who first published the manuscript, preserved this idiosyncratic character of the original, making only the minimal changes necessary for comprehension. It is his edited version that follows here. Since the first page of the original is missing, Eichner omits the rest of the introduction and begins with the next section, commencing on what would have been the fourth side of Kandinsky's manuscript. In certain instances, it has been possible to verify Eichner's reading of doubtful passages by a study of the original. Some slight improvements to the text are incorporated without specific mention in the following translation.

My process of development consists of three periods:

1. The period of dilletantism, my childhood and youth, with its uncertain, for the most part painful emotions and, to me, incomprehensible longing.

2. The period after leaving school, during which these emotions gradually took on a more definite and, to me, clearer form. I sought to express them by means of all kinds of external forms, forms borrowed from external nature, by means of objects.

3. The period of conscious application of the materials of painting, the recognition of the superfluousness, *for me*, of real forms, and my painfully slow development of the capability to conjure from within myself not only content, but also its appropriate form—thus the period of transition to pure painting, which is also called absolute painting, and the attainment of the abstract form necessary for me.

On this long path, which I *had* to follow, I used up a great deal of energy in my struggle with the traditional. Only gradually did one prejudice collapse after another. Apart from my innumerable experiments, I also spent much time in reflection, wishing to solve many

things by way of logic. Yet what was logically so easy simply would not come in practice. As a rule it is not a difficult, but often an enjoyable task to get to the point at which one can say *ergo*. One knows much more often *what* one wants than how to attain it. This *how* is only and exclusively *good*, properly speaking, if it has come of its own accord, if the hand that has been blessed with the necessary gift is not dependent upon reason, but rather, contrary to the dictates of reason, often creates what is correct *of its own accord*. And apart from the satisfaction thus attained, only such a form can bring a kind of pleasure that is beyond comparison.

This important, apparently simple, but in reality complex question today takes on a decisive significance. Its present-day form can be defined for the coming period in the following terms: Do intuition and logic have equal status in producing a work of art? I cannot at this point immerse myself in the profundities of this question. On the other hand, I may content myself with the concise answer that corresponds to my way of thinking. The birth of a work of art is of cosmic character. The originator of the work is thus the spirit. Thus, the work exists *in abstracto* prior to that embodiment which makes it accessible to the human senses. For this therefore necessary embodiment, every means is justified. I.e., logic just as much as intuition. Both these factors are examined by the creating spirit, which rejects the false in both of them. Thus, logic may not be rejected simply because it is by nature foreign to intuition. Neither may intuition be rejected, for the same reason. Both factors are in themselves, however, barren and dead without the control of the spirit. If the spirit is absent, neither logic nor intuition can create an altogether proper work of art.

I can in general characterize the three periods of my development, to which I have referred, in the following manner:

I. I remember the first, or (as I called it) dilletante, period as the simultaneous effect of two different impulses. These two different impulses were, as my later development shows, fundamentally different.

1. Love of nature.

2. Indefinite stirrings of the urge to create.

This love of nature consisted principally of pure joy in and enthusiasm for the element of color. I was often so strongly possessed by a strongly sounding, perfumed patch of blue in the shadow of a bush that I would paint a whole landscape merely in order to fix this patch. Of course, such

studies turned out badly, and I used to search after the kind of "motifs" of which each constituent part would affect me equally strongly. Of course, I never found any. Then I would try to make more effective those parts of the canvas which produced a lesser effect. It was out of these exercises that my later ability developed, as well as my way of painting sounding landscapes, examples of which are to be seen in this exhibition.

At the same time I felt within myself incomprehensible stirrings, the urge to paint a *picture*. And I felt dimly that a picture can be something other than a beautiful landscape, an interesting and picturesque scene, or the portrayal of a person. Because I loved colors more than anything else, I thought even then, however confusedly, of color composition, and sought that objective element which could justify the [choice of] colors.

This was the transition to my time of study, and to the second period of my search.

II. It soon appeared to me that past ages, having no longer any real existence, could provide me with freer pretexts for that use of color which I felt within myself. Thus, I chose first medieval Germany, with which I felt a spiritual affinity. To become more closely acquainted with this period, I made drawings in the museums, in the Munich print-room, and traveled to the old towns. Yet I treated quite freely the material I had thus accumulated, and did not worry too much about questions such as whether one particular costume had existed at the same time as the next or as the style of the architecture. I also created many things from within myself, something which, in my subsequent Russian period, went so far that I drew and painted everything freely from memory and according to my mental picture. I was far less free in my treatment of the "laws of drawing." E.g., I regarded it as necessary to keep people's heads more or less in a straight line, as one sees them on the street. In [my picture] *Colorful Life*,[4] where the task that charmed me most was that of creating a confusion of masses, patches, lines, I used a "bird's eye view" to place the figures one above the other. To arrange the dividing-up of areas and the application of the brushstrokes as I wished, on each occasion I had to find a perspective pretext or excuse.

Only very slowly did I come to free myself from this prejudice. In *Composition 2*,[5] one can see the free use of color without regard for the demands of perspective. I always found it unpleasant, however, and often distasteful, to allow the figures to remain within the bounds of physiological laws and at the same time indulge in compositional dis-

tortions. It seemed to me that if one physical realm is destroyed for the sake of pictorial necessity, then the artist has the artistic right and the artistic duty to negate the other physical realms as well. I saw with displeasure in other people's pictures elongations that contradicted the structure of the body, or anatomical distortions, and knew well that this would not and could not be for me the solution to the question of representation. Thus, objects began gradually to dissolve more and more in my pictures. This can be seen in nearly all the pictures of 1910.

As yet, objects did not want to, and were not to, disappear altogether from my pictures. First, it is impossible to conjure up maturity artificially at any particular time. And nothing is more damaging and more sinful than to seek one's forms by force. One's inner impulse, i.e., the creating spirit, will inexorably create at the right moment the form it finds necessary. One can philosophize about form; it can be analyzed, even calculated. It must, however, enter into the work of art of its own accord, and moreover, at that level of completeness which corresponds to the development of the creative spirit. Thus, I was obliged to wait patiently for the hour that would lead my hand to create abstract form.

Secondly (and this is closely bound up with my inner development), I did not want to banish objects completely. I have in many places spoken at length about the fact that objects, in themselves, have a particular spiritual sound, which can and does serve as the material for all realms of art. And I was still too strongly bound up with the wish to seek purely pictorial forms having *this* spiritual sound. Thus, I dissolved objects to a greater or lesser extent within the same picture, so that they might not all be recognized at once and so that these emotional overtones might thus be experienced gradually by the spectator, one after another. Here and there, purely abstract forms entered of their own accord, which therefore had to produce a purely pictorial effect without the above-mentioned coloration. In other words, I myself was not yet sufficiently mature to experience purely abstract form without bridging the gap by means of objects. If I had possessed this ability, I would already have created absolute pictures at that time.

In general, however, I already knew quite definitely at that time that I would conquer absolute painting. Experience bade me have the utmost patience. And yet, there were many times when it was infinitely difficult to follow this bidding.

In *On the Spiritual in Art,* I define present-day harmony as the collision and dramatic struggle of individual elements among them-

selves. I sought for this harmony even at that time, but I never had the inner desire to take it to its limits, to make all pictorial means serve equally the ends of purest tragedy. My inner sense of moderation never permitted me to descend to this one-sidedness. Thus, e.g., in *Composition 2* I mitigated the tragic element in the composition and drawing by means of more indifferent and [totally] indifferent colors. Or I sought involuntarily to juxtapose the tragic [use of] color with sublimity of linear form (*Picture with Rowboat*[6] and several of the landscapes). For a time I concentrated all my efforts upon the linear element, for I knew internally that this element still requires my attention. The colors, which I employed later, lie as if upon one and the same plane, while their inner weights are different. Thus, the collaboration of different spheres entered into my pictures of its own accord. By this means I also avoided the element of flatness in painting, which can easily lead and has already so often led to the ornamental. This difference between the inner planes gave my pictures a depth that more than compensated for the earlier, perspective depth. I distributed my weights so that they revealed no architectonic center. Often, heavy was at the top and light at the bottom. Often, I left the middle weak and strengthened the corners. I would put a crushing weight between parts that weighed little. I would let cold come to the fore and drive warm into the background. I would treat the individual color-tones likewise, cooling the warmer tones, warming the cold, so that even one single color was raised to the level of a composition. It is impossible, and relatively fruitless, to enumerate all the things that served me as means to an end. The attentive visitor will discover for himself many things of which I myself have perhaps no inkling. And what use are words for those who will not hear!

The summer of 1911, which was unusually hot for Germany, lasted desperately long. Every morning on waking, I saw from the window the incandescent blue sky. The thunderstorms came, let fall a few drops of rain, and passed on. I had the feeling as if someone seriously ill had to be made to sweat, but that no remedies were of any use: hardly had a few beads of sweat appeared than the tortured body would begin to burn all over again. One's skin cracked. One's breath failed. Suddenly, all nature seemed to me white; white (great silence—full of possibilities) displayed itself everywhere and expanded visibly. Later, I remembered this feeling when I observed that white played a special role and had been treated with particular attention in my pictures. Since that time, I know what undreamed-of possibilities this primordial color conceals within itself. I

saw how wrongly I had hitherto conceived of this color, for I had regarded its presence in large masses as necessary merely to emphasize the linear element, and had been afraid of the reckless quality of its inner strength. This discovery was of enormous importance for me. I felt, with an exactitude I had never yet experienced, that the principal tone, the innate, inner character of a color can be redefined *ad infinitum* by its different uses, that, e.g., the indifferent can become more expressive than what is thought of as the most highly expressive. This revelation turned the whole of painting upside-down and opened up before it a realm in which one had previously been unable to believe. I.e., the inner, thousandfold, unlimited values of one and the same quality, the possibility of obtaining and applying infinite series simply in combination with one single quality, tore open before me the gates of the realm of absolute art.

A spiritual-logical consequence of this experience was the impulse to make the external element of form even more concise, to clothe content in much cooler forms. To my way of thinking, which was at that time still completely unconscious, the highest tragedy clothed itself in the greatest coolness, that is to say, I saw that the greatest coolness is the highest tragedy. This is that cosmic tragedy in which the human element is only one sound, only a single voice, whose focus is transposed to within a sphere that approaches the divine. One must employ such expressions with care, and not play with them. Here, however, I use them consciously, and feel entitled to do so, for at this point I am speaking not about my own pictures, but about a kind of art that has never yet been personified and in its abstract being still waits for incarnation.

It was in this spirit, as far as I personally am concerned, that I painted many pictures (*Picture with Zig Zag*,[7] *Composition 5*[8] and 6,[9] etc.). I was, however, certain that if I lived long enough, I should enter into the realm I saw before my eyes. Just as one sees the summit of the mountain from below.

For the same reason, I became more and more strongly attracted by the unskilled. I abbreviated the expressive element by lack of expression. By the external position in which I placed it, I would emphasize an element that was in itself not very clear in its expression. I deprived my colors of their clarity of tone, dampening them on the surface and allowing their purity and true nature to glow forth, as if through frosted glass. *Improvisation 22*[10] and *Composition 5* are painted in this way, as

well as, for the most part, *Composition 6*. The latter acquired three centers and a considerable complexity as regards composition, which I have described in detail in my album (perhaps read!).[11] *Composition 2* is painted without theme, and perhaps at that time I would have been nervous of taking a theme as my starting point. On the other hand, I calmly chose the Resurrection as the theme for *Composition 5*, and the Deluge for the sixth. One needs a certain daring if one is to take such outworn themes as the starting point for pure painting. It was for me a trial of strength, which in my opinion has turned out for the best.

The pictures painted since then have neither any theme as their point of departure, nor any forms of corporeal origin. This occurred without force, quite naturally, and of its own accord. In these latter years, forms that have arisen of their own accord right from the beginning have gained an ever-increasing foothold, and I immersed myself more and more in the manifold value of abstract elements. In this way, abstract forms gained the upper hand and softly but surely crowded out those forms that are of representational origin.

Thus, I circumnavigated and left behind me the three greatest dangers on the path I had foreseen. These were:

1. The danger of stylized form, which either comes into the world stillborn, or else, too weak to live, quickly dies.
2. The danger of ornamental form, the form belonging mainly to external beauty, which can be, and as a rule is outwardly expressive and inwardly expressionless.
3. The danger of experimental form, which comes into being by means of experimentation, i.e., completely without intuition, possessing, like *every* form, a certain inner sound, but one that deceitfully simulates internal necessity.

Inner maturity, upon which in general I have firmly relied, but which has afforded me nonetheless many a bitter hour of hopelessness, has of itself created the [necessary] formal element.

As has been said often enough, it is impossible to make clear the aim of a work of art by means of words. Despite a certain superficiality with which this assertion is leveled and in particular exploited, it is by and large correct, and remains so even at a time of the greatest education and knowledge of language and its material. And this assertion—I now abandon the realm of objective reasoning—is also correct because the artist himself can never either grasp or recognize fully his own goal.

And finally: the best of words are no use to him whose sensibilities have remained at an embryonic stage.

In conclusion, therefore, I shall embark upon the negative path and explain as clearly as possible what I do not want. Many assertions of present-day art criticism are refuted in the process, for such criticism has, alas, until now been often rebarbative and has shouted falsehoods into the ears of many who were inclined to hear.

I do not want to paint music.

I do not want to paint states of mind [*Seelenzustände*].

I do not want to paint coloristically or uncoloristically.

I do not want to alter, contest, or overthrow any single point in the harmony of the masterpieces of the past.

I do not want to show the future its true path.

Apart from my theoretical works, which until now from an objective, scientific point of view leave much to be desired, I only want to paint good, necessary, living pictures, which are experienced properly by at least a few viewers.

As in the case of every new phenomenon that has, and will continue to have, any considerable significance, many objections are leveled at my pictures; one maintains that I paint too quickly and too easily; another, that I paint too laboriously; a third, too abstract; a fourth, not abstract enough; a fifth, too insistently and clearly; a sixth, that I paint completely unclearly. Many people regret that I did not stick by the ideals out of which arose my pictures of ten years ago. Others think even that was going too far, while yet others draw the dividing line between the allowed and the forbidden nearer to the present-day.

All these objections and prescriptions could be regarded as correct and perceptive if only the artist worked as those people who criticize him imagine. Their principal mistake, however, lies in the fact that the artist works not to earn praise or admiration, or to avoid blame and hatred, but rather obeys that categorically imperative voice, which is the voice of the Lord, before whom he must humble himself and whose servant he is.

Letters to Arthur Jerome Eddy
Arthur J. Eddy,
Cubists and Post-Impressionism
(Chicago), 1914

Arthur Jerome Eddy, author of *Delight, the Soul of Art* and *Recollections and Impressions of James A. McNeill Whistler*, was one of the first protagonists of modern European painting in the United States. As emerges from his letters, preserved in the Gabriele Münter und Johannes Eichner Stiftung ("I was glad to get this commission for Herr Kandinsky"), it was Eddy who persuaded his friend Edwin R. Campbell to commission from the artist four panels, thought to represent the four seasons, which were installed in the vestibule of Campbell's apartment at 635 Park Avenue, New York.[1] These panels are now separated, two being the property of the Museum of Modern Art in New York, two belonging to the Solomon R. Guggenheim Museum.

Eddy appears to have become acquainted with Kandinsky's work through the Armory Show in 1913. The following year he wrote *Cubists and Post-Impressionism,* no doubt as a result of the impact produced by that exhibition and by work he had seen both during his travels in Europe and at Alfred Stieglitz's gallery at 291 Fifth Avenue. This book, one of the most important appreciations of avant-garde art prior to the First World War, was published by the firm of McClurg & Co. in Chicago; an English edition was published in 1915 by Grant Richards Ltd., London. One chapter of *Cubists and Post-Impressionism* is devoted to the "New Art in Munich"; in it, as well as giving an extended résumé of Kandinsky's

theories set out in his published writings—*On the Spiritual in Art,* "On the Question of Form," "Painting as Pure Art"—Eddy reproduces substantial extracts from letters he had received from the artist. Of particular interest is Kandinsky's account of his painting *Improvisation No. 30 (Cannons);* although he insists that the designation "Cannons" was selected "purely for his own use," he also refers explicitly to the "secondary tone" produced in the spectator by "larger or smaller remains of *objectivity.*"

Kandinsky, in turn, tried to enlist Eddy's support for certain of his artist friends such as Albert Bloch. In a letter of October 1913, he wrote: "He [Bloch] works most energetically, accomplishes much, makes fine progress, and constantly gains in the form of inner expression. Him, too, I really can recommend warmly."[2]

The designation "Cannons," selected by me *for my own use,* is not to be conceived as indicating the "contents" of the picture.[3]

These contents are indeed what the spectator *lives,* or *feels,* while under the effect of the *form and color combinations* of the picture. This picture is nearly in the shape of a cross. The center—somewhat below the middle—is formed by a large, irregular blue plane. (The blue color in itself counteracts the impression caused by the cannons!) Below this center there is a muddy-gray, ragged second center almost equal in importance to the first one. The four corners extending the oblique cross into the corners of the picture are heavier than the two centers, especially heavier than the first, and they vary from each other in characteristics, in lines, contours, and colors.

Thus the picture becomes lighter, or looser in the center, and heavier, or tighter towards the corners.

The scheme of the construction is thus toned down, even made invisible for many, by the looseness of the forms. Larger or smaller remains of *objectivity* (the cannons, for instance) produce in the spec-

tator that secondary tone which objects call forth in all who feel.

The presence of the cannons in the picture could probably be explained by the constant war talk that had been going on throughout the year. But I did not intend to give a representation of war; to do so would have required different pictorial means; besides, such tasks do not interest me—at least not just now.

This entire description is chiefly an analysis of the picture which I have painted rather subconsciously in a state of strong inner tension. So intensively did I feel the necessity of some of the forms, that I remember having given loud-voiced directions to myself, as for instance: "But the corners must be heavy!" In such cases it is of importance exactly to discern all things, the weight, for instance, by the feeling. Generally speaking, I might almost declare that where the feeling that lies in the soul, in the eye, and in the hand is strong enough to faultlessly determine the finest measurements and weights, "schematism" and the much-dreaded "consciosity" will not become dangerous. On the contrary, in this case, the said elements will even prove immeasurably beneficial.

I would that all my pictures might be judged exclusively from this point of view, and that the nonessentials might completely disappear from the judgment.

Whatever I might say about myself or my pictures can touch the *pure artistic meaning* only *superficially.* The observer must learn to look at the picture as a graphic representation of a *mood* and not as a representation of *objects.*

All that anyone can say about pictures, and what I might say myself, can touch the contents, the *pure artistic meaning,* of a picture *only superficially.* Each spectator for himself must learn to view the picture *solely* as a graphic representation of a mood, passing over as unimportant such details as representations or suggestions of natural objects. This the spectator can do after a time, and where one can do it, many can.

As regards other artists, I am very tolerant, but at the same time most severe; my opinion of artists is influenced but little by considerations of the element of form, pure and simple; I expect of the artist to bear within at least the "sacred spark" (if not "flame"). There really is nothing easier than to master the form of something or someone. Boecklin is quoted as having said that even a poodle-dog might learn how to draw, and in this he was correct. At the schools I attended, I had more than a hundred colleagues who had learned something, many had in good time managed to draw quite well and anatomically correct—still, they were not artists, not a pfennig's worth. In short, I value *only* those artists who really are artists; that is, who consciously or unconsciously, in an *entirely original form*, or in a style bearing their *personal imprint*, embody the expression of their *inner self*; who, consciously or unconsciously, work *only* for *this end* and cannot work *otherwise*. The number of such artists is very few. If I were a collector I would buy the works of such even if there were weaknesses in what they did; *such* weaknesses grow less in time and finally disappear entirely; and though they may be apparent in the earlier works of the artist, still they do not deprive even these earlier and less perfect works of value. But the *other* weakness, that of *lack of soul*, never decreases with time, but is sure to grow worse and become more and more apparent, and so render absolutely valueless works that *technically* may be very correct. The entire history of art is proof of this. The *union* of *both* kinds of strength—that of intellect or spirituality with that of form, or technical perfection—is most rare, as is also demonstrated by the history of art.

I have now been exhibiting for almost fifteen years, and for the same fifteen years I have been hearing (although more rarely of late) that I have gone too far on my way; that in time my exaggerations will most surely decrease, and that I would yet paint in an "entirely different manner"; that I would "return to nature." I had to hear this for the first time when I exhibited my studies painted on the naturalist basis with the horn (spatula).

The truth of the matter is that every really gifted artist, that is, an

artist working under an impulse *from within,* must go in a way that in some mystical manner has been laid out for him from the very start. His life is nothing but the fulfillment of a task set for him (*for him, not by himself*). Meeting with enmity from the start, he feels only vaguely and indistinctly that he carries a message for the expression of which he must find a *certain* manner. This is the period of "storm and stress" then follow desperate *searching,* pain, great pain—until *finally* his eyes open and he says to himself, "There is my way." The rest of his life lies along this path. And one must follow it to the very last hour *whether one wants to do so, or not.* And no one must imagine that this is a Sunday afternoon's walk, for which one selects the route at will. Neither is there any Sunday about it; it is a working day, in the strongest sense possible. And the greater the artist, the more one-sided is he in *his* work; true, he retains the ability to do "nice" work of other kind (by reason of his "talent"), but *innerly* weighty, infinitely deep, and immeasurable serious things he can achieve *only* in his *one-sided* art. Talent is not an electric pocket lantern, the rays of which one may at will direct now hither and then thither; it is a star for which the path is being prescribed by the dear Lord.

As far as I am concerned personally, I was as if thunderstruck, when for the first time and in only a general manner I began to see my way. I was awed. I deemed this inspiration to be a delusion, a "temptation."

You will easily understand what doubts I had to overcome, until I became convinced that I had to follow this way. Of course, I clearly understood what it means "to drop the objective." With what doubts I was troubled regarding my own powers! For I knew at once *what* powers were *absolutely* required for this task. How this inner development proceeded, how *everything* pushed me on to this way and how the exterior development slowly but logically (step by step) followed suit, you will see from my book that is to appear shortly (in English). All that I still see *ahead* of me, all these tasks, the ever-increasing wealth of possibilities, the ever-growing depth of painting I cannot describe. And one must and *may* not describe such things: they must mature *innerly* in secret confinement and may not be expressed otherwise than by the painter's art.

If in time you acquire the ability to more exactly *live* my pictures you will have to admit that the element of "chance" is very rarely met with in these pictures, and that it is more than amply covered by the large positive sides—so amply, indeed, that it is not worth while to mention

those weak spots.

My constructive forms, although outwardly appearing indistinct, are in fact rigidly fixed as if they were cut in stone.

These explanations lead us too far; they could help only if illustrated by examples. Also, this letter is already much longer than it ought to be. I trust that I have expressed myself clearly! These things are so infinitely complicated, and how often do I deviate from my theme and thus (instead of producing "clarity") cause confusion to become worse confounded!

On the Artist
[Om Konstnären]
(Stockholm), 1916

At the beginning of 1916, the Stockholm art dealer and
publisher Carl Gummeson, in collaboration with Herwarth
Walden, organized a series of three exhibitions of artists
associated with *Der Sturm*. The first exhibition was devoted
to Franz Marc, the second to Kandinsky, the third to Münter.
Kandinsky was in Stockholm from December 1915 until
March 1916 in connection with his exhibition,[1] at which, in
addition to the works listed in the catalogue, the four panels
he had painted for Edwin R. Campbell were shown prior to
their shipment to New York.[2] During this period, he was
briefly reunited with Münter, and it was to Münter that he
dedicated his essay "On the Artist," published as a brochure
by Gummeson. Kandinsky's German manuscript, entitled
"Über den Künstler," is preserved by the Gabriele Münter
und Johannes Eichner Stiftung; according to Eichner, this
German version is fuller and contains specific references to
Münter that were omitted from the Swedish publication.
Despite our requests, the Director of the Münter-Eichner
Stiftung, Dr. H.K. Roethel, was not able to provide access
to the German manuscript for the purpose of comparison.[3]

On the dazzling white a black dot unexpectedly burns. It becomes larger, still larger, unceasingly larger.

Suddenly, an archipelagic scatter of black spots, which continually increase in number and size, is sifted out over the intense-white, as through a fine sieve.

Over the fields rises the sound of invisibly flowing waters, at first hardly audible, then louder and louder. Many voices, each singing a different song, uniting, interweaving—a multi-voiced choir.

And the light becomes dark; the dark, light.

In the rose-colored sky the yellow sun rolls, surrounded by a violet wreath of rays. Strident yellow and pale-blue rays sting the lilac-colored ground, piercing it, luring forth thousands of voices—the air vibrates with soughing.

Gray clouds veil the yellow sun and turn black. Long, straight, unpliable silver threads streak the introverting space.

Suddenly, everything becomes silent.

In rapid succession, burning zig-zag rays split the air. The skies burst. The ground cleaves. And rumbling thunderclaps break the silence.

The lilac-colored earth has turned gray. The gray sweeps violently, irresistibly, along the hills. Gaudy colors filter through the mesh of the sieve.

Space trembles from thousands of voices. The world screams.

It is an old picture of the new spring.

*

The old picture of the new spring is our time. The time of awakening, resolution, regeneration, and the hurricane, the time of glowing vigor and wondrous power.

During such a time of sweeping upheaval, when white becomes black and black white, when the world is full of radiant colors and the echoes of thousands of voices—during such a time when visions blur and faith crumbles—do you then believe in the white that only a moment before was black?

Turning away from all that is reserved and severe; the loosening, the revaluation of the petrified, bound, firmly ordered forms, which only yesterday were infallible; the tempting desire to throw oneself into the unknown, to follow the thousands of new paths that take off in all

directions and seemingly lead to the goal—two roads running parallel, which suddenly part and diverge into the distance—and finally, the powerful flood that no eye is able to discern, which blinds the eyes through closed eyelids and seemingly dominates everything—all of these can bring man to despair; again, he will try to force them into a new, stable form. The powerful flood carries him against his will, but he wants to command it.

Man can no longer wander without guidance. He does not want to lose his way and abandons only reluctantly the known path. He does not want to discard the old guideposts, and grudgingly accepts the new. But when he finally decides to take the new path, he treads upon it with firm strides, as he had done upon the old, and does not wish to know about other roads: he believes that there is always only "one road leading to Rome."

*

The direct goal to which these lines refer involves a two-fold desire:——

1. The desire to show that in the seeming confusion of the current stormy times there is the same conformity to law that always controls the world of art.
2. The desire to demonstrate that there is no unified song to be found or enjoyed within that unity which evidently prevails in the present, already solidified times; that there is only one choir where each specific voice does not lose, but only gains in independence— just as the *differences* in the various voices within this rich, full-sounding choir must be considered as the good fortune of our time.

Our providential time is the time of the *great liberation*, liberation from the formal, from the superficial. The free individual not only rises upward; he also lets himself sink to the depths. Wherever he goes, he observes with wide-open eyes and listens intently, seeking life everywhere and everywhere listening to the voice of the living spirit which is hidden from the superficial; this is the spirit that he wants to discern. It is in the spirit where life can be recognized and not in those forms that even dead things possess. The unfree individual recognizes life only in the form, and thereby often mistakes the dead for the living.

The free individual, who is now reborn, looks for signs of life in the content and turns away from cunning death; and death, ashamed, turns away.

The obedience to law which even today clearly reveals itself and which in the sharp light of our time stands out even more clearly, consists of the fact that artists, according to the nature of their talents, divide themselves into two groups. Each of these groups has its own special basic significance and its own mission. One can only hope that this mission might emerge in an increasingly personal way.

That unity, which today penetrates everything within the spiritual life and unites them all in the same aspirations, consists of the desire to put the internal in place of the external. This uniformity does not mean that all artists use similar forms, but that each one eschews the aimlessness of using various "beautiful" or "true" forms, so that *his own form* serves *his own spiritual content.* The artist is recognized not by form but by content.*

In this way, Henri Rousseau stands formally outside of the major trends, since no labels can be attached to his personal form. But as to content, he is more inseparably tied to the spiritual aspirations of the time than many an artist whose form is infallibly "modern." Through his admirable form Rousseau has made the inner voice of the world resound. This world, which to present-day artists is merely a pretext for art, in Rousseau's pictures is the only indispensible means of expression for the voice of his spirit.†

To evaluate a work according to currently accepted form has always led to the most gross mistakes. By adhering only to this stubbornly maintained point of view, wrongs have been committed that have

*"Content" is here understood not as a "literary story," but as the sum of those indescribable inner experiences that are the basis of the work. These experiences belong to a world that cannot be reached by any "literary means." They can only be brought to light through art without words, i.e., through those means of expression that belong only to such art—within the lines and colors of the art of painting, those means that are predestined for painting—and that, if necessary, can seek nature's assistance.

†See my article "On the Question of Form," in *The Blaue Reiter* [*Almanac*], 2d ed. Munich: R. Piper & Co. [1914], (see edition, pp. 235–256).

brought shame on humanity. Thereby, all the great artists who have required a more unusual form for their content have been labeled swindlers, fortune hunters without talent, or insane decadents.

In normal conversation we try to understand the meaning of the discourse—without which every conversation would be impossible. But in art there is no intention to listen to *what* the artist has to say; people are only satisfied by superficially observing *how* the artist talks.

*

In considering the artist of today according to the principle of the external, i.e., the form, one finds two groups: the "modern" and the "old-fashioned." The artist is praised or criticized according to the spectator's degree of development. The question of whether the artist belongs spiritually to one group or the other is not taken into consideration; what he says is unimportant.

If a new fad would occur tomorrow, then this present division would become useless. Consequently, it is fundamentally meaningless.

To devise an apt classification, one should not reckon only with modern man, but try to find an enduring taxonomy. Lasting, not perishable, landmarks should be sought, since only these show adherence to law. In this manner a true judgment can be made.

In this process it becomes immediately apparent that through the whole history of art two kinds of talents and two different missions are simultaneously at work.

According to us, only those artists who have within themselves the calling to create new spiritual values are necessary for art—what we today call *pure art.*

These are the *creative artists,* who fundamentally and completely differ from the *virtuoso artists.*

This division is the result of the secret law of duality in the field of the human spirit. Each group has its own functions and differs in principle from the other. In this respect there is indeed an *outward* similarity, but that is deceptive since the two kinds of artists do not belong to the same dominion of art, but to two different ones.

One is art in the purest sense of the word. Creations of this art are spiritual beings that have no practical use and are therefore of no material value. These works belong to the spiritual world.

The other category is art in a broader sense. Its creations are material

entities that have no spiritual content, but only an inner voice as each object has in the world known to us—whether it be a human being, a tree, a word, a sound, a spot. These works belong to the material world.

It is evident that those artists who serve two opposing worlds must essentially differ.

*

The talent that the two kinds of artists possess is different.

The virtuoso has a brilliant, versatile talent that is extremely sensitive to every impression, reacts very strongly to everything beautiful, and with the greatest skill and ease develops in many directions—often completely different, sometimes contradictory; a talent that can disdain means of expression (drawing and color) and completely change them. He does not possess an inner source for creativity because his talent does not need it; he has other means and other goals. Therefore, his sensitive eye does not become receptive to the influence of an inner dream that lives within himself. And so, he even sees external nature through the lens of a strange dream. Unable to create in isolation, he needs outside influence; without this, the development of his eye is hampered. And to achieve this development, the *external development* that exists all around him is absolutely necessary.

The virtuosos form "schools." Carried away by the strange dream, they create works increasingly inferior to the originals. But these works possess a moderate beauty, as if forming a bridge from the original to the public and popularizing the dream of the original. Such artists are like starlings who do not know a song of their own, but imitate more or less well that of the nightingale.

In music, such talented individuals often become great virtuosos. They fulfill a great and necessary role that is indispensable for the world of art. They seldom attempt composing, and when they do their works are only parlor-pieces that lack true musical content. Here the lack of an inner source is revealed.

Even within the art of painting this division will finally become definite. Thereby, many unnecessary paintings will disappear. A great field for new activity will open up endless vistas. Many areas, which for a long time have desired the hand of the artist, will become not only richer, but so perfected that they will form great new fields.

During great epochs such richly talented painters have, to an amazing

degree and with unbelievable power, woven the art style of their times into all life. Only through them the great styles, which permeate the whole life of their times and which we now preserve in our museums, are diffused—the materialization of the immortal spirits of the great past.

Even in our time, which is the beginning and continuation of one of the most important great spiritual epochs, there are signs of revival in this respect. The Russian theater, for example, soon recognized the value of giving projects to such virtuoso painters. After that the initiative was taken by a private opera in Moscow,* and then the imperial theaters in the two capitals exchanged their previous banal "decorators" for real artists.

So artistic decoration started in the theater, not mechanically, but as a living organic part forming a new scenic unity—a fact of great importance because it will become the basis of the *scenic composition* of the future.

*

The *creative artist* comes into the world with his own soul's dream. The justification for his existence is the materialization of that dream. His whole talent exists merely for this goal alone. Therefore, it is stubborn, seemingly unpliable, adverse to impressions, does not let itself be carried away by the trends of the day, stands apart, is misunderstood and underestimated, and is initially overlooked. Such artists are often bad students in school, do not want to obey the teachers, often fail their exams, and are considered less talented even by their friends. They see other art and everything else around them with their own eyes. When they speak with the help of nature, they do so in their own way, and even here cannot conform to the currently accepted "correct principle." Thus, in the beginning of their careers and often for many, many years, they are considered "second class" artists.

The creator of the new walks straight ahead on his own difficult path. When later on the art historian looks back at the artist's career, he sees a straight line. He sees that from the beginning the line (drawing), and the

*It was in the opera of the versatile and artistically talented patron S. I. Mamontov. Later his example was followed by the famous Diagilev.

color (harmony), remain the same, and that during the course of the work they develop, purify, concentrate, and are brought to perfection. Drawing and color come naturally to the creative artist. He cannot change them. A sensitive eye will always recognize the same character in his most varied works. His line and color are necessary tools, subservient to the dream of his soul; they fail any other purpose.

The creator of the new learns from other artists. But he can never accept any foreign form because his own form is impossible to exorcize. Help from others can be useful to him, but it has no fundamental importance. It is not within his ability to reproduce something accurately, "as it is." He is not able to reproduce nature "accurately" when it is a requisite for his expression because he unconsciously and irresistibly transforms external nature into internal nature. He does not reproduce the objects themselves but the spirit of those objects his dream reveals to him. This is called reproducing nature "such as he sees it"—as one's inner eye sees it. This explains "faulty drawing," which thus originates from an inner force.

The hand is unconsciously and absolutely subordinate to the soul, and the artist is not satisfied with his drawing until he has made it express precisely the visions of his dreams. And thus, the drawing primarily bears a clear witness to the artist's soul. Only in these terms is the creator of the new recognized. If such a drawing is copied, it will immediately acquire an impression of weakness, flatness, and lack of character.

The creative artist does not need a direct external influence. The work he has created is for him an internal experience—like a natural phenomenon that has made him internally richer, but externally is not necessary for him. If he does not have it, he will still realize his dream in one way or another, as long as the dream remains alive within him. Thus, unlike the virtuoso, he needs *inner development.*

*

Consequently, the personal comes naturally to the creative artist. It consists of two elements, which of necessity are inseparably united with one another:

1. The internal world, i.e., the ideal, the artist's dream, which seeks embodiment

2. The necessary power for this purpose—and for this only—the artistic means—his own lines, his own colors

This is a simple thing that "everyone knows about." And yet it is always forgotten. Particularly in the time of great whirlpools, as in our time, artists are often judged, not according to the harmony between these two elements, but exclusively according to the latter, which insists upon being "modern." Often the artist is reproached for his greatest quality: his individuality, differing from the most recent "Credo," is accused of being old-fashioned, backward. We tend to cling to the form because it is easier to sense with the eye than with the soul, and particularly in our time, filled with great spiritual revolutions, we still prefer to deal with external things, a preference that is a sad survival of the extreme materialism of the past. According to that system, artists are recognized by their external signs, are sorted and bundled up like a bunch of radishes. Like smoked fish, they are put according to form, color, and size, into small cans, upon which labels are already printed. Weak artists are good little fish who themselves prepare their own cans and proudly crawl into them. In this way "trends" are established.

Nevertheless, it would be so easy to discern from the "generally known" viewpoint mentioned above that not the form alone, but the specific content of this form constitutes the only important element in art.

It would be so easy to see that basically there are neither modern nor old-fashioned artists,* because all new art is neither better nor worse than all genuine, already existing art—totally regardless of time and country. To divide artists according to country or time can be of purely cultural-historical interest, but in no case has any value for art.

*

*To today's burning question about modernism, another question is linked: What will happen to the "material" art of painting if the so-called "abstract" art is spreading downwards? It is easy to answer this by using an analogy. Music, which was originally only vocal, after thousands of years was enriched by instrumental and especially symphonic form. This fact did not keep composers from using both forms and combining them with each other. If at last vocal music, in its present form (song with explanatory words), presumably becomes unnecessary and no longer of interest to the composer, then in its retrospective form, it will retain its ability to create spiritual experiences, a phenomenon that is still the case today with *"les instruments anciens."*

The eternal tendency and imagined necessity of measuring the internal with external measurement, then judging according to this measurement, is the most angry enemy of all true art and the best friend of false art. The shrill voice of the label cries louder than the internal voice of the true work and gives a false voice to a mute work: it suppresses real life and gives to something dead an air of being alive.

The external measurements and labels are external results of art that has lived for a long time.

The internal is changed into the external. Inner necessity is disguised as an external fashion. A new classification emerges, new names are invented, new labels are produced. And what yesterday was rejected with disgust is today highly praised—what was praised yesterday is today rejected with disdain. A new personal language is developed into a new formula. And nobody worries about content any longer.

The accepted formula is attached to newly made pictures, and woe to that artist whose works do not correspond to this formula. No one will give him the least attention, and no one will understand that it is easier to acquire an already finished formula than to find one's own necessary language.

Precisely those artists who cannot be led by the nose, who are lonely dreamers, who in spite of being overlooked and hated by their fellow beings, build up art and create indestructable values. If their language is modest, they will not be noticed. If their dream is dressed in powerful words, they will be hated.

Souls will, like soldiers, be forced into the same uniforms—the soul that does not have one will be "worthless."

When will the question of form no longer replace the question of art? When will it really be understood that art does not derive from form, but form from art? How many thousands of years are yet needed (nothing was learned from the previous thousands) for man to realize that each new content demands its own form, and that form without content is a sin against the spirit?

Empty forms float around on the surface in empty barrels, until the water penetrates them and they sink eternally into the dark depths.

A true work of art speaks immediately to the spectator. The spectator should immediately respond to the work of art.

It should not be forgotten that art is not a science where the latest "correct" theory declares the old to be false and erases it.

The only artistic attitude toward art demands clearly that we surren-

der to the individual voice of the artist, that he be given our confidence, that we penetrate his work so deeply that everything old and familiar is brought to silence. Then a new world will open up to the true spectator, a world previously unknown to him. He will travel in the land of the new spirit, which will enrich him.

This land that the artist must show to his fellow beings, and that in spite of it all he must embody, is created by the will of destiny, not for the artist's sake, but exclusively for the sake of the spectator, because the artist is the slave of humanity.

Stockholm, February 1916

Art without Subject
["Konsten utan ämne",] *Konst*
(Stockholm), 1916

Having written a lengthy essay for his Stockholm exhibition at Gummesons, Kandinsky must have felt that a short, pungent statement was an appropriate response to the critical reaction the show inspired.[1] The editor of *Konst* introduced Kandinsky's letter with the following comment: "From the distinguished Slavic artist Kandinsky, the editor has received the following spirited statement regarding his art, which has been fiercely debated abroad."

A person attending an instrumental concert who had never before listened to instrumental music and who conceived of music in terms of ballads or songs, would surely think that either he or the performing musicians had lost their minds.

He would look with suspicion and apprehension at these four people, each of whom sat with serious face in front of his music stand, and oblivious to each other, produced tunes that bore no relationship one to the other.

Soon he would either leave the room very upset or wait patiently until the last note had died away, hoping that this incomprehensible, meaningless cacophony would finally end, or that these four serious people would make the meaning of the tunes understandable.

But how astonished he would be when he finally saw these four people suddenly stop playing, stand up, and leave, silent and serious!

If this person was of a very sensitive nature, he would perhaps wake up in the middle of the night, turn in his bed, and insulted, think: Is that what you call music? Could they even play together properly? It could be interpreted any way you liked! What did they want to say? And what was the subject of what they played?

Love? Sorrow? Happiness? Despair? Hope?

This is illogical! Arbitrary!
In this manner you can continue to play indefinitely or stop at will.
Without beginning! Without end!
Such music even I can make! Ha!

Little Articles on Big Questions
["Malen'kie stateiki o bol'shim
voprosam: O tochke; O linii"]
Iskusstvo: Vestnik Otdela IZO NKP
(Moscow), 1919

IZO NKP (the abbreviation stands for Visual Arts Section of the People's Commissariat for Enlightenment) was established under David Shterenberg in Petrograd and Vladimir Tatlin in Moscow in January 1918. Most members of the avant-garde, including Kazimir Malevich, Aleksandr Rodchenko, Liubov Popova, and Varvara Stepanova, played active roles on various levels within IZO NKP. According to the Directory of IZO NKP for 1920, Kandinsky was commissioned by the Literary and Publishing Section to write a book on Shterenberg, and his *On the Spiritual in Art* was also scheduled for publication in Russian.[1] *Iskusstvo: Vestnik Otdela IZO NKP* was one of several journals issued by IZO NKP, the most famous of which are *Iskusstvo kommuny* [Art of the Commune] (Petrograd, 1918–1919) and *Izobrazitel'noe iskusstvo* [Visual Art] (Petrograd, 1919). A translation of Kandinsky's article "On Stage Composition" (see pp. 257–265) appeared in the latter (no. 1: 39–49).

1919–1920 was a period of intense theoretical and critical activity for Kandinsky. During these few months he published six major articles on aspects of modern art and design in the new Soviet context.[2] "On Point" and "On Line" demonstrate Kandinsky's particular interest in the intrinsic elements of art, which was already manifest in his earlier essays. While still using a Symbolist vocabulary here ("thick veil,"

"words have lost their power"), he was extending specific ideas formulated and developed by the Russian Cubo-Futurists in 1912–1914. For example, Kandinsky's categories of line as *"allegro, grave, serioso, scherzando"* bring to mind David Burliuk's classification of the "Petrography of Painting" according to the structure of a picture's surface—"granular, fibrous, lamellar," etc.[3] Kandinsky's emphasis on the spontaneous "arabesque" of line is also reminiscent of the Cubo-Futurists' concern with the force of intuition in art and literature, and on a different level, with "words at liberty." Furthermore, the Cubo-Futurists had experimented with punctuation and typographical layout as early as 1912: David Burliuk's article on Cubism published in *A Slap in the Face of Public Taste,*[4] for example, was interspersed arbitrarily with capital letters, and standard punctuation was disregarded.

While Kandinsky advocated the intuitive application of artistic elements such as the point and the line and declared that the "clatter of the falling ruler speaks loudly of total revolution," some of his colleagues, particularly El Lissitzky and Rodchenko, called for the rejection of caprice and intuition and reliance on more scientific methods. A few months later, almost in response to Kandinsky, Lissitzky asserted that "those of us who have stepped out beyond the confines of the picture take ruler and compasses . . . in our hands."[5] Kandinsky, of course, could not support this more mechanical approach to art and a major reason for his emigration in 1921 was no doubt his estrangement from an avant-garde already oriented toward Constructivism and Formalism.

I. On point

The accustomed eye responds dispassionately to punctuation marks. It transmits its impression to the brain dispassionately, and in accordance with these marks, the brain judges the greater or lesser completeness of the idea expressed.

The point is the completion of a more or less complex idea. It does not appear to have its own life and *in itself* denotes nothing.

The accustomed eye slithers dispassionately over objects. The dulled ear accumulates words and transmits them mechanically to the consciousness.

The outer expediency and practical significance of the entire world around us have concealed the essence of what we see and hear behind a thick veil. And often we do not even suspect the resonance of phenomena or their radiant emanations.

This thick veil hides the inexhaustible material of art. And yet, beyond it there live innumerable beings—each with its own essence, its own destiny. From among their infinite number the various arts could and soon will—indeed, have already begun to—select their requisite materials of construction.

Such are the resources of painting (abstract and realistic), of sculpture, poetry, dance—of all the arts.

In these few lines I shall dwell only upon one of these beings, which, in its tiny dimensions approaches "nothing," but has a powerful living force—the point.

Our normal encounter with this living, powerful being constantly occurs in the written or printed line, where it serves as an outwardly expedient sign with a factual meaning.

By carrying out a few experiments with this point to which we have become accustomed, I shall try to part the thick veil dividing us from the inner essence of the point and stifling its inner sound.

At this juncture I put a . A whole world now vacillates because of this unimportant event. The point is in the wrong place and its external expediency has suffered radically. The accustomed eye has already lost its total indifference. It is rather puzzled and insulted. The reader explains this abnormality as a misprint or an accident. So thanks to one or another explanation, the practical meaning of the point remains constant. But the veil has been raised. From behind it the secret meaning of the point can be discerned. Our experience of it has become stronger,

and its inner sound now reaches the ear, albeit superficially.

I refute the practical meaning of the point and put one here:

•

In doing so, I abstract the point from its usual conditions of life. It has become not only not expedient, but also unpractical, nonsensical. It has begun to break through the conventions of its existence; it is on the threshold of an independent life, an independent destiny. The thick veil has been rent from top to bottom. The astounded ear perceives an unfamiliar sound, the new utterance of what once seemed a speechless being.

Once and for all, I sever the point's connection with what seemed to be its own peculiar environment. I transfer it into the extraordinary condition of total freedom from outer expediency, from practical meaning. The reader, who has suddenly been transformed into a spectator, sees the point on a clean part of the page. He says farewell to the now insane punctuation mark and sees before him a graphic and painterly sign. The point, liberated from its coercive destiny, has become the citizen of a new world of art. The veil has been rent in twain. The inner sound fills the ear that can hear.

The door has been flung open. I summon my reader to enter a new world, one that is called now a temple, now a studio, and one whose eternal name is *art*.

For the moment I have done all I can in my modest assignment. The reader, who is now a spectator, must open his eyes and ears.

II. On Line

Following a well-tried path, an established approach, I tear the veil from the fate of a new entity that owes its origin to that very same point.

At some time, the point was given a greater or lesser impetus, so that it traversed a greater or lesser area of space. From its movements originated two new signs having an outer expediency and practical meaning. We likewise encounter these two signs in written and printed lines:

First, the short stroke, the tie, or the hyphen -

Second, the long stroke, the dash ——

The reader, transformed into a spectator, gradually extracts the outer expediency, then their practical meaning from these signs and on a clean

sheet of paper suddenly obtains a second graphic sign, a second graphic entity ——————————————— line.

From these two graphic entities—point and line—derive the entire resources of a whole realm of art, graphics.

The point is now able to increase its size *ad infinitum* and becomes the spot. Its subsequent and ultimate potential is that of changing its configuration, whereby it passes from the purely mathematical form of a bigger or smaller circle to forms of infinite flexibility and diversity, far removed from the diagrammatic.

The fate of line is more complex and requires a special description.

The transference of line to a free environment produces a number of extremely important results. Its outer expediency turns into an inner one. Its practical meaning becomes abstract. As a result, the line discloses an inner sound of artistic significance.

A fundamental turning point is attained. Its fruit is the birth of the language of art.

<div align="center">*</div>

<div align="center">* *</div>

Line experiences many fates. Each creates a particular, specific world, from schematic limitation to unlimited expressivity. These worlds liberate line more and more from the instrument, leading to complete freedom of expression.

At first, line is able to move along a straight path in various directions: to the right, to the left, up and down, and in all intermediate directions. In this way, a world of straight lines is born, whose length, direction, convergence, and intersection provide adequate material for primitive graphic expression.

Where their extremities meet and where they delineate particular spaces, lines create new beings—p l a n e s. Both straight lines and the planes created by them remain within the confines of geometrical figures—the triangle, the square, the rhomboid, the trapezoid, etc.

The graphic work that speaks by means of these forms belongs to the first sphere of graphic language—a language of harsh, sharp expressions devoid of resilience and complexity. This sphere of draftsmanship, with its limited means of expression, is akin to a language without declensions, conjugations, prepositions, or prefixes—just as primitive peoples, when they first try to speak a foreign language, use only the nominative case and the infinitive mood.

There then follows the line's first-ever liberation from that most primitive of instruments, the ruler.

The clatter of the falling ruler speaks loudly of total revolution. It acts as a signal for us to enter the second world, the world of freer graphics.

If we return to the moment of the line's inception, to the point, we see it turning from the very outset, constantly and evenly to one side. Here in this new realm, we encounter another unfamiliar being—the curved line in its schematic form: the semicircle or the parabola.

This form is a freer line, but it is still subject to that precise and primitive instrument, the compass, and can therefore be given precise designation.

We have still not left behind the major area of graphics that, encompassing the two above-mentioned spheres, can be called draftsmanship.

<p style="text-align:center">*</p>
<p style="text-align:center">* *</p>

The clatter of the compasses falling still does not completely liberate line from its subordination to the instrument. Yet the emancipation of line from subordination to external conditions constitutes its penultimate phase. The line produces a long series of new movements, angular and curved, not lacking in a certain capriciousness and unexpectedness, but which, all the same, can be accommodated within the forms described by various curved rulers. This is the world of the arabesque, the world of the graphic arabesque, often seeming deceptively like a world of total freedom, but which conceals its servile subordination to the more complex instrument. Even here, albeit in hidden form, the mechanical action remains the distinguishing characteristic of this language.

This language is like the official style of state documents, where strict limits of conventionality hamper freedom of expression.

<p style="text-align:center">*</p>
<p style="text-align:center">* *</p>

From the fateful paths of line the independent hand seizes the ultimate achievement of the ultimate freedom—the freedom of unconstrained expression.

The line curves, refracts, presses forward, unexpectedly changes direction. No instrument can keep up with it. Now comes the moment of maximum potential, of a truly infinite number of means of expression.

The slightest inflection of the artist's feeling is readily reflected in the slightest inflection of line.

The door opens: from a series of confined spaces to a boundless space, to a world of pure graphics, or pure art.

The theorist tries to distinguish between groups of related lines (however slight their similarity) according to different headings, to find a definition that will at least give some clue as to their essential qualities. Hence the classification of lines according to the nature of their effect on the spectator. For there can and do exist cheerful lines, gloomy and serious lines, tragic and mischievous, stubborn lines, weak lines, forceful lines, etc., etc. In the same way, musical lines, according to their character, are denoted as *allegro, grave, serioso, scherzando*.

But these attempts of the theoretician are, as far as line is concerned, only partly justified. Such denotations are rudimentary and cannot encompass the depth, the subtlety, the certain uncertainty, the lucid simplicity, and elaborate complexity of the innumerable forms of independent lines. Even if we accept the theorist's classification and denote a certain line as "serious", the line whose nature is thus characterized will simply ridicule this definition by the mischievous play of its separate parts. The tragic will reveal elements of cheerfulness; a weak line will, at one curve or another, manifest the persistence of its aspirations; a thin line will thicken unexpectedly, only to compress itself once more into a hair's breadth. And what will the classifier say when he looks at the dispassionate line, whose power resides in its lack of expression? The sensitive spectator knows that inexpressivity can be more expressive than expressivity itself.

Words have lost their power. Only an adjacent art form, e.g., music, can create something resembling the spirit of graphics through its own means of expression. The language of graphics, however, in all its complexity and subtlety cannot be replaced, even by another art form.

The limited space allotted to my little articles does not permit me even to touch upon a question of immeasurable importance—linear composition.

The aim of this article will have been achieved if the reader discovers within himself the ability to examine the life of a very special world, to see it with his own eyes, to touch it, to sense its aroma and its own language—inimitable, so fine and of such great importance.

1919

Russia's Artistic Spring
["Kunstfrühling in Russland"]
Die Freiheit
(Berlin), 1919

The following letter appeared in the Berlin newspaper *Die Freiheit* [Freedom], which was published from November 1918 until March 1922. *Die Freiheit* was the Berlin organ of the German Independent Social-Democratic Party; its editor was Alfred Wielepp. Kandinsky's letter, which appeared in the evening edition for Wednesday, 9 April 1919, was one of the first accounts of the postrevolutionary artistic situation in Russia to appear in the German press. It was preceded by an editorial note describing Kandinsky as "the well-known champion and stimulator of the new art, from whose views the most vital and active painters in Germany likewise derive their creative impetus."

Moscow, 22.2.19.

... Since your departure, those aims of ours which are familiar to you have in some cases been extended. Many of our goals have been redefined.

Exhibition policy has been given a wider scope by extending our original aims. The Museum of the Culture of Painting, with its historical orientation, has been joined by another—that of modern international art. For this purpose, a large number of pictures have been purchased. It is to be hoped that this section will soon be able to acquire foreign pictures as well. Provincial museums have been in some cases extended, in others newly founded.

Lectures on art and art history for working people are held every

428

Sunday, involving good young art historians. A number of monographs on individual artists are being published. Likewise various longer or shorter essays on art. Since Christmas two new art journals have been appearing—one here, the other in Petersburg. A special translation bureau has been working for some time on translating a number of classic works from German, French, English, etc.

The architects, who are holding a big conference at the end of March, are working on plans for the development and rebuilding of Moscow. These plans contain much that is new and interesting. Old Italian architectural ideals and mathematical principles are being revitalized and woven into these new plans.

The sculptors have formed their own section and a new association. The aim of these endeavors is finally to make sculpture, formerly the poor cousin of art, its legitimate offspring, with all due entitlements. This task is still in its early stages and has not yet gone beyond erecting monumental works for our towns and their streets and squares.

In the realm of theater special mention must be made of our workers' theater. The workers, who direct and participate in the theater themselves, bring in fact a fresh, naive and living element to the dead atmosphere of conventional theater. Once a theme has been established in broad outline, they improvise directly on the stage, so that one performance is, in its details, always different from the next.

There are frequent lectures on art, and discussions in which the public take part. At one of these lectures, one worker spoke particularly well. "The working class," he said, "wants a completely free art, which is in the sole service of beauty. Dividing art up into different tendencies is of interest only to the specialist. The people want only what is beautiful, without worrying about whence it derives. The people are starved of beauty, which is not to be found in everyday life. And as one of the workers, I who have been and still am a worker thank artists from the bottom of my heart for enriching my life. . . ."

Recently a photographic studio has been opened, which will undertake to study technical, theoretical, and artistic problems. As director, I plan to add to this a studio for reproductions (blocks, phototype, etc.). I am working hard, although not, unfortunately, at pictures. . . .

1919

Self-Characterization
["W. Kandinsky: Selbstcharakteristik"]
Das Kunstblatt
(Potsdam), 1919

During the 1920s and 1930s, the periodical *Das Kunstblatt,* edited by Paul Westheim, assumed a role in Kandinsky's eyes similar to that which Walden's *Der Sturm* had played during the prewar years.[1] Kandinsky submitted to Westheim some of his most important articles, including his "Reply to a Questionnaire" and "The Blaue Reiter (Recollection)" (see pp. 762–763 and 744–748). *Das Kunstblatt* also published the following autobiographical note; together with the artist's letter to the Berlin newspaper *Die Freiheit* (see pp. 421–427), it constitutes his first statement in any Western publication since the advent of war and revolution.

The editor's note that precedes this article in the original indicates that it was intended as an entry in a Russian encyclopedia.[2] According to Andersen,[3] Kandinsky had been appointed to a committee that was to prepare and edit an "Encyclopedia of Fine Arts"; the committee also included the architect I. V. Zheltovsky and the poet V. Shershenevich. This encyclopedia, which was supposed to contain biographical material as well as "articles of a general nature on questions of fine art," appears never to have been published. The text as it appeared in *Das Kunstblatt* is evidently a reworking for the benefit of a German audience. Notwithstanding several mistaken dates, the reader will notice that Kandinsky is here more certain in his own mind regarding the origins of his first abstract picture than at any time before the war.

An abbreviated version of "Self-Characterization," with

some minor changes, was published in volume 42 of the series *Junge Kunst,* edited by Georg Biermann (Leipzig, 1924), p. 15; see Roethel/Hahl, 1980. p. 63f.

Kandinsky Wassily—painter, printmaker, and author—the first painter to base painting upon purely pictorial means of expression and abandon objects in his pictures. Born in Moscow in 1866, he studied at Moscow University, where as cand. jur., he was appointed "assistant" to the faculty (of economics and statistics). At the age of thirty he threw overboard the results of his scholarly work and traveled to Munich to study painting. Here he worked for two years at the Ažbè school, and for one year at the Academy under Franz Stuck. He soon began to take part in exhibitions and was condemned by the majority of the critics for his "exaggerated drawing and messy, strident colors." Shortly afterward, he was elected a member of the Berlin Secession and the Deutsche Künstler-Bund, as well as the Salon d'Automne in Paris. His pictures were frequently refused by the Munich Secession. Worked a great deal with tempera, oil, and Japan colors, and made a number of black-and-white and colored woodcuts. Initial success failed to impede his further development. He progressed with logical, precise steps on the path that led to pure painting, and gradually removed objects from his pictures. During the years 1908–1911 he stood almost alone, surrounded by scorn and hatred. Colleagues, the press, and the public labeled him as charlatan, trickster, or madman. Many wanted to lock him up to prevent his capacity for destruction from causing any further damage. The first person to stretch out a friendly hand was Franz Marc. He tried to help Kandinsky in every possible way and found him a publisher and an agent. Then, of the great artists, came Alfred Kubin and Arnold Schoenberg. Herwarth Walden offered to assume responsibility for Kandinsky's exhibitions and sales and initiated a lawsuit in response to the unprecedented attacks on Kandinsky in the press.[4] Occasional admirers of Kandinsky's art are to be found in various countries. In 1911 he painted his first abstract picture, and in 1912 made *inter alia* a series of nonobjective etchings (dry-point). His book *On the Spiritual in Art* (published by R. Piper & Co., Munich) appeared and went through three editions in one winter. A lively battle continued in the daily press, in the professional journals and in books on art—but now a number of voices could

be heard raised in support. In 1913, with the Erste Deutsche Herbstsalon organized by Herwarth Walden, the ramparts were breached, and German, Austrian, Dutch, Swiss, English, and American collectors began energetically to acquire Kandinsky's works. A. J. Eddy (Chicago) began to collect Kandinsky's pictures from all phases of the artist's development. In 1913 the *Blaue Reiter Almanac* appeared (edited by Kandinsky and Franz Marc and published by Piper).[5] In his article "On the Question of Form" Kandinsky put an = sign between pure abstraction and pure realism. To his other article, "On Stage Composition," he appended a stage play (*Yellow Sound*, with music by Thomas Hartmann). The publishing house "Der Sturm" brought out a "Kandinsky Album" with many reproductions from the period 1901–1913. In 1914 R. Piper published his book *Sounds* (a limited deluxe edition with small prose poems and a number of woodcuts).[6] His book *On the Spiritual* was translated into English by T. H. Sadler [sic] (Constable & Co. Ltd., London).[7] Further editions of this book in Dutch, French, and Russian were planned, but prevented by the war, as was a performance in Munich of Kandinsky's stage play, accompanied by an exhibition and lectures. In 1914 Kandinsky returned to Moscow and began to concentrate especially on drawing. In 1916 he completed in Stockholm a second series of etchings. In 1917 and 1918 he worked in Moscow on the practical and theoretical problems of abstract art. His monograph with reproductions from the period 1902–1918 and a text by the artist (published by the Moscow branch of the Department of Fine Arts of the People's Commissariat for Enlightenment) appeared in 1918.[8] For a second time, a start was made in printing his *On the Spiritual* in Moscow.[9]

Kandinsky's theories are based on the principle of "inner necessity," which he defines as the guiding principle in all realms of spiritual life. His analysis of linear and colored forms is founded upon the psychic effect that form produces upon the individual. He rejects, however, attempts at a purely formal solution and asserts that the question of construction can only be of relative value: every work of art selects its own form, depending solely upon internal necessity. Every formal element has its absolute physical effect (= value); construction selects from among these resources, making an absolute into a relative value, so that, for example, a warm element can become cold and a sharp form blunt. The interval or chord thus produced offers unlimited possibilities. It is internal necessity that limits the artist's freedom, being determined by three demands: (1) those of the individual artist, (2) those

of period and race (as long as the individual race continues to exist), and (3) those of the elements of art that exist in the abstract, awaiting materialization, the elements of the personal, of time, and of the eternal. These first two elements diminish with the passage of time, while the third remains eternally alive. Kandinsky regards the end of the nineteenth century and the beginning of the twentieth as the beginning of one of the greatest epochs in the spiritual life of mankind. He calls it "the Epoch of the Great Spiritual."

1920

Artistic Life in Russia
["Muzei zhivopisnoi kul'tury";
"O velikoi utopii"; "Shagi otdela
izobrazitel'nykh iskusstv v
mezhdunarodnoi khudozhestvennoi
politike",] *Khudozhestvennaia Zhizn'*
(**Moscow), 1920**

The journal *Khudozhestvennaia Zhizn'* [Artistic Life]
was published from 1919 to 1920 by the Visual Arts Section
of Narkompros, the so-called Commissariat of Enlighten-
ment (IZO NKP). The three articles that follow—"The
Museum of the Culture of Painting," "The Great Utopia,"
and "Steps taken by the Department of Fine Arts in the
Realm of International Art Politics"—appeared during the
first months of 1920. The third of these articles is unattrib-
uted, signed merely with a K, but it describes Kandinsky's
activities and interests, and is undoubtedly from his hand.

During its brief existence, *Khudozhestvennaia Zhizn'* ran
several articles on the function of the new Soviet museum.[1]
Among the innovations proposed by the IZO NKP was the
establishment of a complex of new museums of art, the
Museums of the Culture of Painting (or Museums of Paint-
erly Culture). The idea was first outlined on 5 December
1918 in Petrograd by the Commission on the Organization of
the Museum of Painterly Culture, which included the artists
Natan Altmann and Alexei Karev. Their proposals were dis-
cussed and elaborated at the First Conference on Museum
Affairs on 11 February 1919 (also in Petrograd), attended by
the Commissar of Enlightenment himself, Anatoly Lun-

acharsky.[2] At this conference, the aims of the Museums of Painterly Culture were stipulated as "(1) Artistic and scientific, (2) Demonstrative, (3) Pedagogical," and there were to be four departments in each museum: "(1) Experimental technique, (2) Industrial art, (3) Drawings and Graphics, (4) Synthetic art."[3]

The principles underlying the creation of the Soviet Museums of Painterly Culture represented a radical departure from the traditional, prerevolutionary conception of the art museum, and they were implemented as a direct result of the administrative power and prestige enjoyed by the avant-garde within the art section of the Commissariat of Enlightenment. The argument Kandinsky puts forward in the first of his articles reflects a current attitude among many progressive artists and critics of the time. Art, to use Tarabukin's words, was now to be regarded as "chemistry," not as "alchemy," as "astronomy," not "astrology."[4]

Five Museums of the Culture of Painting were opened (in Moscow, Petrograd, Nizhnii-Novgorod, Vitebsk, and Kostroma). Rodchenko was head of the Museum Bureau and Purchasing Fund, which by the mid-1920s had acquired twelve hundred paintings and drawings and over one hundred sculptures, dispersed among the above museums and other provincial centers. The museums were designated as "constructed on the principle of the evolution of purely painterly and plastic forms of expression."[5] The largest, in Moscow, contained examples of the work of many of the avant-garde, including Kandinsky, Malevich, Popova, and Tatlin.

The years immediately following the revolution of 1917 appear in retrospect a period characterized by utopian ideals. Tatlin's unrealized project for a Monument to the Third International could only have been created in such an age.

Kandinsky, a born cosmopolitan, dreamed of a dissolution of the boundaries not only between the different arts, but also between countries. His rejection of a national, parochial view of art, and his internationalist outlook, were in keeping with the Soviet belief in imminent world revolution, a hope that the German and Hungarian revolts seemed to justify. His project for the "building of an international house of the arts" attracted other cosmopolitans within IZO NKP, such as Lunacharsky, David Shterenberg (head of IZO), and the artist Nikolai Punin. Kandinsky's notion of an international art fraternity was, of course, shared by Gropius at the Bauhaus. It is perhaps more than coincidence that Kandinsky should have departed for that "international house of the arts" shortly after his article "The Great Utopia" was published in Russia.

Kandinsky's desire to bring together artists of different cultures working in different countries was not an isolated phenomenon. Although his contact with the Moscow Institute of Artistic Culture was brief, the Institute did for a time assume an internationalist stance, maintaining contact with cultural life in France, Germany, Hungary, and Japan, and contributing directly to the development of the International Style in the 1920s. And as early as 1918, Tatlin and Punin had planned a journal to be called *Internatsional iskusstv* [International of the Arts], thus anticipating the famous Lissitzky-Ehrenburg *Veshch/Gegenstand/Objet* of 1922. Kandinsky's desire to organize a Congress of Representatives of All the Arts of All Countries was not fulfilled, at least not in the terms he envisaged. The various "international" conventions and exhibitions in Germany and France in the 1920s were actually limited to very few nations and even fewer artistic media. Yet, as his report "Steps taken by the Department of Fine Arts" makes clear,[6] the members of the

Department did succeed in mustering support for their aims from radical artists' associations in Germany. This support was an important link in the chain that led to the Berlin exhibition of Russian art in 1922, the first opportunity in the West to see the latest developments in Constructivist, Suprematist, and abstract art since the war.

THE MUSEUM OF THE CULTURE OF PAINTING

The usual approach to museum organization, an approach that is well-established everywhere (i.e., in Russia as well as abroad), is a historical one. Museums divide art up into period after period, century after century, regardless of whether one period has any relation to another, apart from that of historical sequence. Thus, the usual type of museum is reminiscent of some chronicle that draws its thread from one event to the next, without seeking to penetrate their inner meaning. Such art historical museums have a definite value as a treasury of artistic production that can serve as the raw material for different kinds of research and exposition. But the evident deficiency of this kind of museum is, in general, its lack of any guiding principle or system.

In this respect, the Department of Fine Arts has decided to embark on a new path in setting up museums, making a definite principle and system its first priority, in conformity with one general aim.

This one, general aim is our desire to show the development of art not in chronological, chaotic fashion, but on the contrary by giving strict prominence to two aspects of artistic development:

1. New contributions of a purely artistic nature, i.e., the invention, as it were, of new artistic methods.
2. The development of purely artistic forms, independent of their content, i.e., the element, as it were, of craft in art.

This unconventional method of museum organization has been dictated to the Department by the burning desire of our age to democratize generally every aspect of life. This method, opening the doors as it does to the artist's studio, will illuminate with complete clarity that aspect of the artist's activity which, thanks to the way matters were previously arranged (by museums and exhibitions), has remained un-

known to the nonspecialist.

For this reason, the task that holds the highest importance for the artist, namely, the study of the technical aspect of his art, has been completely ignored and lost from sight. The general impression that artists, without exception, create somehow mysteriously and naturally; the general ignorance of the artist's need to struggle painstakingly with the purely material aspect of his work, with technique—all this has placed the artist, as it were, above and beyond the conditions that determine the life of the working man. The artist has appeared pampered by fortune, habitually living in luxury, a law unto himself, creating at his leisure objects of value, and being rewarded for them by all the benefits life has to offer.

Whereas, in fact, the artist works doubly hard: (1) he himself must be the inventor of his own art, and (2) he had to master the techniques necessary for him. His importance in the history of art can be measured by the extent to which he possesses these two qualities.

Illuminating the activity of the artist from this point of view, which has long remained shrouded in obscurity, reveals the new image of the artist as a worker who, by a combination of genius and toil, creates works of real value, and demonstrates his definitive right to take, at the very least, equal place among the ranks of the working population.

This same viewpoint gives the broad masses an accurate insight into art as the result of labor, no less essential for life in general than any other kind of creative work, and not as a mere adjunct of life, with which, *in extremis*, society could equally well dispense.

These will be the natural results of the museums brought to life by the Department [of Fine Arts], to say nothing of their constant value in illuminating fully the history of art, i.e., for the scholar, but also for artists themselves, for whom these museums must function as strict and fertile schools.

This principle was first elaborated last year at the conference held in Petrograd (see at greater length *Art of the Commune* and *Proceedings of the Petrograd Department of Fine Arts*), in which members of the Moscow and Petrograd Departments of Fine Arts took part, as well as staff of the Moscow and Petrograd museums. After a series of papers from the Departments of Fine Arts and some heated discussion, the museum principle outlined was accepted by the conference, and a resolution was adopted designating such museums Museums of the Culture of Painting. The following took an active part in putting

into practice the principles of the Departments of Fine Arts: D. Shteren-berg, N. Punin, O. Brik, Grishenko, and Chekhonin.

Immediately after the conference, the college of the Moscow Depart-ment selected from its midst a Purchasing Commission, which pro-ceeded to acquire for the general state reserve a whole series of works of painting and sculpture. Following upon which, a special commission was selected from the college for the purpose of organizing the Museum of the Culture of Painting. This commission, having established the general basis for setting up the museum, chose about a hundred pictures from the total number of works acquired for the state reserve, leaving the remaining works in the reserves for provincial museums to draw upon, in response to the provinces' continual de-mands for both the further development of existing museums and the foundation of new ones.

The Museums Commission has defined the character and aim of the Museums of the Culture of Painting as follows:

"The Museum of the Culture of Painting shall have as its goal to represent the different stages of purely pictorial attainment, pictorial methods, and resources in all their fullness, as expressed in the paintings of all periods and peoples."

Methods that have enriched the resources of pictorial expression, solutions to the problem of the correlation of color-tones, the correla-tion between the color-tone and the application of color, compositional methods—i.e., the building up of the whole composition and of its individual parts, their treatment, the overall *facture* and structure of parts, etc.—these are examples of the criteria that shall determine the acquisition of works by the museum.

It follows from this that the Museum of the Culture of Painting will not try to show in its entirety the work of any one artist, nor to trace the development of the above problems solely in any one period or country, but will show, independently of any trends, only those works which introduce new methods. In this manner, the Museum of the Culture of Painting is distinguished by its definite approach to the question of evaluating the products of different epochs: it will classify the historical development of painting from the point of view of the conquest of the material, both real and ideal, as a purely pictorial phenomenon. In this way the Museum, having set itself purely technical-professional object-ives, will at the same time be seen as indispensable for the masses, who until this time have never in any country had a collection capable of

439

opening the way to this branch of painting, without which the complete understanding of art is unthinkable.

Being of the view that museums and repositories of art in the Russian Republic should contribute from their own resources to the general state reserves, the Department has taken steps to obtain from the Moscow collections of Western European art those works which are regarded as essential for the Museum of the Culture of Painting and which, at the same time, can be removed from these collections without detracting from their scope and effectiveness.

To this end, the Museums Department and the Department of Fine Arts have established a Commission for [Public] Contacts. The Museums Department, in accordance with the principle and the necessity of the Museum of the Culture of Painting, has agreed that a series of works by French artists should be selected from collections of Western European art (principally from the galleries of Shchukin and Morozov). For this purpose, pictures by Braque, van Gogh, Gauguin, Derain, Le Fauconnier, Matisse, Manet, Monet, Picasso, Pissarro, Rousseau, Renoir, Cézanne, Signac, Vlaminck, and Friesz were chosen.

Developing further the principles upon which the Museum of the Culture of Painting is to be constructed, and bearing in mind the aim outlined above, namely, that the Museum should reflect the technical side of the artist's craft, the Museums Commission adopted the following resolution:

"The Commission for the organization of the Museum of the Culture of Painting considers it essential for its work that a section for [the study of] experimental techniques in painting should be established."

The materialistic-realistic trend in painting in the nineteenth century, in general bound up with excessive enthusiasm for materialistic systems in science, morals, literature, music, and other areas of spiritual life, severed all connection with the purely pictorial methods of previous ages. The thread leading from antiquity to modern times was broken. The major preoccupation of all art—composition—was, from the point of view of artistic resources, pushed into the background by materialistic-realistic aims: pictorial composition was to be derived from nature. Deprived of this, its most important foundation, painting ceased to be an autonomous art of expression and became instead an art of representation: all the painter's skills were directed exclusively toward the depiction, the almost mechanical rendering of natural

phenomena. It was evidently from the middle of the nineteenth century onward that European artists, under the influence mainly of Japanese prints, began to realize that painting had embarked on a life, not of independence, but of mere imitation: all that remained was a mere soulless semblance.

From this moment dates the beginning of the striving to create the so-called new art, which is nothing other than the organic continuation of the growth of art in general.

The distinctive characteristic of the art of painting is its striving to clothe pictorial content in pictorial form. The emergence of this striving has given such prominence to the question of form that in many cases it has come to be seen as the one essential problem in painting. Despite the one-sidedness of this attitude, and apart from certain damaging temporal consequences, it has brought to formal refinement a tension that provides art with a powerful arsenal of expressive means. The fruitfulness of these discoveries—or inventions as one says today—needs no further proof.

The Museum of the Culture of Painting will display from its own resources a collection of works of art based on painterly principles— painterly content and painterly form. Thus, there will be no room for works of purely and exclusively formal value. Such works must still be collected, however, both as a testimony and monument to one particular artistic attitude of our day, and as a stimulus for the production of further formal discoveries. The enrichment of the means of pictorial expression will be the first consequence of this proposed section.

In connection with this, it will be necessary to make experiments, starting with formal construction and going all the way through to questions of technique in the completely specialized sense of the word, i.e., ending up with different kinds of treatment of the ground. These are all the different trials of the resources of pictorial expression that must flow from the hand of the experimenting artist. In this way, there will be no place here for canvases, brushes, colors, or other instruments that have not been treated by the artist himself. Only if they have been prepared by the artist's own hand must these material means find a place in the collection. Further, it is the task of the Department to collect all essential and significant experiments with the treatment of raw materials, *facture*. Finally, for the purposes of comparison, there must be room for experiments with formal construction, according to the principle of juxtaposition: the colored surface and the linear surface; the

correspondence, collision, dissolution of surfaces; the correspondence between surface and volume; the handling of surface and volume as self-sufficient elements; the coincidence or divergence of linear or painterly surfaces or volumes; attempts to create purely volumetric forms, either in isolation or in combination, etc. It is, of course, difficult to draw an exact line between an experiment and a work of art, inasmuch as a carefully thought-out experiment may become a work of art, while a carefully calculated work of art may fail to transcend the boundaries of the experimental. The possibility of error in drawing this line, however, and an unavoidable degree of subjectivity in the evaluation of a given work should not constitute a hindrance to beginning to assemble a collection of specifically experimental techniques.

Any such mistakes will be corrected by the lapse of time, and by the burning necessity to create, slowly but surely, a theory of painting.

Thus, the second result of this section of experimental techniques will be to accelerate and facilitate the development of a theory of painting we can sense even today.

In Petrograd, the purchase of works of art for the museums will be carried out by a commission for acquisitions, consisting of members of the Department of Fine Arts, of the Museums Department, and professional organizations. They will acquire works representative of every tendency in art, starting with the realists of the second half of the nineteenth century: didactic painting (Repin, the two Makovskys, Kustodiev, etc.), painterly Naturalism, Neo-Academicism, Retrospectivism; then Impressionism, Neo-Impressionism, and Expressionism, whence begins contemporary painting, or what is called the new art (whose point of departure is, historically speaking, the work of Cézanne): Primitivism, Cubism, Simultanaeity, Orphism, Suprematism, Nonobjective Creation, and the transition from painting to the new plastic art—relief and counter-relief.

In this way, the Departments of both capital cities have given an unprecedented breadth and freedom to the matter of museums. The professional museum directors have distinguished themselves by unwarranted caution in the formation of their museums, fearing every new movement in art, and recognizing it as a rule not at the moment of its blossoming (except in rare cases), but only at the moment it begins to wither and decay. One encounters this practice especially in the state museums of the West. In this respect, the artistically more significant countries—France and Germany—may serve as an instruc-

tive example of how the state usually not only fails to encourage any new movement, but places in the way of any newly developing, powerful idea in art every means of obstruction the state has at its disposal. Thus, everything new in art, its immeasurable value being with time generally accepted and understood by all nonspecialists, has either had to surmount these officially devised obstacles, or else pursue its path in spite of the state, receiving more or less accidental, capricious, and arbitrary support from the private sector.

Exceptions have been so rare that they have been perceived as an entire revolution and are indelibly imprinted upon one's memory. The agents of the state who have resolved to go against the routine tendency in museum affairs have had to possess heroic qualities of personal bravery, energy, tenaciousness, and finally, self-sacrifice, for they have brought down on their heads the wrath not only of the government, but of every basest representative of public opinion—especially the press.

Thus, in Berlin occurred the battle between Tschudi, the director of the Prussian Museums, and Wilhelm. This battle concluded with (1) the private donation of the pictures by the great French masters in the National Gallery, the purchase of which had not been authorized by Wilhelm or his servile committee for acquisitions; (2) the dismissal of Tschudi; and (3) the first collective protest against this dismissal by the hitherto loyal student body. This battle exerted an enormous influence upon the conduct of museums in Germany, bringing in its train two consequences: (1) the organization of a succession of private and profoundly significant museums in several quite small centers (Barmen, Hagen, Elberfeld, Krefeld), and (2) the emergence of a new type of young museum director who modeled himself after Tschudi. Thus, thanks to this one powerful man's selfless, independent love of art occurred a serious change in direction in one of the most important areas of public life.

In this respect, Russia offers an unparalleled example of state organization of museums. The definite principle of the Museum of the Culture of Painting; its complete freedom to establish the right of every innovator in art to seek and to receive official recognition; encouragement and adequate reward— these are the unparalleled attainments in the field of museum affairs that have been achieved by the Fine Arts Commission of the People's Commissariat of Enlightenment. And if the Department has had the practical opportunity of bringing these principles to life, then it is

thanks to the Commissar of Enlightenment himself, A. V. Lunacharsky.

THE "GREAT UTOPIA"

Barriers are overturned by the march of necessity. Explosions demolish the walls that lie in its way; slowly, pedantically, the stones are removed from its path. The forces that serve this necessity mass themselves gradually, with unyielding stubbornness. The forces that oppose this necessity are fated nonetheless to serve it.

The link between individual manifestations of the new necessity has long remained obscure. Here and there, different kinds of shoots grow through the surface at indeterminate distances, and it is difficult to believe they have a common root. This root is in fact a whole complex of roots, intertwined in no apparent order, but subordinated to a higher order, a natural orderliness.

Before the march of necessity, stout walls are constantly erected by persistent toil. Those who build these walls believe them impregnable, not realizing that their stubborn labor does not harm necessity, but benefits it. For the stouter the wall, the larger and more numerous are the tireless forces arrayed against it. The greater the resistance, the greater the struggle. The massed forces will, at a predetermined hour, unite into a single force and, as if unexpectedly, the wall that yesterday was impregnable today will crumble into dust. The thicker the wall, the more deafening the explosion and the greater the advance made by necessity. And what yesterday appeared a utopia today becomes reality.

*

*　　*

Art always goes in advance of all other realms of spiritual life. Its advanced role in the creation of nonmaterial benefits, by comparison with other realms, derives naturally from that high degree of intuition that is essential to art. Art, producing as it does nonmaterial consequences, continuously increases the stock of nonmaterial values. But since from the nonmaterial is born the material, art, too, with time, freely and inevitably produces material values as well. What yesterday was a mad "idea" today becomes a fact, from which, tomorrow, will come material reality.

*

*　　*

Barely a decade ago, I unwittingly called forth an outburst of indigna-
tion among groups of radical artists and aestheticians, still young men at
that time, with my assertion that there would soon be "no more fron-
tiers between countries." This was in Germany, and those artists and
intellectuals who were outraged by this "anarchistic idea" were Ger-
mans. At that time there was a partly natural, partly artificial cultiva-
tion of the spirit of German nationalism in general, and in art in
particular.*

In the last few years, the frontiers between countries have not only not
disappeared, but have been given a stoutness, strength, and impregnabil-
ity scarcely approached since the middle ages. These impassable fron-
tiers have, at the same time, constantly shifted as a result of the
movements of armed forces against each other. This unprecedentedly
restless shifting of frontiers has on the one hand strengthened the
barriers all the more and on the other has weakened them.

Separate nations have, with involuntary secretiveness, kept their
strivings from each other—so stubbornly that they have firmly pre-
vented, by means of frontiers, those strivings from passing from one
country to another.

And yet, one can truly affirm that the different strivings of a spiritual
nature that have been pent up in separate countries will in time be seen
to be not merely related, but to have sprung from the subterranean roots
of one single necessity, for whose strength and clarity the stubborn
barriers of materialism have, preeminently, created the most favorable
conditions.

*

*　　*

Russian artists, belonging to the Russian nation, bearers of the cos-
mopolitan idea, were the first who addressed themselves to the West at
the earliest opportunity, calling for a collaborative effort under the new

*An echo of this can be found in the present number of this journal in the program of the
Baden Organization for Fine Arts. Here, among aims of a general character, emerges an
unexpected concern at the possibility of German artists' leaving their homeland. This
provides an interesting example of how rarely phenomena can be properly observed:
dying and even dead ideas continue to exist all the same alongside living, fully de-
veloped ideas, and even ideas that have scarcely been born. It is hardly ever possible to
separate yesterday, today, and tomorrow.

conditions resulting from the international crisis, the purpose of which, it transpired, was equally foreign to art and to its interests.

What art was unable to gain from peace it gained from war. Until its appointed time, the envisaged aim conceals unforeseen consequences. The striving toward materialism gives birth to the nonmaterial. The hostile becomes the friendly. The greatest minus turns out to be the biggest plus.

<p style="text-align:center">*</p>
<p style="text-align:center">* *</p>

The response of the "West" to the call of the "East" will be familiar to readers of the article "Steps taken by the Department of Fine Arts in the Realm of International Art Politics," which appeared in the present number of this journal. But the Russian artists, in their call to their colleagues, also wrote of their desire for an international art congress. One must hope that active steps and real measures will soon be taken in this connection, so as to bring about the first world congress of art on an unprecedented scale.

It seems to me that this congress should adopt a theme of a real, albeit utopian character. Without a doubt, one of the most forcible questions in art, as regards both its internal and external significance, concerns the forms, methods, scope, possibilities, and present and future attainments of m o n u m e n t a l a r t.

Naturally, questions of this kind cannot be decided by a congress only of painters, or only of representatives of the three main branches of art, which would, in the end, only succeed in finding general subjects and problems—that is to say, a congress of painters, sculptors, and architects.

To consider the question outlined, it would be necessary to attract representatives of all the arts. One would have to mobilize, apart from the three arts already mentioned, all the others: music, dance, literature in the broad sense, and poetry in particular, as well as theatrical artists from all branches of the theater, including the intimate stage, variety, etc., right up to the circus. It is right that this apparently utopian idea should come from the ranks of the painters, with whom, perhaps, only musicians can compete in their unchecked striving to open up new, unknown territories in art.

The real collaboration of a l l branches of art on o n e real task is the only way of finding out (1) to what extent the idea of a monumental art

has matured, both in its potential and in concrete form, (2) to what extent the ideas about such an art developed by different peoples are related to each other, (3) to what extent the different realms of art (painting, sculpture, architecture, poetry, music, dance) are prepared for this kind of genuinely collective creation, (4) to what extent the representatives of different countries and different arts are prepared to speak the same language regarding this most important subject, and (5) how far the actual realization of this idea, which is still in its infancy, can be carried.

Bähr, in his letter to the Collegium of the Department of Fine Arts, writes that he is hindered by the fragmentation of German artistic forces in carrying out many of the tasks with which he was entrusted. This "fragmentation" is a chronic ailment not only of German, but up until now of the greater part of all artistic forces throughout the world.

One must conclude that a congress would constitute a curative means of heroic proportions, which would bring this illness to a crisis of unprecedented force. After such a crisis, the still-ailing elements would fall prey to the disease of separation, while the remaining healthy ones would be united with unprecedented strength by a bond of mutual attraction.

Such a congress, having set itself this real task of admittedly utopian character, would not only be a way of determining the above-mentioned questions, but also act as a touchstone of the inner worth of artistic forces in resolving one of the most powerful questions in art.

And, ultimately, it would here be necessary to hold discussions, discussions on one and the same theme, between painters and musicians, sculptors and dancers, architects and dramatists, etc., etc.

The most unexpected degree of mutual understanding, surprising discussions in different languages between the more advanced painters and the less advanced theatrical artists, clarity and confusion, a thundering collision of ideas—all this will constitute such a shock to the accustomed forms, divisions, and partitions between the different arts and within the different arts that as a result of unprecedented pressure, strain, and explosion, the spheres of the commonplace will be rent asunder, and distant horizons will open up, for which we have as yet no name.

*

* *

A theme for the first Congress of Representatives of All the Arts of All Countries would be the building of an international house of art and the working out of plans for its structure. Such a structure would have to be designed by representatives of all the arts, since it would have to accommodate all branches of art, not only those which already exist in reality, but also those which have existed and which exist only in dreams—without any hope of these dreams ever being realized. This edifice should become for all nations the house of utopia. I believe I would not, in fact, be the only one to rejoice if it were given the name "The Great Utopia."

Let this structure be characterized by its mobility, its flexibility, so as to accommodate not only what is alive today, even if only in dreams, but also what will first be dreamed of tomorrow.

STEPS TAKEN BY THE DEPARTMENT OF FINE ARTS IN THE REALM OF INTERNATIONAL ART POLITICS

From the very first days of its constitution, the Department of Fine Arts has considered one of its most important tasks to be attracting artists to organize and create a new artistic culture. Artists, according to the plan of the Department, should take a direct and active part in all spheres of artistic life.

During these same early days, a no less serious but, as regards its consequences, even more significant problem was raised, that of extending the sphere of the artist's activity, as already defined, beyond the borders of the Russian Republic and uniting not merely Russian, but also foreign artists to attain these goals.

At the resolve of the Department's steering committee, an International Bureau was constituted. Availing itself of the opportunity presented by Ludwig Bähr's departure for Germany, the Bureau charged the artist (along with several other artistic missions of international scope), to convey an appeal to German artists' organizations of a similar mind to the Department. This appeal consisted of a comradely greeting and a call to international unity in the creation of a new artistic culture.

Bähr left for Germany in December 1918. The first reply to our call reached the Department only last summer by way of the German Soviet of Soldiers' Deputies in Moscow. The Arbeitsrat für Kunst [Workers' Art Council] wrote: "We greet with warmest sympathy the efforts of the

Moscow Collegium for Art. We are prepared to work in unity with the Collegium, and with all artists of all as yet unaligned nations." The signatories were Bruno Taut, Walter Gropius, Cäsar Klein, and Max Pechstein.

And only the other day, the Collegium of the Department received a greeting from other, mostly radical organizations: the November-Gruppe [November Group] in Berlin, the Organization for Fine Arts in Baden, and one of the most radical of all the German unions, West-Ost [West-East].

This forceful letter, full of character and decision, will undoubtedly remain a historic document as regards both purely German attitudes and the unity of artistic ideas between two countries that were, for four years, mutually hostile—Russia and Germany.

The exalted tone of this letter can be unequivocally explained by the state of war that exists between themselves and a government disenchanted with artists, and by the impossibility of putting their ideas into practice with the same freedom Russian artists enjoy.

Here follows the almost complete text of their letter of 3 March 1919:

> To the Moscow Collegium of Art:
>
> The West-Ost group of radical artists in Baden replies with greetings to the appeal by Russian artists to their German comrades, celebrating the all-embracing victory of the new, sincere spirit. It rejoices in the organization and the success of consistently pursued leftist policies.
>
> Within us burns anger and hatred, and our dark despair at the immaturity of our nation is assuaged only by the firm stance of isolated individuals.
>
> The faint-heartedness of the government, the present siege conditions, general strikes, unemployment, the sound of machine-gun fire—we see all these as heralds of a new age, burning and seething, when in our country too the mighty red image will be carried through the streets.
>
> Spare the rod and spoil the child.
>
> Ours is the true consciousness. We lead, because it is we who know the way.
>
> We shall hold to the straight path, and we shall not be turned aside by persecution or promises. We want to preserve in our hearts, shrouded by a veil, the image of brotherly love, until the day when that veil shall be rent asunder.
>
> And then we shall remember the hand that Russian artists extended to us.
>
> The task of the West-Ost group is seen as the conversion of the populace from the aesthetically political to the politically practical, motivated by

the character and strength of artistic strivings. Corporate resistance to and active hatred of the bourgeois ethos in art. To carry war and destruction into the well-worn halls of tradition.

The West-Ost group recognizes that a revolutionary situation does not in itself bring freedom. The group is determined to turn its own hand to the plow that must till again the littered fields of our society, and raise on them the fruits of the new spirit.

There exists in Baden no other radical association apart from the West-Ost group, but this group has gathered to itself all those like-minded artists who are scattered throughout the entire country.

The efforts of all other artistic organizations in Baden are founded upon the present situation, have regard to the present government, and content themselves with shameful compromises, which obtain for them only such benefits as were already gained in the very first stages of the revolution.

The West-Ost group asks the Moscow Art Collegium for recognition. Our concern with the progress of future attainment must call forth the sympathy of Russian artists.

We also beg the Moscow Collegium for further information about its progress that would serve as authoritative confirmation of our own activities.

From the West-Ost group of radical artists: Walter Becker, Georg Scholz, Vladimir Zabotin, Egon Itta, Rudolf Schlichter, Oskar Fischer, Eugen Senewitz.

There will be a report in the next number concerning the other Baden group, as well as the large Berlin union, which unites the capital's outstanding forces of the left and center.

Evidently, the most powerful and significant of the two as regards its constitution is the Berlin association. Its list of members brings together all the most famous German artists who, in their time, fought with the German Secessions. It is both interesting and indicative that not only this, but also other German associations are comprised of not simply painters, or sculptors, or architects; rather, members of all three professions participate in the general organization.* This synthetic unity has

*The second paragraph of the statutes of the November-Gruppe reads: "The aim of the association is to unite radical artists, painters, sculptors, and architects for the protection and advancement of their artistic interests." As far as I am aware, the first such synthetic association was the Neue Künstler-Vereinigung München [New Artists Association of Munich], founded in 1909, where according to the constitution drawn up by myself, members could include, apart from painters, sculptors, and architects, also writers, musicians, composers, dancers, poets, and aestheticians.

also been pursued, as far as I am aware, at the new Weimar Academy—not merely mechanically, as in our art schools, but organically: every student is obliged to study all three arts. Artists returning from Germany have told me that the Weimar Academy regards as inadmissible that state of affairs whereby an architect erects a building, a sculptor adorns it with his embellishments, and a painter is given this or that surface for his paintings, with no connection whatever to the general plan of the edifice. All three artists have to create the plan of the edifice, which fuses into one whole the elements of all three arts. The head of this academy is the architect Walter Gropius.

The above-mentioned Berlin union is called the November-Gruppe.

Its statutes are as follows:

I. The November-Gruppe is a (German) union of radical activists in the fine arts.*

II. The N. G. is neither an association of material interests nor (exclusively) an exhibiting society.

III. The N. G. aims to exert an authoritative influence in deciding all artistic questions, by means of a broadly based union of all like-minded creative forces.

IV. We demand that our group should influence and be involved:

1. In all questions of construction work, being a manifestation of civic order: urban and municipal housing, administrative offices, factories, welfare and private buildings, the erection of monuments, and the abolition of imposing edifices of no artistic value.†

2. In all reforms of art schools and their curricula: the abolition of government tutelage, the selection of teachers by artists' unions and by students, the abolition of scholarships, the unification of the schools of architecture, sculpture, painting and the applied arts, and the establish-

*I have had to use the Russian term for fine arts, which does not exactly correspond to the German *"bildende Künste."* The German term might be rendered better by the expression creative arts, which more accurately expresses the idea of art in general and is in particular more appropriate to contemporary art, to which the term fine is now foreign.

†This point, which may appear somewhat strange in itself, will be perfectly clear to all who are acquainted with Berlin; the conglomeration of disjointed, tasteless buildings and the erection of monuments horrifying in their lack of talent are thorns in the flesh of every inhabitant who is not utterly devoid of taste.

ment of practical and experimental workshops.

3. In the restructuring of museums: the abolition of the one-sided collectioneering of the past, the elimination of excessively literary theorizing, and the changeover to people's repositories of art, which would reflect eternal laws, without preconceived ideas.

4. In the redistribution of gallery space, the elimination of favoritism and the influence exerted by capitalistic forces.

5. In the regulation of artistic matters, social equality for artists as the bearers of spiritual culture and the exemption of works of art for tax purposes (free import and export).

V. The N. G. will give evidence of its existence and activity by continual publications, and by the holding of annual exhibitions in November.

The organization of serial publications and of exhibitions will be the responsibility of a Central Workers' Committee.

The members of the society have equal rights to equal places at exhibitions, and are not subordinate to a jury.

Questions as to holding nonperiodic exhibitions will be decided by the Central Workers' Committee.

Berlin, 21 December 1918

The last association about which we have received news is the second Baden society, which bears the name Baden Organization of Fine Arts. Here is its program:

The organization aims to further the realization and development of that ethos which it recognizes as being the most important in our own time in the realm of art. The basic attitudes of the organization are embraced by the following statement:

Art is not to be regarded as a luxury, not as an object of delectation for the privileged classes, nor as existing in order to satisfy aesthetic demands; rather, it must be recognized as the spiritual food of the people. It must be recognized that questions of art are questions of the culture of the people, that art is the fundamental attribute of the people, that art is a document of the life of the people. From this it follows that such an organization must create the kind of conditions that would rule out any possibility of artists' wishing to leave their own country (even less should such conditions force artists to leave, as has often happened in the past).

Only when everyone recognizes that our group cannot be seen as pursuing the aims of one particular circle; that our program is the manifesto of a movement that, as it gathers strength, will be of significance for the entire epoch in the realm of artistic life; that our association, as it follows this program, will be ready for every sacrifice—only then will our strivings assume true strength, and create for every individual artist the possibility

of a meaningful existence.

To give all artist-creators a sense of solidarity with our association, as well as a guarantee against any overprecise definition of art, we declare: We wish to encourage a belief in the immeasurable richness of the human spirit, to call forth trust in the power of that spirit, to revitalize joy in mankind emancipated from all boundaries, and thus elevate the significance of art. We wish to exalt art to its rightful place in the realm of spiritual life. Lest any individual artist should harbor the thought that our association pursues the one-sided cultivation and encouragement of any one tendency, we reject the concept quality as a measure of artistic worth. We see in the use of this term the possibility of promoting in a biased manner one particular kind of art (*l'art pour l'art*). Thus, we have turned against this term, because of its unsuitability to the just and accurate evaluation of all true works of art, and we shall try to find some new principle of classification.

The organization has as its aim to cultivate the free spiritual and material development of Baden's artists. Hence its demands: the most emancipated and the most significant artistic forces must be summoned to participate in the administration of our artistic foundations and institutes. The constitutions of the aforesaid foundations and institutes should contain no hindrance to the realization of the foregoing demands. Every possible help should be given in creating the conditions whereby art in Baden may be placed on the highest level. In particular, these conditions must be such as to give living art the lively, active possibility of developing fully, so as to realize the highest spiritual demands—the highest manifestation of humanity.

From the foregoing derives the organization's active program, both for artists and for the masses: exhibitions, lectures, and visits. The organization is determined to attain the greatest possible creative freedom by exploring practical possibilities: contacting official organs and exhibition committees, conducting war against the abnormal conditions represented by the system of juries, and dealing in works of art, against the misconceived literature of art, the activities of the collectors, and all the related fuss. In extreme cases, the organization would even consider a boycott. The chief means of influence of the organization, however, must be its moral bearing and ethical integrity. The organization will constantly and undeviatingly demand the cooperation of the Ministry of Culture and Art, unless the Ministry is prepared to renounce all claim to its title. This is the aim of our organization.

Apart from the answers from Germany cited here, which were communicated by Bähr, we also were sent replies by the following: the New

Dresden Artists' Association, the Baden Workers' Council for Art, the State Building School in Weimar (Walter Gropius), the Marées-Gesellschaft in Dresden (Maier-Graefe), and the Worpswede Artists' Union (Heinrich Vogeler and H. Zehder). Unfortunately, these replies have not yet reached us. This is particularly sad, as there are to be found among them replies from some of the older associations, which have existed for decades, and Bähr also mentions the names of other established theoreticians like Maier-Graefe. The comparison of these documents with the texts by the younger associations would have been extremely instructive.

In any case, we have every right to hope that the wall dividing nations has not only been breached, but razed to the ground, from the ruins of which we shall create the possibility of both continuous contact with our Western comrades and actual international cooperation in art. The fourteen cases of pictures, graphics, and art books sent to us by Bähr, which were seized by the Lithuanian government (it would be interesting to know the reasons for this act) will reach us some time, and will be only the first of a constant series of *envois*, a continuous exchange of the results of artistic work by the internationally united artistic forces of East and West. There can be no doubt that we are standing on the threshold of an age in which we shall no longer prefix East and West with the word "Far," when, in an ever-broadening stream, East and West will meet at one single point, and the international unity of artists will embrace the whole globe and rise to the level of the unification of all mankind.

Program for the Institute of Artistic Culture

[*Programma Instituta Khudozhestvennoi Kultury*] (Moscow, 1920);
reprinted in I. Matsa et al., eds.,
Sovetskoe iskusstvo za 15 let
(Moscow and Leningrad), 1933

The Institute of Artistic Culture, better known by its abbreviated name, Inkhuk, opened in Moscow in May 1920, initially under Kandinsky. Subsequently, branches were established in Vitebsk under Malevich (1920–1921) and in Petrograd at first under Tatlin and then under Malevich, Matiushin, and Nikolai Punin. Inkhuk also tried to maintain contact with Berlin institutions through El Lissitzky and the journal *Veshch/Gegenstand/Objet,* and with centers in Holland, Hungary, and Japan. Inkhuk was founded as a laboratory for the analysis and appraisal of artistic materials, methods, and functions.

Kandinsky presented his program for the Institute in a paper read at the First Pan-Russian Conference of Teachers and Students at the State Free Art and Industrial Art Studios in Moscow in June 1920. His ideas were received with particular sympathy and the audience "warmly supported the initiative of IZO NKP (Visual Arts Section of the People's Commissariat for Enlightenment) to work out the basic problems of art scientifically, without which its subsequent development is unthinkable."[1] Many members of Inkhuk, however,—and membership included most of the avant-

garde—were not in agreement with Kandinsky's approach, and questioned his emphasis on the role of intuition, of the subjective element, of the occult sciences, and so forth. It should be remembered that in contrast to his colleagues within Inkhuk (Ivan Kliun, Malevich, Aleksandr Rodchenko, Liubov Popova, etc.) Kandinsky belonged to an older generation, and his ideas extended the aesthetic of Symbolism rather than that of Cubo-Futurism, especially in his concern with a monumental or synthetic art, with music and with movement. Obviously, Kandinsky's insistence that a "fundamental concern of the Institute of Artistic Culture must be not only the cultivation of abstract forms, but also the cult of abstract objectives" could not have won the support of artists who were already doubting the value of pure or abstract art and were tending toward a more "relevant," utilitarian interpretation of art.

Not surprisingly, Kandinsky's program was not ratified by his colleagues, and under the auspices of the sculptor Aleksandr Babichev, leader of the so-called Working Group of Objective Analysis within Inkhuk, a counterprogram was compiled toward the end of 1920. Babichev's program, which gave particular attention to exact analysis, to material organization, and to the mechanical process of artistic creation, but which minimized the importance of the roles of the subconscious, of fortuity, also became the subject of criticism, as the reaction against the pure "culture of materials" intensified. The culmination of this was the advocacy of industrial and applied art in the autumn of 1921 just after the conclusive exhibition of nonfigurative painting known as "5 × 5 = 25" (Ekster, Popova, Rodchenko, Aleksandr Vesnin, and Stepanova contributed five works each). Thereafter, Inkhuk became closely identified with the production/industrial design movement, thanks not only to its artists,

but also to its theorists, such as Boris Arvatov, Osip Brik, and Nikolai Tarabukin. At the very beginning of 1922, Inkhuk was attached to the Russian Academy of Artistic Sciences (RAKhN) and quickly lost its autonomy.

Because of disagreements with his colleagues, Kandinsky left Inkhuk shortly after its inception, and adapted part of his program to a scheme he helped compile for the Physico-Psychological Department of RAKhN in 1921.[3] Subsequently, he developed his researches at the Bauhaus, establishing points of contact with the theories of Itten and Schlemmer.

This translation is based on Matsa's 1933 reprinting.

The aim of the Institute's research is to find a discipline whereby the basic elements of the individual arts, as well as of art in general, will be investigated. This will be carried out on both an analytical and a synthetic level.

This entails three types of assignment:

1. A theory of the individual arts.
2. A theory of the interrelationships of the individual arts.
3. A theory of monumental art or art as a whole.

These three tasks require a specific approach, which should encompass the entire scope of research, whatever its character. This approach should be dictated by the simple consideration that the purpose of any potential work of art is to produce some kind of effect on man. The creator of the work is subject to an exclusive, instinctive, and peremptory desire to express himself in the form peculiar to his art. As he creates the work, he gives no thought to what its effect will be or whether it will have any effect at all. But the moment the work is completed, he transfers all his attention to the question: Will his work be effective and, if so, how? On the other hand, we see, hear, perceive a work of art only in order to experience it in a given form, i.e., to experience its effect.

This effect is attained via the means of expression peculiar to the

given work, i.e., its language.

It is clear, therefore, that to investigate any art in theoretical terms, we must use the analysis of the media of this art as a point of departure.

It is equally clear that this analysis must be undertaken from the viewpoint of how these media are reflected in the experience of the person perceiving the work, i.e., in his psyche.

In this way, physiological effect should serve simply as a bridge to the elucidation of the psychological effect. We know, for example, the powerful and invariable effect of different colors (proven by experiment): red (in a color bath) increases the activity of the heart, which is expressed, in turn, by the acceleration of the pulse; blue, however, can lead to partial paralysis. Facts such as these have great importance for art, although only inasmuch as they lead to psychological deductions.

Consequently, the question of analyzing the means of artistic expression should be formulated as follows:

> What is the effect on the psyche of
> (a) painting in its color-volumetric form?
> (b) sculpture in its spatio-volumetric form?
> (c) architecture in its volumetric-spatial form?
> (d) music in its phonic and temporal form?
> (e) dance in its temporal and spatial form?
> (f) poetry in its vocal-phonic and temporal form?

This method will produce substantial results that are as yet largely unknown. They will shed light on the questions and answers of composition (especially construction) both in a single artistic discipline and in the combination of two or more disciplines within a single work. At the moment these issues are, by and large, receiving only intuitive attention. In this way, the intuitive element of creation will perhaps acquire a new ally, perhaps new or perhaps merely forgotten and now resurrected in the form of the theoretical element. The possibilities are so complex, so very full, that it is impossible to consider them here. Inasmuch as one can envisage them at the moment, they are a truly thrilling experience. The time is ripe for such researches.

RESEARCH PLAN FOR PAINTING

The media of expression in painting are drawn form and colored form.

Consequently, these two forms should constitute the object of

theoretical investigation.

Drawn form can be reduced to:

1. line and its moment of departure—the point, and
2. plane, produced by line

In turn, these two elements of drawn form fall into two groups:

1. A group of lines and planes of a schematic or mathematical character: the straight, the curved, the parabolic (zig-zag) line, the plane—the triangle, the square, the circle, the parallelogram, etc.
2. A group of lines and planes possessing a free character, which cannot be accommodated by geometrical terms.

Analysis must begin with the first group. The effect of these simple forms is investigated by collating specific information from questionnaires and from interviewing people interested in such researches: What kind of experiences do they have when they give their mind to these forms? They will try to describe their sensations by every means possible. They will, for example, look for parallel impressions in the sounds of different musical instruments and in the impressions of various words, objects, natural phenomena, in works of architecture, in animals, plants, etc. It is essential to establish a link between the movement of lines and the movement of the human body (of the whole and of its individual parts)—to translate line into the movement of the body and the movement of the body into line. These kinds of observations must be recorded both verbally and graphically. These records will then comprise, so to speak, a directory of abstracted movements. One result of this directory would be to supply new material for the composition of the dance. The dance is awaiting its reform with impatience, but whenever it comes near to this reform, it finds the entrance barred.

The transition to the second group of drawn forms is gradually occurring. Tabulations of compound forms are being compiled. New directories are being put together. These initial activities and our deeper understanding of them will disclose many new ideas and methods in the search for and compilation of material. This, in turn, will produce the concept of—and a new approach to—monumental composition. For painting the principal result will be a better opportunity to experience drawn form, i.e., in its absolute, independent value. This will provide the artist with new possibilities of creation, and the spectator with new revelations, new experiences of the work of art.

Apart from its self-sufficient value, linear form in painting has another one, i.e., a value, so to speak, related to and deriving from its combination with colored form. It may or may not coincide with it. But in every case colored form exerts an influence on drawn form, and the two together produce a dual sound. Consequently, colored form also has two values: an absolute one and a relative one.

Investigation into colored form should begin with its absolute value. Three groups of colors should here form the object of investigation:

1. The elementary color triad:
 a) red
 b) blue
 c) yellow
2. The spectral mixture of colors, i.e., the combinations of the three elementary colors:
 a) violet
 b) orange
 c) green
3. The painterly mixture of colors, i.e., the combinations of all the above colors on the palette: from brown, gray, lilac, russet, etc., to extremely complex colors that words cannot define.

The research should utilize many diverse approaches, although they will be united by the general approach to the effect of color on the psyche referred to above. At this juncture we should collate materials from the various sciences that work in one way or another with color. We should inform specialists in these sciences of the aims of the Institute's research on color and should invite them to come and work with us. Most prominent among these kinds of sciences are physics, physiology, and medicine (diseases of the eye, chromotheraphy, psychiatry, etc.). We should also address ourselves to the science of the occult, where we can find many valuable guidelines in the context of supersensory experiences.

Special research on sense association is also essential—to trace parallels in the experiences of color not only through sight, but also through the other senses: touch, smell, taste, and above all, hearing. The perception of color as sound is certainly not a new issue. As is well known, it has attracted the attention of many people, especially musicians, and physicists have also studied it. Now, by dint of necessity, painters are at

last confronting the problem.

All these researches should serve, incidentally, as material for the compilation of tables and directories, just as we stipulated in the context of drawn form.

The relative value of color is to be found in its combination with drawn form.

In this respect, we should investigate the change in color conditioned by this or that form. At first we combine elementary colors with simple, i.e., geometrical, forms: the three elementary colors are introduced in varying combinations into the three elementary plane figures—yellow, red, and blue in all their combinations into the triangle, the square, and the circle. Corresponding planes are then combined with the spectrally mixed tones. Initially, these combinations are of two different kinds: consonant and antithetical. After that, attention is given to combinations that are decreasingly schematic. Finally, freely mixed tones are combined with freely drawn forms—again, of course, according to the principle of parallels and antitheses. Tables and directories are then compiled.

During work on these combinations, particular attention should be paid to the way in which material color is applied, i.e., how the paints are applied to the surface. The same surface may be covered with the same color by various technical methods. This provides valuable material for resolving questions of *facture*. Further combinations of techniques of applying paint (or various paints) to the same surface (or various surfaces) and the principle by which they are constituted are largely self-evident. Still, this path will open up the most unexpected vistas, astounding new discoveries.

TOWARD A THEORY OF THE CORRELATION OF THE SEPARATE ASPECTS OF ART: RESEARCH PLAN

The elaboration of specific methods for the investigation of volumetric and volumetric-planar forms must be entrusted to sculptors and architects.

We will simply indicate here the general principle of this type of investigation, i.e., as it coordinates with the above principle for the study of painterly forms.

In the narrow sense of the word, monumental art derives from the united means of expression of the three arts: painting, sculpture, and

architecture. The nineteenth century completely destroyed the collaboration of these three arts: all the traditions that had been created through the ages were utterly annihilated and, apparently, were forgotten forever. A lifeless memento was all that remained. At times of particular solemnity this caused buildings to be plastered with all sorts of flourishes and beloved Greek ornaments; it caused stereotype copies of Classical reliefs to be stuck onto lifeless buildings and, in some cases of particular luxury, to support balconies by extraordinarily anatomical caryatids. Painting was palmed off with this or that facade, staircases in vestibules, ceilings, and to some extent, walls of rooms. The artist covered them with whatever entered his head. Unfortunately, it never entered his head that his work should retain some organic connection with the architect's or sculptor's work. The three artists shared only one inner standpoint: that the arts could act together in a single work never occurred to any of them.

From the above, we should grasp the principle of the authentic interaction of the three arts in a single work.

How to research the second component part in the monumental work—sculpture—should also be clear.

Research begins with elementary volumetric forms of the geometrical kind: the pyramid, the cube, the sphere. The element of displacement is then introduced. This gradually leads us into the realm of free forms. In this way, a whole world of abstracted, volumetric bodies is created. Compound forms are created from this arsenal of isolated forms. A whole and cohesive work can thus be created by means of this research.

These forms submit to investigation according to the same principle whereby drawn and painterly form were investigated.

Parallel directories of painting are then compiled.

There now arises the second assignment involved in analyzing volumetric forms. This is also the first problem involved in analyzing monumental forms: color is introduced into volumetric forms. As in the case of painterly form, elementary forms of a geometrical type are combined initially with simple colors: the pyramid, the cube, and the sphere are painted yellow, red, and blue. The same procedure as in the case of painterly forms is followed.

Work carried out in accordance with this system will have equal value for the two arts—for sculpture and for painting.

As far as architecture is concerned, this art possesses a particular

condition that distinguishes it from painting and sculpture—its applied aspect, i.e., the necessity to adapt a building to the existence of people inside it. Inevitably, therefore, abstract form is left out. This omission, however, is not so great as to cause architecture to be gripped by the necrotic and decaying forms of a static tradition. So in this case, research on abstract volumetric and spatial forms will have the invaluable asset of first weakening and then destroying this tradition. A breath of fresh air will be allowed into this fetid atmosphere. The earth will flower again. Architecture will be renewed. At long last it will heed the reson- ant voice of the new, still unseen renaissance of art.

This dead architecture of ours has the habit of dominating painting and sculpture (which, in their subservience, play a pathetic role), even though it has no prerogative to do so. But when the renaissance occurs, architecture will become an equal member of the three arts in monumental creation.

This synthetic department, so to speak, will create complete, detailed models of buildings, as well as a whole arsenal of abstract forms. A great model of the building dedicated to the great utopia could be built: the utopia that has always terrified the narrow-minded philistines, but without which no spiritual movement is possible. Whatever has no movement must decompose. Perhaps this building will never be built—so much the better, because the death of true creation lies pre- cisely in the realization that any aspiration not leading to tangible, practical results is futile.

A fundamental concern of the Institute of Artistic Culture must be not only the cultivation of abstract forms, but also the cult of abstract objectives.

MONUMENTAL ART OR ART AS A WHOLE: RESEARCH PLAN

In this section research is carried out by representatives of all the arts and of their adjacent disciplines: by painters, sculptors, architects, musicians (especially composers), poets, dramatists, theater people (especially directors and those connected with the ballet), the circus (especially clowns), variety (especially comedians), etc.

Almost all these spheres (especially acting) manifest an extraordinary stagnation, a total deafness to the resonant voice of the age. No doubt, comedians will prove to be the most sensitive to this voice. At least, the

creative work of the comedian is diametrically opposed to our usual approach to the theater: the comedian demonstrates the freest form of composition; his art is not bound by his arms and legs to the logical progression of the narrative (which suffocates the usual kind of theatrical composition). First and foremost, it is precisely this field that must be revitalized and cleared of methods that belong to a tradition once alive, but now long dead (yet which still raises its ugly head). In this respect, all forms of the modern stage must be forgotten in the Institute of Artistic Culture. The stage must be approached as if it had to be invented for the first time.

It is precisely the stage that may serve as the first arena for implementing the monumental work in the broad meaning of the term.

From the very beginning, however, we must aim to produce a work that can be realized only through the interaction of all the above disciplines.

For this, each of them will have to work exclusively with its own, peculiar means of expression. These means must first be differentiated and particularized in a highly pedantic manner. In this respect, we will have to observe a purely schematic approach (especially at the beginning).

Obviously, in order to follow this kind of research program, we must:

1. determine exactly which discipline contains its own, particular means of expression;
2. analyze this means of expression according to the principle established above for painting, sculpture etc.

Re (1)

Realm of art	Means of expression
(a) Painting	Color, surface, illusory space.
(b) Sculpture	Volume, space: both positive and negative.
(c) Music	Sound, time: both positive and negative.
(d) Dance	Movement of the body and its parts.
(e) Poetry	Words, sound, time.

Re (2)

Consequently, the following elements should be subjected to analysis:

1. Color 2. Plane	} Color in plane
3. Volume 4. Space	} Illusory space
5. Sound 6. Time	} Sound in time, time without sound
7. Movement 8. Word	} Concrete, abstract.

As indicated above, all these elements must be investigated by the most diverse approaches, although the ultimate, unifying purpose will be a single approach: the investigation of the effect of the elements on the psyche. At this juncture it is essential to carry out a substantial number of experiments on each individual element, and then to move gradually from simple combinations of two elements to increasingly complex ones, introducing one element after the other. These experiments will rely on both a clear, theoretical objective and a practical one (which may be a little surprising). These experiments will untie the hands bound by tradition; they will arouse due fear before the inner voice, which, timidly but persistently, summons the artist from the petrified deserts of art toward new creative endeavors. The displacement and refraction of real form in the most liberated of the arts (painting and music) were the first signs of the transition to this new plane. Both these arts are advancing with steady and measured tread toward the ultimate transition from the material to the abstract level, i.e., from the level of logic to that of alogicality. It is better to blindfold yourself and to fling your palette at the canvas, to pummel a piece of clay or marble with your fists or with an axe, to sit on the keyboard, than to serve an exhausted stereotype blindly and heartlessly. In the former case, accident might create something pulsating with life—a live mouse is better than a dead lion.

In light of this it might be better to invite only painters and composer-musicians to the initial experiments. Their approach to the problem would serve as a kind of sieve through which the other arts would be sifted as they are introduced to the Institute's research. Many people attracted to the work will grow apprehensive at the strange atmosphere; they will take to their heels and leave behind only the boldest. These are the only ones who will be able to adapt to the Institute's program of research.

To explain the system of analyzing the means of expression in individual art forms, let us take, by way of example, movement.

The movement of the human body and of its individual parts serves two completely different aspects of human life:

1. The material aspect—moving about, food, needs of hygiene, etc.
2. The spiritual aspect—particularly the expression of emotional experiences.

For our purposes only the second aspect is of interest. It is well known that emotional experiences are expressed involuntarily and partly by reflex action in outward manifestations, i.e., in the movements of the muscles in various parts of the body. These movements are a kind of language without words, but man consciously joins these movements with his language of words. Sometimes he uses them consciously to replace verbal speech. So, everyday life clearly reveals the meaning, the expediency of the body's movements, and explains its simple combinations.

This has produced mime, the dance, and in particular, ballet—the language of the legs. Old balletomanes can still hear with their eyes what the wordless legs of the ballerinas say. This has also produced the pantomime that used to be so popular. Today these art forms have become more or less museum relics. A possible explanation for this is that time has introduced more subtle, more intricate spiritual experiences—the time of the flowering of the psychological element in literature. Literature, in its dictatorial and exclusive fashion, took over the stage. This is still true today. But now literature too must surrender to the new demand for more subtle spiritual experiences—and these can no longer be expressed by the word. A new language must be found for them.

Within the old form of the dance one could accommodate (more or less) the circus movements of acrobats, gymnasts, clowns, and last but

not least, comedians. Many spectators, tired of the excessive psychology of the theater, often escaped to the world of freer and purer movement. In their search for vulgar entertainment these spectators discovered unexpected and more subtle impressions.

Aside from comedians, any acrobat makes movements (suffice it to recall that distinctive, elastic movement he makes after each number) distinguished by an expressivity that cannot be translated into words. No material feeling is expressed—neither joy, sadness, fear, love, despair, nor hope—and there is no way of describing this movement: one has to perform it in order to convey some understanding of it. It is here that we can perceive the clear, albeit entirely unconscious approach to that sense of movement which acts as a transition to the new level of composition.

Comedians, in particular, build their composition on a very definite alogicality: their action has no definite development, their movements are incongruous, their efforts lead nowhere, and indeed, they are not meant to. But at the same time the spectator experiences impressions with total intensity.

The inner value of movement should be analyzed in such a way that its outer expediency is totally excluded from the experiments. Movements we use in our normal life or on the stage, which we conjure up by our voluntary or involuntary desire to express emotional experiences, are too familiar to us to require research. But the movements used in ancient, bygone cultures for the same purpose of expressing primitive feelings, movements we have forgotten, must be carefully sought in any surviving monuments of the time and reproduced by contemporary man for the purpose of studying their effect on the psyche. Included are movements used in rituals. For instance, an instructive example of this kind might be ancient Greek rites (as far as I am acquainted with them). Certain gestures, distinguished by their extreme schematicism, possess a superhuman power of expression.

One should apply research on movement in general to the study of these particular movements (i.e., quite independent of any practical function, even though this function might be a more or less abstract feeling). Movement and gesture must be created and examined from the standpoint of the inner impression gained from them—of psychic experience. Both the movement of the whole body and, for example, the hand, the fingers, or just one finger, must be recorded photographically and graphically, together with accurate observations of their effects. It is

essential to note down, to draw, to notate (musically), etc., these re-
marks and those on the associations aroused by the movements. Associ-
ations could be of the most surprising kind.

Thus, we might obtain the associations of cold, color, acid, sound,
animals, a season of the year, daylight, etc., etc. Special graphs should be
used to trace associations that relate to the other arts. Such associations
will serve as an arsenal for monumental compositions made by various
methods of construction. Other associations might arouse our desire
and enable us to introduce new, unknown elements into a composition.
In this way, it might prove possible to utilize resources that affect not
only the senses of sight and hearing (as we have at the moment), but also
the other senses—smell, touch, and perhaps even taste. The world of
possibilities is boundless. All records must be tabulated, indexed, and
entered in directories.

There are two obvious ways of analyzing the inner value of the word:

1. Analysis of an existing word: the concrete meaning of the word
 must be rejected, and the word must be studied as a simple sound
 independent of its meaning, and

2. Analysis of the resonance of the individual sounds that serve as
 material for the formation of words: analysis of these sounds com-
 bined into syllables and, finally, into nonexistent words.

Re 1. From the very beginning poetry has used the resonance of the
word apart from its concrete meaning. This condition is analogous to
that of certain other arts, painting, for example, in which form, besides
its subservience to the subject, has always lived its own, independent
life. Rhyme at the end, the middle, and the beginning of words, the
repetition of individual sounds, and all manner of combinations of
resonances are examples of conventional forms of poetry. In some cases,
the word's resonance is allotted such a primary place that the meaning
of the words is eclipsed by their resonance, and the meaning can be
revealed only after considerable effort. The meaning of the whole poem
is eclipsed, as it were, by the resonance. A poem of this kind, once read,
cannot be retold in narrative form.

Re 2. One of the Italian Futurists once read out all the vowels one after
the other instead of reciting poetry. But apparently, the poets of the West
never went beyond that purely cerebral experiment. As far as I know, it
was only in Russia that O. V. Rozanova and V. F. Stepanova wrote poetry
consisting of nonexistent and newly created words. These poems ac-

quired the title nonobjective, by analogy with nonobjective painting. I introduced the resonance of vowels and consonants and also indistinct speech made up of nonexistent words into my stage composition, whose production in Munich was prevented by the war.[4]

Of course, the study of individual sounds serving as material for the formation of words must be undertaken in accordance with the principle referred to in the context of the study of movement. In words, too, we must carry out experiments of the same kind, tabulate them, index them, and enter them in directories.

We will then compare and contrast the material received with that of the other disciplines. This will be used for subsequent experiments (at first of a schematic nature only): these will be exercises in composition like the practice pieces that music students write according to the strict rules of theory. But the main difference will lie in the fact that there will be no strict rules—we will have to find them. This will give a somewhat intuitive element to the schematic experiment.

A FEW EXAMPLES OF CONSTRUCTION AND COMPOSITION IN MONUMENTAL ART

Composition consists of two elements—the inner artistic function and devices that implement this function by means of specific construction. From a formal standpoint, one of the most essential issues is precisely that of structure, or construction.

All material acquired by the above means will serve as material for the construction of works of monumental art. But the methods of construction are infinitely diverse and cannot be confined to any one definite theory. Still, certain basic possibilities and groupings can be indicated.

The individual means of expression in individual art forms can take various directions. The simplest method of combining these directions was applied by Skriabin in his *Prometheus*[5]—the parallel tendency of sound and color. It is interesting that at that time the theory of music forbade lines of sound running parallel to one another. Incidentally, continued use of parallelism, if applied exclusively, can produce at first sight extraordinary and very instructive results. I once happened to see how Arabs used the continuous parallelism of sound (a monotone drum) and primitive movement (a pronounced, rhythmic kind of dancing) to achieve a state of ecstasy. Even a simple, schematic divergence of similar lines could never produce such a result. I also happened to observe

the audience during one of Schoenberg's quartets, in which the manipulation of the line of the instruments and, in particular, the incorporation of the voice, produced the impression of the lashing of a whip. It is interesting to note that Arnold Schoenberg introduced the movement of parallel lines into some of his compositions with (at least for musicians) virtually the same revolutionary effect.

THE POSITIVE SCIENCES

I indicated at the beginning of this program that approaches to the study of the material of the various arts are extremely diverse: the more diverse the approaches, the richer and more substantial the results of the research. The general uniting principle—the effect on the psyche—does not exclude the use of sciences that have no direct bearing on the objective we have set ourselves. In this respect, the Institute should encompass a broad spectrum of disciplines, even though at first glance this may seem alien to its purpose. Rather surprisingly, crystallography proved to have something in common with painting with regard to construction. V. F. Franchetti carried out a small experiment in the Nizhnii-Novgorod Svomas: an engineer gave a series of lectures to painters on the resistance of building materials. The experiment revealed a connection between what would seem to be a discipline quite foreign to painting and issues of painterly construction. As people have been repeating since the time of King Solomon, numbers lie at the basis of all things. Perhaps astronomy will prove to be more useful to painting than chemistry. Perhaps botany, which has already taught architecture something, will contribute still more important material toward constructing of the future art of movement, which at the moment we call the dance. Scarcely any positive natural science might be found, of which one could say that it did not repay examination with useful pointers or, at least, inferences for the work of the Institute.

We should, however, by no means confine ourselves only to the positive sciences and seek in them a universal solution to the questions confronting the Institute. In truth, such an approach would lead merely to biased answers and would therefore be pernicious. We must never forget that positive science itself is confronted with the inadequacy of its own conventional methods and is compelled to search for new ones. Who knows, perhaps art will be no less useful to science than science is to art.

In art, the concept of number and how we deal with it will rely on other methods and will demonstrate qualities different from those of positive science. Every artist knows that in art a simple, arithmetical progression is turned upside down: subtraction often brings the same results as addition. Moreover, in painting, for example, inverse construction, i.e., the disposition of heavy masses on top vis-à-vis light masses at the bottom (which is inconceivable in nature because of the law of gravity), is quite possible.

Without any doubt, positive science can provide the Institute with extremely valuable material. But the Institute should not expect to find an ultimate solution to any question of art in this material. We must never lose sight of our general approach to solving the questions of art that we indicated at the very beginning of this program, i.e., the effect of the means of expression on the inner experience of man. Because art, at the end of the day, exists for the sake of man.

Even though art workers right now may be working on problems of construction (art still has virtually no precise rules), they might try to find a positive solution too easily and too ardently from the engineer. And they might accept the engineer's answer as the solution for art— quite erroneously. This is a very real danger, and it is essential to warn oneself and one's colleagues engaged in theoretical research about it.

Apart from all that has been said, we should also remember that art operates with infinitely small dimensions, which are as yet not susceptible of measurement. These tiny dimensions can be determined during the process of work only with great difficulty and effort; ultimately, they are discovered subconsciously. Observation of the artist at work, measurement of both his true and false color-tones by the most delicate of instruments—such conditions would render the artist incapable of working. Be that as it may, more or less rational experiments along these lines will have to be carried out. A first experiment could be to juxtapose two or three colored spots and then to elaborate them bit by bit, entrusting the measurements to a specialist. In some arts this kind of assignment can be carried out without difficulty, as in sculpture, for example, which uses masses that can be measured. Here again, of course, complete accuracy of measurement is hardly possible.

In conclusion, I should state that the laws that have hitherto been found in art have always proved to be transient, i.e., true only for a given period of time. It would seem that an epoch has its own objectives: ergo,

its own methods of resolving them. Hence, analysis of these methods might reveal their operative principle, their law. It is too easy and too dangerous to accept this law as an eternal one. But man does not stop before the unanswerable: an invincible force attracts him toward the eternal. The Institute will aspire to find the eternal in the transient. The more forcefully it examines these tasks, the more valuable will be its discoveries on the (perhaps) utopian path toward their ultimate resolution.

<div align="right">Praesidium</div>

Report to the Pan-Russian Conference, 1920
Vestnik Rabotnikov Iskusstv
(Moscow), 1921

The first Pan-Russian Conference of heads of art sections operating under Narkompros (Commissariat of Enlightenment) was held in Moscow from 19 to 25 December 1920. Apart from the Commissar himself, A. V. Lunacharsky, speakers included the stage director Meierkhold, the poet Briusov, and Kandinsky, who appeared as representative of the Institute of Artistic Culture [Inkhuk]. His report on the activities of the Institute was summarized in the journal *Vestnik Rabotnikov Iskusstv* [Bulletin of Art Workers], under the general heading "Papers on Scientific and Artistic Questions."[1] Although couched in the form of a brief abstract, the style leaves little room for doubt that this summary was written by the artist himself. The description of how one of Kandinsky's watercolors was interpreted independently by a musician and by a dancer evidently harks back to the years in Munich before the war. The dancer was almost certainly Aleksandr Sakharov, who, like Kandinsky, was a member of the Neue Künstler-Vereinigung München; apart from its activities as an exhibiting society, the NKVM under Kandinsky's presidency was also dedicated to "synthetic" aims in art.

In recent times, two extremely powerful tendencies have emerged simultaneously: the tendency of each art to become immersed in itself, the desire to study its fundamental resources, to illuminate their nature

and worth; and, on the other hand, a tendency toward the unification of the arts. Naturally, as each individual art becomes immersed in itself, it looks with involuntary interest into adjacent areas to observe how another art will apply itself to the same problems. Never have musicians followed with such interest the development of painting, painters, of architecture, architects, of poetry, etc., as happens today before our very eyes.

We already know of several instances of combining different arts in one work (monodrama, chamber-dance, etc.). These are the most straightforward examples of synthetic art. In the theater, music can be synthesized with dancing, decoration, costumes.

For the purpose of studying this synthetic art, the Institute of Artistic Culture was founded on 12 May 1920 in Moscow. Experiments carried out have shown that art can be divided up into parts corresponding to certain mathematical relationships. The important work done in this direction by the composer Shenshin has demonstrated the possibility of translating from one artistic language into another. He took a Michelangelo tomb and a musical composition by Liszt on the same theme. Dividing the musical composition into its constituent parts, Shenshin obtained a certain correlation between the [numbers of] bars, which he translated into graphic form corresponding to the mechanical form that lay at the basis of the work by Michelangelo.

I myself had the opportunity of carrying out some small experiments abroad with a young musician and a dancer. From among several of my watercolors the musician would choose one that appeared to him to have the clearest musical form. In the absence of the dancer, he would play this watercolor. Then the dancer would appear, and having been played this musical composition, he would dance it and then find the watercolor he had danced.

In the Institute of Artistic Culture, similar experiments have been going on. Musicians took three basic chords, which the painters had to draw first of all in pencil; then compiling a table, each painter had to represent each chord in colors.

These experiments show that the Institute is on the right path.

Interview with Charles-André Julien
["Une interview de Kandinsky en 1921"]
Revue de l'Art
(Paris), 1969

Charles-André Julien was one of the first Western Europeans officially invited to report firsthand on the situation of art in Russia after the 1917 revolution. He visited Moscow and Petrograd in the summer of 1921; *L'Illustration*, no. 4095 (27 August 1921), published a long article in which he described the reforms taking place in Russian museums and the confiscation of private collections. He also took notes of an interview he had with Kandinsky, presumably in Moscow, on 10 July; these remained unpublished until their appearance in the *Revue de l'Art* in 1969.

Kandinsky spoke with remarkable frankness to Julien, perhaps precisely because the latter was a foreigner. His misgivings about the contemporary artistic situation are more than apparent, while his references to "black on black" and "white on white" paintings reveal that he can subscribe to neither the Constructivism of Rodchenko nor the Suprematism of Malevich. His growing disenchantment with the opinions of his colleagues in the Constructivist and "productivist" camps led to his departure for Germany in December 1921.

Julien's notes were apparently rather hasty and contained many abbreviations. In the 1969 French publication, much of the original character has been preserved, but with abbreviations and omissions discreetly filled in; this is the version followed here. On the other hand, a brief scattering of editorial footnotes, mainly bibliographic, has been omitted in this edition.

Two directions in Russian art. One, seen inwardly, toward theory. Until now no science of art. In 1912 in Munich I published a book about art theories: *On the Spiritual in Art*. I was the first to break with the tradition of painting existing objects. I founded abstract painting. I painted the first abstract picture in 1911. Until then, following the Impressionists it was said that the artistic point of view consisted less in knowing what to paint than how to paint it. I say in my book that the *what* prevails over the *how*. Now I place them on the same footing. My earlier point of view was opposed to the point of view that had abandoned the soul of art. I noticed through my own work that the "how" resembles the jacket on the body, and that balance is true harmony. I studied ancient art, Egyptian art, which I like so much, the Italians of the Florentine and Venetian Renaissance, and Russian art of the icons.

At present in Moscow (not in Russia) people think the qualification "how" has become singularly out of fashion. Instead of creating paintings, works, one makes experiments. One practices experimental art in laboratories. I think these are two different things. People paint black on black, white on white. Color evenly applied, skillfully handled. Those who paint in that way say that they are experimenting and that painting is the art of putting a form on the canvas so that it looks as if it had been glued to the canvas. Yet is is impossible to paste black on yellow without the eye tearing it from the canvas. Moreover, in science one does not experiment at random, as do those painters who have no direction whatsoever. It is not a very widespread movement. I am expecting a reaction that might perhaps be too widespread and academic.

My ideal since 1900: to paint an extremely dramatic picture, a "tragic" picture. I have painted a quantity of such works. And I did so until the revolution. During October I saw the revolution from my windows. Then I painted in a totally different manner. I felt within myself great peace of soul. Instead of the tragic, something peaceful and organized. The colors in my work became brighter and more attractive, in place of the previous deep and somber shades.

In Russia they are debating the question of art education.

It is said that in art it is not necessary and even dangerous to have intuition. This is the view of a few young painters who push the materialistic viewpoint to absurdity. They are purists of a revolutionary viewpoint who believe that the purpose of painting is a public one, that any art object without use is bourgeois, that the epoch of pure art is finished. It's rather curious that I, who am against that point of view,

should have been the first to make cups. There are not very many of them. Stenberg talks in this manner, but paints otherwise. I believe that theory is necessary, as always, but that it is fine for the past and only one of the elements for the future. Anything done theoretically is dead. An X must continue to exist that makes art alive. Practice is one thing and theory another. One must work in both ways without confusing the two. Personally, I theorize a great deal, but I never think about theory when I am painting.

What is missing here is the opportunity to produce. We are kept busy with official jobs. We asked Krupskaia for the opportunity of working at our own profession, instead of making a career of teaching. For my part, I spent three years organizing over thirty museums in the provinces. What is really painful is the paperwork. We have to keep the accounts in order, justify the money we need. The cups, made in December, have not been paid for. Hours are wasted in formalities. Painters do not have much spare time.

In 1913 over thirty paintings and two big compositions five meters long, preceded by all kinds of preparatory work; in 1918, not one painting, only drawings. My whole day was taken up by official work; in 1919, I managed to get some spare time, and I began painting: in 1920, ten [paintings], in the first half of 1921, eight [paintings], cups, embroideries.[1]

They are going to found an academy for the science of art where I shall work.

Next spring I am going to give a course on modern painting.

Paintings: the State buys some, and private individuals as well, who buy above all works by deceased artists. They pay 300,000 R. The tax is determined according to the number of hours used for the conception of the painting, the sketch, the execution. It's a bonus for mediocre painters. The great ones are being humiliated.

30,000 R. is being paid for a drawing of a cup, no matter who did it. Most painters work to make a living: posters (etc.). What is more, you have a whole lot of mediocre posters (for which the pay was 10,000 R). The *nouveaux riches* do not buy paintings, but silk stockings, trinkets.

The professional union includes all artists of all categories. It decides on the prices. Great painters no longer work at the presidium; the actors remain there because they have more freedom, since they work for their art in the evening.

1922

Foreword to the Catalogue of the First International Art Exhibition, Düsseldorf
"Vorwort", [*Katalog der Ersten Internationalen Kunstausstellung im Hause Leonhard Tietz, A.G.,*] (Düsseldorf), 1922

The first International Art Exhibition was held to coincide with the Düsseldorf Congress of International Progressive Artists in May 1922. It was organized by the "Young Rhineland" group under the leadership of the painters Arthur Kaufmann, Adolf Uzarski, and Gert Heinrich Wollheim. The congress was attended by artists from France, Russia and Switzerland, as well as members of the November-Gruppe, representatives of the Bauhaus, and a number of Dadaists, including Hausmann and Schwitters. The congress is remembered for the unexpected revival of Dada in Germany and the protests and interruptions for which the Dadaists were responsible.[1]

The Düsseldorf exhibition and congress immediately preceded Kandinsky's appointment to the teaching staff of the Bauhaus in June 1922. In the following statement, printed as the foreword to the exhibition catalogue, he returns to some of his preoccupations of the Blaue Reiter period, especially the notion of synthesis. There are also noticeable stylistic similarities with certain passages from his "Reminiscences" (see pp. 357–82), and especially p. 361.

We are born under the sign of **synthesis.** We—men on this earth.

All the paths we trod until today, divorced from one another, have become **one** path, on which we march united—whether we want to or not.

The walls that hid these paths from one another have fallen.

All is revealed.

Everything trembles and shows its **Inner Face.** The dead has become living.

* *

*

The realms of those phenomena we term art, without knowing what art is, which yesterday were clearly divided from one another, today have fused into one realm, and the boundaries separating it from other human realms are disappearing.

The last walls are falling, and the last boundaries are being destroyed.

* *

*

The irreconcilable is reconciled. Two opposing paths lead to one goal—analysis, synthesis.

Analysis + synthesis = the **Great Synthesis.**

In this way, the art that is termed "new" comes about, which apparently has nothing in common with the "old," but which shows clearly to every living eye the connecting thread. That thread which is called **Inner Necessity.**

Thus the Epoch of the Great Spiritual has begun.

Berlin, April 1922

A New Naturalism?
["Ein neuer Naturalismus?"]
Das Kunstblatt
(Potsdam), 1922

The August 1922 issue of *Das Kunstblatt* contained the following editorial announcement:

> In the studios, and even more animatedly in print, artists are discussing more and more determinedly whether the development of art is tending toward a new naturalism. These discussions seem to us symptomatic, and have caused us to circulate a questionnaire to artists, writers, teachers of art, and museum directors, with the aim of provoking them to express opinions that might help clarify the issue.[1]

The purpose of the questionnaire was to determine whether "naturalism" should be considered merely as the latest "catch-phrase," or whether it represented a development of substance. Archipenko, Döbling, Hartlaub, Hausenstein, Hofer, Kirchner, Meidner, Purrmann, Thoma, and Uhde were among those who responded. The number of replies was so great that the whole of the September issue of *Das Kunstblatt* was devoted to the question of the new naturalism. Kandinsky's answer was printed on pp. 384–87. The statements were accompanied by photographs of petrified bodies of human beings and animals excavated from the ruins of Pompei, intended to represent "the truest form of naturalism."

The fact that the question of "naturalism" is raised today in a quite acute form is due to many reasons, of which the following two belong to

the category of the external:

1. The tensile strength, the rapid, somewhat febrile development of abstract art; and
2. as a result, the one-sided despondency, the involuntary desire of the weaker elements to draw breath in the realms of accustomed, long-since tried and tested forms.

Among the other, likewise external reasons that also affect the issue, which today take on a particular importance and meaning, are the whole political situation—the political situation of all countries—and the resulting, mainly financial phenomena: hesitation, uncertainty, and fear.

Far more important are the inner reasons, which carry within themselves much that is cheering and even fortunate. When I, some ten years ago, at last tore open the previously invisible door that had slowly come into sight, and finally began to create in concrete terms in the realms of abstract art, I wrote concurrently an article for the *Blaue Reiter* [*Almanac*] called "On the Question of Form," in which I was able with certainty to place an = sign between abstraction and realism.

The period of the coming realism, which I described as the first true realism, is destined to achieve important things—the emancipation of man from the conventional, from narrow-mindedness and hatred, the enrichment of his sensitivity and life-force. This period will serve, further, as the final segregation of art from nature. Thus, realism will serve the ends of abstraction. We, the abstractionists of today, will be regarded in time as the "pioneers" of absolute art, who had the good fortune, through clairvoyance, to live perhaps centuries ahead of our time.

The great age of the Spiritual, whose existence only a few can sense, and which even fewer can see, must undergo many stages of development. Our present stage has as its task, among many others, to open wide men's eyes, to sharpen their hearing, to liberate and develop all the senses, so that they are able to perceive the living element in "dead" matter. The man of the future, who is met with only singly today, but who is to be encountered with increasing frequency, is distinguished by his inner freedom, the long striven-for ability to see beyond without blinkers.

If already today abstract art were by some miracle to be generally accepted, it would be taken up slavishly, mechanically, because blinkers

are incompatible with inner freedom. There are still far too few who are inwardly capable of living in freedom—the rest have first to win that freedom. The path to freedom is through a developed feeling of relativity—knowledge is not able to achieve a great deal. Already in the above-mentioned article I wrote that there is no question of form as such. Today, on the contrary, exclusive emphasis is placed on the question of form. The damper of the material prevents the sound of the content from being heard through the form. The practical consequences of this attitude can be seen perfectly clearly in many works that are born in the realms of different "isms": the inevitable "simplification" of forms produces, when carried to its logical conclusion, a form scarcely distinguishable from a void. And for ten years we have been hearing from many small groups the cry: "Down with art!"—this is the logical consequence of the development of the same attitude in theory.

Complete harmony between "form" and "content," where form = content and content = form, can only exist if it is the content that creates the form. And this remains the same in every art, and in every period of art.

The general content of our time, however, can as yet give rise to no general form, because this content is itself only at the beginning of its development. Thus, if I were asked, "Should abstract art be recognized as the only art today?" I would say without hesitation, "No!"

But it should not be forgotten that opposite paths lead today to one single goal. And the coming realism, toward which the naturalism referred to in the question is perhaps a step, is destined ultimately to make plain the way of abstract art.

Foreword to the Catalogue of the Kandinsky Exhibition at Gummesons
(Stockholm), 1922

Kandinsky's second exhibition at Gummesons was less ambitious and less successful than his first exhibition in 1916. It consisted of ten oils, painted between 1919 and 1921, and fourteen watercolors, some of them dating from 1915 to 1916. The small catalogue included a photograph of the artist, a facsimile of his flowing signature, a cover print, and reproductions of three oils.[1] Apparently nothing sold, which prompted Kandinsky's comment to Grohmann that the Swedish people purchased only his earlier, figurative works, but did not understand "abstract art" (Letter to Grohmann, 29 September 1925). After his 1934 exhibition in Stockholm he wrote—with evident satisfaction—that a Swedish museum owned one of his oils (Letter to Grohmann, 5 August 1934).

If the Swedes did not respond, Katherine Dreier did. She purchased two paintings from the exhibition and used the cover print (reproduced sideways) for the catalogue of her Kandinsky one-man show (Galleries of the Société Anonyme, New York, 23 November—4 May 1923).

The essay expresses the artist's continuing faith in the triumph of synthesis, urging the reader to use "and" instead of the disruptive "either-or."[2]

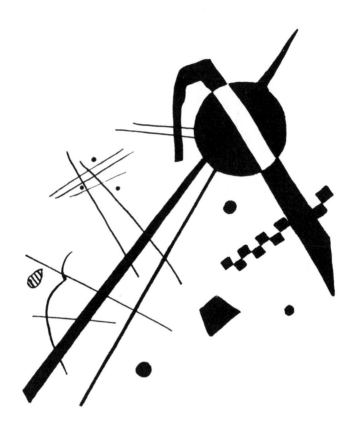

Six years have passed since my first exhibition in Stockholm, six years that seem like at least sixty. Life accelerates faster and faster with each day, so that in some areas it almost turns into a windstorm. Therefore, the new image of the world has become so complicated and so large that with our present viewpoint we are not able to grasp it in its entirety.

At first glance two major movements can be noticed—in addition to the great thrusts—the analytic and the synthetic. These two opposing paths lead to the same goal—**the great synthesis.**

In painting as well as in the other fine arts, it is not difficult to distinguish these two movements. It is more difficult to fit these two motive forces into the right places. Therefore, there will be confusion arising here as the two movements fight with each other. Analysts, educated purely in the materialistic, only want to create art "consciously," and therefore feel that they must throw the subconscious element—intuition—overboard.

This is not the right place to discuss art theory. But the actual making of art has a perpetual goal, the creation of artistic entities, which resemble organisms. Would it be permissible to create organisms that lack head or heart? Head or heart, the conscious or the subconscious, calculation and intuition—what might be thrown overboard?

Synthesis, which "today" controls everything, which chosen to create the new world and is already creating it, replaces the words "either-or" with the conclusive and decisive word "and."

As usual, it is within art that this new trend—**"and"**—first becomes apparent, but it also dawns here and there in other areas, and slowly backs will be turned on **"either-or."**

Timmendorferstrand, September 1922

1922

Small Worlds
[*Kleine Welten*]
(Berlin), 1922

Kandinsky's album *Small Worlds* was published in the autumn of 1922 by Propyläen Verlag in Berlin, in a limited edition of 230 copies (30 of them a deluxe edition on Japan paper). It consisted of twelve original prints, produced under the artist's supervision: four lithographs, four etchings, and four prints, two of which, although described as woodcuts, appear in fact to be lithographs.[1] Stylistically, *Small Worlds* occupies an important place within Kandinsky's *oeuvre*, marking a transitional phase in his development: the forms that occur in these prints are no longer the easily identified abstractions from natural phenomena, which persist even in much of his work from the Russian period, but neither have they yet become part of the more strictly geometrical morphology of his later years at the Bauhaus. According to the artist, the prints were produced partly in the graphic workshops of the Bauhaus itself, partly by an independent printing firm in Weimar;[2] they were preceded by the following introduction.

The "Small Worlds" sound forth from 12 pages.
4 of these pages were created with the aid of stone,
4—with that of wood,
4—with that of copper.

$4 \times 3 = 12$

Three groups, three techniques.

486

Each technique was chosen for its appropriate character. The character of each technique played an external role in helping to create 4 different "Small Worlds."
In 6 cases, the "Small Worlds" contented themselves with black lines or black patches.
The remaining 6 needed the sound of other colors as well.

$$6 + 6 = 12$$

In all 12 cases, each of the "Small Worlds" adopted, in line or patch, its own necessary language.

12

WEIMAR, 1922

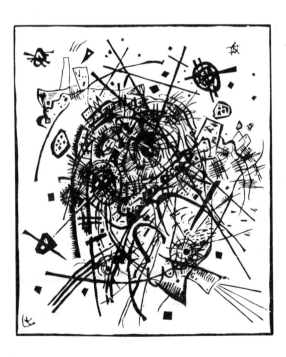

1923

On Reform of Art Schools

["K reforme khudozhestvennoi shkoly"]
Iskusstvo
(Moscow), 1923

By the time this essay was published, Kandinsky had once again taken up residence in Germany. It is no accident that he chose to review a book on German educational reform.[1] Not only did he himself maintain close ties with German artists, scholars, and cultural institutions, but also Germany—or rather the Weimar Republic—had been the first foreign nation with which Soviet Russia had established cultural and commercial links after the blockade and Civil War. Symbolic of this political and cultural sympathy was the large exhibition of Russian art held at the Galerie Van Diemen in Berlin in 1922, at which most of the avant-garde, including Kandinsky, were represented. Inasmuch as the two revolutionary states shared ideological tendencies, their aspirations to reconstruct the culture of the Imperial past to conform with proletarian democracy followed similar patterns. In this respect, it is interesting to compare the directives issued by the respective cultural organs of both sides, i.e., by the Soviet People's Commissariat for Enlightenment in 1918 and the Weimar Arbeitsrat für Kunst in 1919. From Soviet Russia: "The Academy as a state institution is abolished. . . . The Museum of the Academy of Arts comes under the control of the People's Commissariat for Enlightenment. . . ." From Weimar: "Dissolution of the Academy of Arts, the Academy of Building and the Prussian Provincial Art Commission in their existing forms. . . . Enli-

venment of the museums as education establishments for the people. . . ." Representative of this mutual endeavor to "start again" were the several proposals both in Russia and in Germany to replace the traditional academic system of art instruction by a new and radical approach. In Russia, this ambitious desire to break with the past gave rise to the establishment of the complex of art schools known as Svomas (Free Art Studios), created in 1918 in Moscow, Petrograd, and other centers.

Kandinsky, who lived in Moscow during these years of change and had some experience of the first reforms of the art education program there, was in a position to compare Waetzoldt's allegations and proposals with what had happened in Russia. As Kandinsky indicates in his essay, the Svomas were centers of the most provocative ideas: the entrance examination was abolished, art history courses were optional, some "studios without supervisors" were organized, the old teaching faculty was replaced by artists of the avant-garde, and students were free to choose their own professors. The immediate result was confusion and embarrassment among both faculty and students, so that in 1920 a partial return to more traditional methods was adopted; the Petrograd Svomas reverted to the Academy and the Moscow Svomas became the Vkhutemas (Higher State Art-Technical Studios). Kandinsky, therefore, had grounds for observing that "in following Waetzoldt page by page, we are touching on all the sore points of the art schools in Russia." Moreover, as he himself would learn in years to come, the stifling intrusion of politics into art education was to develop as rapidly and as perniciously in Hitler's Germany as in Stalin's Russia.

It would seem that countries that in previous times were very different are now experiencing the same dramatic condition, the confrontation of two opposing and hostile forces—a maximum demand for construction in all walks of life and a minimal feasibility for fulfilling it.

Examination of the various systems explored to overcome this condition would be a useful piece of research on the national characteristics of individual nations.

In this respect one of the most important spheres in the life of any nation, i.e., art, could serve as one of the most exciting objects of research.

Art and its contiguity, the destiny of the art school, are inspiring a very great effort of national will to remove the huge question mark looming over them.

I can remember that about ten years ago in Germany ardent prophesies were made to the effect that the end of art, its obsolesence, was nigh. Such were the panic-stricken voices of the extremely conservative theorists frightened by threats of "Expressionism" and by the first works of the form of painting that German theorists then christened "nonobjective"—not a very successful term.

It was in those days that the triumphant advance of the "transvaluation of values" created the right atmosphere for the most audacious destruction of conventional lifestyles. And a question mark was written above the whole of art—Life or death?

A particular and gigantic question mark was put above the teaching of art in those days—Was art school needed or not?

The first question mark, effortlessly removed by the subsequent development of German art, has turned up here in Russia this year: Art—to be or not to be? In this way, our theorists, our "innovators," now prove to be the belated allies of the German conversatives. They are reviving their voices long silent.

The second question mark (judging by Waetzoldt's book) has attracted to itself such a large number of young students that their voices cannot but be heard. The many German school reforms, especially the academic structure of the German school over recent years, together with the many victims of the cruelty and oppression inherent in school systems, their unfair organization, has obviously led these young students to a state of despair and to conclusions promising no hope.

At the moment we, on the other hand, are experiencing a period of ecstatic delight in "ideal" systems of art teaching and in our naive belief

in the perfection of an exact, strict, and uniform kind of art education: the only defect here is that this has not yet been found. This explains why we have had reform after reform in our school system, and why we have witnessed a breathtaking flight from a formless, free kind of teaching to an extreme regimentation and severity of program. One would suppose that the result of this flight might be a limited possibility for combining regimentation where it is inevitable with complete freedom where severity is not only unnecessary, but also destructive.

Some of the German theorists, who are vexed at the very small potential for any extensive state construction as a result of Germany's impaired economy, are calling for the state to withdraw from various aspects of national life. These "fanatics of federal unloading," as Waetzoldt calls them, propose that the state renounce, *inter alia*, any regimentation of artistic life and of the art school in particular.

In this matter Germany would be close to the American system of "nonintervention" in artistic affairs and would occupy a position diametrically opposed to that of Soviet Russia, where the state endeavors precisely to regulate artistic life and the art school in particular.

Waetzoldt considers both systems incorrect and proposes a number of principles that, in his opinion, should form the basis of a specific policy for the art school.

These principles and the history of their evolution are so astonishingly close to the opinions expressed by some of our more experienced art teachers in Russia that one would think that no impenetrable wall had cut us off from Germany for years and that we had all been searching together for a way out of this labyrinth of artistic complexity.

"The joyful passion for reforms during the first months of the revolution gradually gave way to a certain distrust of reform. . . . Not everything that existed before 9 November 1918 was bad, and evidently, not everything will prove to be worthwhile simply because it is taking place today. School reforms must, in any case, guarantee to some extent a period of viability—that is why they must be implemented according to principles standing beyond the topical interests of the day, especially beyond political and artistic fashion" (p. 5).

Waetzoldt has an entirely critical attitude toward the old academy. "In comparison with the new special schools, its organization and methods seem truly medieval" (p. 7). Since the time of da Vinci in Italy and Dürer in Germany, art has ceased to be the "delicate flower of just a craftsman's endeavor" and has come to be born "on the basis of theoreti-

cal and scientific education." Hence the corresponding pedagogical viewpoint—the classroom teaching of theory, science, or the semiscientific takes the place of the master's studio. "There began the ill-fated 'scientification' of the academies, the elimination of which must constitute one of the primary tasks for reform in the art school" (p. 8). The German students of today are protesting vehemently and "passionately" against "exaggerated naturalism and intellectualism." "Intuition is summoned once again, the irrational again becomes of value" (p. 9).

Our largely unsuccessful and rather pitiful experience of "studios without supervisors" was, apparently, greeted with great joy by those German pedagogues whom the monstrous German academy had driven to extreme conclusions: "The most determined reformers actually dismiss the teaching and learning of art as being not only useless, but also pernicious to art." Waetzoldt does not know that our students hold the opposite point of view (the studios without supervisors were empty) and that, in this matter, we have moved from an extreme freedom to a no less extreme severity in our school structure. He himself is quite against such a radical resolution of the problem and thinks that the experience of an intelligent, uncoercive supervisor saves students from the many aberrations, mistakes, and disillusionments that they will inevitably encounter on the path toward success.

"What, undoubtedly, must not be taught in schools is art movements and styles. Life, unfortunately, cannot do without party factions, but a school should have nothing to do with them. The aim of a school is to show the path and provide the means, but finding the goal and the ultimate decision is the task of the artist's individuality." Consequently, basing itself on any kind of "dominant academic trend" (p. 11) cannot be the task of an art school.

We might note with particular delight that Germans are reaching the same contention that is uniting more and more of our own serious artists and theorists. More and more often, we are hearing the Russian version of what we read in German in Waetzoldt: "There are neither 'conservatives nor revolutionaries' in art; there is simply good or bad art." Substitute "rightists" for "conservatives" and "leftists" for "revolutionaries," and you have a literal concurrence. Perhaps Rosa Luxemburg, whom Waetzoldt quotes, is even nearer to our own technology: "The sobriquets 'reactionary' or 'innovator' actually mean very little in art. . . . The social formula that an artist might profess is, for him, a

secondary matter" (p. 33). In the selection of teachers, it's not Impressionists or Expressionists that are needed, but powerful individuals irrespective of what movement they belong to. It is a mistake to think that an antiquated system can be renewed by attracting only the champions of some new movement to the school. Today's revolutionaries would be destined to turn into the academicians of tomorrow" (p. 11).

The reader will have noticed that, in following Waetzoldt page by page, we are touching on all the sore points of the art school in Russia. Until recently, the different fates of the art school in Russia and Germany occasioned the different attitudes to the question raised simultaneously in both countries. In Germany—exhaustion from overloading the academy with theoretical and scientific knowledge—whence, above all, comes Waetzoldt's *cri de coeur*: "Back to handicraft!"; in Russia— the still-systemless endeavor to fill our gaps in this knowledge.

The burning question of "production art" stands in equal need of resolution in both countries. Both in Germany and in Russia the "applied arts" long played the role of art's stepchild, and the "applied artist" felt equally insulted in both countries. The widespread mistake was that applied art could make do with less talent, that the teaching of this art could be second-rate and that its cherished ideal was to pass on to the academy to receive a higher education in art. Finally, the long-awaited moment arrived when this really abnormal condition was to be resolved. But it was a moment that, in view of its particular importance, required complete objectivity, composure, and the involvement of competent artistic forces. Dilettantism could not be allowed. Among the competent voices that echoed down to us was doubtless that of Waetzoldt: The talent of an artist of "pure" art and that of an artist of "applied" art are "equal in value although different in their specifics" (p. 31). Right up until the eighteenth century the artist learned art in the master's studio, where, austerely and deliberately, he learned how to work with a particular material, how to recognize its qualities, and how to control them. That is how "consciousness of the quality of work" was born. Art students from Weimar to Moscow are demanding a chance to receive training in craftmanship, something that cannot be replaced by any "higher pedagogical system" (p. 13). One cannot but wish that these lucid and objective arguments by Waetzoldt would be of benefit to our extreme reformers, for whom handicraft is the enemy of art, and art the enemy of handicraft: Down with pure art; long live craft! Waetzoldt returns to the same question on the last page of the theoretical section in

his book, and once again we encounter an assertion that unites our most serious art workers: "Only those who have no conception of the natural interdependence of things could believe in the possibility of good industrial art production without any concern for the free (in Russian: "pure") arts. . . . An indissoluble chain entwines and unites all the degrees and kinds of artistic creativity and it is impossible to exclude this or that link from the chain" (p. 45).

Waetzoldt requires that a student at an art school be given the chance to acquaint himself freely with all types of visual art so that he would receive "training" in them. At the beginning of a course a student embarks on the "trial semester," when he "wanders" among the various specialities (we also had this idea but it was not implemented), so that the novice can test himself and find which area attracts him most. At this juncture the teacher must not push the student or pressure him. Rather, the teacher must limit his activity to giving advice and general instruction and to familiarizing the student with the nature of artistic resources.

Passing on to the question of practical production in the school, Waetzoldt points to the necessity of providing the student with the chance of learning simultaneously both free ("pure") and applied ("production") art. Apart from his special classes in construction, the architect must work in the relevant practical studios: joinery, plasterwork, interior design, etc. Apart from his painting studio, the painter should learn graphics, script, decorative and glass-painting, lithography, and etching. The aspiring monumental painter should have the chance of working on monumental painting while still at school; otherwise he will be powerless to act when confronted with an actual task of monumental art later on.

"The less talk about movements and styles in art school, and the more talk about art, the better it will be. . . . Establishing spiritual (not intellectual) principles among artists has very deep significance both for art and for culture. Today, in fact, we must not forget that the right to lead, the right to a creative role in all spheres of culture, must belong to our spiritual forces" (p. 24).

Higher schools of free and applied art are headed by "masters' studios" (cf. our "special studios," or as they were called after the first reform, "individual studios"). The average student finishes his higher art education in studio and class work within three to four years. After this he should be quite ready for independent work. The "masters' studios"

should admit only the very gifted student, one who would be expected to take on a leading role in art, in its subsequent development both in its free and applied phases (something like our category of "those who stay on for university"). Waetzoldt is correct in affirming that at the moment the importance and influence of strong individuality are underestimated, and that "organization and method" are regarded as "everything." However substantial the role of production art, it does not give us grounds for rejecting free art. However substantial the role of the collective, it does not give us grounds for rejecting individuality. You should not undermine the roots of the tree whose fruits you partake of. Such are the truths that have to be asserted!

Masters' studios should receive both state and civic commissions. These commissions should be fulfilled by the supervisors in conjunction with their students and should integrate masters' studios representing different spheres of art in the implementation of these commissions. As far as I have gathered, the Germans' theoretical interest in synthetic art, which we have also witnessed here, has now shifted to a practical level, at least at school. For example, students at the reformed Weimar Academy are obliged to attend courses in two other visual arts courses outside their special subject. Our first school reform was indifferent to this issue. Our second reform, now taking place, is obviously hostile to it: apart from a few isolated instances where special permission is required, our students are denied not only the chance of simultaneous instruction, but even the possibility of acquainting themselves with the work of other "departments." They are stuck with their special subject, and only on termination of a complete course of study may they test their potential in some other field of art—with which they immediately get stuck again. And despite the heightened concern with production art, students who, for example, are studying easel painting are deprived of the opportunity of specializing simultaneously in some area of production. So inflexible is this organization within art schools that, as in the old days, we will be embarrassed by the "overproduction" of quite superfluous "pure" works of art and will be horrified at the anemic impotence of "applied" art.

Waetzoldt attaches great importance to the active participation of students both in reforming the school structure and in the everyday life of the school. Reforms should be decided upon not just "from above." School reforms should not be implemented without the participation of the students or, even worse, against their will: "The development of the

higher art school of the future will depend not so much on the resolutions and injunctions of the authorities as on the spirit of the students" (p. 41). The whole story of the protest made by our "realism"-oriented students, the whole story of our "realist" studios that still cannot get off the ground, are a vivid testimony to how we "listen" so one-sidedly to the voice of our students and to our absence of absolute objectivity so essential in this matter.

As regards the appointment of professors in particular (where the final decision rests with a minister), Waetzoldt asks that students be given the chance to speak their opinions concerning the candidates, because they possess a fine instinct for determining both the artistic and the human qualities of a teacher. Within the actual administration of the school, and in particular within its highest organ of authority, the senate, students have their own representative carrying a consultative and decisive vote (p. 32). On the other hand, the students' task is to defend "purely artistic interests from any party pressure" (p. 33). "To ensure the proper development of German art, a vital cultural awareness is essential, one that would stand above any political, economic, and artistic polemics; what is also essential is a willpower, a resolute, cultural guide that can unite both head and hand to attain a single, common goal" (p. 45).

Among the titles recommended by Waetzoldt, we encounter two books by Russian authors: A. Lunacharsky's *Cultural Tasks of the Working Class* (Berlin, 1919) and K. Umansky's *New Russian Art* (Munich [sic], 1920).[2]

One of the essential themes in the historical section of Waetzoldt's book concerns the derivation and vacillation of the idea of education in industrial art. Concern over the increasing number of "pure" artists who possessed talents incongruous with this sphere of art, and the resulting increase in the number of "proletarian artists" was, it turns out, a matter of urgent attention for the German and, in particular, the Prussian government in the dim and distant past. As early as the seventeenth century Prussia received her higher art schools. The Berlin Academy was founded by the Elector Friedrich III in 1696. In 1699 the Academy of Fine Arts and Mechanical Sciences was founded on the models of Louis XIV's Paris Academy and Sixtus IV's Roman Academy. The Berlin Academy, incidentally, was assigned the role of a consultative organ for the Elector in matters of art. It was not supposed to be merely a "higher art school or art university," but was called upon to

concern itself with "practical art work," i.e., with "decorations for our buildings, architectural sculpture, goldsmith work, joinery," etc. For this the Academy was required to provide "advice, active participation, designs, models, and sketches." About one hundred years later, at the end of the eighteenth century, this idea was given such a radical resolution that we fly one hundred and fifty years into the future and hear the discussions of our own time: a plan is proposed for cutting the number of students of free art and for attracting more students to make "designs for factories." Doesn't this remind one of certain speeches made at our art conferences last winter?

At the end of the eighteenth century a warden of the Berlin Academy by the name of Heinitz informed Friedrich Wilhelm II of the need to "educate not only specialist artists at the Academy, such as painters, etc., but also to make the Academy a cultivator and protector of good taste in all areas of our national industry . . . so as to raise its level: in order that our manufacturing and industrial art works would not lag behind those from abroad and in order, thereby, to link the interests of art to the incomparably more important interests of the state" (p. 90).

Here we have the origin of the condition that incites Waetzoldt's *cri de coeur*: "Back to handicraft!"

But the same Waetzoldt, with his experience of German art education, issues an urgent warning many times in his book against exaggerating the value of industrial art. He suggests we should not forget that industrial art derives its strength, its potential, and its vital energy from the sphere of "free art" (p. 45).

Bauhaus, 1919–1923
["Die Grundelemente der Form";
"Farbkurs und Seminar"; "Über die
abstrakte Bühnensynthese"]
Staatliches Bauhaus Weimar, 1919–1923
(Weimar and Munich), 1923

The Bauhaus staged its first major exhibition in
Weimar in the summer of 1923.[1] The teaching blocks
showed the work of the foundation year and of the various
studios and workshops. An international architectural sec-
tion was housed in the school's main building. The Landes-
museum also made space available for the display of inde-
pendent creative work. The opening of the exhibition was
followed by a "Bauhaus Week" (15–19 August), with lec-
tures, plays, and concerts both in Weimar and in Jena. The
fact that the Deutsche Werkbund was holding its conference
in Weimar at the same time ensured the presence of a wider
audience.

The exhibition also engendered a succession of reviews,
articles, and other publications, of which the most signific-
ant was the documentary anthology *Staatliches Bauhaus
Weimar, 1919–1923*. It appeared under the imprint of the
school's own publishing house, established to facilitate wider
dissemination of the principles upon which the Bauhaus had
been founded.[2] The typography was the responsibility of
Moholy-Nagy; the binding was designed by Herbert Bayer.
The book was divided into three sections: I. School, II. Build-
ing, III. Independent Pictorial and Sculptural Work. Included
among the textual contributions were articles by Gropius

and Gertrud Gronow,[3] Klee's "Ways to Studying Nature,"[4] and Kandinsky's essays "The Basic Elements of Form," "Color Course and Seminar," and "Abstract Synthesis on the Stage."

These three essays may be seen as the logical development of ideas Kandinsky had put forward in his prewar writings, particularly in his treatise *On the Spiritual in Art* and his essay "On the Question of Form." His more "scientific" approach of the Bauhaus years is, however, readily observed, especially in "Color Course and Seminar" (cf. his more "intuitive" discussion of the effects of color in *On the Spiritual in Art*). In "Abstract Synthesis on the Stage," Kandinsky refers the reader to his earlier essay on stage composition (in the *Blaue Reiter Almanac,* pp. 257–265); the affinity between "Abstract Synthesis" and his discussion of the "monumental art of the future" that occurs in the latter part of *On the Spiritual* is even more marked. In a footnote to "The Basic Elements of Form," Kandinsky also mentions his "article in the *Proceedings of the Pan-Russian Congress of Artists,* Petersburg 1910." This reference has puzzled scholars, since the 1910 *Proceedings* do not exist; the artist evidently has in mind the Russian version of *On the Spiritual* published in the *Proceedings* of the 1911–12 St. Petersburg congress. In later years, Kandinsky mistakenly continued to ascribe this publication to 1910.

THE BASIC ELEMENTS OF FORM

Our work at the Bauhaus is in general subordinate to the finally dawning unity of different realms that only a short time ago were held to be strictly divided one from another.

The realms that have recently striven to unite are: art in general, in the forefront of which are the so-called plastic arts (architecture, paint-

ing, sculpture), s c i e n c e (mathematics, physics, chemistry, physiology, etc.) and i n d u s t r y, regarded from the standpoint of technical resources and economic factors.

Our work at the Bauhaus is of a synthetic nature.

Synthetic methods also, of course, embrace the analytical. The interrelation of these two methods is inevitable.

●

On this basis our teaching on the basic elements of form must also be constructed.

The question of form in general must be divided into two parts:

1. Form in the narrower sense—surface and volume
2. Form in the broader sense—color and its relationship with form in the narrower sense

In both cases our exercises must proceed logically from the simplest forms to the more complicated.

Thus, under the first part of the question of form, surface is reduced to three basic elements—triangle, square, and circle—and volume to the basic solids deriving from them—pyramid, cube, and sphere.

Since neither surface nor volume can exist without color, i.e., since in reality form in the narrower sense must at once be examined as form in the broader sense, dividing the question of form into two parts is something that can only be done schematically. Furthermore, the organic relationship between the two parts must be established in advance—the relationship of form to color, and vice versa.*

The science of art that is only now coming into being can, seen from the perspective of the whole history of art, provide little illumination in this matter, for which reason our present task must be first to level the path just described.

●

*See color Plate V: The relation of the three basic forms—of surface and volume—to the three basic colors (see my article in the "Proceedings of the Pan-Russian Congress of Artists," Petersburg 1910, and On the Spiritual in Art, Munich, 1912).[5]

Thus, every individual form of study has before it two important tasks:

1. The analysis of given phenomena, which must as far as possible be regarded in isolation from other phenomena, and
2. The relation of those phenomena which have just been analyzed in isolation to one another—synthetic method.

The first should be as narrow and as limited as possible, the second as broad and as unfettered.

COLOR COURSE AND SEMINAR

Color, like all other phenomena, must be examined from different viewpoints, in different ways, and by the appropriate methods. From a purely scientific point of view, these ways may be divided into three areas: that of physics and chemistry, that of physiology, and that of psychology.*

If these areas are applied particularly to man, and viewed from the standpoint of man, then the first area deals with the nature of color, the second with external means of perception, and the third with the results produced by its internal effect.

It is clear, therefore, that these three areas are equally important and indispensable for the artist. He must proceed synthetically and employ the available methods most appropriate to his aims.

But apart from this, the artist can examine color theoretically in two ways, such that his own point of view and his own characteristics must supplement and enrich the three above-mentioned areas.

These two ways are:

1. The examination of color—nature of color, its characteristics, power, and effects—without reference to any practical application, i.e. as "purposeless" science.
2. The examination of color in the way dictated by practical necessity—more limited purpose—and the carefully planned study of color, which presents its own considerable problems.

These two ways are, for the artist, closely bound up with one another, and the second is unthinkable without the first.

*Of particular importance is the special question of sociological relations; this, however, goes beyond the scope of the question of color as such, and hence necessitates a special study.

The method applied to these tasks must be both analytical and synthetic. These two methods are closely bound up with one another, and the second is unthinkable without the first.

Of these methods we may ask three main questions, which are organically linked to three further main questions, and which, taken together, embrace all the individual questions involved in our two ways of proceeding:

1. The examination of color as such—of its nature and characteristics:
 (a) colors in isolation
 (b) colors in juxtaposition } absolute and relative value
 Here, one should begin with the most abstract possible colors (color as one imagines it), and proceed via those that occur in nature—starting with the colors of the spectrum—to color in the form of pigments.
2. The purposive juxtaposition of colors in a unified structure—the construction of color—and
3. The subordination of color—i.e., of an individual element—and of its purposive juxtaposition—i.e., of construction—to the artistic content of the work: composition of color.

These three questions thus correspond to three more, arising out of the question of form in the narrower sense—in reality color without form cannot exist:

1. Organic juxtaposition of color in isolation with its corresponding primary form—pictorial elements (see color chart).
2. Purposive structuring of color and form—construction of the complete form, and
3. Subordinated juxtaposition of the two elements in the sense of the composition of the work.

Since at the Bauhaus color is associated with the aims of different workshops, solutions to individual, particular problems must be deduced from the solution to the main problems. Here, the following conditions must be observed:

1. The demands of two and three-dimensional forms.
2. Characteristics of the given material.

3. Practical purpose of the given object and the actual commission.

Here, a logical set of relationships has to be devised.

The individual applications of color demand a special study of the organic makeup of color, its life-force and expectation of life, the possibility of fixing it with bonding materials—according to the actual instance—the technique naturally associated with it, the way of putting on color—according to the given purpose and material—and the juxtaposition of color pigment with other colored materials, such as stucco, wood, glass, metal, etc.

These exercises must be carried out with the precisest possible means, special calculations. They are linked with precise experiments—experimental procedures—that advance logically from the simplest possible forms to ever more complex ones. These experiments must likewise employ both the analytical and the synthetic method: the purposive dissection of given forms and their logical and purposive restructuring.

All these exercises in the science of art are implemented by:

1. The guiding lectures of the teacher.
2. The lectures delivered by the students as a result of their independent solution of a special task.
3. Cooperation between teacher and students on scheduled course material—common observations, conclusions, setting of individual exercises, examining the solutions, and further developing the work process (seminar).

Particular emphasis is laid upon architectonic considerations: the interior and exterior of architecture, which must in our terms be understood as providing a synthetic basis.

•

Examples of the experimental and constructive exercises of the color seminar:

PLATE I: Construction 1:2

PLATE II: Construction: Hovering circle

The object of my experiments is to examine the tensions between colors in constructive juxtapositions, where precise measurements are employed (Plate I: ratio 1:2; Plate II: The Golden Section), and all chance elements are as far as possible excluded. Red and blue are chosen on purpose. Aim: to establish the results achieved by the experiments. L. HIRSCHFELD-MACK

PLATE III: Four-color print. L. Hirschfeld-Mack.

PLATE IV: **Examples of experiments with black and white:**
Top: Spatial effects of white and black, on gray.
Middle: Spatial effect of black and white in combination with gradations of gray.
Bottom: Example of the different effects produced on white and on black by the same linear and two-dimensional elements.
R. PARIS

PLATE V: The three primary colors distributed among the three primary forms.

ABSTRACT SYNTHESIS ON THE STAGE

Theater conceals within itself a strange magnet, with a strange, hidden power.

Not infrequently, this magnet has been capable of exerting great tension, an attraction that apparently led to the exertion of powerful side-effects.

But this upward turn was followed by a decline, and a hard, cold crust congealed around the inner essence of theater.

Especially today, that crust has become so strong, so thick and cold, that it appears as if pulsating life has been petrified for all time.

Today, more than ever before, one is entitled to talk of the decline of the theater. Not for nothing do people turn their backs on it with indifference; not for nothing are expectant faces turned towards the music hall, the circus, cabaret, and film. The old forms of theater—drama, opera, ballet—have hardened into museum forms, and can produce their effect only in the same way a museum does. Everything else has been lost to them.*

*See my article "On Stage Composition," in *Der Blaue Reiter*, 2d ed. (Munich: Piper-Verlag 1916 [sic]). [See this edition, p. 257.].

And yet, today marks the threshold of a new upsurge, which in its potential, pupating greatness will far surpass all previous pinnacles of achievement.

The hidden magnet comes to life, and its pulsations are more and more clearly perceptible. From outside, freshly sharpened weapons are called to help break through the hard crust.

•

That building (architecture), which can be nothing if not colored (painting), and which at any given moment is capable of fusing divisions of space (sculpture), sucks in streams of people through the open doors and lines them up according to a strict schema.

All eyes in one direction, all ears tuned to a given source. The highest receptive tension waiting to be discharged.

This is the outward power of the theater, which only has to be given new form.

•

In this isolated world of tension is to be found another isolated world, toward which eyes and ears are turned—the stage.

Here is the wish-fulfilling center of the theater, which through its own extreme tension of life is to release the extreme tension that runs through the expectant rows.

This center's capacity for absorption is unlimited—by its extreme tensions it is able to communicate all the powers of all the arts to the expectant rows.

This is the inward power of the theater, which only has to be given new form.

•

Today, all the individual arts have for decades been preoccupied with their own resources. They uncompromisingly dissect their own means, right up to the limits, and weigh these means, consciously or unconsciously, upon an inner scale.

This is the period of the great analysis, which speaks out loud of the great synthesis. Dissection should serve the ends of joining together, demolition—construction.

That is how the "wide world" looks today, and the small worlds that have their existence within it reflect their fates exactly. This fate is to be shared by the theater as well.

•

Every art has its own language and means appropriate to itself alone—the abstract, inner sound of its elements. As far as this abstract, inner sound is concerned, none of these languages can be replaced by another. Thus every abstract art is, at bottom, different from all others. Herein lies the strength of the theater.

The magnet concealed within the theater has the power of attracting all these languages to itself, all those artistic means that, taken together, offer the greatest possibilities for a monumental abstract art.

Stage:

1. Space and dimension—the resources of architecture—the basis that enables each art to raise its voice, to formulate joint sentences.
2. Color, inseparable from the object—the resources of painting—in its spatial and temporal extension, especially in the form of colored light.
3. Individual spatial extension—the resources of sculpture—with the possibility of structuring positive and negative space.
4. Organized sound—the resources of music—with temporal and spatial extension.
5. Organized movement—the resources of dance—temporal, spatial, abstract movements not of people alone, but of space, of abstract forms, subject to their own laws.
6. Finally, the last form of art known to us, which has not yet discovered its own abstract resources—poetry—places the temporal and spatial extension of human words at our disposal.

Just as sculpture is partially subsumed by architecture, so poetry is partially subsumed by music. Thus, strictly speaking, the purely abstract form of the theater is the total of the abstract sounds:

1. of painting—color
2. of music—sound
3. of dance—movement

within the general sound of architectonic form.

Here, abstract stage begins, which can become the pure forms of abstract stage composition, and soon will, and for which the analytical period of all the arts represents an inevitable first step.

•

The arts, which will continue to lead their own life, for which the analytical period is equally important and indispensable, will be able to serve the stage purely synthetically. In which case they will renounce their own goals, so as to subordinate themselves to the law of stage composition, which, like the other arts, will be able to establish its new *modus operandi* only with the aid of art theory.

The methods of the science of art, of the individual arts, and of the synthetic art of the theater remain the same, i.e., they must embrace three principal questions:

In particular, on the stage:

1. The elements of stage, and their inner power—basic elements, auxiliary elements, etc., i.e., a precise, systematic examination of their abstract values.
2. The law of construction—the structure of the elements of stage, which likewise presupposes purely scientific experimentation.
3. The law of subordinating both elements and structure to the inner purpose of the work: composition.

Theater laboratories should be established in which individual elements should be examined with reference to and for the purpose of the theater. The schematic construction of individual parts should discover and evaluate the forces and resources of structure, employing the law of opposites, in the sense of convergence and divergence in the first instance—color, sound, movement, in the appropriate contexts and temporal collaboration.

These preparatory studies will serve the creative spirit as tools for the creation of the living work of art.

1925

Yesterday—Today—Tomorrow
["Gestern—Heute—Morgen"]
Paul Westheim, ed.,
Künstlerbekenntnisse
(Berlin), 1925

The volume *Künstlerbekenntnisse* consisted of "letters, diary entries, and reflections by present-day artists" assembled by Paul Westheim, editor of the periodical *Das Kunstblatt;* it was published by Propyläen Verlag in Berlin in 1925. The contents ranged from letters by Hans von Marées to articles by artists of the avant-garde. These were preceded by an introduction by Westheim, which began with the famous words of Hugo von Tschudi: "Certainly the best, the most substantial and the most informative that has been said about art has been said by artists themselves." Kandinsky's article "Yesterday—Today—Tomorrow" appeared on pages 164–65.

Two movements, running in opposite directions, lead to one goal. Both originated yesterday, are gathering speed today, in order to reach their goal tomorrow.
 They are:

1. The analytical movement, which is within sight of its final conclusion, and indeed appears to have reached it.

2. The synthetic movement, which is gathering its strength for tomorrow, and seems to be dreaming its first dreams.

*

These two opposing movements are bound up with a second pair of likewise opposing movements, which also lead to one goal. Both likewise originated yesterday, are gathering speed today, in order to reach their goal tomorrow.

They are:

1. The materialistic movement, which appears to have reached its final conclusion.
2. The spiritual movement, whose momentum is increasing.

*

To these two pairs must be added, in art, a third pair of likewise opposing movement, which again leads to one goal.

They are:

1. The intuitive method of constructing a work, deriving from the second element of the second pair.
2. The theoretical method of constructing a work, deriving from the first element of the second pair.

These two methods lead likewise to one goal. This last pair is bound up with the first two, although each movement wants to remain autonomous.

Thus, our picture of the present, which has its origins in yesterday and strives toward tomorrow, appears outwardly confused, while being inwardly united.

Among many other consequences of this picture that may be predicted today, the most important appear to be:

1. In practice—a partly new, partly reborn synthetic, "monumental" art.
2. In theory—a partly reborn, partly newborn science of art.

All these seemingly exclusive tendencies will be amalgamated in these two goals, which themselves are amalgamated further in one goal.

Thus, the worn-out words of yesterday, "either-or," will be replaced by the one word of tomorrow, "and."

Weimar, April 1923

* * *

1925

Twilight
["Zwielicht"]
Carl Einstein and Paul Westheim, eds.,
Europa-Almanach
(Potsdam), 1925

The anthology *Europa-Almanach*, published in 1925 by the firm of Gustav Kiepenheuer in Potsdam, was a "synthetic" publication in a sense of which Kandinsky himself would have approved, embracing "painting, literature, music, architecture, sculpture, stage, film, and fashion." As far as painting was concerned, the volume contained reproductions of the work of virtually every important artist of the avant-garde. Kandinsky must also have been pleased to appear in the company of "professional" poets like Cendrars, Laske-Schüler, Maiakovsky, and Mombert. His poem "Twilight" was accompanied by two drawings.

Some people sat in a circle.
After a long silence their voices were softer.
One said,
"Look at the goal."
There followed a long silence.
Then said another,
"Look at the aimless."
And a third,
"Make smooth!"
At this all were silent for a long time. You could almost
Suppose it became smooth.
And a fourth,
"Make rough!"
Then they all laughed with rough voices.
And the fifth, in a deep bass,
"Da capo!"
In this way one knew there were five,
And passed on.

1925

Abstract Art
["Abstrakte Kunst"],
Der Cicerone
(Leipzig), 1925

The Leipzig periodical *Der Cicerone* was founded in 1909 by Dr. (later Professor) Georg Biermann. It described itself as a "twice-monthly journal for artists, art lovers, and collectors." Kandinsky's essay "Abstract Art" appeared in the second volume for 1925.

Kandinsky himself derived little financial benefit from his dealings with the publishers of *Der Cicerone*. In a letter dated 16 July 1925 he wrote to Will Grohmann: "Just imagine, these dear people deducted the price of the two photos (40 M.) from my honorarium, so that I received 50 M. for the article! . . . Apart from which, I got only two free copies of *Cicerone* with my article, although I asked the publishers for several off-prints. Do you feel inclined to write the firm a few forceful lines about it? Perhaps you can shame them."

"Abstract Art" was also published in Serbo-Croatian in the Belgrade periodical *Zenit* (November–December 1925). It was translated by Nina-Naj, allegedly from the original Russian manuscript.

The present day can be characterized schematically in terms of the following phenomena:

1. Advance of material phenomena and facts, something that—being a superficial movement—is constantly exposed to observation.

2. Advance of spiritual phenomena and facts, bound up, sometimes perfectly clearly, sometimes indistinctly, with the above, a

movement that—since it takes place in the depths—can today be observed only on occasion and as an isolated occurrence.

3. Bound up with both the above-mentioned processes, the slow, exceptionally slow advance of people's evaluative standpoint, the transvaluation that very gradually abandons the external and very gradually turns toward the internal.

This process, which can be observed only in the rarest instances, is the natural herald of one of the greatest spiritual epochs, which *inter alia*—something of decisive importance in relation to abstract art—transplants fundamental values from the realm of the material to that of the spiritual, without, however, depriving the material of its own significance. If art continues to evolve as something other than a purely practical, utilitarian concern on the one hand, or an airy-fairy kind of *l'art pour l'art* on the other, its relationships with other spiritual realms and, ultimately, with the totality of "life" in the most general sense will emerge with full force. Art will then be so clearly seen as a life-giving force that our present doubts about its significance and justification will seem to us the result of an inexplicable dazzlement.

It is perfectly possible that among the various processes we see today, we are witnessing at the moment a special case—a shift in art's center of gravity, signifying at bottom the transition from the Romanic principle to the Slavic—from West to East.

Inner criteria—the relative value of the external, which finds its justification only in the internal—are the basis of the Russian "peasants' courts," which developed free from any Western European influences (Roman law), and which despite Western European influences, continued to hold their own right up to the Revolution, even in the jury-system of the Russian educated classes.*

This is the origin of the ever-deepening dichotomy between the Romanic art movements on the one hand and the Germanic and Slavic on the other, in which respect today is the decisive day.

Here are the beginnings of abstract art, the justification of whose existence, apart from the external question of form (as one observes

*To my great astonishment, I noticed this basis many years ago when studying the Russian peasants' courts, and I later rediscovered its often covert effect in various manifestations of Russian life. The great impact of Dostoyevsky in Western Europe must be attributed to this same basis.

predominantly in the case of "constructivism") necessarily demands the inner evaluation of the elements of art.

This assertion is of decisive importance; inability or spiritual unpreparedness to follow it rules out any possibility of making the leap into the new world.

When the formal element in art is assessed exclusively by cold, external criteria, works of abstract art appear dead (so too in "life").

But when these external criteria are augmented by inner criteria, which we may take as our principal basis for judging the formal element, in the broadest sense, those same works of abstract art respond to the effect of warmth and come to life.

The nineteenth century—as we see it today—was a logical, mighty, and increasingly rapid advance toward the above-mentioned standpoint, and therefore toward abstract art. First, external evaluation had to clear the ground, for which task the French, with their highly developed sense of form, inevitably took on the role of the most appropriate implement. The unconscious accomplishment of this mission suddenly pushed French art, in the guise of French painting, which had until then been of little influence, so far to the forefront that it was recognized no less suddenly by all other countries as a world model and a world champion.

It was economically sound to proceed first by (1) accumulating the external materials of art, and (2) dissecting them and subjecting them to external analysis.

These tasks were accomplished in a planned and precise manner by Impressionism, Neo-Impressionism, and Cubism.*

But once these aims had been attained, and it was found to be impossible to draw any kind of internal conclusions from what had been achieved, French art was forced to abandon this path, only to turn once more to the corporeal, as it is doing today. It is not difficult to see that if French art remains loyal to the purely external Romanic principle, it will be forced back into the shadows of art theory, from which it emerged almost a century ago.†

*The unconscious detours made in an attempt to arrive at abstract values, for example "Purism," necessarily remained irrelevant, and thus failed.

†It is thus that we must understand the present "reaction" in France, in which French imitators in other countries are participating.

Of great consequence are those thought processes characteristic of the Germanic psyche, which manifested themselves in individual instances even before the war. First of all, there was a general enthusiasm for Russian literature, usually beginning—and this is particularly significant—with Dostoyevsky, and proceeding by way of the Russian theater to dance, to music, and finally to poetry. Of course, a German is generally incapable of perceiving with complete clarity in what is outwardly Russian that which is quintessentially Russian. Even Russia is obliged to experience the death throes of external-materialistic development, which means that Russians themselves are generally unable to judge of these differences.

Such details, however, cannot drown today the resounding triad: Romanic, Germanic, Slavic.

The fate of abstract art is intimately bound up with the sound of the individual notes that constitute this triad.

* *

*

Naturally, the general question of "abstract art" is closely related to the greatest present-day problems:

1. The question of content and form.
2. The question of analysis and synthesis.
3. The supplementary question, which here becomes necessary, of a science of art.
4. The question of synthetic art.

These questions will start to gain in clarity from the moment at which we start to become clear about the subject of external means and their inner values.

Doubts and disputes about the content of painting, for example, will always produce indefinite and obscure answers, so long as the realms of the individual arts are not carefully examined with an eye to their means of expression (analytical method), and these means of expression are not separated one from another with perfect clarity.

As soon as this happens, the confusion between purely pictorial content and literary content that still occurs frequently will disappear of its own accord.

The general—one might say, subterranean—relationship between the

arts—which can, basically, be traced back to one single root (synthetic method)—reveals the shared content of the arts as a whole, whose blossoms, when they appear above the earth, are quite separate from one another, something that should never be forgotten.

Our standpoint admits of a general definition of content, which is equally valid for art as a whole and for the individual arts.

Content consists of a complex of effects organized in accordance with an inner purpose.

Here are united the concepts construction and composition, which are, alas, all too often confused.

<p style="text-align:center">* *
*</p>

The difference between so-called "objective" and "nonobjective" art thus consists in the difference between the resources and means that have been chosen in each case to express content.

In the first instance, e.g., in painting, apart from purely pictorial means, elements of nature have been employed, so that the overall sound of the work is made up of two different—one might say, fundamentally different—kinds.

In the second instance, the content of the work is realized exclusively by purely pictorial means.

The most recent period in the development of painting since Impressionism can, apart from other important impulses, be characterized in terms of a more or less conscious, but always organized repression of the objective sound. The final result of this process is that the objective sound has been dispensed with altogether, enabling the purely pictorial elements to develop their inner effects completely undistorted, i.e., clearly and purely.

<p style="text-align:center">* *
*</p>

A somewhat rude schematization of the history of art as a whole, so far as we know or can guess at its earliest beginnings, allows us to put forward with some certainty the following assertion:

The progress of art in general, leaving aside its more or less numerous offshoots, is a slow-moving advance, having as its point of departure purely external practical-purposive aims. The "purely artistic," first noticeable as an almost invisible embryo, continues to develop, so that

this embryo is constantly growing, until the purely artistic finally takes on a fully fledged form.

The intermediary period, which has drawn to a close in the last few decades, must be characterized in terms of a more or less complete equilibrium between both aspects: the two spheres—the world of nature and the world of art—overlapped so as to constitute a pure unison [*Doppelklang*].

Today we stand on the threshold of a third period in the history of art, which in conventional terms may be described as its abstract period.

A necessary precondition for the further development of this period is the inner evaluation of external resources.

This enables us to organize, in accordance with our inner purpose, our means of expression, so that they necessarily conjure up their own individual effects.

<p style="text-align:center">* *
*</p>

The experimental program I proposed some three years ago to the Russian Academy of Art Sciences (founded in Moscow in the summer of 1921)[1] took the foregoing observations as a basis upon which it would be possible to conduct purely scientific research into "problems of art."

This program consists of three starting points, which are on the one hand successive; on the other, inextricably linked:

1. The question of which elements belong to which individual arts, which means distinguishing the fundamental from the merely accidental.

2. The question of how these elements are structured, even if this structure remains purely experimental, without the living pulse of the work of art—a question of construction.

3. The question of how these elements and construction are to be subordinated to a mysterious law of pulsation—a question of composition.

The first question will—so far as one can suppose today—expose both to external and to internal scrutiny the individual element (= forces) of the different arts, not only in isolation, but also with regard to their profound affinity one with another. The minimal differences between the different arts will presumably bring in their train the

greatest degree of effectiveness of the individual arts—analytical task. On the other hand, we shall see that all the arts—so far as one can predict today—have a common root, something we shall achieve by synthetic methods.

The second question, embracing not only construction in art but also construction in "dead" and "living" nature, will likewise expose the differences between different worlds, distinguishing between these worlds and at the same time bringing to light their profound affinity with one another.

The third question, the most difficult of the three, involving a kind of enquiry for which there exists no preparation and no precedent, will lead to discoveries undreamed of today. This is a path untrodden by science, a path whose starting point is the question: What is that secret, elusive, miniscule "plus," invisible to us today, which, like a flash of lightning, has the immeasurable power of turning a correct, precise, but still dead construction into a living work? Here, perhaps, coincide questions about the soul of art and the soul of the world, to which the human soul also belongs. Shall we find minimal differences here, too; and here, too, will the common root be visible?

The broad basis of this planned research inevitably brings in its train the collaboration of artists, aestheticians, and scientists (both positive and spiritual science). (The membership of the Russian Academy of Art Sciences is made up on this basis.)

It seems to me perfectly clear that we shall only be able to attain inner affinities (synthetic results, and therefore synthetic art) if we separate individual worlds from one another in the most clinical way. In which case, the fundamental elements must, not only in practice, but also in theory, be liberated from all overtones and associations, so that we are able to distinguish their absolute sound and examine it for itself.

And as long as, e.g., in painting pictorial elements are hung from the scaffolding of natural forms, it will continue to be impossible to avoid such associations and thus to discover the pure law of pictorial construction. In this case, the question of composition is enveloped in still greater, deeper darkness, and the path to the *nervus rerum* remains blocked.

The logical manipulation of these basic elements, examining and utilizing their inner power—in other words, an inner standpoint in general—this is the first and most essential precondition for abstract art.

It seems to me that the time has come for just such an attitude toward

"nature," and toward "man" as part of "nature," even in the positive sciences; by taking the path of inner values, we can avoid many a dead end.

In this way, both science and art will depart from the one-sided specialization that can only bring with it a fatal dissipation (nineteenth century), and has already done so to a frightening degree, and they will attain the long-lost unity that conceals beneath an external veneer inner forces as well. The missing link between the internal in every realm, the diffraction of these realms will be transformed into a mighty confluence—external differences, internal unity.

Art has set foot on this pioneering path, and it may be assumed that the great dawning period of abstract art, this fundamental turning point in the history of art, represents one of the most important beginnings of the spiritual overthrow that, in its day, I dubbed the "Epoch of the Great Spiritual."

Dance Curves: The Dances of Palucca
["Tanzkurven: Zu den Tänzen der Palucca"]
Das Kunstblatt
(Potsdam), 1926

Gret Palucca was born in Munich on 8 January 1902. Of German dancers of her generation, she was considered the wittiest, the most light-hearted and carefree. A student of Kröller and of Mary Wigman, she joined the latter's group in 1923. Her simple and expressive movements, which had nothing to do with the fashionable contortions of the day, brought her international fame. In 1925 she opened her own dance school in Dresden.

Kandinsky had a great admiration for Palucca; he translated her stage movements into line drawings, which he published both in the following article from *Das Kunstblatt* and in his book *Point and Line to Plane* (see p. 524). She, in turn, seems to have been greatly interested in abstract painting. Lehning recalled that Palucca's father-in-law owned a notable collection of modern art, including works by Kandinsky. When he visited Palucca in Dresden in 1926 on his way to Dessau, she had hanging in her room a painting by Mondrian, "one of his rectangular panels: a white surface with two black lines."[1] The names she gave to some of her early dances—*Broadly Swinging, Dying Away, Sudden Outbreak*—are also suggestive of the kinds of titles Kandinsky gave many of his paintings of the Bauhaus period.

Complete mastery is impossible without precision. Precision is the result of protracted effort. But a tendency to precision is inborn, and is an extremely important precondition of outstanding talent.

Palucca's dances are varied, and may be illuminated from different standpoints. But what I wish to emphasize here is not only the extraordinarily precise construction of the dances in their temporal development, but also, first and foremost, the precise structuring of individual moments, which can be captured by instantaneous photography.

A number of examples may serve to isolate two important characteristics of this structure:

1. The simplicity of the overall form.
2. The way in which the structure is based upon form in the large.

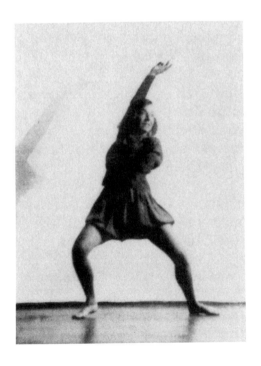 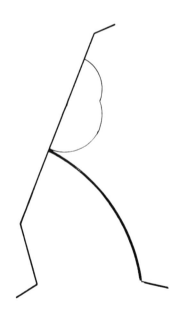

Palucca
A long, straight line, striving upward, supported upon a simple curve. Beginning at the bottom—foot; ending at the top—hand; both in the same direction.

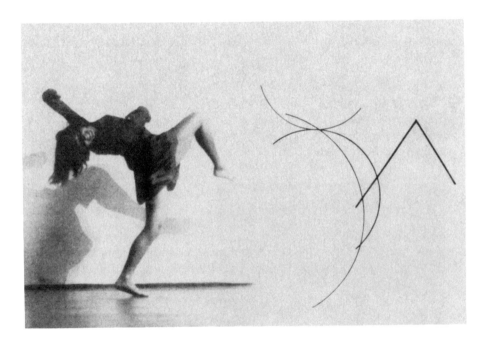

Palucca
Three curves meeting at a single point. In contrast—two straight lines forming
an angle. An example of the extreme pliability of the body—curves as the best
means of expressing this.

It may sound simple to the layman—but the artist knows the value of
these qualities; very few people have the gift of large, simple form.
 Nothing can serve better to prove my assertion than the translation of
the four instantaneous photographs into diagramatic form.
 The precision carries with it even the folds and corners of the drapery.
Even "dead material" is subordinated to the overall construction.

The instantaneous photograph shows stiff, abruptly cut-off forms, being sometimes the beginning of a particular development, sometimes the end. The slow, organic development of the form, the transitional stages, are absent and can only be captured by slow-motion photography, which extends our field of vision in a quite surprising way.

The dances of Palucca definitely ought to be filmed in slow motion, which would make possible a precise examination of this precise dancing.

I do not wish to be misunderstood—I have here illuminated only one side of Palucca's art. But it is just this side that is of particular importance today: the science of art is in the ascendant, and we are born under its sign. And I am sure that, in this sphere too, Palucca has much of importance to contribute.

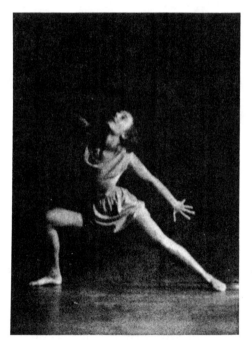

Palucca
Two large, parallel lines, supported upon a right angle. Energetic development of the diagonal. Observe the exact positioning of the fingers as an example of precision in every last detail.

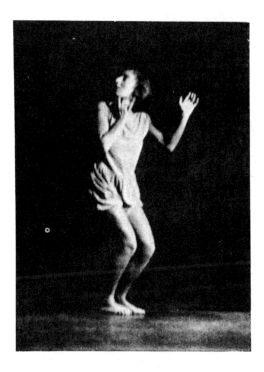

Palucca
Parallel construction deriving from a single point at the bottom. Gradual development from below, with the angles becoming continually more acute.

1926

Point and Line to Plane
[*Punkt und Linie zur Fläche*]
(Munich), 1926

In 1925 Walter Gropius's *International Architecture* was published by the firm of Albert Langen in Munich as no. 1 in the series Bauhaus Books. The series, edited by Gropius and László Moholy-Nagy, comprised fourteen volumes, which appeared at intervals until 1929, including Klee's *Pedagogical Sketchbook*, Malevich's *Nonobjective World*, and Gleizes's *Cubism.* [1] Kandinsky's *Point and Line to Plane*, subtitled *A Contribution to the Analysis of Pictorial Elements*, appeared in 1926 as volume 9. The typography was by Herbert Bayer. A second edition was published in 1928, the text unaltered except for an additional preface.

The preface to the first edition is dated "Weimar 1923/ Dessau 1926." The earlier date refers presumably to the start of Kandinsky's work on his book. According to his own recollection, his notes for *Point and Line* began in the summer of 1914, when after being forced to leave Germany as an enemy alien at the outbreak of war, Kandinsky took refuge at Goldach in Switzerland. He also mentions that these notes "lay untouched for almost ten years." A date of 1923 for the resumption of work on *Point and Line to Plane* is therefore quite plausible. Kandinsky seems to have been working intensively on the final draft over the summer of 1925. The manuscript was finished, apart from a few corrections, by November of that year.[2]

Kandinsky himself regarded *Point and Line to Plane* as the logical development of the ideas put forward in *On the*

Spiritual in Art and "On the Question of Form." There is, however, a world of difference between *Point and Line* and *On the Spiritual.* Although Kandinsky, in the 1920s, is still concerned with the need to evaluate the "inner worth" of pictorial elements, the "prophets and visionaries" whose images are conjured up in *On the Spiritual*—Blavatsky and Steiner, Maeterlinck and Edgar Allan Poe—have been replaced by handbooks of popular astronomy and diagrams of molecular structure, photographs of radio masts and of the skeleton of a motor vessel. Another marked difference is that in the sixth chapter of *On the Spiritual,* entitled "The Language of Forms and Colors," Kandinsky pays almost exclusive attention to color, and neglects form; whereas in *Point and Line* we find a great deal about form and precious little about color. His concern with form and the elements of composition allows us to infer his own answer to the question posed in the "Reminiscences": "What is to replace the missing object?" In his view, one task of the future "science of art" was to reveal the compositional laws inherent in abstract forms, enabling the artist to discard fidelity to merely "external" nature.

Many of the topics raised in *Point and Line to Plane* are also dealt with separately, at greater length, in Kandinsky's other essays of the 1920s; the dances of Palucca, for example, are discussed in the article "Dance Curves," published in *Das Kunstblatt* in March 1926 (see pp. 519–523). Sometimes the overlap is considerable. Kandinsky's article "Analysis of the Primary Elements of Painting," published in *Cahiers de Belgique* in 1928,[3] is such a literal rewriting of passages from *Point and Line* that the question arises whether it should properly be considered an "original" publication. In this edition it has for this reason been banished to the appendix.

In the first and second editions of *Point and Line to Plane,* the text was followed by an appendix consisting of twenty-five black-and-white reproductions and one color plate. In this edition, the black-and-white reproductions have been reprinted in their proper place; but the one color plate, of Kandinsky's painting *Little Dream in Red,* has been reproduced in black and white.

KANDINSKY

PUNKT UND LINIE ZU FLÄCHE

BEITRAG ZUR ANALYSE DER MALERISCHEN ELEMENTE
1 VIERFARBENDRUCK 102 FIGUREN 25 TAFELN
VERLAG ALBERT LANGEN MÜNCHEN

POINT AND LINE TO PLANE

A CONTRIBUTION TO THE ANALYSIS OF PICTORIAL ELEMENTS

CONTENTS

FOREWORD

It is, perhaps, not without interest to observe that the thoughts I develop in this little book are an organic continuation of my book *On the Spiritual in Art.* Once I have set out in a particular direction, I have to carry on.

At the beginning of the Great War, I spent three months at Goldach on Lake Constance. I occupied my time almost exclusively in systematizing my often still imprecise theoretical reflections and practical experience. In this way, a fairly large amount of theoretical material came into being.

This material lay untouched for nearly a decade. Only recently have I had the opportunity of doing further work on it. This book bears witness to my efforts.

I have deliberately posed these questions of the incipient science of art in the narrowest possible way. Taken to their logical conclusion, however, they go beyond the boundaries not only of painting but, in the end, of art in general. Here, I am trying only to erect a few signposts—analytical method taking account of synthetic values.

Weimar 1923
Dessau 1926

FOREWORD TO THE SECOND EDITION

Since 1914 the tempo of our age seems to increase continually. In every realm of our experience, inner tensions accelerate this tempo. One year corresponds perhaps to at least ten years of some "normal," "peaceful" period.

The one year therefore that has elapsed since the appearance of the first edition of this book might likewise be counted as ten. The correctness of the principle that has served as my main basis in this book is confirmed by further progress of analytical and associated synthetic methods in theory and practice, not just in painting, but in the other arts, at the same time, in the "positive" and "spiritual" sciences as well.

The further expansion of this book could for the moment only be achieved by an increase in the number of individual instances or examples, something that would lead to a quantitative increase and must be rejected for practical reasons.

Thus, I decided to leave the second edition unchanged.

Dessau
January 1928

INTRODUCTION

External —Internal

Every phenomenon can be experienced in two ways. These two ways are not random, but bound up with the phenomena—they are derived from the nature of the phenomena, from two characteristics of the same:

External—Internal

The street may be observed through the window pane, causing its noises to become diminished, its movements ghostly, and the street itself, seen through the transparent but hard and firm pane, to appear as a separate organism, pulsating "out there."

Or one can open the door: one can emerge from one's isolation, immerse oneself in this organism, actively involve oneself in it and experience its pulsating life with all one's senses. Sound, with its constantly changing frequencies and rhythms, weaves itself around the individual, spiraling to a crescendo and suddenly falling away as if lamed. Likewise, movement, which also wraps itself round one—a play of horizontals and verticals, lines and dashes that are bent by motion in different directions, and of accumulating and dispersing patches of color, sometimes low, sometimes shrill.

The work of art is reflected on the surface of one's consciousness. It lies beyond and, once the stimulus has gone, vanishes from the surface without trace. Here, too, is a kind of glass pane, transparent, but hard and firm, which precludes any direct, inner contact. And here, too, exists the possibility of entering into the work of art, involving oneself actively in it, and experiencing its pulsations with all one's senses.

Apart from its scientific value, which depends upon a precise examination of the individual elements of art, the analysis of artistic elements constitutes a bridge leading to that inner pulsation of the work.

Analysis

The view, prevalent to this very day, that it would be fatal to "dissect" art since any such dissection would necessarily bring about its death, derives from a mindless underestimation of the elements thus exposed and of their primary force.

Curiously, as regards analytical examination, painting occupies a special place among the other arts. Architecture, for example, which by its very nature is linked to practical purpose, presupposes a certain degree of scientific knowledge. Music, which has no practical purpose (apart from marches and dances), and which until now has been uniquely fitted for the creation of abstract works, has long since possessed its own theory, still a somewhat one-sided science, but one that is constantly developing. Thus, these two arts, standing in polar opposition to one another, both possess a scientific basis, and nobody objects.

Painting and other arts

If the other arts have, to a greater or lesser extent, lagged behind in this respect, the degree of difference may be attributed to the level of development each of these arts has attained.

Painting in particular, which in the course of the last few decades actually has made a marvelously strenuous leap forward, has only recently been emancipated from "practical" meaning and from its adaptability to many of its former applications. Now it has attained a level that inevitably demands a precise, purely scientific examination of pictorial means for pictorial purposes. Further steps in this direction cannot be attained without such an examination—neither for the artist, nor for the "public."

Theory

In earlier times

One may safely assume that painting was not always in such a helpless state as it is today, that there existed certain kinds of theoretical knowledge relevant not merely to purely technical questions, that the beginner could be and was taught a certain theory of composition, and in particular, that a degree of knowledge about the nature and application of [pictorial] elements was taken for granted among artists.*

With the exception of purely technical formulas (ground, binding materials, etc.), which were still being discovered in abundance scarcely twenty years ago,† and which, especially in Germany, had a certain part to play in the development of colors, in our own day virtually nothing of earlier knowledge—possibly even of a highly developed theory of art—has been handed down to us. It is a remarkable fact that the Impressionists, in their battle against "academicism," destroyed the last remnants of the theory of painting, only to lay the foundation-stone themselves, albeit unconsciously, for a new science of art—despite their assertion that nature constitutes the only theory for art.‡

*E.g., the compositional use of the three primary planes as the basis of construction in the picture. Remnants of this basic instruction were current in art academies until recently and are perhaps still current even today.

†See, e.g., the valuable study by Ernst Berger, *Beiträge zur Entwicklungsgeschichte der Maltechnik,* in 5 parts, published by Georg D. W. Callwey, Munich.
Since then a considerable amount of material has been published on these questions. Prof. Dr. Alexander Eibner's great work *Entwicklung und Werkstoffe der Wandmalerei vom Altertum bis zur Neuzeit* has just appeared, published by B. Heller, Munich.

‡Whereupon there promptly appeared P. Signac's book, *De Delacroix au Néo-Impressionisme* (German version published by Axel Juncker, Charlottenburg, 1910).

One of the most important tasks for the incipient science of art would be a penetrating analysis of the whole history of art. On the one hand, it should examine the elements of art, the methods of construction and composition employed at different times by different peoples. On the other, it should seek to determine the nature of growth in each of these three areas—the path by which enrichment was achieved, at what pace, and the necessity of its attainment—as well as how the development of art probably occurs in fits and starts, representing perhaps in the whole history of art a definite line of development—possibly an undulating line. The first part of this task—the analytical part—verges on the tasks of "positive" science. The second part—the manner of development—verges on the tasks of philosophy. Here is tied the thread of order that runs through human development generally.

Art history

I should observe in passing that this discovery of the forgotten knowledge belonging to earlier periods of art can only be achieved by a great effort, which should completely assuage any fears about the "dissection" of art. For if these "dead" doctrines lie so deeply buried in living works that they can only be brought to light with the utmost difficulty, then their "harmful" effects can be nothing more than fear of the unknown.

"Dissection"

The experiments that must be made the foundation-stone of this new science—the science of art—have two goals and derive from two needs:

Two goals

1. The need of science in general, which springs freely from a nonpurposive or extrapurposive thirst for knowledge: 'pure' science.

2. The need for a balance of creative forces, which may be divided up under two schematic headings—intuition and calculation: "practical" science.

Elements The first, inevitable question naturally concerns the elements of art, which are the building materials for the work itself, and must therefore be different in each of the different arts.

Here, first and foremost, it is necessary to distinguish between basic and other elements, i.e., elements without which a work of any particular art cannot exist at all.

All other elements must be characterized as ancillary elements.

In each case, it is necessary to organize them into an organic series of gradations.

In this text I shall consider two basic elements that serve as the ultimate starting point for every work of painting, without which it is impossible to begin. At the same time, these elements represent the entire resources for one independent category of painting—graphics.

Method of research Thus, here we must begin with the primordial element of painting—the point.

The ideal of every kind of research is

1. A pedantic examination of each individual phenomenon—in isolation.
2. The reciprocal effects of phenomena upon each other—juxtapositions.
3. General conclusions, which are to be drawn from the two preceding parts.

My purpose in this text extends only as far as the first two parts. The material of this text is insufficient to undertake the third part, which should on no account be done too hastily.

Our examination should proceed with painful, pedantic precision. This "tedious" path should be measured pace by pace—not the tiniest change in the substance, in the qualities, or in the effects of each individual element should be allowed to escape the attentive eye. Only by a process of microscopic analysis will the science of art lead to an all-embracing synthesis, which will ultimately extend far beyond the boundaries of art, into the realm of "union" of the "human" and the "divine."

This, then, is our visible goal, which still remains far removed from "today."

As far as my own particular task is concerned, not only is my ability adequately to develop the necessary initial exactitude somewhat lacking, there is also a shortage of space. The purpose of this little book is simply to point in the most general terms, purely as a matter of principle, to the basic "graphic" elements, namely,

Purpose of this text

1. "In abstract," i.e. isolated from the real environment of the material form of the material surface, and

2. Upon the material surface—the effects produced by the basic characteristics of this surface.

But even this is only possible here within the framework of a relatively fleeting examination—an attempt to establish a normal method of scientific investigation in art, and test its practical application.

Geometrical point

In geometry, the point is an invisible entity. It must, therefore, be defined as a nonmaterial being. Thought of in material terms, the point resembles a nought.

In this nought, however, are concealed various "human" qualities. In our minds, this nought—the geometrical point—is associated with the utmost conciseness, i.e., the greatest, although eloquent, reserve.

Thus, the geometrical point is, in our imagination, the ultimate and most singular combination of silence and speech.

For this reason, the geometrical point has assumed material form primarily in writing—it belongs to speech and indicates silence.

Writing

In speech, the point is a symbol for interruption, for nonbeing (negative element), and at the same time a bridge from one entity to the next (positive element). In writing, this is its inner significance.

Outwardly, it is here merely a sign having a practical application, carrying within itself the element of "practical purpose," which we learn to recognize as children. We habituate ourselves to the outward sign, which obscures the inner sound of the symbol.

The internal is hemmed in by the external.

The point belongs to a narrow circle of everyday phenomena having a conventional sound that is mute.

The sound of that silence habitually associated with the point is so deafening that it drowns all its other qualities.

Silence

All such customary phenomena become mute as a result of their one-sided language. We can no longer hear their voices, and are surrounded by silence. We are condemned by our subjection to "practical purpose."

Occasionally, some extraordinary disturbance is capable of shaking us from our dead state into living experience. But not infrequently, even the most violent shock is powerless to transform this state of death into the state of life. Disturbances that come from outside ourselves (sickness, misfortune, sorrow, war, revolution) tear us forcibly from our habitual sphere; as a rule, however, they are seen merely as a more or less violent "wrong," so that our desire to return as quickly as possible to that state of conventional habits from which we have departed outweighs all other feelings.

Jolt

The disturbances that come from within are of a different kind—they are occasioned by man himself and thus find within him a fertile field. This field is not the capacity merely to observe the "street" through the "window-pane," which is hard, firm, but easily broken; but rather, the capacity of betaking oneself into the street. The open eye and the open ear transform the slightest disturbance into a profound experience. Voices are heard on every side. The world resounds.

From within

Like an explorer immersing himself in new, unknown lands, one makes discoveries in one's "daily round," and one's environment, normally mute, begins to speak an increasingly distinct language. Thus, dead signs turn into living symbols. The dead comes

to life.

Naturally, the new science of art can only come about provided that signs become symbols and the open eye and open ear make possible the passage from silence to speech. Whoever is not capable of this had better leave both "theoretical" and "practical" art alone— his striving for art will never lead him to a bridge, but rather widen the gulf that today separates man from art. It is just such people who are today concerned to put a full stop after the word Art.

Divorce

If we gradually divorce the point from the narrow sphere of its customary activity, its inner qualities— silent until now—take on an increasingly powerful sound. These qualities—inner tensions—emerge one after another from the depths of its being, emitting a radiant force. And their influence and effect upon the individual conquer his defenses with ever greater ease. In short, the dead point becomes a living being. Out of many possible examples, let us cite two typical cases:

First instance

1. The point is transferred from its practical, purposive state into one that is nonpurposive, i.e., alogical.

> Today I am going to the cinema.
> Today I am going. To the cinema
> Today I. Am going to the cinema

Clearly, it is still possible to regard moving the point in the second sentence as purposive—stressing the goal, emphasizing the intention, fanfare.

In the third sentence, the purely alogical form comes to the fore, something that can, however, be explained away as a misprint. The inner value of the

point flickers forth for an instant and is immediately extinguished.

2. The point is divorced from its practical, purposive state, so that it stands outside the sequential chain of the sentence.

Second instance

<div style="text-align:center">Today I am going to the cinema</div>

<div style="text-align:center">●</div>

In this instance, the point requires a larger empty space around it, so that its sound can resonate. Nonetheless, this sound remains delicate, modest, and is drowned by the writing surrounding it.

If the size of the point itself, and of the empty space surrounding it are increased, the sound of the writing becomes diminished, and the sound of the point gains in clarity and strength (Fig. 1).

Further emancipation

<div style="text-align:center">●</div>

<div style="text-align:center">**Fig. 1**</div>

Thus, a chord is sounded[4] —writing—point—which exists apart from their practical, purposive connection. It is the balancing of two worlds that can never attain equilibrium. It is a purposeless revolutionary state—the writing is disturbed by the presence of a foreign body that cannot be made to relate to it.

Nonetheless, the point has been wrenched free from its habitual state and thus prepares itself for the leap from one world into another, in which it is emancipated from the tyranny of the practical-purposive, in

Independent entity

541

which it begins to live as an independent enti-
ty, and where its subordination has an inner purpose.
This is the world of painting.

**Through
encounter**

The point is the result of the first encounter between
implement and material surface, the basic plane.
Paper, wood, canvas, stucco, metal, etc., may all con-
stitute this basic material plane. The implement may
be a pencil, a burin, a brush, a pen, a stylus, etc.
Through this initial confrontation, the basic plane is
made fertile.

Concept

The outward concept of a point in painting is im-
precise. The invisible, geometrical point must, once
materialized, assume a certain size, occupying a cer-
tain area of the picture surface. In addition, it must
have certain boundaries—outlines—that separate it
from its surroundings.

This is self-evident, and appears extremely simple.
But even in this simple instance, we immediately
come up against inexactitudes, which indicate just
how embryonic is the state of art theory today.

The sizes and shapes of the point may alter, causing
the relative sound of the abstract point to change too.

Size

Externally, the point may be described as the
smallest elementary form, although this is not pre-
cise. It is difficult to circumscribe exactly the concept
"smallest form"—the point may grow, turn into a
plane, and unnoticed, cover the whole of the surface.
Then where would one draw the line between point
and plane?

Here, two conditions must be taken into account:

1. The relationship of point to surface as regards its
 size, and

2. the relationship between its size and that of the
 other forms on the same surface.

Anything that counts as a point while the surface
remains otherwise bare must be considered a plane if,
e.g., a very thin line also makes its appearance upon
the surface (Fig. **2**).

Fig. 2

The difference in size between the first and second
examples determines the concept of the point, al-
though today this is something that can only be
gauged by feeling—since we have no way of express-
ing it in numbers.

At the boundary

Thus, we are today in a position to determine and to evaluate purely in terms of feeling the extent to which the point approximates to its external dimensions. This approaching of external boundaries—indeed, the crossing of these boundaries to a certain extent, reaching the moment at which the point as such begins to disappear and, in its place, the plane begins to live an embryonic existence—all this is means to an end.

The end, in this instance, is the c o n c e a l m e n t of the absolute sound: the emphasis upon dissolution, imprecision of form, instability, positive (or possibly negative) movement, flickering tension, unnaturalness in abstraction; the hazard of internal overlapping (the inner sounds of the point and of the plane converge, overlap and rebound); two voices resounding in o n e form, i.e., the creation of a two-part melody by means of o n e form. This multiplicity and complexity of expression in the case of the "tiniest" form—achieved by only minimal variations in size—offer even the nonspecialist a convincing example of the expressive power and expressive depth of abstract forms. As these means of expression are developed further in the future, and as the receptivity of the spectator increases, more precise concepts will become indispensible and will certainly, in the course of time, be arrived at by measurements. Mathematical expression will here become essential.

Abstract form

Mathematical expression and formulas

There is, however, the danger that mathematical expression will lag behind emotional experience and thus limit it. Formulas are like glue, or like a "fly paper" to which the careless fall prey. A formula is also a leather arm-chair, which holds the occupant firmly in its warm embrace. On the other hand, the effort necessary to wrest oneself from its grip is a precondition of further progress toward new values and, ultimately, new formulas. Even formulas die and

are replaced by new ones.

The second inevitable fact is the external boundary of the point, which determines its external form.

Thought of in the abstract, or in one's imagination, the ideal point is small and round: in fact, an ideally small circle. But like its size, its boundaries too are relative. In reality, a point can assume an infinite variety of shapes: its circular form can have a zig-zag edge; it may tend toward other geometrical or ultimately indeterminate forms. It can be pointed, approaching a triangle. Or it may be transformed by a desire for relative immobility into a square. If it has a serrated edge, the zig-zags may be either small or large, having various relationships to one another. Here, it is impossible to determine any limits, for the realm of the point is limitless (Fig. 3).

Fig. 3
Examples of different-shaped points.

Like its size and its shape, the basic sound of the point is correspondingly variable. This variability should not, however, be understood as anything more than a

relative, inner coloration of its fundamental inner being, which still always gives forth its own pure sound.

The absolute

It must, however, constantly be stressed that entirely pure-sounding elements, radiating one single tone, so to speak, do not exist in reality. Even those elements characterized as "basic or primary elements" are not of a primitive, but of a complex nature. All concepts that relate to the notion of the "primitive" are likewise only relative, even our "scientific" language is purely relative. We have no knowledge of the absolute.

Inner concept

At the beginning of this section, where we discussed the practical, purposive value of the point in written language, the point itself as a concept was defined as consonant with a shorter or longer silence.

Understood inwardly, a point as such makes a certain assertion, which is organically bound up with the utmost reserve.

The point is inwardly the most concise form.

It is introverted. It never entirely loses this characteristic—even in instances of its externally jagged form.

Tension

Thus, its tension is ultimately always concentric—even in those cases where it shows a tendency to eccentric motion, and the con- and eccentric resound in one single chord.

The point is a tiny world—more or less equally cut off from all sides and almost divorced from its surroundings. The degree to which it can be absorbed into its environment is minimal and entirely lacking where the point has been made perfectly round. On the

other hand, it stands its ground steadfastly and shows not the slightest inclination to move in any direction, neither horizontally nor vertically. Even any tendency to advance or retreat is completely absent. Only its concentric tension betrays its inner resemblance to the circle—its other characteristics point more toward the square.*

Plane

The point burrows into the surface and establishes itself for all time. Thus, it is inwardly the most concise constant assertion, which is made briefly, firmly, and quickly.

Definition

For this reason, the point is, both in an external and in an internal sense, the primordial element of painting, and especially of "graphics."†

The concept of an element can be understood in two different ways—as an external and as an internal concept.

"Element" and element

Externally, every individual linear or painterly form is an element. Internally, it is not this form itself, but the inner tension that lives within it that is the element.

*On the relation between elements of color and form, see my article "The Basic Elements of Form," in *Staatliches Bauhaus 1919–1923*, Bauhaus-Verlag, Weimar and Munich, p. 26 and color plate V.[5] [See this edition, pp. 608–9.]

†Geometrically speaking, a point can be represented by 0 = "origo," i.e., "beginning" or origin. The geometrical and the pictorial viewpoint coincide.
Symbolically, also, the point is characterized as a "primordial element." (*Das Zeichenbuch*, by Rudolf Koch, 2d ed., published by W. Gerstung, Offenbach a.M., 1926.)

And in fact, the external forms do not materialize the content of a pictorial work, but rather, the forces = tensions living within these forms.*

If by magic these tensions were suddenly to disappear or die, the living work would instantly die as well. And on the other hand, any random juxtaposition of a few forms would become a work of art. The content of a work finds expression in composition, i.e., in the inwardly organized sum of the tensions necessary in this [particular] case.

This apparently simple assertion has, as a matter of principle, a vital significance. Its recognition or rejection divides not just artists today, but modern man in general into two opposing factions:

1. Those people who recognize, apart from the material, the nonmaterial or spiritual, and
2. Those who are not prepared to recognize anything other than the material.

For the second category, art cannot exist, which explains why these people today deny the word art itself and try to substitute some other word.

In my view, one should differentiate between element and "element," taking the latter to mean a form separated from its tension, and the former, the tension that lives within that form. Thus, elements are, properly speaking, abstract, indeed, form itself is "abstract." Yet if it were actually feasible to work with abstract elements, the external form of present-day painting would change radically as a result, which would not signify the redundancy of painting in general: the abstract pictorial elements,

*Cf. Heinrich Jacoby, *Jenseits von "musikalisch" und "unmusikalisch,"* (Stuttgart: Verlag F. Enke, 1925). Difference between "material" and sound-energy (p. 48).

too, would retain their pictorial coloration, just like musical ones, etc.

The lack of any impulse to move either upon or from the surface reduces to a minimum the amount of time required to perceive a point, which excludes the element of t i m e almost entirely. In special cases, this makes the point indispensable in composition. Here, it resembles in music a short stroke upon the drum or the triangle, or in nature, the staccato noise of the woodpecker.	**Time**
Even today, many theorists of art disapprove of using a point or a line in painting. Among many ancient walls they wish to see preserved, they would gladly include what until recently seemed to divide sharply two realms of art—painting from graphics. At all events, there can exist no inner justification for this division.*	**The point in painting**
The question of time in painting exists in its own right and is highly complex. Here, too, people started a few years ago to demolish a wall.† This wall for-	**Time in painting**

*The reason for this division is an external one. If a more detailed description is required, it would be more logical to divide painting up into painted works and printed works, which would rightly indicate the technical origin of the work in question. The concept graphics has become unclear—watercolors are not infrequently counted as graphics, which may serve as the best of proof of the confusion that bedevils our customary concepts. A hand-painted watercolor is a work of painting, or more correctly, of hand-painting. The same watercolor reproduced exactly in the form of a lithograph is also a work of painting, but more exactly, of printed painting [Druckmalerei]. As an important distinction, one might add the description "black and white," as opposed to 'colored.'

†Such beginnings were, e.g., first made by the Pan-Russian Academy of Art Sciences in Moscow in 1920.

merly divided two realms of art from one another—
the realm of painting from that of music.

The apparently clear and justified division:

painting—space (plane)

music—time

has on closer (even if, until now, cursory) examina-
tion suddenly been called in question—and to the
best of my knowledge, in the first instance by paint-
ers.* The habit, still common today, of ignoring the
element of time in painting shows clearly the super-
ficial character of the prevailing theories, which pa-
tently shy away from any scientific basis. This is not
the place to deal with this question in more detail—
certain moments that clearly reveal the element of
time must, however, be emphasized.

The point is the temporally most concise
form.

**Number of
elements in
a work**

Purely theoretically, the point, which is

1. a complex (of size and shape) and
2. a sharply circumscribed unity

should in certain cases constitute a sufficient means
of expression by being juxtaposed with the surface.
Considered quite schematically, a work of art can
consist ultimately of one point. This should not be
regarded as just an idle assertion.

If, today, the theoretician (and he is, not infrequently,
a "practising" artist at the same time) must separate
and examine with particular attention the basic ele-

*When I went over to abstract art definitively, the element of time in painting became
indisputably clear to me, and I have employed it in practice ever since.

ments of art in the course of systematizing them, then—apart from the question of their application—the question of the number necessary for a work of art (even if conceived only schematically) is equally important.

This question belongs to that great body of compositional theory that has until now remained obscure. But even here, it is necessary to proceed logically and according to plan—let us begin at the beginning. In this text, my purpose can only be, apart from briefly analyzing the two primary elements of form, to indicate connections with the general, scientific work method and the guidelines for the science of art in general. These indications are here only intended as signposts.

In this sense we shall deal with the question that has arisen: whether one point is sufficient to create a work of art.

Here, there are various cases and possibilities.

The simplest and most concise is the case of the point placed centrally—the point in the middle of the surface, which is a square (Fig. 4).

Fig. 4

The primal picture	Repulsing the effect produced by the picture plane here attains maximum force, representing a unique instance.* The two sounds—point, plane—here take on the character of a unison: the relative portion emanating from the surface cannot be calculated. In our progress toward simplification, this is the last in the sequence of resolutions of simple and complex chords, excluding any more complicated elements— tracing composition back to the single, primordial element. Thus, this instance represents the primal image of pictorial expression.
Concept of composition	My definition of the concept of composition is: Composition is the internally purposive subordination
	1. of individual elements
	2. of the structure (construction)
	to a concrete pictorial goal.
Unison as composition	Thus: if a unison exhaustively embodies the given pictorial goal, then this unison must in this instance be equated with composition. Here, a unison is a composition.†
Basis	Conceived of externally, differences in compositions (= pictorial goals) can be exclusively equated with differences in ratios. These are quantitative differences, and in our case—the "primal image of pictorial expression"—any qualitative element is of course en-

*This observation only becomes entirely clear in the course of our deliberations in the chapter on the picture plane.

†With this question is linked another, peculiarly "modern" one: Can a work of art come about by purely mechanical means? In the case of the most elementary proportional exercises, it must receive an affirmative answer.

tirely lacking. If, then, one is to judge a work of art on a qualitative basis, a composition requires a minimum of two sounds. Here, we have one of those examples that clearly underlines the difference between external and internal measurements and resources. The fact that, on closer examination, absolutely pure composite sounds [*Zweiklänge*] are found never to occur can only be put forward here as an assertion that will be proved elsewhere. But at all events, a composition can, on a qualitative basis, only be created by the use of complex chords.

As soon as the point is moved from the center of the surface—acentric structure—the dual nature of the sound becomes audible:

Acentric structure

1. absolute sound of the point
2. sound of its given position upon the surface

This second sound, which is almost completely drowned in the case of a centralized structure, is clearly heard once again, transforming the absolute sound of the point into a relative one.

If this point has a companion upon the surface, the result will automatically be still more complex. Repetition is a powerful means of intensifying inner emotion and at the same time creating a primitive rhythm, which is in turn a means of attaining a primitive harmony in every form of art. Apart from which, we are here confronted with two dual sounds: each position on the surface is unique, having its own individual voice and inner coloration. Thus it is that apparently unimportant facts give rise to unexpectedly complex results.

Quantitative increase

The constituents in the given example are:

Elements 2 points + plane
Results 1. inner sound of one point

2. repetition of this sound
3. dual sound of the first point
4. dual sound of the second point
5. sound produced by the sum of all these sounds

Since a point is also in itself a complex unity (its size + its shape), it may easily be imagined what a gale of sound develops as a result of still-further accumulation of points on the plane—even when such points are identical—and how this gale intensifies if, in the course of development, points of differing, ever-increasing dissimilarity in size and shape are strewn upon the surface.

Nature

In another, undifferentiated realm—that of nature—accumulations of points often occur, and they are invariably purposive and organically necessary. The forms of nature are in reality tiny particles in space and bear the same relation to the abstract (geometrical) point as does the pictorial point. Admittedly, the entire "world" can, on the other hand, be regarded as a self-contained, cosmic composition, which itself consists of innumerable, independent, hermetic compositions, getting smaller and smaller, and which—large or small—were ultimately created from points; while on the other hand, the point reverts to its original state as a geometrical entity. There are complexes of geometrical points that, in various orderly forms, hover in geometrical infinity. The smallest, hermetic, purely centrifugal forms indeed appear to the naked eye as points, having only a loose relationship with one another. Many seeds look like this, and if we open the handsome, smoothly polished, ivory seed-case of the poppy (which is ultimately a large, spherical point), we find within this warm sphere an accumulation of cold blue-gray dots,

organized into a compositional structure, and carry-
ing within themselves their latent, reproductive
force, just like the pictorial point.

Sometimes, similar forms arise in nature as a result of
the dissection or decomposition of the above-men-
tioned complexes—a hankering, as it were, after
the primordial form of the geometrical state. When
one considers that the desert is a sea of sand, com-
posed exclusively of points, then it is not surprising
that the indomitable, storm-driven mobility of these
"dead" points produces a frightening effect.

In nature, too, the point is an introverted entity preg-
nant with possibilities (Figs. 5 and 6).

Fig. 5
Nebula in Hercules (*Newcomb-Engelmanns
Popul. Astronomie*, Leipzig, 1921, p. 294).

Fig. 6
Formation of nitrite, magnified 1000× (*Kultur d. Gegenwart,* T. III, Abtlg. IV, 3, p. 71).[6]

Other arts

Points can be found in all the arts, and their inner force will certainly impinge more and more upon the consciousness of artists. Their significance should not be overlooked.

Sculpture, architecture

In sculpture and architecture, the point results from the overlapping of more than one surface—it is the culmination of a corner of space and, on the other hand, the germinal point of these surfaces. The surfaces are directed to it and developed out of it. In Gothic buildings, points are especially stressed by angular forms, and often emphasized sculpturally— something achieved just as clearly in Chinese buildings by a curve leading to a point. Short, sharp chords resound as a bridge to the dissolution of that spatial form whose echoes die away in the empty space surrounding the building. It is to buildings of precisely this kind that one may attribute the conscious use of the point, since it here occurs in logically distributed masses that strive compositionally toward the highest point. Point = point (Figs. **7** and **8**).

Fig. 7
Outer gateway of the Ling-ying temple
(*China*, by Bernd Melchers, vol. 2, publ. by Folkwang
Vlg., Hagen i. W., 1922).

Fig. 8
"Pagoda of the Dragon Beauty" in Shanghai
(built 1411).[7]

Dance

Even in the oldest form of ballet one had *"pointes"*—a terminological reference that must derive from "point." Running quickly on the tips of one's toes leaves behind points on the floor. In his leaps, too, the ballet dancer uses the point, aiming clearly toward it with his head as he leaps upward, then touching the floor in his downward motion. High jumps in the n e w d a n c e form may in certain instances be compared with the "classical" ballet leap, in the sense that the earlier jump formed a straight vertical, whereas the "modern" jump sometimes creates a five-sided figure with five points—head, two hands, two tips of the feet, with the ten fingers forming ten smaller points (e.g., the dancer Palucca, Fig. **9**). Likewise, the brief moments of stiff immobility can be conceived of as points. I.e., active and passive punctuation, which is connected with the musical form of the point.

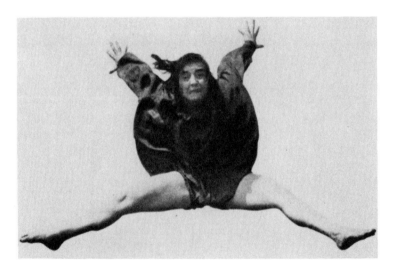

Fig. 9
A leap by the dancer Palucca.

558

Fig. 10

Diagram of a leap (cf. the photograph opposite, Fig. 9).

Apart from the drum and triangle strokes already mentioned, points in music can be produced by all kinds of instruments (especially percussion), and especially the piano, which enables one to create self contained compositions exclusively from the juxtaposition and succession of points of sound.*

Music

*Points have certainly exerted upon some musicians an attraction that, though it may have been more or less conscious, can still be clearly recognized in the inner essence of the point. This emerges clearly from Bruckner's "compulsive visions," whose inner content many people have succeeded in perceiving beneath the visible surface: "If this (fascination for dots in signatures and on doorplates) was a sign of compulsive neurosis, it seems, nevertheless, to have been no will-o'-the wisp that lurked in these points. Anyone who knows Bruckner's inner nature, especially his search for laws (in his theoretical studies as well) will recognize the psychological significance of this attraction to the ever-diminishing primary unit of spatial extension. He sought basically the ultimate, inner point in everything; for him, there flowed out from them infinite magnitude; in them, he could hear the call for a return to the primary element." *Bruckner,* by Dr. Ernst Kurth, vol. 1, p. 110n. Published by Max Hesses Verlag, Berlin.

Strings and clarinet.
Beethoven's Fifth Symphony (the first bars).

Fig. 11
The same, translated into points.

Fig. 11
The same, translated into points.

Coda.

strings + woodwind + trumpets
 horns timpani

Fig. 11*
The 2nd subject, translated into points.

In that particular realm of painting called graph-
ics, the point develops its autonomous powers with
particular clarity. As for the multiplicity of shapes
and sizes, the material implement [employed] pres-
ents many different possibilities for the development
of these powers, shaping the point into innumerable
different entities, each with its own sound.

Graphics

But here, too, this multiplicity and variety can easily
be ordered, if one takes as the basis for one's ordering
the specific characteristics of graphic procedures.

Procedure

*Herr Generalmusikdirektor Franz v. Hoesslin gave me his valuable assistance with these translations, for which I offer him my warmest thanks.

The typical procedures are:

1. etching, and especially dry-point
2. woodcut and
3. lithograph

Precisely in relation to the point, and the process by which it comes into being, the differences between these three techniques emerge with particular clarity.

Etching

It is the nature of etching that the tiniest black point can be obtained with playful ease. A large, white point can, on the other hand, only come about as a result of considerable effort and various ruses.

Woodcut

With woodcut, matters are quite the reverse: the tiniest white point needs but a prick, whereas a large black one demands effort and care.

Lithograph

With lithograph, the path is equally smooth in both these cases, and all effort disappears.

Likewise, the possibility of making corrections differs in each of the three techniques: strictly speaking, corrections are impossible in etching, limited in woodcut, and unlimited in lithograph.

Atmosphere

From this comparison of the three techniques, it should become clear that the technique of lithography must have been discovered most recently of all, not in fact until "today"—facility cannot be achieved without effort. Yet on the other hand, facility of execution and ease of correction are characteristics singularly appropriate to the present day. The present day is only a springboard to "tomorrow," and only this character enables us to accept it with inner tranquility.

No difference produced by nature can remain superficial, nor should it—it must direct us to the very depths, i.e., to the inner nature of things. Technical resources arise no less intentionally and purposively than all other phenomena, both in the "material" world (spruce, lion, star, louse) and in the "spiritual" (work of art, moral principle, scientific method, religious idea).

If the physiognomy of individual phenomena (= plants) differs to such an extent that their inner affinity remains hidden, if the external appearance of these phenomena seems a jumble to the superficial eye, nonetheless, they can be traced back to one root, by reason of inner necessity.

Root

In this way, one learns the value of differences, which are at bottom always purposive and not without reason, but which, if treated lightly, wreak a terrible revenge in the form of unnatural freaks.

Wrong turnings

This simple fact may be clearly observed in the comparatively limited field of graphics. A misunderstanding in the basic differences between the abovementioned technical resources has here often led to useless and therefore repulsive works. They owe their existence to an inability to recognize the inner nature of things in their outward appearance. The soul, hardened like an empty nutshell, has lost its capacity for penetration, and can no longer pierce its way through to the depths of things, where beneath the external husk the pulsating heartbeat becomes perceptible.

The graphic specialists of the nineteenth century were not infrequently proud of their ability to imitate a pen drawing by a woodcut, or an etching by a lithograph. Such works can only be described by the term

testimonia paupertatis. The crowing cock, the creaking door, the barking dog, however artfully they may be imitated upon the violin, can never rate as artistic achievements.

Purposiveness The materials and the tools of the three graphic arts, in the course of nature, go hand in hand with the necessity of realizing three different characters of the point.

Material Paper can be used as the material in all three cases. But the manner of employing the particular implement is fundamentally different in each case. It is for this reason that the three different techniques came into existence, and continue to coexist even today.

Implement and birth of the point Of the various types of etching, there exists today a preference for dry-point, since it accords particularly well with our frenetic atmosphere, and on the other hand possesses the incisive character of precision. Here, the surface can stay completely white, and the dots and strokes lie deeply and sharply embedded in this white. The stylus works confidently, most decisively, digging its way happily into the plate. In the first instance, the point comes about in a negative way, by means of a short, precise thrust into the plate.

The stylus is sharp metal—cold.
The plate is polished copper—warm.

The color is applied thickly to the whole plate, and then cleaned off in such a way that the little point lies simply and naturally in its bright womb.

Then comes the mighty pressure of the press. The plate bites its way into the paper. The paper penetrates into the tiniest recesses, forcing the color out. A passionate process, which results in the complete

merging of the color with the paper.

So it is that the little black point here comes to life—the primordial element of painting.

Woodcut:
Implement—chisel—metal—cold.

Plate—wood (e.g., boxwood)—warm.

The point is created in such a way that the instrument does not touch it—it circumscribes it with a groove, like a fortress, and must take every care to avoid injuring it. Its entire surroundings must be defiled, gutted, destroyed in order that the point can be brought into the world.

The color is rolled onto the surface in such a way that the point is covered, but its surroundings left untouched. Even on the block, the future print can be clearly seen.

Then the gentle pressure of the press—the paper must not penetrate the recesses; it must remain on the surface. The little dot sits not in, but on the paper. Any burrowing into the surface has to be left to its inner powers.

Lithograph:
The plate—stone, indefinable, yellowish tone—warm.

Implement—pen, chalk, brush, any more or less sharp object, whose area of contact may be of quite different sizes, right down to a fine shower (spray technique). Utmost variety, utmost flexibility.

The color sits lightly and insecurely. Its association with the plate is extremely loose, and it can be easily

sanded down—the plate at once returns to its virgin state.

The point is there in an instant—quick as a flash, without any effort, any time lost—merely a brief, superficial touch.

Pressure of the press—fleeting. The paper touches the whole plate evenly, and reflects merely the fertilized places.

The point sits so lightly upon the paper that it would be no wonder were it to fly away.

Thus the point sits:

> in the case of etching—in the paper
> in the case of woodcut—in and on the paper
> in the case of lithograph—on the paper

Thus the three graphic processes differ from one another, and thus are they interwoven.

Thus the point, which remains always a point, takes on various faces and hence various expressions.

Texture These latter observations belong to the special question of texture. By the word texture we understand the outward manner by which the elements combine with one another and with the surface. Represented schematically, this manner depends upon three factors:

1. The character of the surface, which may be smooth, rough, flat, sculptural, etc.
2. The character of the implement (bearing in mind that the most common implement in painting today—different varieties of brush—can be replaced by others), and

3. The manner of application, which may be loose, compact, stippled, spray-like, etc., according to the consistency of the paint—hence the variety of fixatives, pigments etc.*

Even in the very limited realm of the point, the possibilities of texture must be considered (Figs. **12** and **13**). Here, despite the narrowly defined limits of this smallest element, the different methods of production are still important, since the sound of the point is given a different coloration each time by the manner in which it is produced.

One must therefore consider:

1. The character of the point in relation to the implement that produces it, in combination with the quality of the receptive surface (in this case, the variety of plate).
2. The character of the point in the manner of its combination with the final, receptive surface (in this case, the paper).
3. The character of the point as dependent upon the characteristics of the ultimate surface itself (in this case, smooth, pearl, striped, rough paper).

If, however, an accumulation of points is necessary, the three above-mentioned instances are further complicated by the manner of producing the accumulated points—not only an accumulation produced directly by hand, but also in a more or less mechanical way (all kinds of spray processes).

*This question cannot be treated in more detail here.

Fig. 12
Centralized complex of independent points.

Naturally, all these possibilities play a still larger role in painting—the difference will consist here in the unique characteristics of painterly means, which offer infinitely greater possibilities of texture than the narrow sphere of graphics.

But even within this narrow sphere, questions of texture retain their entire significance. Texture is a means to an end, and must be understood and used as such. In other words, texture must not function as an end in itself, it must serve the compositional conception (purpose), just like every other element (means). Otherwise, there occurs an inner discord, whereby the means drown the end. The external has outgrown the internal—mannerism.

Fig. 13
A large point consisting of small points
(spray technique).

Abstract art	In this instance we can see one of the differences between "representational" and abstract art. In the former, the sound of the element "in itself" is muffled, suppressed. In abstract art the full, unsuppressed sound is attained. To which our own little point can bear incontrovertible witness.

In the sphere of "representational" graphics there exist prints made up exclusively of points (a famous Head of Christ can be cited as an example), so that the points are supposed to give the impression of lines. Clearly, we are confronted with an unjustified use of the point, since the point, suppressed by the objective [element] and weakened in its sound, is condemned to a miserable half-life.*

In abstract art, a given technique can naturally be purposeful and compositionally necessary. Here, proofs are superfluous.

Force from within	Everything that has been said in very general terms about the point applies to the analysis of the point in repose, absorbed in itself. Any alteration in its size brings in its train an alteration in its relative being. In this case, it expands from within itself, from its own center, which results only in a relative decrease of its concentric tension.
Force from without	There can, however, exist another force, which arises not inside but outside the point. This force attacks the point as it burrows its way into the surface, forces it to emerge, and pushes it across the surface in one direction or another. This at once obliterates the con-

*Naturally, dividing a surface up into points as a result of technical necessity is quite different, as in, e.g., the case of zincography, where a screen of dots is unavoidable. Here, the point is not supposed to play an independent role and is, as far as the technique permits, suppressed.

centric tension of the point, which itself perishes, and out of which comes into being a new entity leading a new, self-sufficient life and thus subject to its own laws. This entity is line.

In geometry, line is an invisible entity. It is the trail left by the point in motion. Hence it comes about through movement—indeed, by destroying the ultimately self-contained repose of the point. Here we have a leap from the static to the dynamic.

Line is therefore the ultimate contrast to the primordial element of painting—the point. In very precise terms, it can be described as a secondary element.

Birth

The forces that operate from outside to transform the point into line can be very different in character. Variations in line depend upon the number of these forces and their combination.

In the end, all forms of line, however, can be traced back to two instances:

1. Application of a single force and
2. Application of two forces
 a) single or multiple, alternating effect of both forces
 b) simultaneous effect of both forces

Straight

IA If a force coming from outside moves the point in any direction, the first type of line comes about, where the direction embarked on remains unchanged, and the line has a tendency to run straight on to infinity.

This is the straight line, which as regards its tension thus represents the infinite possibility of movement in its most concise form.

I have substituted "tension" for the almost universally accepted term "movement". The usual term is imprecise and therefore leads us in the wrong direction, bringing in its train further terminological confusions. "Tension" is the force inherent in an element, which represents only one part of its generative "movement". The other part is its "direction" which is also determined by "movement." The elements of painting are the concrete results of movement, in the form of:

1. tension, and

2. direction

This division also creates a basis for differentiating between different kinds of elements, e.g., point and line, of which the point carries within itself only a tension and can have no direction, whereas line necessarily partakes both of tension and direction. If, e.g., a straight line were examined only as to its tension, it would be impossible to distinguish a horizontal from a vertical. The same is also entirely valid for the analysis of color, for certain colors differ only in their tensions-directions.*

Among straight lines we may observe three typical varieties, of which other straight lines are only mutations.

1. The simplest form of the straight line is the horizontal. To the human mind, it corresponds to

*See, e.g., the characterization of yellow and blue in my book *On the Spiritual in Art*, published by R. Piper & Co., Munich, 3rd edition, 1912, Tables I and II [see this edition, pp. 178, 184]. Cautious application of concepts is particularly important in any analysis of "linear form," since it is here that direction plays a decisive role. It must be said with regret that the last thing painting possesses is an exact terminology, which makes scientific work uncommonly difficult and sometimes even impossible. Here, one must begin at the beginning, and a terminological dictionary is a precondition. An attempt made in Moscow (in about 1919) unfortunately led to no results. Perhaps the time was not then ripe.

that line or plane on which man stands or moves. The horizontal is therefore a cold, basic support that can be extended in various directions. Coldness and flatness constitute the basic sounds of this line, which can be described as infinite, cold possibility of movement in its most concise form.

2. Completely opposed to this line, both outwardly and inwardly, is the vertical, standing at right angles to it, where flatness has been replaced by height, i.e., coldness by warmth. Thus, the vertical is infinite, warm possibility of movement in its most concise form.

3. The third typical variety of straight line is the diagonal, which schematically, diverges to the same degree from both the above-mentioned lines, which means that it has an equal tendency toward each of them, determining its inner sound—equal combination of cold and warm. I.e.: infinite cold-warm possibility of movement in its most concise form (Figs. 14 and 15).

Fig. 14
Basic types of geometrical straight lines.

Fig. 15
Schema of basic types.

574

These three varieties are the purest forms of the straight line, which differ from one another by their temperature:

Infinite movement
1. cold form Infinite possibilities
2. warm form of movement in
3. cold-warm form most concise form

All other straight lines are only greater or smaller deviations from the diagonal. Their inner sounds are determined by their more or less pronounced tendency toward cold or warm (Fig. 16).

Fig. 16
Schema of deviations in temperature.

Thus the straight lines, which distribute themselves around a common center, form a star.

The star can become denser and denser so that the **Creation of** converging lines create a denser center, where a point **plane** forms and appears to spread. It is the axis around which the lines move and in which they can ultimately converge. A new form is born: a plane in the lucid shape of a circle (Figs. 17 and 18).

Fig. 17
Densifying.

Fig. 18
Circle produced by
densifying.

Let me observe in passing that we are in this case confronted with a particular characteristic of line—its capacity to create surface. This capacity is here expressed in the same way that a spade by its movement creates a surface on the ground, with sharply delineated lines. Lines can, however, form a surface in another way, which I shall discuss later.

The difference between diagonals and other, diagonal-like lines, which might correctly be termed independent straight lines, is also a difference in temperature, since the independent straight lines can never attain equilibrium between warm and cold.

Moreover, independent straight lines can, on a given surface, pass either through a common center (Fig. 19) or on either side of it (Fig. 20), according to which they may be divided into two categories:

4. Independent straight lines (without equilibrium):
 a) central, and
 b) acentral

Fig. 19
Central independent straight lines.

Fig. 20
Acentral independent
straight lines.

**Color:
yellow and
blue**

Acentral, independent straight lines are the first to possess a particular capacity that enables a certain parallel to be drawn between them and the "chromatic" colors, and distinguishes them from black and white. In particular, yellow and blue carry within themselves various tensions—the tensions of advance and retreat. The purely schematic straight lines (horizontals, verticals, and diagonals— especially the first two) unfold their tensions upon the surface and display no tendency to move away from the surface. In the case of the independent straight lines, especially of the acentral variety, we observe a looser connection with the surface: they are less bound up with the surface and seem on occasion to pierce it. These lines are at the furthest remove from the point that burrows into the surface, since they in particular have abandoned the element of repose.

On the delimited surface, however, this loose connection is only possible if the line lies upon it freely, i.e., does not touch its extremities, something to be discussed in more detail in the chapter "Picture Plane."

At all events, there exists a certain similarity between the tensions inherent in the acentral, independent straight lines and the "chromatic" colors. The natural links between "linear" and "painterly" elements, which up to a certain limit we are able to recognize today, are of immeasurable importance for the future theory of composition. Only in this way can planned, precise experiments be made as to construction, and the pernicious fog in which we are compelled to stray in our laboratory work today will of necessity become somewhat less opaque and suffocating.

Black and white

If the schematic straight lines—in the first instance, horizontals and verticals—are examined for their color characteristics, we are faced with an obvious comparison with b l a c k and w h i t e. Just as these two colors (which until recently were called "noncolors" and today are termed, somewhat awkwardly, "nonchromatic" colors) are silent colors, the two kinds of straight line described are silent lines. In both cases, resonance is reduced to a minimum: silence, or rather a scarcely audible whispering and repose. Black and white lie outside the color circle,* and horizontals and verticals likewise occupy a special position among lines, since in a central placing they are unrepeatable and therefore isolated. If we consider black and white from the standpoint of temperature, white is in any case warmer than black, and absolute black is necessarily cold within. It is not for nothing that the horizontal gamut of colors runs from white to black (Fig. 21):

*See *On the Spiritual in Art,* where I call black the symbol of death, and white that of birth. The same can quite rightly be said of horizontals and verticals—breadth and height. The former is lying; the latter standing, walking, moving, finally climbing upward. Carrying—growing. Passive—active. Relatively: female—male.

| White | Yellow | Red | Blue | Black |

Fig. 21

A slow, natural slide from top to bottom (Fig. **22**).

Thus, we may further catalogue in white and black the elements of height and depth, making possible an association with vertical and horizontal.

"Today," man's attention is completely claimed by the external, and the internal is dead for him. This is the last step downward, the last pace into the dead end—in earlier times, such places were called the "abyss," but today the modest expression "dead end" suffices. "Modern" man seeks inner peace, because he is numbed from without and believes he will find this peace in inner silence. Hence, in our case, the exclusive penchant for the horizontal-vertical came about. The logical consequence of this would be an exclusive penchant for black and white, something on which painting has already several times embarked. But we have yet to encounter the exclusive association of horizontal and vertical with black and white. Then, everything is plunged into inner silence, and only external noises will disturb the world.*

*One can expect a violent reaction against this exclusiveness, but not in the form of seeking salvation in the past, as is partly the case today. One has in recent decades frequently been in a position to observe such a flight into the past—Greek "Classicism," Italian Quattrocento, late Roman, "primitive" art (including the "Fauves"), now in Germany the "old German masters," in Russia icons, etc. In France, a modest glance over the shoulder from "today" to "yesterday"—in contrast to the Germans and Russians, who descend into the depth of depths. To "modern" man, the future appears empty.

Fig. 22
Graphic representation of descent.

These relationships, which are to be understood not as exactly equal values, but simply as inner parallels, lead us to the following table:

Linear Form	Painterly Form
Straight Lines	Primary Colors
1. horizontal	black
2. vertical	white
3. diagonal	red (or gray or green)*
4. independent straight lines	yellow and blue

Red

The parallel: diagonal—red is here put forward as an assertion, which to prove in detail would lead us too far from the subject of this book. I can only say briefly: red† is distinguished from yellow and blue by

*Various parallels can be drawn between red, gray, and green: red and green—transition from yellow to blue; gray from black to white, etc. This belongs to color theory. For an indication, see *On the Spiritual in Art.*

†See *On the Spiritual.*

its tendency to lie firmly upon the surface; from black and white by its intensive, inner simmering and its tension within itself. Diagonals display, by contrast with independent straight lines, firm adherence to the surface; by contrast with horizontals and verticals, greater internal tension.

The point that reposes in the center of a square surface was defined above as a unison between point and surface, and the whole picture as the archetypal image of pictorial expression. Horizontals and verticals placed centrally upon a square surface complicate this example further. Both these straight lines are, as already noted, individual and isolated living entities, since they know no repetition. They thus develop a powerful sound, which can never entirely be drowned, and therefore represent the primordial sound of the straight line. The following construction is thus the archetypal image of linear expression or linear composition (Fig. 23).

Primordial sound

Fig. 23

It consists of a square divided into four squares, producing the most primitive form of division of a diagrammatic surface.

The sum of the tensions is made up of 6 elements of cold repose and 6 elements of warm repose = 12. Thus the immediate step from the diagrammatic image of the point to the diagrammatic linear image is achieved by an astonishing increase in resources: a jump from a single unison to a 12-note chord. These 12 notes, on the other hand, are made up of 4 surface sounds + 2 line sounds = 6. Juxtaposition doubles these 6 sounds.

This example, which actually belongs to the theory of composition, has deliberately been introduced here in order to indicate the reciprocal effects of simple elements in elementary juxtapositions. Here, the expression "elementary"—a loose, imprecise term— betrays the "relative" character of its identity. That is to say, it is not easy to separate out the complex and use only the elementary. Nonetheless, these experiments and observations offer the only way of getting to the bottom of pictorial entities, which put themselves in the service of compositional aims. This is the method used by "positive" science. In this way, it has, despite excessive one-sidedness, created what is initially an outward order, and today still penetrates with the help of dissective analysis to the primary elements. And in this manner, philosophy has ultimately been provided with an extensive amount of ordered material that will certainly lead sooner or later to synthetic results. It is this same path that the science of art must tread, but must from the outset combine the external with the internal.

In the gradual transition from horizontal to independent, acentral lines, the coldly lyrical is just as gradually transformed into something warmer, its warmth increasing until finally it takes on certain dramatic overtones. The lyrical aspect, however, remains dominant—the whole realm of the straight line is lyrical, something to be explained by the operation of a single force from outside. Apart from the sound of displacement (in the above-mentioned case, the acentral), the dramatic carries within itself the sound of collision, which requires at least two forces.

Lyrical and dramatic

The effect of two forces upon the realm of line can proceed in two ways:

1. the two forces operate in sequence alternating effect
2. the two forces operate together simultaneous effect

Clearly, the second way is more spirited and therefore "hotter," especially since it may also be regarded as the product of numerous alternating forces.

The dramatic effect increases accordingly, until finally purely dramatic lines come into being.

Thus, the realm of line embraces the whole range of expressive sounds, beginning with cold lyricism and ending with ardent drama.

Naturally, every phenomenon in both external and internal worlds can be given linear expression—a

Linear translation

kind of translation.*

The results that correspond to our two types [of forces] are:

		Forces	Results
Point	1.	Two alternating	Zig-zag lines
	2.	Two simultaneous	Curved lines

Zig-zag

IB Zig-zag lines or angular lines.
Since zig-zag lines are composed of straight lines, they belong under heading **I**, being assigned to the second category under this heading—**B**.

Zig-zag lines result from the pressure of two forces in the following manner (Fig. **24**):

Fig. **24**

*Apart from intuitive translations, organized laboratory experiments should be made along these lines. It would first be advisable to examine every phenomenon chosen for translation so as to establish its lyrical or dramatic content, and hence find in the corresponding compartment of line a form suitable to the given instance. Moreover, an analysis of those "works of translation" already available would shed a penetrating light upon this question. In music we find numerous such translations: musical "pictures" after natural phenomena, musical forms for works produced by other arts, etc. The Russian composer A. A. Shenshin has made extremely valuable experiments along these lines—*Années de pèlerinage* by Liszt, which are based on Michelangelo's *Pensieroso* and Raphael's *Sposalizio.*

IB 1. The simplest forms of the zig-zag consist of two parts and are the result of two forces, whose effect ceases after the initial impact. This simple process leads us, however, to one important difference between straight lines and zig-zags: in the case of the zig-zag there arises a far greater sympathy with the surface, and zig-zags have, indeed, something surface-like about them. The zig-zag acts as a bridge for the surface that is in the process of becoming. The differences between the innumerable varieties of zig-zag depend solely upon the size of the angle, in terms of which they may be divided up into three schematic types:

a) with acute angle—45°

b) with right angle—90°

c) with obtuse angle—135°

All others are atypical acute or obtuse angles, and deviate from the typical to a greater or lesser extent, according to the size of the angle. Thus to the first three types of zigzag may be added a fourth—a non-schematic zig-zag:

d) with independent angle
so that this zig-zag must be characterized as an independent zig-zag.

The size of the right angle makes it unique, and it can change only its direction. Only four right angles can touch one another—either they touch at the angles, forming a circle, or else their diverging sides touch so as to create rectangular surfaces—in the most regular instance, a square.

The horizontal-vertical cross consists of one warm and one cold [element]—it is nothing more than horizontal and vertical adjusted to the center. Hence the cold-warm or warm-cold temperature of the right angle, according to its direction—about which, more in the chapter "Picture Plane."

Lengths A further difference between simple zig-zags consists in the lengths of the individual sections—which may circumstantially modify to a large extent the basic sound of these forms.

Absolute sound The absolute sound of the given forms is dependent upon three conditions, changing in the following manner.

1. Sound of straight line with above-mentioned modifications (Fig. **25**).
2. Sound of tendency to more or less acute tension (Fig. **26**).
3. Sound of tendency to greater or lesser domination of surface (Fig. **27**).

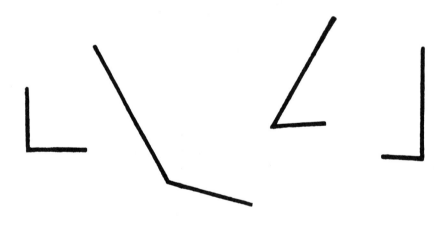

Fig. 25
Some zig-zags.

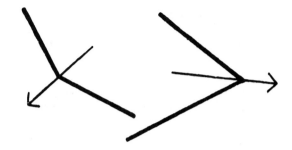

Fig. 26

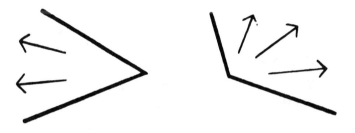

Fig. 27

These three sounds can form a pure tri ad. They can also be used, however, singly or in twos, depending upon the overall construction. It is not possible to eliminate completely all three sounds, but one or the other may drown the rest to such an extent that the remainder are scarcely audible.

Triad

The most objective of the three typical angles is the right angle, which is thus also the coldest. It divides a square surface relentlessly into four parts.

The tensest is the acute angle—and hence the warmest. It dissects the surface relentlessly into eight parts.

Exceeding the right angle leads to a lessening of its forward impetus, and the desire to conquer the surface grows accordingly. This ambition is, however, hampered by the fact that the obtuse angle is not capable of relentlessly dividing the whole surface: it extends into two sectors, leaving an area of 90° unconquered.

Three sounds

These three forms have their three corresponding, different sounds:

1. cold and restrained
2. acute and highly active
3. helpless, weak, and passive

These three sounds, and hence also these three angles translate beautifully into graphic terms the process of artistic creation:

1. acute, highly active [aspect] of inner thought (vision)
2. cool, restrained [aspect] of masterly execution (realization) and
3. feeling of dissatisfaction and awareness of one's own weaknesses on completion of the work (what artists call "hangover")

Zig-zag and color

We spoke earlier about four right angles forming a square. Links with the elements of painting can here be discussed only briefly, but the parallel between zig-zags and colors should not go without mention. The cold-warm aspect of the square and its pronounced, surface-like character point at once to red, which represents a mid-point between yellow and blue and carries within itself cold-warm characteris-

tics.* It is not for nothing that the red square has turned up so frequently in recent times. Thus, it is not entirely unjustified to draw a parallel between the right angle and red.

Under category (d) of zig-zags, a special kind of angle should be singled out, which lies between right angle and acute—an angle of 60° (right angle − 30 and acute + 15). If two such angles are placed face to face, they produce an equilateral triangle—three acute, active angles—and point the way to yellow.† Thus the acute angle is inwardly colored yellow.

An obtuse angle loses more and more of its belligerence, its astringency, its warmth, and is hence distantly related to the curving line, which, as will be demonstrated below, creates the third primary plane figure—the circle. And the passive element of the obtuse angle, its almost nonexistent forward tension gives to this angle a delicate blue color.

In addition, further links can be suggested—the more acute the angle, the nearer it comes to acute warmth, while conversely this warmth decreases gradually beyond the red right angle, tending more and more toward cold, until the obtuse angle (150°) is reached, a typically blue angle, which gives an intimation of the curved line and eventually has the circle as its goal.

This process can be expressed graphically as follows:

*See *On the Spiritual,* Table II [see this edition, p. 184]; also Plate V, "Basic Elements," in the Bauhaus book, Bauhaus-Verlag 1923.

†Ibid.

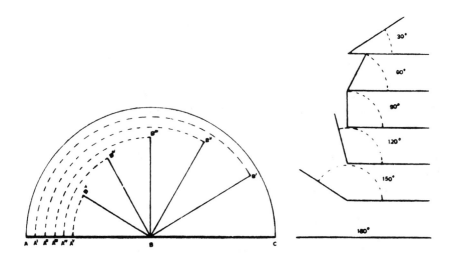

Fig. 28
System of typical angles ⇄ colors.

Fig. 29
Degrees of angles.

With the result:

A^v B B^v yellow
A^{iv} B B^{iv} orange
A^{iii} B B^{iii} red
A^{ii} B B^{ii} violet
A^i B B^i blue

acute angle

right angle

obtuse angle

The next jump of 30° marks the transition from zig-zag to straight line.

A B C black horizontal

Since, however, the typical angles can, if further developed, create planes, the further connections between line-plane-color press themselves upon us of

their own accord. Thus the following schematic in-
dication of these line-plane-color relationships can be
given:

Zig-zag	Primary Forms	Primary Colors	Plane and color

Fig. 30
Acute angle ⇄ △ ⇄ yellow

Fig. 31
Right angle ⇄ □ ⇄ red

Fig. 32
Obtuse angle ⇄ ○ ⇄ blue

If these and the above-drawn parallels are correct, the
following conclusion may be drawn from a compari-
son of the two: the sounds and characteristics of the
component elements produce in individual instances
a sum total of qualities not covered by the former.

Comparable facts are not unknown in other sciences,
e.g., chemistry: the sum of the component elements
when separated is not the same as the total produced
by their combination.* In such cases, we are perhaps
confronted with an unknown law, whose indistinct
features strike us deceptively.

To wit:

Line and color

Line	Color	In relation to temperature and light
Horizontal	black =	blue
Vertical	white =	yellow
Diagonal	gray, green =	red

Plane and Components

Plane	Components	Sum produces third primary	

Triangle	horiz.	diagon.	
	black = blue	red	yellow

Square	horiz.	vertic.	
	black = blue	white = yellow	red

Circle†	Tensions (as components) active = yellow		blue
	passive = red		

*In chemistry, = signs are not used for such cases, but a ⇌ instead, which indicates
links.
It is my task to interpret "organic" links in painting. Even in cases where it is
impossible to prove, i.e., establish beyond doubt the identical [nature of two elements],
I wish to indicate their inner relationship by erecting two signposts ⇌ . Nor should
one be put off in such cases by the possibility of mistakes: truth is not infrequently
discovered by means of the erroneous.

It is the summation of the component elements that establishes equilibrium by supplying the missing link. In this way, the elements are produced by the sum—lines by the plane—and vice versa. Artistic practice bears out this supposed rule, since black-and-white painting, which consists of lines and points, is given a more conspicuous balance by the addition of plane (or of planes): lighter weights demand heavier ones. This requirement can be observed perhaps to even a greater degree in painting with colors, as every painter knows.

In the course of such observations, my purpose extends beyond attempts to establish more or less precise rules. It seems to me almost as important to stimulate discussion about theoretical method. Until now, methods of analyzing art have always been extremely arbitrary, and often of much too personal a nature. The future impels us upon a more precise and objective path, whereby collective work upon the science of art will become possible. Preferences and talents will differ here, as everywhere, and each of us can only work to the best of his abilities. For precisely this reason, it is particularly important that the guidelines determining our work should be agreed by several parties. Here and there, the idea of art institutes with a carefully planned curriculum has come up—an idea that surely will soon be realized in different countries. Without any exaggeration it may be suggested that any broadly based science of art must have an international character; it would be interesting, but certainly not sufficient to construct a purely European theory of art. In this respect geographical or

Method

International Art Institute

†The origin of the circle is shown in the analysis of curved lines: impact followed by decreasing assertiveness.

In any case, the circle is the exception among the three primary figures—it cannot be formed from straight lines.

other external conditions are not the most important (or at any rate the only ones); first and foremost, differences of inner content in the case of different "nationalities" are decisive, particularly in the realm of art. Our use of black for mourning, whereas the Chinese use white, is an adequate example.* There can scarcely exist any greater contrast between responses to colors—the expression "black and white" is just as common to us as "heaven and earth." And yet, it is possible to identify here an underlying and hence not immediately recognizable affinity between the two colors—both are silence, an example that perhaps illuminates with particular clarity the difference between the inner content of Chinese and Europeans. We Christians, after millenia of Christianity, experience death as a final silence, or to use my own description, a "bottomless pit"; the heathen Chinese conceive of this silence as the prelude to a new language, or according to my description as "birth."†

*If such an inquiry is precisely and logically thought out, differences that demand closer examination, not just with respect to "nationality," but also with respect to race, can presumably be isolated without particular difficulty. As regards details, however, that not infrequently assume an unexpected importance, it will sometimes be impossible to obviate insuperable difficulties. Influences, which at the beginning of a given culture often manifest themselves precisely in details, in several cases lead to external imitations and thus obscure further development. On the other hand, logical inquiry pays little attention to purely external phenomena, which need not be considered in this kind of theoretical work—something that would of course be impossible in an exclusively "positivistic" approach. Even in these "simple" cases, a biased approach can lead only to biased results. It would be shortsighted to assume that a particular people is placed "by chance" in a certain geographical environment that determines its further development. And it would be no more satisfactory to maintain that political and economic conditions that flow ultimately from the people itself direct and determine its creative force. The aim of creative force is internal—this internal cannot be entirely separated from its external shell.

†See *On the Spiritual in Art.*

"Nationality" is a "question" that today is either underestimated, or else treated merely from an external and superficial-economic standpoint. As a result, the negative aspect comes very much to the fore, and the other side of the question is buried without trace. It is precisely this other side, i.e., the internal, that is essential. Seen from the latter standpoint, the sum of all nationalities would create not a dissonance, but a consonance. Even in this apparently hopeless case, art will probably—this time in a scientific way—exert, unconsciously or involuntarily, a harmonious effect. Realizing the idea of organizing international art institutes can serve as an introduction.

IB 2. The simplest forms of the zig-zag become complex when further lines link up with the two original ones creating them. Then, the point receives not two, but several impulses, which for the sake of simplicity we can trace back to two alternating forces. The schematic type of multiple zig-zag is composed of several sections of the same length, at right angles to one another. Subsequently, the innumerable series of multiple zig-zags—is modified in two directions:

Complex zig-zags

1. by the combination of acute angles, right angles, obtuse angles, and independent angles, and
2. by varying lengths of section

Thus, a multiple zig-zag can be made up of the most diverse parts—from the simpler to the increasingly complex:

Sum of obtuse angles, having equal sections,
 ″ ″ ″ ″ ″ unequal sections,
 ″ ″ ″ ″ alternating with acute angles and having equal or unequal sections,
 ″ ″ ″ ″ alternating with right angles

and acute angles, etc. (Fig. **33**).

Fig. 33 Free multiple zig-zag.

Curve These lines are also called h e r r i n g b o n e, and represent, when their sections are of equal length, a straight line in motion. In their acute form, they indicate height and hence the vertical; if they have obtuse angles they tend toward the horizontal; but composed as described they invariably retain the infinite capacity for movement that is characteristic of the straight line.

If, in particular, a force consistently increases as an obtuse angle is being formed, and the angle is thus magnified, this shape is pulled in the direction of the plane, and especially of the circle. The affinity between the obtuse angle, the curve and the circle is not just of an external, but also of an internal nature: the passive character of the obtuse angle, its unbelligerent attitude to its environment make it tend to increasing absorption, culminating in the ultimate self-absorption of the circle.

II If two forces exert their effect simultaneously upon the point in such a way that the pressure of one force consistently exceeds that of the other to the same extent, a curved line is formed, whose archetype is the

1. simple curve

It is in fact a straight line that has been diverted from its path by consistent sideways pressure—the greater this pressure, the greater the deviation from the straight line, and the greater the build up of outward tension, and ultimately the tendency toward self-completion.

The inward difference between it and the straight line resides in the number and kind of tensions: the straight line has two distinct, primitive tensions that play an unimportant role in the case of the curve—whose main tension lies in the arc (third tension, opposed to and overwhelming both the others: Fig. **34**). While the sharpness of the angle disappears, here there is greater pent-up force, which though it may be less aggressive, conceals within itself greater stamina. There is an element of reckless youth about the angle, in the arc—mature, justly self-confident energy.

Fig. 34

Tensions in straight line and curved.

Because of this maturity, and the sonorous elasticity
of the curve, we are obliged to look for the opposite of
the straight line, not in the angle, but quite definitely
in the curve: the manner in which the curve is born
and its resulting character, i.e., the complete absence
of the straight line, compel us to assert:

the straight and the curved constitute in the case
of line the original pair of opposites (Fig. 35).

Fig. 35

The zig-zag must therefore be regarded as an intermediate element: birth—youth—maturity.

Whereas the straight line is the complete negation of the plane, the curved line bears the kernel of the plane within itself. If conditions remain unchanged, and the two forces continue to bowl the point further and further forward, the resulting curve will sooner or later arrive once more at its starting point. Beginning and end converge and at the same instant vanish without trace. The least stable and at the same time the stablest plane figure comes into being—the circle (Fig. 36).*

Fig. 36
Birth of the circle.

Fig. 37
Birth of the spiral.

*A regular variant of the circle is the spiral (Fig. 37)—the force operating from within outweighs the external force by a constant amount. A spiral is a circle that has gone off the rails evenly. For painting, however, apart from this difference, a much more vital difference can be observed: a spiral is a line, whereas a circle is a surface. Geometry fails to make this distinction, which is of prime importance for painting: apart from the circle it describes the ellipse, figure-of-eight, and comparable plane figures as lines (curves). And the description employed here, "curved," again does not correspond to more precise geometrical usage, which by its own lights has to determine fixed categories on the basis of formulas, of which painting in this respect takes no account—parabola, hyperbole, etc.

Contrast in relation to plane

In addition to its other qualities, the straight line, too, carries within itself the ambition—albeit deeply buried—to give birth to a plane figure: to transform itself into a more compact, more self-contained entity. The straight line is capable of doing so, even though here, three impulses are necessary to create a surface, by contrast with the arc, which can create a plane figure out of two forces. Only in the case of this new figure, beginning and end cannot vanish without trace, but can be distinguished in three places. On the one hand, the complete absence of straight lines and angles; on the other, three lines with three angles— these are the attributes of the two primary, most strongly contrasting plane figures. Thus, these two figures relate to one another, as

Fig. 38
The original pair of contrasting plane figures.

Three pairs of elements

Here we may proceed logically to verify various connections between the three elements of painting, interrelated in practice, separable in theory: line— plane—color.

straight line	triangle	yellow
curve	circle	blue
1st pair	2nd pair	3rd pair

600

Three original pairs of contrasting elements.

This abstract, logical structure peculiar to one form of art, which finds in this art a constant, more or less conscious application, can be compared to the logical structure found in nature, and both cases—art and nature—offer the inner man a quite special kind of satisfaction. The other arts, too, most certainly possess at bottom the same abstract, logical structure. In sculpture and architecture the element of space,* in music the element of sound, in dance the element of movement, and in poetry the element of words† —all these elements demand to be similarly sifted and summarily juxtaposed, with reference to their external and internal qualities, which I call sounds.

Other arts

The tables set forth here in the sense I have suggested must then be subjected to a precise examination, and it is perfectly possible that these individual tables will ultimately produce o n e synthetic table.

Pure conjecture, which must originally have had its roots in intuitive experience, succeeds in taking the first steps along this enticing path. Intuition alone can, however, in this instance easily lead us astray, something that can only be avoided with the help of precise analytical research. But given the right‡ method, one can steer clear of the wrong paths.

*The identity of the basic elements of scupture and architecture partly explains today's successful annihilation of sculpture by architecture.

†The nomenclature employed here for the basic elements of different arts must be regarded as provisional. Even the common terms are hazy.

‡This is a clear example of the necessary, simultaneous application of intuition and calculation.

Dictionary The progress achieved by systematic research will give birth to a dictionary of elements that, developed further, will lead to a "grammar," and finally to a theory of composition that will overstep the boundaries of the individual arts and refer to "Art" in general.*

A dictionary of a living language is not a petrified thing, since changes occur constantly: words are submerged, die; words emerge, newborn; "foreign" words are brought home from across the frontiers.

Curiously, however, a grammar of art even today appears dangerous to many, if not fatal.

Surfaces The more alternating forces that affect the point, the more diverse their directions, and the greater the difference in length between different sections of a zig-zag line, the more complex are the surfaces that are created. The number of variations is inexhaustible (Fig. **39**).

Fig. 39

*For clear indications, see *On the Spiritual* and my article "On Stage Composition" [p. 257] in *Der Blaue Reiter,* publ. Piper, Munich, 1912.

This is mentioned here to clarify the distinction between zig-zag and curve.

The likewise inexhaustible variations of surfaces owing their origin to the curve never lose their affinity, however distant, with the circle, whose tensions they carry within themselves (Fig. **40**).

Fig. 40

A number of possible variations of the curve have still to be mentioned.

II 2. A complex curve or w a v y l i n e can consist **Wavy lines**

1. of geometrical arcs, or
2. of independent sections, or
3. of various combinations of both

These three types cover all forms of curve. A few examples should confirm this rule.

Curve—geometrically undulating.
Equal radius—evenly alternating positive and nega-

tive pressure. Horizontal course with alternating increase and decrease in tension (Fig. **41**).

Fig. 41

Curve—independently undulating:
Distortion of the above, given the same horizontal extension:

1. Geometrical aspect disappears.
2. Positive and negative pressure alternate unevenly, with the former strongly dominating the latter (Fig. **42**).

Fig. 42

Curve—independently undulating.
Increased distortion. Especially spirited contest between two forces. Positive pressure attains very considerable altitude (Fig. **43**).

Fig. 43

Curve—independently undulating:
Variations of the latter:

1. Tip deflected to the left by the forceful impact of the negative thrust.
2. Tip emphasized by thickening the line—stress (Fig. **44**).

Fig. 44

Curve—independently undulating:
After the initial climb to the left, immediate, broad, definite thrust upward and to the right. Decreasing tension in leftward arc. Four waves are subordinated to an energetic impulse from lower left to upper right.* (Fig. **45**).

Fig. 45

Curve—geometrically undulating:
Contrast to the earlier geometrically undulating line (Fig. **41**)—pure ascent, with modest deviations to right and left. The sudden diminution of the waves leads to increased vertical tension. Radius from bottom to top—4, 4, 4, 2, 1 (Fig. **46**).

*More about the sound of "right" and "left" and its tensions in the chapter "Picture Plane".

The effects of right and left may be examined by holding the book in front of a mirror. Top and bottom by turning the book upside down.

The "mirror image" and "upside down" are still rather mysterious matters of great significance for the theory of composition.

Fig. 46

In the examples given, the result is produced by two kinds of factors:

1. combination of active and passive thrust

2. collaboration of sound produced by direction

Effects

To these two sound-factors we can add

3. emphasis of the line itself

This linear emphasis is a gradual or spontaneous increase or decrease in strength. A simple example renders detailed explanation superfluous:

Emphasis

Fig. 47
Ascending geometrical curve.

Fig. 48
The same, with evenly decreasing emphasis, increasing the tension of the ascent.

Fig. 49
Spontaneous emphases within a free curve (Fig. **49**).

Thickening, especially of a short, straight line, is linked with the growth of the point: here, too, the question "When does the line stop being itself and give birth to a plane surface?" remains without a precise answer. How is one supposed to answer the question "When does the river stop and the sea begin?"

The boundaries are indistinct and mobile. Here, everything depends upon proportions, just as in the case of the point—the relative reduces the sound of the absolute to imprecision. In practice, going to the limit is far more precise than in purely theoretical terms.* Taking things to the limit is a powerful possibility of expression, a mighty means (ultimately, an element) to compositional ends.

Where the principal elements within a composition are drily piquant, this is a means of producing within these elements a certain vibration, bringing a certain loosening-up into the stiff atmosphere of the whole, and if used to excess, it can lead to almost repulsive gourmandizing. At all events, here one is still entirely dependent upon feeling.

A generally accepted distinction between line and plane is for the moment impossible—a fact perhaps not unrelated to the still-backward state of painting, its today still almost embryonic character, or else perhaps determined by the very nature of this art.†

*Some of the whole-page tables in this book provide visible examples of this (see the appendix).

†The device of going to the limit extends naturally far beyond the bounds of the question of line-plane to embrace all the elements of painting in their various applications. E.g., color is far better acquainted with this device, through which it disposes of innumerable possibilities. The picture surface, too, makes use of this device, which together with other means of expression, belongs with the rules and laws of the theory of composition.

A special sound-factor of lines are

4. the outer edges of the line
which are partly formed by the emphases I have just
mentioned. In such cases, the two edges of the line are
also to be counted as two independent, external lines;
this is, however, of theoretical rather than practical
value.

The question of the outward formation of the line
reminds us of the same question asked about the
point.

Smooth, jagged, perforated, rounded—these are qual-
ities that conjure up tactile sensations even in our
imagination. For this reason, the external limits of
line, in purely practical terms, should not be underes-
timated. Line offers far more possibilities of translat-
ing its various combinations into tactile sensations
than the point: e.g., smooth edges of a jagged line,
jagged of smooth; rounded, perforated edges of jagged;
perforated edges of rounded; etc. All these qualities
can be applied to each of the three types of line—
straight, zig-zag, curved—and each of the two sides
can be given individual treatment.

III

Combined

The third and last basic type of line is the result of
combining the first two types, for which reason we
must christen it c o m b i n e d. The characteristics of
its individual sections determine its particular
character:

1. It is a geometrical combination if its component
 parts are exclusively geometrical.
2. It is a m i x e d c o m b i n a t i o n if independent
 elements join with the geometrical parts.
3. It is an i n d e p e n d e n t c o m b i n a t i o n if it is
 composed exclusively of independent lines.

Quite apart from differences in character determined by inner tensions, and quite apart from any generative processes, the fundamental source of every line remains the same—force.

<div style="text-align: right">Force</div>

The intervention of force introduces into any given material a living element, which is expressed in tension. Tensions, for their part, give expression to the inner aspect of the given element. The element is the concrete result produced by force operating upon the material. Line is the most distinct and simplest instance of this formative process, which occurs every time with logical precision, and hence permits and demands logically precise application. Thus, composition is nothing other than the logically precise organization of those living forces encapsulated within elements in the guise of tensions.

<div style="text-align: right">Composition</div>

In the end, every force can be expressed in mathematical terms, something we call mathematical expression. In art today, this remains more a theoretical assertion, but one we should not leave out of account. Today we lack the ability to take measurements, although these will, leaving the utopian aside, be discovered sooner or later. From that moment on, every composition will be capable of being expressed in numbers, even if perhaps this is true initially only of its "outlines" and its larger complexes. The rest is mainly a matter of patience, to be able to dissect larger complexes into ever smaller, more subordinate ones. Only the conquest of mathematical expression will enable us to realize fully a precise theory of composition, on the threshold of which we stand today. Simpler proportions, expressible in mathematical terms, were used in architecture, in music, and to a certain extent in poetry perhaps even thousands of years ago (e.g., the

<div style="text-align: right">Number</div>

temple of Solomon); whereas more complex ratios were unable to find mathematical expression. It is extremely tempting to work with simple proportions—something that, with some justification, corresponds especially to present-day tendencies in art. But once we have achieved this level, more complicated proportions will appear equally tempting (or perhaps even more so) and find an application.*

Interest in mathematical expression tends in two directions—the theoretical and the practical. In the former, it is the logical that plays the more important role; in the latter, the purposive. Here, logic is subordinated to purpose, so that the work attains the highest quality—that of naturalness.

Linear complexes

So far, we have classified individual lines and examined their characteristics. Various ways of using several lines, the manner of their reciprocal effect, subordination of individual lines to a group of lines or linear complex, are questions of composition, and hence overstep the limits of my present aims. Nonetheless, a few more characteristic examples are necessary, inasmuch as the nature of individual lines may be illuminated by these examples. Here, a number of combinations are shown, not in any exhaustive way, but solely as an indication of the path to more complex formations.

A few simple examples of rhythms:

*See *On the Spiritual*.

Fig. **50**. Repetition of a straight line with alternating weights.
Fig. **51**. Repetition of a zig-zag.
Fig. **52**. Face-to-face repetition of zig-zag, forming a surface figure.
Fig. **53**. Repetition of a curve.
Fig. **54**. Face-to-face repetition of a curve, repeated creation of a surface figure.
Fig. **55**. Centralized, rhythmic repetition of a straight line.
Fig. **56**. Centralized, rhythmic repetition of a curve.
Fig. **57**. Repetition of a stressed curved by another passing through it.
Fig. **58**. Opposing repetition of a curve.

Fig. 50

Fig. 51

Fig. 52

Fig. 53

Fig. 54

Fig. 55

Fig. 56

Fig. 57

Fig. 58

Repetition　　The simplest case is the exact repetition of a straight line at equal intervals—primitive rhythm (Fig. **59**), or at evenly increasing intervals (Fig. **60**), or at unequal intervals (Fig. **61**).

Fig. 59

Fig. 60

Fig. 61

The purpose of the first species of repetition is, first and foremost, a quantitative increase, as is achieved, e.g., in music by reinforcing the sound of one violin by that of many violins.

The second species, apart from quantitative reinforcement, has overtones of the qualitative, which in music corresponds roughly to a repetition of the same bars after a long pause, or a repeat marked *piano*, being a qualitative modification of the phrase.*

The third species, where a more complicated rhythm is employed, is more complex.

With zig-zag lines, and especially with curved lines, significantly more complex combinations are possible.

<div align="right">Fig. 62</div>

Conflicting combination of curved line with zig-zag. The qualities of each take on a stronger sound.

*Repetition by other instruments at the same pitch must be seen as a qualitative color modification.

Fig. 63
Curved lines running together.

Fig. 64
Diverging.

In both cases (Fig. **63** and **64**) we find quantitative and qualitative increase, but which have something soft, velvety about them, so that the lyrical predominates over the dramatic. For the opposite case, this species of displacement is inadequate: the contrast cannot achieve its full resonance.

Naturally, such—in fact, independent—complexes can be subordinated to other, still larger ones, which themselves form only part of the overall composition—in much the same way that our solar

system forms only one point within the cosmos as a whole.

The overall harmony of a composition can thus reside in a number of complexes that themselves scale the heights of contrast. These contrasts can even have a disharmonious character; nonetheless, if correctly used they will affect the overall harmony not in a negative, but in a positive way, lifting the work to the highest level of harmonic being.

Composition

In general, the element of time can be recognized to a far greater extent in the case of line than in that of point—extension being a temporal concept. On the other hand, the course of a straight line is, temporally speaking, different from that of a curve, even if they are of the same length, and the more agitated a curved line is, the greater is its extension in time. There exist, therefore, in line manifold possibilities of exploiting time. The application of time in the case of horizontal and vertical lines is, given the same length, of a different inner hue, and perhaps in reality it is a case of different lengths, which would at all events be explicable in psychological terms. Thus, the element of time must not be overlooked in pure linear composition and in the theory of composition must be subjected to a thorough examination.

Time

Just like the point, the line is, apart from painting, also used in other arts. Its essence can be more or less exactly translated by the resources of other arts.

Other arts

It is well known what a musical line is (see Fig. 11).* Most musical instruments have a linear charac-

Music

*Line grows organically from points.

ter. The pitch of the different instruments corresponds to the breadth of a line: violin, flute, and piccolo produce a very thin line, viola and clarinet a somewhat thicker one; and by way of the lower instruments, one arrives at broader and broader lines, right down to the lowest notes of double bass or tuba.

Apart from its breadth, various colors of line are produced by the manifold colors of the different instruments.

The organ is just as much a typical line-instrument as the piano is a point-instrument.

It may be suggested that in music, line offers the greatest store of expressive resources. Here, line operates in exactly the same temporal and spatial way as is to be seen in painting.* How time and space relate to one another in these two arts is another question. The differences between them have perhaps given rise to exaggerated disquiet, with the result that the concepts time-space and space-time have been so widely separated from one another.

The scale of values from *pianissimo* to *fortissimo* can be expressed by increasing or decreasing intensity of line, or by its degree of lightness. The pressure of the hand upon the bow corresponds perfectly to the pressure of the hand upon the pencil.

It is especially interesting and significant that our present way of commonly representing music by graphic means—musical notation—is nothing other

*In physics, special apparatus is used to measure pitch, which projects the sound vibrations onto a surface, thus giving musical sound a precise, graphic form. A similar method is used for color.

Thus even today, the science of art can, in many important instances, make use of exact graphic translations as material for the synthetic method.

than different combinations of points and lines. Time is to be identified exclusively from the color of the dots (in fact, only black and white, leading to a limitation of resources) and the number of strokes (lines) joining their tails. Pitch, too, is indicated by lines, the five horizontals of the stave forming the basis. One can learn a great deal from the complete conciseness and simplicity of these elements of translation, which in the clearest possible language transmit to the trained eye (and indirectly to the ear) the most complex sound phenomena. Both these qualities are extremely enticing for the other arts, and one can understand why painting or dance are on the lookout for their own "notation." But here, too, there is only one way—analysis in terms of basic elements, so as to attain ultimately one's own means of graphic expression.*

In dance the whole body, in modern dance every finger, draws lines with a very precise expression. The "modern" dancer moves across the stage in exact lines, which he incorporates as an essential element into the composition of his dance (Sakharov). Apart from which, the dancer's entire body, right down to the fingertips, is at every moment a continuous linear composition (Palucca). Use of line is perhaps a new achievement, but not of course the invention of "modern" dance; classical ballet aside, all races at every stage of their "development" work with line in their dance.

Dance

*The relationship between pictorial resources and the resources of other arts, and ultimately the phenomena of other "worlds," can be indicated here only in an entirely superficial way. In particular, the possibilities of "translation" in general—turning different phenomena into the appropriate linear ("graphic") and colored ("painterly") forms—demand a detailed study—linear and colored expression. In principle, it cannot be doubted that every phenomenon in every world permits of such an expression—the expression of its inner being—whether it be a thunderstorm, J. S. Bach, fear, a cosmic event, Raphael, toothache, some "exalted" or "debased" phenomenon, or an "exalted" or "debased" experience. The only danger would be that of hanging upon the external form and ignoring the content.

Sculpture, architecture

As far as the role and significance of line in sculpture and in architecture are concerned, there has been no need here to hunt for proofs—any construction in space is, at the same time, linear construction.

An extremely important task for art-scientific research would be an analysis of the fate of line in architecture, at least in the typical works of different races at different times and, linked with it, a purely graphic translation of these works. The philosophical justification of this research would be to establish the relationship between graphic formulas and the spiritual atmosphere of a given period. For today, the final chapter would be the logically necessary limitation to horizontal-vertical, together with the conquest of space by means of the projecting, upper parts of the building, made possible by the greater and more secure resource of present-day building materials and techniques. The structural principle I have described must, according to my terminology, be classed as cold-warm or warm-cold—according to the emphasis upon horizontal or vertical. A number of important works have, within a short space of time, been created after this principle, and continue to rise in the most diverse countries (Germany, France, Holland, Russia, America, etc.).

Poetry

The rhythmic forms of verse are expressible by means of straight and curved lines, which exactly express in graphic terms the logical, metrical alternation of verse. Apart from this precise rhythmic extension, verse develops in the course of delivery a certain musical-melodic line, which in vacillating, variable form expresses rising and falling, increase and decrease in tension. This line is fundamentally law-governed, since it is bound up with the literary content of the verse—tension and release are matters of content. The variable element, that which deviates

from the law-governed line, depends (with greater freedom) upon the speaker, just as in music the variable element of volume (*forte* and *piano*) is dependent upon the performing artist. This imprecision that affects the musical-melodic line is not so dangerous for "literary" verse. It is fatal to an abstract poem, since here the line of pitch-values represents an essential, decisive element. For this kind of poetry, a system of notation ought to be found that could indicate the pitch as precisely as the system of musical notation. The question as to the possibility and limits of abstract poetry is a complex one. I should only mention that abstract art has to reckon with a more precise form than representational art, and that the question of pure form is in the first instance essential, in the second sometimes incidental. I have discussed the same difference with reference to use of the point. As has already been said above, the point is—silence.

In the neighboring area of art—the art of the engineer and its closely associated technology—line gains increasingly in importance (Figs. **65** and **66**).

Technology

As far as I know, the Eiffel Tower in Paris was the most significant early attempt to create a particularly tall building out of lines—line having ousted surface.*

*In technology, a special and extremely important case is the use of line to express figures graphically. Automatically produced graphs (such as those used in meteorological observations) are a precise, graphic representation of increasing or decreasing force. This representation minimizes the need to use figures—which are partly replaced by line. The resulting tables can be easily read, and are accessible even to the layman (Fig. **67**).

Fig. 65
Diagram of a sailing ship. Linear structure for
the purpose of movement (ship's hull and rigging).

Fig. 67
Curve produced by re-formation of current. From
Physik in graphischen Darstellungen, by Felix Auer-
bach, Verlag Teubner.

The same method—expressing a process of development or a momentary state by a
linear graph—has been used in statistics for years, although the tables (diagrams) have
to be produced by hand, and are the result of arduous, pedantically executed toil. This
method is also used in other sciences (e.g., astronomy, "light curve").

Fig. 66
Skeleton of cargo-carrying motor-vessel.

Fig. 68
Radio tower, seen from below (photo by Moholy-Nagy).

Fig. 69
Pylons.

Fig. 70
A room at the Constructivist Exhibition in Moscow,
1921.

The joints and screws are points in these linear constructions. These are line-point constructions, not on the surface, but in space (Fig. **68**).*

"C onstructivist" works of recent years are for the most part, and especially in their original form, "pure" or abstract constructions in space, without practical application or purpose, something that distinguishes these works from the art of the engineer and compels us to ascribe them to the realm of "pure" art. The forceful use of and marked emphasis on line, in combination with a nexus of points, are striking in these works (Fig. **70**).

Constructivism

The use of line in n a t u r e is extremely frequent. This subject, which deserves a special examination, could be mastered by a scientist-scholar of synthetic leanings. It would be especially important for the artist to see how the independent realm of nature uses the basic elements: which elements are given consideration, what qualities they possess, and how they are formed into combinations. The compositional laws of nature give artists the possibility not of external imitation, which they not infrequently see as the main purpose of natural laws, but of juxtaposing these laws with those of art. In this point, which is of decisive importance for abstract art, we now discover again the law of opposition and of juxtaposition. This law gives rise to two principles—the principle of parallelism and the principle of contrast—in the same way as has been shown in the case of combinations of lines. The thus divided and independently existing

Nature

*A special kind of technical construction offers an instructive instance—pylons erected to carry electricity across a distance (Fig. **69**). Here, one has the impression of a "technological forest," resembling a "natural forest" of palms or firs pressed flat. The linear construction of such a pylon employs only the two basic linear elements—line and point.

laws of these two great realms—art and nature—will lead ultimately to an understanding of the general law of world-composition, and reveal the independent operation of each within a higher synthetic order—External + Internal.

Until today, this viewpoint has been clearly expressed only in abstract art, which has recognized its privileges and obligations, and no longer props itself up on the outer shell of natural appearances. It need not be repeated here that "objective" art subordinates this outer shell to inner purposes—it is impossible to transform utterly the inner element of one realm into the outer of another.

Line occurs in nature in countless guises: in the mineral, plant, and animal worlds. The diagrammatic structure of a crystal (Fig. **71**) is a pure linear form (e.g., in plane form—an ice crystal).

Fig. 71
"Trichites"—hair-shaped crystals. "Crystal skeleton."
(Dr. O. Lehmann, *Die neue Welt d. Flüssigen Kristalle*, Leipzig, 1911, pp. 54–69.)

The whole development of the plant, from seed to root (downward) to sprouting stem (upward)* proceeds from point to line (Fig. **73**), leading in due course to more complicated linear complexes, to independent linear constructions, as in the network of veins on a leaf, or the eccentric construction of the pine tree (Fig. **74**).

Fig. 72
Diagram of leaf positions (growing points of successive leaves on the shoot).
"Grundspirale" (*K.d.G.*, Botan. Teil, T. III, Abtlg. IV/2).[10]

Fig. 73
Plants swimming by means of their "tails" [*flagella*].
(*K.d.G.*, T. III, Abtlg. IV/3, p. 165).

*The way in which the leaves grow from the stem occurs in the most precise possible way, which can be expressed by a mathematical formula—mathematical expression—and which science schematizes in the form of a spiral (Fig. **72**). Cf. above, the geometrical spiral, p. 599, Fig. **37**.

The organic linear development of the branch proceeds invariably from the same basic principle, yet displays the most diverse combinations (e.g., among trees alone: fir tree, fig tree, date palm, or the utmost confusion of the liana and other various creepers).

Geometrical and loose structure

Many of the complexes produced by animals are, on the other hand, of a clear, precise, geometrical nature, and remind one vividly of geometrical construction, such as the amazing form of the spider's web. Yet others are of the "independent" variety, composed of independent lines, their loose structure displaying no precise geometrical construction. Not, of course, that the fixed and precise are excluded, but simply deployed in another way (Fig. 76). Likewise, both forms of construction occur in abstract painting.*

*There are two reasons why, in recent years, precise geometrical construction in painting has seemed so important to artists: (1) the necessary and natural use of abstract color in architecture, which had suddenly "awakened," where color plays a subordinate role to general purpose, something for which "pure" painting had unwittingly prepared itself with its "horizontal-vertical"; and (2) the naturally arising need, which has carried painting along with it, to reach back to elementary [forms], and to seek the elementary not simply in the elementary itself, but in its structure. Art aside, this striving makes itself noticed in the attitude of "modern" man toward more or less every realm of activity, marking a transition from primary to complex, which sooner or later will be definitely accomplished. Abstract art, despite its emancipation, is subject here also to "natural laws," and is obliged to proceed in the same way that nature did previously, when it started in a modest way with protoplasm and cells, progressing very gradually to increasingly complex organisms. Today, abstract art creates also primary or more or less primary art-organisms, whose further development the artist today can predict only in uncertain outline, and which entice, excite him, but also calm him when he stares into the prospect of the future that faces him. Let me observe here that those who doubt the future of abstract art are, to choose an example, as if reckoning with the stage of development reached by amphibians, which are far removed from fully developed vertebrates and represent not the final result of creation, but rather the "beginning."

Fig. 74
Clematis blossom (photo by Katt Both, Bauhaus).

Fig. 75
Linear formation of lightning.

Fig. 76
"Loose" connective tissue of the rat.
(*K. d. G.*, T. III, Abtlg. IV., p. 75.)

This affinity, one might even say "identity," is a persuasive example of the relationship between the laws of art and those of nature. One should, however, refrain from drawing false conclusions from such instances: the difference between art and nature lies not in their underlying laws, but in the material that is subject to these laws. Likewise, the fundamental characteristics of the material, different in each case, should not be left out of account: what is recognized today as the primary element in nature—the cell—is in a state of constant motion; whereas the primary element of painting—the point—is motionless, in repose.

The skeletons of different animals, in their ascent toward the highest form known today—man—display the most diverse forms of linear construction. These variations leave nothing to be desired as far as "beauty" is concerned, and constantly surprise one by their multiplicity. Most surprising of all is the fact that these jumps, from giraffe to toad, from man to fish, from elephant to mouse, are nothing other than variations on one theme, and that these endless possibilities are derived exclusively from the one principle of concentric construction. The creative force here has to observe definite natural laws, which rule out the eccentric. Such natural laws do not determine the course of art, and the path of the eccentric remains for art entirely free and untrammeled.

Thematic structure

A finger grows from the hand in exactly the same way a twig must grow from the branch—according to the principle of gradual development from the center (Fig. 77). In painting, a line can lie "freely," without externally subordinating itself to the whole, without any external relationship to the center—its subordination is here of an internal nature. Even this simple fact should not be underestimated in any analysis of the relationship between art and nature.*

Art and nature

*Within the narrowly defined limits of this book, these important questions can only be touched on: they belong to the theory of composition. Here, it is necessary only to emphasize that the elements are the same in different creative spheres, and that differences reveal themselves only in the manner of construction. Here, too, the examples used are to be regarded merely as such.

Fig. 77
Diagram of the extremity of a vertebrate.
Terminal part of centralized structure.

The basic difference is the purpose, or more precisely, the means employed for that purpose; for the purpose must, in relation to man, ultimately be the same both in art and nature. At all events, in neither the one nor the other is it advisable to take the shell for the nut.

As far as means are concerned, art and nature move, in relation to man, on different paths, widely separated from one another, even if they tend toward the same point. We should be completely clear as to the difference.

Each variety of line seeks the appropriate external means of incarnation on each occasion—to wit, on the basis of the general economic principle: minimum effort for maximum return.

The material characteristics of the "graphic" arts, discussed in the chapter on point, relate in the same general way to line, being the immediate natural consequence of the point: ease of execution in the case of etching (especially line etching), the line being deeply embedded; careful, arduous work in the case of woodcut; a simple laying upon the surface in the case of lithograph.

Graphics

It is interesting here to make several observations regarding these three technical processes and their degree of popularity.

The sequence is:

1. woodcut—surface, easiest result
2. etching—point, line
3. lithograph—point, line, surface.

This is the rough hierarchy of artistic preference for the various elements and their corresponding techniques.

1. After a long period of interest in easel painting, during which graphic techniques were, as a result, undervalued (and in many cases despised), there has been a sudden awakening of interest in forgotten, and especially German woodcuts. Woodcut is initially cultivated only on the side, as an inferior species of art, until eventually it becomes more widespread and prevalent, creating the special type of the German graphic artist. Other reasons aside, this fact is inwardly closely linked to the surface, which at this period demands close attention—the age of planar or surface art. The plane, the principal means of expression of painting at that time, soon after conquered sculpture, which became planar sculpture. Today, it is clear that this stage of development in painting, and at almost the same time—about thirty years ago—in sculpture, was a then-unconscious leaning

Woodcut

toward architecture. Hence the above-mentioned "sudden" awakening in the art of building.*

Line in painting

It goes without saying that painting must once again occupy itself with its other principal resource—line. This occurred (and is still occurring) in the guise of a normal development of expressive means, a calmly advancing process of evolution that was initially taken for revolution, and still is by many theoreticians today, especially as regards the use of abstract line in painting. Insofar as abstract art is recognized by these theoreticians, they judge the use of line in graphics favorably, but condemn its use in painting as contrary to its nature, hence unallowable. This instance, too, is illuminating as a characteristic example of conceptual confusion: what is easily distinguished, separated, is muddled up (art, nature); while on the contrary, what belongs together (in the present case, painting and graphics) is painstakingly divorced. Line is here reckoned as a "graphic" element, that may not be employed for "painterly" ends, although no essential difference between "graphics" and "painting" can be found, and thus could never be established even by the above-mentioned theoreticians.

Etching

2. Of the available techniques, etching is best able to produce with the utmost precision the kind of line that is firmly embedded in the material, and in particular, very thin lines. For this reason, it was salvaged from the old storage chest. And our incipient search for elementary forms leads necessarily to the thinnest line, which, viewed abstractly, is an "abso-

*An example of the seminal influence of painting on the other arts. Detailed work on this subject would certainly lead to surprising discoveries in the history of the development of all the arts.

lute" sound among lines.

There is, on the other hand, another consequence of the same penchant for the primary—the most exposed possible use of one half of the total form, while excluding the other.* In etching, especially, given the difficulties encountered by the use of color, it is quite natural to limit oneself to purely "linear" form, with the result that etching is a specifically black-and-white technique.

3. Lithography—the most recent discovery in the sequence of graphic techniques—offers the greatest flexibility and elasticity of handling.

Lithography

Particular rapidity of execution, linked to the almost indestructible solidity of the plate, corresponds perfectly to the "spirit of our times." Point, line, plane, black-and-white, colored works—all this can be attained with the utmost economy. The flexibility with which one can treat the lithographic stone, i.e., the ease of application with any implement, and the almost unlimited possibility of making corrections— especially the eradication of mistakes, something that neither woodcut nor etching willingly permits—and hence the ease of execution of works without any exact preliminary plan (e.g., in the case of experiments)—all this corresponds in the highest degree to present-day necessity, not just external, but internal.

Ultimately, one of the partial aims of this book has been to discover and illuminate, in the course of our logical progression toward the primary elements, the particular qualities of the point. For this, too, lithog-

*E.g., the elimination of color, or at least its reduction to minimum volume in a number of Cubist works.

raphy places its wealth of resources at our disposal.*

Point—repose. Line—inner tension, derived from motion. Both elements—intersections, juxtapositions that create their own "language," unattainable in words. Cutting out the "frills," which muffle and obscure the inner sound of this language, gives pictorial expression the utmost conciseness and the utmost precision. Pure form offers its services to living content.

*It should be mentioned further that these three techniques have a social value and relate to social forms. Etching is certainly of an aristocratic nature: it can produce only a small number of first-rate pulls, which, moreover, turn out differently each time, so that every print is unique. Woodcut is more generous and more egalitarian, but poorly adapted to the use of color. Lithography, on the other hand, is capable of churning out in a purely mechanical way an almost unlimited number of prints at top speed. By the constantly developing use of color, it approximates more and more to the hand-painted picture, and at all events provides a kind of substitute for a picture. This clearly indicates the democratic nature of lithography.

PICTURE PLANE

By plane we understand that material plane which is called upon to accomodate the content of the work of art.

Concept

It is referred to here as the P[icture] P[lane].

Schematically, the PP is bounded by two horizontal and two vertical lines, and thus delineated within its environmental sphere as an independent entity.

According to the characterization of horizontal and vertical we have given, the basic sound of the PP must become clear of its own accord: two elements of cold repose and two elements of warm repose make a double, two-part chord of repose, determining the tranquil (= objective) sound of the PP.

Pairs of lines

The preponderance of one or the other pair, i.e., the predominant breadth or predominant height of the PP, determines in each case whether the objective sound will be predominantly cold or warm. Thus, individual elements are, from the very beginning, introduced into a colder or warmer atmosphere, a condition that later the greatest number of opposing elements cannot entirely negate. One should never forget this fact, which naturally affords numerous compositional possibilities. E.g., an accumulation of energetic, upward-striving tensions on a colder PP (horizontal format) will invariably "dramatize" these tensions to a greater or lesser extent, since confinement here exerts a particular power. This kind of confinement, if taken beyond the limits, can give rise to painful, even unbearable sensations.

The most objective form of the schematic PP is the s q u a r e—each of the two pairs of boundary lines possesses the same strength of sound. Cold and warm are

Square

relatively balanced.

Combining the most objective PP with one single element that likewise embodies the utmost objectivity results in a chill resembling death—which can serve as a symbol of death. It is no coincidence that our own age has afforded such examples.

But the "perfectly" objective combination of a "perfectly" objective element with the "perfectly" objective PP may only be conceived of in relative terms. Absolute objectivity cannot be attained.

Nature of the PP

And this depends not merely upon the nature of the single elements, but upon the nature of the PP itself, which is immeasurably important and must be regarded as a fact independent of the artist's powers.

This fact is, on the other hand, a source of great compositional possibilities—means to an end.

To which the following simple data are basic.

Sounds

Every schematic PP produced by two horizontal and two vertical lines, correspondingly has four sides. And each of these four sides develops a sound peculiar to itself, which goes beyond the limits of warm or cold repose. On each occasion, therefore, a second sound is associated with the sound of warm or cold repose, being immutably and organically linked to the position of the line-boundary.

The position of the two horizontal lines is above and below. The position of the two vertical lines is right and left.

The fact that every living being stands and must necessarily remain in a constant relationship to "above" and "below" applies equally to the PP, which is itself a living being as such. This can also be explained partly in terms of association, or the imposing of our own observations upon the PP. One must, however, presume that this fact has deeper roots—a living being. This assertion may sound foreign to the ears of a nonartist. One can, however, take for granted that every artist can hear the "breathing" of the still untouched PP—albeit unconsciously—and that he will feel—more or less consciously—responsible for its existence, knowing that wanton ill-treatment smacks of murder. The artist "inseminates" this being, and knows how logically and "joyously" the PP accepts the right elements in the right order. This admittedly primitive, but living organism becomes, if correctly treated, transformed into a new, living organism that is no longer primitive, but manifests all the characteristics of a developed organism.

Above and below

"Above" conjures up an image of greater rarification, a feeling of lightness, of emancipation, and ultimately, of freedom. Each of these three qualities produces overtones having in each instance a slightly different coloration.

Above

This "rarification" negates density. The nearer to the upper limits of the PP, the more scattered appear the smallest individual planes.

"Lightness" further intensifies this inner quality— the smallest individual planes are not just more widely separated from one another; they themselves lose in weight and even more in solidity. All heavier forms, when placed within this upper part of the PP, gain in weight. Their heavy sound is thus reinforced.

"Freedom" produces the impression of greater ease of "movement,"* and tensions can here be more easily dissipated. "Rising" and "falling" gain in intensity. Constraint is reduced to a minimum.

Below "Below" has entirely the opposite effect: density, weight, bondage.

As one approaches more toward the lower limit of the PP, the atmosphere becomes denser, and the smallest individual planes lie closer and closer together, enabling them to support larger and heavier forms with increasing ease. These forms lose in weight, and their heavy sound is diminished. "Rising" becomes more difficult—the forms appear to tear themselves loose by force, and the grating noise produced by friction is almost audible. Upward effort and restrained "falling" downward: freedom of "movement" is increasingly limited. Costraint attains its maximum.

These characteristics of the upper and lower horizontals, whose dual sound constitutes the ultimate contrast, can be further intensified for "dramatic" purposes. The most natural way of achieving this is by a certain accumulation of heavier forms below and lighter ones above. The pressure, or the tension, in each direction is thus significantly increased.

The reverse is also true: these characteristics can be partially balanced, or at all events toned down— naturally enough by using the opposite means: heavier forms above, lighter ones below. Or, given the case of tensions, these can be oriented so as to operate from above to below, or from below to above. This likewise creates relative equilibrium.

*Terms such as "movement," "rising," "falling," etc., are derived from the material world. On the pictorial PP they are to be understood as the tensions residing in [individual] elements, themselves modified by the tensions of the PP.

These possibilities may be represented in quite schematic form as follows:

1. Instance—"dramatization"

	PP-weight	**2**
above		
	form-weight	**2**
		4

4 : 8

	PP-weight	**4**
below		
	form-weight	**4**
		8

2. Instance—"equilibrium"

	PP-weight	**2**
above		
	form-weight	**4**
		6

6 : 6

	PP-weight	**4**
below		
	form-weight	**2**
		6

Perhaps one can assume that we shall in time discover the possibility of taking measurements, in the sense defined above, with more or less complete accuracy. Then at least the rough formulas I have just produced in diagrammatic form could be corrected so as to show clearly the relative aspect of this "equilibrium." But the means of measurement at our disposal are still excessively primitive. Today one can, e.g., scarcely imagine how the weight of a scarcely visible point might be expressed in exact numbers. Precisely because the term "weight" does not corre-

spond to material weight, but rather expresses an inner force, or in our case an inner tension.

Right and left

The position of the two vertical boundary lines is to right and left. These are tensions whose inner sound is determined by warm repose, and which we associate in our minds with ascent.

Thus to the two [elements] of cold repose, each with its different coloration, we must add two warm elements that, by definition, cannot be identical.

Here at once, the question crops up: Which side of the PP should we regard as the right, and which as the left? Strictly, the right side of the PP ought to be that which is opposite our own left side, and vice versa— as in the case of every other living being. If this is really so, then we should be able easily to ascribe to the PP our own human characteristics, and thus be in a position to define the two sides of the PP in question. With the majority of mankind, the right side is the more developed and hence the freer, whereas the left is more limited and constrained.

With the sides of the PP the reverse is, however, the case.

Left

The "left" of the PP conjures up an image of greater rarification, a feeling of lightness, of emancipation, and ultimately, of freedom. Thus, the characteristics of "above" are here repeated exactly. The main difference is solely one of degree. The "rarification" of "above" necessarily manifests a higher degree of dispersion. To the "left" are more elements of density, but the contrast with "below" is still considerable. In lightness, "left" likewise defers to "above," but the weight of "left" is far less than that of "below." Similarly with emancipation; and "freedom" is more constrained on the "left" than "above."

What is especially important is that, with "left," these three qualities themselves vary in degree, so that, starting from the middle, they increase in an upward direction, and lose their sound in a downward direction. Here, "left" is, so to speak, infected by "above" and "below," which is of particular significance for the two angles formed by "left" on the one hand, and "above" and "below" on the other.

On the basis of these facts, it is easy to draw a further parallel with man—increasing emancipation from below to above, to wit on the right-hand side.

We may thus assume that this parallel is a genuine parallel between two kinds of living being, and that the PP must indeed be understood and treated as just such a being. But since in the course of work the PP is still completely joined to the artist and cannot be separated from him, it must be imagined as a kind of reflection of himself, so that the left side is its right. Hence, it is clear that I must stick to the accepted definition: here, the PP is treated not as part of a finished work, but simply as the plot upon which the work is to be erected.*

*It seems that this attitude later applies to the finished work, probably not so much in the case of the artist himself as in that of the objective observer, although to some extent the artist must also be counted as such, as when, e.g., he adopts the position of an objective observer with respect to the works of other artists. But perhaps this view—what lies in front of me to my right is the "right"—is to be explained in terms of the genuine impossibility of relating to the work wholly objectively, and completely excluding the subjective.

Right

Just as the "left" of the PP is inwardly akin to "above," so "right" is to some extent the continuation of "below"—a continuation characterized by the same diminution. Density, weight, bondage all decrease, but nonetheless these tensions encounter a resistance that is greater, denser, and harder than that of "left."

But just as with "left," this resistance is divided into two parts—starting from the middle, it increases in a downward direction and loses strength in an upward direction. Here, the same influence exerts itself upon the formation of the corners that we noticed in the case of "left"—the upper right-hand corner and the lower.

Literary

Bound up with these two sides is a specific feeling that is to be explained in terms of the characteristics described above. This feeling has a "literary" aftertaste, which once again discloses profound affinities between the different arts, giving us a sense of the extremely deep, common root that all the arts—and ultimately, all spiritual realms—share. This feeling is the result of the two sole possibilities of movement open to man, which despite their different combinations, are in fact only two.

Distance

Movement to the "left"—toward freedom—is movement toward the far-away. Man distances himself from his habitual environment, liberates himself from those conventions that weigh down upon him, restricting his movements with their almost petrifying atmosphere, and breathes more and more fresh air. He goes in search of "adventure." Those forms whose tensions are directed toward the left have, as a result, something "adventurous" about them, and the "movement" of these forms increases continually in speed and intensity.

644

Movement to the "right"—toward captivity—is a homeward movement. This movement is associated with a certain weariness, and its aim is repose. The nearer to the "right," the slower and more torpid is this movement—thus, the tensions of forms that tend toward the right continually diminish, and the possibility of movement becomes increasingly limited.

If one needs a corresponding "literary" term for "above" and "below," association immediately leads one to think of the relation between heaven and earth.

Thus, the four boundaries of the PP can be represented as follows:

Sequence	Tension	"Literary"
1. above	toward	heaven,
2. left	toward	distance,
3. right	toward	home,
4. below	toward	earth.

One should not imagine that these relationships are to be understood literally, and in particular, one must not think that they can determine the compositional idea. Their purpose is to represent analytically the inner tensions of the PP and to make us conscious of these tensions. This is something that, as far as I know, has never before been put into clear form, although it must be considered an important component of any future theory of composition. Here, I can only remark in passing that these organic qualities of the surface apply equally to space, although the concept of space in front of the individual and space around the individual—despite their inner kinship—will manifest certain differences. A chapter in itself.

At all events, as one approaches each of the four boundaries of the PP, one detects a certain resistance, which firmly divorces the unity of the PP from the surrounding world. Thus, the proximity of a form to the edge subjects it to a specific influence, which is of decisive importance in the composition. The edges are distinguished from one another by their varying degree of resistance, which can, e.g., be represented graphically, as in Fig. 77.

Fig. 77
Varying resistance of the four sides of a square.

Or these resistances can be translated into tensions, being expressed graphically by the distortion of the angles.

Fig. 78
External expression of the square, four angles of 90°.

Fig. 79
Internal expression of the square,
e.g., angles of 60°, 80°, 90°, 130°.

At the beginning of this section, the square was dub- **Relative**
bed the "most objective" form of the PP. Further
analysis has, however, clearly shown that here, too,
objectivity can only be understood as relative, and the
"absolute" cannot be attained. In other words, the
point only offers perfect "repose" as long as it re-
mains isolated. Horizontals and verticals in isolation
have, so to speak, a colored repose, since warmth and
cold are to be conceived as colored. Thus, the square,
too, must not be characterized as a colorless form.*

Of planar forms, it is the circle which inclines most **Repose**
to colorless repose, because it is the product of two
forces that always operate equally, and knows noth-
ing of the violent aspect of the angle. Accordingly, a
point in the middle of a circle is the most complete
repose that can be attained by the point when no
longer in isolation.

As has been indicated already, the PP can, in princi-
ple, afford two typical possibilities as regards the

*Not for nothing is the affinity between square and red so marked: square ⇄ red.

elements it bears:

1. The elements lie relative to the PP in so material a way, that they particularly emphasize the sound of the PP or,
2. They are so loosely associated with the PP that its sound is almost inaudible, disappears, so to speak, and the elements "hover" in space, although it has no precise limits (especially as regards depth).

This discussion of these two cases belongs to the theory of composition and construction. The second case, in particular—the "annihilation" of the PP—can only be explained clearly in conjunction with the inner qualities of the individual elements: the way in which the formal elements advance and recede extends the PP forward (toward the spectator) and backward into depth (away from the spectator) so that the PP is pulled in both directions like an accordion. Color elements possess this power in extreme measure.*

Formats

If a diagonal is drawn across the square PP, this diagonal stands at an angle of 45° to the horizontal. As the square PP is transformed into other rectangular shapes, this angle increases or decreases. The diagonal tends increasingly toward the vertical or toward the horizontal. For this reason, it may be thought of as a kind of tension meter (Fig. **80**).

*See *On the Spiritual in Art.*

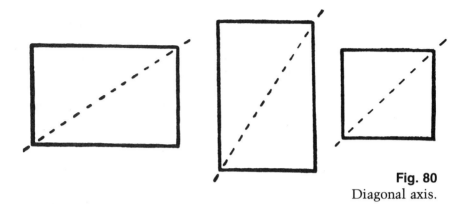

Fig. 80
Diagonal axis.

It is in this way that so-called upright and tilted formats come about, which in "representational" painting have for the most part a purely naturalistic significance, remaining untouched by [this] inner tension. Even in art school one got to know the upright format for portraits, and the tilted format for landscapes.* These definitions had become especially entrenched in Paris, and it was presumably from there that they were transplanted to Germany.

Abstract art

It is perfectly clear that in compositional, and especially in abstract art, the slightest deviation of the diagonal, or tension meter, from the vertical or the horizontal is decisive. As a result, all the tensions of individual forms upon the PP take on, in each instance, a different direction, and naturally have a different coloration each time. But the complexes of forms, too, are either compressed upward or extended outward. Thus, a careless choice of picture format can turn a well-conceived order into repellent confusion. Of course, by "order" I understand here not

*Naturally, the nude demanded a particularly tall vertical format.

Structure simply mathematical "harmony," where the disposition of all the elements is clearly calculated, but also construction according to the principle of contrast. Upward-striving elements can, e.g., be "dramatized" by the use of a horizontal format, which introduces them into a restricted milieu. I mention this simply as a pointer toward the theory of composition.

Further tensions The point at which two diagonals cross determines the center of the PP. A horizontal drawn through this center and then the vertical divide the PP into four primary areas, each of which has its own specific visage. They all touch with their points at the "neutral" center, from which tensions stream forth in diagonal direction (Fig. 81).

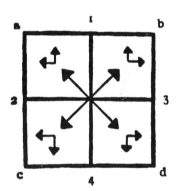

Fig. 81
Tensions from the center.

The numbers 1, 2, 3, 4 refer to the degree of resistance of the boundaries. a, b, c, d indicate the four primary areas.

Contrasts From this schema we may deduce the following:

650

Area *a* —tension toward 1, 2 = loosest combination.
Area *d* —tension toward 3, 4 = greatest resistance.

Thus, areas *a* and *d* stand in the g r e a t e s t c o n t r a s t
to one another.

Area *b* – tension toward 1, 3 = moderate upward
resistance,
Area *c* – tension toward 2, 4 = moderate downward
resistance.

Thus, areas *b* and *c* stand in m o d e r a t e c o n t r a s t
to one another, and their affinity can easily be recog-
nized.

In combination with the different degrees of resis-
tance of the boundaries of the surface, the following
schema of weights is produced (Fig. 82).

Fig. 82
Division of weights.

The combination of these two facts is decisive, and
answers the question, which of the diagonals—*bc* or
ad—should be called the "harmonic" and which the

"unharmonic" (Fig. **83**).*

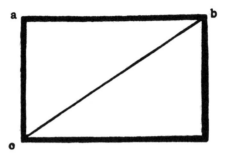

Fig. 83
"Harmonic" diagonal.

Fig. 84
"Unharmonic" diagonal.

*Cf. Fig. **79**—axis deviating toward upper right-hand corner.

The triangle *abc* definitely lies more lightly upon the lower one than the triangle *abd,* which exerts a certain pressure, bearing down heavily upon the lower. This pressure is concentrated particularly upon point *d,* so that the diagonal appears to have a tendency to deviate upward from point *a,* being thus displaced from the center. By comparison with the tranquil repose of *cb,* the tension *da* is complex in nature—to the purely diagonal direction is added an upward attraction. These two diagonals can, therefore, also be characterized differently:

Weight

cb —"lyrical" tension
da —"dramatic" tension

These terms are of course to be understood only as arrows pointing in the direction of inner content. They are bridges from the external to the internal.*

Content

At all events, we may repeat: Every point of the PP is unique, having its own individual voice and inner coloration.

The analysis of the PP employed here is an example of the principles of that scientific m e t h o d destined to participate in the construction of the nascent science of art. (This is its theoretical value.) The following simple examples point the way to its practical application.

Method

A simple, wedge-shaped form, which represents the transition from line to surface and hence unites within itself the characteristics of line and of surface,

Application

*An important exercise would be to examine different works having a pronounced diagonal structure, with regard to the kind of diagonal and its inner link with the pictorial content of these works. I have, e.g., used a diagonal structure in various ways, something I noticed consciously only later. E.g., on the basis of the above formula, *Composition 1* (1910)[11] can be defined as follows: Structure *cb* and *da* with forceful emphasis upon *cb*—this is the backbone of the picture.

is placed on the "most objective" PP in the directions discussed. What are the consequences?

Fig. 85

A I. Vertical position
"Warm repose"

Fig. 86

II. Horizontal position
"Cold repose"

Contrasts

Two pairs of opposites have come about:

The first pair (I) is an example of extreme contrast, since the left-hand form points toward the most widely dispersed resistance, and the right-hand form toward the densest.

The second pair (II) is an example of mild contrast, since both forms point toward milder resistances, and their formal tensions are only mildly different.

654

In both cases, the forms are in a parallel relationship to the PP, here representing an external parallelism, since the external boundaries of the PP have here been taken as the basis, and not the inner tension of the PP.

Elementary combination with the inner tension demands the diagonal direction, again producing two pairs of opposites:

B I. Diagonal position
 "unharmonic"

Fig. 87

II. Diagonal position
 "harmonic"

Fig. 88

Contrasts

These two pairs of opposites differ from one another in the same way as did previously the two pairs under heading **A.**

The left-hand form points toward the most rarified angle; the right-hand form points to- } above
ward the densest angle; hence they represent extreme contrast.

It is equally clear why the two lower forms } below
constitute a mild contrast.

Inner parallel

Here, however, the relationship between pairs **A** and **B** ends. The latter is an example of inner parallelism, since the forms here travel in the same direction as the inner tensions of the PP.*

Composition, construction

These four pairs thus offer the possibility of eight different bases for compositional construction, whether lying upon the surface or buried in the depths. Upon these bases, further principal directions of forms can be superimposed, either remaining central or else moving away from the center in various directions. But of course, the initial basis can likewise move away from the center and the center can be eschewed altogether—the number of constructional possibilities is infinite. The inner ethos of the time, of race, and ultimately—not entirely independent of the first two—the inner content of personality determine the basic tone of compositional "trends." This question does not belong within the framework of this specialized treatise. I can only mention here that we have, in recent decades, seen the high tide and then the ebb of both concentric and eccentric (construction). This depended upon various causes, bound up partly with temporal phenomena,

*In (I) the forms run in the direction of the normal tension of the square; in (II) the forms run in the direction of the harmonic diagonal.

but which were often causally related to much deeper needs. In painting, specifically, changes in "mood" succeeded one another as the result of a desire, at one moment, to abandon the PP; at another, to assert it.

"Modern" art history ought to deal with this topic in detail, since it goes far beyond the bounds of purely pictorial questions, and many aspects of the relationship with the history of culture could well be clarified. Today, much has come to light in this connection that until recently still lay concealed in mysterious depths.

Art history

Schematically speaking, there are three basic kinds of connections between art history and the history of "culture" (under which we must also include the chapters on nonculture):

Art and epoch

1. Art is subordinate to the epoch—
 (a) Either the epoch is powerful, having a consistent content, and art, no less powerful and consistent, willingly goes the way of the epoch, or
 (b) the epoch is powerful, but its content is torn by internal divisions, and art, in its weak state, is subject to these divisions;
2. Art is, for various reasons, opposed to the epoch, expressing possibilities that are themselves in opposition to the epoch;
3. Art oversteps the boundaries within which the epoch would like to confine it, and predicts the content of the future.

It should be remarked in passing that the tendencies of our own day, which derive from constructive bases, can easily be subsumed under the above-mentioned principles. The "eccentric" tendency in American stage design, which has been given precise form, is an illuminating example of the second principle. The

Examples

present reaction against "pure" art (e.g., against easel painting), and the fundamental controversies associated with this reaction belong under section (b) of the first principle. Abstract art frees itself from the oppressive atmosphere of the present, and hence belongs under principle (3).

In this way, it is possible to explain phenomena that seem initially indefinable or, in other cases, completely senseless. The exclusive use of horizontal-vertical (construction) can easily appear to us inexplicable, while Dada appears senseless. One might well be astonished that both these phenomena were born on almost the same day, and yet are irreconcilably opposed to one another. Avoiding every kind of constructive basis apart from the horizontal-vertical condemns "pure" art to death, and only the "practical-purposive" can reprieve it; the inwardly divided, but outwardly powerful epoch bends art to its purpose, denying its autonomy—section (b) of principle (1). Dada seeks to reflect these internal divisions, and naturally loses in consequence its artistic bases, which it is incapable of replacing with its own—section (b) of principle (1).

Culture and the question of form

These few examples, taken exclusively from our own times, were purposely chosen to illuminate the organic, often inevitable links between the question of pure form in art and cultural or uncultural forms.* In addition, however, my aim is, to indicate that efforts to derive art from geographical, economic, political, or other purely "positive" factors can never be exhaustive, and that such methods cannot be free

*"Today" is composed of two fundamentally different elements—dead end and threshold—the former strongly predominating. The predominance of the dead end theme rules out the term "culture"—our age is thoroughly uncultured, although we may discover here and there a few seeds of future culture—threshold theme. This thematic discordance is the "sign" of "today," which forces itself continually upon our attention.

from bias. Only the connection between questions of form in each of the above-mentioned realms, based upon spiritual content, can here guide us along the right lines; "positive" factors play a subordinate role—they themselves are not the basic determinants, but the means to an end.

Not everything is visible and tangible, or—put better—beneath the visible and tangible lies the invisible and intangible. Today, we stand on the threshold of an era; one step—only one—leading downward, gradually emerges with increasing clarity. At all events, we today have some notion of the direction in which our feet have to search for the next step. And that is our salvation.

Despite all the apparently insuperable contradictions, even today man is no longer satisfied with the external. His eye becomes sharper, his ear more acute, and his desire to see and hear the internal within the external grows. This is the only reason why we are able to sense the inner pulsation even of a reticent, modest being like the PP.

This pulsation of the PP is transformed, as we have shown, into straightforward or complex chords by introducing even the simplest element into the PP.

Relative sound

An independently curving line, consisting of two undulations on one side and three on the other, has an obstinate "countenance" as a result of its thick, upper point, while below it finishes in a downward loop, constantly diminishing in strength. This line gathers itself up from below, expressing itself in the form of an increasingly forceful wave, until its "obstinacy" attains a maximum. What becomes of this obstinacy if it is turned in the one instance to the left, in the other to the right?

Left, right

Fig. 89
Obstinacy mixed with indulgence.
Bends are loose.
Resistance from the left weak.
Denser layer at right.

Fig. 90
Obstinacy with stiffer tension.
Bends firmer.
Sharp braking effect of resistance
from right. Free "air" at left.

Upside down

This example, if turned upside down, is useful for examining the effects of above and below, something the reader can do for himself. The "content" of the line alters so radically that the line itself is no longer recognizable: its obstinacy vanishes without trace, and its place is taken by a labored tension. The element of concentration is no longer apparent, and ev-

erything is in a state of becoming. Turned to the left, the element of becoming comes more to the fore, to the right—its laboured aspect.*

I now transgress beyond the limits of my task and introduce onto the PP not a line, but a plane, which is, however, nothing more than the inner sense of the tension of the PP (see above).

Plane on plane

Normal, distorted square on the PP.

Fig. 91
Inner parallel,
lyrical sound.
Concurrence with inner,
"unharmonic" tension.

Fig. 92
Inner parallel,
dramatic sound.
Contrast with inner,
"harmonic" tension.

As regards the relation between forms and the borders of the PP, the d i s t a n c e between a form and the border plays a specific and extremely important role. A simple, straight line of constant length is placed on the PP in two different ways (Figs. **93** and **94**).

Relation to border

*With such experiments, it is advisable to rely more upon first impressions, since one's sensations quickly become tired, giving free rein to fantasy.

In the first instance it lies freely. Its proximity to the border gives it a pronounced, heightened tension toward the upper right, with a resulting decrease in tension at its lower end (Fig. **93**).

In the second instance, it collides with the border and, as a result, immediately forfeits its upward tension, while the downward tension is increased, expressing something sickly, almost despairing (Fig. **94**).*

Fig. 93

Fig. 94

In other words, as a form approaches the edge of the PP, its tension increases until, at the moment of contact with the border, this tension suddenly ceases. And; the further a form is from the edge of the PP, the more its tension toward the border decreases. Or: those forms that lie in close proximity to the border of the PP heighten the "dramatic" sound of the construction; whereas those that are far removed from the border, grouped more around the center, give the construction a lyrical sound. Naturally, these are schematic rules, which can be given their full force by other means, but also muffled to such an extent that

*This increased tension and its adherence to the upper border cause the line to appear longer in the second case than in the first.

their sound is barely audible. They always produce, however, a greater or lesser effect, which underlines their theoretical value.

A few examples should clarify typical instances of these rules in undisguised form:

Fig. 95
Silent lyricism of the four elementary lines— frozen expression.

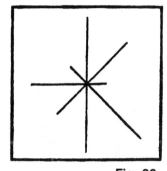

Fig. 96
Dramatization of the same elements—expression of complex pulsation.

Use of the eccentric:

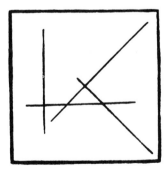

Fig. 97
Diagonal central. Horizontal-vertical acentral. Extreme tension of diagonal. Balanced tension of horizontal and vertical.

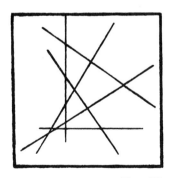

Fig. 98
All elements acentral. Diagonal reinforced by its repetition. Dramatic sound restrained at point of contact above.

The acentral structure here serves the purpose of intensifying the dramatic sound.

Multiplication of sounds

If, e.g., in the examples just used, we were to employ simple curves instead of straight lines, the resulting total of sounds would be increased threefold—every simple curve, as was stated in the section on line, consists of two tensions that produce a third. Further, if we were to substitute undulating lines for simple curves, each undulation would represent one simple curve with its three tensions, and thus the sum of the tensions would be correspondingly increased. Moreover, the relationship of each undulation to the edges of the PP would further complicate this total by its louder or fainter sound.*

Logicality

The attitude of the individual planes to the PP is a topic in itself. Yet the laws and rules discussed here continue in full force, and indicate the direction in which this specific topic should be pursued.

Other forms of the PP

Until now we have considered only the square PP. Other rectangular shapes are the product of the predominance or preponderance of the horizontal boundary lines or the vertical. In the first case, cold repose gains the upper hand; in the second, warm repose, which naturally predetermines the basic sound of the PP. Soaring and spreading are contradictories. The objective aspect of the square vanishes and is replaced by a one-sided tension of the entire PP, which—more or less audible—will influence every element upon the PP.

I should not fail to mention that both these varieties are of a considerably more complex nature than the

*The appended compositional tables illustrate such instances (see appendix).

square. In the case, e.g., of the horizontal format, the upper edge is longer than the vertical edges, giving the elements more opportunities of "freedom," although this [effect] is soon muted again by the brevity of the verticals. With the vertical format, the reverse is true. In other words, the boundaries are much more dependent upon each other in these cases than in that of the square. One has the impression that the environment of the PP is also playing a part, exerting pressure from outside. Thus, with the vertical format, it is easier to advance one's pieces upward, because in this direction pressure from the outside environment is almost entirely lacking and is concentrated principally upon the sides.

Further variations upon the PP are produced by the use of acute and obtuse angles in the most diverse combinations. New possibilities are afforded by, e.g., shaping the PP so that the upper right-hand corner invites, or then again confines the elements of the picture (Fig. 99).

Various angles

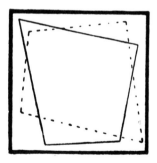

Fig. 99
Inviting and (in dotted lines)
confining forms of the PP.

In addition, there can exist further polygonal ground planes, although these must in the end be subordi-

nated to one basic form, and are thus merely more complex instances of the given basic form, which need detain us no longer (Fig. **100**).

Fig. 100
Complex polygonal PP.

Circular form

The angles, however, can occur in ever-increasing number, becoming more and more obtuse—until in the end they completely disappear, and the surface becomes a circle.

This is a very simple and at the same time very complicated case, about which I intend to speak in detail on some occasion. Here, let me just observe that both the simplicity and the complexity result from the absence of corners. The circle is simple, because the pressure of its boundaries is equalized, by comparison with that of rectangular forms—the differences are not so marked. It is complicated, because the transition from top to right and left proceeds unnoticed; likewise the transition from right and left to bottom. There are only four points that retain the pronounced sound of the four sides, something that, from the standpoint of feeling, is likewise perfectly obvious.

These are points 1, 2, 3, 4. The contrasts are the same
as in the case of rectangular forms: 1–4 and 2–3 (Fig.
101).

Fig. 101

The section 1–2 from top to left is a gradually pro-
gressing limitation of optimum "freedom," which in
the course of section 2–4 turns into rigidity, etc.,
until the circuit is complete. As regards the tensions
of the four sections, what we have established in our
account of the tensions of the square applies again
here. Basically, therefore, the circle conceals within
itself the same inner tension we discovered in the
square.

The three basic planes—triangle, square, circle—are the natural product of the logically moving point. If two diagonals pass through the center of a circle, their tips joined by horizontals and verticals, there is produced, as A. S. Pushkin asserts, the basis of the Arabic and Roman numerals (Fig. **102**).

Fig. 102

Triangle and square within a circle,
as the origin of numbers: AD = 1
Arabic and Roman. ABDC = 2
(A. S. Pushkin, *Works*, ABECD = 3
publ. Annenkov, St. Petersburg ABD + AE = 4
1855, vol. V, p. 16) etc.

Here coincide, therefore:

1. the roots of two numerical systems and
2. the roots of artistic form.

If this profound affinity really does exist, it confirms to a certain extent our intimation of a common root

shared by phenomena that, on the surface, appear fundamentally different and quite separate from one another. Especially today, the necessity of discovering these common roots appears to us unavoidable. Such necessities are not brought into being without their inner justification, but their ultimate satisfaction demands numerous determined attempts. These necessities are of an intuitive nature. The way of satisfying them is likewise chosen by intuition. The rest is a harmonious combination of intuition and calculation—neither the one nor the other is sufficient in itself for the path that lies before us.

By way of the evenly compressed circle, i.e., that which produces an oval, we proceed further to independent plane surfaces that are, it is true, devoid of angles, but transgress beyond the bounds of geometrical form, just as angular forms are able to do. And here, too, the basic principles will remain unaltered, and will be recognizable behind the most complex forms.

Oval form, independent forms

Everything I have said here, in very general terms, about the PP must be thought of as fundamentally a schematization, a way of approaching inner tensions that, so to speak, exert their effect in planar guise.

The PP is material, the product of purely material processes, and is dependent upon the nature of these processes. As has already been mentioned, the most diverse textural possibilities exist for its production: smooth, rough, granular, prickly, shiny, matt, and finally, three-dimensional surface, which

1. in isolation, and

2. in combination with other elements

particularly accentuates the inner effects of the PP.

Of course, the character of the surface depends exclu-

sively upon the character of the material (canvas and its techniques, stucco and the manner of its employment, paper, stone, glass, etc.), and upon the tools associated with the medium, how they are treated and handled. Texture, which cannot be discussed here in further detail, affords—like every other means—a precise, but elastic, flexible opportunity of proceeding in two directions:

1. Texture strikes out in a parallel direction to the elements, and thus reinforces them by preponderantly external means, or it is

2. used according to the principle of contrast, i.e., it is in external contradiction to the elements, and reinforces them inwardly.

Between the two lie all the possibilities of variation.

Apart from the medium and the implements used to create a material PP, we must naturally consider to the same extent the medium and the implements used to create the material form of the elements, something that comes within the purview of a detailed theory of composition.

A pointer in the direction of such possibilities however, is important here, since all the techniques I have indicated, with their own inner consequences, can serve not only for the creation of the material surface, but also for the optical annihilation of that surface.

Dematerialized surface The firm (material) placing of the elements upon a firm, more or less solid, and to all appearances tangible PP and the contrasting "floating" of these elements having no material weight in an indefinable (nonmaterial) space are fundamentally different, diametrically opposed phenomena. The viewpoint of common materialism, which of course had to extend to the phenomena of art, produced as a natural-organic consequence an exaggerated appreciation of the material surface, with all its complications. It is

to this prejudice that art owes its healthy, indispensable interest in handicraft, in technical expertise, and particularly, in a thorough examination of "material" generally. It is especially interesting that this detailed knowledge is essential not merely to the material production of the PP, but also, as has been said, to its dematerialization, in combination with its elements—the path from the external to the internal.

Spectator

It must, however, be clearly stressed that "floating sensations" depend not only upon the abovementioned conditions, but also upon the inner attitude of the spectator, whose eye may be capable of seeing in one manner or in the other, or in both: if the inadequately developed eye (something that is organically linked to the psyche) cannot experience the depths, then it will be in no position to free itself from the material surface in order to perceive indefinable space. The practiced eye must possess the ability to see that plane which is necessary for the work of art, partly as such, but partly to ignore it when it dons the guise of space. A straightforward complex of lines can, in the end, be treated in two ways—either it becomes one with the PP, or it lies freely in space. The point that burrows its way into the surface is likewise capable of freeing itself from the surface and "floating" in space.*

*It is clear that the transformation of the material surface and, associated with it, the general character of the elements with which it is combined, must in many respects have very important consequences. Of these, one of the most important is a change in our perception of time: space is synonymous with depth, and therefore also with those elements that extend into depth. It is not for nothing that I have termed the space created by dematerializing [the surface] "indefinable"—its depth is in the end illusory and thus cannot accurately be measured. In such cases, therefore, time cannot be expressed in figures, and can collaborate only to a relative degree. On the other hand, illusionistic depth is real, from the painter's standpoint, and thus demands a certain, albeit immeasurable amount of time in order to follow those formal elements that extend into depth. Therefore, the transformation of the material PP into an indefinable space affords the opportunity of extending the dimension of time.

Just as the inner tensions of the PP I have described are still valid for complex forms of the PP, these tensions apply equally not only to the dematerialized surface, but also to indefinable space. The law never loses its force. If one's starting point is correct and one's direction well chosen, one cannot miss the goal.

Aim of theory

And the aim of a theoretical examination is:

1. to discover the living,
2. to make perceptible its pulsation,
3. to establish the law-governed nature of life.

In this way, one collects living facts—as individual phenomena and for their interrelations. To draw final conclusions from this material is the task of philosophy, and is synthetic work in the highest sense.

This work will lead to revelations in the internal—insofar as that is given to any age.

APPENDIX

Plate 1
Point
Cool tension toward center.

Plate 2
Point
Progressive dissolution (diagonal $d-a$ indicated).

Plate 3
Point
9 Ascending points (diagonal *d–a* stressed by weight).

Plate 4
Point
Diagram of horizontal-vertical-diagonal points for an independent linear structure.

Plate 5
Point
Black point and white point as elementary color values.

Plate 6
Line
The same in linear form.

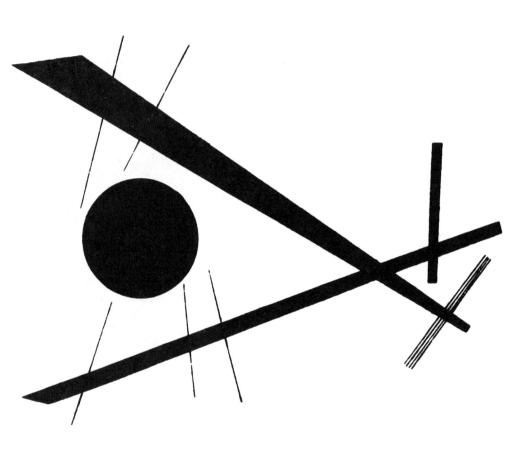

Plate 7
Line
With point at edge of plane.

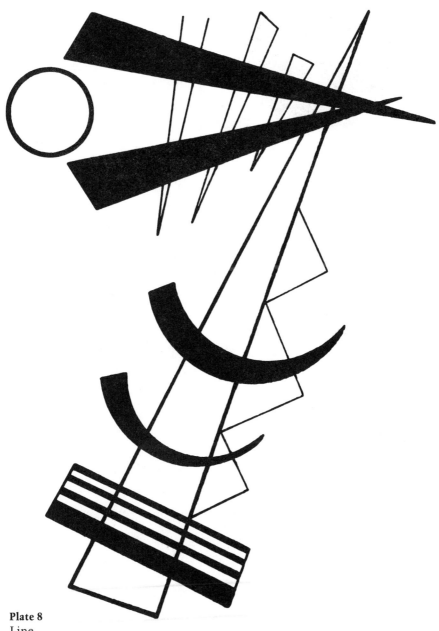

Plate 8
Line
Stressed weights in black and white.

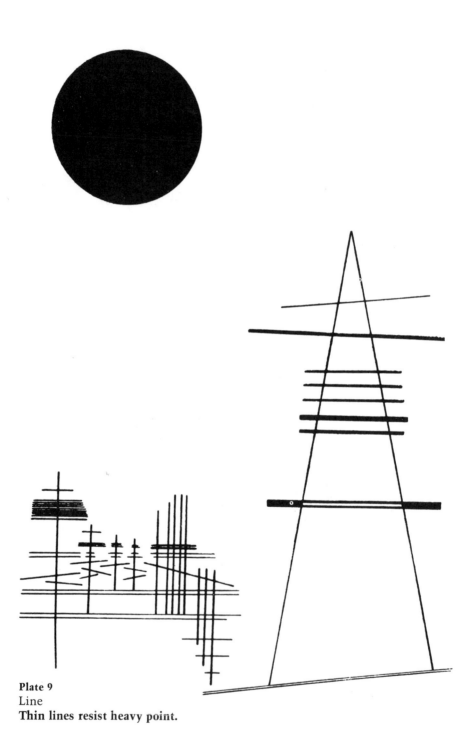

Plate 9
Line
Thin lines resist heavy point.

Plate 10
Line
Linear structure of part of *Composition 4* (1911).

Plate 11
Line
Linear structure of *Composition 4*—vertical-diagonal ascent.

Plate 12
Line
Eccentric structure, the eccentric being stressed by creation of plane.

Plate 13
Line
Two curves juxtaposed with straight line.

Plate 14
Line
Horizontal format favors overall tension created by individual forms having no great tension.

Plate 15
Line
Independent curves juxtaposed with point—added sound of geometrical curve.

Plate 16
Line
Independent undulating line with emphasis—horizontal position.

Plate 17
Line
The same undulating line accompanied by geometrical elements.

Plate 18
Line
Simple and unified complex of a number of independent lines.

Plate 19
Line
The same complex, made more complicated by independent spiral.

692

Plate 20
Line
Diagonal tensions and countertensions with a point, which causes an external construction to pulsate internally.

Plate 21
Line
Dual sound—cold tension of straight lines, warm tension of curves, loosening of rigid, yielding to dense.

694

Plate 22
Line
Vibration of color in diagrammatic form, achieved by minimum use of color (black).

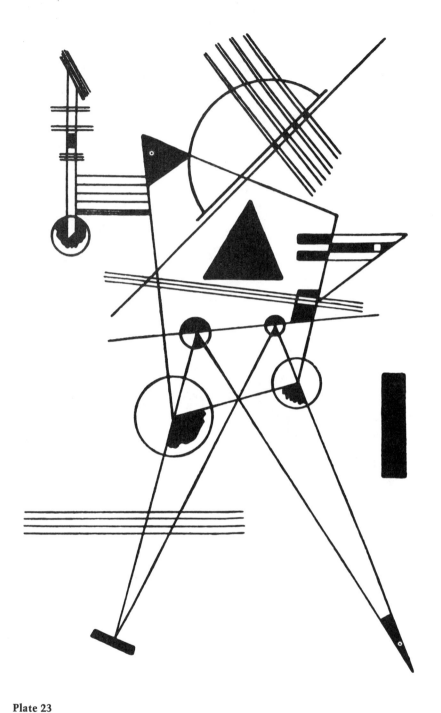

Plate 23
Line
Inner relationship between complex of straight lines and curve (left-right), for the picture *Black Triangle* (1925).[12]

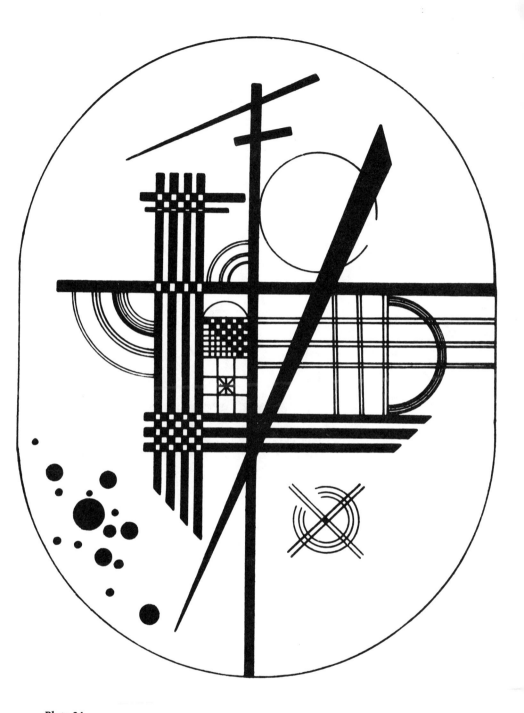

Plate 24
Line
Horizontal-vertical structure with contrasting diagonal and tensions created by points—schema of the picture *Intimate Message* (1925).[13]

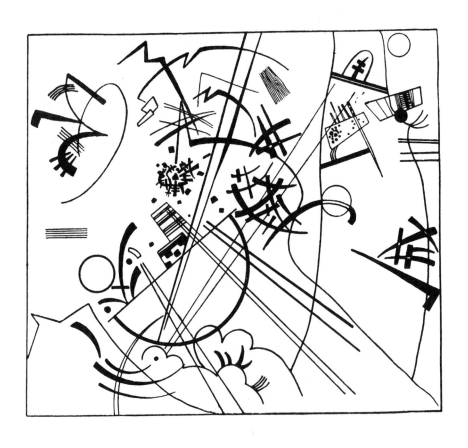

Plate 25
Line
Linear structure of the picture _Little Dream in Red_ (1925).[14]

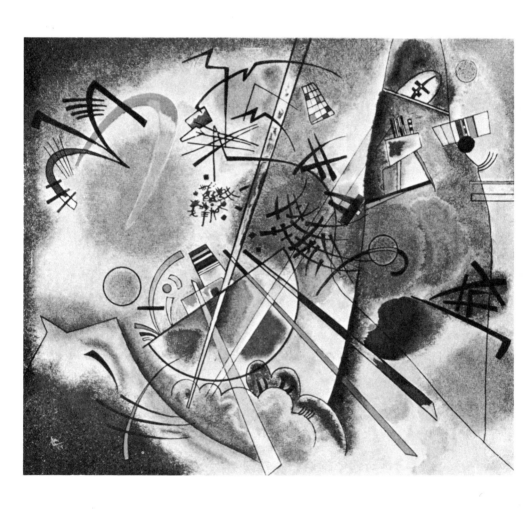

The Value of Theoretical Instruction in Painting

["der wert des theoretischen unterrichts in der malerei"]
bauhaus
(Dessau), 1926

Not until after its move to Dessau did the Bauhaus publish its own magazine, which, although described as a quarterly, appeared at somewhat erratic intervals until 1931. The first number, containing Kandinsky's "The Value of Theoretical Instruction in Painting," was published on 4 December 1926 to mark the official reopening of the school. Its appearance also coincided with Kandinsky's sixtieth birthday, and his article is preceded by a warmly worded tribute from his friend Paul Klee (Kandinsky returned the compliment, at rather greater length, on the occasion of Klee's departure from the Bauhaus, see pp. 752–54). It reads:

> in the next few days, wassily kandinsky will have attained his sixtieth year. one is amazed, delighted, and one's delight is of a special kind. at the age of fifty, he still found room to take decisive, mettled strides into new territory, and from that day to this, he has expanded upon his achievements in the richest possible way. not evening, simply deeds that, whether earlier or later, rarer or more frequent, because of their lavish perfection surpass the time span not merely of the artist's life, but of the epoch.

The magazine was printed in lower case throughout, one of the typographic reforms with which the Bauhaus experimented during the Dessau period. This mannerism, and

the eccentric layout of the text, are preserved in the following.

the value of theoretical instruction in painting

different methods may be employed to teach painting, but these methods remain divided into two main groups:

1. painting is treated as an aim in itself, i.e., the student is trained as a painter, to which end he acquires at school the necessary knowledge—so far as this can be achieved through instruction—and does not necessarily need to go beyond the bounds of painting.
2. painting is treated as a co-organizatory force, i.e., the student is led beyond the bounds of painting, albeit by means of its logical character, toward the synthetic work.

this second approach forms the basis on which painting is taught at the bauhaus. here, too, different methods can of course be employed. as far as my own specific guidelines are concerned, the following considerations must, in my opinion, serve as the principal and, ultimately, the final goal:

1. analysis of the external and internal value of pictorial elements
2. relationship between these elements and those of other arts and of nature
3. structuring of pictorial elements in thematic form (solutions to planned thematic exercises) and in the work of art
4. relationship between this structure and the other arts, and nature
5. logic and purpose

i must here content myself with indicating the direction in these general terms, since the details are unsuited to the scope of a newspaper. but even this brief schema shows what i am aiming for. until now, no planned analytical thought has in fact existed in questions of art, and to be able to think analytically means to be able to think logically. it would be inappropriate to speak here in more detail about art schools, whose purpose is painting as such, i.e., where it is an aim in itself, although i

gradually came to the conclusion that even in that kind of school the previous way of giving a very brief scientific "bonus" in the form of anatomy, perspective, and art history is no longer viable: even "pure" art needs today a more precise, consistent scientific basis. the one-sided emphasis upon the intuitive element, and the "aimlessness" of the art associated with it have frequently led young artists (would that it were only "young" artists!) to ungainly conclusions that distract one from art. "neue sachlichkeit" [the new sobriety] would suffice as an example from the present day, trying to give art "political" aims—the ultimate in confusion.

the young artist, especially when starting out, must from the outset accustom himself to objective, i.e., to scientific thought. he must understand how to seek his way independently of all the "isms," which as a rule strive not toward the essentials, but mistake transitory details for basic questions. the capacity to view unfamiliar works objectively does not exclude one-sidedness in one's own work, something that is natural and entirely healthy: in his own work the artist can (or rather "must") be one-sided, since objectivity could in this case lead to inward blurring. in his own work he should be not merely one-sided, but fanatical! full-fledged fanaticism requires, however, many years of violent inner tension.

by absorbing himself in those elements that are the building blocks of art, the student acquires—apart from the capacity for logical thought— the necessary inner feeling for artistic resources. this simple assertion should not be underestimated: since the end determines the means, it is through the means that one comprehends the end. the inner, self-absorbed selection of one's means, and one's unconscious and at the same time conscious involvement with one's resources eliminate those aims that are foreign to art, and thus produce an unnatural and repulsive effect. thus, the means here in fact serve the end.

one's feeling of affinity with the elements of one art is further intensified by studying the relationships between these elements and those of other arts, which are immediately self-evident.
the relationships between the elements of art in general and those of nature place the whole question on a still broader philosophical basis, something that is likewise immediately self-evident.
thus, our path proceeds from the synthetic in art to the synthetic in general. if today we do not know in reality exactly what is or should be

hidden behind the concept "education," or "educated," we are nonetheless perfectly entitled to assert that it is not a greater or lesser accumulation of specialized knowledge (so-called "expertise") that here plays the principal role or constitutes the principal ingredient, but rather, the properly developed capacity to sense and ultimately to "understand" the seemingly disjointed picture of individual phenomena in terms of organic links. and conversely: the absence of this capacity may, despite the presence of "encyclopedic expertise," be regarded as the sign of the uneducated man.

and finally: a school that is incapable of conveying to the student in a planned manner the knowledge of this general basis is not entitled to call itself a "school"—least of all if it aspires to recognition as a university [*Hochschule*].

quite apart from the value of "education" in a genuine sense, something that is incontrovertible on principle, this school training would act as a powerful remedy against the extreme specialization that we have inherited from the previous century, which is to be resisted not only for general philosophical reasons, but also for purely practical ones. in practice, extreme specialization is a stout wall dividing us from synthetic creation. i venture to hope that i do not have to prove various facts generally recognized today: e.g., the logical character of pictorial construction. and yet, recognizing this fact in principle is, for the student, not sufficient—it must be implanted in his interior so thoroughly that it penetrates to his fingertips of its own accord: the artist's "dream," be it modest or most powerful, is of no value in itself—as long as the fingertips are incapable of following the "dictates" of this dream with the utmost precision. to this end, practical (thematic) exercises must be combined with theoretical instruction: what use is a splendid cookbook without ingredients and cooking pots? and: it is only by repeatedly getting one's o w n fingertips burned that the beginner is able to progress. the laws of nature are living laws, since they unite within themselves the static and the dynamic, and in this respect they have the same value as the laws of art. thus learning to recognize natural laws is, apart from its philosophical-educational importance, indispensable for the artist. but this simple fact remains, alas, entirely foreign to institutes of art education.

the following diagram is intended to summarize in concise form the sense of this article:

means	end
means	**end**
1 analysis of pictorial elements	analytical (in general, logical) thought
2 relationships to other arts and to nature	synthetic thought, capacity to unite the diffuse
3 construction of pictorial elements in thematic form and in the work	theoretical and practical laws, and their relative value in practice
4 relationships to other arts and to nature	synthetic creation and work and recognition of creative principle in nature, and inner affinity of same to art
5 logic and purpose	developing the "fingertips" and developing the man

it is clear that, apart from painting, other arts would serve to attain this pedagogic aim. it is, however, equally clear that, at the bauhaus, painting should be the most suitable educatress:

1. color and its application have a place in every workshop, where the method described serves, therefore, purely practical ends as well; and

2. painting is the art that has, for several decades, advanced at the forefront of all other art movements and has fertilized the other arts—especially architecture.

<div align="right">

dessau
20.3.26

</div>

1927

i10
["Und, Einiges über synthetische Kunst";
"Malerei und Photographie"]
i10
(Amsterdam), 1927

The Amsterdam periodical *i10*, edited by Arthur Müller Lehning, began publication in 1927. In the first issue, Lehning outlined the aims of this new monthly, in a statement printed in Dutch, German, French, and English. The English version reads:

> The international review *i10* will be an organ of the modern mind, a documentation of the new streams in art, science, philosophy and sociology.

> It will give an opportunity to express the renewal of one domain with that of another, and it arms [sic] as large a connection as possible between these different domains.

> As this monthly asserts no dogmatic tendencies nor represents any party neither any group, the contents will not always have a complete homogeneous charakter [sic] and will be mostly more informative than following at one line of thought. Its idea is to give a general view of the renewal which is now accomplishing itself and it is open, international, for all wherein it is expressed.[1]

In later years, Lehning recalled that he had been disturbed by the lack of any journal devoted to "abstract" tendencies in painting and architecture. He had consulted Mondrian, then living in Paris, who had given him an introduction to the

architect J. J. P. Oud, who became architectural editor of the journal. The other assistant editors were Willem Pijper for music, and László Moholy-Nagy for film and photography. Lehning also recalled that Kandinsky, whom he had visited in Dessau in 1926, was "very enthusiastic" about the plan for the new journal: "The problem of the unity of the arts had always held his particular attention, and had also formed the basis of the *Blaue Reiter* [*Almanac*], which he had edited with Franz Marc."[2]

Kandinsky contributed two articles to *i10* during the first year of its existence. "And, some Remarks on Synthetic Art," appeared in the first issue; it is dated October 1926. In this article, Kandinsky returns to a subject he had broached in the statement he wrote for his exhibition at Gummesons in Stockholm in 1922, and in his essay "Yesterday—Today—Tomorrow" (see pp. 508–509): the many, mutually exclusive demands made of the artist, of the intellectual, of every man—demands that exclude the possibility of resolution, of synthesis.

A few months later, Kandinsky appeared again in print in *i10*, this time with an untitled response to Ernst Kállai's article "Painting and Photography," published in the fourth issue of the journal. Moholy-Nagy had accepted Kállai's article as a basis for discussion in *i10*: "i must affirm, however, that i do not agree with him on every point. for this reason, and because the problem: painting and photography, is especially relevant today, i would like to initiate a discussion in these columns about his article."[3] Kandinsky's reaction, together with those of Willi Baumeister, Adolf Behne, Max Burchartz, Will Grohmann, Ludwig Kassak, Moholy-Nagy, Mondrian, and Georg Muche, was published in the sixth issue, followed by a reply from Kállai himself.[4]

AND, SOME REMARKS ON SYNTHETIC ART

It is by no means pure chance that centuries sometimes differ markedly from one another.

While the nineteenth century still had its last few years ahead of it, and the twentieth century hove in sight, the question arose: when should one regard it as actually having started? For the acute of hearing were already able to perceive an ever more distinct, "subterranean" rumbling.

The "revolution" was approaching.

But the surface remained calm, motionless, still.

Nearly the whole of the nineteenth century consisted of a more or less calm process of *ordering*.

This ordering occurred on the basis of categorization, division. At the same time, specialization became both cause and effect.

Specialization led to ordering. Ordering—to specialization.

Specialization had, since the first advance of technology, been regarded by economists as the ideal manner of working, of normal production: maximum result in return for minimum effort. Every worker—whether by hand or brain—was driven to the utmost degree of specialization, becoming what today is called an "expert."

A simple schema may be used to represent this consequences of this *ordering:*

I DIVISION

Material Life Wall Spiritual Life

II DIVISION

Religion Morality Art Science Philosophy

(Spiritual Life)

III DIVISION

A. Visual Arts:
 (a) Painting A
 (b) Sculpture
 (c) Architecture

a	B
b	C
c	D

B. Music C. Dance D. Poetry

(Art in General)

IV DIVISION

Painting: (a) Portraiture
 (b) Genre
 (c) Landscape

a
b
c

(Painting)

709

Science itself would produce a far more complicated schema. But the principle remains the same—the astronomer had just as little time for Sanskrit as the musician had for sculpture. On this basis, all possible kinds of colleges were built, which produced highly trained specialists and completely uneducated people. And still do so today.

Although the "subterranean" rumblings of the early twentieth century penetrated the frozen surface, tore it apart in many places, materializing in the form of various kinds of "catastrophes," which today still threaten, shake, or destroy every realm of "life," the "order" already described remained just as much in force.

Specialization demands choice, separation, and categorization. The man of today likewise stands in the shadow of the device *either-or*.

These two words provide an exhaustive definition of the nineteenth century, and we have taken them over as a guiding principle for our own times. Examples of this can be found every day in all realms—whether art, politics, religion, science etc.

Viewed from without, our own time—by contrast with the "order" of the preceding century—can likewise be characterized by *one* word: *chaos*.

The most extreme contradictions, the most bitterly opposed views, denial of the common good for the sake of the individual, overthrow of the accustomed and attempts immediately to re-erect what has been overthrown, conflict between the most varied ideals—all these things create an atmosphere that brings modern man to despair, to a kind of confusion that, it appears, has never before existed.

Modern man is constantly faced with split-second decisions: he is supposed to affirm immediately one given phenomenon and reject another—either-or—which means that both phenomena are regarded in a purely external, exclusively external light. This is the tragedy of our age. New phenomena are viewed from the old standpoint and treated in a dead manner.*

*A simple example is the opposition of abstract art to the "New Sobriety." The despairing art critic has to adopt one or the other, and take it under his wing. No wonder if sometimes, in extreme desperation, which naturally he would wish to conceal, he cries out: "Heaven only knows which of the two will be victorious in the end!" This state of affairs will only change once the question of form has been recognized as subordinate to the question of content.

But just as, at that time, those with acute hearing were able to perceive the rumblings within the ordered calm, the sharp-eyed can see within the present chaos a new order. This order departs from the basis of "either-or" and gradually attains a new one: *and.*

The twentieth century stands in the shadow of the device "and."

This "and" is, however, only a consequence. The cause is the slow, almost invisible move away from the previous standpoint of the external (form) and the attainment of a new one, the internal (content).

I cannot here produce any evidence for my assertions, which would lead me beyond the limits of this short article. But I believe that careful observation of different realms of human activity, patient analysis of various contradictions and oppositions, will provide the missing evidence in plenty.

Inner necessity must sometimes make considerable detours to reach its goal. E.g., in painting, the inner evaluation of one's "material" has only become possible after years of theoretical work on "technical" problems.

Even complete familiarity with the external aspect of one's material does not enable one to advance the question of art beyond the boundaries of the "technical" and, in the end, only serves the purposes of further categorization, which of course renders any nearer approach to the problem impossible.

Or, familiarity with the external can only become a gateway to the future if this kind of familiarity has succeeded in creating a link with the internal.*

Seen from the standpoint of these detours, the path of revolution reveals itself as an evolutionary process. Spreading waves and sudden jolts usually appear, in the perspective of history, as a straight line. Sometimes the line is invisible—then the thread appears broken.

During the period of exclusive categorization in art, three different relics of earlier periods of synthetic art can be seen:

1. the church
2. the theater
3. building

*I have made an attempt in this direction in my book *Point and Line to Plane:* the analysis of the external element of form should act as a pointer to its internal element.

In *building,* the relationship between the three plastic arts (architecture, painting, and sculpture) has become purely external, devoid of internal necessity—typically nineteenth century.

In the two oldest synthetic forms of the *theater*—opera and ballet—the nineteenth century, in addition to external "effects," also sought to affect people inwardly, something made possible by Wagner's efforts in the realm of opera.

It may be regarded as more or less proven that in the old Russian *church* all the arts served, with equal prominence and to the same extent, a *single* goal—architecture, painting, sculpture, music, poetry, and dance (movement of the clergy).* Here, the aim was purely internal—prayer.

This is a particularly important example, since even today attempts are being made in various countries to build churches in the old style, which every time and without exception produces nothing but a lifeless architectural schema. The widespread view that some "lost formula" could obviate these failures is a superficial one. Every true formula is nothing other than the precise, appropriate expression of a particular epoch. That is, each epoch is called upon, duty bound, to create a new formula, characteristic and expressive of itself.

As much as several decades ago, during the dead period of cemetery-like order, painting was the first area in which "unexpected," "incomprehensible" explosions "suddenly" occurred in an ever more dramatic sequence. Painting was seeking after "new forms," and there are still few people capable of understanding that this was an unconscious search for new content.

These efforts brought in their train two important consequences:

1. The further divorce of painting from "life," its consistent self-absorption in its own aims, resources, and means of expression and

2. At the same time, a natural and lively interest in the aims, resources, and means of expression of other arts—primarily music.

*It would be important to examine various religions from this point of view. As far as the Russian church is concerned, the composer Alexander Shenshin in Moscow had made some extremely valuable observations along these lines, observations that still, unfortunately, remain unpublished. One and the same formula was found in each of the above-mentioned art forms.

This first consequence led to further, especially precise theoretical and practical analyses, which today help toward pictorial synthesis.

The second consequence paved the way for the creation of synthetic art in general. Here, only individual instances can be observed. The first attempt to unite two art forms *organically* in one work was Skriabin's *Prometheus*—parallel motion of musical and pictorial elements. Its purpose is to intensify the available means of expression.

Thus it was that the barriers erected by the nineteenth century between two different arts were first overthrown.

This happened, however, in the realm of art in general (see Division III [in table] above), and marked the beginning of the demolition of the walls dividing up the territory of art, which had been divorced from all other realms. Since then, there has been an accumulation of experiments, which up to the present time have remained at the nursery stage, with color organs (England, America, Germany, etc.), the colored play of lights in conjunction with music (Germany), abstract film with music (France, Germany), etc.*

Comparable phenomena are occurring in dance (Russia, Germany, Switzerland, etc.), which has set foot on the path trod decades before by painting, and is likewise developing in two directions:

1. dance as an end in itself
2. dance as one element within the total work—dance, music, painting (costume and staging).

Admittedly, in such works dance is usually regarded as the principal element, to which the others are subordinated. Here, however, there has been another advance, which, as a matter of principle, is of great importance in undermining the walls—dance has taken over acrobatic elements (Germany), something that occurs more and more frequently in the theater as a whole (Russia). Thus the walls collapse that separated realms regarded only a short time before as completely divorced, even in part hostile to one another: theater, music hall, and circus.†

*Some years ago I attempted to employ different art forms in one single work, according to the principle not of parallelism, but of opposition—*Yellow Sound* in the *Blaue Reiter* [*Almanac*]. Piper Verlag, Munich, 1912 [see this edition, p. 267].

†Of particular relevance to our times is the new evaluation of the circus and the cinema, which until now have been regarded as inferior and degenerate affairs, unworthy of being counted as art.

I should remark here in passing that the extraordinary magnetic power exerted by painting in the last few decades (around forty thousand painters still live in Paris today; in Munich before the war there existed an academy of art, an academy for ladies, and more than forty private schools) is no "accident."

Nature, faced with some great task, is extravagant, and its laws determine not only the material but, to the same extent, the spiritual life. The war (or wars), revolutions in political life were experienced years before in the sphere of art—in painting. Here, the most extreme tensions necessarily developed, since painting, apart from its own tasks, had the important duty to fructify all the other arts and guide their development along the right lines.

The realm of painting was the source of yet further impulses, as a result of which even more solid walls dating from the previous century were undermined and, in part, destroyed. These impulses go beyond the realms of art and extend considerably further into the surrounding environment.

The differences, laid down almost by Providence, between art and science (especially "positivistic" science) are being consistently examined, and it is not particularly difficult to see that the methods, the materials, and their treatment in each case are not essentially different in the two areas. The possibility arises for the artist and the scientist to work together on one and the same task (Pan-Russian Academy of Art Sciences, founded in Moscow in 1921).

By contrast with the first demolished wall (between music and painting—see Division III above), here, a wall is being destroyed that divided two far more widely separated realms (see Division II).

Analytical work in each of these two realms turns into synthetic work. A theoretical synthesis comes about, which smooths the path for a practical synthesis.

A further impetus and the researches leading from it, which were likewise the product of painting, has the same value in principle—the collapse of the wall dividing art from technology, and the consequent reconciliation of these two sharply divided and, as people in general thought, hostile realms.

The first, albeit extremely indistinct impulse came from the schools of applied arts, which "suddenly" came to life again, and which in various countries continually increased in number, even before the war

(Germany, Austria, Russia, etc.).

Now, in the selfsame year, two new schools have been created, independently of each other, for the purpose of uniting art with craft and, ultimately, with industry:

1. Vkhutemas, Moscow, 1918[5]
2. Staatliches Bauhaus, Weimar, 1919

By contrast to the normal school of applied arts, which accords pride of place to art and considers technology partly as a subordinate, sometimes a disruptive element, the two above-mentioned colleges sought to place both elements on the same level and unite them as equal partners in the work of art. As a natural result of the earlier attitude and as a natural reaction against it, in their early years, both schools undervalued art as a collaborative element and transferred primary emphasis to the technical. This was the usual effect of the law of the pendulum.

The Bauhaus (now in Dessau) continues to develop along the path of equalized treatment of both factors, and has apparently arrived at the correct solution to this difficult problem.*

This example of yet another demolished wall is, in principle, the most important: the first occurred in the sphere of art in general (Division III); the second, in the sphere of the spiritual in general (Division II); the third occurs in between two realms that previously had not even the remotest relationship with one another—the realms of matter and spirit (Division I).

The abolition of categorization develops logically, while connections ("and") spread to embrace the furthest realms.†

The narrow scope of this short article must serve as my excuse for having treated the exceedingly important topic of synthetic art so nar-

*In the course of last summer a new timetable was worked out at the Bauhaus, which made possible more broadly based teaching. Art, technology, and science constitute the foundation-stones—balanced against one another and organically interrelated. The aim is that the student should, apart from his specialist studies, receive as broad a synthetic education as possible.

†In Division IV the walls have fallen, thanks to abstract art—no subdivisions, but painting as such.

rowly and fragmentarily.

My purpose was merely to indicate the extent of this crucial problem, to point to the significance for all mankind of the latest moves from the old basis to the new, something that goes far beyond the limits of art, and will sooner or later occur in every important sphere of human development.

The layman has long since become accustomed to regarding questions of art and science as something foreign to him, something outside his real life, about which he need not trouble himself.

Among the "general public," the perhaps not altogether conscious view that market prices and the affairs of the political parties constitute the spiritual basis of human life gains ever greater currency, that anything that exists outside these interests can have no essential value.

This attitude is the organic-natural result of extreme specialization and of (admittedly trivialized) materialism. Here is to be found no new beginning, but only the conclusion of the past.

The beginning consists in the recognition of interrelationships. More and more, people will see that there exist no "specialized" questions, to be identified or solved in isolation, since in the end everything is interconnected, interdependent. The continuation of this beginning consists in discovering further interrelationships and exploiting them in the service of human development, the most important task of mankind.

The roots of individual phenomena are joined beneath the surface, and the man of the future will soon, perhaps, be able to trace all these roots back to *one* common root.

In any epoch that has spiritual validity, art cannot remain divorced from life. But in the period of preparation art may withdraw from "life," concentrating upon her own tasks, so that she may be adequately equipped to assume her important place once again in the dawning spiritual epoch.

Today, art is experiencing the final results of the external "period of materials" and, taking the achievements of this period as her starting point, is now proceeding to the content of the new epoch that is beginning.

Probably it will be art, yet again, that is the first to depart from the "either-or" of the nineteenth century and go over to the "and" of the scarcely started twentieth century.

This *"and"* in art means, in our case, the external and the internal as regards material, one's resources, the work itself, etc.

When the period of the internal has reached external maturity, there arises the possibility of proceeding from the purely theoretical to the practical—in our case, to the *synthetic work of art*.

Dessau, October 1926

[Painting and Photography]

On the questions "painting and photography" there still prevails a good deal of confusion, which is entirely understandable, given the youth of these questions. It is only the greatly increased tempo of our times that makes such immature questions, such as, e.g., the question "painting or film?" possible and discussible. In the few lines permitted me, I would like to consider this extremely complex question from only one standpoint, namely, the standpoint that Herr Kállai brings to the fore.

When Herr Kállai puts forward the assertion that we stand "on the borderline between a static culture, which has become socially ineffectual, and a new, kinetic form of worldview," one might be permitted to observe that the kinetic power of, e.g., an "easel painting" does not consist in its immobility on the wall, or wherever, but is rather to be found in the temporal kind of "radiation" or effect that it produces upon mankind—in other words, people's temporal "experience" of it. In reality, however, we are faced today with the theoretical question of how the element of time in a painting might be measured. The difference between painting (or, more precisely, "easel painting") and film, as represented by Herr Kállai, can only be understood in purely relative terms: the application of "time" in each sphere reveals no *essential* difference in the mode of application.

I cannot resist making one further observation. Especially today, we "occidentals" often (perhaps much too often) direct our fading gaze toward the "orient." Not infrequently, our "salvation" is sought there. In my view, those of us who live in the occident might do well to adopt one typical characteristic of the orientals, the faculty of concentration, which is first and foremost bound up with immobility.

As long as we continue to pose questions on the basis of "either . . . or," we cannot escape from the psychology of the past. What does it profit mankind, in whom today we are all particularly interested, if it is divided up into "static" and "kinetic," who do not want to hear each other or about each other?

Please do not retort that the mail coach has been overtaken by the

express train, and that the express train will soon be replaced by the airplane. In every illustrated newspaper, and even sometimes on the streets, we see people who . . . walk. These same people do not always walk. Sometimes they travel by train; it all depends. The determining factor is *purpose*, and, therefore, the appropriate form of motion.

I find all one-sidedness dangerous. Constantly jumping up and down on one and the same foot will necessarily lead to the permanent atrophy of the other foot.

But Nature looks after mankind and has provided it with two eyes, so that it may see not only in two dimensions, but also in depth.

Dessau 2 May 1927

Violet

["aus 'violett,' romantisches bühnenstück
von kandinsky"]
bauhaus
(Dessau), 1927

Kandinsky's stage play *Violet*, like *Yellow Sound*, *Black and White*, and *Green Sound*, was composed during his years in Munich before the First World War. Despite the date given below by the artist himself, Grohmann ascribes the composition of the play as a whole to 1911.[1] Unpublished at the time, the following excerpt appeared in the third issue of the periodical *bauhaus*, dated 10 July 1927. The different numbers of the magazine were the responsibility of different members of the teaching staff; this particular issue was edited by Oskar Schlemmer, director of the school's experimental theater. Despite his evident interest in Kandinsky's stage works, none of them seems to have been performed at the Bauhaus.[2]

In the extract that follows, the reader will notice the stress Kandinsky lays on precise timing, a feature that distinguishes *Violet* from his other dramatic experiments.

Scene VI (beginning)

dark.

a cheeky **boy's voice** sings loudly: "a birdie came a-flying."

male voice: no! no! no!

the song stops.

(3●)

a **violin** tunes up and "in the deep cellar" is played at very low pitch (a few bars).

(3)

two alternating choirs—simply and heartily:

men: don't look at the trees. don't look at the trees in the air. but look at the trees in the water.

(3)

how their branches, leaves, needles are transformed, and what confusion is born—arches, curves, zig-zags. and beside these arches, curves, zig-zags, still more arches, curves, zig-zags.

(3)

but in-between blueish, greenish, whitish, rosy, and . . . white small, smaller, quite tiny spots ripple.

women: don't look at the boat, and not at the man in the boat, nor even at the . . . oars.

look at the little mountain of water that is conjured up out of the water by the stroke of the oars. only at the little mountain of water is it necessary to look: what flanks and ribs it has—the ribs are particularly important! on the ribs and flanks are runnels that climb their way up the ribs and flanks.

(3)

it is important to see how flexible and hard the ribs and runnels are, and sharp and ah! soft. you couldn't crush them, but you could put your finger through them—that's very important! the little mountain of water has a tip of spray. the spray in part coalesces with the tip, in part grows out of the little mountain, in part hangs in the air above the little mountain, which is very important.

men:	don't look at the boat.
	(3)
	don't look at the deep blue, dark green water. not at the white, pink-colored, blue-colored, purple-colored, red, black, lilac-colored, olive-colored, brown water.
women:	not even at the violet-colored—we all implore you!
	(the word "violet-colored" long drawn out)
men:	don't look at the hard water, nor at the airless.
	(3)
	(very emphatically) but only, only and only at the bright green, which ought to be stroked, which could be licked, into which one's hand absolutely wants to, must plunge, which one would have to take home, which makes breathing seem possible, which keeps one feeling young, fresh, clear, bright, cool, cheerful, self-assured within one's breast, which has a smack of eternity, which can only, only, only be seen beneath the boat. who can believe that this bright green water can support the boat?
	reason is silent.
women:	(very quickly) don't look at the man, but at his legs, or rather at his feet—how each foot bends in its own way, flies in the air, strikes the ground with its heel, supports itself upon the ground. and again bends in its own way, flies in the air.
bass voices:	don't look at the trunks.
children's voices:	but rather at what is between the trunks,
alto voices:	what is under the table,
soprano:	on top of the roof,
tenor:	beneath the ant,
child:	look behind the zeppelin,
bass:	look under the tongue in your mouth,
soprano:	into the bell—whether it be large or small—
child (very high):	behind the curtain
bass (very low):	and ... in ... the ... midst ... of ... its tassels.

•the figures indicate time in seconds.

this extract from "Violett" was written in summer 1914.

721

1928

Art Pedagogy/Analytical Drawing
["kunstpädagogik"; "analytisches zeichnen"]
bauhaus
(Dessau), 1928

At Weimar, Kandinsky had been responsible for the workshop for mural painting. At Dessau, in addition to his own "optional painting classes," he contributed to the foundation-year course, which was under the general direction of Moholy-Nagy (subsequently, of Josef Albers). In the first term, he taught analytical drawing, mainly from still-lifes composed of objects chosen by the students themselves. The students for the most part showed a strong preference for regular or geometrical objects, or at least objects that could easily be reduced to regular or geometric form. A photograph of a typical still-life of 1929 is reproduced in Wingler, 1968, p. 414.

Kandinsky's account of the aims of his drawing course, accompanied by four students' drawings, was published in the magazine *bauhaus* in 1928 (2, nos. 2–3, edited by Ernst Kállai). It was preceded by his article "Art Pedagogy."

See also the description of Kandinsky's courses printed in the Bauhaus prospectus the following year (p. 856).

art pedagogy

until recently, it was the general opinion, and still is for the most part today, that "art teaching" is a special area having virtually nothing in common with questions of "general" education.

on the other hand, the concept of "general" education is thoroughly vague. one is entitled to maintain that there exists in our own times no general education without the " ".

there do exist, on the other hand, endless varieties of "specialist training," which have nothing whatever to do either with education in general, or with each other.

thus, art teaching today aims to provide a specialist training, limited in itself—just like the specialist training of a doctor, lawyer, engineer, mathematician, etc.

opposed to this general state of affairs is the opinion that art teaching cannot exist at all as such, since art can be neither taught nor learned: art is a matter of pure intuition, which in the natural course of events cannot be produced by force or by means of instruction.

the influential heritage of the nineteenth century—extreme specialization, and consequently dismemberment—imposes itself upon every realm of present-day life, and forces the problems of art teaching, too, further and further into a dead end. it is astonishing how few people have been capable of drawing the necessary conclusions from the events of the last few decades, and how rarely one encounters any understanding of the inner meaning behind the great "upsurge."

this inner meaning, or the inner tension of further "development," should be made the basis of all teaching; dispersion is replaced by integration. "either-or" must give way to "and."

specialist training without a general, human basis ought to be no longer possible.

every kind of teaching today—almost without exception—lacks any "worldview" of an internal nature, any "philosophy" to establish the meaning of human activity. it is remarkable that young people today are still trained as specialists in an old-fashioned and inwardly stultifying way—people who may be very useful in their external lives, but who are rarely capable of representing any purely human values.

as a rule, teaching consists of the more or less forcible accumulation of individual pieces of knowledge, which young people are supposed to digest inwardly, and which are no use to them outside their "speciality." of course, the ability to make connections, in other words, the capacity for synthetic observation and thought, is so little taken into account that it largely atrophies.

the main aim of all teaching should be to develop the capacity for thought in two simultaneous directions:

1. the analytical and
2. the synthetic

we should thus exploit the heritage of the preceding century (analysis = dissection) and, at the same time, so extend and deepen it by our synthetic approach that young people acquire the ability to experience and to demonstrate organic connections between apparently widely separated realms (synthesis = connection).

then young people would desert the petrified atmosphere of "either-or" for the flexible, living atmosphere of "and"—analysis as a means to synthesis. from here it is easy to conclude that

1. the main basis of all education or of all teaching is always the same.
2. art teaching is therefore not divorced from all other kinds of teaching.
3. first and foremost, it is not what is taught that is important, but how.

point 3 ought not to appear paradoxical.

from the standpoint of our "and," the superstition that arose during the period of dissection that there exist different forms of thought, and therefore different forms of creativity also, is to be definitively rejected:

modes of thought and the process of creativity differ not in the slightest, even in the most various realms of human activity—whether they be art, science, technology, etc.

the decisive factor is whether a method of inculcating specialist knowledge (teaching) contents itself with accumulating information, or whether it aims first and foremost to develop and to cultivate the capacities of analytical-synthetic power of thought.

it is more profitable for an artist to acquire specialist knowledge of some unfamiliar subject, provided he is able to develop the above-mentioned capacity for thought, than to be narrowly "educated" in his own subject, and to remain just as incapable of such thought as he had been before.

there is no need of further proof that the ideal instruction in every "speciality" should consist of two parts, which would have to be inextricably bound up with one another:

1. training in analytical-synthetic observation, thought, and action and

2. systematically imparting and assimilating the appropriate specialized knowledge.

it goes without saying that this applies likewise to art instruction.

art cannot in fact be learned—in just the same way that creative work and ingenuity in science or technology cannot be taught or learned.

great periods in art, however, have always had their "doctrine" or "theory," whose necessity is just as self-evident as was and is the case in science. these "doctrines" could never oust the intuitive element, because knowledge is barren in itself. it must content itself with the task of passing on materials and methods. fertile is intuition, which employs these materials and these methods as means to an end. the end cannot, however, be attained without the means, and in this sense intuition might likewise be considered infertile.

no "either-or," but "and."

the artist works like every other man, on the basis of his knowledge, and with the aid of his capacity for thought and his intuitive impulse.

in this case also, the artist is indistinguishable from every other creative person.

his work is law-governed and purposive.

1 above: overall theme.
 below: four different constructional variants, achieved by eliminating indi-
 vidual parts of the construction.
 variants as a way of stimulating four fundamentally different ways of struc-
 turing the tension of the overall theme.

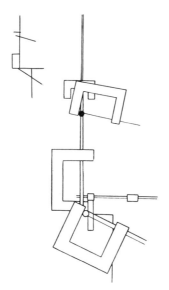

2 beginning:
 connection between similar individual objects within one larger form.
 top left: concise schema of the structure.

r. l. kukowka

3 third level:
 objects completely transformed into tensions between forces, complex con-
 structions with distortions in individual parts. the larger structure is made
 visible by the dotted lines.
 lower left: schema.

fritz fiszmer

analytical drawing

(1st term)

from the start the students themselves select their own still-lifes. the first tasks of analytical drawing are:

1. to subordinate the whole complex to one simple overall form, which, within the limits determined by the student himself, must be precisely drawn in.
2. to realize the formal characterization of individual parts of the still-life, regarded both in isolation and in relation to other parts.
3. to represent the whole construction by means of the most concise possible schema.

(see drawing 2.)

gradual transition to second-level exercises, which, put briefly, consist in the following:

1. making clear the tensions discovered in the structure, which are to be represented by means of linear forms.
2. emphasizing the principal tensions by means of broader lines, or, subsequently, colors.
3. indicating the structural grid by means of starting or focal points (dotted lines).

(see drawing 4—the objects clearly represented: saw, grindstone, bucket.)

third level:

1. objects are regarded exclusively in terms of tension between forces, and the construction limits itself to complexes of lines.
2. variety of structural possibilities: clear and concealed construction (see drawing 3).
3. exercises in the utmost simplification of the overall complex and of the individual tensions—concise, exact expression.

the teaching and its methods can only be represented very generally in these brief words.

in many of the subsidiary exercises, more possibilities and necessities

are taken into account than indicated here. e.g., the main theme can be examined on the basis of the most varied kinds of partial tension—the significance of individual structural components with their weight, center, formal character, etc. (see drawing 1; above, the overall theme, below, four different ways of underlining the structure.)
the following must also be observed:

1. the teaching of drawing at the bauhaus is an education in looking, precise observation, and the precise representation not of the external appearance of an object, but of constructive elements, the laws that govern the forces (= tensions) that can be discovered in given objects, and of their logical construction—an education in clearly observing and clearly reproducing relationships, where two-dimensional phenomena are an introductory step leading to the three-dimensional.

2. the teaching of drawing is based on a method that remains the same in my other kinds of instruction, and in my opinion should be the method for all other areas of teaching (see my essay "art pedagogy" in this volume).

4 second level:
objects recognizable, principal tensions by means of color, essential weights indicated by reinforced lines, point of departure for structural grid.
top left: concise schema.

erich fritzsche

1928

Statement in the Catalogue of the October Exhibition, Galerie F. Möller
Oktober-Ausstellung
(Berlin), 1928

Ferdinand Möller was, together with Flechtheim, Cassirer, and Nierdendorf, one of the most prominent dealers in modern art in Berlin in the twenties and thirties. His gallery showed the work of most of the leading expressionists: in May 1928, for example, drawings and watercolors by Nolde; in autumn 1929, works by Paula Modersohn-Becker; in November 1929, an exhibition of the "Blue Four": Kandinsky, Klee, Jawlensky, and Feininger. An exhibition of drawings by Kandinsky was also shown at the Galerie Möller in February 1932 (see p. 761).

I do not wish my works to be understood in terms of "principles" ("is 'abstract painting' justified or not?").
I do not wish to be considered

 a "symbolist"

 a "romanticist"

 a "constructivist"

I would be content if the viewer were to experience the inner life of the living forces employed, their relationships, if proceeding from one picture to another, he were to discover on each occasion
 a different pictorial content.
The question of form is not only interesting; it is extremely important, but it does not cover art as such.
 Whoever is satisfied with the question of form remains on the surface.

October 1928

Bare Wall
["Die kahle Wand"]
Der Kunstnarr
(Dessau), 1929

Kandinsky's essay "Bare Wall" appeared in the first and only issue of the periodical *Der Kunstnarr* in April 1929. *Der Kunstnarr* was the brainchild of Kandinsky's colleague, the Hungarian Ernst Kállai, who also edited the Bauhaus magazine for the period of Hannes Meyer's directorship. Kállai published extensively during the 1920s; his monograph *New Painting in Hungary* [*Neue Malerei in Ungarn*] appeared in 1925, and he contributed to numerous periodicals, including *bauhaus, Die Weltbühne,* and *i10.* His article on "Painting and Photography" in the latter provoked a response from Kandinsky, among others (also published in *i10;* see p. 717).

"Bare Wall" is a spirited defense of painting, which despite the "optional classes" run by Kandinsky, Klee, and others, always enjoyed a somewhat precarious position at the Bauhaus. On the same subject, Kállai himself wrote, also in *Der Kunstnarr:*

> It is . . . not without interest to observe that what goes on at the Bauhaus in Dessau is not only building and workshop production of objects of practical use. There is also painting. Cheek by jowl with the imposing reinforced concrete forms and glass expanses, so to speak, in the shadow of these icily rational, purpose-dedicated spatial constructions that vaunt their industrial aesthetic. If the nocturnal devil of the legends were to peep into the cubicles and studios of the Bauhäusler, he would be astounded by the number of painters standing

around, here and there, in front of their easels, dabbing at pictures.[1]

During the same spring of 1929, exhibitions of the work of young Bauhaus painters were shown at Brunswick by the Gesellschaft der Freunde junger Kunst (March– April) and at Erfurt by the Verein für Kunst und Kunstgewerbe (May).

The bare wall! . . .

That ideal wall, where nothing stands, against which nothing leans, on which no picture hangs, where n o t h i n g is to be seen.

The egocentric wall, living "in and for itself," self-assertive, chaste.

The romantic wall.

I too love the bare wall, for it is one of the sounds of the coming new Romanticism.

The heralds of the bare wall, the opponents of Romanticism are firm friends of art today, and of painting in particular.

Indeed, especially of painting, since of all the arts it is only painting that they fight against.

He who is able to e x p e r i e n c e the bare wall is best prepared to experience a work of painting:

The two-dimensional, immaculately smooth, vertical, well-proportioned, "reticent," sublime, assertive, introspective wall, its limits externally determined, radiating outwards is virtually a primary "element."

Primary elements are the *A* in understanding art, upon which *B* must inevitably follow: must, because it can.

Ale-house music is noisy and strident, like the average middle-class apartment. Modern man is numbed—he can only hear things if they are loud. Unless he is taken by the scruff of his neck and thoroughly shaken, he remains unmoved.

But noise is only o n e part of the whole—who knows whether the soft (and reticent) is not a still more important part of the whole?

We painters owe a debt to our "enemies," because they are our friends.

Depending on "tendency" and disposition, quite different things are demanded of the painter of today. Especially the "abstract" painter.

Many people insist that we should only paint walls.

And only inside.

Many people wish us to paint the outside of their houses.

And only the outside.

Many demand that we should serve industry, that we should supply patterns for materials, ties, socks, crockery, parasols, ash trays, carpets.

Just applied art.

Only we should leave off painting pictures once and for all.

Some people are more amicably disposed, and allow us to paint pictures straight on to the walls, as long as we abandon easel painting.

Depending on "tendency" and disposition, the painter of today is forbidden:

to paint easel paintings

to paint fresco paintings

to paint patterns for materials and any other objects

to paint external walls

to paint internal walls

to paint at all

There are people today who love painting. Sometimes, they consider there is no "proper" painting today.

In the opinion of these art lovers, painters have been punished by infertility for abandoning the old, secure tradition.

How often people bewail, verbally and in writing, the fact that there is no "new blood." "Always the same aging painters—and where are the youth who could and should take up the "sacred banner" of art?"

"Painting is in a state of degeneration and decay."

Some people mourn, others rejoice.

Some people mourn, others rejoice at the fact that painting is practised at the Bauhaus, not only by the "masters," but also by the young people, that for two years now the Bauhaus has been giving regular instruction—apart from the practical "Wall-Painting Workshop," painting is now also being cultivated in the nonpractical "free painting classes."

One does, however, encounter in the same Bauhaus students who are to be found neither in the practical department, nor in the nonpractical painting classes, and who are nonetheless involved in "free painting": e.g., carpenters, metal-workers, weavers, even architects.

Even architects.

Is it any wonder that all these young people love the bare wall, although they often have no inkling of how romantic it is?

They paint because of an inner need, and have no doubts about the future of painting. If they theorize, it is in a painterly, that is to say an artistic, way.

The obsolete word Art has been positively resurrected at the Bauhaus. And, linked to the word, the deed.

At last, thanks to our friends (of the bare wall), the misbegotten works of painting are fortunately disappearing from our walls.

And not only we ourselves, patient, persistent, albeit "aging masters," but with us the rising generation will see to it that, where necessary, the bare wall remains bare, and that the other walls will not be packed with freaks again, but will, in a "planned and purposive" way, accept "pictorial worlds" with tacit joy.

He who finds here cause for regret can continue regretting.

We shall rejoice.

Dessau, January 1929

Two Suggestions
["Zwei Ratschläge"]
Berliner Tageblatt
(Berlin), 1929

This essay was published to coincide with the opening of the "Jury-free" exhibition in Berlin of autumn 1929. It appeared in a supplement to the *Berliner Tageblatt* under the heading "Artists among themselves. . . ." The supplement was edited by Walter Zadek. Kandinsky's contribution returns to a theme the artist had already discussed in his 1914 Cologne lecture notes (see pp. 392–400): the relation between inspiration and the irrational on the one hand, and calculation and reflection on the other, in the genesis of the work of art.

I have long since discovered the answer to this question.

In Russian schools drawing was not compulsory. The lessons took place after the compulsory ones had finished. Thus, few of the boys attended these lessons. And still fewer took them seriously. More than fifty years ago, I belonged to those very few.

Then, I was a little grammar school boy in a blue coat with silver buttons, heavy satchel, and big drawing board.

Our drawing teacher was a man of medium height with a pasty face and a very long, thin, reddish beard, on account of which we dubbed him "The Goat." At that time I admired him greatly, for not only could he draw and paint mere heads or landscapes, but he also possessed a little table he had painted himself, on which banknotes, a silver coin, and a fly had been so realistically painted that to my eyes they surpassed "nature."

This teacher used to say: "Boys, drawing is a difficult thing. It's not like Latin or Greek—here, you have to think!"

Some twenty years afterward I studied drawing in the then famous Ažbè school in Munich. I already had a full beard, and many of my colleagues were under twenty. Anton Ažbè was a very small man with a big moustache combed upward, a large, broad-brimmed hat, and a long Virginia [cigarette] in his mouth (which often went out, and which he sometimes used for correcting the drawings). Outwardly he was tiny; inwardly he was immense—gifted, clever, strict, and kindly beyond all bounds.

I didn't like anatomy, and I asked Ažbè whether I absolutely had to learn it.

"Yes, my friend, you've got to know anatomy properly. But woe betide you if you think about anatomy in front of the easel! When he's working, the artist shouldn't think!"

I have followed these two suggestions to this day and have remained true to them to the end.

Hendaye-Plage, 7 August 1929

The Psychology of the Productive Personality
Paul Plaut, *Die Psychologie der produktiven Persönlichkeit* (Stuttgart), 1929

Plaut's study *The Psychology of the Productive Personality*, published in Stuttgart in autumn 1929 by the firm of Ferdinand Enke, made an important contribution to the field of applied psychology.[1] The author had circulated a questionnaire among artists in an attempt to clarify the role played by conscious volition in the various stages of the creative process. His three questions were:

1. How does the artist arrive at what is glibly called his "conception"? What kind of mental process gives birth to the idea of a new work of art?

2. What path does inspiration follow to arrive at a clearly defined chain of thought, motif, etc. and beyond, up to the finished work?

3. Does consciousness play a leading role in all this, or not? If so, at what stage?[2]

Kandinsky's answer is given below.

1. My first idea is formed in various ways: sometimes it is an external impression (some natural occurrence, natural phenomenon, a street scene, a "chance" effect of light, just a mailbox, a mailbox by a fruit shop, people in the fields, in a cafe, theater, tram, etc.) that gives the first impulse to some new idea (something one realizes only later—in the

"Kandinsky" album produced by Der Sturm in 1913, I describe such incidents in my "Reminiscences": the yellow Bavarian mailboxes, blue Munich trams, black Venice (when I was three or four years old), etc.). These are all external impressions transmitted through the eye.

I was often excited by sounds: real music (e.g., Wagner, Beethoven, later Mozart, Bach, etc.) or individual sounds (barrel organ, mouth organ, etc.) or "noises" (falling board, murmuring water, bird song etc.)—i.e., structured and unstructured sounds. I.e., external impressions transmitted through the ear.

The other senses, too, certainly possess the power of bringing about creative impulses: touch, taste, smell. In any case, colors (and to a certain extent "form" are for me bound up with these other senses, i.e., that is how I experience them. That is to say, impulses can arise in this way.

I wish to assert that there exist, apart from these external impulses, other, internal ones, which have little or nothing to do with the external; they arise without, as it were, giving their reasons. That is: so-called "spiritual" experiences, one's sensitivity to the spiritual atmosphere, sympathetic or countervibrations—to put it in simple terms, being in a good or bad "mood," a powerful inner tension whose origin I am unable to explain, which discharges itself in the form of artistic (in my case, for the most part pictorial) "ideas," which sometimes "appear to one" so rapidly and continuously that one has no time to fasten onto them, even to a limited extent. Even this expresses itself in different ways: sometimes one sees only fragments, isolated juxtapositions, pictorial, linear "sounds," sometimes the whole picture, which only has to be held fast, i.e., must be given material form.

I must observe in passing that for many years I have known only pictorial (under which I also include linear) "ideas," i.e., I only get ideas that can be expressed pictorially, and do not permit description in words. For me, there are colors that have accompanied me throughout my life (mainly blue), others that operate as *leitmotifs* for some years or months (white, red, black, yellow), and yet others that nearly always take the form of accompanying elements and only in exceptional cases play a leading role (red, green, violet). I introduce these colors here only as an example, i.e., they are not supposed to be exhaustive. I love colors simultaneously in two different ways: with the eye (and other senses) and with the soul, i.e., for their content—one would be perfectly entitled to use the today prohibited word "symbolic"! I don't know whether you

are acquainted with my latest book, *Point and Line to Plane.* There, I write at length about the tensions between different elements. One need not and should not interpret these tensions exclusively, or primarily, in a "literary" manner, as has been done until now, putting people on the wrong track. But this is not part of your theme. I only mean to say that one's "conception" is not just an external, "pictorial" idea of beauty, but is bound up inextricably with these tensions within different elements.

2. As I have already said, one sometimes "sees" the finished picture before one's eyes—in such cases there remains, therefore, only the technical execution to be completed.

Sometimes, one only knows what the basic character of the picture should be, and tries to achieve the clearest possible expression of this basic idea (e.g., dark, warm, very controlled, radiant, introverted, restrained, aggressive, "disharmonious," concealed, overpowering, etc.). This is what is called "mood," something that can hold good for a whole series of works, but sometimes achieves a particularly high degree of concentration in individual pictures. In the course of work, one sometimes gets an "order," which one then has no choice but to obey slavishly. This order can sometimes lead one down other paths, which one at first is unable to understand—one's "intentions" being one thing, the result something completely different. The "joyful" becomes transformed into the "oppressive," *allegro* into *andante,* cold into warm, and vice versa. In such cases, one just has to let it happen.

To this chapter belong also developments of a "theme." Sometimes one has an imprecise, sometimes a very precise vision of one's theme. For me, this is something that is nearly always "fun": one's inner tensions are resolved, one feels good, in an agreeable mood—as long as no mistake occurs, something that rarely happens in these cases.

3. Perhaps the most difficult question! Nearly all theoreticians reproach me personally with the fact that I work too "consciously," too much, or exclusively, with my "head," that in my case "intuition" is lacking, or plays too small a part.

As far as point number one, "conception," goes, conscious decision-making plays absolutely no part, something that can be clearly seen from my answer. Of course, one could say to oneself: now do this or do that (something warm-cold, or radiant, or controlled). I could also assert that in this way, apart from "experimental" works, worthwhile works, proper works of art come into being. Perhaps, "unfortunately"!, perhaps, "fortunately"!, I don't happen to work in this way. In the course

of work, my "head" keeps completely silent. But apart from my "practical" pictorial work, I particularly enjoy exercising myself theoretically, which I do, alas, all too infrequently. Those theoretical matters on which one reflects, and in the course of time understands and makes one's own, naturally produce an effect (in unconscious form) in one's subsequent works—in exactly the same way as the necessary theoretical knowledge produces its effect in "objective," and especially in naturalistic painting, something that, in the case of the true artist, also occurs unconsciously (anatomy, perspective, reflection, modeling, etc.). If I have, e.g., in recent years so frequently and so enthusiastically made use of the circle, the reason (or the cause) is not the "geometrical" form of the circle, or its geometrical characteristics, but rather my own extreme sensitivity to the inner force of the circle in all its countless variations. I love circles today in the same way that previously I loved, e.g., horses—perhaps even more, since I find in circles more inner possibilities, which is the reason why the circle has replaced the horse. All this has, I have already mentioned, no role to play in the course of working; I do not choose form consciously, it chooses itself within me. In pictorial terms, I have said in my pictures a great deal that is "new" on the subject of the circle; but in theoretical terms, despite every effort, I can't say a great deal about it. I would like to, but am unable to. I hope you will excuse me for writing so much about this particular instance—to me, however, it seems appropriate, and illuminates this difficult question. I demand of my students that they think very precisely, that they execute purely cerebral exercises with exactitude; we even discuss the works they submit in purely theoretical terms. But I always emphasize with particular force that this theoretical path, this theoretical point of view is only a way of arriving at the "content," which is why I place particular value upon the living experience of "tensions."

Theory is (especially today) indispensable and fruitful. But woe betide him who would create a "work" in this way alone.

Reply to a Questionnaire
["Enquête: 1830–1930"],
L'Intransigeant
(Paris), 1929

During the 1920s and '30s, Kandinsky devoted a good deal of energy to responding to questionnaires—a task he would perform punctiliously, and sometimes at length. His statement printed below, written while he was still at the Dessau Bauhaus, marks his first appearance in the Parisian daily press. In November and December 1929, the newspaper *L'Intransigeant* ran a questionnaire under the heading "Enquête: 1830–1930," with replies from Rouault, Jacques-Emile Blanche, Chagall, and others. The questions, printed in the issue for 2 November 1929, were as follows:

1. For more than a century, painting has developed by way of fluctuations as fortunate as they have been various, leading to a surprising degree of activity during these last thirty years.
Do you see in this the fertile product of a certain revolutionary continuity?
2. Do you see an analogy between the aesthetic movements characteristic of the XIX century, with the flowering of Classicism under David and Ingres, the romantic reaction of Géricault, Delacroix, followed by that of Corot and the school of the 1830s, and the XX century after Cézanne, Seurat and Renoir, e.g. Fauvism, Cubism, the post-war artists and our younger painters?
In your opinion, which of these analogies are the most obvious?

I perceive in the tortuous evolution of painting from 1830 to 1930 a rigorous logic, an almost superhuman tension.

As far as one can see today, the final goal remains the synthesis of Classicism and Romanticism, in the sense in which these two ideas, although often conceived of as mutually exclusive, complement one another in parallel fashion within one and the same work.

This is the essential line of development that characterizes the pictorial "revolution." It is subject to the "law of the pendulum," as happens in every period of evolution.

In my opinion, pure formalism is giving way to something new, a "new and essential line."

Moreover, within this same line, one can detect certain smaller movements of the pendulum. In human evolution, every essential line is made up of smaller lines tending either to the left or the right. Taken as a whole, they constitute a clear-cut straight line.

These smaller, pendular movements explain the reaction that proceeds from the Classicism of David and Ingres to the Romanticism of Delacroix and Géricault and beyond, to Corot and the Barbizon painters (Millet).

Impressionism tends toward the classical. The reaction against it was necessarily romantic. It was this that produced Fauvism, Expressionism, etc. . . .

I perceive in Cubism and in "absolute" and "abstract" painting a first attempt at synthesizing within one and the same content the two antagonists, classical form and romantic form.

Expressionism seethes with temperament (the handed-down principle of seeing nature through a temperament).

Cubism and abstract painting abandon this seething temperament in favor of a cooler mode of expression (another pendular movement).

These two species set up principles of construction and, what is more important, of a new composition.

Abstract painting is continuing to evolve further and is tending toward a cooler manner. Here, evidently, cool is becoming warm, so to speak.

One important postwar phenomenon is Surrealism, which is trying to create a new relationship with nature: abstract form might appear cold to the Surrealist.

It seems to me that the Surrealists give precedence to the "romantic," while abstract painters, on the contrary, give precedence to the "classi-

cal." They are, nonetheless, inextricably related, since in both one can see the two forms of expression: Classicism and Romanticism.

These two species are the offspring of the nineteenth century. They have simultaneously espoused both tendencies, that of Ingres and that of Delacroix. But the greatest progress consists in the fact that this handing-down has taken place on a synthetic basis, and that romantic content has become very much more profound.

Finally, the difference between these two species is that the Surrealist utilizes nature in his work (albeit in a sur-natural way) as if it were a "plus," whereas the abstract painter omits nature as if it were a "minus."

One puts alongside nature a nature that is surreal. The other considers nature and art as two worlds coexisting in parallel fashion. Both, nature and art, are the offspring of nature and create a surreal dual sound.

Dessau

1930

The Blaue Reiter (Recollection)
["Der Blaue Reiter (Rückblick)"]
Das Kunstblatt
(Berlin), 1930

At the beginning of 1930, Paul Westheim, editor of the periodical *Das Kunstblatt,* invited Kandinsky to recall the origins of the Blaue Reiter. The artist's recollections, in the form of a letter to Westheim, were published to coincide with the fiftieth anniversary of the birth of Franz Marc, on 8 February. During the same month, the Galerie Hermann Abels in Cologne showed a commemorative exhibition of Marc's work. An editorial note appended to Kandinsky's article in *Das Kunstblatt* reads as follows:

> On 8 February, Franz Marc would have been fifty. Kandinsky's account of the founding of the "Blue Rider" evokes the memory of the painter of the "Blue Horses," who, as one of the pathfinders of the new art in Germany, was to stir up men's spirits, giving the impulse to so much of decisive importance. "In our epoch of the great struggle for the new art," he wrote in the *Blaue Reiter* [*Almanac*], "we fight like 'savages,' without organization, against an old, organized power. The battle appears unequal; but in spiritual things, it is not numbers that triumph, but the strength of ideas. The dreaded weapons of the 'savages' are their new ideas: they kill more effectively than steel, and shatter what was considered unbreakable." Word for word, the same is true today; the battle continues.

Kandinsky's text was accompanied by reproductions of two of his woodcuts.[1]

Dear Herr Westheim,

You have invited me to relive my memories of the origin of the "Blaue Reiter."

Today—after so many years—this wish is justified, and I comply with it willingly.

Today—after so many years—the spiritual atmosphere of beautiful Munich, a city that despite everything remains dear to me, has altered fundamentally. Schwabing, in those days so loud and bustling, has become silent—not a sound is to be heard from there. A pity for Munich, and even more of a pity for funny, somewhat eccentric and self-confident Schwabing, in whose streets a person—whether man or woman (*a Weibsbuild*)—not carrying a palette, a canvas, or at the very least a portfolio was immediately conspicuous. Like an "intruder" in a "nest." Everybody painted . . . or wrote poetry, or played music, or learned to dance. In every house, one could find under the eaves at least two studios, in many of which not so much painting went on as constant discussion, debate, philosophizing, and a good measure of drinking (which depended not so much upon one's moral state as upon one's pocket).

"What is Schwabing?" someone from Berlin once asked in Munich.

"It is the northern part of the city," said one Münchner.

"No way," retorted another, "it is a state of mind." Which was more correct.

Schwabing was a spiritual island amid the wide world, in Germany, for the most part even in Munich.

There I lived for many a long year. There I painted the first abstract picture. There I brooded over reflections on "pure" painting, pure art. I sought to proceed "analytically," to discover synthetic relationships, dreamed of the "great synthesis" to come, felt obliged to communicate my thoughts not only to the surrounding island, but also to mankind beyond this island. I considered them seminal, essential.

Thus came into being my fleeting notes *"pro domo sua,"* my first book, *On the Spiritual in Art.* In 1910 I had the finished text lying in my drawer, since not a single publisher had the courage to wager the (as it turned out, quite low) cost of publication.

Even the warm sympathy evinced by the great Hugo von Tschudi went for nothing.

At the same time there matured within me the desire to compile a book (a kind of almanac), to which exclusively artists should contribute

as authors. I dreamed of painters and musicians in the front rank. The harmful separation of one art from another, of "art" from folk art, children's art, "ethnography,"* the stout walls erected between what were to my eyes such closely related, often identical phenomena, in a word, synthetic relationships—all this left me no peace. Today, it may seem remarkable that for a long time I could find no collaborators, no resources, nor simply sufficient interest for this project.

These days saw the violent birth pangs of the many "isms," at that time still oblivious to synthetic feeling, whose principal interest lay in waging flamboyant "civil wars."

Almost on the same day (1911–1912), two mighty "currents" in painting came into being: Cubism and abstract (= absolute) painting. And at the same time Futurism, Dadaism, and (soon to be victorious) Expressionism.

You could hardly see us for smoke!

Atonal music, and its master Arnold Schoenberg, at that time an object of general derision, enflamed people's sensibilities no less than the above-mentioned pictorial "isms."

It was about then that I got to know Schoenberg, and at once found in him an enthusiastic supporter of the Blaue Reiter idea. (At that time it was only an exchange of letters; our personal acquaintance came about only later.)

I was already in touch with a number of potential authors.

The Blaue Reiter existed already in spe, but still without any prospect of incarnation.

And then Franz Marc arrived from Sindelsdorf.

One conversation sufficed: we understood one another perfectly. I found then in this unforgettable man an extremely rare example (are they equally rare today?) of an artist capable of seeing far beyond the boundaries of the "closed shop," who internally rather than externally was against all limiting, restrictive traditions.

I owe the fact that the firm of R. Piper published On the Spiritual to

*My original enthusiasm for ethnography dates right back to my student days at Moscow University, when I noticed, albeit somewhat unconsciously, that ethnography was just as much an art as a science. The deciding factor was, however, the shattering impression made on me by Negro art, which I saw much later in the ethnographic museum in Berlin!

Franz Marc; it was he who smoothed the path.

For days on end, whole evenings, on occasion even half the night, we discussed our project. From the outset, it was for both of us cut and dried, that we would have to proceed in a strictly dictatorial manner: complete freedom for the realization of the idea incarnate.

Franz Marc brought in extra help, in the person of the then very young August Macke. We gave him the task of procuring most of the ethnographic material, in which we also engaged ourselves. He performed this task brilliantly, and was given another—that of writing an article on masks, which he accomplished equally well.

I took care of the Russians (painters, composers, theoreticians) and translated their articles.

Marc brought from Berlin a great number of pages by the "Brücke," which had just been formed, and which was completely unknown in Munich.

"Artist, create, don't talk!" a number of artists wrote and said to us, and declined our invitation to furnish articles. But that belongs to the chapter of refusals, opposition, and outrage, which must here remain closed.

What haste! Even before the volume appeared, Franz Marc and I organized the "first Exhibition of the Editors of the Blaue Reiter"* in the Galerie Thannhauser—its basis was the same: no advancement of any definite, exclusive "tendency," the juxtaposition of the most varied manifestations of the new painting, on an international basis, and . . . dictatorship. "The manifold forms assumed by the inner wishes of the artist," I wrote in the foreword.

The second (and last) exhibition was one of graphics, in the newly opened Galerie Hans Goltz, whose owner, shortly before his death some two years ago, wrote to me in great enthusiasm about those famous times.

My neighbor in Schwabing was Paul Klee. In those days he was still very "small fry." I can claim with justifiable pride, however, that I was able to detect in his little drawings of that period (he had not yet started to paint) the great Klee of later years. A drawing by him can be found in the *Blaue Reiter* [*Almanac*].

*We made up the name "Der Blaue Reiter" over coffee in the leafy garden at Sindelsdorf; we both loved blue, Marc—horses; I—riders. So the name invented itself. And Frau Maria Marc's fabulous coffee tasted even better.

I cannot fail to mention in addition Franz Marc's excessively generous patron, the likewise recently deceased B e r n h a r d K o e h l e r. Without his helping hand, the Blaue Reiter would have remained a beautiful utopia; likewise, Herwarth Walden's Erste Deutsche Herbstsalon, and much else besides.

My immediate plans for the next volume of the *Blaue Reiter* were to put art and science next to one another: origins, realization through various work processes, purpose. Today, I know better than I did then, how many smaller roots can be traced back to one single big one—a task for the future.

But then came the war, which swept even these modest plans away.

Yet that which is fundamentally necessary—internally!—can be postponed, but never uprooted.

<div align="right">

With best wishes,
Yours, Kandinsky.

</div>

Pictures at an Exhibition
["Modeste Mussorgsky:
'Bilder einer Ausstellung'"]
Das Kunstblatt
(Berlin), 1930

According to Nina Kandinsky, her husband's greatest ambition was to create a large-scale, multimedia ballet.[1] This wish was never realized. Kandinsky's most important step in this direction was the staging of Mussorgsky's *Pictures at an Exhibition* at the Friedrich-Theater in Dessau. At the request of the theater's director, Georg von Hartmann, Kandinsky designed the scenery and costumes, transforming the ten "pictures" of the original into sixteen scenes. Like *Yellow Sound*, two decades earlier, Kandinsky's staging of *Pictures at an Exhibition* called for the combination of music, stage movement, lighting, and decoration: he was assisted in the details by the artist Paul Klee's son Felix, who later made a short score of the choreography. The premiere took place on 4 April 1928, under the baton of Artur Rother.[2]

The artist's own account of his intentions was published two years later in Paul Westheim's periodical *Das Kunstblatt*. It was preceded by an illustration of the decor for the last scene, "The Great Gate of Kiev." In the text Kandinsky recalls that he used dancers for only two of the scenes, and that the others remained "abstract"; the preceding illustration suggests that "abstract" is here used in a rather unusual sense, since Kandinsky's scenery unequivocally recalls the spires and onion domes of Russian churches, in a hilltop setting (a favorite motif of the Blaue Reiter years), as well as clouds, sun, moon, etc.

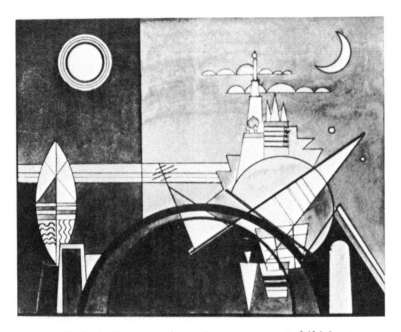

Modeste Mussorgsky: 'Pictures at an Exhibition'

Directed and designed by Wassily Kandinsky
(Performed at the Friedrich-Theater in Dessau, 4 April 1928)

The work consists of sixteen scenes, which render the impressions experienced by Mussorgsky at an exhibition of pictures. The pictures were of course "naturalistic" (presumably all watercolors).

The music, however, turned out to be anything but "program music." If it does "depict" anything, it is not the painted pictures, but Mussorgsky's own experiences, which went far beyond the painted "content" and assumed purely musical form. This was the reason I readily accepted the invitation of the then-director of the Friedrich-Theater in Dessau, Dr. Hartmann, to stage this piece of music.

With the exception of two scenes—"Samuel Goldenberg and Schmuyle" and "Market Place at Limoges" (for which I used in addition two dancers)—the entire staging was "abstract." I also used occasional forms that were distantly related to objects. Thus, I too did not proceed in a "programatic" way, but rather used forms that swam before my eyes on listening to the music.

My principal resources were:

1. form itself,
2. color and form, to which
3. the color of the lighting was added as a kind of more profound painting,
4. the independent play of the colored lights, and
5. the structure of each scene, which was bound up with the music, and of course the necessity of dismantling it.

One example: Scene 4—"The Old Castle." The stage is open, but completely dark (the black plush curtain used as backdrop creates a "nonmaterial" depth).

At the first *espressivo*, there is nothing to be seen except three long, vertical stripes in the distance. They vanish. At the next *espressivo* there emerges on the right the large red prospect (doubling of colors).

Whereupon at the left, similarly, the green prospect. Out of the dip appears the central figure, which is illuminated with intense colors. And so on.

At *poco largamente* the light fades more and more, until at *p* darkness falls. At the last *espressivo* the three stripes—as at the beginning— become visible. At the final *f* sudden darkness.

1931

Tribute to Klee
bauhaus
(Dessau), 1931

When Paul Klee resigned from the Bauhaus in April 1931 to take up a professorship at the Düsseldorf Academy, Kandinsky accepted the task of editing the number of the magazine *bauhaus* that marked his friend's departure. The cover carried a reproduction of Klee's drawing *Over and Up* of 1931; the texts began with a short tribute by Mies van der Rohe, who had succeeded Hannes Meyer as director of the school. It read:

> in paul klee, the bauhaus has lost an eminent artist, an outstanding teacher and, most irreplaceable of all, a great personality, and in him, we have all lost a true friend.

Kandinsky's essay touches only in passing upon the early years of his friendship with Klee in Munich. We know from Klee's diaries that the two artists initially treated one another with a measure of skepticism. Only during the Bauhaus years, and especially at Dessau, did they become intimate, although Kandinsky preserved a certain distance even in his relationship with Klee, preferring the formal mode of address "Sie" to the familiar "Du."[1]

In 1933, both Kandinsky and Klee left Germany, Kandinsky for Paris, Klee for Switzerland. Once again, their friendship survived the years of separation. In 1937, despite Klee's illness, the two artists together visited the Kandinsky exhibition staged by the Kunsthalle in Bern. Kandinsky was much affected by Klee's last illness and death, in June 1940, as attested by his letters to Hermann Rupf.[2]

this number of the *"bauhaus"* magazine is dedicated to paul klee.

it is occasioned by klee's departure from the bauhaus. i would have preferred to take on this task, given me by my colleagues at the bauhaus, of editing the current issue, had it been for quite the opposite reason— not his departure, but his return.

for fully ten years, work at the bauhaus has been closely bound up with klee's activity at our institute. such links cannot be severed painlessly.

this is strongly felt by everyone associated with the bauhaus—teachers and students, especially those who participated in klee's classes.

nor did klee himself, as i know, find it easy to decide to make the break.

as far as i personally am concerned, may i permit myself to express something subjective. more than twenty years ago, i moved into the ainmillerstrasse in munich, and soon learned that the young painter paul klee, who had just made his successful debut at the galerie thann-hauser, lived almost next door to me. we remained neighbors up until the outbreak of war, and from this period dates the beginning of our friendship. we were blown apart by the war. only eight years later did fate bring me to the bauhaus at weimar, and so we became—klee and i—neighbors for a second time: our studios at the bauhaus were situated almost side by side. soon followed another separation: the bauhaus flew from weimar with a rapidity that a zeppelin might have envied. to this flight klee and i owe our third and closest period of proximity: for more than five years we have been living right next to one another, our apartments separated only by a fire-proof wall. but despite the wall, we can visit one another without leaving the building, by a short walk through the cellar. bavaria—thuringia—anhalt. what next? but our spiritual proximity would have existed even without access through the cellar.

for klee, the bauhaus already belongs in the realm of memory. but he will not forget it so soon. almost from the very beginning, klee witnessed and shared the fate of this much-tried institute: the early, "heroic" period, when the young people nearly all preferred the hitch-hiker image—long hair, which after a few days began to get shorter and

shorter; décolletage, soon covered by a tunic; sandals, which later even turned into patent-leather shoes.

this was only the exterior, transitory aspect of the bauhaus students. inwardly they were, even in those days, young adults seeking with earnest endurance to involve themselves in the creation of a new mode of living, serious students who respected creative ideals. even if klee did not directly influence the reduction in the length of their hair, his words and deeds and his own example went a long way toward developing their interior, positive side. words alone are feeble if they go unsupported by active, outstanding example. as an example of unswerving dedication to his work, we could all learn something from klee. and undoubtedly have learned.

here, not only purely artistic, but also purely human qualities come to the fore. these latter are not so obvious, and their influence not so immediately noticeable. but my pedagogic experience has taught me that youth shows (even if often unconsciously) no less lively an interest in a teacher's human qualities than in his other attributes—artistic, scientific, etc.—any knowledge that is without a human basis remains superficial: quantity (accumulation of information) increases, but quality (seminal power of knowledge) remains unchanged. an increase in outward quantity sometimes leads to an inner "zero," and not infrequently to a "minus."

at the bauhaus, klee exuded a healthy, generative atmosphere—as a great artist and as a lucid pure human being. the bauhaus appreciates his worth.

Reflections on Abstract Art
["Reflexions sur l'art abstrait"]
Cahiers d'Art
(Paris), 1931

The magazine *Cahiers d'Art* was an "arts review published ten times each year," devoted to "painting, sculpture, architecture, ancient art, ethnography, and the cinema." The editor was Christian Zervos. Zervos, like Walden before him, was also a publisher and dealer; his books and exhibitions also went under the title of "Les Cahiers d'Art." It was Zervos who, in 1930, had published a monograph on Kandinsky by the artist's friend and biographer Will Grohmann.[1] In 1934 and 1935 his gallery staged two important one-man shows of Kandinsky's work, which helped to establish his reputation in Paris.

According to Grohmann, "Reflections on Abstract Art" was the last essay Kandinsky wrote in Dessau before the Bauhaus moved to Berlin.[2] It appeared in *Cahiers d'Art* 1, nos. 7–8 (1931), preceded by a reproduction of Kandinsky's painting *Surfaces and Lines*,[3] painted the preceding year. The essay is a response to several quite specific criticisms of abstract painting, enumerated by Zervos in a brief and somewhat defensive editorial:

> Not wishing to break the rule of impartiality they have always imposed upon themselves, the editors of *Cahiers d'Art* have asked all those artists and writers on art interested in the abstract art movement to offer our readers their observations with regard to this art, which is accused: (1) of being deliberately inexpressive and excessively cerebral, of contradicting, moreover, the very nature of true art, which has in essence a

sensuous and emotive character; (2) of having deliberately banished that emotion which derives from the furthest depths of the unconscious in favor of an exercise of greater or lesser skill and subtlety, in favor of pure colors and geometrical forms; (3) of having so far restricted the possibilities open to painting and sculpture as to reduce the work of art to a simple play of colors circumscribed by forms characterized by a limiting plastic rationalism more appropriate to a poster or publicity leaflet than to works that claim to belong to the domain of art; (4) of having brought art to an impasse, by virtue of its technical stringency, a complete whittling away that deprives it of all possibility of evolution and development.

"Abstract" painters are the accused, that is to say, they have to defend themselves. They must prove that painting without an "object" is really painting and has the right to exist alongside the other kind.

This way of asking the question is inaccurate and unfair.

I would be tempted to turn the question around and ask those who advocate exclusively the painting of objects to prove that theirs is the only real painting.

In other words: that the supporters of painting objects *prove* that the object in painting is as indispensable as color and form (in the limited sense), without which painting would be unimaginable.

The experience of different ages produced paintings that did not resort to representation, and therefore especially increased the value of the essential elements: form and color.

Some of our current "abstract" paintings are, in the best sense of the word, endowed with artistic life: they possess the throbbing of life, its radiance, and they exert an influence on man's inner life via the eye. *In a purely pictorial manner.* Likewise, among the innumerable paintings of today that have objects,[4] only a few are endowed with artistic life in the best sense of the word.

I would like to point out briefly that the label "abstract" is misleading and detrimental as long as it is taken literally. But to the best of my knowledge, the label "Impressionism," was devised and used in its day

to ridicule the movement. The term "Cubism," taken literally, is a detrimental banalization of what is new in Cubism.

The reproaches aimed at "abstract" painting have been known to me for a long time.

It is supposed to lead to an impasse: the Impressionists, the Cubists, the Expressionists and the Post-Impressionists, didn't they undoubtedly hear exactly the same prophecies? All those "trends"—that is what revelations are usually called—have been regarded as "anarchic" by the press, the public, and the artists themselves (Bolshevism did not exist yet), as threatening to destroy the "eternal" principle of painting. They found comfort by saying that they lead to an impasse.

It was asserted that the Impressionists debase art through their love of landscape, and that this love corresponds to a catastrophic decline of creative power. Not only was there talk of a dead end, but also of the death of painting, etc., etc. It is not difficult to find such examples in the history of art.

The nature of art remains forever immutable, whether it is, for example, painting or music that is being discussed. Would it be possible to find a man who would maintain that only lieder or opera match up to the true essence of music, and that pure symphonic music is intellectual and artificial, and leads to a dead end? There was a time when one heard such assertions.

Only what turns its back on the spirit leads to dead ends, whereas what is born of the spirit and serves it opens up all dead ends and leads to freedom.

Intellectual work. It is always a little hazardous to rely on the past alone. It is dangerous to pretend that innovations are errors because they have never yet existed, if only because our knowledge of the past is very defective. Quite often, indeed, phenomena can be found in the past that are at least closely related to the "most recent" and previously nonexistent phenomena. Think, for example, of Frobenius and his discoveries of recent times.

As far as intellectual work is concerned, we are entitled to assert that in the history of art there were periods in which the collaboration of reason (intellectual work) played not merely an important part, but a

crucial one. It is therefore undeniable that intellectual work sometimes constitutes a necessary force of *collaboration*.

We can, on the other hand, as legitimately maintain that until now intellectual work by itself, that is to say, without the intuitive element, never gave birth to living works.

But, furthermore, one can only be "convinced," "firmly believe," foretell that it is never otherwise for the very reason that it *cannot* be otherwise.

This is also my personal "conviction," but without my being able to prove it in a purely theoretical manner. I can only talk from my personal experience: my few attempts to proceed in an exclusively "reasonable" manner from beginning to end have never reached a real solution. For example, I have drawn an image projected upon a surface calculated according to mathematical proportions, but the color already so profoundly modified the proportions of the drawing that it was impossible to rely on "mathematics" alone.

This is what any artist knows for whom elements are living things. Besides, in the realm of color alone (by abstracting form as much as possible), "mathematical" mathematics and "pictorial" mathematics belong to completely different realms. When to an apple one adds an ever-increasing number of apples, the number of apples grows and one can count them. But when to yellow one keeps adding more and more yellow, the yellow will not increase, but decrease (what we have at the beginning and what remained in the end cannot be counted).

Woe betide him who relies solely on mathematics—on reason.

The fundamental law that governs the method of working and the energies of both the painter "with an object" and the painter "without an object" is absolutely the same.

Normal works of abstract painting spring from the source common to all the arts: intuition.

In all those cases reason plays the same part: it collaborates, whether or not it is a question of works copying objects, but always as a secondary factor.

Artists who call themselves "pure Constructivists" have made varying attempts to construct on a purely materialistic basis. They have tried to eliminate "out-of-date" feeling (intuition) in order to serve our present "reasonable" age through means adapted to it. They were forgetting that there are two kinds of mathematics. And besides, they have never been able to establish a clear-cut formula that would corre-

spond to every proportion of the painting. They have thus been obliged either to paint poor paintings, or to correct reason by means of "out-of-date" intuition.

Henri Rousseau said one day that his paintings were particularly successful when he would hear within himself in an especially distinct manner "the voice of his deceased wife." Likewise, I advise my pupils to learn how to think, but to paint *pictures* only when they hear the voice of "their deceased wife."

Geometry. Why is a painting, in which "geometrical" forms can be recognized, called "geometrical," whereas a painting in which vegetable forms can be recognized is not called "botanical?"

Or can one really call "musical" a painting in which one can make out a guitar or a violin on the canvas?

A few "abstract" painters are being blamed for being interested in geometry. When I had to study anatomy at art school (for which I had little taste, so bad was the teaching of the anatomy professor), my master Anton Ažbè used to say to me: "You *must* know anatomy, but in front of your easel, you *must* forget it."

After the era of landscape, after it was "accepted," the press, the public, and even artists themselves were gripped by a new fear, when one suddenly began to paint more and more *"natures mortes."* Landscape at least is something alive *(nature vivante)*, people said at the time, and it is not for nothing this kind of "nature" is called "dead."

But the painter needed discreet, silent, almost insignificant objects. How silent an apple is next to the Laocoön!

A circle is even more silent! Much more so than an apple. Our age is not an ideal one, but among the few important "innovations" or among mankind's new qualities, one must know how to appreciate this growing ability to hear a sound in the midst of silence. And it is thus that noisy man was replaced by the more silent landscape, and landscape itself by still-life, more silent yet.

One more step was taken. Nowadays, in painting a point sometimes expresses more than a human face.

A vertical associated with a horizontal produces an almost dramatic sound. The contact between the acute angle of a triangle and a circle has no less effect than that of God's finger touching Adam's in Michelangelo.

And if fingers are not only anatomy or physiology, but more—namely,

pictorial means—the triangle and the circle are not only geometry, but more—pictorial means. It also happens that at times silence speaks louder than noise, that muteness acquires a sharp eloquence.

Abstract painting can, of course, in addition to the so-called strict geometrical forms, make use of an unlimited number of so-called free forms, and besides primary colors can make use of an unlimited quantity of inexhaustible tonalities—each time in harmony with the aim of the given image.

As for why this newly acquired faculty is beginning to develop in men, this is a complex question that would lead us too far. Let it suffice to say at this point that it is linked to that newly acquired faculty that enables man to touch under the *skin* of *Nature* its essence, its "content."

In time it will be demonstrated for certain that "abstract" art does not exclude an association with nature, but that on the contrary, this liaison is greater and more intimate than in recent times.

Those spirits who, at the sight of a few triangles in a painting, remain prisoners of those triangles and are thus incapable of seeing the painting, are of the same mind as those who had a fig-leaf added on to any male figure from antiquity.

But I believe that the fig-leaf itself was powerless to pry their eyes open to the sculptural form of the antique.

Moreover, let us not forget that as Nelidov, a great man of the stage, says in his history of the Russian theater, nothing in art is opposed with such tenacity as a new form.

The unaccustomed form conceals what lies beneath: that's the way it is with most men.

Only time can change this state of things.

Extract from a Letter
Published in the Catalogue of the
Kandinsky-Ausstellung at the
Galerie F. Möller
(Berlin), 1932

See p. 730.

. . . I spent virtually the whole of today selecting drawings and it was a difficult task. Since I have never before exhibited drawings (except at the Bauhaus last autumn), I naturally wish their variety to be clearly emphasized in the exhibition. My criterion for choosing them was: no repetitions, indeed, nothing too closely related. In fact, I succeeded in adhering to this criterion, and the result is—at least to my eyes—highly satisfying. In this instance, it is a matter not only of myself, but of the purely linear resources of so-called abstract painting.

I have always been convinced that this kind of painting offers no fewer possibilities than objective painting—but rather more! I think definitely: More! Originally, I wanted to limit myself to about thirty drawings, but was forced to realize that such limitation would produce a positively harmful effect. I am sending you, therefore, fifty-three items that when perceived in unison heighten the individual sound of each drawing. Their great variety must certainly appear sufficient, even to the most "obstinate skeptic," to undermine any cerebral prejudice against abstract form. Of course, always assuming that the aforementioned skeptic is prepared to see: if one wishes, one can remain blind even though one's eyes are wide open. For which there exists no remedy.

Dessau, 23 January 1932

1933

Reply to a Questionnaire
Minotaure
(Paris), 1933

André Breton and Paul Éluard asked of a variety of artists, writers, and intellectuals: Can you say what has been the most important encounter in your life? And to what extent did, or does, that encounter give you an impression of chance or of necessity? The replies, from personalities as diverse as Kandinsky and Jung, René Lalou and Aldous Huxley, were printed in the December 1933 issue of the Surrealist journal *Minotaure.* They were preceded by the famous quotation from Lautréamont's *Les Chants de Maldoror:* " . . . as beautiful as the chance encounter of a sewing machine and an umbrella upon a dissecting table." A drawing by Man Ray illustrated his conception of what such an encounter would look like. The accompanying editorial indicated that Breton and Éluard found the replies in many ways disappointing, particularly since most of them failed to attend to what the Surrealists considered the dual nature of chance, defined as *"la rencontre d'une causalité externe et d'une finalité interne."* Kandinsky's answer follows.

Once—over twenty years ago—I happened to be present at a conference of vegetarians in Munich whose aim it was to celebrate their *great apostle* Gutzeit.

After a few impassioned speeches in his honor, the apostle told his "disciples" that a few weeks before he had given himself permission to eat liver, a dish he had especially relished before he became a vegetarian. Finding it rather difficult to eat, he said to himself: "You don't want to! Well then! Force yourself." The first piece he put in his mouth tasted

awful, but "Force yourself!" And he swallowed it.

This confession naturally caused a great scandal; the "disciples" jumped off their seats, shouting and banging the tables like madmen. The apostle had betrayed! Having finally been permitted to defend himself, the false apostle said calmly: "It is not such a great crime to swallow a piece of liver. The really pernicious crime would be to follow a principle outwardly when it has not ripened inwardly."

This is what I find "necessary." This law of *inner freedom*. This selfsame law that is truly the *only reliable one* in Art.

1935

Art Today
Cahiers d'Art
(Paris), 1935

The first issue of *Cahiers d'Art* for 1935 begins with the declaration: "This number intends to show that art today is more alive than ever." The editor, Christian Zervos, evidently exercised at the state of contemporary art, opens with a broadside:

> Today, no one can deny any longer the importance of revising plastic values.
> Never, perhaps, have the artist's resources been so undermined: emotion, intellect.
> Social conflicts of considerable importance add to the confusion and perplexity of men's minds.
> Nonetheless, the older generation, spurred on by their *élan,* continue to produce important works that constitute an example and a lesson.
> But what of the YOUNG?
> Do not many of them offer a profoundly distressing spectacle?
> Lacking independence and self-confidence, they hang on like parasites to the innovations of the past.
> What do they propose to do with the formal lessons they learned from their masters, with their pure products?
> What do they propose to play on this keyboard?
> This is the reason for this
> INQUIRY ..

There follows a long questionnaire that further develops the view that contemporary art is stagnating and that the younger generation has reached an impasse. The question-

naire was circulated to various contributors to *Cahiers d'Art;* Kandinsky's response is given below. The following issue of *Cahiers d'Art* (10, nos. 5–6) also contained his essay "Empty Canvas, etc." (see pp. 780–83).

All the questions asked by this inquiry are the legitimate progeny of the crisis. Not of the disturbing economic crisis, which is only one consequence of a deeper crisis, but of the crisis of the Spirit.

This crisis of the Spirit is itself a result of two forces that are battling with each other today: materialism, which since the nineteenth century is spreading in all directions, and synthesis.

In 1910 I wrote: "The nightmare of materialistic ideas that turn cosmic life into a sorry and aimless game is not over yet. Cruder emotions, such as fear, joy, sadness, etc., will no longer attract the artist's interest. He will try to awaken inexpressible and more refined feelings. These are, indeed, very subtle emotions, which our language would be powerless to express. Each art is deeply rooted in its age, but the higher art is not only an echo and a mirror of the epoch; it possesses, in addition, a prophetic force that reaches far and very deeply into the future."

The drama we have been witnessing for some time between the death-throes of materialism and the beginnings of a synthesis, which seeks to rediscover the forgotten relationships between individual phenomena and between those phenomena and greater principles, will lead us, in the last resort, to a feeling of the cosmic: "the music of the spheres."

The path followed by contemporary science is consciously or unconsciously synthetic. Every day, the stoutest barriers that separate apparently incompatible sciences crumble a little more.

Art, too, cannot avoid this path. I have already tried for many long years to call attention to the beginnings of a synthesis between the arts. If a thorough scrutiny of the arts shows us that each makes use of its own peculiar means of expression, it shows us at the same time the kinship of all the arts as far as their prime intentions are concerned. Each art possesses its own particular power, and it is impossible to apply the resources of one art to another, as in painting and music, for example. But if one uses within the same work the various resources belonging to

different arts, one achieves monumental art.

One must never prescribe "flawless remedies" for youth, nor administer such remedies by force. This kind of thing leads only to falsehood. Youth needs an education oriented toward synthesis. If they manage to hear, even faintly, the "music of the spheres," they could no longer be harmed by any remedy.

Among the various voices that make up the "music of the spheres," one is surprised to hear the voices of times past, especially of great epochs. Youth should study the spirit of those epochs thoroughly, while discarding their forms, for these were necessary and unavoidable in the past, means of expression belonging to the spirit of the epoch. In the hands of today's youth, they are devoid of content.

There is modern and "modern." Modern man (or better, the man of sound mind), works to create synthesis. "Modern" man, for lack of intuition and thanks to his "intelligence," remains attached to the external side of life. He stands with both feet on the foundations of real life. This is why he has lost direct contact with life. Hence his despair and his need to stop up his ears. Is it up to artists to adapt themselves to that "modern" man, or up to the latter to approach them?

If he wants to "understand" with his head what is accessible through feeling, he must turn things topsy-turvy. If a "simple" man (a worker or a peasant) says, "I don't understand a thing about this art, but I feel as if I were in church," he proves by that that his head has not yet been thrown into confusion. He does not understand, but he feels.

A worker said once, "We do not want an art that has been manufactured just for us, but a true, free art, a great art."

For the artist, there is indeed only one recipe: honesty.

Man would be unable to do without the surrounding world, but he is able to liberate himself from the object. This is a question upon which I would like to dwell, for it is essential for today's painting and for that of the future.

The statement that the choice of an object plays no part in painting ("the object considered as a pretext for painting") is grounded in error. A white horse or a white goose create different emotions altogether. In this case you have: white + horse, or white + goose.

The color white "in isolation" conjures up an emotion, an "inner sound." So do the horse and the goose. But the last two emotions are totally different. White cloud. White glove. White fruit dish. White butterfly. White tooth. White wall. White stone. You can see that the color white in all those cases is an element of secondary importance. For the painter it can be a major element, as a color, but in all those cases it is itself colored by the "inner sound" of the object. The object here speaks in a distinct voice that must not be suppressed. It is not by accident that the Cubist painters persistently used musical instruments and objects: the guitar, the mandolin, the piano, notes, etc. The choice, unconscious to be sure, was dictated by the proximity of music and painting.

It is not by accident either that people began, at the same time, to speak of the "coloring" of a musical work and the "musicality" of a painting.

It is wrong to assert that a single musical tone or a single color do not arouse emotions. But those emotions are too limited, or too "simple," or too "poor," in a word, too ephemeral.

That is a static fact. The dynamic moment starts with the juxtaposition of at least two emotions: elements, colors, lines, sounds, movements, etc. ("contrast"!) "Two inner sounds." It is here that one must search for the tiny beginnings of composition.

The question is more complicated with painting than it is with music. In music, pure sound (created by electricity), that is to say, a sound that has not been colored by a given instrument, and even the sound of a given instrument (the piano, the horn, the violin), are "limited" by their very nature. The same sound can be loud or soft, long or short, but it does not require limits, as do colors on a surface.

If objects did not have "inner sounds," the question of abstract limits or of the limits set by an object would not exist. In my opinion, a so-called geometrical boundary gives color greater opportunity of creating a pure vibration than do the limits of some object, which always speak with a louder and more precise voice by creating a vibration peculiar to it (horse, goose, cloud . . .). The "geometrical" or "free" limits, which are not associated with an object, arouse emotions, as colors do, but these are less precise than the object itself, more free, more flexible, in a word: "abstract." This abstract form does not have a belly like a horse, or a bill like a goose. If you want to subordinate an object to your plastic idea, you must usually change or modify the natural limits

that it presents to you. To stretch a horse, you must pull him by the head or by the tail. That is what I used to do before I found within myself the possibility of liberating myself from the object.

But just as a musician is able to convey his impressions—emotions of sunrise without utilizing the sounds of the crowing rooster—so too the painter disposes of purely pictorial means in which to "dress" his morning impressions without painting a rooster.

That particular morning, or let us say, all of nature, life, and the whole world surrounding the artist, and the life of his own soul—these are the unique source of each art. It is too dangerous to leave out one part of that source (external life around the artist) or another (his inner life); even more dangerous than cutting off a man's leg, which can be replaced by an artificial one. In this case, one is cutting off more than just the leg. One is cutting off the life of one's own creation. The painter "feeds" himself on external impressions (external life); he transforms them within his soul (inner life), reality, and dream! Without being aware of it. The result is a work of art.

This is the general law of creation. The difference appears only in the means of expression (inner life) of the "tale," with or without the rooster.

In general, all artists (not "artists") are alike in their first roots (emotions of external life). (Of course, there are always exceptions to rules!) They differ in the second part of the root (inner life) and consequently in their ways of expressing themselves. Why is it that I, an "abstract" painter, shout, "Long live the rooster!" and that the opposing party shouts, "Death to the triangle!"

Just as music with words has already existed for a long time (generally speaking), song and opera, as well as music without words, purely symphonic music or "pure" music, likewise, painting with and without objects has existed for twenty-five years.

In my opinion, one attaches too much importance to the question of form. Almost twenty-five years ago I wrote, "In principle, the question of form does not exist," (the *Blaue Reiter* [*Almanac*]).

The question of form is always a personal one and is therefore relative. To be sure, man is bound up with the past, the present, and . . . the future. Only a few "Constructivists" have declared that "there exists neither yesterday nor tomorrow, but only today." Indeed!

And it is not form that constitutes our natural liaison with the past, but the kinship between certain aspects of today's spirit and the spirit of

certain bygone periods.

A triangle evokes a living emotion because it is itself a living being. It is the artist who kills it if he uses it mechanically, without *inner prompting*. This is the same artist who kills the rooster. But, just like an "isolated" color, this "isolated" triangle is not sufficient for a work of art. It is the same law of "contrast." One must not forget, however, the power of this unassuming triangle. It is a well-known fact that if one draws a triangle with lines, even very thin lines, on a piece of white paper, the white inside the triangle and the white around it become different, they take on different *colors* without any color having been applied. This is at the same time a physical and psychological fact. And, with the change of color, the "inner sound" changes.

If you then add one more color to the triangle, the sum of the emotions increases by geometrical progression; it is no longer an addition, but a multiplication.

Once I painted a picture made up of a single red triangle very modestly surrounded by colors without "limits" (forms that were not very clear-cut), and I have often noticed that this "poor" composition arouses in the beholder vivid and complicated emotions, even in the beholder who "does not understand avant-garde painting." These very limited means would no doubt be insufficient for me, and besides, I like very complicated and "rich" compositions. It all depends on the aim of the given composition.

To avoid misunderstandings, I must add that in my opinion the painter never worries about that aim or, to put it better, he is not aware of it while he is painting. His attention is focused exclusively on form. The goal remains in the subconscious and guides his hand. While painting a picture, the painter always "hears" a "voice" that simply tells him, "That's right!" or "That's wrong!" If the voice becomes very faint, the artist must put his brushes down and wait.

Within this general law of the equality of the source of each art (around and within me), there is an exception that has caused misunderstandings and harmful "mix-ups." I am talking about the "Constructivists," most of whom state that the impressions-emotions received by the artist from outside are not only useless, but must be fought against. They are, according to those artists, "remnants of bourgeois sentimentality" and must be replaced by the pure intention of the mechanical process. They try to build "calculated constructions" and

want to do away with feeling, not only within themselves, but also within the beholder, to liberate him from bourgeois psychology and turn him into "a man of the present."

In truth, these artists are mechanics (spiritually limited children of "our mechanistic age"); yet they produce machines deprived of movement, engines that do not move, planes that do not fly. It is "art for art's sake," but carried to the extreme limit and even beyond. This is why most "Constructivists" have very quickly stopped painting. (One of them has declared that painting is but a bridge that must be crossed to reach architecture. He forgot that there are great architects of the extreme avant-garde who do not cease to paint at the same time.) If man begins to do things aimlessly, he ends by being destroyed himself (inwardly at least), or else he produces things that are condemned to death.

Finally, it is for this reason that an "abstract" painter may come under the general law of art (common and unique source) or constitute an exception to that law. It is a defect in our "terminology" not to make the distinction between those two kinds of "abstract" artists, and since it is impossible to avoid labels (which are convenient where one wants to make oneself understood and harmful if one sticks to them without recognizing what is hidden behind the label), a more accurate terminology should be created, and the facts should be "classified" not according to external resemblance, but to inner kinship. In that case, one would have to make two labels instead of one, carefully distinguishing them one from the other. They are:

1. Abstract artist
2. Constructivist artist (or, if you prefer, "without-aimist" [*sansbutiste*]).

If an artist uses "abstract" means, it still does not mean that he is an "abstract" [artist]. It does not even mean that he is an artist. And just as there are enough dead triangles (whether white or green), there are no fewer dead roosters, dead horses, dead guitars. In the same way, one can easily be either a realist "hack" or an abstract "hack."

Form without content is not a hand, but an empty glove filled with air.

The artist loves form passionately, just as he loves his tools or the smell of turpentine, because they are powerful means of expressing content.

But the content, of course, is not a literary narrative (which may or may not in general constitute a part of painting), but the sum of the

emotions aroused by *purely pictorial* means.

(One way to find out: if the literary narrative prevails over the pictorial means, a reproduction in black and white does not emphasize the regrettable absence of colors. If on the contrary, the content is purely pictorial, this absence becomes painful.)

Finally, art is never produced by the head alone. We know of great paintings that came solely from the heart. *In general,* the ideal balance between the head (conscious moment) and the heart (unconscious moment—intuition) is a law of creation, a law as old as humanity.

1935

Thesis-Antithesis-Synthesis
Statement in the catalogue of the exhibition
["thèse—antithèse—synthèse"]
at the Kunstmuseum
(Lucerne), 1935

The following essay by Kandinsky on the significance
of calculation in art appeared in the catalogue of the exhibi-
tion, followed by a statement by Fernand Léger.

what is a cookbook? an ordered collection of useful recipes.

what are recipes? enumeration of "constituents" and an indication of
their proportions. hence a way of preparing food.

can one say with complete certainty that following these recipes
exactly will produce palatable food as a result?

any true cook would smile at such a question. you have to have a
"tongue."

a picture is also a kind of "dish," consisting of elements in various
proportions and demanding a particular method of "preparation." for
this reason there exist manuals of painting.

there exists even more. in certain cases we are able, even today, to
"dissect" a genuine work of art, which is not only amusing, but also not
infrequently instructive. it is perhaps just as instructive as that
specialized science called anatomy. elements, proportions, juxtaposi-
tions, expressible in numerical terms. just as, in my view, in the case of
every phenomenon. but just don't ask an anatomist whether, given the
anatomical details—elements, proportions, laws of construction—one
can produce a living human being.

i prefer not speak of the cosmos and cosmic laws. that works of art can
be given numerical expression (something that becomes even easier to
achieve as time goes on) simply means that our judgments about art do
not just "appear out of thin air," but that they have a natural basis, are
founded upon nature. in particular, the german expression *es sitzt* [it
sits] enables one to glimpse this natural basis.

there is an easy answer to the question why "new tendencies in art" are always rejected (and, at times, with what a fuss!): because the eye, accustomed to earlier "recipes," is not immediately capable of perceiving the newly discovered "recipes." it has to have time to get used to them. something i might describe as "conservatism of the eye."

in conclusion, i would cordially like to advise the transmitter (the artist) and the receiver (the admirer of art) to keep thought and feeling separate from one another.

just as all the recipes in the world can never succeed in creating a work of art **by themselves,** so too they can never supplant the kind of feeling that is vitally necessary in order to "understand art."

one's head is not a bad device.

but an "unfeeling" head is worse than a "headless" feeling. at least in art.

paris, january 1935

1935

Line and Fish
Axis,
(London), 1935

The English periodical *Axis* described itself as a "quarterly review of contemporary 'abstract' painting and sculpture." Edited by Myfanwy Evans, it appeared irregularly from 1935–1937. Regarding this publication, Kandinsky wrote in January 1936 to Hans Thiemann: "In a month or two there arrives from London a lady, Miss Myfanwy Evans, who for the last few months has been editing an English art journal, *Axis.* At all events, she intends to come, and if she does, I will show her your photos. Her main interest is abstract art, but she is by no means narrow-minded. *Axis* is really good...."[1]

"Line and Fish" was preceded by a reproduction of Kandinsky's painting *Each for Himself* (1934).[2]

Approaching it in one way, I see no essential difference between a line one calls "abstract" and a fish.

But an essential likeness.

This isolated line and the isolated fish alike are living beings with forces peculiar to them, though latent. They are forces of expression for these beings, and of impression on human beings. Because each being has an impressive "look," which manifests itself by its expression.

But the voice of these latent forces is faint and limited. It is the environment of the line and the fish that brings about a miracle: the latent forces awaken, the expression becomes radiant, the impression profound. Instead of a low voice, one hears a choir. The latent forces have become dynamic.

The environment is the composition.

The composition is the *organized* sum of the *interior* functions (expressions) of every part of the work.

But approaching it in another way there is an essential difference between a line and a fish.

And that is that the fish can swim, eat, and be eaten. It has, then, capacities of which the line is deprived.

These capacities of the fish are necessary extras for the fish itself and for the kitchen, but not for painting. And so not being necessary, they are superfluous.

That is why I like the line better than the fish—at least in my painting.

Paris, March 1935

1935

Baumeister
Il Milione: Bolletino della Galleria del Milione
(Milan), 1935

In a letter to Grohmann (3 November 1925) Kandinsky mentioned Klee's opinion concerning exhibition catalogues. Klee thought several small articles written by various authors would enhance the presentation. Kandinsky himself appreciated what others wrote for him (André Breton and Diego Rivera, to mention two), and favored Baumeister, Domela, and Sophie Taeuber-Arp with his pen. His statements tend to be general affirmations, far removed from his incisive early criticisms of other artists' work. In later years, however, he was rarely specific, even about his own work.

The Baumeister exhibition catalogue also included paragraphs by Le Corbusier, Will Grohmann, Herbert Read, and Hans Hildebrandt, as well as an introductory essay by Alberto Sartoris.

Today is a time of sickly apparitions that appear in the sky like rockets of a thousand colors, or sometimes burst like stink-bombs. A den of abnormality, the unnatural, and the disgusting. Examples of the opposite, that is to say, the healthy, the natural, the attractive, are not so readily visible, since Today is grudging with them. These examples seem to disappear among the negative ones.

They will not disappear among the negative ones, however, because the Future belongs to the healthy. It will be the sickly, the unnatural, the revolting, that will decline.

To these examples of the healthy, the natural, the attractive, belongs the art of W. B.

I believe that even for one inexperienced in art, this art must arouse, even if unconsciously, the impression of something that grows from a healthy soil and rests solidly on two feet. A natural positive force that, with lively composure, remains the conqueror despite everything.

Two Directions
["to retninger"],
Konkretion
(Copenhagen), 1935

Danish interest in abstract art crystallized in 1934 with the formation of a group calling itself "The Line" [*Linien*]. The leaders were Eiler Bille and Vilhelm Bjerke-Petersen (who studied with Kandinsky at the Bauhaus in Dessau). Others in the group included Henry Heerup, Richard Mortensen, and Hans Øllgaard. Their first journal, also called *Linien,* was supplanted by *Konkretion* after April 1935, although special numbers of *Linien* still appeared from time to time (see pp. 798–804).

If one recalls the adverse economic and military conditions which prevailed in 1935, Kandinsky's demand for more than food, machines, and weaponry prompts a comparison with the old Hebrew prophets who warned that men do not live by bread alone. The search for more food was commendable; but a one-sided pursuit of material and practical ends could not, by itself, lead to happiness. Only by using inner vision to penetrate the hard exterior shell of things can humanity regain its feeling for the underlying pulse of nature, and thus its larger purpose. St. Augustine and St. Francis would have understood what Kandinsky was saying.

The first direction is the most dominant; it seems to rule over everything and everyone. This is the direction in which at present all countries are moving, or seem to be moving.

This direction sees its goal as emphasizing material values, reaching the greatest possible "prosperity," not only getting humanity "bread," but also "happiness." Of course "happiness" will have to wait awhile—

that will come naturally when everyone has enough bread.

All countries exert themselves to the utmost to reach this goal.

This is a passionate, heroic exertion, for those means are holy that lead to individual "happiness."

This is a commendable, extremely valuable work, but one that, unfortunately, has its dark sides as well.

The one dark side is that this passionate, heroic exertion leads to a result that is almost = 0. There is not enough "bread" in any country. "Happiness" is too rare and looks more like anesthesia.

The other dark side is that humanity increasingly forgets that the "nonmaterial" values are also necessary. The past sources of "spiritual" values—religion, science, and art—are subject to growing misunderstanding, and attempts are made to dispose of them in favor of material life.

This frightening, dark side is the logical consequence of "pure materialism"—the material has caused the spirit to be forgotten. From this originates the "modern," "practical" individual, who bows deeply to war machines and household machines, who only has an eye for the external and merely smiles at the internal.

This one-sidedness is disastrous. It will finally replace humanity with a chew-and-digestion machine.

But there is also *another direction* that shows only occasional signs of life, and receives little attention, or is misunderstood.

This direction is the logical result of the "internal turn of the tide" that was recognized already before the war (our modern measure of time!) and is still growing, even if at first glance it seems to decrease more and more.

This direction has a double meaning:

1. It opens up and develops the "internal view" and thereby makes possible:
2. The experience of the small and great, the micro- and macrocosmic, coherence.

Synthesis

> In 1913 I wrote in a small autobiography ("Der Sturm" publ., Berlin): Everything "dead" trembled. Everything showed me its face, its innermost being, its secret soul, inclined more often to silence than to speech—not only the stars, moon, woods, flowers of which poets sing, but even a cigar

butt lying in the ashtray, a patient white trouser-button looking up at you from a puddle on the street, a submissive piece of bark carried through the long grass in the ant's strong jaws to some uncertain and vital end, the page of a calendar, torn forcibly by one's consciously outstretched hand from the warm companionship of the block of remaining pages. Likewise, every still and every moving point (= line) became for me just as alive and revealed to me its soul. This was enough for me to "comprehend," with my entire being and with all my senses, the possibility and existence of that art which today is called "abstract," as opposed to objective."[1]

This experience of the "hidden soul" in all the things, seen either by the unaided eye or through microscopes or binoculars, is what I call the "internal eye." This eye penetrates the hard shell, the external "form," goes deep into the object and lets us feel with all our senses its internal "pulse."

And this experience enriches the individual, and specifically the artist, because within this experience lies the inspiration for his works. *Unconsciously.*

The "dead" material trembles. And in addition, the internal "voice" of simple objects sounds not alone, but in harmony—the "music of the spheres."

One more quotation. In 1912 I wrote in my article "On the Question of Form" (the *Blaue Reiter* [*Almanac*], Munich: Piper): "The line is an object having the same practical-functional importance as a chair, a fountain, a knife, a book, etc. And this object, i.e., its pure internal voice . . . is used as a purely pictorial means. When a line in the picture is thus liberated from having to represent an object, but functions as an object in itself, its internal voice does not in any way become weaker, but acts with its full internal power."[2]

The line is here only one example from the large assortment of "abstract" elements, which can be used in constructing a picture.

Pure sounds! i.e., without impure secondary sounds, *"les parasites,"* as the French so pertinently call them. It is the "material" the abstract painter uses to "build" his pictures.

He does not let the composition be dictated by a "slice of nature," but by the laws of all nature, by those laws of nature that control the universe, the cosmos.

Therefore, abstract art is a "pure" art (just as, e.g., there is a "pure" music), and therefore, the *seeing* spectator often gets a "cosmic" impression of abstract pictures.

To put the final dot over the final *i:* Abstract art is independent of "nature," but subordinate to the laws in NATURE.

To listen to its voices and to obey it, is the height of happiness for the artist.

Paris, August 1935

1935

Empty Canvas, etc.
["Toile vide, etc."]
Cahiers d'Art
(Paris), 1935

During the Paris years Kandinsky often refashioned ideas he had ventured earlier, with the adaptation reflecting a more certain mood and the lyric capabilities of the French language. His wish that paintings be considered in and for themselves, expressed in the phrase "Here I am!," has its source in the last chapter of *On the Spiritual in Art* (see p. 218n).

Empty canvas. In appearance: truly empty, keeping silent, indifferent. Almost doltish. In reality: filled with tensions, with a thousand low voices, full of expectation. A little frightened because it can be violated. But docile. It willingly does what one wants of it; it asks only for mercy. It can carry anything but cannot sustain everything—it intensifies the true, but also the false. And it devours without pity the face of the false. It amplifies the voice of the false to a piercing scream—impossible to bear.

Wonderful is the empty canvas—more beautiful than some paintings.

Simplest elements. The straight line, straight and narrow surface: hard, resolute, holding its own regardless, apparently "going of its own accord"—like destiny already lived. That way and no other. Bent, "free," vibrant, evading, yielding, "elastic," seemingly "indeterminate"—like the fate that awaits us. It could become something else, but it will not. Some hardness and some softness. Combinations of both—infinite possibilities.

Each line says, "Here I am!" It stands its ground, shows its eloquent face—"Listen! Listen to my secret!"

Wonderful is a line.

A little point. Many little points, which are a bit, a bit smaller here, and a bit, a bit bigger there. They are all lodged inside, but they remain

mobile—many small tensions that keep repeating in chorus, "Listen!" "Listen!" Small messages that gather strength in concert until the great "Yes."

Black circle—distant thunder, a world of its own that seems to care about nothing, a retiring-within-itself, a conclusion then and there. A "Here I am" spoken slowly and rather coldly.

Red circle—stands fast, keeps its position, absorbed in itself. But it strolls along at the same time, since it would like to secure for itself all the other positions—thus, it radiates over all obstacles into the furthermost corner. Thunder and lightning at the same time. A passionate "Here I am."

Wonderful is the circle.

But most wonderful of all is this: to add up all these voices together with many, many others (there are really, in addition to these simple forms, many colors and forms) in a single painting—the whole painting becomes a single "HERE I AM!"

Restriction, "avarice," excessive wealth, "prodigality," clap of thunder, the buzzing of mosquitoes. Everything that exists in between. Thousands of years were barely enough time to reach the bottom, to the ultimate limits of possibility. The bottom, finally, does not exist.

I have been occupying myself for some twenty-five years with these "abstract" things. Even before the war I liked and made use of the clap of thunder and the buzzing of mosquitoes. But the diapason was the "dramatic." Explosions, patches that violently collided, despairing lines, eruptions, rumblings, burstings—catastrophes. The pictorial elements, such as colors-lines, the structure, the way of handling the color, technique itself—all this was and had to be "dramatic," subordinate to that aim. Lost balance but no annihilation. Everywhere a foreboding of resurrection, as far as cold tranquillity.

From the beginning of 1914 on I felt the desire for a "slightly cold tranquillity."—I did not want something rigid, but cold, quite cold. At times, even freezing cold. Chinese upside-down cakes, as it were, hot and concealing ice cream inside. I wanted a reversal of this (and I still like it today)—red-hot "stuffing" inside an icy-cold chalice.

Concealment. There are myriad ways of concealing.

Already in 1910 I concealed the "dramatic" *Composition No. 2* behind "amiable" colors. Subconsciously, one contrasts a "bitter" luster with something "sweet," "warm" with "cold," one lets fall into the "positive" a few drops of the "negative."

In my "cold" period, quite often I would restrain burning colors with hard, cold, "insignificant" forms. Sometimes boiling water runs under the ice—nature "works" with contrasts, without which it would be insipid and dead. The same with art, which not only is nature's kin, but gladly submits to its laws. To submit to its laws, to guess their message filled with wisdom—that is the artist's greatest joy.

To submit means to show respect. Each new spot of color that appears during work on the canvas submits itself to the previous spots—even in its contradiction it is a small stone added to the great edifice "HERE I AM!"

Finally, one is much more often "misunderstood" than "understood." This happened to me often, but never in such an obvious fashion as in the days of my "cold" period, when even many a friend would turn his back on me. But I knew that the ice (not that of my paintings, but that of misunderstanding) would melt some day. Perhaps it has already melted a little today. Time sweeps men along—but what grows too fast, withers even faster—without depth there is no height.

After this leap (which in my case must be seen in slow motion) from one "extravagance" to another, my desires changed once more, that is to say, the direction of the inner force that impels me forward. But what I want today is not as easy to explain as the previous desires (if indeed the latter could be explained that easily). In reality, one does not change. Change is, at most, understanding better how to go upward and downward at the same time—at the same time "up" (toward the heights) and "down" (toward the depths).

This power no doubt always involves extension as a natural consequence, a solemn tranquillity. One grows on all sides.

In any case, my desire today is: "Broader!" "Broader!". What the musician would call polyphony. At the same time: a liaison between "fairy-tales" and "reality." Not outer reality—a dog, a vase, a naked woman—but the "material" reality of pictorial resources, tools, which necessitates changing completely *all* means of expression, as well as technique itself. A painting is the synthetic unity of all its parts. To make a "dream" come true one does not need fairy tales such as "Seven-League Boots" or "Sleeping Beauty," nor even phantasms derived from everyday objects, but only purely pictorial fairy tales and someone who knows how to "tell the story" of a painting uniquely and exclusively—through its "reality." Inner cohesion achieved by external divergence, unity by disintegration and destruction. In the midst of

anxiety, tranquillity; in the midst of tranquillity, anxiety. "The action" in the picture must not take place on the surface of the physical canvas, but "somewhere" in "illusory" space. Through a "lie" (abstraction), truth must speak. A healthful truth that is called "HERE I AM!"

I look through my window. Several chimney stacks of lifeless factories rise silently. They are inflexible. All of a sudden, smoke rises from a single chimney. The wind catches it and it instantly changes color. The whole world has changed.

1936

Abstract Painting
["Abstrakte Malerei"]
*Kroniek van hedendaagsche
Kunst en Kultuur*
(Amsterdam), 1936

The Dutch periodical *Kroniek van hedendaagsche
Kunst en Kultuur* [Chronicle of Contemporary Art and Cul-
ture] began publication in June 1935, appearing not quite
regularly during the first year of its existence. In January
1940, its name was changed to *Kroniek van Kunst en Kul-
tuur;* from early that year it described itself as a monthly,
although it actually appeared twice a month from November
1938 to December 1940.[1] There were, however, a good many
"double issues." The editors included the sculptor L. P. J.
Braat and Johan Polet, who wrote the editorial for the first
issue.[2] Apart from the Dutch editors, early contributors to
the journal included Ernst Ludwig Kirchner, Paul Westheim,
Paul Valéry and Federico García Lorca. Kandinsky's article
"Abstract Painting" appeared in German in the issue for
April 1936.
 Politically, the editors were mostly left of center; artisti-
cally, the journal had no particular policy other than to keep
its readers abreast of the latest artistic developments. It did,
however, sponsor the exhibition of abstract art held at the
Stedelijk Museum, Amsterdam, in spring 1938. Kandinsky's
catalogue essay "Abstract or Concrete?" (see pp. 831–32)
was reprinted in *Kroniek* 3, no. 6 (April 1938).

The expression "Abstract Art" is not popular. And rightly so, since it says little, or at least has a confusing effect. For this reason, the Parisian abstract painters and sculptors have tried to invent a new expression: they say *"art nonfiguratif."* Meaning the same as the German term *gegenstandslose Kunst.* The negative parts of these words (*non* and *los*) are unfortunate: they negate the "object" and put nothing in its place. For a long time now, people have been trying (as I, too, did before the war) to replace "abstract" with "absolute." In fact, scarcely an improvement. In my view, the best name would be "real art," because this kind of art puts a new artistic world, spiritual in nature, alongside the external world. A world that can be brought about only through art. A real world. The old term "abstract art" has, however, by now become firmly entrenched.

In my opinion, the terms "Impressionism" or "Cubism" say equally little, and are just as often confusing. They, however, have already become part of history, being recognized classifications, sacrosanct phenomena.

It is remarkable how Cubism, which is just as old (or young) as abstract painting, has nonetheless already become "historical," and hence sacrosanct. Neither its existence nor its name is contested today. A "progressive" art theorist, in particular, would never display enough courage to attack it. This is, perhaps, because Cubism in its purest form was of short duration and very quickly spent itself, and *"de mortuis aut bene aut nihil."*

How often people have tried to bury abstract painting as well, and how often its ultimate demise has been predicted. To the horror of these prophets, there exists today in many countries a new abstract generation. Allow me to mention in this context that I painted my first abstract picture in 1911, that is, twenty-four years ago. That was also roughly the year in which Cubism was born. At that time, one saw the beginning of many "explosions" in art—just think of the innumerable "isms" that, for the most part, very quickly disappeared and were forgotten (Dadaism, Purism, Expressionism, Suprematism, Machinism, and many, many more). The others have, as noted, been catalogued. Thus, abstract painting is a living, vital phenomenon, which—fortunately— escaped being classified and catalogued.

The still-persisting (sometimes venomous) opposition to this art is the best proof of its life-force and significance. I am sure that this life-force and significance are, in turn, the best proof that abstract art is the art not only of the present, but also of the future. At present, the great mass of humanity is extremely materialistic and formalistic. And hence retarded. Retarded people have no sense for the spiritual future. Thus, there remains nothing for them other than to hold tightly onto the past. The eternal mistake of such people is to imagine that they are remaining faithful to the spirit of the past, whereas they remain faithful not to the *spirit,* but to the *form.* Hence the false conclusion: There has until now existed no abstract form in art; so neither can there exist any in the future. This is the famous "historical" argument against abstract art. It has been "proved" in the same fashion that airplanes cannot exist. If one listened to such prophets, mankind would still be living in caves.

Apart from the "historical argument," there are many more that aim to deny the possibility of abstract art. I will name them.

Many (really quite naive) "theoreticians" maintain that there exists no "yardstick of quality" for abstract art, that is to say, there is no method of distinguishing between good abstract pictures and bad ones. This assertion is correct. Only it is correct not only with respect to abstract art, but to art in general. Everyone knows that great artists not infrequently starved, and not infrequently died in oblivion and poverty, while quite mediocre painters, sculptors, poets, and musicians (called *"Kitschier"* in German, and *"pompiers"* in French), who were often not artists, but "artists" (and still are today), enjoyed fame, popular acclaim, and wealth. Furthermore, in the case of generally and rightly acknowledged artists, some "specialists" constantly rate their "early" period far higher than their "later" works, while other "experts" maintain the opposite. Thus, there exist not simply individual works, but whole "periods," made up in turn of numerous individual works, for which no one has yet devised any "yardstick of quality" either. Or else an artist is not merely "rejected," but despised, year in, year out, and only as the evening of his life draws near is he suddenly recognized and praised to the skies (Henri Rousseau, for example, if we think of his last years and an experience we all went through).

The estimation of quality produces strange anomalies: it happens that artists are only "rediscovered" after several centuries (El Greco, for example). It also happens that the title of "greatest painter of all time" is awarded today to one artist, tomorrow to another (for example Raphael,

Giotto, Grünewald, and so on). Equally, it happens that a "period of flowering" is suddenly demoted to a "period of decline" (for example, the "Classical" age of Greek sculpture). Etc., etc.

There has never been a "thermometer" for measuring the level of art, and there will never be one.

Further, one used to hear all too often (now with less frequency) that abstract art is too limited in its expressive resources, that it must consequently always make use of the same "motives" or "elements," and thus would very soon be "exhausted." On these grounds one would have to reject many great artists and label them as "repetitive," tedious nonartists without much expression. How, for example, would one have to rate Michelangelo, who throughout his long life used only the human figure, and always stuck to the same choice of (as many consider "exaggerated" and "unnatural") musculature? Should he not be branded the "most boring and least expressive" sculptor of all time? From this standpoint, one would undoubtedly have to "station" Michelangelo in the famous row of Berlin's *Siegesallee*.

And poor music! How "perilously" limited its resources are. The same strings and wind instruments over and over again, with just a touch of timpani thrown in. How is one supposed to distinguish between Bach and Johann Strauss? Being "formalistic" (or, to put it crudely, "superficial") is a dangerous business, inevitably leading one down blind alleys. And another "canon" against abstract art, directed in fact against abstract painting: Color comes "to life" only when linked to an object; without objects it remains "dead." This assertion could be proved only by one's "word of honor," since there exists no other proof for it. Indeed, I believe that color, "in and for itself," is always alive, and that only bad painters possess the gift of "killing" it.

Last of all, let us not forget one further "objection" to abstract painting, since the latter's enemies scarcely ever forget it, considering it "devastating." It might be summed up in the following syllogism:

1. Only nature (including, it is true, objects as well, whether the product of the human hand or of the machine—providing the material for *"natures mortes,"* or still-lifes) has the capacity to stimulate the artist and rouse his intuition.

2. The abstract painter does not use nature (or "nature"), and aims to manage without it. Therefore:

3. Abstract painting excludes intuition, and hence becomes "cerebral."

A few words from me provide the right answer to this illogical conclusion. Permit me to express them in French, as I wrote them for *Cahiers d'Art* at the invitation of M. Ch[ristian] Zervos.[3]

> Toute la nature, la vie et le monde entier entourant l'artiste, et la vie de son âme à lui sont la source unique de chaque art. C'est trop dangereux de supprimer une partie de cette source (vie extérieure autour de l'artiste) ou l'autre (sa vie intérieure), même plus dangereux que de couper à un homme une jambe, parce qu'elle peut être remplacée par une jambe artificielle. Ici, on coupe plus que la jambe. On coupe la vie à sa propre création. Le peintre se "nourrit" d'impressions extérieures (vie extérieure), il les transforme dans son âme (vie intérieure), la réalité et le rêve! sans le savoir. Le résultat est une oeuvre. C'est la loi générale de la création. La différence se montre seulement dans les moyens d'expressions (vie intérieure).
>
> And somewhat further on: Comme il existe depuis déjà assez longtemps, une musique avec paroles (je parle généralement),[4] la chanson et l'opéra, et une musique sans paroles, la musique purement symphonique, ou la musique "pure," il existe de même, depuis vingt-cinq ans, une peinture avec et sans objet. (*Cahiers d'Art*, 10, nos. 1–4 [1935], p. 54).

"Naturalistic" painting, so-called, means that the painter has to have a tiny piece of nature (landscape, person, flowers, etc.) before his eyes in order to create a pictorial work called a picture. The "realist" copies this fragment "exactly" (as if it were possible to reproduce anything "exactly"). The "naturalist" painter changes this fragment of nature "according to his temperament." According to the extent of this change, he is termed variously an "Impressionist," an "Expressionist," or finally, a "Cubist." As a typical part of the general process of specialization characteristic of the nineteenth century, deriving partly from the machine and mechanized production, there occurred in painting, too, a specific and extreme form of specialization. Earlier categories of painters became ossified into proper "boxes," divided from one another by solid walls—portrait painters, landscape painters, marine painters, still-life painters, etc. This rigid division is typical of the mental attitude of the previous century, and is still prevalent today—analysis.

In abstract art, analysis is part of acquainting oneself with the "technical," whereas the *basis* of one's creative force has become a synthetic one. It would lead us much too far, were we to speak in detail here about

this vitally important subject. I simply mention one fact that bears out my assertion: The abstract painter derives his "stimulus" not from some part or other of nature, but from nature as a whole, from its multiplicity of manifestations, which accumulate within him and lead to the work of art. This synthetic basis seeks its most appropriate form of expression, which is called "nonobjective." Abstract form is broader, freer, and richer in content than "objective" [form].

This is the nub of the whole "question." One should leave the choice of form to the artist, and not attach so much importance to form.

Thanks to the materialism of the nineteenth century, we have, alas, become too accustomed to take the external for the internal, hence failing to experience the content within form. It is for this reason that so much is thought, said, and written about the question of form.

I, too, have written "On the Question of Form" as early as 1912 in the *Blaue Reiter* [*Almanac*], where I said the following:

"There exists no question of form in principle."

Paris, July 1935

1936

Reply to Gaceta de Arte
Gaceta de Arte, Revista internacional de cultura (Tenerife), 1936

The review *Gaceta de Arte,* a little-known avant-garde review which became a moving force behind the promotion of modern art in Spain, was published from 1932 to 1936 in Tenerife (Canary Islands). Eduardo Westerdahl Oramas (born in Tenerife in 1902) founded and directed this monthly. His editorial staff consisted of Domingo Pérez Minik, Francisco Aguilar, Domingo López Torres, Oscar Pestana Ramos, and José Arozena. Westerdahl published monographs on Baumeister, Goeritz, Peire, Ferrant, Dominquez, Nazco, and Serrano and continues to this day an active life in the field of modern art.

The major part of the thirty-eighth issue was devoted to Kandinsky. It included a Kandinsky bibliography, a long essay on the artist by Will Grohmann (in reality, part of a monograph scheduled for publication by the *Gaceta de Arte*), and the following response to a questionnaire. In a letter to J. B. Neumann dated 12 November 1936, Kandinsky encouraged Neumann to obtain this particular issue, since the bibliography was the most complete to date.

In his response, Kandinsky sidestepped the direct thrust of the politically loaded questions. This is hardly surprising: having emancipated his art from subservience to literature and to objects, he was not eager to put it at the disposal of politics. He was disinclined to paint a *Soft Construction with Boiled Beans: Premonition of Civil War in Spain,* or a

Guernica.
The questions posed by *Gaceta de Arte* are here printed in italics.

1. *Does there exist in present-day art a line that brings together, estab-lishes a conciliation between tendencies as opposed as the flight from the object toward pure zones of abstraction and the return to the object as a representation of our visual or tactile world?*

"The flight from the object" does not mean the flight from Nature in general. Every true art is subject to its laws. Art need not rely on Nature, since it is only a part of Nature. It can dispense with the mediation of Nature provided it can put itself directly in relation with Nature's totality.

So-called abstract art is subject to the same laws. If this tie does not exist in the work of art, it means that it is not a work of art. This is why there is no need for a "conciliation." This is why I wrote over twenty years ago that "the question of form *in principle* does not exist" (see the *Blaue Reiter* [*Almanac*], Munich, 1912).

2. *What is the artist's position, confronted by the socio-political or moral-economic problems of the day?*

The artist's position, "confronted by the complex political, social, and moral-economic problems," is above these problems. The artistic task demands the man in his totality, and a complete inundation in the world of art.

3. *Can he evade its influence?* 4. *Are its influence and participation natural?*

But the artist is a natural member of his times. If the *spirit* of the times has the force to drag him into its service, it does so without knowing it. It is possible to say, "Starting tomorrow I will do political, social, Marxist, or fascist art," but it is impossible to do it expressly. When, at the beginning of the "Great War," one of my colleagues in Moscow said to me, "Good! Now let's paint the national feeling," I asked, "And after the war?" National anthems have now been sung in almost all countries; but I am content not to be a singer. And I remain so even today. This is my answer to the fourth question.

5. *Is there such a thing as a propagandistic art?*

These national anthems are precisely a type of lure. But there does exist a propagandistic art—for the best chocolate in the world, and "Balto" cigarettes.

6. *Does art perform a service or not?*

Art, without any doubt, does perform a service, but not for the present. It performs a spiritual service, above all today when the spirit is merely a spare tire in the back of the car: sometime later on it will be needed.

7. *Is contemporary art in a crisis?*

Besides the terrible worldwide economic crisis, there exists today an even more terrible crisis: that of the spirit. The cause of this crisis is the propagandizing of the most rigid materialist ideas. One of the most dangerous results of this propaganda is the increasing loss of interest in the manifestations of the spirit. Thus the increasing loss of interest in art. Here one finds the explanation of a pernicious phenomenon: Art is outside "life." Also from this, the attempt to "save" art by forcing it to put itself "at the service of present-day life." This is why I see only crisis for art in the gloomy days ahead. But art will remain the victor.

8. *What is the future of art? The immediate reality of a world outside ourselves, foreseen? Or that constant recreating which, starting from our world within, leads us toward an interpretation that announces a new man or a new era of decadence or one in which culture is overcome?*

A glance, either superficial or profound, at the "life" of the "civilized" nations is enough to appreciate the absence of authentic culture today. The need and the duty to guarantee nourishment and the minimal comforts for every human being is easily understood. Yet a human being guaranteed his necessities but deprived of spiritual culture is nothing more than a machine to direct. Nonetheless, beneath this horrible surface exists a spiritual movement still faintly visible, but which will bring an end to the crisis and the decadence. One of the forces preparatory to this "resurrection" is free art.

Franz Marc
Cahiers d'Art
(Paris), 1936

The following essay was published in the Parisian journal *Cahiers d'Art*, edited by Christian Zervos, to commemorate the twentieth anniversary of the death of Marc, on 21 February 1916. An editorial note accompanying the article reads:

> It is twenty years since the painter Franz Marc fell near Verdun. Despite his youth, he left behind an important body of work, which has been shown in the course of 1936 in various German cities.
>
> It is sad that, beyond the Rhine, so little importance has been attached to commemorating one of Germany's finest artistic hopes.

A further essay on Marc, written at the request of the artist's widow, Maria, remained unpublished during Kandinsky's lifetime.[1]

I made Franz Marc's acquaintance in rather dramatic circumstances.

In 1910, after having struggled against unnamable difficulties, a group of "avant-garde" artists from Munich succeeded in organizing an exhibition in one of the most beautiful and largest art galleries of this city, which they called "Modern Athens."

For this exceptional affair, the "Athenians" unmasked their true temperament, which until then they had carefully concealed. The press demanded the immediate closure of this "anarchist" exhibition (the word "Marxist" was not yet in fashion), made up of foreigners dangerous to the old Bavarian culture. They made it clear that the Russian artists especially were the most dangerous—Dostoyevsky, with his "all is permitted!" Actually, there were Russians among the group, but also

French, Italians, Austrians, and finally North Germans. Not one Bavarian. The owner of the gallery complained that after the exhibition closed each day he had to wipe clean the canvases upon which the public had spat. One must say that this horrified public was well brought up—they spat, but they did not cut up the canvases, as happened to me once in another city during my exhibition.

To save the good name of the Bavarian residents of Munich, I must add that not one voice was raised in defense of the exhibition. Not a single Bavarian voice, but a Prussian voice. That voice belonged to Hugo von Tschudi, the Director General of all the art museums of Bavaria. He came from Berlin, where he had been the director of the National Gallery, and where he had created the French art section with the help of private donations. He was a man of a free and pure spirit, of inexhaustible energy, of strong will—to make concessions was foreign to him. To make a long story short, he was obliged to leave Berlin, and the Prince Regent of Bavaria entrusted him with the Bavarian museums. It was thanks to him that we managed to organize our exhibition, and that "the immediate closure" demanded by the press did not take place. Further, it was he who came to the exhibition to cheer up the owner of the gallery, who at times would completely lose his head. And finally, it was he who had made the Alte Pinakothek into a marvel of past art. A marvel that disappeared right after his death.

But suddenly a purely Bavarian voice was heard, coming from a small village in Upper Bavaria. Franz Marc had written a letter to our group, full of enthusiasm and congratulations. He had had the tact not to appear in person so as not to oblige us to make personal contact with him. Later, when I saw him for the first time, I understood that he had acted according to his noble nature.

He was a somewhat rare human type. His outer self corresponded exactly to his inner self: a harmonic combination of "hardness" and "softness."

He looked like a mountaineer with his great height, his broad shoulders, his almost gaunt face, his black hair, his long, unerring stride. In the city he appeared too tall, too confined. I liked to see him in the mountains, in the meadows, in the woods. There he was "at home." He was always accompanied by his big white dog "Russi" (a tribute paid to Russia), who resembled his master as far as size, strength, and tranquillity were concerned. The dog showed the same combination of "hardness" and "softness." They complemented and understood each other

wonderfully. Black would say something to White in a low voice, and White would answer with a nod.

In general, Marc enjoyed a direct relationship with nature, like a highlander or even an animal. Sometimes I had the impression that nature was pleased to see him.

Everything in nature attracted him, but especially animals. There existed a reciprocal connection between the artist and his "models," and this is why Marc could "enter" the life of animals. And it was this life that inspired him.

Yet he never lost himself in details, and for him the animal was always *one* of the elements of the totality, sometimes not even an essential element. He "constructed" his canvases like a painter, not like a "narrator." And this is the reason why he has never been an "animalist." He was always attracted by the Great Organic, that is to say, by nature in general. Here lies the explanation of the original world created by Marc, which others unsuccessfully tried to repeat.

Since then, time has changed his activity, even in some essential directions. I think that it is rather difficult nowadays to find somebody who would be capable of getting angry or taking offense at seeing on a canvas a bright yellow cow, an ultramarine-blue horse, a vermilion-red lion. But in those days, the public "raised walls" and was agitated to the very depth of its soul by those "grimaces," those tendencies to "startle the bourgeoisie" and to offend them. People felt reviled; better still, they spat on our works.

They did not understand that those colors and those forms, which had been altered in this "disgusting" manner, that this "violation of nature," were natural and purely artistic means to achieve the creation of Marc's specific world. A fantastic, but real world.

They would ask, "Have you ever seen blue horses?" And rarely, some well-disposed person would answer in a low and halting voice: "But . . . sometimes, in the evening, at sunset, a black horse looks almost blue."—"What a joke!"

The times were difficult, but heroic. We painted our pictures. The public spat. Nowadays, we paint our pictures and the public says, "That's pretty." This change does not mean that the times have become easier for the artist.

Instead of looking for a direct and natural contact with art, new difficulties and new obstacles are being devised today and placed between the work and the beholder. Thus, people wonder with a preoc-

cupied mien whether Marc's art stemmed from Germanic sources, that is to say, from a "German soul," and whether his painting was truly German. I do believe so, because Marc loved his country. In my opinion, it would be essential to see beneath "the national soul" a universal human source.

Marc and I were deeply immersed in painting; [yet] painting alone was not sufficient for us. At the time I was contemplating a "synthetic" book, which was to eradicate superstitions, "demolish the walls" that existed between one art and another, between official and rejected art, and finally prove that the question of art is not that of form, but that of artistic content. The separation of the arts, their isolated existence inside small "boxes" with high, rigid, and opaque walls, was to my mind one of the unfortunate and dangerous consequences of the "analytic" method, which was suppressing the "synthetic" method in science, and was starting to do the same in art. The consequences were rigidity, narrow viewpoint and feeling, loss of the freedom of feeling, perhaps even its ultimate death.

My idea then was to point out by means of examples that the difference between "official" and "ethnographic" art had no reason to exist; that the pernicious habit of not seeing the organic inner root of art beneath outwardly different forms could, in general, result in total loss of reciprocal action between art and the life of mankind. Likewise, the difference between the art of the child—the "dilettante"—and "academic" art—the gradual differences of "perfect" and "imperfect" forms—concealed their power of expression and their common root.

Today, the idea is no longer all that new, twenty-five years having elapsed since then. But to tell the truth, the point of view has not changed much in general, and the "question of form" still smothers artistic content (see, for example, the question of the "possibility of nonfigurative art").

Moreover, my idea was also to have a painter, a musician, a poet, a dancer, etc., work side by side, and it was with this purpose in mind that I wanted to ask artists in their separate "boxes" to collaborate on the projected book.

Marc was enthusiastic about this plan and we decided to go to work immediately. It was a marvelous task and, within a few months, the *Blaue Reiter* [*Almanac*] had found its publisher. It appeared in 1912. For the first time in Germany we showed in an art book the art of "savages," the Bavarian and Russian "popular" arts (the "under-glass

pictures," the *"ex-voto,"* the *"lubki,"* etc.), the "childish" and "dilettante" arts. We presented a facsimile of "Herzgewächse" by Arnold Schoenberg, the music of his pupils Alban Berg and Anton von Webern, ancient painting side by side with modern painting, etc.

Articles were written by painters, musicians. Delacroix and Goethe supported our ideas with their maxims. One hundred and forty-one reproductions "illustrated" all these ideas.

The great success of the book, especially with young people, proved that it came to the world at the right moment.

Encouraged, we were making plans for the next book, which was to unite the forces of both artists and intellectuals. To discover the root common to both art and science was then our dream, and it demanded immediate realization.

But the war put an end to those dreams.

Just a few months before the beginning of the war, Marc had by chance managed to realize one of his greatest desires, to own a small estate in the country. He gained possession of a very attractive little house on the edge of a forest, a small garden, and a plot of grass on which his roe-deer dwelt. It was there that I went to say "good-bye" to him after the war broke out—people were convinced then that the war could not last for more than a few months. But Marc answered me with an "adieu."— "What do you mean, 'Adieu'?"—"But we won't see each other again, I know it."

Franz Marc was killed on 21 February 1916 near Verdun.

Assimilation of Art[1]
["Tilegnelse af Kunst"]
Linien
(Copenhagen), 1937

A major exhibition of two hundred works, entitled "Post-Expressionism—Abstract Art—Neoplasticism—Surrealism," staged in Copenhagen during September 1937, prompted the sponsors, Sonja Ferlov, Richard Mortensen, Hans Øllgaard, Eiler Bille, and Egil Jacobsen, to publish a special issue of *Linien* [The Line]. In addition to paintings by twenty-three Danish artists, some seventy works by foreign guests were included (Kandinsky, Miró, Sophie Taeuber-Arp, Arp, Ernst, van Doesburg, Tanguy, Mondrian, Klee, and the American John Ferren). Though the Danish sponsors did not entirely share the viewpoint of these foreign artists, they felt the inclusion of such works would stimulate local interest in what transpired elsewhere, and demonstrate how "living art" can "conquer humanity for humanity." Kandinsky's work enjoyed special emphasis. His article, along with Paul Éluard's "The Evidence of Poetry," accompanied the listing of works printed in the catalogue.

Since *Linien* included a number of artists with strong Surrealist leanings, it can scarcely be coincidence that Kandinsky, in his essay, should have touched on the topic of a superior reality compounded of the unreal and the dream. He did this without mentioning Surrealism or using the movement's jargon. He disclaimed the presence of secrets, and of a special language in his own art—an oblique reference to the Surrealists' attachment to such matters. This gentle, veiled criticism stands in sharp contrast to the repugnance for some aspects of Surrealism he expressed privately in letters.

"The time of technology."

A new, but already old theme. We adjust quickly to new wonders. The old dreams of adventure have come true and have become replaced by others. The splitting of atoms is already an old story, and soon flights into the stratosphere will be as well. Inaudible ultrasounds will begin to be heard, become amenable, and serve practical purposes. The flight over the North pole today brings good-bye kisses at airports and railway stations. For how long?

What, on the other hand, are the "wonders of art"?

Logic. Mathematics—calculation. The inexhaustible source. A road that disappears into infinity. Mathematics obtains a stronger position each day in the most varied of sciences and transcends them. Obviously, we cannot do without calculation in any field. Logic often causes people to make faces. But remains secure.

The road for triumphant art, the road that disappears into infinity, does that also start here?

Two times two herring = four herring, and seems to be an everlasting law that remains absolutely firm. Two times yellow and two times yellow is? Often = zero.

In art, enlargement is often reached through diminution. What happened to calculation? Logic smiles, embarrassed. Mathematics scratches its head. Is there something else that might calculate a work of art?

The artist "hears" how something or other tells him: "Hold it! Where? The line is too long. It has to be shortened, but only *a little bit!*" "Just *a little bit, I tell you.*" Or: "Do you want the red to stand out more? Good! Then add some green. Now they will 'clash' a little, take off a little. But only *a little,* I tell you": what Henri Rousseau considered to be his "dead wife's" "dictate."

— — — —

"The dead wife" is the inexhaustible source of the "wonders of art." The road that leads there disappears into infinity. One must have the perception to "listen" when the voice sounds. Otherwise, no art.

— — — —

In such a way does the artist "create" and "measure" the forms, and in such a way arises "proportion, balance." "Construction!"

— — — —

But all of this does not help if the spectator does not have an "ear." He does not need to hear what will be created, but he ought to be able to hear the "sound" from the work of art that has already been created.

The spectator, however, is too often deafened by the "propeller." "Real" life has made him blind. Here is the origin of today's statement, that art has lost contact with life.

— — — —

No, not art, but all of humanity has lost contact. Not the contact with life but how to *live*.

— — — —

Life does not only consist of "realities." What then will happen to the "unreal?" Where would we be able to find room for the dream? Not the dream about the "Seven-League Boots," which has already come true, but the "unreal"—which together with the real world creates *the world*.

— — — —

The spiritual individual has been "castrated"; only half a man has been put into the place of the whole one.

When people in the good old days (before the World War, which is still not "paid for") made fun of our dreams, then they were still alive because they spat out of indignation. They spat because they apparently had their own dreams, which were offended by ours. They spat because they had *experienced* the work of art, even if in reverse. When today they have lost this negative connection with art, then the "propeller" is more than a little guilty.

— — — —

No, it is not megalomania to dare to state that the art of today does not "say" less than was the case hundreds of years ago, yes, even further back in time.

Twenty-five years ago painting discovered, and so did sculpture quite soon afterward, a new "language"—a "speech" with exclusively artistic means—without a single "addition." This language is the so-called "abstract," or whatever one wants to call it. Isn't it remarkable how this "pure," unmixed language (without "stucco"), according to many people, completed the gap between art and life.

Art does not seem to be able to follow life.

Or was it maybe life that was unable to follow art?

I would like to answer "Yes" to this question. A very energetic "Yes."

— — — —

Present-day humanity is not at all to blame for the fact that it only manages to understand everything in the world in a purely materialistic way, and that it is standing there confused and without understanding in front of things to which it cannot find a material road. Or—more correctly—calmly turns it back upon such unintelligible things without troubling itself to assimilate them. It is not to be blamed.

— — — —

Is it going to continue this way? Is it impossible to fill in the gap between art and life?

To this question I would like to answer "No."

— — — —

No, and once again, No! The fact still remains that the half-man is a transitional form, because man cannot be satisfied with only *the one* side, when he also feels the hunger and thirst for "the other" side?

Art is that other side, which holds the possibility and the strength to relate those things that life necessarily keeps secret.

And only those two together—life and art—fulfill *life*, let *life* prevail. It senses every little thing. This sense already means a lot. It promises that the fatal one-sidedness is eventually doomed to vanish and to be replaced by a many-sidedness, which will finally lead to deeper understanding about life.

Please let me say a few words about my painting. I ask you to understand that my painting does not try to reveal "secrets" to you, that I (as many people think) have not found "a special language" that has to be "learned" and without which my painting cannot be read. This should not be made more complicated than it really is. My "secret" consists solely of the fact that over the years I have obtained that fortunate skill (have maybe fought for it unconsciously) to liberate myself (and with that my painting) from "destructive secondary sounds," so that *each* form comes alive—acquires sounds and consequently expression, too. Simultaneously, I have experienced the bliss of hearing the weakest language. And so I have fortunately been able to extract, with complete freedom and without restraint, whatever form from the endlessly great "treasure of form" that I need for a particular moment (work of art). Here, I do not need to worry about the "content," but solely about the right form. And the correctly extracted form expresses its thanks by providing the content all by itself.

— — — —

Here lies the solution to the "abstract art" issue. Art remains silent only to those who are not able to "hear" the form. But! not only the abstract, but each kind of art, however thoroughly "realistic" it may be.

— — — —

The content of painting is painting. Nothing has to be deciphered. The content, filled with happiness, speaks to that person to whom *each* form is alive, i.e., has content. The person to whom the form "speaks" will not unconditionally look for "objects." I willingly admit that "objects" are a necessity of expression for many artists, but these objects remain something *incidental* to painting. Thus the conclusion follows that objects do not necessarily have to be regarded as something inevitable in painting; they can just as well have a disturbing effect, which is what I feel they have in my painting.

— — — —

Also, I ask you to understand that I am not developing a "program" for you. And that under no circumstances do I want to force a "program" upon you.

Programs can be very beautiful and attractive, but only when they become crystallized by finished works of art. They have to be the *result* of the works of art, not their origins. The creation is free and shall remain so, i.e., not becoming oppressed by anything except what is performed by "the internal dictate": "The voice of the dead wife."

— — — —

Therefore, I do not become shocked when a form that resembles a "form in nature" insinuates itself secretively into my other forms. I just let it stay there and I will not erase it. Who knows, maybe all our "abstract" forms are "forms in nature," but . . . "objects of use?"

These art forms and forms in nature (without purpose) have an even clearer sound that we must absolutely listen to.

One more thing: We have to watch out for program art and always follow only an undefined longing. An artist's fortune is to be able to dress this longing in forms. His misfortune would be not managing to "express" this longing through form, but causing its restlessness to come to a standstill.

I know how difficult it is for many people to "read"—especially when the writing is in abstract form. "The spectator" is often shocked, because it seems to him as if the ground has been torn away from under his feet—he "drifts." Especially today, it is expected that the "normal individual" should stand solidly with both feet on the ground. Unfortunately, he accedes to this demand too often and obviously forgets that the ancient dream of flying has come true in our time.

— — — —

Isn't it easier "to fly" in art?

Let me finally give you a small citation from my short autobiography, which was published in 1913 (Berlin: Der Sturm):

I became liberated, and new values were revealed. Everything "dead" trembled. Everything showed me its face, its innermost being, its secret soul, inclined more often to silence than to speech—not only the stars, moon, woods, flowers of which poets sing, but even a cigar butt lying in the ashtray, a patient white trouser-button looking up at you from a puddle on the street, submissive piece of bark carried through the long grass in the ant's strong jaws to some uncertain and vital end, the page of a calendar, torn forcibly by one's consciously outstretched hand from the warm companionship of the block of remaining pages. Likewise, every still and every moving point (= line) became for me just as alive and revealed to me its soul. This was enough for me to "comprehend," with my entire being and with all my senses, the possibility and existence of that art which today is called "abstract," as opposed to objective."[2]

Paris, July 1937

Interview with Karl Nierendorf
["Interview Nierendorf—Kandinsky"]
M. Bill, ed.,
Kandinsky, Essays über Kunst und Künstler
(Bern-Bümpliz), 1963

In 1937, Kandinsky gave the following interview to
the New York dealer and collector Karl Nierendorf. Nieren-
dorf, a German emigré, had known Kandinsky since the
Bauhaus years; together with J. B. Neumann and Galka
Scheyer, he was responsible for the further spread of the
artist's reputation in the United States.[1] The interview re-
mained unpublished during Kandinsky's lifetime; it is, how-
ever, of such interest that it is reprinted here in its rightful
chronological position.

By this date, Kandinsky had firmly convinced himself that
his first abstract picture had been painted in 1911. It has
recently been suggested that the picture he had in mind may
have been *With Circle*.[2] His claim to have painted his "first
abstract watercolor" as early as 1910 almost certainly rests
upon the misdating of a watercolor formerly in the collection
of the artist's widow, to which the signature and date "Kan-
dinsky, 1910" appear to have been added some years after the
event.[3] The exact chronology of Kandinsky's development
toward nonrepresentational art remains a matter of debate.[4]

Some of the topics mentioned in this interview are familiar
to us from the "Reminiscences," e.g., the journey to Vologda,
and the Moscow Impressionist exhibition. Other recollec-
tions add to the mosaic of the artist's early years, for instance,
the definite statement that he had seen Matisse's work as

early as 1906. His reference to Walden recalls the latter's campaign against the critic Kurt Küchler, and the concerted defense of Kandinsky orchestrated by *Der Sturm*. (See pp. 348–54.) He also refers to the inquiry conducted by the periodical *Cahiers d'Art* in 1935 under the heading "L'Art aujourd'hui est plus vivant que jamais" (see pp. 764–71), and his own response—a statement he seems to have accorded considerable importance.

Nierendorf's questions are printed in italics.

1. *Date of the first abstract picture?*
1911, i.e., twenty-six years ago. Abstract watercolor as early as 1910.

2. *How did you arrive at the idea of "abstract" painting?*
Difficult to say. Even in very early youth I sensed the unparalleled expressive power of color. I envied musicians, who could create art without "narrating" anything "realistic." Color, however, seemed to me just as expressive and powerful as sound. When I was about twenty, I was sent by one of the academic institutes of Moscow University to the province of Vologda (the northeastern part of European Russia) to undertake juristic and ethnographic research. There, I saw farmhouses completely covered with painting—nonrepresentational—inside. Ornaments, furniture, crockery, everything painted. I had the impression I was stepping *into* painting that "narrated" nothing. A few years later, I saw a large Impressionist exhibition in Moscow, some of which aroused a good deal of controversy, because the painters "treated objects carelessly." But I had the impression that *painting itself* had here come to the fore, and wondered whether one could not go a long way further in this direction. Since then, I looked at Russian icon painting with new eyes, that is to say, I "acquired eyes" for the abstract element in this kind of painting. In 1906 I saw for the first time Matisse's early pictures, which were also highly controversial—for the same reason as those of the Impressionists in Moscow. Much encouraged, I asked myself once again the question whether one might not simply reduce or "distort" objects, but do away with them altogether. So I went over to abstract painting, by way of "Expressionism"—slowly, as a result of endless experiments, doubts, hopes, and discoveries.

As you see, I never had anything to do with Cubism. When I first saw photos of Picasso's Cubist paintings (1912), my first abstract picture was already painted.

3. People often say abstract art no longer has any connection with nature. Do you think so too?

No! And no again! Abstract painting leaves behind the "skin" of nature, but not its laws. Let me use the "big words" cosmic laws. Art can only be great if it relates directly to cosmic laws and is subordinated to them. One senses these laws unconsciously if one approaches *nature* not outwardly, but—inwardly. One must be able not merely to see nature, but to *experience* it. As you see, this has nothing to do with using "objects." Absolutely nothing!

I have written about this in *Cahiers d'Art,* at the request of M. Zervos.

If an artist has both an outward and an inward eye for *nature,* she rewards him with "inspiration."

4. Equally, people quite often say "abstract painting" comes exclusively "from the head." Is that true?

It happens not infrequently that it is true. But . . . it is no less often true of "representational" and "realistic" painters. Man's "head" is a necessary and important "organ," but only if organically linked to the "heart," or to "feeling"—call it what you will. Without this link, one's "head" is the source of all kinds of dangers and disasters. In all realms. Hence in art too. In art even more so: there have been great artists "without heads." But never without "hearts." During great periods, and in the case of great artists, there has always been this organic link between head and heart (feeling). It is only in times of great confusion such as we have today that one can possibly nurture the miserable thought that art can be arrived at by the head alone. I think, however, that this miserable thought is already dead. Henri Rousseau used to think his best works were dictated to him by his "late wife." Maybe! At all events, art cannot be born into the world without an "inner directive." Intuition!

5. What was the public response to your first abstract works?

At that time, I stood completely alone, my paintings being rejected in the most vehement manner. What I had to listen to by way of accusations was really fantastic. "Untalented swindler" was the favorite ex-

pression. Later, my Berlin dealer, Herwarth Walden, instigated an action against a German critic who had called me the founder of a new art movement that he dubbed "Idiotism." But even today, there are still "critics" here and there who try to prove that abstract painting "is not possible." And as you know, it is not only "critics" who share this view.

In my opinion, this consistent opposition to abstract art, an opposition that has lasted for more than twenty-five years, is the best proof of the necessity of abstract art, and the extent of its power. Anything that progresses smoothly and quickly is invariably a nonentity.

6. *What do you think about American "possibilities"?*

I have never been to America, but the things I see and hear from over here are often heartening. America is a young giant that often reminds me of Russia—the same complexity, variety, and love of life, freedom, and novelty . . . in the best sense.

Americans have managed to keep an enviable freshness that we find here all too seldom. Of course, one finds everywhere—in America as well as in Europe—"modernists," that is, people who are terrified of being "left behind," and therefore embrace with enthusiasm everything new. They forget how many such novelties have, in the course of the last twenty or thirty years, turned out to be nothing more than a "dry run." But without "derailments" there can be no progress—a cruel "law of nature," perhaps, but an eternal one. They say, don't they: "Only he who does nothing never errs." But I would say: He errs the most.

Four Poems
Transition
(New York), 1938

Apart from *Twilight* (see p. 510), the four poems by Kandinsky that follow were the first to appear in print since the publication of his album *Sounds* in 1912 (see pp. 291–340). "Ergo," "S," and "Always Together" are dated May 1937; "Memories" is dated March 1937. They were published in the tenth anniversary issue of the New York quarterly *Transition,* edited by Eugène Jolas, and were accompanied by a reprinting of two of the *Sounds* poems: "Gaze and Thunderbolt" and "Different."

"S" poses literally insuperable problems of translation, not simply because the repeated sibilants cannot be rendered in English, but because Kandinsky plays upon the way polysyllabic words are built up in German from particles, each with its own independent meaning. Nor was it possible to find an English equivalent for the play upon sound *"mässig . . . Essig."* We have, therefore, reprinted "S" in the original German, followed by an English version that captures the sense of the words, but not their sound.

The juxtaposition of these poems with Kandinsky's earlier verses from *Sounds* serves to accentuate how little his style as poet changed in the course of twenty-five years.

Ergo

Slipping and climbing at the same time is no miracle.

Like diving to the summit of Mont Blanc.

Little dashes (thus: - - - - - - - - -) are a miracle, because some time they stop.

When?

If all the bread-crumbs, all the pharaohs, all the gnats, all the malignant gaps, the torn into scraps, together with all the wars, and aeons, and skiers (not forgetting the boxers!), all the painters who ever painted, the horse trams, which have turned into flying machines, the stockings, the ichthyosaurs, the Milky Way, all the drops of milk from the cows, whales, goats, seals, lionesses of the entire prehistoric and simply historic periods, which were sometimes black, sometimes red, and sometimes white—from time immemorial until today, until the second that has just elapsed, were black red and white and . . . are

HAVE

determined,

attained

their end.

Rather not.

Paris, May 1937

S

Un—regel—mässig
Regel—mässig
Mässig
Wo ist es?
Aber tatsächlich—wenn Eins steigt, sinkt das Andre.
Wenn beides steigt, . . . oder beides sinkt, ist es dann mässig?
Uebermässig immer nachlässig.
D.h. wie man es so unendlich schön, lilienduftend, unwirk-
lich tief mit spitzen Höhen sagt:
Essig.
SSS - - -

Paris, May 1937

Irregular
Regular
Moderate
Where is it?
But in fact—if the one rises, the other falls.
If both rise . . . or both fall, is that then moderate?
Immoderate always careless.
I.e., as one says with such infinite beauty, with a scent of lilies, with
profound irreality, with sharp peaks:
Vinegar.
SSS - - -

•

Memories

Do you still remember how once you wanted to climb the narrow,
steep path that turned off to the right? And how you said at the time: "I
would prefer to turn off to the left"? How, in the midst of the ascent, you
then stopped and said to me: "In the tight, narrow crevice sits a moth. It

does not care which is right and which is left. Is it not right?"

You must still remember how once you waded into the green, cold water and said, "Brrrr. . . ." Then you said: "Funny, I got undressed so as to get into the water. Why do fish never climb out of the water to get dressed?"

And how once you lay on your belly on the fine sand of the beach and said: "How I wish for once I could lie on my belly and on my back at the same time! Will there come a time when one will be able to lie on one's belly and on one's back at the same time? How I long for that time."

And once, when we were both sitting in our dentist's waiting-room, you said to me: "Why are there ventriloquists?" And after a long pause: "Why should one speak from one's stomach when we have mouths and tongues?" And after another, still longer pause: "Don't you believe nature intended mouth and tongue for talking?" As I didn't want to disturb your thoughts, I kept silent. So a still longer pause elapsed. We were both silent. And after this much much longer pause, you said, full of convincing warmth: "*I* believe it. . . . Oh, nature!"

Once, we were both sitting quite alone in a train compartment. Twilight crept in on us; the lights were not yet turned on. The engine whistled. And afterward, when we could hear only the rattling of the wheels, you said to me: "What would it be like if ants were as big as elephants, and elephants as small as ants? Wouldn't you believe nature had made a mistake in that case?" All three of us were silent—you, the engine, and I. Oh, nature!

And once, you said to me: "In the east there is west, in the west there is east, in the north south, in the south, north. Bah!"

Since then I met you no more.

Paris, March 1937

•

Always Together

Mr. Rise and Mr. Fall said to one another:
"I'll soon be coming to you. Yes indeed!"
And Mr. Rise: "You to me?"
And Mr. Fall: "You to me?"
Who to whom?
When?

Paris, May 1937

1937–1938

XX^e Siècle

["L'Art Concret;" "Mes gravures sur bois"]
XX^e Siècle **(Paris), 1938;**
["The Value of a Concrete Work"]
XXth Century
(Paris), 1938–39

The journal *XX^eSiècle,* subtitled *Chroniques du Jour,* was founded in the spring of 1938 by Gualtieri di San Lazzaro, the Italian writer, critic, and art lover, who was then domiciled in Paris. It appeared at irregular intervals. From no. 4 (December 1938) onward, it was published in an English edition, as well as in French. The sole agent for *XX^e Siècle* in England was A. Zwemmer; the American agent was Karl Nierendorf.

According to Nina Kandinsky, she and her husband first met San Lazzaro at the exhibition of Kandinsky's work mounted by the Galerie de France in Paris in 1930. San Lazzaro later became a close friend and one of Kandinsky's most active champions. Mme. Kandinsky paid tribute to his "tireless work, his intensive concern with exhibitions, and his undeterred advocacy of abstract art." She also recalls that San Lazzaro confessed to her that it was for Kandinsky and his art that he started *XX^e Siècle.*[1]

In the first year of its existence, the journal published no less than three articles by Kandinsky: "Concrete Art," "My Woodcuts,"[2] and "The Value of a Concrete Work." The last-named, accompanied by "unpublished drawings" and an original woodcut in two colors,[3] appeared in both the English and French editions; it is the English version that is reprinted

here. A further article that appeared in *XX^e Siècle* in 1943, and begins, "Toute époque spirituelle . . .," is not, strictly speaking, an original publication (and is, therefore, omitted from this edition);[4] it consists of a reprint of passages from "Concrete Art" and "The Value of a Concrete Work," together with the introductory statement written for Max Bill's graphic album *10 Origin* (see pp. 842–43).

CONCRETE ART

All the arts stem from the same and unique root.

Consequently, all the arts are identical.

But the mysterious and precious thing is that the "fruits" produced by the same stem are different.

The difference manifests itself by the means of each single art—by the means of expression.

It is quite simple at first. Music expresses itself by sound, painting by color, etc. Everybody knows that.

But the difference goes further. Music, for example, arranges its means (sounds) in time, while painting arranges its means (colors) on a surface. Time and surface must be "measured" with exactness, and sound and color must be "limited" with exactness—these "limits" are the basis of "balance" and consequently of composition.

The enigmatic but exact laws of composition destroy differences, since they are the same in all the arts.

I would like, by the way, to emphasize the fact that the "organic difference" between time and surface is generally exaggerated. The composer leads his listener by the hand into his musical work, guides him step by step, and leaves him once the "piece" is over. The exactitude is perfect. It is imperfect in painting. Nevertheless! . . . The painter is not deprived of this "guiding" power—he can, if he wants to, compel the beholder to enter here, to follow a given path into his pictorial work and to "come out" there. These are extremely complicated matters, still not very well known, and above all scarcely resolved.

I would only wish to say that the relationship between music and painting is obvious. But it manifests itself in an even deeper manner. You

know of course about "associations" elicited by the means of the different arts? A few scholars (especially physicists), a few artists (especially musicians) have noticed for quite a while that, for example, a musical sound provokes an association with a definite color. (See, for example, the correspondences worked out by Skriabin.) In other words, you "hear" the color and you "see" the sound.

It has been almost thirty years now since I published a little book that also dealt with this problem. YELLOW, for example, has the special capacity for "rising" higher and higher and for reaching heights unbearable to the eye and to the spirit: [it is like] the sound of a trumpet played louder and louder, becoming "shriller and shriller," hurting the ears and the spirit. BLUE, with its totally opposite power of "descending" into unfathomable depths, takes on the sound of the flute (when the BLUE is light), that of the cello by "going further down," that of the double bass, with its deep and magnificent sounds, and in the depths of the organ you "see" blue depths. GREEN, well balanced, corresponds to the extended middle register of the violin. Skillfully applied, RED (vermilion) can give the impression of loud beats on the drum. Etc. (*On the Spiritual in Art*, Munich, 1912. English and American editions, *The Art of Spiritual Harmony*.)[5]

Vibrations of air (sound) and of light (color) surely form the basis of this physical kinship.

But it is not the only basis. There is still another one: the psychological basis. The problem of the "spirit."

Have you ever heard or have you yourself used the expressions, "Oh, what cold music!" or "Oh, what a glacial painting!"? You have the impression of icy air coming in through an open window in winter. And your entire body is displeased.

But an adroit application of "warm tones" and "sounds" gives both the painter and the composer a fine opportunity to create warm works. They burn you directly.

Pardon me, but it is truly painting and music that [can] give you (although not too often) heartburn.

*

You also know how, when running your finger over various combinations of sounds or colors, you have the impression that your finger is "pricked." As if by thorns. But at times your "finger" runs over a

painting or a piece of music, as if over silk or velvet.

Finally, isn't the "fragrance" of VIOLET unlike that of YELLOW, for example. And of ORANGE? Of light BLUE-GREEN?

And as "taste," aren't these colors different? What a tasty painting! With the beholder or the listener it is the tongue that begins to participate in the work of art.

There they are, the five senses known to man.

Do not make the mistake of thinking that you "receive" painting only through your eyes. No, you receive it without your knowledge through your five senses.

Do you believe it could be otherwise?

In painting what is meant by the word "form" is not color alone. What is called "drawing" is another inevitable part of the means of pictorial expression.

And beginning with the "point," which is the origin of all the other forms, whose number is unlimited, this small point is a living being that exerts many influences on man's spirit. If the artist aptly places it on his canvas, the small point is pleased, and satisfies the beholder. It says "Yes it's me—do you hear my small but necessary sound in the great 'chorus' of the work?"

And how painful it is to see this small point where it does not belong! You have the impression of eating a meringue and of tasting pepper instead. A flower with the odor of rot.

Rot—that's the word! Composition becomes decomposition. It's death.

Have you noticed that while I was talking rather at length about painting and its means of expression, I have not said a word about the "object"? The explanation of this fact is quite simple: I have talked about the essential pictorial means, that is to say, the inevitable ones.

One will never discover ways of painting without using "colors" and "drawing," but painting without an object has existed in our century for over twenty-five years.

As for the object, it can be *introduced* in a painting or not.

Whenever I think about all those disputes around that "not," disputes that started almost thirty years ago and are not completely over today, I see there the tremendous power of "habit," and at the same time the tremendous power of what is called "abstract" or "nonfigurative" painting, which I prefer to call "concrete."

That kind of art is a "problem" which they have too often wanted to

"bury," which was said to be definitively solved (in the negative sense of course), and which does not allow itself to be buried.

It is far too alive.

The problem of either Impressionism or Expressionism (the Fauves!) or Cubism no longer exists. All those "isms" are being put away into the different boxes of the history of art. The boxes are numbered and carry labels corresponding to their contents. And in this manner the disputes are ended.

That's the past.

And one cannot as yet anticipate the end of the disputes concerning "concrete" art. Capital! "Concrete" art is in full growth, especially in the free countries, and the number of young artists who support the "movement" keeps increasing in those countries.

That's the future!

Paris, January 1938

MY WOODCUTS

For many years I have written, from time to time, "poems in prose" and even some "poetry."

Which for me means a "change of instrument"—the palette put aside and in its place the typewriter. I use the word "instrument" because the force that prompts me to work always remains the same, that is to say, an "inner pressure." And it is this pressure that often asks me to change instruments.

Oh! I remember very well: when I started "writing poetry" I knew that I would become "suspect" as a painter.

In the past they used to look "askance" at the painter whenever he wrote—even letters. They almost expected him to eat not with a fork, but with a brush.

Those were hard days, filled with strict "divisions" and rather simple in their logic. If the theorist thinks without being able to paint, it is up to the painter to paint without being able to think.

Those were the days of the "analytical" world of specialization, permanently divided from one another, the "boundaries" of which were not to be crossed. A state of things in which, nowadays, nations and different countries take the place of "specialization." The strict division has passed from the realm of the "spirit" to that of "realities."

This "analytical world" in art, in science, etc., has since then been profoundly shaken; nowadays, people have almost rid themselves of those notions. It is unwise and unfortunate to close one's eyes to some few facts (one could say "events") that surround us and push us toward the liberation of synthesis. So much the worse for those who want to bar the way.

One would be over-optimistic, however, to believe that the analytical moment has disappeared and has been definitively replaced by synthesis. It is still far from having disappeared and only prevents the small root of synthesis from developing. Capital! All "facts," and especially "events," develop slowly—the root must have the necessary time to push downward and to gather the strength necessary to feed the plant. Short root—short life for the plant. And there is no difference between nature's plant and Nature.

My book *Sounds* was published in Munich in 1913 (R. Piper & Co.). It was a small example of synthetic work. I wrote the poems, and I "adorned" them with many woodcuts, in color and in black and white. My editor was rather skeptical, but he had the courage nevertheless to publish it in a deluxe edition: special type, transparent hand-made Holland paper, a costly binding printed in gold, etc. In brief, a deluxe edition of three hundred copies, signed and numbered by the author. But his courage brought him total satisfaction.

The book was very quickly out of print.

According to our agreement, neither of us was allowed to make a new edition. Therefore, I can only publish fragments of the book.

Here are six woodcuts. In these woodcuts as in everything else—woodcuts and poems—one discovers the steps of my development from the "figurative" to the "abstract" ("concrete" according to my own terminology—which is more accurate and more expressive—in my opinion at least).

The largest of the three colored woodcuts did not appear in the book. It dates back to 1908.

Twenty-five years, according to statistics, is sufficient time for a new generation to be born and to mature.

It is a joy for me to show my early efforts to that new generation.

Paris, June 1938

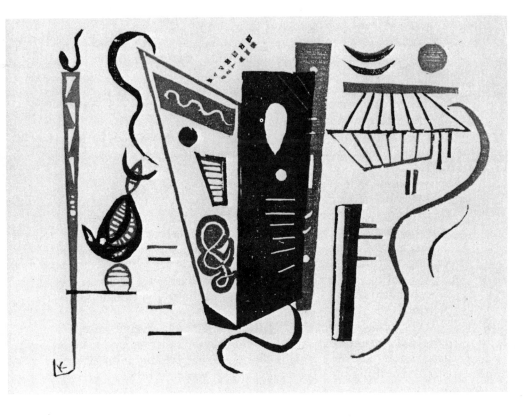

THE VALUE OF A CONCRETE WORK*

Put one apple beside another and you will have two apples. By simple addition you get hundreds and thousands of apples, and the increase can continue indefinitely: arithmetical process.

Addition in art is enigmatic. Yellow + yellow = yellow2. Geometrical progression.

Yellow + yellow + yellow + yellow + . . . = gray. The eye grows tired of too much yellow: psychological limitation.

Therefore the increase becomes a decrease and arrives at zero.

Beware of pure reason in art, and do not try to "understand" art by following the dangerous path of logic.

Neither reason nor logic can be excluded from any consideration of art, but perpetual corrections are necessary from the angle of the irrational. The feelings must correct the brain.

This assertion applies to art in general, without distinction between representational and concrete art. From this point of view the two kinds are alike.

The two kinds, however, exist:

Representational painting: the artist cannot do without the object (or he imagines he cannot). He uses the object as a "pretext" for pure painting, which is always more essential for him than the object.

The spectator cannot do without the object (or he imagines he cannot) to "understand" the painting.

Concrete painting: the artist frees himself from the object, because it prevents him from expressing himself exclusively through purely pictorial means.

The spectator is deprived of the "bridge" which gives him the possibility of entering into the field of pure painting, and if he is deprived at the same time of the necessary feeling he is disconcerted. He thinks he has no longer any standard by which to appreciate art.

The result of this difference in kind:

Representational painting is based on a more or less "literary" content, since the object (even the most quiet and modest one) "speaks" by the side of the pure painting. (Here is a parallel, comprehensible and

*Generally, but incorrectly, called "abstract."

at the same time more or less fundamental: a popular song, composed of a simple narrative clothed in a fairly primitive musical form, when it is deprived of its words becomes monotonous and finally impossible. In the same way representational painting "clothed" in monotonous pictorial forms is only possible as long as the object is constantly varied.)

Concrete painting offers a kind of parallel with symphonic music by possessing a purely artistic content. Purely pictorial means are alone responsible for this content.

From this *exclusive responsibility* arises the necessity for the *perfect accuracy* of the composition from the point of view of balance (values, weights of forms, and of color-masses, etc.) and for the perfect accuracy of every part of the composition, *to the least little detail,* since inaccuracies cannot be concealed.

There arises also the possibility and the necessity for the fancy of the painter, deprived of a "pretext," to develop freely and to make new discoveries constantly. These possibilities are unlimited.

As we have seen that increase in art often turns into decrease; now we find that the opposite is true, and that decrease can become increase.

When the object is suppressed the means of expression are not diminished, but infinitely multiplied. This is artistic mathematics, the opposite of the mathematics of science.

*

But quantity is not of course quality. This richness in the means of expression of concrete painting must have, I repeat, an *irreproachable accuracy* for basis.

How can this be measured? That is to say, what is the proper method of assessing the *value* of a work?

The most obvious methods of assessing this value would seem to be:

1. through knowledge of the constant rules of painting, compulsory for the artist, and

2. through the degree of application of these rules in his work.

We shall see whether these compulsory rules exist, or used to exist in the past, and whether it is possible, or used to be possible, to discover their application in a work of art.

Here are several examples which I consider striking:

The old Italian recipes ordained, strictly and definitely: "If you want to paint a fish in water, the first coat on the canvas should be such and such, the second such and such . . ." "If you want to paint an old man in the shade, your first coat . . ."

In this way the painter arrived easily, it seems, at producing a work of value, and the connoisseur was perfectly able to affirm it. If the coats of paint are wrong the picture is worthless.

Later, after the discovery of perspective, the theory of coats of paint was discredited. This new formula appeared: if the perspective is false the picture is worthless.

Science entered the realm of art. And since the favorite theme of "high" art was the human body, the study of anatomy became indispensable—the structure of the bones (especially of the skull), of the nose, the nostrils, the forms and functions of the muscles, etc.

Drawing became a science, and the academies prescribed four years to be devoted to the study of drawing, followed by four more years of instruction in painting proper.

A fine system which has done a great deal toward the production of "pompiers."

And it was considered absolutely certain (as it is sometimes even now) that this course of consecutive studies would guarantee the value of a young painter's work. Quite a dramatic point of view for the connoisseur, who did not usually have the faintest idea of anatomy.

Now this gives a puzzling sort of result. Among thousands—we can safely say hundreds of thousands—of canvases irreproachable from the points of view of anatomy and perspective we find in general a negligible quantity of pictures that leave a deep impression on the memory of the spectator. These correct canvases are forgotten as easily as a piece of music composed according to all the rules of the academy, which passes from the memory as soon as the concert-hall is left; or as a book written according to the rules of etymology and syntax which is shut without regret for a single comma.

Why?

Can this mystery be elucidated through an analysis of the *harmony* of the work?—since "painting is beautiful if it is harmonious." This question embraces two elements of painting—the element of color and that of form proper (drawing).

Harmony of color. Leonardo da Vinci, according to an authentic account, invented a system of little spoons of different sizes to measure

accurately the quantities of colors to be used on a canvas: an exact proportion of blue, violet, white, etc.

These spoons were filled with dust in the master's studio—he never made use of his invention.

Another more attractive system, which is still sometimes followed, consists in adding a "suspicion" of some particular color to all the colors which go to make up the canvas as it is painted—a little green or red or some other color serves as a "bridge" between all the colors applied and is a sure guarantee of harmony, complete harmony. As you see, this system excludes the use of pure colors, which I will consider next. As for this "bridge" system with its full guarantee of irreproachable harmony, would it not be dangerous to use it on every occasion without exception? Wouldn't the artist run a terrible risk of producing an unlimited number of desperately boring and monotonous works?

To enrich the possibilities, perhaps it would be profitable to admit the opposite of the "bridge" system also, that is to say the system of pure colors. The rainbow is harmonious. The possibilities of variation would be very limited, but harmony would be assured. It would be assured if we could have exactly the same palette as the rainbow. But the painter receives his colors not from the sky, but from factories—each of these "pure" colors is supplemented by a dash of white and black. So, for example, the vermilions of different factories are never the same. The idea of pure colors is therefore a beautiful Utopian dream.

"Absolute" means do not exist in painting; its means are relative only.

This is a positive and cheering fact, since it is from interrelation that the unlimited means and inexhaustible richness of painting arise.

Harmony is indeed a complicated subject—the brain reels before it. The opposite of harmony is disharmony. And throughout the history of painting the disharmony of yesterday has always become the harmony of today. Art is a complicated phenomenon.

*

I do not wish to become tedious by going into too much detail; I must however give a few examples which I will briefly mention: the part played by the dimensions of the color-masses, by the neighborhood of other colors, and by the dimensions of their masses, the reciprocal influence of every part of the canvas, etc. A small form may receive so

strong an "accent" that it completely changes the size, the intensity, and at the same time the importance of the large forms. It works in the same way as a siren which envelops all the noises of the town, narrowing the streets and diminishing the buildings.

I cannot omit some mention of the importance of the place occupied on the canvas by a form. In one of my books I have attempted to give an analysis of the "tensions" of the empty canvas, that is, of the latent forces inherent in it, and I think I have arrived at several just definitions of the essentially different tensions of the top and the bottom, of the right and the left. A blue circle set at the top left-hand corner of the canvas is not at all the same as one set at the bottom to the right—the weight, the size, the intensity, the expressions are different. This is an example of the immense part played by "details."

The canvas is divided into large and small parts. The dimensions of these parts produce the proportion. The proportion determines the value of the work, the *harmony of forms* of the design.

How is the true proportion to be found? Is it possible to calculate it?

A simple trial: on a piece of paper measuring 20 × 40 cms. two rectangles are placed, one of 2 × 4 cms., the other of 4 × 8. Harmony is attained schematically by true proportion. Not a very cheering composition, but at least of guaranteed value.

But there is another obstacle: colors change dimensions. A very simple example: a black square on a white ground gives the impression of being smaller than a white square on black. Optical proportions destroy mathematical proportions and replace them.

The effect of a painting—unhappily or happily—is of an *optical* nature.

Then what remains of "true proportion"?

(It is true in the sparrow or the ostrich?—the giraffe or the mole?)

*

What can we say, then?

We know examples of calculated works. It is certain that sometimes this calculation is made by the subconscious, sometimes mathematically. Either it leaps to the eye or it requires measuring to be brought out.

A Russian musician, M. Shenshin, undertook an impressive analysis more than twenty years ago. By counting the notes he measured two parts of Liszt's "Années de Pèlerinage," which had been inspired by the

"Pensieroso" of Michael Angelo and by the "Sposalizio" of Raphael respectively. In continuation of his research he measured the two plastic works. The result was surprising: the "Pensieroso" of Michael Angelo showed the same formula as the musical work of Liszt dedicated to this sculpture. (Formula in figures.) The same with the "Sposalizio" of Raphael and of Liszt. I think that in these cases we have the two kinds of calculation. If we can take it that the two plastic works were calculated directly, that is to say by a mathematical method, there is on the other hand no doubt that Liszt divined the two formulas with his subconscious mind. He had translated the plastic works by means of identical formulas without knowing them.

And, after all, it would be pernicious to put all one's faith in calculations. It would perhaps work with the even numbers, 2, 4, 6, 8—(but don't forget the black square and the white square!) Color cannot be measured, and it changes the dimensions of the design. But apart from the color, the design cannot be measured either down to the final details, to the smallest differences which can only be discovered through feeling, that is, through intuition. And there you are—it is exactly the details which make the "music." If you find two people of exactly the same figure, of the same breadth of shoulders, of hips, having identical dimensions of arms, hands, legs, and feet, yet you would never say that the two people are identical. The "general proportion" is never decisive, it is the details which count—the eyelid, the little fingernail of the left hand, etc.—the tiniest details.

It is the same in painting: the most "insignificant" differences, sometimes "invisible" differences, are often more important than the "general proportion" and decide the value of the work. There are no other means of arriving at the "optical proportion."

We cannot but wholeheartedly love the pure faith of Henri Rousseau, who was entirely persuaded that he painted according to the dictates of his dead wife. Artists know well this mysterious voice which guides their brush and measures the design and the color.

Art is subordinate to cosmic laws revealed by the intuition of the artist for his work's sake and for the sake of the spectator who is often delighted through the operation of these laws without knowing it. It is an enigmatic process.

Is it sad to have to do with riddles in art?

I began with a question, and I have put a questionmark at the end of the last sentence—a vicious circle.

All the same, I consider that I have said two important things. I have firmly underlined the decisive part played by *detail*. And I hope I have provoked a certain distrust of art criticism based on exterior indices, such as the criterion of the "technique" of painting, "objective" standards of value, and in short all 'scientific" indices generally. All these give negative results.

Now I will attempt to supplement this negative by a positive remedy. It is well enough known that every period in art has a special physiognomy which distinguishes it from the past and the future. The period offers a new spiritual content which it expresses through exact and convincing forms. They are new forms, unexpected, surprising, and for that reason annoying. There is general opposition to these annoying forms, since they express a *new content of spirit*, the spirit of an age hostile to an accustomed and now facile tradition. Humanity is only very slowly adapted to changes in spiritual content.

Any given period with its decided physiognomy is no more than the sum of the complete works of the artists of the period. And it is only natural that every complete work of any artist of the time should reveal on its own account a decided physiognomy.

This physiognomy is an expression of a new world unknown till that time and discovered by the intuition of the artist.

In consequence it is evident that:

1. It is difficult, if not impossible, to judge a single work of any artist without knowing his complete work as much as possible, and that

2. When this knowledge has been obtained, it is necessary to consider whether it reveals a new world unknown before.

The value of the complete work depends on the diversity of the forms of expression (the richness of the content) and on the force (the accuracy) of this expression. At the same time, in spite of this diversity, each of the separate works of an artist of value is so distinct, and is bound up so closely with his complete work, that the origin of this separate work is evident, the artist's "handwriting" is recognized.

To my mind the *key to the value* of a "figurative" or "concrete" work is the force of expression in the diversity of the separate works and then in the complete work, that decided "physiognomy" of an artist who offers to humanity a world unknown before. This is the key which opens the doors of painting with an "object," or without one, alike. And it is this key which shows clearly that the difference between these two

kinds of painting has been exaggerated. An unknown world may be revealed with or without an object.

Yet on the other hand there is a decided difference between these two manners of expression or of revelation.

The object! It is common enough for the spectator who sees the object to imagine he sees the painting. He recognizes a horse, a vase, a violin, or a pipe, but may easily let the purely pictorial content escape him. On the other hand, if the object is veiled or made unrecognizable by the painter, the spectator clings to the title of the picture, since it alludes to the object. He is satisfied and thinks he is pleased with the painting itself. Sometimes the object deludes the mind. In such a case it is no longer a "bridge," but a wall between the painting and the spectator. To see the object and the painting together is a capacity which springs from innate feeling and from practice.

The capacity of seeing concrete painting is the same. I have often seen spectators who were very much interested in concrete art, though they "did not understand it" until at an unexpected moment their eyes were opened. It was fine to see the joy of their discovery.

I should like now to say a few words about my personal intention. For long years I have been occupied with concrete painting, and not without considerable effort, since it was necessary to replace the object by a purely pictorial form. I had to wait for the dictates of the "mysterious voice." It was favorable to me, because I loved painting too much to veil it in objects. Art forms are not found "on purpose," by willpower, and nothing is more dangerous in art than to arrive at a "manner of expression" by logical conclusions. My advice, then, is to mistrust logic in art. And perhaps elsewhere too!*

*For example, several new theories of physics have given proof of the insufficiency of "positive" methods. We are beginning to hear of the "symbolic character of physical matter." The world seems to be under the influence of "the action of incomprehensible ideal symbols," etc. As a nonscholar, in the quality of an artist, perhaps I may ask this question: are we on the eve of the breakdown of purely "positive" methods? Surely it has become necessary to complement them by unknown or forgotten methods with the aid of the "subconscious" and of the "feeling"—methods which have often been called "mystic." In my quality of irresponsible artist I will allow myself to make this statement: the walls between the different arts are continually disappearing— Synthesis—and the vast wall between art and science is tottering—the Great Synthesis. Then do not let us attempt to apply to questions of art methods which are beginning to lose their value in scientific questions.

Personally, I am happy to know that "scientific standards" of the value of art can never exist. Indeed, these standards would offer a new obstacle to the effort to "understand" art. Reason would replace feeling; and feeling, for the artist, is creative power, and for the spectator it is the necessary guide by which he can enter into a work of art. Reason, overestimated today, would destroy the only "unreasonable" domain left to our poor contemporary humanity.

It is exactly at this time that we can see many examples of "art" forced into becoming reasonable—humiliating examples indeed.

In the past I used often to say to my pupils: think as much as you like and as much as you can, it's an excellent habit—but never think in front of your easel.

I should like to give the same advice to people who vainly seek "standards of value": open your ears to music, your eyes to painting. And don't think! Examine yourselves, if you like, when you have *heard* and *seen*. Ask yourselves, if you like, whether the work of art has made you free of a world unknown to you before.

And if it has, what more do you want?

Letter to Irmgard Burchard
Peter Thoene, *Modern German Art*
(Harmondsworth), 1938

Modern German Art was, according to the cover advertisement, "the only work in English on the subject . . . a remarkable survey of 20th-century German art. . . . Its publication co-incides with the London opening of the famous Munich exhibition of 'degenerate' German art.[1] The author is a very well known German art critic who for special reasons must hide his identity under the name of PETER THOENE."

Peter Thoene was a pseudonym for the critic Peter Meril. In his book, Meril took a determined stand against the Nazis' disdain for the German artistic avant-garde, devoting a whole chapter to abstract and nonobjective tendencies, at the beginning of which he published the following fragment of one of Kandinsky's letters. His text concludes:

> In what age of darkness we must live . . . when art, the great protectress of the living, has to be protected; art, that creative force which expands the prison house of our being and allows a vision of eternity to be glimpsed beyond the brief span of our existence.
>
> But art, if it is to live, needs freedom. Its dreams, with their abundance of solace cannot flourish in the arid atmosphere of duress.

Abstract or non-figurative or non-objective art (which I myself most prefer to call concrete) differs from older forms of expression and from Surrealism today by reason of the fact that it does not set out from nature or from an object, but itself "invents" its forms of expression in very different ways. A subdivision of this general form is Constructivism, which operates with "exact," "strict," or, as is often said, "mathematical" forms and rejects "free" forms on principle. . . .

Abstract or Concrete?
["Abstract of Concreet?"]
Tentoonstelling abstracte kunst
(Amsterdam), 1938

Kandinsky had a disconcerting way of countering adverse criticism with a demolishing statement of fact. In this essay, published in the catalogue of the exhibition "Abstract Art" held in 1938 at the Stedelijk Museum, Amsterdam, he pointed to the works in the exhibition as evidence that abstract painting was indeed flourishing, that the expressive possibilities of such an art were not quickly exhausted—as if this art were some passing fad. At the same time, he revealed his way of judging if an artist's work was authentic: whether it creates a new world "that has never existed" before.

The roster of artists included well-known figures like Arp, Brancusi, Klee, Mondrian, Moore, and Léger, as well as lesser lights like Gorin, Kosnick-Kloss, and Vezelay. The other essays were written by H. Buys, Mondrian, Gorin, Georg Schmidt, and Siegfried Giedion.

So-called abstract painting is now more than twenty-five years old.

This fact in itself refutes a number of the "reproaches" that have been leveled against this painting, especially those that were made so heatedly, and from all sides, during its beginnings.

I will discuss only the most important reproach here. It has been asserted (and frequently still is today) that the expressive means of abstract art are so limited and so quickly exhausted, that this art has pronounced its own death sentence. Abstract painting has, accordingly, repeatedly been consigned to the grave.

A lack of expressive possibilities? That would be serious indeed! I can omit, in this context, the theoretical refutation of this assertion. Why theorize while we have this exhibition in the Amsterdam Municipal Museum before our eyes?

This exhibition speaks not with words, but with deeds, and proves that time and again, after every one of its "burials," abstract form has grown in power, in expressive means, and in boundless possibilities.

Expressive potential!

What is it that art in general, and painting in particular, can and ought to express?

A complicated question, to which the answer is simple. In every truly new work of art a new *world* is created that has never existed. Thus, every true work of art is a new discovery; next to the already known worlds, a new, previously unknown one is uncovered. Therefore, every genuine work says, "Here I am!"

The question ought to be posed at the time as to *how* (a formal question!), in comparison with an abstract work, a realistic, a naturalistic, a cubistic, a surrealistic work (add, if you will, the remaining "isms") comes into being.

In every more or less naturalistic work a portion of the already existing world is taken (man, animal, flower, guitar, pipe . . .) and is transformed under the yoke of the various means of expression in the artistic sense. A linear and painterly "reformulation" of the "subject."

Abstract art renounces subjects and their reformulation. It creates forms in order to express itself.

How this takes place is a complicated question. I can say only one thing: To my mind this creative path must be a synthetic one. That is to say, feeling ("intuition") and thought ("calculation") work under mutual "supervision." This can happen in various ways. As for me, I prefer not to "think" while working. It is not entirely unknown that I once did some work on the theory of art. But: woe to the artist whose reason interferes with his "inner dictates" while he is working.

Thus, next to the "real" world abstract art puts a new world that in its externals has nothing to do with "reality." Internally, however, it is subject to the general laws of the "cosmic world."

Thus, a new "world of art" is placed next to the "world of nature" . . . , a world that is just as real, a concrete one. Personally, then, I prefer to term so-called "abstract" art *concrete art.*

Paris, February 1938

Statement in *Journal des Poètes*
Cahier du Journal des Poètes: mensuel de création et d'information poètiques **(Brussels), 1938**

The periodical *Journal des Poètes* was published in Brussels from April 1931 until December 1935; from 1936 it was supplanted by the *Cahiers du Journal des Poètes.*

During the early years of his career, Kandinsky had envisaged an art emancipated from subservience to literature and to objects. He realized this dream prior to 1913, and at the same time wrote poetry *(Sounds)* in keeping with his new vision. In this short statement on the poetic spirit, he apostrophized the universal language of the soul, a language that transcends the confines of the individual arts.

Original not located.[1]

The poetic spirit! Poetry!

Each true painting is poetry.

For poetry is not made solely by use of words, but also by colors, organized and composed; consequently, painting is a pictorial poetic creation.

It possesses its own means of being "pure poetry." It is so-called "abstract" painting that "talks" (or "recites") through its exclusively pictorial forms—an advantage it has over the poetry of words. The source of both languages is the same; they share the same root: intuition—soul.

Seen in this light, there is no difference at all between Painting—Poetry—Music—Dance—Architecture.

All art.

Stabilité Animée
M. Bill, ed.,
Essays über Kunst und Künstler
(Bern-Bümpliz), 1963

Apart from the three short essays in the Sturm album of 1913 (see pp.383–91), the following is Kandinsky's only published text devoted solely to describing a single specific picture. It was written at the request of Max Bill, who had intended to publish descriptions and reproductions of paintings by Kandinsky, Mondrian, and Vantongerloo in the Zürich periodical *Werk* in 1938. Kandinsky's text, however, was not used, and was first published by Bill in 1955.

Short supplementary analysis

Stiff, schematic structure: two stressed verticals. At the upper right a circle—a form that is simultaneously hard and soft, stiff and loose, displaying concentric and eccentric tensions. In this case, the concentric tension is emphasized by the deep-violet color of the circle, and the neighboring area of green. This somewhat poisonous green intensifies the depth of the violet, and with it the concentric element.

The combination of these two colors and the combination of rounded and angular [forms] create at this point the strongest *accent* in the picture.

"Distortion" is used sparingly: a few crookedly placed rectangular and oval forms. Below them, the large red rectangle at the lower left.

The combination of white, black, and red within the red rectangle creates the second *accent*, to which the "crooked" position of the rectangle contributes most.

These two accents manifest an invisible *tension* between them (see the dotted line in the sketch). This main tension goes in a diagonal direction, loosening the larger and smaller horizontal-vertical tensions.

The three long rectangular forms (from left to right: white, black, and green), being lesser contrasts, are given for the most part thin horizontal lines with very few diagonals. In this way, a number of gentler tensions are created.

A few "independent" forms and finally the lower acute angle intensify this "loosening," "enrich" the stiff structure, and accelerate its "pulse."

In this way what is hard and stable becomes "animated."

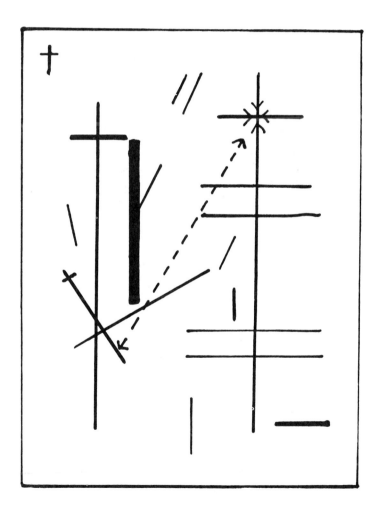

1939

Three Poems
["Salongespräch"; "Testimonium
Paupertatis"; "Weiss-Horn";]
Plastique
(Paris, New York), 1939

These three poems appeared in the fourth number of
the journal *Plastique*, founded and edited by the artist Sophie
Taeuber-Arp. *Plastique* described itself as an "international
review, dedicated to plastic and literary works of avant-garde
art," with texts printed in English, French, and German.
After the death of its editor in 1943, Kandinsky wrote a
sensitive appreciation of her work, under the title "Les reliefs
colorés de Sophie Taeuber-Arp" (see pp. 845–46).

SALON TALK

— "I know a man who makes above into below".

— "Thou, my faithful fellow man, tell me once and (perhaps) for all the real truth: dost thou know him too"?

— "I know another man—a second man, that is—who never starts stopping"?

— "Tell me, thou true fellow man, does this mean too, that this second man never stops starting"?

— "I know another man—a third man, that is—who keeps silent with such a noise that one can't hear him speak".

— "Profound fellow man, which do you prefer, noisy silence or inaudible talk"?

My faithful, truthful fellow man, who had left all my questions unanswered, looked me honestly in the eyes and asked me, in his faithful, truthful, profound voice:

— "Thou, my deceitful, cunning, shallow fellow man, which do YOU prefer, black white or white black"?
We both smiled.
In some embarrassment.

Paris, June 1937

TESTIMONIUM PAUPERTATIS

Pleasant sounds.
Long silence.
Where art Thou,
Fused Chain?

So far you were in many pits.
Where did you lead, long thin thread?

Come from you,
Fused chain,
Long thin thread,
Pleasant sounds?

Pleasant sounds?
Perhaps not.
But long silence.

Paris, March 1937

CANDOCEROS

A circle is always something.

Sometimes, indeed, a great deal.

Sometimes — rarely — too much.

Just as a rhinoceros is sometimes too much.

Sometimes it sits in com — pact violet — the circle. The circle the white.
And becomes, of necessity, smaller. Still smaller.

The rhinoceros bends its head, Its horn. Threatens.

The com — pact violet looks cross.
The white circle has grown small — a little point an ant's eye.
And shimmers.

But not for long. It grows again — the little point (ant's eye).
It grows in growing.
In growing the little point grows (ant's eye).
Into a white circle.

It is convulsed once — just once.

Everything white.

Where has the com — pact violet gone?

And the ant?
And the rhinoceros?

Paris, May 1937

1939

Abstract and Concrete Art
London Bulletin
(London), 1939

The following statement appeared in the *London Bulletin* (formerly the *London Gallery Bulletin*) in May 1939. It had been written as the preface to the catalogue of the exhibition "Abstract and Concrete Art" shown by the Guggenheim Jeune Gallery, 30 Cork St., London W1, from 10–27 May. The *London Bulletin*, which served as a forum for the various Cork Street galleries, published the catalogue in its entirety, by way of an advertisement.[1] The catalogue lists four works by Kandinsky (nos. 28–31);[2] other contributors to this important show included Arp, Baumeister, Calder, van Doesburg, Freundlich, Gabo, Barbara Hepworth, Mondrian, Nicholson, Schwitters, Sophie Taeuber-Arp, Paule Vezelay, Edward Wadsworth, Alberto Magnelli, and Georges Vantongerloo.

Even at this comparatively late date, the English evidently regarded Kandinsky with some suspicion. An editorial note, published at the end of this issue of the magazine, insists: "The editors of the *London Bulletin* accept no responsibility for the ideas expressed in the article by Mr. Kandinsky printed on p. 2 of this number."

PREFACE

I once wrote, "Just as there has already existed for a long time, music with words (generally speaking), song and opera, and music without words, purely symphonic music, or 'pure' music, there has likewise existed for twenty-five years painting with and without objects."

In my opinion, too much importance has been given to the question of form. And I added: "In principle, the question of form does not exist." (See my article "On the Question of Form," *The Blaue Reiter* [*Almanac*], Munich, 1912.)

No, don't think that "abstract" painting (which I prefer to call "concrete") is "painted music." Each art has its own means of expression (form), and an exact "translation" of one art to another is impossible. Fortunately.

I only want to make it understood that the *manner* of listening to a "pure" musical work is identical to that of seeing a work of "concrete" painting.

The musical composition without words presents a *purely* musical world—without a literary narrative. This narrative (the object) is also lacking in a work of "concrete" painting—it presents a *purely* pictorial world.

To enable this first world to enter one's "interior," one has only to open one's ears. For the second, one opens one's eyes. The entrance must be kept strictly free, and there must never be "philosophical" barriers imposed between the work and one's interior. In a word: one must be "naive."

You recall who said, "be simple as little children"?

Paris, April 1939

1942

Every Spiritual Epoch
M. Bill, ed., *10 Origin,*
(Zürich), 1942

In 1942, the publishing house Allianz-Verlag in Zürich brought out a portfolio, edited by Max Bill, under the title *10 Origin.* It contained ten original prints by Arp, Bill, Sonia Delaunay, Domela, Kandinsky, Leo Leuppi, Richard Paul Lohse, Magnelli, Sophie Taeuber-Arp, and Vantongerloo. The firm's prospectus advertised the publication in the following words: "These 10 sheets, printed from the original plates under the artists' supervision, represent the most important tendencies in concrete art, from its actual founder, Kandinsky, to the representatives of strict Constructivism. Their limited selection offers a conspectus of the present state of concrete art in Europe."[1]

According to Bill, some of the works had been printed secretly in Paris and in the South of France, and smuggled into Switzerland.[2] Short texts by Kandinsky, Arp, Bill, and Magnelli served as an introduction. Kandinsky's text, which begins with the words "Every spiritual epoch . . .", is his penultimate published theoretical statement.[3]

Every spiritual epoch expresses its particular content in a form that corresponds exactly to that content. In this way, every epoch assumes its true "physiognomy", full of expressive power, and thus "yesterday" is transformed into "today" in every spiritual realm. But apart from this, art possesses another capacity, unique to itself, that of sensing "tomorrow" in "today"—a creative and prophetic force.

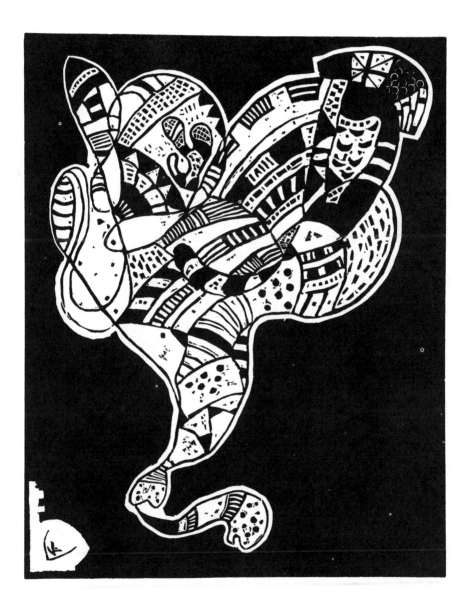

1943

Domela
Domela, six réproductions en couleurs d'après quelques oeuvres récentes (Paris), 1943

Kandinsky's last published statement was the preface for an album of six color reproductions of works by his friend, the painter César Domela. The album was published by the Galerie Jeanne Bucher in Paris, which had also staged several Kandinsky exhibitions during the thirties and early forties.

Original not located;[1] a facsimile of Kandinsky's handwritten text has been published in Michel Seuphor, *L'art abstrait, ses origines, ses premiers maîtres* (Paris) 1949, p. 182ff.

A river does not allow itself to be stopped, even by lock-gates or dams. Checked for a moment, it leaps over and resumes its course. To eliminate it for good one would have to destroy its "source" completely, which is beyond human power.

It would be even less possible to check the course of art phenomena. Their "source" lies in the very depths of the world of the spirit. Their evolution is organic, logical, inevitable, and wholly necessary to mankind. Their origin is lost in the darkness of the past, their outcome in the darkness of the future.

Any attempt to regulate their flow, to select from among their manifestations, is a puerile endeavor.

This obvious reality does not, however, give food for thought to those who claim to direct art and who, rather simple-mindedly, come running at the beginning of each new period to stir up clamors of indignation, outbursts of denial and hatred. But as soon as the "new period" starts to recede into the past, one always finds out that it was the normal, positive, and beneficial result of an endless evolution.

The age in which we are living had its first impetus in Impressionism and especially in the works of Cézanne. All the obstacles, all the dams, only add to the force of that impetus. And nothing shall curb its progress.

The Colored Reliefs of Sophie Taeuber-Arp
["Les reliefs colorés de Sophie Taeuber-Arp"]
G. Schmidt, ed., *Sophie Taeuber-Arp*
(Basel), 1948

Kandinsky was deeply affected by the death of the artist Sophie Taeuber-Arp in January 1943 (see also pp. 836–39). The following tribute remained unpublished during his lifetime; written in June 1943, it is almost certainly the last text from his hand, and for this reason alone deserves a place in this edition.

Sophie Taeuber-Arp expressed herself by means of the "colored relief," especially in the last years of her life, using almost exclusively the simplest forms, geometrical forms. These forms, through their sobriety, their silence, their self-sufficiency, invite the skillful hand to make use of its own particular language, which is often only a whisper; but frequently, the whisper is more expressive, more convincing, more persuasive than the "loud voice" that here and there gives way to sudden uproars.

To possess full command of "silent" forms, one must be endowed with a refined sense of restraint, and know how to choose the forms themselves according to the relationship between their three dimensions, according to their proportions, height, depth, combinations, their way of uniting into a whole—in a word, one must have a sense of composition.

All these requirements complicate the task, even if it is a question of monochrome sculpture (sculpture in stone, for example). To the beauty of the masses in the "colored reliefs" of Sophie Taeuber-Arp is added the mysterious and moving power of color, which at one moment accentuates the voice of the simple form, at another moment lowers its tone;

this brings out the hardness of one form while it adds softness to another; it emphasizes one projection, and indescribably attenuates another. And so on to infinity. A ringing of voices, a fugue.

The arsenal of expressive means is inexhaustibly rich. The greatest contrasts are: "In a loud voice," "In a low voice." To the thunderous clatter of the timpani and the trumpets in a Wagner overture, a tranquil "monotonous" fugue by Bach is opposed.

Here, thunder and lightning rend the sky, shaking the earth; there, a vast, smooth gray sky, the wind subsided to remote parts, the smallest bare twig still, the weather neither hot nor cold.

Peaceful language.

Sophie Taeuber-Arp unerringly, "fearlessly and blamelessly" approached her goal.

Paris, June 1943

Appendix

Kandinsky's Drawing and Painting School

Kandinsky placed the following advertisement in the Munich press around the beginning of 1902 in connection with his newly established school in Schwabing, the artists' quarter of Munich.

PAINTING AND DRAWING SCHOOL
W. KANDINSKY
MUNICH, HOHENZOLLERNSTRASSE 6 RGB

Ladies and gentlemen of all ages accepted. Admission and withdrawal on the 1st and 15th of each month. No enrollment for periods of less than one month.

The fees are as follows

Full time **with** evening classes in life drawing M. 30.-

Full time **without** evening classes in life drawing M. 25.-

Mornings or afternoons **with** evening classes in life
drawing .. M. 20.-

Mornings or afternoons **without** evening classes in life
drawing .. M. 15.-

Evening classes in life drawing M. 10.-

Minimum 14 days' notice of withdrawal.
Hours of instruction are:

from 9–12 (head and shoulders)

from 2–4 (life drawing)

from 5–7 (evening classes in life drawing).

Sketching every Saturday from 7–8.
In addition, still-life once a week.

Advertisement for
Der Blaue Reiter

The following advertisement for the *Blaue Reiter Almanac* appeared at the rear of the first edition of Kandinsky's *On the Spiritual in Art,* published in December 1911.

In spring 1912, R. Piper & Co., Munich, will publish:

"DER BLAUE REITER"

Contributors to the publication, which will appear as an occasional series, will be mainly artists (painters, musicians, sculptors, poets).

From the **contents** of the first volume:

Roger **Allard**	The New Painting
August **Macke**	Masks
M. **Pechstein**	The "Neue Sezession"
Franz **Marc**	The German "Fauves"
" "	Spiritual Treasures
D. **Burliuk**	The Russian "Fauves"
N. **Briusov**	Musicology
Th. **v. Hartmann**	"Anarchy" in Music
Arnold **Schoenberg**	The Question of Style
Kandinsky	"Yellow Sound" (a stage composition)
	Construction in Painting
	etc.

Circa 100 Reproductions:

Bavarian, French, Russian folk art; primitive, Roman, Gothic art; Egyptian shadow figures, children's art, etc. XXth century art: V. Burliuk, Cézanne, Delaunay, Gauguin, Le Fauconnier, Girieud, Jawlensky, Kubin, Kandinsky, Marc, Matisse, Münter, Picasso, Pechstein, Schoenberg, van Gogh, Werefkin, Wieber, etc.

Musical supplement: Lieder by Alban Berg, Anton v. Webern.

It can be seen even from this list of contents that this publication will be a focus for strivings that today are so conspicuous in all realms of art, whose underlying tendency is: to extend the former limits of the power of artistic expression.

The volume will cost approx. 10 Marks

Editors: **Kandinsky, Franz Marc.**

Color Questionnaire, 1923

The following questionnaire was distributed by the work-shop for mural painting to all students at the Bauhaus.[1]

Specialization (Profession):
Sex:
Nationality:

For test purposes, the workshop for mural painting at the Weimar Bauhaus requests you to complete the following exercises:

1. Fill in these three forms in the three colors yellow, red, and blue. In each case, the color should fill the whole form.

2. Give, if possible, an explanation of your distribution of colors.

Explanation:

Analysis of the Primary Elements in Painting
["Analyse des éléments premiers de la peinture"]
Cahiers de Belgique
(Brussels), 1928

The following text consists largely of a paraphrase of passages from Kandinsky's treatise *Point and Line to Plane* (see pp. 524–700). It is reprinted here without its accompanying illustrations, which were also taken from *Point and Line to Plane.*

It is impossible for me to undertake in a short essay a detailed study of such a large subject. The ideas I am summing up here are bound to have a schematic character. This schema is nothing other than a root from which the various ideological developments are necessarily excluded.

In the present "chaotic" state of our epoch, we can distinguish different manifestations of order in various realms; in art in general, and in painting in particular.

This order manifests itself especially in painting by renewed attempts to build *afresh* a pictorial theory, by starting with principles so as finally to reach a "treatise of composition."

It is true that the penchant for theory seems to many people to be very uncertain, if not dangerous and even baneful. Not only historians, but artists themselves recoil before reflection, before "cerebration," fearing to injure pure "invention," a danger that would have as a natural consequence the end of all art.

On the other hand, some artists are so convinced of the importance of the theoretical approach that they come to the point of denying the intuitive phase.

Here again, the abnormal state of modern thought has destroyed the balance between the two phases: intuition and reflection.

One can admit in all certainty that the great artistic periods posessed fully developed art theories, a few scanty remnants of which can still be discovered today. The "academic" period prior to Impressionism undoubtedly possessed rare fragments of a treatise on composition passed on by the past, but the use made of it was totally mechanical, which could no longer result in really living plastic organisms.

It is more or less unconsciously that the first stone of Impressionist theory, still young nowadays, was laid down. The principle was developed by the Neo-Impressionists (Signac published the first theoretical book on the matter), and the evolution proceeded through Expressionism, Cubism, and other "isms."

Abstract painting was going to be called upon to give to those first theories a very clear basis and a particularly clear-cut method of creation and realization.

It is by giving attention to the objective character of pictorial processes that theory led to this indispensable clarity of fundamentals and theory itself. Even today, one is entitled to assume that pictorial theory has set foot on a scientific path in order to lead without doubt to precise instruction.

Theory will have to:

1. Establish a well-ordered vocabulary of all the words that are now scattered and out of orbit.
2. Found a grammar that will contain rules of construction.

Plastic elements will be recognized and defined in the same way as words in language.

As in grammar, laws of construction will be established. In painting, the treatise on composition corresponds to grammar.

Abstract painting seeks, then, to arrange those elements in groups, as for example:

1. To specify the primary elements and designate the more diverse and complicated that issue from them—the analytical part,
2. The possible laws for the grouping of those elements within a work—the synthetic part.

The primary element of linear form is the *point*, which is indivisible. *All* lines organically issue from that point:

A. Lines
 I. Straight lines:
 a) horizontal;
 b) vertical;
 c) diagonal;
 d) straight.
 II. Angular or crooked lines:
 a) geometrical;
 b) free—in horizontal, vertical directions, etc.
 III. Curved lines:
 a) geometrical;
 b) free—in the same directions as in case II.
B. Surfaces:
 1. Triangle;
 2. Square;
 3. Circle;
 4. Freer forms of the three fundamental ones;
 5. Free surfaces, which no longer emanate from geometry.

I insist on the totally relative character of the expression *drawing*,* which I have used in connection with these forms: linear form is, in the *last analysis*, plastic, since the "outline" and the "color" are, in painting, equal elements. Theoretically, these two types [of form] must be distinguished one from another.

The linear and the plastic elements have a permanent, organic connection between them.

The connection can be recognized in those tensions that are nothing other than the inner forces of the elements.

These inner forces, which I call *tensions*, are exclusively active, both in theory and in practice.

In an element as isolated as possible, the tension must be looked upon as absolute.

*I cannot here systematize more precisely.

In the joining of two or more elements, absolute tensions subsist, but they acquire thereby a relative value.

These relative values belong to the only means of expression of the composition, that is to say, they are useful to the subject as a unique means and lead it to expression.

I can give here only a few examples of the organic connections between painted form and linear form, without establishing the reasons for it.*

Angle	∠	∟	╲
Surface	△	□	○
Color	yellow	red	blue

I explicitly point out that these relationships, unalterable in principle, must be considered only theoretically.

In practice, plastic forms and linear forms can be combined differently in every possible way, but this leads to important consequences.

In theory, the triangle is always yellow. In practice, the association gives:

1 (the absolute value of the triangle) + 1 (the absolute value of the color yellow) = 2

A blue triangle will give:

1 (the triangle) + 1 (the color yellow) + 1 (the additional value of the "inharmonious") = 3

The first combination is, so to speak, intimately tinged with "lyricism" and the second with "drama." Both are possible in practice, but since the results are different, they must be used deliberately, according to the nature of the painting.

The painting is nothing but the sum total of organized tensions. Viewing it in this light, one discovers the original identity of the law of composition in the different arts, since the arts can materialize their subject only by means of organized tensions.

*The reader will be able to find in my book *Point and Line to Plane* more reasoned developments (Verlag Albert Langen, Munich, 2d ed.)

It is here that one discovers both the solution and the loss of the future "synthetic" work.

Viewing it in this light, one discovers the deep and intimate correspondence between art and nature: like art, nature also "works" by its own means (the primary element in nature is also the point), and even today one can admit with certainty that the deep root of the laws of composition is identical for both art and nature.

The connection between art and nature (or "the object," as one says today), does not lie in the fact that painting will never be able to avoid the representation of nature or the object. But both "realms" carry out their works according to a similar or identical mode, and both works, which burst open simultaneously and live independently, must be considered as such.

Dessau, March 1928

Kandinsky's Courses
"Unterricht Kandinsky" in the Prospectus of the Bauhaus for 1929

On Kandinsky's analytical drawing course, see also pp. 726–29.

in the 1st term:

a. abstract elements of form.
introduction: transition to the new basis of 1. unity, 2. inner evaluation (from "either-or" to "and", the affinity, sometimes identity between different realms—whether "spiritual" or "material"—the common root of unity.

analysis of formal elements, color, form (in the narrower sense), surface (planar art).

"material" and "abstract" resources of painting and other arts.

inner evaluation in terms of tensions, and system behind it—relationships between individual parts.

synthesis of past epochs and the basis of future. students' exercises, independent work, communal discussions.

b. analytical drawing.

precise drawing from still-lifes constructed by the students. objects as energy-bearing constructs (entities). connections between tensions and structure based on them (constructive grid).

two kinds of work: 1. utmost economy, 2. precise, exhaustive execution.

both courses, erected on the same basis, have as their main aim: to enable the student to feel, think, and draw both analytically and synthetically at the same time by educating the eye (sharp focus and inner freedom).

in the 4th term:

creation of artistic form (lectures and seminar):

lectures: primary elements as the basis of architecture, painting, and other arts (past and present); employment of the tensions belonging to these elements as "language"; form and purpose of construction; form and structure in art and technology (intended and "accidental" "expression"); psychological needs and the consideration of same, etc..

seminar: students work their way through the basic subject matter independently. communal discussions and criticism: examples: form and content in art and technology, forms determined by purpose (external, internal functions), Gothic cathedral and modern factory, abstract and representational art, "life" and life, etc.

optional painting class:

students' independent work, communal discussions, exercises in form and color—constructive tensions as resources for composition. joint analyses of works of ancient and contemporary painting (purpose and structure, etc.). technical exercises.

Extract from a Letter
From the Catalogue of the Exhibition
"Erich Mendelsohn—Wassily Kandinsky—
Arno Breker,"
Saarbrücken), 1931 [?]

The following is an extract from a letter by Kandinsky, printed in the catalogue of a three-man exhibition apparently held at the Staatliches Museum, Saarbrücken, beginning on 5 June 1931. The present Saarlandmuseum no longer possesses this catalogue, and it has proved impossible to locate a copy of the original, or to verify the dates of the exhibition.[1]

. . . in recent years I have become interested in, among other things, one particular characteristic of black and white—its coloristic variety. One hardly ever comes across what is actually pure black and white; one can, on the other hand, do a great deal to increase its colorfulness. Recently I have also done oil paintings consisting only of black and white, which are, nonetheless, capable of developing extreme intensity of color. How strange that people for so long regarded these colors, extraordinarily rich in content, as "noncolors"—one consequence of external naturalism.

Note on the Translations

All the translations in this volume are by Peter Vergo, except for the following: "Little Articles on Big Questions," translated by Peter Vergo and John E. Bowlt; "Critique of Critics," "Whither the 'New' Art?" "Letter to the Editor," "Program for the Institute of Artistic Culture," and "On Reform of Art Schools," translated by John E. Bowlt; "Empty Canvas, etc.," translated by Christine Lindsay; "Analysis of the Primary Elements of Painting," "Reflections on Abstract Art," "Art Today," "Franz Marc," "Concrete Art," "My Woodcuts," Statement in *Journal des Poètes*, "Abstract and Concrete Art," "Domela," "The Colored Reliefs of Sophie Taeuber-Arp," "Interview with Charles-André Julien," and "Reply to a Questionnaire," translated by Karen Pohlmann; Reply to *Gaceta de Arte*, translated by John Incledon; "Baumeister," translated by Gustave Pellon; "On the Artist," "Art without Subject," Foreword to the Catalogue of the Kandinsky Exhibition at Gummesons, "Two Directions," and "Assimilation of Art," translated by Ann-Kristin Sterud; "Abstract or Concrete?," translated by James Marrow. Letters to Arthur Jerome Eddy, "Line and Fish," "The Value of a Concrete Work," and Letter to Irmgard Burchard were originally published in English.

In order to ensure a uniformity of style, the editors have reserved the right to revise or amend translations where necessary.

Abbreviations

Certain references contained in the footnotes are given in abbreviated form. The full bibliographic references are as follows:

R
: Kandinsky, V. V. "O dukhovnom v iskusstve." *Trudy vserossiiskago s'ezda khudozhnikov, Dekabr' 1911 – Ianvar' 1912.* Vol. 1, Petrograd: Golike and Vilberg, 1914, pp. 47–75.

S
: "Stupeni." *V. V. Kandinsky, Tekst Khudozhnika.* Moscow: IZO NKP, 1918, pp. 9–56.

Grohmann, 1958
: Grohmann, Will. *Wassily Kandinsky, Leben und Werk.* Cologne: M. DuMont Schauberg, 1958.

Lankheit, 1974
: *The Blaue Reiter Almanac.* Edited by Wassily Kandinsky and Franz Marc. Documentary ed. by Klaus Lankheit. New York: Viking Press, 1974.

Macke-Marc: Briefwechsel
: *August Macke – Franz Marc: Briefwechsel. Mit einem Vorwort von Wolfgang Macke.* Cologne: M. DuMont Schauberg, 1964.

Roethel, 1970
: Roethel, Hans Konrad. *Kandinsky, Das Graphische Werk.* Cologne: M. DuMont Schauberg, 1970.

Roethel/Hahl, 1980
: *Kandinsky. Die Gesammelten Schriften, Band I. Herausgegeben von Hans K. Roethel und Jelena Hahl-Koch.* Bern: Benteli Verlag, 1980.

Rudenstine, 1976
: *The Guggenheim Museum Collection: Paintings, 1880–1945.* Catalogue in 2 vol., by Angelica Zander Rudenstine. New York: The Solomon R. Guggenheim Museum, 1976.

Wingler, 1968
: Wingler, Hans M. *Das Bauhaus.* 2d rev. ed. Bramsche: Gebr. Rasch, 1968.

Bouillon, 1974
: Kandinsky, Wassily. *Regards sur le passé et autres textes, 1912–1922. Edition établie et présentée par Jean-Paul Bouillon.* Paris: Hermann, 1974.

Editors' Notes

Preface and Acknowledgments

1. Many of the texts presented here have never been previously translated into English. A good number have not been republished in any language since their original appearance. Some texts were located only with extreme difficulty; a few, though thought to exist, could not be located at all. Some references printed and reprinted in modern bibliographies of Kandinsky's writings appear, however, to rest on a confusion (see, for example, p. 419, n. 1 to "Art without 'Subject'" regarding "Answer to Critics" in *Konst).*
2. For translation credits see p. 859
3. Neither editor has been able to locate the original of a statement entitled "Ueber die abstrakte Malerei" Kandinsky is known to have published in the catalog of an exhibition held by the Frankfurter Kunstverein in 1928 (see Grohmann, 1958, p. 416). This catalog does not appear to have been preserved in any German library or archive; and though many friends and colleagues have aided us in our search, it has proved unsuccessful. This item is, however, included in the Bibliography of Kandinsky's Writings for the sake of completeness.

Notes

Introduction

1. *The Blaue Reiter Almanac,* ed. Klaus Lankheit (New York: Viking Press, 1974), p. 18. (Henceforth, Lankheit, 1974).
2. "Die weisse Wolke, der schwarze Wald/Ich wart' auf dich. O, komm' doch bald. / So weit ich sehe, so weit nach vorn, / Das glänzend, gold'ne, reife Korn. / Du kommst ja nicht. O, welcher Schmerz! / Es zittert und blutet mein armes Herz. / Ich wart' auf dich. O komm' doch bald! / Ich bin allein im schwarzen Wald" [The white cloud, the dark wood / I wait for you. Oh come then soon. / As far as I see, so far away then / The radiant, golden, ripening grain. / You do not come. Oh, what pain; / My poor heart trembles and bleeds. / I wait for you. Oh, come then soon. / I am alone in the dark wood]. From a letter from Kandinsky to Münter, 9 February 1903. Unless otherwise noted, all quotations from Kandinsky's letters in this introduction come from copies given to us by their recipients. The role Münter played in Kandinsky's life and the development of her own artistry have been generally overlooked during the past twenty years. Fortunately this situation is beginning to change. See in particular Sara Helen Gregg, *The Art of Gabriele Münter: An Evaluation of Content,* Masters Thesis (State University of New York at Binghamton, 1980); and Anne Mochon, *Gabriele Münter: Between Munich & Murnau,* exhibition catalogue (Busch-Reisinger Museum, Harvard University, and Princeton University Art Museum, 1980).
3. Cf. Jean Arp, "Kandinsky the Poet," in *Arp on Arp,* ed. Marcel Jean (New York: Viking Press, 1972), pp. 282ff.
4. To give the reader an idea of their substance and the disposition of Kandinsky's thinking, John Bowlt has prepared the following summary of their contents for this publication: "The first article is entitled 'On the Punishments Given in Accordance with the Regional Courts of Moscow Province.'

 "In this essay Kandinsky presents a factual description of various punishments for criminals (major and minor) meted out in the above area. He gives particular space to corporal punishment, defining three categories when this is applied: (a) insulting behavior by word or deed toward authorities; (b) insulting behavior toward one's parents; (c) insulting behavior toward strangers. He discusses the variants in whipping that he encoun-

862

tered at various courts. Although Kandinsky gives us to understand—by certain allusions—that he is against corporal punishment, he does not examine the 'theory' behind such a form of punishment and does not investigate its potential as a deterrent. Kandinsky is especially concerned with the fate and suffering of women in this context; it is evident from the tone of the passage that he was against the domestic oppression of women. Toward the end of the article, Kandinsky seeks to explain the causes of crime—in a very general way—seeing the principal stimulus to crime in the economic structure of the existing society, i.e., in the total dependence of the peasantry (Kandinsky does not use this word). Kandinsky refers to the dire impoverishment of the peasants; he is shocked at the number of lashes they receive, but appreciates that a male peasant prefers to be whipped rather than arrested and imprisoned, since this would deprive him of work, for example, in local factories. Kandinsky mentions the appalling conditions of drunkenness among the peasantry. His final line reads: 'This pressure of economic conditions leaves a deep imprint on the system of punishments practiced by the Regional Courts.'

The second article is entitled 'From Material on the Ethnography of the Sysolsk and Vychegodsk Zyriane' and subtitled 'National Deities.'

"The article concerns the Syryenians, one of the nationalities or tribes of Greater Russia. It is written in a professional style and displays a serious anthropological approach to the subject—methodical, factual, objective. Kandinsky has been searching for relics of pagan traditions among the Syryenians, but has found very few indeed. He mentions that the Syryenians deify the sun and the wind, inasmuch as they personify them, but it is not possible to refer to a 'cult' of the sun, the wind, etc. In his searches Kandinsky interviewed certain old people, and he bases his findings on their information (what there was of it). Kandinsky discovered that the Syryenians have a very vague notion of 'life after death.' He has detected signs of the so-called *domovoi* [hobgoblin] or the goddess of rye [*pölöznicha*]. But in all cases, there is no accurate delineation of functions and forms. The article (like the first one) is footnoted and demonstrates Kandinsky's avid reading of sources. But there is very little indeed that relates to Kandinsky the artist or the thinker of later years."

5. Michel Seuphor, *L'Art Abstrait* (Paris: Maeght, 1949), pp. 183ff.
6. Paris: Éditions Denoël, 1970. The same organization is found in the Italian translation, *Tutti gli scritti* (Milan: Feltrinelli, 1974).
7. In his letter 5 September 1938 to Herbert Read, Kandinsky wrote: "Those were truly heroic days! My God, how difficult it was and yet how beautiful too! People thought then that I was 'crazy,' sometimes that I was 'a Russian anarchist who thinks that all is permitted,' adding, 'a very dangerous example for youth and for great culture in general,' etc., etc. In those days, I thought that I was the first and only artist to have the 'courage' to reject from painting not only the 'subject,' but even any 'object.' And I really believe that I was totally right—I was indeed the first. To be sure, the question of 'who was the first tailor' (as the Germans say) is not all that

important. But the 'historical fact' is not to be changed" (Herbert Read, *Kandinsky* [New York: Wittenborn, 1959], p. 3).

8. In a letter to Hilla Rebay (16 January 1937), he finally identified the museum as the People's Museum in Moscow; cf. exhibition catalogue, *In Memory of Wassily Kandinsky* (New York: The Museum of Non-objective Paintings, 15 March– 15 May 1945), p. 98. For new, but still ambiguous information on this question, see Hans K. Roethel and Jean K. Benjamin, "A New Light on Kandinsky's First Abstract Painting," *Burlington Magazine* 119, no. 896 (November 1977):772ff.

9. Kenneth Lindsay, review of *Kandinsky*, by Will Grohmann, *Art Bulletin* 41, no. 4 (December 1959):348– 50; and Peter Vergo, review of the Kandinsky exhibition, Munich, Haus der Kunst, *Burlington Magazine* 119, no. 887 (February 1977): 140ff. Lindsay's review suggested 1913 as the proper date even though the watercolor sheet is signed and dated 1910 by the artist. The question was stimulated originally by the work itself, whose style did not seem reasonable for 1910. Klaus Brisch noted the exceptional nature of the work in his dissertation "Wassily Kandinsky: Untersuchungen zur Entstehung der gegendstandslosen Malerei an seinem Werk von 1900– 1921" (University of Bonn, 1955), p. 255: "Das Aquarell kann nich mit einem Werk der Jahre vor 1910 in Verbindung gebracht werden; es ist darin eine Ausnahme" [The watercolor cannot be connected to any work of 1910; it is therein an exception]. It seemed curious that this watercolor and another called *With the Red Spot* (signed and dated 1911) should be the only items connected with the preparation of *Composition 7* (1913) that were signed and dated. Furthermore, these two watercolors were the only items related to *Composition 7* that Kandinsky received back from Gabriele Münter in 1926. They were entered in French on the first page of the House Catalogue of watercolors, a listing that began with German titles around 1919. In other words, they must have been entered after 1933, the year Kandinsky came to Paris and began using French titles. The two works, together with *En cercle* [With Circle] (1911), which is tucked in with French title on the third page of the House Catalogue, are signed "Kandinsky" and dated. All the rest of the known watercolors and drawings of 1913 (with one problematical exception) are undated, and when signed, simply done so with a "K" enclosed in a triangle. Consequently, Lindsay suggested that the *First Abstract Watercolor* and *With the Red Spot* were signed and incorrectly dated sometime after 1933. This misdating surely was done in good faith by the artist, who after being separated from a large portion of his own work for many years, had few works from the Munich period to which he could refer. To date no new documentary information has come up that would contradict this reasoning. On the basis of her own recollections however, Mme. Nina Kandinsky disagrees completely with the review article, and in all fairness, her point of view should have a forum. In her letter to Lindsay on 6 February 1960, she recounted how she and Kandinsky received several boxes from Munich in 1926, just after they had moved into the new house at Dessau designed by Gropius. She writes: "Upon opening a box, Kandinsky cried out, 'Look here, my first abstract watercolor; I am happy to get it back.' The

watercolor was signed and dated." She continues with an explanation of why a few of the early watercolors are known with French titles: when Jeanne Bucher exhibited twelve of his watercolors in 1939 (2–17 June, in Paris), Miss Bucher insisted upon titles for the early works. The watercolor in question was one of the twelve, and the title *Première Aquarelle Abstraite* that it then received has remained to this day.

If after thirty four years Mme. Kandinsky's memory of the Dessau unpacking is correct, then of course Lindsay is wrong. We would then change Lindsay's date of "c. 1934" for the entry into the House Catalogue to ca. 1939, accept 1910 as authentic, and consider the style as an exception. But if her memory is at fault, then arguments more compelling than Lindsay's would be required to salvage the inscribed dating.

10. Lindsay's interview with Münter, July 1958.
11. Letter to Grohmann, 10 December 1924. Peter Vergo, in his book *The Blue Rider* (London: Phaidon, 1977), p. 7, stresses the "Russianness of the [Blaue Reiter] Almanac in general." Hans Konrad Roethel, in *Kandinsky: Das graphische Werk* (Cologne: DuMont-Schauberg, 1970), p. 444, reports on the circumstances of the early drafts of *On the Spiritual in Art.*
12. Cf. *Ein Protest deutscher Künstler,* introd. Carl Vinnen (Jena: Eugen Diederichs, 1911); cf. also, *Die Antwort auf den "Protest deutscher Künstler"* (Munich: Piper, 1911).
13. Letter to J. B. Neumann, 6 September 1936: "Es zieht mich wenig an, zum dritten Mal eine Diktatur entstehen zu sehen. So bin ich innerlich bereit, wieder den Pilgerstab zu ergreifen. Gott, wenn es nur ein Stab wäre! Und Möbeln? Und besonders Bilder? Und ganz besonders Gelder, die zum Umzug und dem Aufenthalt im neuem Land erforderlich sind?" [I have little desire to see for the third time the emergence of a dictatorship. Thus I am prepared internally to seize again the pilgrim's staff. My God, if it were only a staff! What about furniture? And especially paintings? And above all money which one needs in order to move house and support oneself in a new land?].
14. Letter to Grohmann, 3 March 1931: "Amerika! Diese Tage erhielt ich ein Telegramm von der 'Art Students League' in New York, die mich für das nächste Wintersemester als Lehrer haben möchte. Ich musste leider absagen, da ich nicht englisch kann. Sonst würde ich die Gelegenheit ausnützen, mir mal Amerika in der Nähe anzusehen" [America! The other day I received a telegram from the Art Students League of New York which would like to have me as a teacher for the next winter semester. Unfortunately I had to decline because I don't understand English. Otherwise I would use the opportunity to inspect America at close quarters.] It is revealing to note that George Grosz accepted an invitation from the League the next year even though he did not know English. Grosz quietly acquired a fine idiomatic feel for the language by watching cowboy movies at Coney Island. The records of the Art Students League show that at the board meeting of 27 February 1931, Ruth Van Cleeve made the motion to invite Kandinsky to teach. He was to be offered the sum of $150 per month which was the top level on the salary scale.

15. James Johnson Sweeney, "Mondrian, the Dutch and De Stijl," *Art News* (Summer 1951), pp. 24–25, 63ff.
16. Cf. Grigori J. Sternin, *Das Kunstleben Russlands an der Jahrhundertwende,* trans. from the Russian by Manfred Denecke (Dresden: VEB Verlag der Kunst, 1976), p. 333. Kandinsky's work, entitled *Abend,* was shown during February 1900, at the Association of Moscow Artists. The painting was not listed in the House Catalogue, nor has the exhibition been previously noted.
17. Klaus Brisch, "Wassily Kandinsky, Untersuchungen zur Entstehung der gegendstandslosen Malerei" (Ph.D. diss., University of Bonn, 1955), p. 28.
18. Jonathan David Fineberg, "Kandinsky in Paris 1906–7" (Ph.D. diss., Harvard University, 1975).
19. Nina Kandinsky, *Kandinsky und ich,* with the help of Werner Krüger (Munich: Kindler, 1976), pp. 125, 188, 202.
20. Erwin Stein, ed., *Arnold Schoenberg Letters,* trans. Eithne Wilkins and Ernst Kaiser (New York: St. Martin's Press, 1965), pp. 88ff.; and the uncritical and damaging article by Harold C. Schonberg, "Schoenberg's Most Personal 'Moses'", *New York Times,* 11 December 1966, p-D15, cols. 1–4.
21. Nina Kandinsky, *Kandinsky und ich,* pp. 89ff. For confirmation, see Stein, p. 94, where Schoenberg asks Mme. Mahler, "Are you trying to cover up?"
22. A. Potebnia, *Iz lekcij po teorii slovesnosti* (Kharkov, 1894), p. 99; quoted in Victor Erlich, *Russian Formalism,* 2d ed. (The Hague: Mouton, 1965), p. 24.
23. For Kandinsky's relationship to Russian poets, see John E. Bowlt, "Symbolism and Modernity in Russia," *Artforum 16,* no. 3 (November 1977). 40–45.
24. Peg Weiss, *Kandinsky in Munich: The Formative Jugendstil Years* (Princeton, N.J.: Princeton University Press, 1979).
25. Daniel-Henry Kahnweiler, *The Rise of Cubism,* trans. Henry Aronson (New York: Wittenborn, Schultz, 1949), p. 22: "This tendency was not called forth by the artistic, but by the decorative urge. What the followers of this movement are creating is simply ornament."
26. Angelica Zander Rudenstine, *The Guggenheim Museum Collection,* vol. 1 (New York: Solomon R. Guggenheim Museum, 1976), pp. 273–77. (Henceforth, Rudenstine, 1976.)
27. Ibid. Cf. also Rose-Carol Washton, "Vassily Kandinsky, 1909–1913: Painting and Theory" (Ph.D. diss., Yale University, 1967), chap. 1.
28. Washton, *Vassily Kandinsky,* chap. 1.
29. Kenneth C. Lindsay, "The Genesis and Meaning of the Cover Design for the first *Blaue Reiter* Exhibition Catalogue," *Art Bulletin 35,* No. 1 (March 1953): 47–52; and "Les Thèmes de l'Inconscient," *XX^e Siècle* 27 (December 1966): 46–52.
30. Cf. Rose-Carol Washton Long, "Kandinsky and Abstraction: The Role of the Hidden Image," *Artforum 10,* no. 10 (June 1972): 42–49; also Sixten Ringbom, "Art in the 'Epoch of the Great Spiritual': Occult Elements in the Early Theory of Abstract Painting," *Journal of the Warburg and Courtauld Institutes* 29 (1966): 386–418.
31. *Publications of the Modern Language Association* 58, no. 4, pt. 1 (De-

cember 1943): 1125–77. Cf. also Klaus Lankheit, "Bibel-Illustrationen des Blauen Reiters," *Anzeigen des Germanischen Nationalmuseums: Ludwig Grote zum 70. Geburtstag*, (Nuremburg, 1963), pp. 199–207; Michael Hamburger, *Reason and Energy: Studies in German Literature* (New York: Grove Press, 1957), pp. 213–38; and Max Peter Maass, *Das Apokalyptische in der Modernen Kunst* (Munich: F. Bruckmann, 1965).

32. E.g., Andrei Bely, "Apokalipsis v russkoi poezii," *Vesy*, 2, no. 4 (Moscow, 1905): 11–28.

33. St. Augustine, for example, associated the Last Judgment with the Deluge in the *City of God* (bk. 20, 16). After quoting St. John—"And I saw a new heaven and a new earth; for the first heaven and the first earth have passed away; and there is no more sea" (Rev. 21: 1)—St. Augustine explains: "Then shall the figure of this world pass away in a conflagration of universal fire, as once before the world was flooded with a deluge of universal water. And by this universal conflagration the qualities of the corruptible elements which suited our corruptible bodies shall utterly perish, and our substance shall receive such qualities as shall, by a wonderful transmutation, harmonize with our immortal bodies."

34. "For when the judgment is finished, this heaven and earth shall cease to be, and there will be a new heaven and a new earth. For this world shall pass away by transmutation, not by absolute destruction" (Augustine, *City of God*, bk. 20, 14); "One day is with the Lord as a thousand years, and a thousand years as one day" (2 Pet.3:8, quoted by Augustine in bk. 20, 7).

35. "And there shall be to them month after month, and Sabbath after Sabbath, as it were said, Moon after moon, and rest upon rest, both of which they shall themselves be when they shall pass from *the old shadows of time into the new lights of eternity*" (Augustine, *City of God*, 20.22, italics added). We have used St. Augustine as exemplification, not as a specific and direct source. For the complexity of theological sources dealing with world destruction and their adaptability by artists, see Bo Lindberg, "The Fire Next Time," *Journal of the Warburg and Courtauld Institutes* 25 (1972), 187–99.

36. Erwin Panofsky, *Early Netherlandish Painting*, vol. 1 (New York: Icon Editions, 1971), p. 66.

37. Cf. Edgar de Bruyne, *Études d'Esthétique Médiévale*, vol. 3 (Brugge: De Tempel, 1946), pp. 3–29.

38. For Dante's use of light, see John Anthony Mazzeo, "Dante's Sun Symbolism," *Italica* (December 1956): 243–51.

39. Erwin Panofsky, "The History of Art as a Humanistic Discipline," *Meaning in the Visual Arts* (Garden City, N.Y.: Doubleday Anchor Books, 1955), p. 25.

40. José Ortega y Gasset, *Idées et Croyances*, trans. Jean Babelon (Paris: Éditions Stock, 1945), p. 129.

41. David Burliuk, quoted in Erlich, *Russian Formalism*, p. 44.

42. Erlich, *Russian Formalism*, p. 41.

43. For penetrating studies of this situation, see the writings of Alan Birnholz, Troels Andersen, and especially Jean-Paul Bouillon, "Le retour à l'ordre en

U.R.S.S. 1920–1923," *Université de Saint-Étienne: Travaux* 8 (Saint-Étienne: 1975), pp. 168–202.

44. Erlich, *Russian Formalism*, p. 106.

45. Cf. Dean Allen Porter, "Equus Caballus as a Major Motif in Modern European Art" (Master's thesis, State University of New York at Binghamton, 1966), pp. 82ff.; for the *Death Rider*, see Katherine S. Dreier, *Burliuk* (New York: Société Anonyme, 1944), p. 75; for Carrà, J. T. Soby and A. H. Barr, Jr., *Twentieth Century Italian Art* (New York: Museum of Modern Art, 1949), illus. 38, *The Cavalier of the West* (1917), Coll. Adriano Pallini, Milan.

46. Troels Andersen, "Some Unpublished Letters by Kandinsky," *Artes* (Copenhagen) 2 (1966): 107.

47. Will Grohmann, *Wassily Kandinsky* (New York: Abrams, 1958), p. 161.

48. Ibid., p. 172.

49. Nina Kandinsky, *Kandinsky und ich*, pp. 89ff.

50. As told to Lindsay, Paris, 1949.

51. As told to Lindsay, Paris, 1950.

52. Hugo Ball, *Flight Out of Time: A Dada Diary*, ed. John Elderfield (New York: Viking Press, 1974), p. 226. Ball's lecture was given 7 April 1917.

53. From Murayama's book, *Kanjinsukii*, ARS Bijutsu Sosho no. 4 (Tokyo: ARS Publishing Co., 1925). Kandinsky was pleased with Murayama's paintings and invited him to the Bauhaus, where he met Klee and Gropius. He returned to Japan in 1922 with four Kandinsky works and shortly thereafter turned to drama. Since then he has directed more than three hundred plays on the Japanese stage.

54. Marcel Franciscono, *Walter Gropius and the Creation of the Bauhaus in Weimar: The Ideals and Artistic Theories of Its Founding Years* (Urbana: University of Illinois Press, 1971), p. 98.

55. Ibid., chap. 3.

56. Ludwig Hilberseimer, "Berliner Ausstellungen," *Sozialistische Monatshefte*, 1 (1922): 699. Hilberseimer later joined the Bauhaus teaching staff, in 1929; cf. Hans M. Wingler, *The Bauhaus*, trans. Wolfgang Jabs and Basil Gilbert (Cambridge: MIT Press, 1969), p. 496.

57. E.g., Elizabeth Cropper, "Bound Theory and Blind Practice: Pietro Testa's Notes on Painting and the *Liceo della Pittura*," *Journal of the Warburg and Courtauld Institutes*, 34 (1971): 262–96.

58. *Bauhaus and Bauhaus People*, ed. Eckhard Neumann, trans. Eva Richter and Alba Lorman (New York: Van Nostrand Reinhold Co., 1970), pp. 39, 54, 154.

59. Cf. L. L. Schücking, *Die Soziologie der literarischen Geschmacks-Bildung* (1931), trans. E. W. Dickes as *The Sociology of Literary Taste* (London: Oxford University Press, 1945), pp. 57ff.; and Wolfgang Paulsen, *Expressionismus und Aktivismus* (Strasbourg: Heitz, 1934), p. 19.

Critique of Critics

1. This introductory note is by John E. Bowlt, who also provided headnotes for the following items: "Whither the 'New' Art?" (p. 96), "Little Articles on Big Questions" (p. 421), "Artistic Life in Russia" (p. 434), "Program for the Institute of Artistic Culture" (p. 455), and "On the Reform of Art Schools" (p. 488). On Kandinsky's ethnographic essays, see note to introduction, p. 862

2. "Nashi nyneshnie dekadenty," in E. Stasova et al., eds., *V. V. Stasov, Izbrannye sochineniia* (Moscow; 1952), vol. 3, p. 319.

3. On Nikolai Tarabukin, see John E. Bowlt, ed., *Russian Art of the Avant-Garde* (New York: Viking Press, 1976), pp. xxxv, 171, 215; also the currently available French translation of Tarabukin's 1923 essay "Ot mol'berta k mashine," under the title "Du chevalet à la machine," in *Le dernier tableau, écrits sur l'art et l'histoire de l'art* . . . présentés par Andrei B. Nakov (Paris: Éditions Champ Libre, 1972), pp. 33f.

4. The reference is to Tolstoi's *Chto takoe iskusstvo?* [What Is Art?]; there have been several English translations, of which that by Aylmer Maude (London, The Walter Scott Publishing Co., 1899) is to be preferred. Despite Kandinsky's disdain of Tolstoy's book, he was evidently impressed by aspects of his thought. There is a marked resemblance between the beginning of the second chapter of Kandinsky's *On the Spiritual in Art* (see p. 133) and Tolstoy's description of the spiritual progress of mankind (Maude, p. 53).

5. *Moskovskie Vedomosti.*

6. *Russkie Vedomosti.*

7. *Odesskii Listok.*

8. The double date Kandinsky gives at the end of his article is curious, since the two parts were actually published in *Novosti dnia* 17 and 19 April 1901. "21 April" may well be a misprint for "12 April."

Correspondence from Munich

1. On the World of Art movement, see the opening chapters of Camilla Gray, *The Great Experiment* (London and New York: Thames and Hudson, 1962); also John E. Bowlt, "The World of Art," *Russian Literature TriQuarterly* (Fall 1972): 183ff and the same author's *The Silver Age. Russian Art of the Early Twentieth Century and the "World of Art" Group* (Newtonville, Mass.:O.R.P.) 1979.

2. E. Roditi, (*Dialogues on Art* [London: Secker and Warburg 1960]), p. 140. On Münter's career, and her relationship with Kandinsky, see Johannes Eichner, *Kandinsky und Gabriele Münter, von Ursprüngen moderner Kunst* (Munich: F. Bruckmann, [1957]).

3. Bilibin, like many of Kandinsky's Russian contemporaries—Grabar,

Kardovsky, Jawlensky—also studied in Munich. The Ažbè school, which Kandinsky describes in his "Reminiscences," acted as a particular magnet for Russian artists at this time (see pp. 373–374).

4. *Mir Iskusstva,* nos. 1–2, (1899): 1–16; nos. 3–4 (1899): 37–61.

5. On the Phalanx, see Hans Konrad Roethel, *Kandinsky, Das Graphische Werk* (Cologne: M. DuMont Schauberg, 1970), pp. 429ff. (Henceforth, Roethel, 1970.)

6. Kandinsky's relation with Munich artists and designers is discussed by Peg Weiss, "Kandinsky and the 'Jugendstil' Arts and Crafts Movement," *Burlington Magazine* 117, no. 866 (May 1975): 270ff.

7. Roethel, 1970 (see note 5 above) provides a *catalogue raisonné* of all the artist's prints.

First exhibition of the Neue Künstler-Vereinigung

1. Roethel, 1970, pp. 438ff.

2. The split within the Neue Künstler-Vereinigung and the steps that led to the Blaue Reiter exhibitions are described by Lankheit 1974, pp. 11ff.

Letters from Munich

1. The Blaue Reiter Almanac was dedicated to the memory of Hugo von Tschudi. On Kandinsky's relations with Tschudi, see Lankheit, 1974, pp. 17ff.; on Tschudi himself see his own *Gesammelte Schriften zur neueren Kunst,* ed. E. Schwedeler-Meyer, (Munich: F. Bruckmann, 1912).

2. On Izdebsky, see Roethel, 1970, p. 442. According to Roethel, Camilla Gray's assertion that Izdebsky was a founder member of the NKVM *(The Great Experiment,* London and New York: Thames and Hudson, 1962, p. 96) was based "almost certainly" upon a mistake. Kandinsky himself, however, specifically names Izdebsky as a member of the association at the end of his second "Letter from Munich" (see p. 63).

3. On this important exhibition, see also the three-volume catalogue edited by F. Sarre and F. R. Martin, *Die Ausstellung von Meisterwerken Muhammedanischer Kunst in München 1910* (Munich: F. Bruckmann, 1912); also the review by E. Gratzl, "Die Münchener Ausstellung Mohammedanischer Kunst," *Kunst und Künstler* 8 (1910): 618ff.

4. The Russian word *bezpredmetnyi* [literally, "objectless"] was, according to Professor John E. Bowlt, used in critical writings on art as early as 1904 to mean "abstracted"; before the First World War, it was currently used by artists such as Petrov-Vodkin to mean "not concerned with material objects." This, however, is clearly not Kandinsky's meaning here; what is implied is "aimless" or "indeterminate."

From the Catalogue of the Second exhibition of the Neue Künstler-Vereinigung

1. G.J. Wolf, *Die Kunst für Alle* (1 November 1910): 68ff.

2. Kandinsky's interest in occultism and theosophy has intrigued several

recent commentators. In the editors' opinion, excessive weight has been given to this topic, for example, by Sixten Ringbom in his article "Art in the 'Epoch of the Great Spiritual,'" pp. 368–418. See also by the same author, *The Sounding Cosmos: A Study in the Spiritualism of Kandinsky and the Genesis of Abstract Painting* (Åbo: Åbo Akademi, 1970).

3. *"Die Komposition mit diesen Mitteln hat nun zu 'unbestimmter Stunde aus einer heute uns noch verborgenen Quelle' zu geschehen, freudvoll leidvoll, kraftvoll, gedankenvoll, furzvoll."* [Composition with these resources must now come about "at an unspecified moment, from a source that today remains concealed from us," filled with joy, with suffering, with power, with thought, with farts.] See *August Macke-Franz Marc: Briefwechsel, Mit einem Vorwort von Wolfgang Macke* (Cologne: M. DuMont Schauberg, 1964), p. 27.

Content and Form

1. Roethel, 1970, pp. 442ff.

2. Roethel, 1970, p. 187.

3. On this first exhibition, see the review by "Lohengrin," *Odesskie Novosti*, 4 December 1909.

4. This edition, p. 196; Kandinsky refers to an article by Rovel that had appeared in the French periodical *Les Tendances Nouvelles*. Some information about this periodical is given by Roethel, 1970, p. 426; more details are supplied by Jonathan Fineberg, *Kandinsky in Paris 1906–7*, unpubl. diss., Harvard University, 1975, Chapters VI, VIII and Appendix A.

5. For example, by Troels Andersen in "Some Unpublished Letters by Kandinsky," p. 90ff. An English translation of "Content and Form," and notes on Izdebsky and "Salon 2" are included in J. E. Bowlt's *Russian Art of the Avant-Garde* (New York: Viking Press, 1976), p. 17f.

6. The editors are unable to attach any meaning to this sentence. In the original, Kandinsky employs the Russian words *tsvet* and *kraska*, both of which signify "color"; *kraska*, however, also means "paint". Significantly, when the artist drafted a German translation of this article, he omitted this sentence.

Footnotes to Schoenberg's "On Parallel Octaves and Fifths"

1. It has often been suggested that Kandinsky and Schoenberg first met as early as 1906, 1907, or 1908 (by Werner Hofmann in the catalogue of the Schoenberg–Berg–Webern exhibition held at the Museum des XX Jahrhunderts, Vienna, in 1969; by Josef Rufer in his article "Schönberg als Maler—Grenzen und Konvergenzen der Künste," in the Festschrift for H. H. Stuckenschmidt, *Aspekte der neuen Musik*, ed. W. Burde, (Kassel: Bärenreiter, 1968); and by Stuckenschmidt himself in "Kandinsky et la musique," *XXᵉ Siècle* (1966): 25ff. There is not a shred of evidence to support this assertion. On the contrary, Kandinsky's first letter to Schoenberg, dated 18 January 1911, makes quite clear that he was personally unacquainted with the composer at that time, his attention having been drawn to Schoenberg's music by a concert given in Munich earlier that month. On the relations between the two artists see now J.

Hahl-Koch, ed., *Arnold Schönberg, Wassily Kandinsky. Briefe, Bilder und Dokumente einer außergewöhnlichen Begegnung* (Salzburg: Residenz Verlag, 1980).

2. *Macke–Marc: Briefwechsel,* p. 40.

3. On Kandinsky's relations with George and the *George-Kreis,* see Peg Weiss, "Kandinsky: Symbolist Poetics and Theater in Munich," *Pantheon* 35, no. 3 (1977): 209ff.

4. "Ueber Oktaven—und Quintenparallelen," *Die Musik,* X Jg., 37 (1910–11): 96ff.

5. Ibid., p. 100.

Whither the "New" Art?

1. Virchow, Rudolf (1821–1902), pathologist and anthropologist, founder of the German Anthropological Society.

2. *Obshchestvo peredvyzhnyky vystavok,* founded in 1871. Known as the *Peredvizhniki* [Wanderers], the members of the society included some of the most eminent Realist painters of the second half of the nineteenth century in Russia, among them Ilia Repin and Vasily Perov.

3. Moscow, State Tretiakov Gallery.

4. *Serres Chaudes* (Paris: Léon Vanier, 1889). Kandinsky also refers to this anthology of poems in his discussion of Maeterlinck in the third chapter of *On the Spiritual* (see this edition, p. 143).

5. A. S. Pankratov, *Idushchie Bogi,* 2 vols., (Moscow, 1911).

6. This quotation, too, is taken from the extract from Schoenberg's *Harmonielehre,* which had appeared in the Berlin periodical *Die Musik* in October 1910 ("Über Oktaven—und Quintenparallelen"; see note 4 to "Footnotes to Schoenberg," p. 872). The original reads: *"Ich selbst möchte nichts Veraltetes tun, weil ich die Vorteile des Neuen kenne, und, weil es unzeitgemäß wäre; unzeitgemäß in einem Sinn, in dem man nie unzeitgemäß sein soll: nach rückwärts!"* [I personally have no use for the outmoded, because I know the advantages of the new, and because it would mean being noncontemporary in a sense in which one should never be noncontemporary: backward!] As can be seen, Kandinsky has treated Schoenberg's original utterance rather freely.

The Battle for Art

1. *Ein Protest deutscher Künstler . . . ,* ed. Carl Vinnen (Jena: Eugen Diederichs, 1911).

2. Franz Marc, in the periodical *Pan* (21 March 1912); see K. Lankheit (ed.), *Franz Marc. Schriften* (Cologne: DuMont Buchverlag, 1978), p. 105.

First Exhibition of the Editors of the Blaue Reiter

1. Letter quoted by Lankheit, 1974, p. 16. Lankheit also describes in some detail the steps that led to the publication of the *Blaue Reiter Almanac* in May 1912.

2. "The Blaue Reiter (Recollection)"; see this edition, p. 744.

3. On Koehler see Lankheit, 1974, pp. 23ff; also Elisabeth Erdmann-Macke, *Erinnerung an August Macke* (Stuttgart: W. Kohlhammer, 1962).

4. Erdmann-Macke, p. 187.

5. Letter of 10 August 1911, in *Macke—Marc: Briefwechsel,* p. 65.

6. "The Blaue Reiter (Recollection)"; see this edition, p. 746.

7. According to H. K. Roethel, *Kandinsky—Painting on Glass* (New York: Solomon R. Guggenheim Museum, 1966), p. 7.

8. *Variant:* "propagandize."

On the Spiritual in Art

1. According to Roethel, 1970, p. 444.

2. On Marc's relations with Reinhard Piper, see Klaus Lankheit, *Franz Marc im Urteil seiner Zeit* (Cologne: M. DuMont Schauberg, 1960), pp. 34ff.

3. Lankheit, 1974, p. 26.

4. "O dukhovnom v iskusstve," *Trudy vserossiiskago s'ezda khudozhikov,* December 1911–January 1912, (Petrograd: Golike and Vilborg, 1914), vol. 1, pp. 47–75 (henceforth: R). Confusion has reigned over the details of this conference, some commentators believing that what was presented was just the sixth chapter of *On the Spiritual* or, alternatively, "extracts" from Kandinsky's text. Even Nina Kandinsky claims that Kul'bin delivered just "a few chapters" from Kandinsky's book (Nina Kandinsky. *Kandinsky und ich,* [Munich: Kindler, 1976] pp. 74–75.) On the contrary: the manuscript Kandinsky sent to the conference was actually an early draft of *On the Spiritual* in Russian, which resembles the German manuscript of 1909, lacking many of the up-to-the-minute references of the published German versions (Cubism, Schoenberg). On the basis of the evidence of Kandinsky's manuscripts and typescripts, the suggestions advanced by John Bowlt and Rose-Carol Washton Long, that the omission of some of these references in the Russian version may have been due to expediency, or to the intervention of the censor, cannot be sustained; see John E. Bowlt and Rose-Carol Washton Long, eds., *The Life of Vasilii Kandinsky in Russian Art. A Study of On the Spiritual in Art* (Newtonville, Mass.: O.R.P., 1980) pp. viii, 47.

5. Kandinsky's text was delivered on 29 and 31 December 1911; it was followed by an animated discussion, a brief resume of which is given in R, pp. 75–76. See also the account of the proceedings in *Apollon, Russkaia Khudozhestvennaia Letopis' 1912g.,* January 1912, pp. 1–6.

6. It is difficult to understand why Jean-Paul Bouillon should believe that the circumstances of its publication prevented Kandinsky from bringing the German version of *On the Spiritual* up to date. Bouillon believes that the text "ne rend qu'assez mal compte de la peinture de Kandinsky à la date où il paraît, ce que seul les conditions de sa rédaction et da sa publication, qu'on passe trop souvent sous silence, peuvent expliquer." (*Regards sur le passé et autres textes, 1912–1922, edition établie et présentée par Jean-Paul Bouillon* [Paris: Hermann, 1974], p. 20; henceforth, Bouillon, 1974).

7. Kenneth Lindsay, "The Genesis and Meaning of the Cover Design for the first *Blaue Reiter* Exhibition Catalogue," pp. 49–52. The 1947 translation, *Concerning the Spiritual in Art* (New York: George Wittenborn, Inc.) also incorporates these "little changes," but without specific footnotes to indicate to the reader which passages are based on this manuscript source.

8. The question of Kandinsky's "debt" to Goethe has been aired by, among others, L. D. Ettlinger, "Kandinsky's 'At Rest' " (The Charlton Lecture, University of Newcastle upon Tyne, 1961); see also John Gage, "The psychological background to early modern colour: Kandinsky, Delaunay and Mondrian", in *Towards a New Art. Essays on the background to abstract art 1910–20* (London: Tate Gallery, 1980) p. 22ff. Kandinsky was evidently well aware of aspects of nineteenth century color theory. A copy of Schopenhauer's *Farbenlehre*, with marginal markings, was found among the books from the artist's library at Murnau. The philosophy of German idealism was familiar to the artists of Kandinsky's immediate circle as well. Franz Marc wrote in an essay published in the periodical *Pan* (21 March 1912): "In Schopenhauer's terms, the world as Will today takes precedence over the world as Representation." And Arnold Schoenberg quoted from Schopenhauer's treatise, *The World as Will and Idea*, in his essay "The Relationship to the Text," published in the *Blaue Reiter Almanac*.

9. Adelung, 1811, Bd. II, p. 561: "Generalbaß . . . derjenige Baß, welcher die ganze Harmonie des Stückes in sich begreift; *ital. basso continuo*"; Grimm, 1897, Bd. IV, I, 2: p. 3382 (5b): "im musikleben 'generalbaß,' it. vielmehr *basso continuo* . . . eig. die notierte baßstimme die zugleich den gang der harmonie des ganzen andeutet, daher dann als inbegriff der regeln der harmonie überhaupt." *Generalbaß* is usually translated as "figured bass" or "thorough-bass," a system of musical notation, a kind of shorthand according to which, in Baroque music, the keyboard player would reconstruct the cembalo part in conformity with a relatively elaborate convention. The significance of this notion for Kandinsky, and of musical theory generally, is discussed by Peter Vergo. "Music and abstract painting: Kandinsky, Goethe and Schoenberg," in *Towards a New Art. Essays on the background to abstract art 1910–20* (London: Tate Gallery, 1980) p. 41ff.

10. Sixten Ringbom, "Art in the Epoch of the Great Spiritual," and *The Sounding Cosmos* (Åbo: Åbo Akademi, 1970).

11. Kandinsky also refers to theosophy in his article "Whither the 'New' Art?," but in a passage that is an exact paraphrase of his description of theosophy in *On the Spiritual* (see p. 101).

12. Kandinsky's letter to Marc is published in Lankheit, 1974, p. 17. Nina Kandinsky dismisses the idea of her husband's involvement with Rudolf Steiner and with the Anthroposophical Society (*Kandinsky und ich*, p. 235).

13. Derick Baegert (active 1476–1515) is now considered to be the painter of this crucifixion. See *Der Maler Derick Baegert und sein Kreis* (Münster: Landesmuseum der Provinz Westfalen für Kunst und Kulturgeschichte, 1936), no. 29, Pl. XVI. Professor James Marrow brought this to our attention.

14. Now Philadelphia, Museum of Art.

15. The photograph of the painting listed here as *Impression "Park"* (1910) is captioned *Impression 4* (see this edition, p. 198). Grohmann, however, identifies the same painting as *Impression No. 5 (Park)*, listed by Kandinsky in his House Catalogue of paintings under no. 141 (1911); formerly Paris, collection Nina Kandinsky. (See Grohmann, 1958, p. 332, and fig. 68 on p. 355). This identification has been retained in all subsequent literature. *Impression 4* is also listed by Kandinsky under 1911, and subtitled "Gendarme." (Grohmann, 1958, p. 331, no. 137.)

Improvisation 18 (With Gravestone); Munich, Städtische Galerie im Lenbachhaus. Listed by Kandinsky in his House Catalogue of paintings under no. 126 (1911); see Grohmann, 1958, p. 331.

Composition 2; destroyed. Listed by Kandinsky in his House Catalogue of paintings under no. 98 (1910); Grohmann, 1958, p. 331.

16. In fact, the German manuscript is dated 1909 (see above, p. 114 and n. 1). The mistaken assertion that *On the Spiritual* was written in 1910 has been repeated in most of the subsequent literature on Kandinsky.

17. The first edition of *On the Spiritual* in fact appeared in print in December 1911.

18. See n. 32 to p. 149.

19. The next section, up to the words "as soon as the ethos that gave rise to it changes" does not appear in the published Russian version of *On the Spiritual* (see n. 4 above). Such omissions are henceforth noted as "not in R."

20. On Kandinsky's view of Tolstoy, see above, n. 4 to p. 36. The artist had a habit of clipping out quotations from newspapers and other publications if they caught his attention, and some of these are preserved among his papers. The Schumann quotation is one such clipping.

21. For the source of Kandinsky's account of the progress of spiritual life, see above, n. 4 to p. 36.

22. The published Russian version here adds the following sentence: "This is one of the terrifying, tangible manifestations of the mysterious spirit of Evil." (Such additions are indicated henceforth by the words: "R adds: . . .")

23. In fact, preceding the first subject of the first movement.

24. Sentence "Sienkiewicz in one of his novels . . . will surely sink" not in R.

25. Reference to Moses and the dance around the golden calf not in R.

26. This footnote occurs as part of the text of chapter 3 of R, in the context of Kandinsky's discussion of Rossetti, Burne-Jones, and the Pre-Raphaelites.

27. Apart from the obvious reference to Karl Marx, *Das Kapital* (Hamburg:Meissner, 1867–94) the other works Kandinsky cites here may cause the reader some puzzlement. As such, there is no work by Ferdinand Lassalle (1825–1864) entitled *The Iron Law (Das Eherne Gesetz)*, the title given by Kandinsky. On 17 and 19 May 1863, however, Lassalle delivered papers before a conference in Frankfurt/M which were subsequently published under the title *Arbeiter-Lesebuch* [A Workers' Reader]; in some editions, this is divided into two sections, the first of which is headed "Das Eherne Lohngesetz" [The Iron Law of Wages]. (See, for example, Ferdinand Lassalle, *Auswahl von Reden und Schriften . . . ausgewählt von Dr. Karl Renner* [Berlin: J.H.W. Dietz Nachf., 1923] p. 347f.) J. B. von Schweitzer (1833–1875), apart from being president of the German *Arbeiterverein*, was also the author of a number of comedies and dramas. The editors have been unable, however, to trace "Emma"; nor is any work by Schweitzer with this title listed in the relevant volumes of Kayser's *Deutsche Bibliographie*, supposedly a complete register of all works published in Germany. Kayser does, however, list a play entitled "Cousin Emil. Lustspiel in 1 Akt von J. B. Schweizer" [sic], published as number 5 in the series *Kühlings Theater-Mappe* (Berlin, 1872–76). Possibly Kandinsky had this work in mind but had only half remembered the title. These references do not occur in R. The

whole of the first part of chapter 3 in the German versions of Kandinsky's text represents a considerable expansion of R, with much new material, including the extended discusion of theosophy.

28. Rudolf Steiner, *Theosophie*, 2d ed., (Leipzig: Max Altmann, 1908); Steiner's articles "Die Stufen der höheren Erkenntnis" and "Wie erlangt man Erkenntnisse der höheren Welten?" were first published in *Lucifer-Gnosis* at irregular intervals between 1904 and 1908. For a list of the theosophical and other literature preserved in Kandinsky's library, see Ringbom, "Art in the Epoch of the Great Spiritual," appendix.

29. Under the title *The Key to Theosophy*. The page references given in Kandinsky's text are to the German edition.

30. Parts of Kandinsky's discussion of Maeterlinck ("And so Maeterlinck . . . in these works. Eventually, manifold repetition . . . *Serres Chaudes.*") and the note on Kubin occur for the first time in the first German edition of *On the Spiritual;* they are absent in the manuscript of 1909.

31. Kandinsky's discussion of Mussorgsky and Schoenberg occurs for the first time in the first German edition.

32. The author's footnote to the first edition reads: "Excerpt from the *Harmonielehre*, shortly to be published by Universal Edition." The excerpt to which Kandinsky refers consisted of the chapter "On Parallel Octaves and Fifths"; see note 4 to p. 91 above. Between the publication of the first and second German editions of *On the Spiritual*, Kandinsky had received a copy of the newly published *Theory of Harmony* as a gift from the composer. The impact Schoenberg's treatise made on him may be judged from the preface to the second edition of *On the Spiritual* (see p. 125 above), where Kandinsky refers to his own desire to write "a kind of *Theory of Harmony* of painting."

33. 1st edition: "*realistische*"; 2d and 3d editions: "*idealistische.*" The former seems preferable.

34. In both the German manuscript and in R, chapter 3 ends at this point; Kandinsky, at this early date (1909), makes no mention of Picasso. Matisse's work would have been familiar to him from his year spent in Paris 1906–1907.

35. The reference is to Matisse's *Notes d'un Peintre*, first published in *La Grande Revue*, 25 December 1908 and translated into German the following year.

36. R adds footnote: "I deem it more correct to speak of paint and not color most of the time. Apart from its abstract color, the concept paint also embraces the material consistency with which the artist operates."

37. In R, chapter 5 ends here.

38. A. V. Zakhar'ina-Unkovskaia, teacher and theoretician with profound mystical tendencies, author of a publication entitled *The Method of Colors, Sounds, and Numbers*. A pamphlet describing this publication was found among Kandinsky's papers.

39. R here adds footnote on the relationship between painting and music, based on the same material as the conclusion of chapter 4 of the German editions, but also containing the further observation: "Nature's language remains her own. If music wishes to express exactly what nature expresses to man in her own tongue, then it takes merely the *inner* value of nature's speech and

repeats this inward reality in the external forms peculiar to music, i.e. musical speech."

40. " . . . *die Malerei ihren Generalbaß erhalten muß.*" The actual quotation, from Goethe's conversations, reads: "Painting has long since lacked knowledge of any *Generalbaß*; it lacks any established, accepted theory, as exists in music." (Conversation with Riemer, 19 May 1807; from *Goethe im Gespräch*, ed. Deibel und Gundelfinger Leipzig: Insel Verlag, 1907], p. 94.) This quotation is also reproduced, without comment, in the *Blaue Reiter Alamanac,* 1st ed. (Munich, 1912), p. 42. On the significance of the term *Generalbaß,* see n. 9 to p. 115 above.

41. 1st edition: *"psychischen Klang"*; 2d and 3d editions: *"physischen Klang."* The former has been followed in this translation, since the latter, from the sense, is evidently a misprint rather than a subsequent revision.

42. In the notes, "Kleine Aenderungen zum 'Über das Geistige,' " the foregoing paragraph is altered to read as follows: "Today, only few artists can manage with purely abstract forms. These forms are *often* too imprecise for the artist. *It seems to him*: to limit oneself exclusively to the imprecise is to deprive oneself of possibilities, to exclude the purely human and thus impoverish one's means of expression. *At the same time, however, abstract form is, even today, already being experienced as something purely precise and employed as the sole material in pictorial works. External 'impoverishment' is transformed into inner enrichment.*" See n. 7 to p. 116 above.

43. In "Kleine Aenderungen," the phrase in brackets is altered to read: "real, or possibly abstract, *or purely abstract.*"

44. *Doppelklang:* literally "double sound," two notes sounded together. Strictly speaking, a neologism that, though its meaning is clear, is almost impossible to translate.

45. Following passage ("Here once again . . . the choice of object also arises from the principle of internal necessity") not in R.

46. R adds footnote: "We are not taking into account the *outwardly* dissimilar nuances of these two *vibrations.*"

47. The following passage, consisting of twenty-two short paragraphs ("Internal necessity . . . All means are sinful if they did not spring from the source of internal necessity.") occurs neither in R nor in the German manuscript of 1909.

48. The next seven paragraphs ("These three mystical necessities . . . may utilize every form as a means of expression.") were included among the additions made by the author to the revised second edition of 1912; they do not occur in the first edition or in R.

49. R adds here the following discussion of Hodler's art:

I would say that modern painting (drawing + color) has, talking especially of our own day, already expressed two clear aspirations: (1) toward rhythmicality, and (2) toward symmetry.

A particularly vivid example is Hodler, who has developed both principles to a level of hypnotic obsession and in some cases to an almost nightmarish condition. I say this not as a condemnation. I am merely pointing to the artist's limitation in his

choice of possibilities. Obviously, this limitation is the natural product of Hodler's soul.

We should not forget this. We should not think that these two principles are beyond art, beyond time. We see these principles in the most ancient art, beginning with the art of the savage, and in the full flowering of different periods of art. We should not object to them *at this moment,* merely on principle. The color white, while especially brilliant if reduced to a minimum and surrounded by a limitless expanse of black, when extended into infinity disintegrates into an unrelieved murkiness. So too, such *principles* of construction that are being applied *indiscriminately* today, lose their resonance, their effect on the soul. Our modern souls are filled with discontent when touched by only one, distinct sound; they need, they long for a double resonance. Just as white and black resound *in opposition,* like the angels' trumpet, so too the whole linear-painterly composition seeks after the same antithesis. This antithesis has, it appears, always been a principle in art, but differences in the emotional tone of various epochs have demanded different applications. And that is why rhythm now demands arhythm; symmetry— asymmetry. The hollow ring of our modern souls demands *this* antithesis. Perhaps the art of today, after its long voyage, will attain that perfection, that flowering which every great and noble epoch undergoes. And perhaps it will then transpire that our hollow dissonance, our disharmony or aharmony, is in fact the harmony of our era; that our arhythm is rhythm, our asymmetry, symmetry; something infinitely refined and rewarding, full of the pervasive scent of our own nascent era.

50. A translation of Merezhkovsky's novel *Voskreshie Bogi* (St. Petersburg, 1902). D. S. Merezhkovsky, Russian novelist and critic, had been closely associated for a time with the World of Art circle.

51. *". . . von einem wenig labilen Gleichgewicht,"* labil meaning "weak" or "shaky." Max Bill, editor of the fourth and subsequent German editions of *On the Spiritual,* is certainly correct in substituting *"wenig stabilen"* [unstable]. He does not, however, add a footnote indicating his authority for this correction. (Kandinsky, *Über das Geistige in der Kunst,* 8th ed., mit einer Einführung von Max Bill, [Bern: Benteli Verlag, 1965], p. 103.)

52. Chapter 6 of R ends here.

53. *" . . . das Auflösen ein- und vielseitiges"*; the syntactical structure is unclear in the original.

54. Le Fauconnier, "Das Kunstwerk," *Neue Künstler-Vereinigung München E.V., II. Ausstellung* (Munich 1910), pp. 3–4. On the NKVM, see above, pp. 52–81.

55. This sentence does not occur in R or in the German manuscript. "Kleine Aenderungen" adds, *"The first hour has already sounded."*

56. "Kleine Aenderungen" adds, in parentheses, *"Purely abstract pictures are still rare!"*

57. *"Summieren des Rots;"* Summieren—literally, "addition" or "accumulation." Here, however, it is evidently the notion of association, of joining together Kandinsky has in mind.

58. *" . . . zweckmäßige Laute"*; an alternative translation might be "applied sounds."

59. Remainder of this paragraph, and the whole section which follows (up to "the principle of internal necessity") not in R.

60. "Kleine Aenderungen" expands the two parentheses, "ornament" and "fantasy," to read "danger of the external in outward ornamentation" and "danger of shallow fantasy."

61. Footnote included only in 2d and subsequent editions.

62. Oscar Wilde, *De Profundis* (London: Methuen & Co., 1905), p. 127. Kandinsky translates this aphorism rather freely as "Art begins where nature leaves off"; Wilde's original has been followed here.

63. In the first edition, chapter 7 ends at this point, as does R. What follows, as far as the end of the chapter, was incorporated by the author into the revised 2d edition of 1912.

64. See above, n. 32, and also p. 125.

65. Both R and the German manuscript end here, lacking the "Conclusion." At this point, the German manuscript bears the date "Murnau (Oberbayern) 3. VIII. 1909."

66. 1st ed.; 2d/3d eds.: "*sechs Reproduktionen*"; there are, however, eight reproductions, as here, in all three editions.

Schoenberg's Pictures

1. An indication of the scope of Schoenberg's activity as a painter is given by Josef Rufer, *The Works of Arnold Schoenberg: A catalogue of His Compositions, Writings, and Paintings* (London: Faber & Faber, 1962). The radio interviews, autobiographical fragments and lecture notes are listed in the section "Poems—Lectures—Essays—Notes" (pp. 152ff.). See also the catalogue *Hommage à Schönberg: Der Blaue Reiter und das Musikalische in der Malerei der Zeit* (Berlin, Nationalgalerie, September–November 1974).

2. On Gerstl, see Peter Vergo, *Art in Vienna, 1898–1918* (London: Phaidon Press, 1975), pp. 200ff.; Nicolas Powell, *The Sacred Spring* (London: Studio Vista, 1974), pp. 164ff.

3. Letter of 27 December 1911 (Munich, Gabriele Münter und Johannes Eichner Stiftung).

4. Unpublished letter dated 7 November 1918 to Alexander von Zemlinsky (London, private collection).

5. See introduction. p. 19; also Nina Kandinsky, *Kandinsky und ich*, pp. 192ff. Schoenberg's letters to Kandinsky, dated 20 April and 4 May 1923, in which the latter's supposed anti-Semitism is discussed at length, are published by Erwin Stein, *Arnold Schoenberg Letters* (London: Faber & Faber, 1974), pp. 88ff. Kandinsky's moving and spirited reply to Schoenberg's accusations has been published by J. Hahl-Koch, ed., *Arnold Schönberg. Wassily Kandinsky. Briefe, Bilder und Dokumente einer außergewöhnlichen Begegnung* (Salzburg: Residenz Verlag, 1980), pp. 91–3.

6. Photo published by Nina Kandinsky, *Kandinsky und ich*, between pp. 128–29.

7. Published by Rufer, *The Works of Arnold Schoenberg . . .*, p. 186 (extract).

8. Kandinsky does not identify by title the paintings by Schoenberg to which he refers, but from the descriptions, they would appear to be the self-portrait seen from the back, and *Vision* (both reproduced in the *Blaue Reiter Almanac*, in "On the Question of Form"), and *Woman in Pink* (reproduced, together with Kandinsky's article "The Pictures," in the Schoenberg volume of 1912). The identity of the landscape remains uncertain.

The Blaue Reiter Almanac

1. For example, by Lankheit, 1974; by Kenneth Lindsay, "The Genesis and Meaning of the Cover Design for the first *Blaue Reiter* Exhibition Catalogue," pp. 47ff.; by Eberhard Roters, "Wassily Kandinsky und die Gestalt des Blauen Reiters," *Jahrbuch der Berliner Museen* 5 (1963):201ff.; by Hideho Nishida, "Genèse du Cavalier bleu," *XXe Siècle*, no. 27 (1966, special number):18ff., reprinted as "Die Geschichte des Blauen Reiters," in *Hommage à Wassily Kandinsky* (Luxembourg: 1976), pp. 22ff. See also Klaus Lankheit, "Zur Geschichte des Blauen Reiters," *Der Cicerone* (1949) Heft 3, pp. 110ff.

2. See Lankheit, 1974, p. 18 and n. 8.

3. Elisabeth Erdmann-Macke, *Erinnerung an August Macke* (Stuttgart: W. Kohlhammer, 1962), esp. pp. 187ff.

4. English translation in Lankheit, 1974, pp. 83ff.

5. Lankheit, 1974, p. 23ff.

6. In this edition, the illustrations that originally accompanied Kandinsky's essays in the *Blaue Reiter Almanac* have been omitted, since for the most part they bore little direct relation to the texts. They can be found in Lankheit, 1974.

7. An interesting precedent for the "Blaue Reiter idea" is to be found in the yearbooks, especially of the last two decades of the nineteenth century, published by the anthropological and ethnographic sections of the Imperial Academy of Sciences and of Moscow University. Like the *Blaue Reiter Almanac*, these publications were the result of a collaboration between artists, scholars, and musicians concerned, in this instance, with the study of aspects of primitive Russian culture. Kandinsky could scarcely have been ignorant of this precedent, since his own early law report concerning the punishments ordained by the local courts of the province of Moscow appeared in one of a series of journals brought out under the auspices of the Imperial Society for Science, Anthropology, and Ethnography of the University of Moscow (see introduction, p. 12 and n.4). The transcriptions of Russian folk music that are inserted at the end of some of these volumes remind one immediately of the "musical appendix" to the *Blaue Reiter Almanac*. On other Russian influences on the form of the almanac, see Peter Vergo, *The Blue Rider* (Oxford: Phaidon, 1977), pp. 6ff.

8. The woodcuts that adorned the covers of the first and second editions of the *Blaue Reiter Almanac* are reproduced in Roethel, 1970, no. 141; see also ibid., App. V, 12, and fig. 58.

9. Lankheit, 1974, p. 90ff.

10. Lankheit, pp. 91–92.

11. On Schoenberg's *Die Glückliche Hand,* see K. H. Wörner, *Schweizerische Musikzeitung* (1964), Heft 9/10.

12. Letter to Hans Hildebrandt, 24 January 1937, in "Drei Briefe von Kandinsky," *Werk* 42, no. 10 (October 1955): 330.

13. "Kandinsky: Symbolist Poetics and Theater in Munich," *Pantheon* 35, no. 3 (1977):211. Weiss had also suggested, in conversation with the editors, that *Yellow Sound* might equally have been intended as a shadow play or puppet play; some of the more bizarre stage directions (e.g., the growing giants) might bear out this suggestion. A further possibility of realizing the complex demands of Kandinsky's "stage composition" would have been through film. It is of some interest that Schoenberg proposed Kandinsky as a possible designer for a cinematographic version of *Die Glückliche Hand,* suggesting that the film should be "hand-colored" by the painter or under his supervision, alternatively, that light from colored reflectors should be cast on the scene during the performance (*Arnold Schoenberg Letters,* ed. Erwin Stein [London, Faber & Faber, 1974], p. 43ff; letter of Autumn 1913 to Emil Hertzka).

13a. We have included the illustrations for the *Yellow Sound* because recent scholarship has shown that they were not decorative devices but instead played an explicatory role. R. W. Sheppard in his essay, "Kandinsky's Abstract Drama *Der Gelbe Klang*: An Interpretation," *Forum for Modern Language Studies,* 14 (1975): 165–76, initiated this line of thinking and emphasized the "intense pessimism" of the work. Susan Alyson Stein, in her thesis, *The Ultimate Synthesis: An Interpretation of the Meaning and Significance of Wassily Kandinsky's "The Yellow Sound,"* Masters Thesis (State University of New York at Binghamton, 1980), examines the meaning each image had in its placement in the original text—a placement that Lankheit did not always respect—and concludes that the work was optimistically affirmative.

14. *Izobrazitel'noe iskusstvo–zhurnal otdela izobr. iskusstv kommissariata narodnogo prosveshcheniia, no. 1 (Petrograd: IZO NKP, 1919), pp. 39–49.*

15. Weiss, "Kandinsky: Symbolist Poetics and Theater."

16. Richard Wagner, "Oper und Drama," *Gesammelte Schriften* (Leipzig: E. W. Fritzsch, 1871–73), vol. 3, pp. 269ff.

17. One of a number of children's drawings reproduced in the almanac. Follows p. 26 in the original edition of 1912. For reproduction, see Lankheit, 1974, p. 89.

18. For reproductions of the paintings Kandinsky refers to, see Lankheit, 1974, pp. 107, 159, 171, 181, 143, 106.

19. Leonid Sabaneev, " 'Prometheus' von Skrjabin," *Der Blaue Reiter,* 1st ed. (Munich, 1912), pp. 57ff.; Lankheit 1974, pp. 127ff.

20. Balilla Pratella, *Manifesto of Futurist Musicians* (1910); translated in Umbro Apollonio, ed., *Futurist Manifestos* (London: Thames and Hudson, 1973), p. 37, sect. 8.

21. On Hartmann, see Lankheit, 1974, pp. 262–63. Kandinsky, in a letter of 1937 (see n. 12 above) gave the impossibility of contacting Hartmann as the reason why *Yellow Sound* was not performed in Berlin in 1922–23.

22. Published in *Der Blaue Reiter*, 2d ed. (Munich, 1914); Lankheit, 1974, pp. 257–58.

On Understanding Art

1. On Walden, see Paul Klee, *Tagebücher*, ed. Felix Klee (Cologne: M. DuMont Schauberg, 1957), p. 284 (no. 914, 1912); Nell Walden and Lothar Schreyer, *Der Sturm, ein Erinnerungsbuch an Herwarth Walden und die Künstler aus dem Sturm-Kreis* (Baden-Baden: Waldemar Klein, 1954); Bouillon, 1974, pp. 13ff.

2. The Sturm gallery moved from Berlin's Königin-Augustastrasse to the Potsdamerstrasse in May 1913, as the advertisements in the magazine reveal. Bouillon suggests that the move took place "after July 1913" (p. 16, n. 8).

3. "Formen—und Farbensprache," *Der Sturm*, No. 106 (April 1912): 11–13.

4. Untitled, *Bewegtes Leben*, and *Schalmei* (Roethel, 1970, nos. 80, 19, 54). Three further Kandinsky woodcuts (Roethel, 1970, nos. 67, 69, 78) were reproduced elsewhere in the same issue of the magazine.

5. "O ponimanii iskusstva," *Odesskaia vesennaia vystavka kartin* (Odessa, March 1914).

Sounds

1. For the detailed printing history of *Sounds* [*Klänge*], see Roethel, 1970, pp. 445ff.

2. In a prospectus for *Sounds* published by R. Piper & Co.; see Roethel, 1970.

3. Roethel, 1970, p. 445.

4. The projected Russian edition of *Sounds* is described by Roethel, 1970, and also by Erika Hanfstaengl, *Wassily Kandinsky: Zeichnungen und Aquarelle im Lenbachhaus München* (Munich: Prestel Verlag, 1974), pp. 63ff. Preserved in the Gabriele Münter Stiftung (GMS) in Munich are vignettes, watercolors, and Russian versions of some of the poems, which, taken together, constitute a kind of "dummy" for a Russian edition of Kandinsky's album. There also exist a cover design (GMS 588) inscribed in Russian *Kandinsky/Zvuki* [Kandinsky/Sounds] and a design for a title page (Roethel, 1970, fig. 35, p. 476), which indicate that the album was to have been published by Vladimir Izdebsky in Odessa. Beyond that fact there exists considerable uncertainty. It is not known what happened to frustrate Izdebsky's plans, nor is it clear exactly what the Russian version of *Sounds* would have looked like. The "dummy" now in Munich contains Russian texts of only some of the poems, and suggests a layout significantly different from that of the published German edition. Kandinsky's designs for the vignettes to accompany the Russian poems, moreover, differ completely from those published in the German edition, although some of the full-page woodcuts were to remain the same. To complicate matters further, Lindsay discovered

among the artist's papers a Russian typescript version of twelve of the poems, a total of twenty pages, inscribed "Für die Klänge—russisch" [For *Sounds—Russian*], and dated 1911. If Hanfstaengl's assumption that the dummy was ready to show to the publisher during Kandinsky's visit to Odessa (1–20 December 1910) is correct, this later version must reflect second thoughts, perhaps concerning an abbreviated version of the album. (The poems the two Russian versions have in common are: "Kholmy" [Hills], "Voda" [Water], "Videt" [See], "Pestryi Lug" [Bright Meadow], "Fagot" [Bassoon], "List'ia" [Leaves], "Kolokol" [Bell], "Vesna" [Spring], "Mel i Sazha" [Chalk and Soot], "Ne" [Not], "Belaia Pena" [White Foam], and a further poem, "Peizazh" [Landscape], which does not correspond to any of those included in the German edition.) It remains possible that Kandinsky in fact gave permission for four of the poems to be included by Burliuk and his friends in their Russian Futurist anthology of December 1912 (see p. 347). If so, this may suggest that he had already abandoned any hope of an Izdebsky edition by the autumn of that year. His letter of protest to the Moscow newspaper *Russkoe Slovo* (see p. 291) asserts, however, that the poems were included without his knowledge or permission. Until further evidence comes to light, it is not possible to devise an entirely satisfactory answer to these questions.

5. For Kandinsky's relations with Ball, see the latter's recollections, *Die Flucht aus der Zeit* (English translation, *Flight Out of Time* [New York: Viking Press, 1974], esp. pp. 7ff.)

6. Hans Arp, "Der Dichter Kandinsky," *Wassily Kandinsky,* ed. Max Bill (Paris: Maeght, 1951), p. 147.

7. Beginning as early as 1918, when "See" was reproduced in lieu of an introduction to the Russian version of Kandinsky's "Reminiscences" (see p. 357), and continuing right up until the end of his life; see for example the woodcuts reproduced to accompany Kandinsky's essay "My Woodcuts" (see pp. 817–18) and the selection of poems and woodcuts republished in *Transition* (see p. 809).

Autobiographical Note/Postscript

1. For a discussion of the different versions of this catalogue, see Rudenstine, 1976, pp. 222–23. It seems that Goltz had intended to show a retrospective exhibition of Kandinsky's work in Munich in either September or October 1912, but this plan came to nothing. Thus, the seventh exhibition of Der Sturm, which opened in Berlin on 2 October 1912, was evidently Kandinsky's first one-man show in Germany; it is advertized in several successive numbers of *Der Sturm* (nos. 129–32) as the artist's "first collective exhibition, with paintings from the years 1901 to 1912." The show closed in Berlin on 28 October, two days ahead of its original schedule, perhaps because it was due to reopen in Rotterdam at the Galerie Oldenzeel on 5 November (see also Donald E. Gordon, *Modern Art Exhibitions, 1900–1916,* vol. 2 [Munich: Prestel Verlag, 1974], p. 610). Rudenstine suggests that the first edition of the catalogue, which Goltz had already published, was used for Walden's Berlin show, that Goltz

republished the catalogue some time early in 1913 to include [Postscript], and that only when this second edition was exhausted was the catalogue reissued, with further changes, under Walden's own imprint. She also conjectures that the Berlin printing may have been used for Thannhauser's exhibition of Kandinsky's work, held in Munich in 1914. It is not explained why personalities like Walden and Thannhauser should have consented to sell catalogues under another publisher's imprint at their own exhibitions; nor why the paintings listed in the Berlin catalogue differ from those included by Goltz, especially if, as Rudenstine asserts, Walden's version did not appear until the end of 1913, when no further Berlin exhibition of Kandinsky's work was contemplated. There is no evidence to support Bouillon's suggestion (Bouillon, 1974, p. 16) that Goltz took over the exhibition after it had been shown by Walden.

2. See Roethel, 1970, pp. 485–86, figs. 75, 76. The composition of the vignette also evinces a certain similarity to the various versions of Kandinsky's painting *Small Pleasures* (see Rudenstine, 1976, pp. 264ff.)

3. Roethel, 1970, no. 107.

4. Even a critic as sensitive as Roger Fry resorted to an analogy with music in an attempt to explain what he thought Kandinsky was doing. Reviewing the Albert Hall exhibition of 1913, he wrote in *The Nation*: "One finds that after a time the Improvisations become more definite, more logical and more closely knit in structure, more surprisingly beautiful in their color oppositions. *They are pure visual music.*" (*Nation*, 2 August 1913, quoted in Arthur Jerome Eddy, *Cubists and Post-Impressionism*, [Chicago: A. C. McClurg & Co., 1914], pp. 116–17).

5. *Variant* (Berlin printing): "at the end of 1913 in Moscow."

Letter to the Editor

1. On the Hylaean group and the anthologies produced by the Russian Futurist poets see Vladimir Markov, *Russian Futurism: A History* (London: Macgibbon & Kee, 1969) especially pp. 29f, 45ff; also Susan P. Compton, *The World Backwards. Russian futurist books 1912–16* (London: The British Library, 1978). The signatories of the opening manifesto of *A Slap in the Face of Public Taste* were David Burliuk, Aleksandr [Aleksei] Kruchenykh, Vladimir Maiakovsky and Viktor [Velimir] Khlebnikov.

2. Despite his protests, it remains possible that Kandinsky had at some earlier stage consented to appear in print in the company of the Hylaean poets. As Markov observes (pp. 40–41), *A Slap* had originally been intended for publication under the auspices of the exhibiting society The Jack of Diamonds. Thus Kandinsky, who had contributed to both the first and second Jack of Diamonds exhibitions in Moscow in 1910–1912, might well have felt his poems were in safe hands. Moreover, during the period *A Slap* was being prepared, Kandinsky and Burliuk had discussed the possibility of various joint publishing ventures: see Nikolai Khardzhiev, "Poeziia i zhivopis' [Rannii Maiakovsky]," in N. Khardzhiev, K. Malevich, M. Matiushin, *K istorii russkogo avangarda* (Stockholm: Almqvist & Wiksell, 1976), p. 17–17.

Against this view, it may be argued that Kandinsky himself subsequently published one of the same poems, "See," in lieu of a preface to "Stupeni," [Steps] the Russian version of his autobiography (in V. V. Kandinsky, *Tekst Khudozhnika,* [Moscow: IZO NKP, 1918]; see also this edition, p. 355ff.). By comparison with this "authorized version," that printed in *A Slap* is quite different in language and layout and reads very much like a translation from the German. The editors of *A Slap* acknowledged that Kandinsky's four "little tales" were taken "from his book *Sounds* (published by R. Piper & Co., Munich)," implying they had had only the published German texts to translate from. (*Poshchechina* . . ., [Moscow: G. L. Kuzmin, 1912] p. 79.) According to Khardzhiev the translations were in fact made by David Burliuk; Khardzhiev does not, however, cite his authority for this assertion. Had Kandinsky consented to the publication of his poems, he could easily have provided his friends the Burliuks with Russian manuscripts, either directly or through the intermediary of Izdebsky in Odessa.

Finally, it is worth noting that, since the "manifesto" that introduces *A Slap* bears the date December 1912, the acknowledgement to the published German version of *Klänge* lends weight to the assumption that the album had already appeared in Munich in the autumn of that same year, as stipulated by Kandinsky's contract with Piper (see above, p. 882 and note 1). In later years, Kandinsky himself repeatedly ascribed the publication of *Klänge* to 1913. His memory for dates was, however, notoriously inaccurate.

3. Kandinsky's letter is also translated and discussed by Troels Andersen, "Some Unpublished Letters by Kandinsky," pp. 96–7.

Painting as Pure Art

1. *Der Sturm,* no. 134–35, pp. 204–5; no. 132, p. 182. See also Bouillon, 1974, pp. 16–17.

2. *Der Sturm,* nos. 150–51, 152–53, 154–55 (March 1913); Bouillon, 1974, p. 17.

3. See Donald E. Gordon, *Modern Art Exhibitions, 1900–1916,* (Munich: Prestel Verlag, 1974) vol. 2, p. 740. The exhibition was held from 20 September –1 December 1913. Kandinsky was represented by seven paintings (cat. nos. 181–87).

4. Bouillon, 1974, p. 33; p. 269, n. 83; and p. 287, n. 134. Other commentators, such as Andersen ("Some Unpublished Letters by Kandinsky," p. 98, n. 11), have confused the two essays; it is "Painting as Pure Art," not "Content and Form" that is reprinted in Herwarth Walden's *Expressionismus* (Berlin: Verlag "Der Sturm") of 1918. Max Bill (*Kandinsky, Essays über Kunst und Künstler,* 2d. ed. [Bern: Benteli Verlag, 1963], p. 63) seems to have been unaware of the original publication of "Painting as Pure Art," believing it to have been written "about 1916."

5. *Der Sturm,* nos. 138–39; Delaunay had also described, in a letter to Kandinsky apparently of spring 1912, his own searches for what he terms *"peinture pure"* (letter published in Gustav Vriesen and Max Imdahl, *Robert Delaunay–Licht und Farbe,* [Cologne: M. DuMont Schauberg, 1967], p. 38).

6. "Die Linie," *Die Zukunft* (6 September 1902); reprinted in *Essays* (Leipzig: Insel Verlag, 1910); see also *Henry van de Velde: Zum neuen Stil, aus seinen Schriften ausgewählt und eingeleitet von Hans Curjel* (Munich: R. Piper & Co., 1955), pp. 181ff. The title of this essay was noted by Kandinsky in his sketchbook GMS 335 (Munich: Städtische Galerie im Lenbachhaus), in use during 1907–8; the name van de Velde likewise appears in the sketchbook GMS 333 of 1905–6. See also Erika Hanfstaengl, *Wassily Kandinsky. Zeichnungen und Aquarelle. Katalog der Sammlung in der Städtischen Galerie München* (Munich: Prestel Verlag, 1974) pp. 155–6.

7. *Gefühl*: also "emotions," but here evidently "sensibility," "feelings."

Reminiscences/Three Pictures

1. See the catalogue by Hans Konrad Roethel, *Kandinsky, Painting on Glass*; Rose-Carol Washton Long, "Kandinsky and Abstraction: the Role of the Hidden Image," pp. 42ff.

2. In a letter Kandinsky wrote from the Bauhaus to Hans Hildebrandt on 25 March 1927, the artist specifically identified the iconography of *Composition 4* with a charge of Cossacks through the streets of Moscow during the abortive revolution of 1905. He adds, "In 1911 no one was capable of recognizing the objective element in this picture, which is very indicative of the visual attitude of that time." (Drei Briefe von Kandinsky," *Werk* 42, no. 10 [October 1955]:328). A further painting *Battle* (London, Tate Gallery) often described as a "sketch" for *Composition 4*, is closely related to the upper left-hand portion of the finished picture.

3. Kandinsky did, however, write other descriptions of individual paintings, which have remained unpublished. An essay "Zum Bild 'Moskau'," describing the genesis of the now-lost *Impression 2*, was discovered among the artist's papers; a further essay on the painting *Small Pleasures* has been partly published by Rudenstine, 1976, pp. 268–69.

4. A most useful "table' is published by Bouillon, 1974, pp. 48–9 in an attempt to reconstruct the chronological sequence of Kandinsky's narrative in "Reminiscences." This "rondo" manner is also characteristic of parts of *On the Spiritual in Art*, where topics, and even verbal "motifs," occur in different contexts and combinations.

5. See Klaus Lankheit, *Franz Marc: Watercolors–Drawings–Writings* (London: Thames and Hudson, 1960), pp. 17–18. Lankheit notes that Ostwald's theories enjoyed a vogue at this time, and cites Marc's later statement: "The theory of energy was a more powerful artistic inspiration to us than a battle or a rushing torrent."

6. The oid controversy regarding the date of Kandinsky's first abstract painting has been rehearsed most recently by Hans Konrad Roethel and Jean K. Benjamin (in *Burlington Magazine* 119, no. 896 [November 1977]: 772ff.). Here, the authors propose a new contestant (albeit no longer traceable) for the title of Kandinsky's first nonobjective painting. Their claim is based on an inscription on the back of a photograph of the now-lost picture *With Circle* of 1911, which

reads in part: *"pervaia bezpredmetnaia"* [first nonobjective]; and on the hypothesis that the iconography of the painting is based on a further picture by Kandinsky, *Garden in Murnau* of 1910, itself "abstracted" from landscape motifs.

It is perhaps worth pointing out that Kandinsky himself used the word *bezpredmetnyi* to describe the work of that well known pioneer of abstraction Edouard Manet (see p. 79 and n. 4); and that to suggest that a picture should be termed "nonobjective" because it derives not from nature, but from another picture that might be termed "abstract" reveals a complete misunderstanding of the distinction Kandinsky drew between the two terms in his famous response to Hilla Rebay (letter of 16 December 1936; translated and discussed in Rudenstine, 1976, pp. 274ff.).

7. "Stupeni" has been published in English by Hilla Rebay in the catalogue *In Memory of Wassily Kandinsky* (New York: Museum of Non-Objective Paintings, 1945). The differences between the 1913 German edition of "Reminiscences" and the Russian version of 1918 are discussed in detail by Bouillon, 1974, pp. 41ff. and in the notes to the translation; see also Roethel/Hahl, 1980, p. 146ff.

8. The translation printed here follows the text of the 1913 German version. Passages altered by Kandinsky for the 1918 Russian edition are indicated in the notes that follow by the words: "S[tupeni] reads:"; omissions or additions by the words: "not in S," or "S adds." Only substantive changes, not minor stylistic differences, are noted.

9. Sentence not in S.

10. Reference to coachman not in S.

11. S Reads: "I remember that my mother's parents . . . "

12. This paragraph not in S.

13. This sentence not in S. S adds new paragraph:

My mother's elder sister, Elizaveta Ivanova Tikheeva, exerted a great, ineradicable influence upon my whole development. Her luminous spirit will never be forgotten by those who encountered her in the course of her deeply altruistic life. It is to her I owe the origin of my love of music, of fables, later of Russian literature and of the profound nature of the Russian people. One of my most vivid childhood memories, in which Elizaveta Ivanova played a part, was of a dun-colored tin horse from a toy racing set, with ochre on its body and a pale yellow mane and tail. At the age of thirty I arrived in Munich to study painting, having abandoned my previous long years of work. There, in the first few days, I encountered just such a dun-colored horse. Every year, he would invariably appear as soon as they started to sprinkle the streets. In the winter he would mysteriously disappear, but in the spring he would turn up again, exactly as he had been the year before. He had aged not a whit; he was immortal.

This paragraph replaces the whole of the passage: "I had a piebald stallion. . . . I moved to Munich."

14. Footnote not in S, being replaced by the new paragraph given in n. 13.

15. Sentence not in S.

16. S reads: "This piebald nag made me aware of the feelings I cherished toward Munich: it had become my second home."

17. To judge from the photographs, the painting reproduced both in the 1913 Sturm album as the second plate in the second section of illustrations, and as the first plate in the Russian version of 1918 (p. 9) is not identical with that listed by Grohmann, 1958, as no. 12 in his transcription of the artist's House Catalogue of paintings, and reproduced on p. 349 of his monograph under the title *Alte Stadt*. See also Lindsay in *Art Bulletin* (December 1959): 350; Bouillon, 1974, p. 243, n. 17; p. 296n. The hypothesis advanced by Lindsay that the painting reproduced by Grohmann must be a study for a now-lost painting still seems tenable.

18. S reads slightly differently here, adding the sentence: "Only once in the entire week did the sun appear for perhaps half an hour."

19. S adds: "I do not know of a single association or artists' society that has not become, in the shortest possible time, an organization against art instead of an organization for art."

20. S has an entirely different footnote at this point, which reads:

> It is with heartfelt gratitude that I recall the genuine warmth and enthusiasm of the help given me by Prof. A. N. Filippov (at that time still a *Privatdozent*). From him I learned for the first time about the entirely humane principle "according to the man." The Russian people differentiate all criminal acts according to this principle, which is given effect by the Regional Courts. This principle takes as the basis for the verdict not the *external* aspect of the act, but the character of its *internal* source—of the mind of the accused. What a resemblance to the basis of art!

The rank of *Privatdozent*, common in both German and Russian universities during the nineteenth century, has no equivalent in the British or American academic system. It was a nonsalaried teaching post, held usually by scholars having private means, who might eventually expect promotion to the rank of professor.

21. It is not possible to be certain which of Monet's *Haystacks* Kandinsky would have seen. Bouillon, (1974, pp. 250ff., n. 37) discusses at some length the spread of Monet's international repute, attributing to the Moscow collector Sergei Shchukin the introduction of Monet's paintings into Russia, although his first purchases of French Impressionist paintings did not occur until about 1897, as Bouillon correctly points out. There was, however, a touring exhibition of works of French art, including a section of paintings by contemporary French artists, which was shown in St. Petersburg and other Russian cities in the autumn of 1896; in addition to paintings by the French academic school, it included works by Boudin, Degas, Moreau, Puvis de Chavannes, Monet, Renoir, and Sisley. A painting by Monet is listed as no. 221 in the catalogue, under the title *Haystack in Sunlight* (see *Ukazatel'frantsuzskoi khudozhestvennoi vystavki, ustroennoi . . . v pol'zu popechitel'nago komiteta o sestrakh krasnago kresta*, [St. Petersburg: September–October 1896]). The catalogue gives no further details about Monet's picture, and it is not illustrated, so it is impossible to be certain exactly which painting was exhibited. What appears to have been the same exhibition, although under a slightly different title, was also shown in Moscow in the course of 1896; on this occasion, Monet's *Haystack* was listed as

catalogue number 202. See also Roethel/Hahl, 1980, p. 151f. The date 1895 usually given by commentators for Kandinsky's first encounter with Monet has not so far been supported by any documentary evidence.

22. S reads: "at the Bol'shoi Theater."

23. S reads: "Up until then I had been acquainted only with realistic painting, and almost exclusively Russian at that; while still a boy I had been deeply impressed by *They Did Not Expect Him*, and as a youth I went several times to study long and attentively the hand of Franz Liszt in the portrait by Repin; many times I copied by heart Polenov's *Christ*; I was struck by Levitan's *Rowers*, and by his brilliantly painted monastery reflected in the river, etc." Of the four paintings mentioned by Kandinsky, only Repin's *Ne Zhdali* [They Did Not Expect Him] of 1884 (Moscow, State Tret'iakov Gallery) can be identified with complete certainty. On the probable identification of the other paintings, see Bouillon, 1974, pp. 248ff, nn. 35, 36.

24. S adds footnoote:

> It was only later that I came to feel all the sickly sentimentality and superficiality of feeling of this, the weakest of Wagner's operas. Other operas by him (e.g., *Tristan, The Ring*) still held my critical faculties in thrall for many a long year by their power and uniqueness of expression. I found objective expression for this in my article "On Stage Composition," first published in German in 1913 (in *Der Blaue Reiter*, publ. R. Piper, Munich).

Note that, even so soon after its appearance, Kandinsky mistakenly ascribes the publication of the *Blaue Reiter Almanac* to 1913, rather than 1912.

25. " ... unterlag der für mich zu starken Untersuchung"; Kandinsky seems to have confused the German words *Untersuchung* [examination] and *Versuchung* [temptation]; the latter is preferred in this translation. Significantly, at this point in "Stupeni" we find the Russian word for temptation, *iskusheniia*, not *iskanie* [examination].

26. S adds: "(as the majority of theories in general are)."

27. S adds: "making my breathing shallow."

28. Sentence not in S.

29. S reads: "I remember distinctly how I loved the materials themselves, how attractive, beautiful, and alive the colors, brushes, crayons seemed to me, my first oval ceramic palette, and later the charcoal wrapped in its silver paper. Even the smell of turpentine was bewitching, serious, and powerful, so that even now this smell conjures up for me a kind of special, resonant state, in which the principal element is a feeling of responsibility."

30. S adds: "He tried from the very beginning to encourage my independence:"

31. S reads: "With unfailing generosity, he supported me materially for many long years, despite his own somewhat modest resources."

32. Sentence not in S.

33. Sentence not in S.

34. S adds: "Even quite recently the use of pure black occasioned in me a significantly different feeling from that of pure white."

35. S reads: " . . . whither I was despatched by the Moscow Society for Science, Anthropology, and Ethnography."

36. For Kandinsky's reports on these subjects, see the resume given in the introduction, pp. 862– 68.

37. S reads: " . . . painted twelve or fifteen years ago . . . "

38. Sentence not in S.

39. S reads: "On days when I became disenchanted with painting in the studio and with my compositional experiments, I would throw myself into painting landscapes, which agitated me like an enemy before a battle, an enemy who would, in the end, conquer me: rarely did my studies satisfy me even partially, although I sometimes tried to extract the healthy sap from them in the form of a painting."

40. S reads: "The very word *composition* called forth in me an inner vibration. Subsequently, I made it my aim in life to paint a 'Composition.' In confused dreams there sometimes appeared before me intangible fragments of something that, though indefinite, at times frightened me by its power. On occasions I dreamed of harmonious pictures that left me on awakening with only an indistinct trace of fantom details. Once, in the throes of typhoid fever, I saw with great clarity an entire picture, which, however, somehow dissipated itself within me when I recovered. Over a number of years, at various intervals, I painted *The Arrival of the Merchants,* then *Colorful Life;* finally, after many years, I succeeded in expressing in *Composition 2* the very essence of that delirious vision—something I realized, however, only recently. From the very beginning, that one word 'Composition' resounded in my ears like a prayer. It filled my soul with reverence. And ever since it has pained me to see how frivolously it is often treated. I allowed myself complete freedom when painting studies, even submitting to the 'whims' of my inner voice."

41. S adds: "At this time, there was great enthusiasm for the drawings of Carrière and the paintings of Whistler. I often harbored doubts about my own 'conception' of art; I tried to conquer my feelings, to force myself to like these artists. But there was a blurriness, a sickliness, something cloyingly feeble about this kind of art that repelled me anew, and I turned once more to my dreams of plenitude, of resounding 'choirs of color,' and eventually of compositional intricacy." The French version published in Bouillon, 1974, p. 105, makes nonsense of this passage by mistranslating the first sentence (*"C'était l'époque où je m'enthousiasmais pour les dessins de Carrière et la peinture de Whistler"*), as does the German version published by Roethel and Hahl (*Das war zu der Zeit, als ich mich für die Zeichnungen Carrières und die Malerei Whistlers begeisterte;* Roethel/Hahl, 1980, p. 156).

42. S reads: "The Russian critics . . . decided either that I was bestowing upon Russia, in diluted form, Western European values (and already outdated ones at that), or else that I had perished under the harmful influence of Munich."

43. S continues: "Experience, and the passing of years increase one's indifference to this kind of judgment. The occasional eulogies (destined to resound more and more loudly) to which my painting is subject have already lost the power to move me, as they did at the time of my debuts: the art criticism one finds in the newspapers and even in journals has never formed 'public opinion,'

but has always been formed by it. And indeed, that opinion reaches the artist's ears long before the columns of the newspapers. But it seems to me even that very opinion can be divined firmly and with precision long before its formation. And however mistaken this opinion, and the critical judgments formed by it, maybe at the outset (and sometimes over a period of many, many years) the artist in general knows at the moment of his maturity the worth of his own art. And for the artist, being outwardly overestimated must count as more terrible still than being outwardly underestimated." Bouillon, 1974, p. 106, mistranslates "vneshniaia ego pereotsenka" as "surestimé de l'intérieur."

44. S reads: " . . . along the tranquil and introverted Sukhona river as far as Ust'sysol'sk. I then had to continue my journey by springless coach between endless forests, among brightly colored hills, across swamps, deserts, being subjected to unaccustomed jolting by forest 'clearings.' I traveled completely alone. . . ."

45. S. continues: "but the nights, despite the almost complete absence of darkness, were so cold that even the sheepskin coat, felt boots, and Syryenian hat, which I had procured on the way with the help of N. A. Ivanitsky, sometimes proved not entirely sufficient, and with warm heart I remember the coachmen. . . ." S also adds the following footnote on Ivanitsky:

> A noble hermit from the town of Kadnikov, secretary of the local council, a botanist and zoologist who had met with no interest in Russia, though he had published in Germany, author of serious ethnographic studies and . . . responsible for organizing the exploitation by the zemstvo [community] of the craft products made from the local horn, which he had wrested from the merciless hands of traders. Recently, N. A. was offered an interesting and rewarding position in Moscow, but at the last minute he refused it; he had not the heart to leave his outwardly modest, but inwardly so significant affairs. On the occasion of this journey it happened more than once that I encountered isolated, entirely selfless creators of the future Russia, which in this respect already rejoiced in its multicolored complexity. Among them the village priests occupied by no means the last place.

46. S reads: " . . . who would from time to time wrap me up again in the rug that had slipped from me in my sleep."

47. S reads: "I arrived in villages where the population, with yellow-gray faces and hair, went about dressed from head to toe in the same yellow-gray clothes, or else, with their white faces, red-painted cheeks, and black hair, would appear so brightly and colorfully dressed that they seemed like moving, two-legged pictures."

48. S reads: "I shall never forget the great, two-storied izbas [wooden houses] covered with carvings, with a samovar glistening on the hearth. This samovar was here no 'luxury' item, but the first essential: in certain localities, the population was nourished almost exclusively on tea (willow-herb tea), if one discounts the bread made from barley or oatmeal, which submitted easily to neither the teeth nor the digestion—all the population there went around with swollen stomachs. In those same extraordinary izbas, I also encountered for the first time the miracle that was subsequently to become one of the elements in my works."

49. S: *"lubki."*
50. Phrase in parentheses not in S.
51. S reads: " . . . all hung with painted and printed images. . . ."
52. S reads: " . . . and especially in the cathedral of the Assumption and the church of St. Basil the Blessed."
53. S continues:

> Often, I closed my eyes to these questions. Sometimes it seemed to me that these questions were impelling me along a false, dangerous path. And only after many years of intense work, innumerable cautious experiments, ever-new, unconscious, or semiconscious impressions which I began to experience and to desire more and more clearly, and by means of which I acquired the capacity inwardly to experience artistic forms in increasingly pure, abstracted form, did I arrive at the pictorial forms I use today, on which I am working today, and which will I hope be given much more fully perfected shape.

54. S reads: " . . . or else, in moments of good fortune, constituting itself actually in the course of work." S continues:

> Sometimes, they came only after a long struggle, and I had to wait patiently, not infrequently with fear in my heart, until they ripened within me. Such inner ripenings do not lend themselves to observation: they are mysterious and depend on hidden causes. Only on the surface of one's spirit, as it were, can one feel indistinctly an inner ferment, a particular summoning-up of inner strength that foretells more and more clearly the attainment of that blessed hour which may last for an instant, or for whole days. It seems to me that this process of spiritual fertilization, the ripening of the fruit, labor, and birth, corresponds exactly to the physical process of the conception and birth of man. Perhaps worlds, too, are born in this way.
>
> But whether by virtue of their degree of tension or of their quality, these "transports" are of entirely different kinds. Only experience can teach one their properties and the possibilities of exploiting them. I have had to train my ability to bridle myself, not simply to let myself go, but to guide these forces.

55. S reads: "Over the years, I have realized that to work with hammering heart . . . your whole body tense does not produce irreproachable results: *these* transports, during which one's sense of self-discipline and self-criticism is, at moments, completely suspended, are invariably followed by rapid disenchantment. Such exaggerated states can, at best, last for a few hours; they will do for some small piece of work (they can best be exploited for sketches or for those small pictures that I call "Improvisations"), but they can never be sufficient for a major piece, which demands sustained inspiration, a persistent tension which does not relax in the course of whole days."
56. Sentence not in S.
57. S continues: "On the other hand, the artist is perhaps in a position— albeit only partially and by chance—to summon up within himself these states of inspiration by artificial means. Moreover, he can qualify the nature of those states which arise within him of their own volition. Years of experience allow

one to preserve such moments within oneself, or else, at times, to stifle them completely, only to resuscitate them almost infallibly later. But here, too, complete exactitude is of course impossible. All the experience and knowledge that relate to this area are but one of the elements of 'consciousness,' 'calculation,' in one's work, which can also be signified by different names. The artist must know. . . ."

58. Sentence not in S.

59. S reads: ". . . to the very limits prescribed by fate." and adds the following footnote:

> Nervosity, that often deplored heritage of the nineteenth century, which has given birth to a whole series of insignificant, albeit extremely beautiful works in all realms of art, but not to anything inwardly or outwardly great, must be considered already on the way out. In my opinion, an age of new, inner definition, of spiritual "knowledge," is coming ever closer, an age that can alone give to artists of every art that indispensable, enduring tension and equilibrium, that confidence, that power over oneself, which constitutes the essential, finest, indispensable soil for the propagation of works characterized by great inner complexity and depth.

60. S reads: "To this very day I have never succeeded in conquering this insuperable difficulty, and I have renounced this kind of knowledge forever. But at a time when I could still be obliged to acquire redundant knowledge, my only salvation was my visual memory."

61. Sentence not in S.

62. S reads: " . . . and later a whole series of German, Dutch, and Arabian tempera drawings."

63. Preceding passage ("In the same way . . . to see continuously.") not in S.

64. S reads: "A few years ago, I noticed completely unexpectedly that this capacity had diminished. I quickly realized that my capacity. . . ."

65. S adds: "Its time simply came, and it started to develop, demanding the aid of my exertions."

66. Phrase "with submissive suppleness and devotion" not in S.

67. Sentence not in S.

68. Paragraph not in S.

69. Next two sentences not in S.

70. S adds footnote: "By comparison with the short German, French, or English words, this long Russian word [*proizvedenie*] itself seems to express the whole history of creation—long, complex, mysterious, with overtones of 'divine' predestination."

71. S reads: "In time, these experiences became the point of departure for those thoughts and ideas that attained the level of consciousness at least fifteen years ago." S continues:

> I noted down these experiences in random fashion, and only later became aware of the organic relationship between them. I felt with increasing strength and clarity that in art, the center of gravity lies not in the realm of the "formal," but exclusively in the inner impulse (content), which imperiously subjugates the formal element.

72. S continues:

It was not easy for me to abandon the commonly held view of the supreme significance of style, of period, of formal theory, to realize inwardly that the quality of a work of art depends not upon the degree to which it expresses the formal spirit of its time, nor upon the extent to which it corresponds to those theories of form that, in a given age, are held to be infallible, but totally and utterly upon the strength of the artist's inner desire (= content) and upon the eminence of the forms he has chosen, which are specifically necessary to him. It became clear to me, *inter alia*, that as regards formal questions, even the "spirit of the age" is formed precisely and exclusively by those grandiloquent artists—"personalities" who, by their strength of conviction, dominate not only their contemporaries, possessed of less intensive content or else of merely external talent (without inner content), but also successive generations and centuries of artists.

73. S continues:

Only in recent years have I finally taught myself to appreciate with love and joy "realistic" art, "hostile" to my own personal art, and to walk coldly and with indifference past works "perfect in form" that might appear spiritually related to my own. But I know now that this "perfection" is only apparent and short-lived, that there can be no perfection of form without perfection of content: the spirit determines matter, not vice versa. The eye charmed from lack of experience quickly loses interest, and the spirit, temporarily deceived, soon turns away. The criterion I have proposed has one weakness—that it is not "verifiable" (especially in the eyes of those deprived not only of active, creative, but also of passive content, i.e., in the eyes of those who are condemned to remain on the surface of form, and are incapable of immersing themselves in the infinity of content). But the great Broom of History, which will sweep away the dross of the external by the spirit of the internal, here too acts as the ultimate, unimpeachable judge.*

*The principle *l'art pour l'art*, in its superficial sense, is still so strong in our contemporaries—their minds are still so choked by this question of "how" in art—that they are capable of believing the now-current assertion: Nature is merely a pretext for artistic expression, and as such it has no essential role in art. Indeed, only a habitual superficiality in experiencing form could have numbed the spirit to such an extent that it is incapable of hearing the resonance of such an element, however secondary it may be, in the work of art. It seems to me that, as a result of the *internal*-spiritual transition that we have in our own quite particular era already achieved, this truly "Godless" attitude toward art will quickly change, even if not completely supplanted in all its scope, i.e., among the mass of artists and the "public," at least as far as the masses are concerned, into a more healthy soil. In many cases, their living souls, which had been but temporarily stifled, are awakening. Here, the development of one's spiritual receptivity, of boldness in one's own, *independent* experiences constitutes the most important necessary condition. I devoted a firmly definite article to this complex question, "On [the Question of] Form," in the *Blaue Reiter* [*Almanac*].

74. Sentence not in S.

75. S reads: "Anton Ažbè, a Slav by extraction, was a gifted artist and a man of rare spiritual qualities."

76. Next two sentences not in S.

77. S reads: " . . . the course given especially for artists by the spirited and lively Professor Moillet of Munich university." Kandinsky also refers to these anatomy lectures in his fourth "Letter from Munich" (see p. 69), where the teacher's name is given not as "Moillet," but as "Mollier"; the latter spelling is correct. It is possible that Kandinsky was, as Bouillon suggests, confusing the anatomist Siegfried Mollier with the Swiss painter, Louis Moilliet. See Bouillon, 1974, p. 271, n. 91; also Roethel/Hahl, 1980, p. 165. In S, Kandinsky adds to the words "especially for artists" the following footnote:

> But not for women artists: women were not admitted to these lectures, nor to the academy, as has remained the case to this very day. Even in the private schools, there always existed a misogynistic element. As was the case after our "canine revolt" (previously, students had come into the studios with their dogs, something subsequently prohibited at the suggestion of those same students), there were quite a few advocates of a "female revolt," "women to be left outside." But the supporters of this "revolt" turned out to be insufficiently numerous, and this sweet dream remained in the realm of unattained desires.

78. S reads: "It seemed strange to me, almost offensive" and omits remainder of paragraph.

79. S adds: "As a consequence, I realized that, for the same reason, everything that is ugly from expediency is beautiful—in the work of art as well."

80. S omits next sentence and continues: "One of my most sympathetic companions told me, by way of consolation, that colorists often fail to master drawing. But this did not assuage my fear at the misfortune that menaced me, and I did not know by what means I should seek my salvation."

81. S adds: "I was discountenanced: it seemed to me that, since I had not mastered drawing in two years, I would never do so."

82. S reads: "the professorial board* approved the kind of drawings I felt perfectly entitled to call stupid, untalented . . . " and adds footnote:

> *Students were accepted into the lower "drawing" classes of the Academy after an official examination set by the whole board of professors who taught these lower classes. Into the higher, "painting" classes, the professor would accept students according to his own personal view, and if he came to the conclusion that he had been mistaken about the talent of a particular student, he was at equal liberty to erase him from his lists—something that it appears, only Stuck actually did, which is why he was especially feared.

83. S adds: "(pictorially speaking, sometimes the weirdest things were done there)."

84. S reads: "This 'allowed' revealed to me the secret of serious work."

85. S adds: "like morals, . . ."

86. Following phrase not in S.

87. S reads: "The development of art resembles the development of nonmaterial knowledge."

88. S adds: "—an essential characteristic of all truth and all wisdom."

89. Next two sentences not in S, which then starts new paragraph.

90. S reads: "And this replication, this further growth and further complexity, which often seem hopelessly confused, or else obscure the path of human development, are nothing other than the necessary stages that lead to the mighty crown: the constituent conditions that lead ultimately to the creation of the green tree."

91. In S, this whole paragraph is considerably altered so as to read: "The progress of moral evolution is also comparable, taking as its starting point religious definitions and imperatives. The moral laws of the Bible, which are expressed in simple formulas, like elementary geometry—thou shalt not kill, thou shalt not commit adultery—in the following (Christian) period are given, as it were, a more flexible, freer outline: their primitive, geometrical character is ousted by an outwardly less exact, free contour. Not only purely material transgressions, but also internal actions that have not yet emerged from the realms of the nonmaterial are accounted inadmissible."

92. S reads: "On the scales of Christianity. . . ."

93. S reads: "As a rule, artists have until now either stifled within themselves the desire to create virtuoso works of this kind, or else denied its existence in works that have come into being in this way—something that is only to be regretted. Great artists have not been afraid of this desire. So-called copies. . . ."

94. S reads: " . . . and thus the merely incidental demands I made of art, which bore no relation to its essence, disappeared one after another."

95. S reads: " . . . grew from the same basis as that of moral judgments." then adds reference to footnote at this point and omits following sentence.

96. S reads: "I observed that this view of art develops at the same time out of the purely Russian spirit, which as it manifests itself in the primitive forms of folk law, appears the antithesis of Western European principles of justice; whose origin was Roman pagan law."

97. S reads: "And finally; every deed is morally ambivalent."

98. S continues:

This gradual emancipation of the spirit—the good fortune of our time—explains the profound interest and increasingly prominent "belief" in Russia that more and more frequently possesses those elements in Germany capable of independent sentiments. During the last years before the war, I had increasingly frequent occasion to receive in Munich representatives of the young, unofficial Germany, which had previously been unknown to me. They manifested not only an intense inward interest in the essence of Russian life, but also a firm belief in "salvation from the East." We understood each other clearly, and had the vivid feeling of living in one and the same spiritual realm. And I was often struck by the intensity of their dream, to "see Moscow one day." And it was especially strange and cheering to observe exactly the same inner stamp among my Swiss, Dutch, and English visitors. During the war, when I was for a time in Sweden, I again had the good fortune to encounter Swedes as well who were of exactly the same turn of mind. Just as the mountains recede slowly and inexorably, slowly and inexorably the

frontiers between peoples will recede, too. And "humanity" will no longer be an empty sound.

99. Last seven words not in S.

100. S reads: "Franz Marc, whom I came to know at this time of general hostility towards me, found a publisher for the former book."

101. Last six words not in S.

102. S continues: " . . . its predominance over the intuitive element, nor, *ultimately*, perhaps the total exclusion of 'inspiration.' We know only the law of today, of those few millennia out of which developed gradually (and with obvious digressions) the genesis of creation. We know only the characteristics of our own 'talent,' with its inevitable unconscious element, having its own *determinate* coloration. But perhaps the work of art that is divided from us by the mists of 'eternity' will be created, as it were, by calculation, in such a way that precise reckoning is revealed, perhaps, only to the 'talented,' as is the case, e.g., in astronomy. And if, indeed, it transpires *only* thus, the character of the unconscious will then assume a different coloration to that of the ages known to us."

103. S reads: "After our Italian journey mentioned above, and after a brief stay in Moscow, when I was five years old my parents were obliged, for reasons of my father's health, to move, together with E.I. Tikheeva, to whom I owe so much, to the South, to Odessa, which was then very little built up."

104. S reads: "Our longing to return to Moscow never deserted us."

105. S reads: "My father comes from Nerchinsk, whither, as the story goes in our family, his forefathers were banished. . . ."

106. S reads: "His profoundly human spirit understood the 'Moscow soul,' which expresses itself so vividly in every detail."

107. S reads: "It was always a real delight for me to hear him recite, for example, with a special love the ancient, redolent names of the 'forty times forty' Moscow churches."

108. S continues: "He is very fond of paintings, and in his youth studied drawing, something he always recalls with affection. He often drew for me when I was a child. Even now, I can remember well his delicate, tender, and expressive line, which so closely matched his elegant figure and surprisingly beautiful hands. One of his greatest pleasures has always been to visit exhibitions, where he looks at the pictures long and attentively. He does not condemn what he does not comprehend, but tries to understand, questioning all those from whom he hopes to obtain some answer."

109. Sentence not in S, which here begins new paragraph.

110. Paragraph not in S.

111. Instead of "Munich, June 1913," S reads:

Munich, June–October 1913
Moscow, September 1918

112. Düsseldorf, Kunstsammlung Nordrhein-Westfalen. Listed by Kandinsky in his House Catalogue of paintings under no. 125 (1911); see Grohmann, 1958, p. 331, and color pl. on p. 123.

113. Destroyed; see n. 15 to p. 124, and n. 5 to p. 395.
114. Leningrad, State Hermitage Museum. Listed by Kandinsky in his House Catalogue of paintings under no. 172 (1913); see Grohmann, 1958, p. 332.
115. Kandinsky's glass-painting *The Deluge* is reproduced in Roethel, *Kandinsky, Painting on Glass*, fig. 33. Present whereabouts unknown.
116. New York, Solomon R. Guggenheim Museum. Listed by Kandinsky in his House Catalogue of paintings under no. 173 (1913); See Grohmann, 1958, p. 332; also Rudenstine, 1976, pp. 256ff.

Cologne Lecture

1. The details given here are based largely on the information provided by Eichner, *Kandinsky und Gabriele Münter*, pp. 108ff.
2. This exhibition was also shown in Barmen and in Aachen during the spring of 1914; see Donald E. Gordon, *Modern Art Exhibitions, 1900–1916*, vol. 2, p. 100. It was not, according to Angelica Rudenstine, shown in Berlin (letter of 28 November 1977 to Peter Vergo); the references in Rudenstine, 1976 (e.g., p. 227) to an exhibition under the heading "Berlin, Kreis für Kunst Köln im Deutschen Theater, *Kandinsky-Ausstellung*, Jan. 30–Feb. 15, 1914" rest upon a confusion. The editors are grateful to Mrs. Rudenstine for helping to clear up this point.
3. See Bouillon, 1974, p. 287, n. 135.
4. *Buntes Leben* (1907); Munich, Städtische Galerie im Lenbachhaus. Listed by Kandinsky in his House Catalogue of paintings under no. 64; see Grohmann, 1958, p. 330 and pl. on p. 261.
5. Destroyed. A sketch for this picture is in the Solomon R. Guggenheim Museum in New York; see Rudenstine, 1976, pp. 228ff. The original was one of the three Kandinsky paintings reproduced in the artist's treatise *On the Spiritual in Art* (this edition p. 216).
6. *See - Kahnfahrt* (1910); Moscow, State Tret'iakov Gallery, no. 4901. Listed by Kandinsky in his House Catalogue of paintings under no. 106; see Grohmann, 1958, pp. 331, 352. The motif of this painting was transposed in literal fashion in one of the color woodcuts from *Sounds* (Roethel, 1970, no. 115).
7. *Bild mit Zickzack*; cannot be located in Kandinsky's House Catalogue of paintings.
8. Solothurn, private collection; Grohmann, 1958, p. 332 and pl., p. 270. Listed by Kandinsky in his House Catalogue of paintings under no. 144 (1911).
9. See n. 114 to p. 898 above.
10. Formerly Brunswick, coll. Otto Ralfs. Listed by Kandinsky in his House Catalogue of paintings under no. 140; see Grohmann, 1958, p. 332.
11. [*evtl. vorlesen!*]; a note by Kandinsky reminding himself that, were he to deliver this lecture on his work, he might perhaps read an extract from his own description of the genesis of *Composition 6*, published in the Sturm album of 1913 (see above, p. 385ff.).

Letters to Arthur Jerome Eddy

1. The genesis of the Campbell panels is described in detail by Rudenstine, 1976, pp. 281ff., who also quotes extensively from the Eddy correspondence. See also Kenneth C. Lindsay, "Kandinsky in 1914 New York: Solving a Riddle," *Art News* 55 no. 3 (May 1956):32–33, 58–60. Eddy's role in introducing Kandinsky's work to the United States was crucial. Stieglitz had brought the only painting by Kandinsky included in the Armory Show, but three works by the Russian master were to be seen at the Allied Artists exhibition at the Royal Albert Hall in London. Encouraged perhaps by Roger Fry's positive review in *The Nation* (2 August 1913), Eddy bought all three and then continued his journey to the continent, buying more paintings and all the publications he could lay his hands on. When he arrived at Murnau, Kandinsky was in Russia and Münter in Berlin; but the housekeeper showed him into Kandinsky's studio, at which time he selected about twelve paintings (letter from Gabriele Münter to Kenneth Lindsay, 10 April 1950).

In Eddy's will, the Bill of Appraisement (by the Fidelity Appraisal Company of Milwaukee) lists fifteen works by "Kandinsky" and "Kamdisky." On his wife's death in 1930, four of Eddy's Kandinskys went to the Art Institute at Chicago. Several more were auctioned by Williams, Barber, and Severn on 20 January, 1937. The auction company went out of business and the knowledgeable people who attended—Katherine Kuh, John Anthony Thwaites, and Daniel Catton Rich—have no detailed records or auction book. Eddy's son, Jerome Orville, moved to Albuquerque, New Mexico to raise livestock; he remembered very little about his father's collection and did not know what had happened to correspondence and other documents (no trace has been found of the originals of Kandinsky's letters to Eddy). Jerome Orville gave one painting to a sister-in-law, and sold several to Walter Arensberg, via Earl L. Stendahl's gallery in California. The whole affair is a depressing example of how the records and achievements of a considerable man could be thrown to the winds by his own family, and how a major museum—the Chicago Art Institute—could let opportunity slip through its fingers.

Though he began with European art, Eddy became increasingly aware of American efforts. He told Stieglitz in a letter of 30 March 1916 (Yale University Library) that he wanted to have an American bibliography included in the first edition of his book on modern art. His will stated that, for want of beneficiaries, one quarter of his estate was to go to the Chicago Art Institute "with which to encourage by prizes and purchases the production of paintings and sculpture, especially decorative and architectural, in America, by native Americans working and residing in this country. This restriction is made because production by native workers is not encouraged as it should be and, of all workers, they are usually in the greatest need."

2. Eddy, p. 200.

3. *Improvisation No. 30 (Kanonen)*; Chicago, Art Institute. Listed by Kandinsky in his House Catalogue of paintings under no. 161 (1913).

On the Artist

1. According to Eichner, *Kandinsky und Gabriele Münter*, pp. 171ff.
2. See Kenneth C. Lindsay, "Kandinsky in 1914 New York," pp. 32–33, 58–60; Rudenstine, 1976, p. 284; this edition, p. 401 and n. 1.
3. Parts of the German *Urtext* are quoted by Eichner, pp. 172ff.

Art without Subject

1. See, e.g., Gregor Paulsson, "Kandinsky utställningen hos Gummesons," *Stockholms Dagblad*, 2 February 1916. The bibliography printed in Grohmann, 1958, pp. 413ff. lists under sec. 3 (journal articles) an "Answer to Critics" in *Konst*, no. 1–2 (1912), but no such article has ever come to light; in our opinion, the date is mistaken, and the entry must in fact refer to "Art without Subject."

Little Articles on Big Questions

1. *Spravochnik Otdela Izo Nar. K. po Pr.*, (Moscow: IZO NKP, 1920), p. 124. On the role of IZO within NKP, see Sheila Fitzpatrick, *The Commissariat of Enlightenment* (Cambridge: Cambridge University Press, 1970), esp. pp. 122ff.
2. Kandinsky's activities in Russia during this period are also described by Troels Andersen, "Some Unpublished Letters by Kandinsky," pp. 90ff. and esp. pp. 99ff. Andersen states that the two "little articles" on point and on line were to have been published in an "Encyclopedia of Fine Arts" planned for publication under the auspices of IZO—apparently the same encyclopedia for which Kandinsky's brief "Self-Characterization" was originally intended. (See this edition, pp. 430–33). Andersen does not, however, indicate his authority for this assertion, nor why the two articles were actually published in *Iskusstvo*, itself the organ of NKP.
3. D. Burliuk, "Faktura," *Poshchechina obshchestvennomu vkusu* (Moscow: G. L. Kuzmin, 1912) p. 115.
4. Ibid., pp. 95ff.
5. "Suprematism in World Construction," in S. Lissitzky-Küppers, *El Lissitzky: Life, Letters, Texts* (London: Thames and Hudson, 1968), p. 329.

Self-Characterization

1. The first issue of *Das Kunstblatt* was published in January 1917 by the firm of Gustav Kiepenheuer in Potsdam. It opened with an essay by Westheim, "Von den inneren Gesichten" [On Inner Visions], and clearly reflected his particular interests: other contributions included an article by Gustav Schiefler, "Das Werk Edvard Munchs," a color reproduction of Munch's painting *Dead Mother*, and (in the deluxe edition) an original woodcut by Nolde. Westheim's own articles of this period betray a marked affinity with Kandinsky's way of thinking: the cover of the first issue bore a programmatic statement as to the aims of the periodical, which began: "*Das Kunstblatt* intends to serve the art of the future. An art that—leaving everything mechanical behind it—puts the

creative urge, divine inwardness, in the place of that beauty born of formulas whose pleasing glitter charms the senses."

2. This prefatory note reads: "We are including as a unique document in the literature of art this self-characterization by Kandinsky that has been sent to us for publication, intended for an encyclopedia that is now in preparation in Russia. Kandinsky is one of the most controversial phenomena within present-day painting. An enthusiastic following is opposed by no less decided condemnation. We have considered it right to allow, entirely objectively, one representative of each opinion the space to justify their attitudes."

3. Andersen, p. 104; see also n. 2 to p. 421 above.

4. The reference is to the notorious "Kandinsky affair" of spring 1913, following the showing of his work by the Galerie Louis Bock in Hamburg; see p. 348 above and n. 2; also Bouillon, 1974, pp. 17ff.

5. Another instance of Kandinsky's shaky memory; the first edition of the *Blaue Reiter Almanac* was published in 1912, the second in 1914.

6. On the dating of *Sounds*, see pp. 291 and 2 above.

7. The reference is to Michael T. Sadler's translation, entitled *The Art of Spiritual Harmony* (London: Constable & Co., 1914).

8. The Russian version of Kandinsky's "Reminiscences," under the title "Stupeni" [Steps]; see above, p. 357.

9. This statement has been the cause of some confusion. Andersen, p. 105, publishes a letter dated 26 May 1921 from Kandinsky to Aleksandr Benois, asking the latter to take a "favorable view" of the possibility of publishing a Russian version of his "German book," *On the Spiritual in Art*. This request is not easily reconciled with the artist's 1919 statement that a start had already been made on printing *On the Spiritual* in Moscow; nor is it clear what Kandinsky means by "for a second time." Roethel, 1970, p. 444, states that "according to the latest scholarship, a Russian edition [of *On the Spiritual*] appears to exist in book form," and cites Nina Kandinsky as his authority for this assertion. No such edition has come to light. A Russian version of *On the Spiritual*, however, had already been published in 1914 in the *Proceedings of the Pan-Russian Congress of Artists* in Petrograd; see above, p. 115 and n. 4.

Artistic Life in Russia

1. Of particular interest in this respect are Nikolai Mashkovtsev's "Printsipy muzeinogo stroitel'stva" [Principles of Museum Construction] and Sergei Oldenburg's "Glavmuzei" [Chief Museum], *Khudozhestvennaia Zhizn'*, no. 4–5, (1920).

2. Other participants included Osip Brik, Sergei Chekhonin, Aleksei Grishenko, and Nikolai Punin. See also *Iskusstvo kommuny*, no. 11 (1919) reprinted in I. Matsa et al., (eds.), *Sovetskoe iskusstvo za 15 let* (Moscow and Leningrad: 1933), pp. 78–86; also *Spravochnik Otdela Izo Nar. K. po Pr.* (Moscow: IZO NKP, 1920), pp. 117–20.

3. *Spravochnik . . .* , pp. 117–18.

4. N. Tarabukin, *Ot mol'berta k mashine* (Moscow: 1923), p. 42; translated into French in *Le Dernier Tableau, écrits sur l'art et l'histoire de l'art . . . présentés par Andrei B. Nakov* (Paris: Editions Champ Libre, 1972), pp. 33ff.
5. *Spravochnik . . .* , p. 80.
6. This report is also discussed by Andersen, "Some Unpublished Letters," pp. 101ff.

Program for the Institute of Artistic Culture

1. *Spravochnik . . .* , p. 126.
2. Published in D. Sarab'ianov, *Aleksei Vasilievich Babichev* (Moscow: 1974), pp. 104–5.
3. Published in John E. Bowlt, ed., *Russian Art of the Avant-Garde* (New York: Viking Press, 1976), pp. 196ff. Although this plan quite clearly reflects Kandinsky's own aims and ideas, the statement as published is not, in our opinion, from the artist's own hand.
4. The reference is to Kandinsky's *Yellow Sound*, published in the *Blaue Reiter Almanac*; see above, pp. 231 and 268.
5. Aleksandr Skriabin, *Prometheus: The Poem of Fire*, op. 60 (1910). This symphonic poem includes a part for "color organ," an instrument that produced no sound, but rather projected different-colored lights according to a predetermined system of notation. See also Leonid Sabaneev, "Prometheus von Skrjabin," *Der Blaue Reiter* (Munich: R. Piper & Co., 1912), pp. 57ff; Lankheit, 1974, pp. 127ff.

Report to the Pan-Russian Conference

1. The conference is described by Sheila Fitzpatrick, *The Commissariat of Enlightenment* (Cambridge: Cambridge University Press, 1970), pp. 160ff; Kandinsky's report is also discussed by Andersen, "Some Unpublished Letters," pp. 105ff.

Interview with Charles-André Julien

1. The French version of the text as published reads ambiguously here: *"en 1920 : 10, en 1/2; 1921 : 8, des tasses, des broderies."* It might equally well mean: "in 1920, ten [paintings], half finished. . . ."

Foreword to the catalogue of the first International Art Exhibition

1. See Dawn Ades, *Dada and Surrealism Reviewed* (London: Arts Council of Great Britain, 1978), pp. 124ff.

A New Naturalism?

1. *Das Kunstblatt*, 6, no. 8 (August 1922):368.

Foreword to the Catalogue of the Kandinsky Exhibition at Gummesons

1. *Roter Fleck II* [Red Spot II], *Schachbrett* [Chess board], *Bunter Kreis* [Motley Circle]; listed by Kandinsky in his House Catalogue of paintings under nos. 234, 237, and 238 (all 1921). See Grohmann, 1958, p. 334.

2. Kandinsky's essay was evidently written, one presumes during the summer holidays, at Timmendorferstrand, a resort on the Baltic coast not far from Lübeck. According to a letter dated 14 December 1936, the Kandinskys spent more than one vacation there as guests of Frau Gropius, mother of the architect. Kandinsky recalled his hostess, more than a decade after his visits, with warm affection. (See "Wassily Kandinsky, Briefe an Hans Thiemann," *Blätter für Buch und Kunst,* Heft 1, Folge 2 (1971), p. 35.) Timmendorferstrand would have been a convenient point of departure for visits to Scandinavia.

Small Worlds

1. According to Roethel, 1970, p. 452.

2. Letter to Galka Scheyer dated 4 May 1932, Galka Scheyer Bequest, Pasadena Art Museum. Cited by Roethel, 1970, p. 452.

On Reform of Art Schools

1. W. Waetzoldt, *Gedanken zur Kunstschulreform* (Leipzig: Quelle & Meyer, 1921).

2. A. Lunacharsky, *Die Kulturaufgaben der Arbeiterklasse* (Berlin-Wilmersdorf: Die Aktion, 1919); K. Umansky, *Neue Kunst in Russland 1914–1919* (Potsdam: Gustav Kiepenheuer, 1920).

Bauhaus, 1919–1923

1. All the preliminary publicity for the exhibition, including the postcards designed by various artists such as Kandinsky and Feininger, and the large poster by Joost Schmidt, gives the dates of the exhibition as either "July–September 1923" or "July–October 1923." However, a photograph reproduced in Wingler, 1968, p. 365, shows one of the entrances to the exhibition with a poster above the doors that reads, "Ausstellung 15 Aug–30 Sept." It seems likely that the exhibition was originally planned to run for a longer period than proved feasible.

2. The book appeared in an edition of twenty-six hundred copies: two thousand in German, three hundred in English and three hundred in Russian. The printing of the texts was in fact done by the firm of F. Bruckmann in Munich: (*Staatliches Bauhaus Weimar, 1919-1923* [Weimar and Munich: Bauhausverlag, 1923], p. 226.) The publication was supported by the art dealer Karl Nierendorf in Cologne.

3. Walter Gropius, "Idee and Aufbau des Staatlichen Bauhauses Weimar"; Gertrud Gronow, "Der Aufbau der lebendigen Form durch Farbe, Form, Ton"; *Staatliches Bauhaus Weimar, 1919–1923*, pp. 20–23. "Idee und Aufbau,"

which served as a preface to the volume, was also issued as a separate pamphlet by the Bauhausverlag G.m.b.H., Munich. See Wingler, 1968, pp. 77, 83ff.

4. Paul Klee, "Wege des Naturstudiums," *Staatliches Bauhaus Weimar, 1919–1923,* pp. 24ff: reprinted in Wingler, 1968, p. 86; see also *Paul Klee Schriften—Rezensionen und Aufsätze,* ed. Christian Geelhaar (Cologne: Du-Mont, 1976), pp. 124–26, 177.

5. "Color plate V" is omitted in this edition, since it shows once again, in a rather similar fashion to the diagrams in the "Color Questionnaire" (See p. 850), the three "basic forms" so beloved of the Bauhaus—square, triangle, and circle, the square colored red, the triangle yellow, and the circle blue. For the correct bibliographic references to the St. Petersburg *Proceedings,* see above, p. 115 and n. 4.

6. Since it was not possible to incorporate color in this edition, the color plates listed by Kandinsky have been omitted; they can be found in the original publication, *Staatliches Bauhaus Weimar, 1919–1923,* following p. 60.

Abstract Art

1. *Rossiiskaia Akademiia Khudozhestvennykh Nauk*—usually known by its acronym RAKhN. RAKhN was formally established on 7 October 1921 by the Commissariat of Enlightenment, under the presidency of Petr Kogan. It later embraced the originally autonomous Institute of Artistic Culture (see above, pp. 455ff.). Kandinsky was head of the Physico-Mathematical and Physico-Psychological Department of RAKhN; an account of his plan for the Physico-Psychological Department has been published by John E. Bowlt, *Russian Art of the Avant-Garde,* pp. 196ff.

Dance Curves

1. Arthur Lehning and Jurriaan Schrofer, eds., *i10, de internationale avant-garde tussen de twee wereldoorlogen* (The Hague: Bakker, 1963), pp. 6–7.

Point and Line to Plane

1. For a complete list of Bauhausbücher, see Wingler, 1968, p. 563.

2. Letter to Will Grohmann dated 3 November 1925; see Grohmann, 1958, p. 180.

3. "Analyse des éléments premiers de la peinture," *Cahiers de Belgique,* 4 (May 1928):126–32.

4. In *On the Spiritual,* Kandinsky makes repeated use of the neologism *Doppelklang* (see n. 44 to p. 168 above); in *Point and Line to Plane,* he several times employs the term *Zweiklang*—again, it seems, to denote two tones sounded together. "Dual sound" or "composite sound" also suggest themselves as possible translations. Cf. also p. 552 below. Other Kandinsky "specials" include *Dreiklang* [triple sound] and *Grundklang* [basic sound].

5. This edition, p. 499; see also n. 5 to p. 500.

6. *Kultur der Gegenwart* [Culture of the Present]; subsequently cited in the captions by the abbreviation "K.d.G." *Kultur der Gegenwart* was an encyclopedic series on science and culture that appeared in Germany during the 1920s. It was popular among the artists of the Bauhaus, especially for its illustrations, which exerted a considerable influence on Klee, among others; see Sara Lynn Henry, "Form-Creating Energies: Paul Klee and Physics," *Arts Magazine* 52, no. 1 (September 1977):118ff.

7. Professor Jonathan Chaves, formerly of the State University of New York at Binghamton, provided the editors with the following note to the caption to Kandinsky's fig. 8 (our gratitude to him for his assistance):

> The temple, from which the pagoda reproduced by Kandinsky comes, is properly called *Lung-hua ssu* in Chinese. It is located in the southwestern part of Shanghai prefecture, on the Ssu river in Chiangsu. "Shanghai" is used here for the whole prefecture; as such, the name goes back to the Sung dynasty.
>
> The name of the temple, *Lung-hua ssu*, is properly translated "Dragon-flower temple." In Kandinsky's caption, the character *hua*, which means "flower," has been misconstrued as "beauty"—another possible meaning of the character, but the wrong one in this context. The name of the temple is based on the Sanskrit *Nāga-puspa*, "Dragon-flower tree."
>
> A temple of this name and in this location existed as early as the third century A.D.

8. See above, n. 5 to 500.

9. The reference is to the dancer Aleksandr Sakharov, before the war a fellow-member, with Kandinsky, of the Neue Künstler-Vereinigung München. See also pp. 52, 81 above.

10. The reference is to the third part of the botanical section of the series *Kultur der Gegenwart*; see n. 6 above.

11. Destroyed. Listed by Kandinsky in his House Catalogue of paintings under no. 92; see Grohmann, 1958, p. 331.

12. *Schwarzes Dreieck* (1925); formerly New York, Solomon R. Guggenheim Museum. Listed by Kandinsky in his House Catalogue of paintings under no. 320; see Grohmann, 1958, p. 335.

13. *Intime Mitteilung* (1925); Paris, formerly collection Nina Kandinsky. Listed by Kandinsky in his House Catalogue of paintings under no. 310; Grohmann, 1958, p. 335.

14. *Kleiner Traum in Rot* (1925); Paris, formerly collection Nina Kandinsky. Listed by Kandinsky in his House Catalogue of paintings under no. 311; Grohmann, 1958, p. 335.

i10

1. *i10*, 1, no. 1 (1927):1–2.

2. Arthur Lehning and Jurriaan Schrofer, eds., *i10, de internationale avant-garde tussen de twee wereldoorlogen*, pp. 6–7.

3. *i10*, 1, no. 4 (1927):148.

4. *i10*, 1, no. 6 (1927):227ff.

5. *Vkhutemas*—an acronym standing for "Higher Art-Technical Studios." Under the auspices of the Fine Arts board of the Commissariat of Enlightenment, Vkhutemas was formed, almost immediately after the revolution, by an amalgamation of the former Moscow School of Painting, Sculpture, and Architecture and the Stroganov School (of applied arts). See John E. Bowlt, ed., *Russian Art of the Avant-Garde*, pp. xxxivff.

Violet

1. Grohmann, 1958, p. 98.

2. Letter dated 24 January 1937 to Hans Hildebrandt, "Drei Briefe von Kandinsky," *Werk* 42, no. 10 (October 1955):330.

Bare Wall

1. Quoted after Wingler, 1968, p. 494.

The Psychology of the Productive Personality

1. The preface to the volume is dated 13 October 1929; in it, the author explains that his work on what he terms "psychography" derived initially from research in preparation for his *Handbook of Biological Working Methods*. [*Handbuch der biologischen Arbeitsmethoden*].

2. Plaut, *Psychologie . . .* , p. 271.

The Blaue Reiter (Recollection)

1. Both woodcuts, reproduced on pp. 58 and 59 of the article are described as being "from Kandinsky's *Sounds*." In neither case is this strictly true. The first, iconographically related to Kandinsky's painting *White Sound* of 1908, would appear to be the original state of the print, without color blocks, not the color woodcut (third state) published in *Sounds* (see Roethel, 1970, p. 226). The second bears no relation to *Sounds* at all, being originally employed as an illustration both for the catalogue cover and for the poster of Izdebsky's "Salon 2" exhibition of 1910–11. (See Roethel, 1970, pp. 162, 442; also this edition, pp. 84–85 and 86.)

Pictures at an Exhibition

1. Nina Kandinsky, *Kandinsky und ich*, p. 159.

2. Ibid., pp. 154ff.

Tribute to Klee

 1. Nina Kandinsky, p. 196
 2. See *Du*, 16, no. 3 (March 1956):27ff.

Reflections on Abstract Art

 1. Will Grohmann, *Kandinsky* (Paris, 1930); one of the series published by Éditions Cahiers d'Art under the title "Les grands peintres d'aujourd'hui."
 2. Grohmann, 1958, p. 204.
 3. *Flächen und Linien* (1930); Paris, private collection. Listed by Kandinsky in his House Catalogue of paintings under no. 522; see Grohmann, 1958, p. 338.
 4. The original reads *"sans objet"* [without object], but from the sense, this is clearly a mistake; it should read *"avec objet."*

Line and Fish

 1. Letter dated 2 January 1936; see "Wassily Kandinsky, Briefe an Hans Thiemann," in *Blätter für Buch und Kunst,* Heft 1, Folge 2 (1971), p. 32.
 2. *Chacun pour soi*; Paris, formerly collection Nina Kandinsky. Listed by Kandinsky in his House Catalogue of paintings under no. 598; see Grohmann, 1958, p. 340.

Two Directions

 1. "Reminiscences," p. 361.
 2. "On the Question of Form," p. 248.

Abstract Painting

 1. The editors are most grateful to Dr. W.H.K. van Dam, of the Rijksbureau voor kunsthistorische Documentatie, The Hague, for providing copies of this rare journal, and supplying many details regarding its publication.
 2. "Ter inleiding," *Kroniek van hedendaagsche kunst en kultuur* 1, no. 1 (June 1935). Polet was later accused by his fellow editors of having been a Nazi sympathizer; see *kroniek van kunst en kultuur, een keuze uit de jaargangen 1935–1952, samengesteld onder redactie van L.P.J. Braat* (Amsterdam: uitgeverei contact 1977), pp. 8ff.
 3. Part of Kandinsky's response to the questionnaire published by Zervos in *Cahiers d'Art* the previous year; for translation, see above, pp. 764ff. The two passages Kandinsky cites here occur on p. 768 of this edition.
 Another case of a mistake in the original, which reads: *"une musique sans paroles. . . ."* It has been amended here to conform to the text as first printed in *Cahiers d'Art,* which reads correctly: *"une musique avec paroles . . ."*

Franz Marc

1. It has now been published by Klaus Lankheit, *Franz Marc im Urteil seiner Zeit* (Cologne: M. DuMont Schauberg, 1960), pp. 43ff.

Assimilation of Art

1. The Danish title of this article, "Tilegnelse af Kunst", has been sub-jected to several mistranslations; see, e.g., Max Bill, ed., *Kandinsky, Essays über Kunst und Künstler* 2d ed., (Bern-Bümpliz: Benteli Verlag, 1963), p. 203, where the same article is titled "Zugang zur Kunst" [Access to Art]. Although it cannot mean "access," the Danish word *tilegnelse* can mean a number of things, including "dedication" or "appropriation." Followed by the preposition *af*, however, as here, it can only mean "appropriation" or "assimilation." Compare the German *Zueignung, sich zueignen*.

2. "Reminiscences," p. 361.

Interview with Karl Nierendorf

1. On Kandinsky's relations with his dealers, see Nina Kandinsky, *Kandin-sky und ich*, pp. 228ff. Before the Nazi period, Nierendorf had been a well-known dealer in Cologne, who assisted the publication of the 1923 Bauhaus volume (see above, pp. 498–99). In later years he also acted as American distributor for the periodical *XXᵉ Siècle*.

2. Hans K. Roethel and Jean K. Benjamin, "A New Light on Kandinsky's First Abstract Painting,": pp. 772ff. See also above, n. 6 to p. 357. *Painting With a Circle* is not listed in Kandinsky's House Catalogue of paintings.

3. See above, introduction p. 13 and n. 9.

4. Some recent contributions to this debate have served only to obscure the matter still further. See, however, the admirably lucid discussion of the proper use of the terms *abstract* and *nonobjective* in Rudenstine, 1976, pp. 274ff. (in connection with Kandinsky's painting *Light Picture*).

XXᵉ Siècle

1. Nina Kandinsky, *Kandinsky und ich*, pp. 162, 180ff.

2. "My Woodcuts" was accompanied by five of the prints from *Sounds* (Roethel, 1970, nos. 95, 106, 111, 105, 145) and the color woodcut *Bogenschütze* [With Archer], first published in the deluxe and museum editions of the *Blaue Reiter Almanac* (Roethel, 1970, no. 79).

3. Roethel, 1970, no. 201.

4. This essay only came to the editors' attention through the version printed in the second volume of the French edition of Kandinsky's writings; see *Wassily Kandinsky, Ecrits Complets, édition établie et présentée par Philippe Sers*, vol. 2 (Paris:Denoël-Gonthier, 1970), pp. 389ff.

5. Translated by M. T. Sadler (London: Constable & Co.; Boston: Houghton Mifflin Co.; 1914).

Letter to Irmgard Burchard

1. As it stands, this reference to "the London opening of the famous Munich exhibition of 'degenerate' German art" is somewhat misleading. What is meant is the exhibition "Twentieth-Century German Art," shown by way of a protest at the cultural policies of Nazism, under the heading "Banned Artists," at the New Burlington Galleries in London 7–31 July 1938. All the artists represented had also been included in the notorious *Entartete Kunst* [Degenerate Art] exhibition, shown by the Nazi government in Munich in summer 1937, and repeated the following year in Berlin. The Munich show was composed entirely of works taken from German museums; the pictures for the London exhibition, by comparison, were borrowed extensively from private collections in France, Switzerland, Holland, Belgium, England and America. The exhibition included works by Barlach, Baumeister, Beckmann, Campendonck, Corinth, Dix, Ernst, Feininger, Grosz, Hausmann, Heckel, Hofer, Kirchner, Klee, Kokoschka, Kollwitz, Macke, Marc, Nolde, Pechstein, Schlemmer, Schmidt-Rottluff, Schwitters, and Slevogt. There were ten works by Kandinsky listed in the catalogue, nos. 74–83. On the Munich *Entartete Kunst* exhibition, see further Ian Dunlop, *The Shock of the New* (London and New York: Weidenfeld & Nicolson, 1972), pp. 224ff.; and, for a more general account of art under the Nazis, J. Wulf, ed., *Die bildenden Künste im Dritten Reich* (Gütersloh: Rowohlt, 1963).

Statement in Journal des Poètes

1. This translation has been made from the version published in *Art d'Aujourd'hui* 6, no. 5 (January 1950).

Abstract and Concrete Art

1. This appears to have been common practice in the case of exhibitions held by galleries in the area, such as the Guggenheim and Mayor galleries, as well as the London Gallery itself, which was at 18 Cork St.; Guggenheim Jeune was at 30 Cork St. The catalogue for "Abstract and Concrete Art" was published in the issue dated 1 May 1939.

2. Two paintings, listed as *Plaisanterie Sérieuse* (1930) and *Tension Claire* (1937), and two gouaches, both of 1922. The two paintings are perhaps identifiable as Grohmann, 1958, no. 514, p. 338, and no. 640, p. 340.

Every Spiritual Epoch

1. Quoted after Roethel, 1970, p. 460.

2. Max Bill, ed., *Kandinsky, Essays über Kunst und Künstler*, 2d ed. (Bern-Bümpliz: Benteli Verlag, 1963), p. 249.

3. See above, p. 814 and n. 4.

Domela

1. This translation has been made from the version of the text in the volume *Domela, par Wassilly Kandinsky et Marcel Brion,* [sic], published by Galerie 93 (93 Faubourg Saint-Honoré, Paris) in October 1956.

Color Questionnaire, 1923

1. A photograph of the original questionnaire is reproduced in Wingler, 1968, p. 89. Kandinsky was in charge of the workshop for mural painting at the Bauhaus in Weimar.

Extract from a Letter

1. That the exhibition did in fact take place, and that the date 1931 is correct, has been confirmed by a letter of 6 June 1978 from Professor Arno Breker to Peter Vergo, but so far it has proved impossible to establish any further details. The editors wish to express their gratitude to Professor Breker, and also to Leopold Sanchez, Nice, for their help in this connection.

Bibliography of Kandinsky's Writings

Below are listed all Kandinsky's writings published prior to his death in 1944, as well as his last essay, "Les reliefs colorés de Sophie Taeuber-Arp." Also noted are some (though not all) translations and republications, whether in whole or in part, authorized by Kandinsky himself. There has, however, been no attempt to list all the various translations and re-editions of major works like *On the Spiritual in Art* and "Reminiscences." Cross-references to the already published French and Italian "complete" editions, which are in fact incomplete, were considered pointless.

Writings are listed chronologically by date of publication. The "See pp." citations following each entry refer to this edition.

1. "O nakazaniiakh po resheniiam volostnykh sudov moskovskoi gub." *Trudy obshchestva liubitel'ei estestvoznaniia, antropologii i etnografii* (Moscow) 51, no. 9 (1889):13–19. For synopsis, see n. 4 to the introduction to this edition, pp. 862–63.
2. "Iz materialov po etnografii sysol'skikh i vychegodskikh zyrian," *Etnograficheskoe obozrenie* (Moscow), no. 3 (1889):102–10. For synopsis, see n. 4 to the introduction to this edition, pp. 862–63.
3. "Kritika kritikov," *Novosti dnia* (Moscow), nos. 6407, 6409 (17, 19 April 1901). See pp. 33–44.
4. "Korrespondentsiia iz Miunkhena." *Mir Iskusstva* (St. Petersburg), nos. 5–6 (1902):96–98. See pp. 45–50.
5. "Vorwort" to the catalogue *Neue Künstler-Vereinigung München E.V.* (Munich); the catalogue exists in two versions, one inscribed "Turnus 1909–1910", the other "Turnus 1910." See pp. 52–53.
6. "Pis'mo iz Miunkhena." *Apollon* (St. Petersburg), no. 1 (Khronika) (October 1909):17–20; no. 4 (Khronika) (January 1910):28–30; no. 7 (Khronika) (April 1910):12–15; no. 8 (Khronika) (May–June 1910):4–7; no. 11 (Khronika) (October–November 1910):13–17. See pp. 54–80.
7. Untitled statement. In [the catalogue] *Neue Künstler-Vereinigung München E.V. (II Ausstellung), Turnus 1910–11* Munich:1910, p. 7. See pp. 81–83.
8. "Soderzahnie i forma." *Salon 2, mezhdunarodnaia khudozhestvennaia vystavka. . . .* Odessa:1910–11, pp. 14–16. See pp. 84–90.
9. Notes to the article "Paralleli v oktavakh i kvintakh," by Arnold Schoenberg. Translated into Russian by Kandinsky. *Salon 2, mezhdunarodnaia khudozhestvennaia vystavka . . .*, pp. 16–18. See pp. 91–95.

911

10. "Kuda idet 'novoe' iskusstvo?" *Odesskie novosti* (Odessa), no. 8339 (9 February 1911). See pp. 96–104.

11. Untitled statement. In *Im Kampf um die Kunst: Die Antwort auf den "Protest Deutscher Künstler."* Munich: R. Piper & Co., 1911, pp. 73–75. See pp. 105–8.

12. Two untitled statements. In [the catalogue] *Die erste Ausstellung der Redaktion "Der Blaue Reiter."* Munich: 2d printing, 1911–12. See pp.109–13.

13. *Über das Geistige in der Kunst.* Munich: R. Piper & Co., 1912. The first edition, published December 1911, bore the date 1912; a second, enlarged edition was published in spring 1912; and a third edition, identical to the second, was published in autumn 1912. See pp. 114–219. Extracts and individual chapters published separately in *Der Sturm* (Berlin) 3, no. 106 (April 1912):11–13; in *Camera Work* (New York), no. 39 (1912):34; and in *Blast* (London), no. 1 (1914):119–25. See also Bibl. 24.

14. "Die Bilder." In *Arnold Schönberg. Mit Beiträgen von Alban Berg . . . W. Kandinsky. . . .* Munich: R. Piper & Co., 1912, pp. 59–64. See pp. 221–26.

15. Untitled statements. In [the catalogue] *Die zweite Ausstellung der Redaktion "Der Blaue Reiter."* Munich: 1912, pp. 3–4. See pp. 227–28.

16. *Der Blaue Reiter. Herausgeber: Kandinsky, Franz Marc.* Munich: R. Piper & Co., 1912. Contains three essays by Kandinsky: "Eugen Kahler," "Über die Formfrage," and "Über Bühnenkomposition" (pp. 53–55, 74–100, 103–13) and his stage composition *Der Gelbe Klang* (pp. 115–31). A second edition of *Der Blaue Reiter* was published in 1914, with an additional preface by Kandinsky. See pp. 229–83. A brief extract from "Über die Formfrage" (p. 98) was reprinted in the catalogue of the exhibition "Le Fauconnier" (Paris: Galerie Joseph Billiet, 1921). "Über Bühnenkomposition" was republished in Russian in the journal *Izobrazitel'noe Iskusstvo,* (Petrograd), no. 1 (1919): 39–49.

17. Untitled, autobiographical statement: In [the catalogue] *Kandinsky: Kollektiv-Ausstellung 1902–1912.* Munich: Verlag "Neue Kunst", 1912, pp. 1–2. See pp. 341–46.

18. "Über Kunstverstehen." *Der Sturm* (Berlin) 3, no. 129 (October 1912):157–58. Republished in Russian in the catalogue *Odesskaia vesennaia vystavka kartin.* Odessa: March 1914, pp. 9–13. See pp. 286–90.

19. *Klänge.* Munich: R. Piper & Co. [1912?]. Individual poems, or groups of poems, were subsequently published on several occasions and in various languages, notably in the anthology *Poshchechina obshchestvennomu vkusu* (Moscow: G. L. Kuzmin, 1912; see p. 347); in lieu of a preface to V. V. *Kandinsky, Tekst Khudozhnika* (Moscow: IZO NKP, 1918; see p. 348); and in the journal *Transition* (Paris, New York) 1938 (see pp. 809–12). See this edition, pp. 291–338.

20. "Ergänzung." In [the catalogue] *Kandinsky: Kollektiv-Ausstellung 1902–1912.* Munich: 2d ed. Verlag "Neue Kunst," 1913, pp. 3–6. See Bibl. 17 above, and pp. 341–46.

21. Letter to the editor. *Russkoe Slovo* (Moscow), no. 102 (4 May 1913). See p. 347.

22. "Malerei als reine Kunst," *Der Sturm* (Berlin) 4, nos. 178–79 (Septem-

ber 1913):98–99. See pp. 348–354. Republished in Herwarth Walden, Expressionismus: Die Kunstwende. Berlin: Verlag "Der Sturm", 1918.

23. "Rückblicke"; "Komposition 4"; "Komposition 6"; "Das Bild mit weissem Rand". In Kandinsky 1901–1913. Berlin: Verlag "Der Sturm", 1913, pp. iii–xxix, xxxiii–xxxiv, xxxv–xxxviii, xxxix–xxxxi. See pp. 355–91 and Bibl. 28 below.

24. "O dukhovnom v iskusstve." Trudy vserossiiskago s'ezda khudozhnikov, Dekabr' 1911–Ianvar' 1912gg. Vol. 1. Petrograd: Golike and Vilborg, 1914, pp. 47–75. Transcript of an earlier, Russian version of On the Spiritual in Art; see pp. 114–219.

25. Letters to A. J. Eddy. In Arthur Jerome Eddy, Cubists and Post-Impressionism. Chicago: A. C. McClurg & Co., 1914, pp. 125–26, 130–31, 135–37. See pp. 401–6.

26. Om Konstnären. Stockholm: Gummesons Konsthandels Förlag: 1916. See pp. 407–18.

27. "Konsten utan ämne," Konst (Stockholm), nos. 1–2 (1916). See pp. 419–20.

28. "Stupeni." In V. V. Kandinsky, Tekst Khudozhnika. Moscow: IZO NKP, 1918. A Russian version of "Rückblicke" (see Bibl. 23 above), considerably altered in parts. See pp. 355–82.

29. "Malen'kie stateiki po bol'shim voprosam: I. O tochke; II. O linii," Iskusstvo: Vestnik otdela izobrazitel'nykh iskusstv Narodnago Komissariata po prosveshcheniiu (Moscow), no. 3 (1 February 1919):2; no. 4 (22 February 1919):2. See pp. 421–27.

30. "Kunstfrühling in Russland." Die Freiheit, Abendausgabe (Berlin), 9 April 1919. See pp. 428–29.

31. "W. Kandinsky: Selbstcharakteristik." Das Kunstblatt (Potsdam) 3, no. 6 (June 1919):172–74. See pp. 430–33.

32. "Muzei zhivopisnoi kul'tury"; "O velikoi utopii"; "Shagi otdela izobrazitel'nykh iskusstv v mezhdunarodnoi khudozhestvennoi politike"; Khudozhestvennaia Zhizn' (Moscow), no. 2, (January–February 1920):18–20; no. 3, (March–April 1920):2–4, 16–18. See pp. 434–54.

33. Programma Instituta Khudozhestvennoi Kul'tury. Moscow: 1920. Reprinted in I. Matsa et al., eds., Sovetskoe iskusstvo za 15 let. Moscow and Leningrad: 1933, pp. 126–39. See pp. 455–72.

34. Résumé of an untitled lecture. In Vestnik rabotnikov iskusstv (Moscow), nos. 4–5 (1921):74–75. See pp. 473–74.

35. "Vorwort" to Katalog der Ersten Internationalen Kunstausstellung Düsseldorf 1922 . . . , Veranstalter: "Das junge Rheinland." (Düsseldorf): 1922. See pp. 478–79.

36. Reply to a Questionnaire ["Ein neuer Naturalismus?"]. Das Kunstblatt (Potsdam) 9, no. 9 (September 1922):384–87. See pp. 480–82.

37. Untitled statement. In the catalogue of a Kandinsky exhibition held by Gummesons Konsthandel, Stockholm: 1922. See pp. 483–85.

38. Introductory statement. In Kleine Welten. Berlin: Propyläen Verlag, 1922. See pp. 486–87.

39. "K reforme khudozhestvennoi shkoly." Iskusstvo (Moscow), no. 1

(1923):399–406. See pp. 489–97.

40. "Die Grundelemente der Form"; "Farbkurs und Seminar"; "Uber die abstrakte Bühnensynthese." *Staatliches Bauhaus Weimar, 1919–1923.* Weimar and Munich: Bauhausverlag, 1923, pp. 26, 27–28, 142–44. See pp. 498–507.

41. "Gestern—Heute—Morgen." In Paul Westheim, ed. *Künstlerbekenntnisse.* Berlin: Propyläen-Verlag, 1925, pp. 164–65. See pp. 508–9.

42. "Zwielicht." In Carl Einstein and Paul Westheim, eds. *Europa-Almanach.* Potsdam: Gustav Kiepenheuer, 1925, p. 65. See p. 510.

43. "Abstrakte Kunst." *Der Cicerone* (Leipzig) 17 (1925):639–47. Also translated into Serbo-Croatian by Nina-Naj and published in the periodical *Zenit* (Belgrade) 5 (1925), in two parts, under the title "Apstraktna umetnost." See pp. 511–18.

44. "Tanzkurven: Zu den Tänzen der Palucca." *Das Kunstblatt* (Potsdam) 10, no. 3 (March 1926):117–20. See pp. 519–23.

45. *Punkt und Linie zu Fläche; Beitrag zur Analyse der malerischen Elemente.* Munich: Albert Langen, 1926. A second edition was published in 1928, unaltered save for an additional preface. See pp. 524–698. A much-condensed fragment of the text was published in French, accompanied by some of the original illustrations, in 1928 under the title "Analyse des éléments premiers de la peinture"; see appendix, pp. 851–55, and Bibl. 82.

46. "der wert des theoretischen unterrichts in der malerei." *bauhaus* (Dessau), 1, no. 1 (December 1926):4. See pp. 701–5

47. "Und, Einiges über synthetische Kunst"; untitled statement [discussion of Ernst Kállai's "Malerei und Photographie"]. In *i10* (Amsterdam) 1, no. 1 (January 1927):4–10; no. 6 (June 1927):230–31. See pp. 707–18.

48. "aus 'violett,' romantisches bühnenstück von Kandinsky. *bauhaus* (Dessau) no. 3 (July 1927):6. See pp. 719–21.

49. "Uber die abstrakte Malerei." Notes published in an exhibition catalogue by the Frankfurter Kunstverein (Frankfurt), February 1928. See note 3 to p. 861.

50. "kunstpädagogik"; "unterricht kandinsky, analytisches zeichnen". *bauhaus* (Dessau) 2, nos. 2–3 (1928):8, 10–11. See pp. 722–29.

51. Untitled statement. In [the catalogue] *Oktober-Ausstellung in der Galerie Ferdinand Möller.* Berlin: 1928. See p. 730.

52. "Die kahle Wand." *Der Kunstnarr* (Dessau) 1 (April 1929):20–22. See pp. 731–34.

53. "Zwei Ratschläge." *Berliner Tageblatt,* no. 412, (1 September 1929.) See pp. 735–36.

54. Reply to a Questionnaire. In Paul Plaut. *Die Psychologie der produktiven Persönlichkeit.* Stuttgart: Ferdinand Enke, 1929, pp. 306–8. See pp. 737–40.

55. Reply to a Questionnaire ["Enquête: 1830–1930"]. *L'Intransigeant* (Paris), 2 December 1929. See pp. 741–43.

56. "Der Blaue Reiter (Rückblick)." *Das Kunstblatt* (Potsdam) 14, no. 2 (February 1930):57–60. See pp. 744–48.

57. "Modeste Mussorgsky: 'Bilder einer Ausstellung.'" *Das Kunstblatt* (Potsdam) 14, no. 8 (August 1930):246. See pp. 749–51.

58. "Réflexions sur l'art abstrait", *Cahiers d'Art* (Paris) 1, nos. 7–8 (1931):351–53. See pp. 755–60.
59. Untitled statement [tribute to Paul Klee]. In *bauhaus*, (Dessau), no. 3 (1931). See pp. 752–54.
60. Untitled statement [extract from a letter]. In [the catalogue] *Kandinsky-Ausstellung*. Berlin: Galerie Ferdinand Möller, February 1932. See p. 761.
61. Reply to a Questionnaire ["Pouvez-vous dire quelle a été la rencontre capitale de votre vie?"]. *Minotaure* (Paris) 1, nos. 3–4 (December 1933):110. See pp. 762–63.
62. Reply to a Questionnaire ["L'art aujourd'hui est plus vivant que jamais"]. *Cahiers d'Art* (Paris) 10, nos. 1–4 (1935):53–56. See pp. 764–71. Part of Kandinsky's article was reprinted in the catalogue *Wassily Kandinsky; Französische Meister der Gegenwart*. Bern: Kunsthalle, February–March 1937, pp. 1–2.
63. Untitled statement. In the catalogue *thèse—antithèse—synthèse*. Lucerne: Kunstmuseum, Spring 1935, pp. 15–16. See pp. 772–73.
64. "Line and Fish." *Axis* (London) 2 (April 1935):6. See pp. 774–75.
65. Untitled statement ["Omaggio a Baumeister"]. *Il Milione: Bolletino della Galleria del Milione* (Milan) 41 (May–June 1935). See p. 766.
66. "To retninger." *Konkretion* (Copenhagen), 15 September 1935, pp. 7–10. See pp. 777–79.
67. "Toile vide, etc", *Cahiers d'Art* (Paris) 10, nos. 5–6 (1935):117. See pp. 780–83.
68. "Abstrakte Malerei." *Kroniek van hedendaagsche Kunst en Kultuur* (Amsterdam) 1, no. 6 (April 1936):224–26. See pp. 784–89.
69. Reply to a Questionnaire ["respuestas ... al cuestionario de gaceta de arte"]. *Gaceta de Arte, Revista internacional de cultura* (Tenerife), no. 38 (June 1936):85–87. See pp. 790–92.
70. "Franz Marc." *Cahiers d'Art* (Paris), nos. 8–10 (1936):273–75. See pp. 793–97.
71. "Tilegnelse af Kunst." *Linien* (Copenhagen), 1937, pp. 2–4. See pp. 798–804.
72. "Ergo"; "S"; "Erinnerungen"; "Immer Zusammen" [together with two poems from *Klänge*, see Bibl. 19 above]. *Transition* (Paris, New York), no. 27 (April–May 1938):104–9. See pp. 809–12.
73. "L'art concret"; "Mes gravures sur bois", *XXᵉ Siècle* (Paris) 1, no. 1, (March 1938):9–15; no. 3, (July 1938):31. See pp. 813–18.
74. Extract from a letter to Madame Irmgard Burchard. In Peter Thoene [pseud.]. *Modern German Art*. Harmondsworth, Middlesex: Penguin, 1938, p. 76. See pp. 829–30.
75. "Abstract or concreet?"In the catalogue *Tentoonstelling abstracte kunst*. Amsterdam: Stedelijk Museum, 1938, pp. 8–10; also published in *Kroniek van hedendaagsche Kunst en Kultuur* (Amsterdam) 3, no. 6 (April 1938):168–70. See pp. 831–32.
76. Untitled statement ["L'esprit poetique"]. *Cahier du Journal des Poètes: mensuel de création et d'information poétiques* (Brussels) 10 (1938); reprinted in *Art d'Aujourd'hui* 6, no. 5 (January 1950). See p. 83.

77. *"The Value of a Concrete Work." XX^e Siècle* [English ed. *XXth Century*] (Paris) 1, nos. 5–6 (Winter–Spring 1939):48–50; supplement to nos. 5–6. See pp. 820–28.
78. "Salongespräch"; "Testimonium Paupertatis"; "Weiss-Horn." *Plastique* (Paris, New York) 4 (1939):14–16. See pp. 836–39.
79. "Abstract and Concrete Art." *London Bulletin*, no. 14 (May 1939):2. See pp. 840–41.
80. Untitled statement ["Toute époque spirituelle . . . ", preface to the portfolio]. M. Bill, ed. *10 Origin.* Zürich: Allianz Verlag, 1942. See p. 842.
81. Statement [Preface]. In the album *Domela, six réproductions en couleurs d'après quelques oeuvres récentes.* Paris: Galerie Jeanne Bucher, 1943. See p. 842.
82. "Les reliefs colorés de Sophie Taeuber-Arp." G. Schmidt, ed. *Sophie Taeuber-Arp.* Basel: Holbein Verlag, 1948. See pp. 845–46.

Bibliography to the Appendix

83. Advertisement for *Der Blaue Reiter.* In Kandinsky. *Über das Geistige in der Kunst.* Munich: R. Piper & Co., 1912 [1911], following p. 104. See p. 849.
84. "Analyse des éléments premiers de la peinture." *Cahiers de Belgique,* (Brussels) 4 (May 1928):126–32. See pp. 851–55.

Note: Apart from items 83 and 84 above, the remaining texts printed in the Appendix (pp. 848–58) are placed there precisely because some doubt exists as to the exact date or manner of their publication; they are not, therefore, listed in this bibliography. Such bibliographic details as the editors have been able to discover are given in the headnote preceding each item.

Index

Index

Index

Other titles of interest

**ART AND POLITICS IN THE
WEIMAR PERIOD**
The New Sobriety 1917–1933
John Willett
272 pp., 218 illus.
80724-6 $17.95

STRANGER ON THE EARTH
A Psychological Biography of
Vincent van Gogh
Dr. Albert J. Lubin
304 pp., 137 illus.
80726-2 $14.95

**THE LEGACY OF
MARK ROTHKO**
Updated Edition
Lee Seldes
432 pp., 31 photos
80725-4 $15.95

ABOUT ROTHKO
Dore Ashton
241 pp., 38 plates, 8 in color
80704-1 $18.95

APOLLINAIRE ON ART
Essays and Reviews 1902–1918
Edited by LeRoy C. Breunig
592 pp., 16 illus.
80312-7 $13.95

THE *BLAUE REITER* ALMANAC
Edited by Wassily Kandinsky
and Franz Marc
296 pp., 113 illus.
80346-1 $13.95

**DIALOGUES WITH MARCEL
DUCHAMP**
Pierre Cabanne
152 pp., 20 illus.
80303-8 $9.95

THE DIFFICULTY OF BEING
Jean Cocteau
Introduction by Ned Rorem
174 pp.
80633-9 $13.95

**EARLY AMERICAN MODERNIST
PAINTING 1910–1935**
Abraham A. Davidson
342 pp., 178 illus., 8 in full color
80595-2 $19.95

JACKSON POLLOCK
Energy Made Visible
B. H. Friedman
New foreword by the author
350 pp., 64 illus.
80664-9 $14.95

JOAN MIRÓ
Selected Writings and Interviews
Edited by Margit Rowell
364 pp., 33 illus.
80485-9 $14.95

A JOSEPH CORNELL ALBUM
Dore Ashton
256 pp., 107 illus.
80372-0 $22.95